HANDS
IN
CLAY

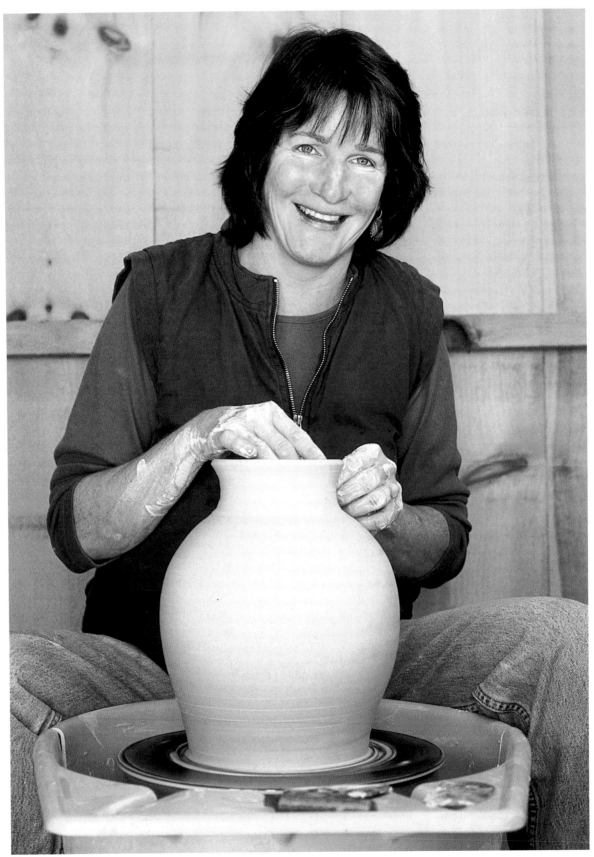

Diane B. Heart, United States. *Photo by Mark Preu.*

HANDS IN CLAY

FIFTH EDITION

CHARLOTTE F. SPEIGHT

JOHN TOKI
California College of the Arts

Boston Burr Ridge, IL Dubuque, IA Madison, WI New York San Francisco St. Louis
Bangkok Bogotá Caracas Kuala Lumpur Lisbon London Madrid Mexico City
Milan Montreal New Delhi Santiago Seoul Singapore Sydney Taipei Toronto

The McGraw·Hill Companies

Mc Graw Hill **Higher Education**

HANDS IN CLAY
Published by McGraw-Hill, an imprint of The McGraw-Hill Companies, Inc. 1221 Avenue
of the Americas, New York, NY 10020. Copyright © 2004 by the McGraw-Hill Companies,
Inc. All rights reserved. Previous editions © 1999, 1995, 1989 by Mayfield Publishing
Company, © 1979 by Alfred Publishing, Inc. No part of this publication may be repro-
duced or distributed in any form or by any means, or stored in a database or retrieval sys-
tem, without the prior written permission of The McGraw-Hill Companies, Inc., including
but not limited to, in any network or other electronic storage or transmission, or broadcast
for distance learning.

Some ancillaries, including electronic and print components, may not be available to cus-
tomers outside the United States.

This book is printed on acid-free paper.

4 5 6 7 8 9 0 DOW/DOW 0 9 8 7 6

ISBN 13 : 978-0-07-251951-8
MHID 0-07-251951-7

Publisher: Chris Freitag
Sponsoring editor: Joe Hanson
Development editor: Carolyn Smith
Marketing manager: Lisa Berry
Production editor: Jennifer Chambliss
Production supervisor: Richard DeVitto
Design manager: Cassandra Chu
Interior design: Glenda King
Cover designer: Cassandra Chu
Art editor: Robin Mouat
Photo research coordinator: Alexandra Ambrose
Photo researcher: Robin Sand
Editorial assistant: Torrii Yamada
Compositor: Thompson Type
Typeface: 9.5/12 Melior
Printer: R.R. Donnelley-Willard

Library of Congress Cataloging-In-Publication Data

Speight, Charlotte F., 1919–
 Hands in clay / Charlotte F. Speight, John Toki.—5th ed.
 p. cm.
 Includes bibliographical references and index.
 ISBN 0-07-251951-7
 1. Pottery craft. I. Toki, John. II. Title.

 TT920.S685 2003
 738—dc21 2003051211

www.mhhe.com

Preface

Hands in Clay, now in its fifth edition, contains material useful to students and professionals at all levels. Expanding on the first edition's goal of providing the basics for beginners—which has always been and continues to be a central objective of *Hands*—this edition represents the culmination of twenty-five years of classroom and studio use that informed the presentation of a truly comprehensive resource for students and professionals.

The book can be read in a variety of ways: as a challenge to the beginning and intermediate student to explore and learn the satisfying craft of ceramics, as a technical resource for the advanced student and professional, and as a glimpse into the wellspring of human creativity.

A stated aim of the book's first edition was to emphasize the special relationship that people of all cultures and eras have developed with this earthy material, believing that readers would benefit greatly from seeing how others before them have worked with clay to create useful and beautiful objects. The revised book still tells the story of how humans developed a new technology, improved it over thousands of years, and continue to work with clay.

There is no one way to work in clay. Creativity develops from exploring and experimenting, and we believe that you will better understand the possibilities inherent in the material if you see how human hands shaped clay in the past. Part 1, "Shaping the Past," describes how clay crafters around the world have built up a body of ceramics knowledge from experience. The illustrations convey a sense of human history preserved in clay, as well as show how many of the ancient techniques are still in use today.

In this first part you will see how ceramics techniques progressed from pinching to coiling to forming on the wheel, and how rudimentary kilns developed into the classic updraft kiln that is the ancestor of today's computerized kilns. But no matter how modern technology has changed ceramics, the excitement is still the same; as we see the raw clay being transformed by the firing process to a new state with totally different characteristics, ceramics history comes alive for us.

By reading Part 1 in conjunction with working through the methods taught in Part 2, you will become a part of the continuum of history. Part 2, "Shaping the Present," begins with "The Artist's Vision" (Chapter 9), which surveys the mysteries of the creative process. Many of the artists featured in this chapter speak of their own interest in ceramics history as an influence on their work. Chapter 10 explains the formation of clay through geologic processes and weathering. It also describes the process of obtaining clay, processing

and preparing it for working, and recycling it. In Chapter 11 the reader proceeds to the major hand methods of working with clay. Chapter 12 illustrates basic wheel techniques, starting with throwing a basic cylinder, to making domestic ware, to creating composite pots and altered wheel forms. Chapter 13 explores making and using molds to cast multiples, and Chapter 14 examines the intricacies of glazing. Chapter 15 demonstrates firing techniques ranging from pit-firing to firing with a computerized kiln. Chapter 16 discusses the process of planning and carrying out commissioned work and site-specific sculpture. Chapter 17 discusses the considerations involved in setting up an individual studio: buying equipment, utilizing space efficiently, and making accommodations to ensure one's health and safety. A new supplement, *Expertise: A Technical Guide to Ceramics,* has been developed from the appendices included in the previous editions of *Hands in Clay.* In *Expertise,* you will find clay and glaze recipes, as well as suggestions on how to repair, attach, and install ceramic works. In addition, there are lists of materials and supplies and sources of information on equipment and materials.

WHAT'S NEW IN THE FIFTH EDITION?

We approached the fifth edition in much the same way a potter develops a personal form or a sculptor evaluates a piece. Looking at the book with this critical spirit, and considering the input of others who have used it, we expanded on an undeveloped area here, moved a topic from one place to another, and enhanced the visual appeal of the book. The extensive technical information has been reviewed and updated, and lists of materials have been expanded, as have sources of information. *Expertise: A Technical Guide to Ceramics* provides information that is useful to all those in ceramics—from beginner to professional. A number of additional changes are highlighted below.

Part 1, Shaping the Past

- There are many examples of historic techniques that have been passed down through the generations. A discussion of their early development enriches the study of contemporary pottery forms. For example, the jug, or pitcher, is a classic form that has appeared in various cultures, serving a variety of uses from practical to display or commemoration. Its form and decoration mirror these differing uses and the cultures in which the pottery was made.
- The use of clay as a sculptural medium goes back to the Ice Age, and clay sculpture still plays an important role in contemporary ceramics.
- In areas of the world where continuing traditions endure, we show how potters there are adapting these traditions to changing markets.
- The survey of sculpture now includes the first clay "installation" in an Ice Age cave and continues to follow the course of ceramic sculpture through life-sized early Renaissance work in Italy to the most recent sculpture of contemporary artists working in both small and large scale.

Part 2, Shaping the Present

New illustrations in Part 2 include the work of a number of potters and sculptors—emerging as well as established—who demonstrate their forming, finishing, decorating, or firing methods. To aid students and professional sculptors, the book now contains an expanded section on armatures, as well as new information on materials, on building and forming methods, and on programming computerized kilns to fire a variety of ware from teacups to massive sculpture.

- In Chapter 9, a sculptor combines slabs and mixed media to create a haunting series of images chronicling the stages of a woman's life. A variety of other artists speak of personal experiences that influence their work.
- New illustrations in Chapter 10 show additional methods for drying work before firing and demonstrate a simple and effective way to recycle used clay without the use of a clay mixer or pug mill.
- In Chapter 11, new material ranges from demonstrating coiling methods to form a torso—a technique that could also be used to build a pot—to building larger-than-life sculpture using the most basic building techniques. Another newly illustrated process in this chapter

uses bundled newspaper as "drape molds" for forming sculptural multiples.

- A revised section in Chapter 12 takes a production potter through the steps of throwing and constructing a teapot.
- Chapter 13 has been substantially expanded to include additional information on mixing plaster to make molds of various types—from small one-part molds to large multipart molds appropriate for casting large sculpture sections. Step-by-step drawings show the making of a multipart mold for slip-casting a vase, while illustrations show a large sectional mold being made from an original clay sculpture and then used to create a porcelain wall piece. The chapter concludes with new illustrations and information on using a jigger and hydraulic press to speed the forming of pottery.
- Additional material in Chapter 14 explores making and using clay stamps for texturing and decorating clay. The chapter also includes illustrations and information on equipment and machinery—such as a ball mill—used for preparing glaze materials. Also included is an explanation of the triaxial-blend method of glaze formulation. There is also considerable added material on using underglazes and china paint.
- Chapter 15 includes new, detailed illustrations that explain the function of various parts of a kiln and kiln furniture. This chapter is also updated to cover computerized kilns and provides programs for unusual firings such as large sculpture. In addition, the firing coverage now demonstrates an ecologically sensitive kiln fired with sawdust, as well as new low-salt-firing information. A modern version of pit firing provides a link to the beginnings of ceramics technology.
- Chapter 16 contains examples of gallery installations and information on new site-specific works ranging from the construction and installation of a wall relief to engineering and installing a large freestanding outdoor sculpture. In addition, a fountain using colorful glazed tiles and a slab-formed sculpture installed in a garden pool illustrate the possibilities of private commissions.
- Chapter 17 has been expanded with photos of working potters and sculptors in their studios, showing how they adapt their spaces to their individual needs. Photos also show ceramists processing clay with a pug mill and

mixer, loading a car kiln, using a slab roller and extruder, weighing chemicals on a gram scale, and building a sculpture. These illustrations, with the text, are designed to help the home potter or new professional set up a convenient and healthy work space.

Expertise: A Technical Guide to Ceramics

The former appendices have been updated and expanded in *Expertise* to include new information on the availability of materials.

- Chapter 1D includes new percentage charts for clays, chemicals, frits, feldspars, and wood ash.
- In Chapter 2B, new kiln firing programs and graphs will help even the most experienced ceramist with unusual firing situations.
- All other sections of *Expertise*, including the sources of health and safety information, equipment, and materials have been expanded and updated to provide an extensive reference manual to ceramics resources of all types.

NOTE TO THE READER

A concern for health and safety in the ceramics studio figures prominently in this book, and the icon shown here in the margin and throughout the text alerts readers to the need for precautions. In addition, the materials lists in *Expertise* rate ceramics materials according to their toxicity. The most up-to-date research in the field of ceramics forms the foundation of this book, and every effort has been made to provide appropriate warning where potentially hazardous substances or procedures are involved. Anyone following these procedures should use his or her best judgment and common sense. The author and publisher shall not be liable in any event for incidental or consequential damages in connection with or arising out of the furnishing, performance, or use of the theories, procedures, and techniques herein.

ACKNOWLEDGMENTS

We are especially grateful to all the potters and sculptors who participated in this edition and

graciously took time to pose for photos, speak of their personal philosophies, explain their forming methods, share glaze and firing information, and encourage us in this revision. We also want to express our thanks for the thoughtful suggestions we received from teachers. There are others who have helped by alerting us to interesting exhibits or putting us in touch with additional people in the field; for this help, a particular thank you to Tom Cook in London and American potter Tim Frederich.

A number of reviewers who read and commented on the fourth edition also gave us useful input. They were:

Idie Adams, Butte Community College

Laura Bloomenstein, Yavapai College

Gina Bobrowski, University of New Mexico

Sadashi Inuzuka, University of Michigan

Amy Kephart, Southeast Missouri State University

Jack King, University of Tampa

Steve Kramer, Austin Community College

Louis Marak, Humboldt State University

Kathryn L. McCleery, University of North Dakota

Joyce Miller, Mt. Wachusett Community College

Marion Munk, Middlesex County College

Jane Rekedal, Gavilan Community College

Mark S. Richardson, Herron School of Art

Linda Speranza, Mesa Community College

Elmer Taylor, University of North Texas

And last, but far from least, during the long production period we have benefited from the dedicated, encouraging, and helpful team at McGraw-Hill Higher Education who gave us advice and encouragement when we needed it, as well as the support of their many professional talents. All of you worked so hard and put so much care and concern into the book to make this the most complete edition ever. Our grateful thanks go to: Joe Hanson, sponsoring editor; Carolyn Smith, development editor; Jennifer Chambliss, production editor; Cassandra Chu, design manager; Glenda King, interior designer; Robin Mouat, art editor; Alex Ambrose, photo research coordinator; Robin Sand, photo researcher; Torrii Yamada, editorial assistant; Andrea McCarrick, copyeditor; and Julianna Scott Fein, proofreader.

Contents

Part Two SHAPING THE PRESENT 157

| 10,000 B.C. | 5000 B.C. | 4000 B.C. | 3000 B.C. | 2000 B.C. | 1000 B.C. |

The movement of ceramics history reflects continuity and interchange of technology. Dates of objects are approximate.

WESTERN ASIA

Turntables to wheel

2-3

2-4

Sumer
Clay tablets

2-9

Covered updraft kilns

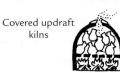
2-6

Babylon
Glazed tiles

2-10

EGYPT

Mythical inventor of the wheel

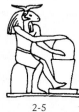
2-5

Painted pottery

1-18

MEDITERRANEAN

Painted pottery throughout western Asia

Cyprus

1-12

GREECE

Geometric

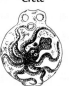
2-19

Crete

2-16

Painted ware

ICE AGE EUROPE

Fired figurines
c. 27,000 years ago

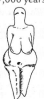
1-3

EUROPE

Incised ware

6-2
Wheel skills

JAPAN

Incipient Jomon

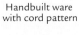

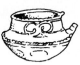
1-4

Handbuilt ware with cord pattern

3-3

KOREA

Old Silla pottery

Figurines

3-4

Figure vessels

3-25

Handbuilding until wheel brought from China

CHINA

Hillside kilns

3-7

Incised ware

3-6

Painted ware

1-19

AMERICAS

c. 12,000 to 14,000 years ago

shards found

MESOAMERICA

Olmec culture influences all Mesoamerica

Olmec

5-8

Tlatilco

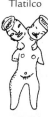

5-9

Lower Amazon Valley

5-3

500 B.C.	100 A.D.	1000 A.D.	1100 A.D.	1200 A.D.	1300 A.D.

AFRICA

Life-sized figures

Islamic influences in North Africa

Handbuilding and open firing of domestic ware

Nok

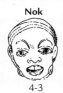

4-3

ISLAM

Glazed tiles in architecture

Luster and underglaze on pottery

Tin glaze and luster spread through North Africa to Spain

3-37

3-35

Spain

Hispano-Moresque tiles influenced by Islamic art

6-5

GREECE

Black and red figure vases

2-24

Tanagra figurines

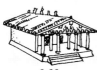

2-29

Greek potters work throughout Mediterranean

ROME

Ceramic factories: Terra sigillata kilns

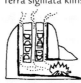

2-33

Roman Empire falls, ceramics technology lost in northern Europe

Byzantium

Lead glazes

EUROPE

Wheel and kiln technology return to northern Europe

Lead glaze

6-15

ETRUSCAN

Architectural sculpture

2-30

Chinese-style kilns
High-firing ash glaze reach Japan

Snake kiln 3-30

JAPAN

3-28

3-29

Wheel comes to **Japan** from **China** through **Korea**

Life-sized figures

3-10

CHINA

High-firing kilns

3-13

Ash glaze on stoneware

3-12

Lead glazes

3-16

Chambered kilns

3-21

CHINA

Imperial kilns

Porcelain

Celadon glaze

Export ware to Europe

3-17

MESOAMERICA

5-11

Maya painted vases

5-10

SOUTH AMERICA

Peru

Moche

5-4

Western Mexico

Figurines

5-14

NORTH AMERICA

Mimbres

5-16

1400	1500	1600	1700	1800	1900

AFRICA

Handbuilt, open-fired ceramics
for ritual use and domestic ware

Clay sculpture
in Benin for
bronze casting

Sudan
pipe bowls

4-9

Ashanti funerary
sculpture

4-6

Ibo
Yam spirit pots

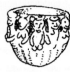

4-7

EUROPE

Italy

Tin glazes from Spain
via Majorca

6-6

"Maiolica" tin
glazes spread
throughout
Europe

Secret of porcelain
discovered, kaolin
found in Europe

Slip-decorated
earthenware

6-17

Great Britain

Staffordshire
potteries

6-22

Arts and crafts
movement: tiles

6-26

Germany

Salt-fired
stoneware

6-16

Improved wheels and kilns

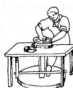

6-7

6-8

Holland

Blue and white
"Delftware"

Scandinavia

Factories
established

France

Chinese glazes

Studio
pottery

6-24

Art pottery

6-25

CHINA

White porcelain,
blue underglaze

3-23

Chinese porcelain reaches Europe

Chinese glazes influence West

JAPAN

Bizen ware

3-32

Raku tea bowls

3-31

Japanese factories fill European
demand for decorative wares

Edoware
3-33

UNITED STATES

Techniques and styles from Europe

Sgraffito

7-2

Stoneware

7-5

Slip-decorated ware

7-3

Lead glazes

7-6

African-American
potters make
face pots

7-4

AMERICAS

Mississippi and
eastern peoples

5-22

Northern
indigenous cultures

5-23

| 1910 | 1920 | 1930 | 1940 | 1950 | 1960 | 1970 |

AFRICA

Traditional forming
and firing techniques

Naa Jato
4-8

Sculptors and painters
work with potters

Fontana
8-3

Arneson
8-18

EUROPE

8-2

Bernard Leach
goes to Japan;
works with
Shōji Hamada

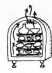

8-1

Gas-fired kilns, electric kilns,
and wheels aid potters

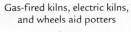

15-7

European artists
emigrate to U.S.A.

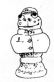

Grotell Natzlers
7-14 7-15

U.S. West Coast

New approach to clay

Gilhooley
8-14

Color comes
to sculpture:
low-fire glazes,
china paint,
luster, decals,
postfiring paint

Funk and Nut art

Bailey
8-12

Slip-cast
sculpture

Shaw
8-11

Price
8-10

Nagle
8-13

NEW WAYS WITH CLAY

JAPAN

Rosanjin 8-6

Japanese tea ceramics
and rural pottery
influence west

U.S.A.

Art pottery

George Ohr:
humor and
experiment

7-9

Art deco designs
in architecture

U.S. artists developing
American style

Robineau 7-7

Poor
7-13

WORLDWIDE INTERACTIONS

Pots to sculpture

Zauli
8-8

Voulkos Mason
8-4 8-9

De Staebler
8-17

Traditional forms

Casson Hill Mansfield
12-2 12-73 12-6

Traditional methods
adapted by potters
everywhere

U.S. Southwest

Painted ware

5-18

Handbuilding, pitfiring,
burnished blackware

5-20

Historic meeting
between Martinez,
Leach, and Hamada

Ethnic traditions
inspire contemporary
artists

WORLD WIDE TRENDS AND INTERCHANGES

New ways with old methods

China
Chen Songxian
11-48

Taiwan
Yeh
14-42

Sun Chao
14-52

Pinching
Walch
11-12

Throwing
Heart
12-85

Coiling
Thorne
11-32

Molds

Slabs

Steyaert
9-2

Bemzle
13-78

Figurative sculpture

Duckers
11-15

Shelton
9-11

Toubes
14-55

Smith
11-18

Altered pots

Kloda
13-72

Mixed media
Sargen-Singer
Realica

De Staebler
11-61

Digging natural clays
10-6

Mixed media

Gregor
11-63

Figurative sculpture
De Staebler
Rushmore

The vessel as art

Bayle
12-1

Hirsch

Tonegawa
14-2

Peggy Pritchett
9-6

Troy
15-38

Chaleff
8-22

Stamper
11-71

Luo Xiao Ping
11-68

GLOBAL CONNECTIONS

Raku firing

Soldner popularizes
raku and post-firing
smoking
15-74

Envelope kiln
15-31

Holt sawdust
kiln 15-49

Traditional firing techniques
adapted for contemporary use

Computer kiln
15-4

Wood firing: Japanese kilns
15-40

Pit firing

Front-loading
electric kiln
15-18

Salt firing
15-54
15-56

Wood kiln
15-36

15-83

Mitford-Taylor vase
15-80

Architectural

Zavadsky 16-10

Ethnic traditions inspire
contemporary artists

Kent
Suárez 16-18

Installations and Site-Specific Works

Spytkowska
16-38

Toki
16-16

Van Bentem
16-33

MacDonald
14-22

Shi Guo
11-69

Gregor
Tiled fountain
16-11b

Zavadsky
Green Donkey
11-62

Thorne
16-27

Winokur
16-15

Bazarir
prayer niche
16-36

Mattes
16-28

Part One

SHAPING
THE PAST

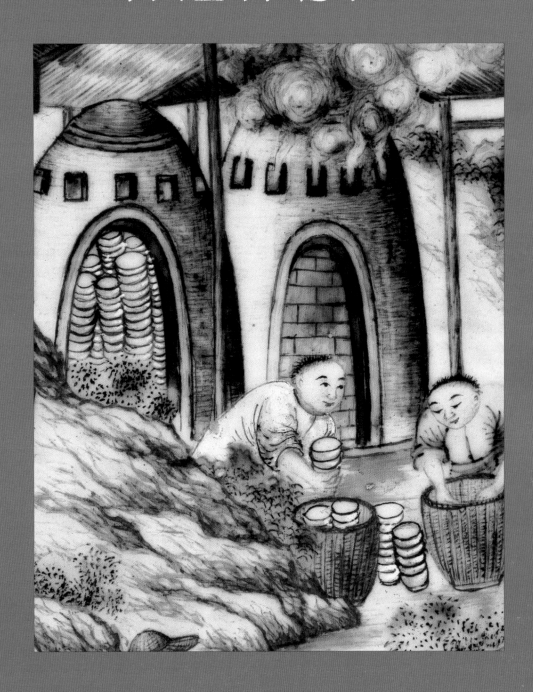

OVERLEAF

Potters in China stacking pots from a
recent firing, while other pots await firing
in saggars. Painted on a porcelain vase
during the Ming Dynasty (1368–1644) in
China. By this time, Chinese factories
were busy filling orders for the Arab
world and Europe (See also Chapter 3.)

1

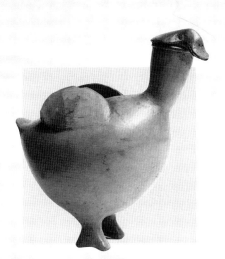

An Introduction to Clay

Clay feels soft and pliable in your hands. Let your fingers respond to its **plasticity,** and as you pinch and poke, the clay seems to have a life of its own. While pinching, you are repeating the gesture used by all the people who have worked with clay since the Ice Age.

The earth's surface was formed from melted rock that cooled and solidified over time. Then, weathered by freezing and thawing, ground by glaciers, pounded by rain, buffeted by wind, and worn down by rushing streams, the earth's crust broke into boulders, stones, then pebbles, and finally into the small particles that make up the different types of clay (1-1). Meanwhile, chemical changes took place as oxygen combined with minerals to form oxides such as iron, bringing important constituents to the clay.

The fertile areas of the earth are covered with a layer of topsoil that is rich in rotted organic matter. Under this soil, or under a layer of rock, deposits of various types of clay may be exposed where rivers cut into their banks, or by earth-moving machines.

CHARACTERISTICS OF CLAY

When dampened with water, clay is easy to form, holding together as it is shaped. When air-dried, it is fragile, crumbling easily. But when **fired** to its correct **maturing point** in a fire or a **kiln,** it becomes hard and permanent, capable of keeping its form for thousands of years.

Clay's plasticity when damp is due mainly to (1) the fineness of its particles (or **platelets**), (2) their flat shape, and (3) the action of the water between them. In addition, the organic materials that become mixed with the clay in its journey from rock to riverbank contribute to its malleability.

Clay was formed when the earth's feldspathic crust was weathered—broken down by rain, snow, frost, and thaw into pebbles, grains, and particles. The clay was then transported by geological upheavals, glaciers, and rivers and deposited in beds.

FIGURE 1-1
The geological origins of clay.

Primary clay, a white, heat-resistant material (**kaolin**), is deposited near the rocks from which it is derived.

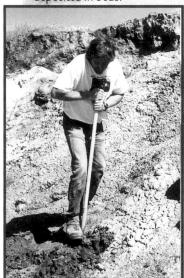

Eric Struck, photo courtesy Industrial Minerals Co.

Secondary clays are found in dry banks, along river beds, or in road cuts as **earthenware**, **stoneware**, or **refractory clays**.

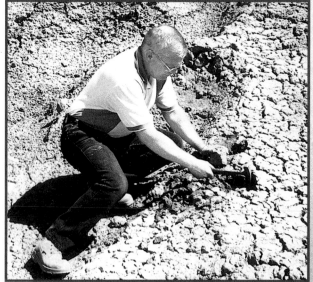

Jerry Rott, photo courtesy Industrial Minerals Co.

Mined throughout the world, natural clay becomes workable when water is added. Cleaned, with temper added, clay can be formed into pots or sculpture. Dried and fired, its chemical and physical composition changes: it becomes **ceramic**.

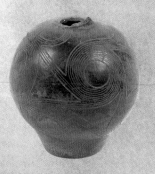

*Mississippi Valley Culture
Courtesy National Museum
of the American Indian,
Smithsonian Institution (00/7380, move image).*

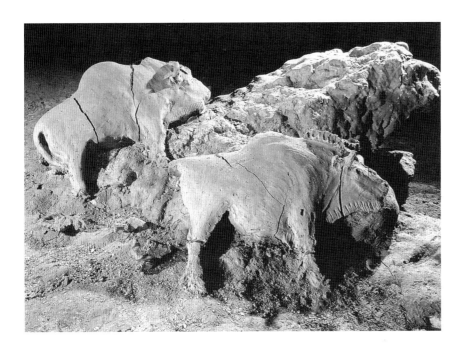

FIGURE 1-2
These unfired sculptured bison were formed in a bank of damp clay in a cave in France, sometime between 15,000 and 10,000 years ago. The relief sculpture clearly shows the marks of human hands in clay. A tool, perhaps of bone, was used to incise the details. The constant cave atmosphere preserved this early clay sculpture although it was never fired. Each relief is about 2 ft. (61 cm.) long. The cave of Tuc'Audoubert, Dordogne, France. *Given anonymously. Photograph © 2001 The Museum of Modern Art, New York/© 2001 Artists Rights Society (ARS), New York/ADAGP, Paris.*

When water is absorbed by dry clay, the film it forms between the platelets lubricates them so that they slip against each other, but the water film also makes them cling together, just as smooth pieces of glass both cling to and slide against each other when they are wet. It is this plasticity that led early peoples to model images in clay (1-2).

Clays differ greatly in their degree of plasticity. Some are so sticky they are almost impossible to shape; other clays, which might work well when used in a semiliquid **slip** state for **casting,** would never hold together if used damp for **throwing** on a **potter's wheel.** Clay that is a joy to shape on the wheel may not be successfully modeled into a large sculpture, so the clay worker must take into account the properties of each clay in relation to the desired results. These variations in clay, as well as the local availability of specific clays, had an important effect on how the craft of ceramics developed in different areas of the world.

COMPONENTS OF CLAY

Feldspar, the most abundant mineral on the earth's surface, is an essential component of granite rocks and is the basis of clay. (For a complete listing of the materials and chemicals used in ceramics, see *Expertise,* Chapter 1E.) Made up primarily of the oxides **silica** and **alumina** combined with such **alkalies** as potassium and some so-called impurities such as iron, it is this feldspathic origin of clay that makes it possible to fire clay objects to a dense and permanent hardness. Just as the intense heat of a volcano can fuse the elements in certain rocks into the glassy substance obsidian, so can the heat of the fire fuse and transform the mineral components of clay into ceramic. To be capable of producing ceramic, a clay must contain, along with other components, a **flux** (a substance that lowers the melting point of another substance) and a **refractory** (a heat-resistant material). The amount of flux a clay contains in relation to the refractory material is one factor that controls the point at which a clay reaches its optimum density, or maturity.

TYPES OF CLAY

Ceramists refer to the particular types of clay they use as **clay bodies.** The clay body may consist of clay as it was found in its natural state, but the term *clay body* usually refers to a combination of materials that the potter, sculptor, or supplier has formulated for a specific purpose. To fuse and mature, each type of clay requires a different heat level and duration in the fire. Some, like **low-fired** earthenware clay, never do become as dense and **vitreous** (glassy) as

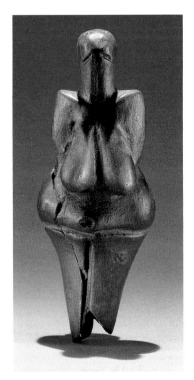

(a)

FIGURE 1-3
(a) Named *The Venus of Dolni Vestonice* for the Ice Age site where it was found in South Moravia, this figure is one of the earliest-known fired sculptures. It was discovered in a vaulted clay structure believed to be a kiln. Ht. 4½ in. (11 cm.). About 30,000 years old. *(b)* Reconstruction of an Upper Paleolithic hut at Dolni Vestonice, 30,000 years old, with a hearth and a clay structure believed to be a kiln in which clay figurines were fired. *(a) Courtesy Moravian Museum, Anthropos Institute, Brno. (b) Adapted from Wymer, J., 1982,* The Paleolithic Age, *Croom Helm, London.*

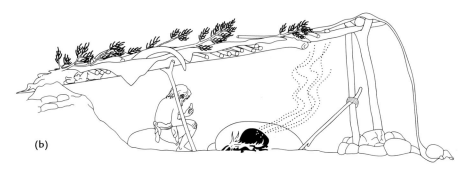

(b)

high-firing clays such as stoneware and **porcelain.** Variations in the size of the clay particles and in the temperatures at which clays reach maturity account for the differences in texture and appearance between, say, a white porcelain vase and a reddish flowerpot. Color variations are produced by the presence or lack of coloring oxides such as iron or manganese.

Later chapters contain detailed information about the composition of clays and the appropriateness of each type of clay for a particular type of ceramic work. In the first part of this book, however, we are concerned primarily with understanding how the characteristics of this earth material affected the development of ceramics technology and how people used ceramics in their lives throughout history and across cultures.

EARLY USE OF CLAY

Although the earliest-known examples of clay objects formed by human hands are unfired representations of animals modeled on a moist clay bank deep in a cave in France (see 1-2) the earliest fired clay objects found to date are animal and human figures found at an Ice Age site in eastern Europe (1-3). These objects reveal the beginning of the history of ceramics.

This very early use of fire to harden clay predates the oldest pottery yet found, but it seems to have been a localized development. So far, the earliest pottery excavated is the Incipient Jomon of Japan (1-4), dating to more than 12,000 years ago, and some **shards** found in northern Africa, dating to about 10,000 years ago.

The knowledge and technique necessary to transform damp clay into a ceramic material developed at various times in different cultures, but no matter where the craft evolved, it influenced the development of that culture. For example, knowledge of ceramics allowed villagers to make vermin-proof jars in which they could store grain against future crop failures as well as accumulate surpluses to trade with neighboring communities.

The new craft of ceramics depended on the exploitation of several intrinsic qualities of clay—its plasticity, its ability to hold its formed shape as it dries, and the fact that heating it to its maturing point transforms it into a new, permanently hard substance. Learning to control fire and deliberately using it to change a natural material was one of the first, if not the first, of humanity's technical achievements. Based on empirical rather than theoretical knowledge, it represents an important step in human history. Although the domestic use of ceramics was gen-

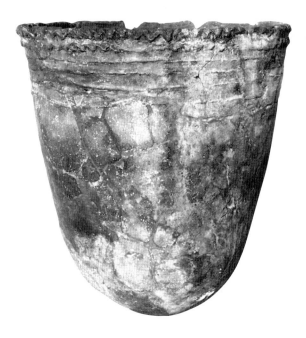

FIGURE 1-4
This vessel from Japan is among the most ancient pieces of pottery yet found, dating around 10,000 A.D. Called *Incipient Jomon* because it predates earlier finds classified *Early Jomon*, it represents a type of pottery that was made continuously for over 10,000 years. Jomon pottery was named for its cordlike decorations—the word *jo* means "straw rope" or "mat," while *mon* means "design." Unearthed in Ishigoya cave, in the city of Suzuka, Nagano prefecture, Japan. *Courtesy Museum of Archeology, Kokugakuin University, Tokyo, Japan.*

erally thought to be the only motivation for the production of the earliest pottery, some recent excavation sites contain only decorated, nonutilitarian pottery. This suggests that in some cultures the use of pottery to display status, or to use in ritual—rather than for domestic use—was the main motivation for developing ceramics.

Whatever the motivation, wherever it occurred, the development of pottery must have eventually altered the way food was prepared, thus changing the way people lived (1-5). Wild grains could now be cooked to a digestible state, and eventually they would be cultivated for food. The hunter-gatherer was now semisettled, at least during certain seasons of the year, leading to an increase in pottery production. Eventually, surpluses of food, pottery, or local natural materials led to trade. This in turn led to the exchange of ideas and technologies. Knowledge of ceramics would have certainly benefited from these interchanges. Some scholars suggest that it was at this point in the development of a society that the craft of pottery became specialized and men rather than women became the potters, producing ware for trade in addition to local use.

The close relationship between human hands and clay, along with the fact that a ceramic object is indestructible unless it has been crushed into such minute fragments that it cannot be repaired, has made it easier for archaeologists and historians to reconstruct how people lived in cultures that disappeared long ago. Even if a clay artifact has been broken, its shards can often be put together again. If the fragments are too scattered, the archaeologist can still study the type of clay in the remaining shards. From the nature of the decoration on the fragments, or the original shape of a pot or sculpture suggested by the preserved sections, it is possible to learn a considerable amount about a society—its degree of technical development, the extent of its trade, and its exposure to migrations of other peoples that may have introduced new ceramics techniques. For example, pottery made 6,000 years ago in Xi'an (Sian), China, reveals techniques and painted designs similar to those on older pottery found in Turkistan in western Asia, showing that interchanges occurred among the potters of these areas.

In addition, since most archaeological sites are rich in pot shards, excavators can often use techniques such as carbon-14 dating to establish a pottery sequence that allows the dating of other materials found in the same stratum, or layer.

EARLY CERAMICS TECHNOLOGY

Refer to the timeline preceding Part 1, and notice that the arrows do not run in straight lines. This configuration suggests the winding and often broken course of ceramics history and the interchanges or separations that existed between various areas of the ceramics-producing world. As new excavations bring more information to light, these connections change, as may our knowledge of when and where the earliest applications of ceramics technology appeared. For example, at one time scholars believed that ceramics developed only in settled villages, but we now know that groups of hunter-gatherer-fishers also developed ceramics technology in various parts of the world (see 1-3, 1-4).

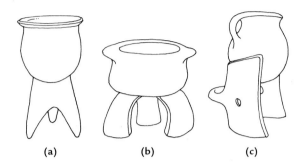

(a) (b) (c)

FIGURE 1-5
The invention of pottery making was a technological advance that changed cooking methods. Foods no longer had to be roasted over an open fire; they could be boiled in liquids directly over the fire. Various ceramic vessels and stands made this possible: In ancient China (a), a pot on three legs held liquids; in prehistoric Anatolia (b), cooks placed casseroles on another form of three-legged stand; while in ancient Greece (c), a stand with a built-in shield protected the fire from breezes and the cook from smoke.

How was ceramics—one of humanity's earliest technologies—discovered? Perhaps early humans observed the hardened clay floors of huts where fires were built, or they discovered how clay was transformed into ceramics by way of domestic accidents. It is probable that the discovery was frequently made by women, who worked around the fire, cooking over the flames and boiling water in finely woven baskets by placing heated stones in them. Indeed, archaeologists and anthropologists are able to determine whether the maker of an early vessel or figurine was male or female. Judging from the size of the fingerprints impressed in the clay, it appears that many early pots were made by women who probably produced these containers for their own domestic use, although there is recent evidence that in some cultures ceramics were used in ritual or for displays of wealth or power before the technology was applied to producing domestic ware. Later, when ceramic **wares** were made in larger quantities and for wider distribution, men apparently took over the work, making **pottery** a male trade.

Any reconstruction of history involves educated guesses, so we cannot say for certain how the earliest potters actually made their pots. However, experts can learn a good deal about their methods through the microscopic examination of ceramics found in excavations and the study of contemporary techniques that are believed to be similar to those of the earliest cultures. Thus, by watching a village potter in Africa or the American Southwest, we may learn something about how our ancestors worked out the problems encountered in preparing and forming the earliest pots and firing them.

Gathering the Clay

For the early potter, the first step in making a pot would naturally have been gathering the necessary material (1-6). An early village potter who had no cart or pack animal would have tried to find a clay source near enough to the village so that she could carry the clay back in baskets or leather bags. Sometimes a particular clay would have to be brought from quite a distance, but pottery was apparently important enough to the village to make even a difficult trip worthwhile. For example, in the Hebrides Islands off the Scottish coast, in the second millennium B.C., clay and the wood for firing it were scarce, and both had to be fetched from across the open water by dugout canoe.

Early potters would have been aware of their dependence on the earth. To potters in the American Southwest the earth was a sacred mother on whom they depended for life and health, and in many cultures a potter would not dig clay without proper religious observances. The potters would ask the earth's permission to remove the clay before digging it out with a stick. Mothers taught their daughters the required rituals, calling the earth Mother Clay, and to this day many potters in New Mexico scatter corn on the ground as an offering before digging clay.

When people first started making pottery, they probably used the damp clay just as it came from the riverbank or hillside, merely picking out the larger impurities. Sometimes the clay would be free of impurities and damp enough to be worked immediately. Alternately, dry chunks of clay dug out of banks could be broken up and softened with water, then spread in the sun to stiffen to working consistency (1-7). Potters still find natural clay deposits to test and fire (see 10-3).

Adding Temper to the Clay

At some point, potters must have discovered that a pot made of coarse-textured clay was less likely to burst or crack in firing than one made of fine-grained clay. This is because the moisture

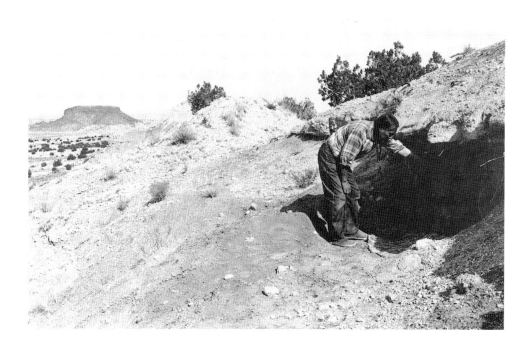

FIGURE 1-6
Julian Martinez, husband of the famous Tewa potter Maria Martinez, digging clay from an exposed bed on a mesa in New Mexico in the 1940s. Maria Martinez recalled that in her grandmother's day the digger always scattered corn as an offering before removing the clay—a custom that many potters still practice in the Southwest. New Mexico, c. 1940. *Photo by Wyatt Davis. Courtesy Museum of New Mexico, neg. no. 723.*

FIGURE 1-7
(a) Outside a workshop in Greece, chunks of clay dry before being broken up and soaked. Early potters could sometimes use clay as it came from the earth, but often the clay had to be cleaned and processed first.
(b) After digging, drying, pulverizing and soaking local clay, Greek potters spread it in the sun to stiffen. When the clay is ready to work, they will wedge and store it.

(a)

(b)

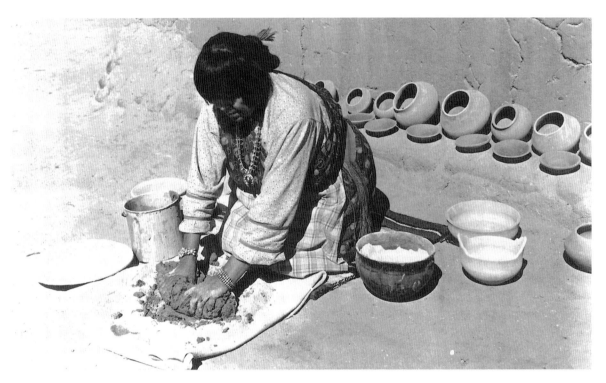

FIGURE 1-8
To create beautiful pottery, Maria Martinez needed nothing more than a level spot in the sun. In this photograph taken around 1940, she showed how she moistened her clay, kneaded tempering material into it, and worked it until she had eliminated the lumps or air bubbles. *Photo by Wyatt Davis. Courtesy Museum of New Mexico, neg. no. 50085.*

contained in damp clay can escape (as vapor) through the pores of coarse clay more readily than through the tighter body of fine clay. Some clays already contain a natural **temper** such as sand, mica, or volcanic ash. If, however, there was no natural temper, the next step was to add tempering material to the clay and mix it in thoroughly (1-8). Usually, all the potters in an area used the same locally available tempering material, so archaeologists can often determine the origin of a piece of pottery by noting what tempering material was used. For example, around 6000 B.C. in some areas of the Middle East potters mixed straw into their clay to open the pores, while in certain parts of the American Southwest traditional potters still use volcanic rock or sand as temper.

Early Forming Methods

The earliest containers probably were made by women who pinched or coiled the soft clay into simple pot shapes.

PINCHING If you pick up a lump of clay and let your thumb sink into it, turning it while pinching and pulling up and squeezing and compressing the wall as it grows between your fingers and thumb, you will find it easy to shape the clay into a rough, thick-walled but serviceable pot. However, it takes considerable skill to shape a thin-walled, aesthetically pleasing pot using the pinching method; if the clay is stretched too much during this process, it tends to crack, or the walls may collapse. It is also difficult when pinching to control the shape of the pot—for example, narrowing in a neck from a swelling body or opening it out into a flaring bowl.

COILING The tendency of clay to collapse might be why early pottery makers devised the **coiling** method, in which the potter built up the wall by adding rolls of clay one at a time, usually waiting for the lower ones to stiffen (1-9).

It would have been possible to make a flat-bottomed pot by coiling clay into a flat base, but to form a pot with a rounded bottom the potter would have more likely patted some clay out

over a smooth rock or pressed it into half a dried gourd, a basket, a broken pot, or even a hollow tree stump. In order to keep the damp clay from sticking to this simple **press mold,** the potter might have placed leaves or ashes under the clay. Special baked clay molds were also used. In the Tewa culture of the American Southwest, these molds were called *puki,* a word that has been adopted into modern ceramics vocabulary.

Once a base was formed, the potter would have rolled out coils between her hands or on a flat surface and then attached them to the base and built up the wall by attaching each coil to the one below it. This is the most common pottery-building method still used in traditional cultures, and it was widely used by the earliest potters.

On occasion, when a pot had been built up of coils or slabs of clay, the potter might have paddled the wall, forcing the clay particles together and thereby strengthening the wall as well as shaping the pot (1-10).

Sometimes, in the process of making a large pot through coiling, a potter might have found that so much clay had been built up on the base that the wall collapsed under its weight. As a solution, she might have built up her next pot only partway and set it aside to harden somewhat before adding more damp clay.

Whatever the method of applying the coils, the process of coiling has played an important role in the history of ceramics and is still used by many potters. As time went on, potters learned to control the clay more competently and were able to mold it into a great variety of shapes (see 1-11–1-15).

FINISHING　As the coiled wall rose under the potter's hands, she would shape and thin the wall and scrape and smooth the inside and outside with a tool made from a natural material—perhaps a piece of dried gourd or a shell. Sometimes this was all the finishing she would do before the pot was fired. But if she wanted an even smoother surface, she could **burnish** the clay when it had stiffened to a consistency called **leather hard.** To burnish, the potter took a smooth pebble, a piece of bone, or a shell and stroked the surface of the pot with rhythmic gestures, polishing the surface to a glossy finish and tightening the clay particles (1-16). This would have worked well on natural clay that did not contain large grains of temper. To burnish the surface of a pot made of coarse clay, the potter might

FIGURE 1-9
As we look at this woman in New Guinea building a pot on her lap using thick, damp coils, it is easy to imagine how the earliest potters pressed chunks and coils of clay together to make roughly constructed pots. Lokanu, New Guinea. © *The Field Museum, #CSA32000.*

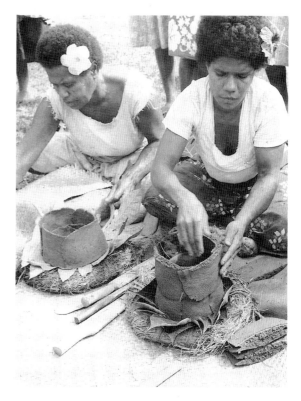

FIGURE 1-10
Resting their pots on bases of grasses and leaves, potters in the Fiji Islands form them with flat slabs of clay, which they will later shape through paddling. The paddling will also help meld the slabs together. *Courtesy Fiji Museum, Suva, Fiji.*

Early potters who lived close to the earth, planting, reaping, sorting, and grinding their food, had responsive fingers, and their pottery reflected this sensitivity. They were also aware of the stances and movements of the animals that shared their lives, so they sometimes shaped their pots into simplified, exaggerated, or distorted shapes of furred and feathered creatures (1-13, 1-14, 1-15). Some of the forms were based on containers made from other materials (1-11), while others were humorous adaptations to specific functions (1-12). Still others resulted from the potter's sensitive attention to the relationship between the rim and the base of a pot. Even if the early potter was making a vessel to hold a ritual libation, the work could still be lively and inventive within the limits set by tradition, showing keen observation and even humor.

FIGURE 1-11
This jar from Yortan, Anatolia, was shaped for easy pouring of liquids. Lines suggest the carrying cords that often made such jars portable. Ht. 9¾ in. (24.8 cm.). Third millennium B.C. *Copyright British Museum, London.*

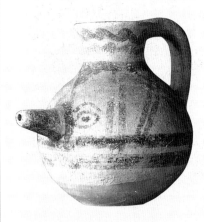

FIGURE 1-12
The shape of this earthenware feeding vessel is emphasized by the painted face with its pointed nose. Cyprus, tenth or eleventh century B.C. *Courtesy Board of Trustees of the Victoria & Albert Museum.*

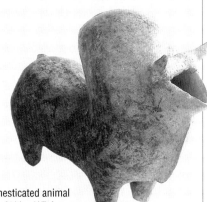

FIGURE 1-13
A lifelike depiction of a domesticated animal as a bull-shaped vessel. Ht. 6⅞ in. (17.4 cm.). First millennium B.C. *Copyright British Museum, London.*

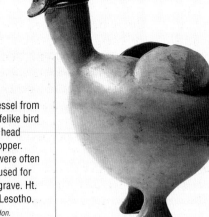

FIGURE 1-14
A bird-shaped pottery vessel from Africa. The neck of the lifelike bird forms the spout, and its head becomes the vessel's stopper. Animal-shaped vessels were often buried with the dead or used for pouring libations at the grave. Ht. 10 in. (25.4 cm.). Suto, Lesotho. *Copyright British Museum, London.*

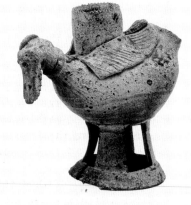

FIGURE 1-15
Potters of the Old Silla dynasty in Korea frequently modeled vessels in the shape of animals or people. Fifth or sixth century A.D. *Courtesy National Museum of Korea, Seoul.*

FIGURE 1-16
Burnishing with a smooth stone while the clay is stiff but still damp gives the pot an attractive glossy surface. It also serves to press the clay particles together, making the earthenware less porous. Smooth stones, like the one this potter in Ndola, Zambia, is using, were treasured possessions, often handed down through several generations. Ndola Rural. Chipulukusu Compound. *Courtesy Zambia Information Services Department, Lusaka, Zambia.*

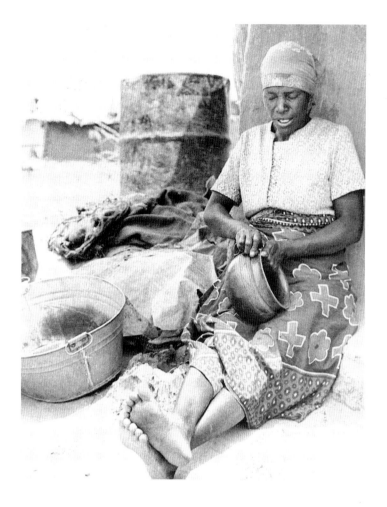

have first painted the pot with a coating of fine clay soaked in water—called slip—and then burnished this to a smooth surface, thereby also closing the pores.

However, even this treatment did not make low-fired earthenware truly watertight, because earthenware clay was not fired high enough to become impervious. So early potters used various methods to make it hold water or give it a smooth surface on which to paint decoration. Besides painting the surface with slip and burnishing, in an attempt to solve the problem of porosity potters treated their fired pots with a mixture made by boiling certain plants; alternatively, they coated the still-hot pots with pitch from native trees. Cooking in earthenware also helps to make it less porous over time, as does soaking it for a long time in water. None of these processes, however, made the earthenware truly watertight. The porosity of earthenware, however, would have been an advantage in hot climates, where water was usually stored in un-glazed earthenware jars so that evaporation through the pores of the clay cooled it.

DECORATING THE DAMP CLAY Some pots were left plain or burnished, but others were decorated with a simple pattern of incised lines that the potter scratched into the clay while it was still damp, using natural tools chosen to achieve texture and pattern. Repeatedly pushing a fingernail into the clay could also form a pattern or texture, as could poking holes into it or combing the serrated edge of a shell across the surface. Sometimes this decorative texture served a function, as on a water vessel that would otherwise be slippery or difficult to carry when wet. The potter's sense of design and awareness of the relationship between a pot's decoration and its shape often showed discernment, control, and aesthetic sensibility. For example, a potter in ancient Japan might decorate his pot with a combination of added texture and carving (see 1-4), while a Bronze Age potter in Scotland might

When potters discovered that certain earth pigments produced colored decorations on their fired ware, they often bathed the pottery with a mineral color—that is, they coated it with slip. If the pot was to be used for ritual or burial purposes, they might paint simple designs on the slip, using various mineral pigments, or simply burnish it and incise decorations into it (1-17). Interestingly, many early painted pots from widely separated cultures display similar spiral designs, leading some scholars to speculate about a common decorative ancestry. Painted on a bulbous early Egyptian pot (1-18), an elegant Chinese vessel (1-19), or a large urn from Crete (1-20), the spirals could have had religious significance, but it is also possible that the potters used these swirls and spirals because their rhythms were particularly appropriate to the swelling profiles of the pottery.

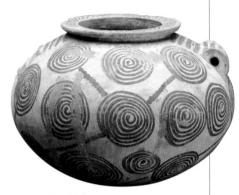

FIGURE 1-17
Dark, burnished pottery, usually with incised decoration, was typical of the Mississippi Valley culture. Its swirl design is remarkably like designs on pottery from Egypt (1-18), China (1-19), and Panama. *Courtesy National Museum of the American Indian, Smithsonian Institution (00/7380, move image).*

FIGURE 1-18
Spirals of purple painted on its surface relate to the bulbous shape of this pot made in Egypt sometime before 3000 B.C. Ht. 7½ in. (19 cm.). *Copyright British Museum, London.*

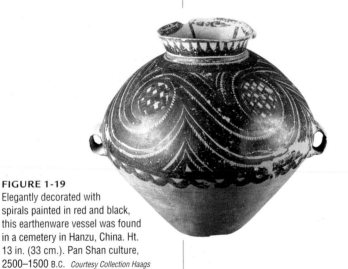

FIGURE 1-19
Elegantly decorated with spirals painted in red and black, this earthenware vessel was found in a cemetery in Hanzu, China. Ht. 13 in. (33 cm.). Pan Shan culture, 2500–1500 B.C. *Courtesy Collection Haags Gemeentemuseum, The Hague.*

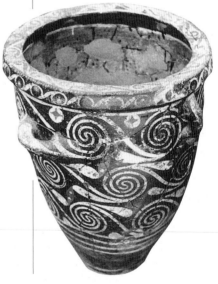

FIGURE 1-20
The spiraling, wavelike design on a large urn from the palace at Phaistos carries our eyes around this jar's form. Crete, 2000–1700 B.C. *© Heracleion Museum/Archaeological Receipts Fund.*

combine simple crosshatching and horizontal lines into an effective decoration.

The scratched or applied decoration was enriched by the color of the clay body, which could range from buff to reddish, from light to dark brown, or from gray to black, depending on its mineral composition or the firing methods used. Some pots, owing to uneven firing, came out of the fire with dark and light red and black splotches on the outside, a decorative effect that is still sought by many potters today. Other effects were created by applying earth pigments to the surface of the ware. The artistic eye of an early potter often enabled him to create a pot with decoration that enhanced its surface (see 1-17–1-20).

Early Firing Methods

Whatever method was used to shape the vessel or sculpture, obviously the piece eventually had to be fired before it could be changed into ceramic. The most abundant clay available throughout the world—earthenware clay—could be fired at a comparatively low temperature, reaching maturity in a relatively short time. This was due to the large amounts of iron in it, which acted as a flux, making it possible for the refractory components to melt at a low temperature. This low-firing clay body still supplies the bulk of cooking and storage containers in the remaining areas of the world where industrial products such as metal and plastics have not taken over the potter's market.

Local clays, local tempering materials, available firing materials, and even local climate also affected how a potter worked. Nowadays we can control humidity and drying by artificial means, but the early potter was at the mercy of the climate. In hot, dry Mesopotamia, for example, the work of building up a pot had to be done quickly, before the evaporation of moisture made the clay unmanageable. By contrast, a different difficulty existed for the Bronze Age potter in misty Scotland; there, getting pots dry enough to fire safely was the problem, and the potter probably had to dry them beside a fire for a long time before the moisture in their walls was completely driven out.

The first earthenware was undoubtedly fired in **open firing** or in pits, much as it is still done in some villages in Africa, Fiji, and parts of the Middle East and the American Southwest (see

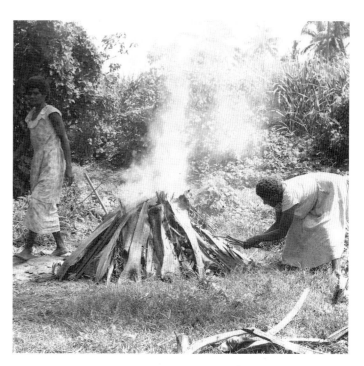

FIGURE 1-21
The earliest potters fired their pots in open fires, just as many village potters do today. In Fiji the pots are stacked together with palm fronds and grasses piled over them. Pots undergoing this type of firing can be damaged by gusts of wind that suddenly cause the fire to burn hotter. *Courtesy Fiji Museum, Suva, Fiji.*

5-21). Before firing, the potter air-dried the pots and sometimes, to speed the drying process and drive out all the water from the clay, may have burned dried grass or dung inside the containers. This process also heated the pots slowly, minimizing the **thermal shock** that could have caused them to crack in the fire.

Once the pots were thoroughly dry, they were stacked along with the fuel. This might have been wood, dung, sugar cane, peat, rice straw, palm fronds, or any combustible material that could be gathered locally in the necessary quantity (1-21).

How to stack the pots, how much straw or wood to use, and how long to burn the fire were technical decisions that potters worked out through experimentation, with some successes and undoubtedly many failures.

ENDURING TRADITIONS

There are gaps in the story of the development of ceramics, and much of the story is based on studies of traditional methods still in use today.

One thing is certain, though: Later generations of potters built directly on the discoveries made by their forebears. In this overview of the beginnings of ceramics, we have compressed thousands of years and the experiments of untold numbers of individual potters in villages around the world. The following chapters continue the story of the development of ceramics technology, leading up to the work of contemporary ceramists. No matter how complex modern ceramics has become, however, a handmade pot is still made of decomposed rock and is still formed by human fingers responding with sensitivity to the plasticity of clay.

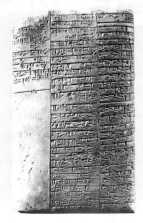

2

Early Western Asia and the Mediterranean

In the Western Hemisphere we have been accustomed to taking a Western-oriented approach to art history and the development of ceramics. We must remember, however, that fired pottery has been found in Japan that predates any found in the West (see 1-4). The science of archaeology itself developed out of eighteenth-century European interest in ancient Egyptian, biblical, and classical cultures. For this reason, the first excavations were conducted in western Asia, Egypt, Greece, and other areas bordering the Mediterranean. Most excavations took place at the sites of ancient villages, so it was assumed for many years that pottery developed only when humans settled into sedentary lives. Now that numerous pottery shards have been unearthed in various parts of the world at sites of the temporary or seasonal camps of hunter-gatherers, it has become clear that quite often pottery was made and used by nonsedentary peoples.

Once village life was well established on the mainland of western Asia in the Fertile Crescent, between the Tigris and Euphrates Rivers, and along the Nile River in Egypt (2-1), the population grew, trade and commercial activity expanded, and the demand for ceramic ware increased.

IMPROVED CERAMICS TECHNOLOGY

The potter was now a specialist, producing ware for a wider market than immediate family or village use. Now the potter became an essential part of the economy. So important was ceramics that the Egyptians believed it had been invented by a god, Khum (see 2-5), and there are references to potters in mythology and in the Old Testament. The

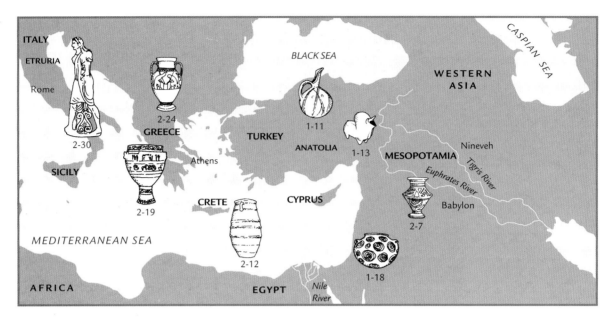

FIGURE 2-1
Potters and sculptors of the Mediterranean area and western Asia used clay to form figurines, vessels, and large sculptures. The drawings on this map show the geographic areas where some of the pots and sculptures illustrated in Chapters 1 and 2 were made.

potter now had to consider ways to increase his output, so the subsequent improvement of forming and firing methods was both a reason for, and a result of, his important role. Moreover, greater demand required faster production, which led to the development of new technologies.

From Turntables to Wheels

To understand how turntables may have evolved into the true potter's wheel, picture a potter kneeling or squatting in the sun outside a mud-daubed hut, coiling a pot. Perhaps she started the base in a broken pot, then rolled out coils to form the wall. As she built, smoothing the coils together, she probably turned the pot to keep the wall even. Then, tiring of holding it, she may have set it down on a flat stone and found that she could turn the pot more easily (2-2). This simple change in her working method may have led, after centuries of experiment, to the invention of the potter's wheels we use today.

It probably took several generations before someone thought of shaping the stone to make a socket that would hold and pivot a flat disk. Made from a smooth stone such as basalt, these shaped pivots could revolve quite quickly and smoothly, making it much easier to coil, smooth, and polish

a pot evenly (2-3, 2-4). Other early turntables were made of stone, wood, or clay disks that revolved on wooden shafts fitted into a stone (see 2-2).

Numerous methods were tried to speed the process of forming pottery, including one illustrated in an Egyptian tomb relief from about 4,500 years ago that shows workers in a pottery shop. Among them, a potter sits on a low seat, shaping a pot with his left hand while his right turns the wheel with a handle. Potters using such methods would have found that the work of shaping a pot became easier as the wheel revolved faster, and this discovery would eventually have led to the development of the true potter's wheel.

The True Potter's Wheel

We do not know exactly what type of wheel it was or just when or where someone added a lower disk that could be kicked by the potter's foot to start it whirling. Perhaps a potter had an assistant rotating the turntable (see 2-13) and discovered how it speeded the work. A true wheel must turn quickly enough—at least 100 revolutions per minute—to give the necessary **centrifugal force** to the lump of clay so that only a comparatively light pressure of the hands is

FIGURE 2-2
This diagram shows examples of turntables from various cultures and times. *(a)* A broken bowl resting on a stone helped the potter turn the pot as it was built. *(b)* A shaped fired-clay mold swiveling on it's rounded base is still used in the American Southwest. *(c)* A turntable with two stones shaped to fit together made it easier for the potter or assistant to turn it. *(d)* Some Mediterranean village potters still use this type of turntable, which pivots on a wooden axle turning in a socket (see 2-13a). *Drawing by John M. Casey.*

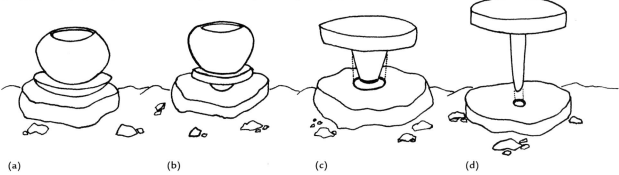

(a) (b) (c) (d)

FIGURE 2-3
This stone pottery-wheel bearing would have turned a disk—probably made of clay or wood—on which a pot was placed, making the forming of the pot easier and quicker. Beth Shean Israel, c. 500 B.C.
Courtesy Israel Antiquities Authority.

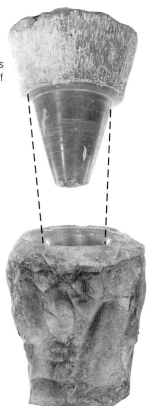

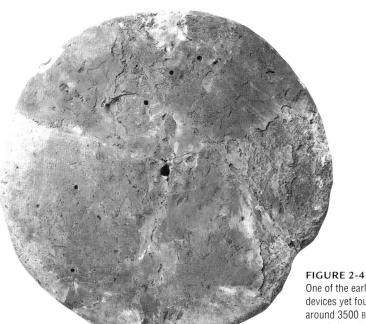

FIGURE 2-4
One of the earliest pottery-turning devices yet found. Used by a potter in Ur around 3500 B.C., it may have pivoted on an axle in a stone socket similar to those still used in Crete (see 2-13. Diam. 29½ in. (75 cm.). *Copyright British Museum, London.*

needed to make the wall rise. The main energy comes from the wheel rather than from the potter's hands.

Archaeologists have studied the characteristic finger marks on pots thrown on true wheels and have set probable dates for the first known use of a **kick wheel** at around 3500 B.C. in Mesopotamia, 2300 B.C. in Sumer, and after 2750 B.C. in Egypt and China. Even with the introduction of this more efficient way to produce uniform pots,

many potters continued to use turntables in traditional potters' villages. In some areas the fast-turning wheel was never used and turntables are still common today.

As potters throughout the whole of western Asia, Egypt, Africa, and the eastern Mediterranean continued to experiment with methods of forming, firing, and decorating pottery, ceramics technology gradually improved. Due to differences in communication or trade between

widely separated areas, the rate at which the technology spread and developed, although steady, was uneven. The Egyptian God Khum (2-5) was apparently seen as an accomplished potter using a kick wheel in early Egypt, while in Mesopotamia potters were developing kilns as early as 4,000 B.C. (2-6). Potters there used these domed **updraft kilns** to fire both utilitarian ware and decorated pots (2-7). By around 3000 B.C., in Nubia, up the Nile river, potters were making a thin ware, called *eggshell* by archaeologists (2-8). As ceramics knowledge grew and spread, the Mediterranean and Western Asia became one of the centers of pottery making.

Firing Technology

Although most early fired pots and sculptures were probably fired in pits or open fires, some may have been placed in a simple kilnlike structure of earth. The changes in firing methods from open firing to pit firing and finally to primitive kilns were perhaps both the result of a more sedentary lifestyle and at the same time a reason for people to settle in one place—at least for a time. Kiln technology probably developed from firing in pits in which the pots were covered with the firing material. Then a rudimentary kiln with a low wall was built around the pit. Eventually the wall was raised higher to protect the ware from erratic drafts, finally evolving into a simple kiln that was often left open at the top for loading the ware, then covered for each firing. This, in turn, led to a permanently covered kiln (see 2-6) with a stoke hole at the bottom for loading the fire, a perforated fired-clay floor or pillars on which to place the ware, and a **flue** to allow the smoke to escape. As mentioned earlier, these circular kilns were developed in Mesopotamia around 8,000 years ago. Variations of these updraft kilns were widely used throughout the ancient world and are still used in many areas today.

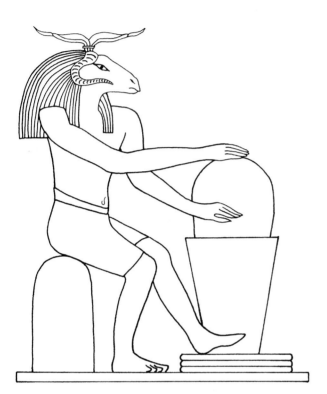

FIGURE 2-5
This drawing, based on an Egyptian carving, shows the god Khum using an early kick wheel. Myths from many cultures tell of gods or goddesses forming humans from clay, while others recount the discovery of pottery making in legendary terms. *Redrawn by John M. Casey.*

FIGURE 2-6
Potters in Mesopotamia around 4000 B.C. built vertical kilns that gave them greater control over the fire. Similar kilns, in which the heat rises from a firing chamber under a perforated floor, are still used in Crete today (see 2-14). *Drawing by John M. Casey.*

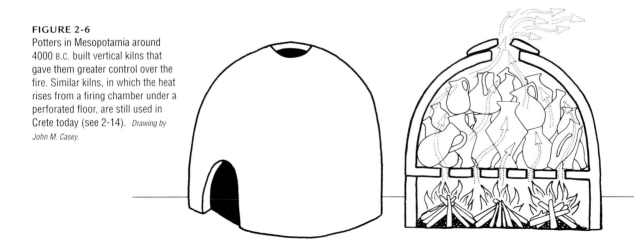

Fired Decoration

Using the developing ceramics technology, potters in various areas of western Asia produced pots of simple but satisfying form. Types of decoration varied widely from one place to another and from one culture to another, enabling archaeologists to trace trade routes with considerable accuracy. As in most cultures, the decorations on pots were simple at first; patterns were pressed into the damp clay, or incised lines were scratched into the surface.

In all the cultures that developed over a long period in western Asia, the bulk of the production was for domestic use, but vessels were also used for religious rituals and for burial. Domestic ware might be left the plain color of the clay, but ritual vessels were often decorated with earth pigments applied before firing (2-7). Generally these were decorated with red iron pigments, but in early Mesopotamia potters mastered the skill of firing both black and red areas on the same pot by adding potash to the iron pigments and changing the atmosphere within the kiln. The method of varying the firing atmosphere to turn entire pots or sections of them black by **reduction** was widely known in the Mediterranean area. In early Egypt, for example, burnished pots were apparently deliberately fired upside down so that the upper part and at least part of the inside became black while the rest of the pot remained red. This could have been achieved by burying the pot, top down, in the ashes of the fire so that only that part would have been reduced. Similar techniques were deliberately exploited by Greek potters, who may have been immigrants or slaves from western Asia. The sophisticated Greek application of this technique is explained fully later in the chapter (see Black-Figure Pottery and Red-Figure Pottery, pages 31–33).

EARLY GLAZES

Glazes are compounds of glass-forming minerals that fuse in the heat of the kiln and adhere to the clay body, coating it with a thin glassy layer. Glazes, like clay, are of geological origin. They consist of the refractories (heat-resistant materials) silica and alumina and a flux to make the ingredients fuse. Sand and flint (or quartz) are almost pure silica, and if they are heated to 3270°F/1798.8°C, they will fuse and form glass.

FIGURE 2-7
Mesopotamian potters formed their urns and jars in a variety of shapes, many of them decorated with earth colors applied in bold linear patterns that accentuated the curves of the vessels. Ht. 4½ in. (11.5 cm.). Nineveh, Mesopotamia, third millennium B.C. *Copyright British Museum, London.*

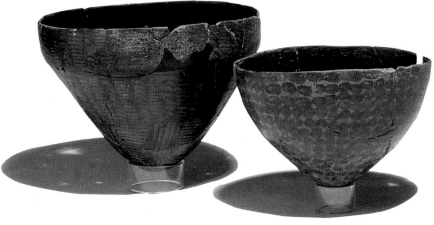

FIGURE 2-8
Pottery was made in the central Sahara desert as early as 7000 B.C., and in the upper reaches of the Nile River, Nubian potters developed a remarkably fine ware as early as 3,000 B.C. The ware was so thin that early archaeologists referred to it as *eggshell* ware. *(Left)* 6½ in. (15.4 cm.), *(right)* 4⅛ in. (12.2 cm.). *Courtesy the Trustees of the British Museum.*

At that temperature, however, the clay under them would also melt, so a flux is necessary to make lower firing feasible.

Glazes as we know them today were not part of ceramic knowledge in early western Asia, Egypt, or Greece. However, the very beginnings of a glaze technology can be seen there. Potters in this area had been experimenting over a long period with limited color and other surface treatments. By around 1370 B.C., some Egyptian potters had added cobalt to their color palette. These experiments required a tremendous investment of time, energy, and patience. Here, as with similar long-term experiments in China and Japan, we can see the beginnings of the use of ceramic coloring materials that would eventually lead to the many surface treatments and glazes available to contemporary ceramists.

Egyptian Paste

Although it is not known whether it was first developed in Mesopotamia or Egypt, the material that we call **Egyptian paste** (or sometimes incorrectly *faience*) has generally been associated with Egypt. This was not an applied glaze. Rather, the glaze was formed by ingredients in the clay body that were carried to the surface with the water as it evaporated, creating a shiny blue-green coating. When such a piece was fired, the **soluble** sodium would have fused with the glass-forming minerals in the sand, and particles of copper contained in the clay body would have given the coating its characteristic color. Once this glaze-forming clay body was discovered and potters realized what caused the color to appear, the Egyptians learned to add alkaline salts to the clay body to produce the colored, glassy surface. Obtained in the lakes formed by alkaline springs in the Nile Valley, the salts became an article of commerce whose revenues went to the pharaohs. The glaze-producing clay body was used mostly for small sculptures, ceremonial vessels, and jewelry.

Early Applied Glazes

Eventually potters in Egypt and Mesopotamia learned to apply an **alkaline glaze** that fired blue-green, owing to the copper it contained, but since this applied alkaline glaze did not adhere well to the surface of fired clay or to the soap-

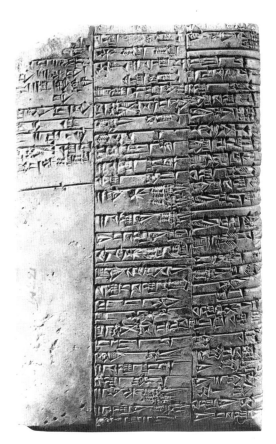

FIGURE 2-9
The Sumerians used slabs of damp clay as writing surfaces. The impressions of the marking tool that a clerk pressed into this tablet around 2100 B.C. are still legible. This tablet records the prescription of a local doctor: "Pulverize the seed of the 'carpenter plant,' the gum resin of the markasi-plant, and thyme; dissolve it in beer; let the man drink." *Courtesy University Museum, University of Pennsylvania (Neg. #55887).*

stone on which they also applied it, they used it only for nonutilitarian objects. Through trade, knowledge of this glaze technique spread to other areas, such as the island of Crete.

OTHER USES OF CERAMICS

Clay Artifacts in Burials

Since ceramic vessels do not disintegrate, many ancient peoples buried their dead in pottery urns. They also buried with them small ceramic containers of oils and perfumes, clay reproductions of servants, and objects they believed the deceased might need in the afterlife. Through

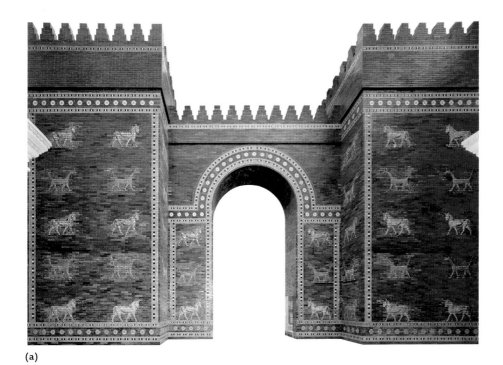

(a)

FIGURE 2-10
(a) The Ishtar Gate, built in Babylon in the sixth century B.C., was built during the reign of Nebuchadnezzer II (604–562 B.C.). The surface of the imposing gate was covered with glazed tiles, and it is now reconstructed in a museum in Germany. *(b)* Detail of one of the animals—dragons, lions, and bulls—that decorated the Ishtar Gate in Babylon. To create these large images, the sculptor probably formed the animals in low relief then cut them into tiles before firing them. Tin-lead glazes. Babylon, c. 580 B.C. *(a) Courtesy Statliche Museen, Berlin, © Bildarchiv Preussischer Kulturbesitz, Berlin, 2001, Vorderasiatisches Museum-VABab. Foto: Klaus Göken. (b) Courtesy Bildarchiv Preussischer Kulturbesitz, Berlin.*

study of these burial finds, archaeologists are able to theorize about a culture's religious beliefs and attempt to reconstruct its daily life. The artifacts discovered in digs can help us visualize the Sumerian doctor dictating a prescription to a scribe (2-9) or the domestic chores of women in an early culture. Anthropologists can even learn much about the physical makeup of a people from potters' fingerprints preserved in clay (see 2-12).

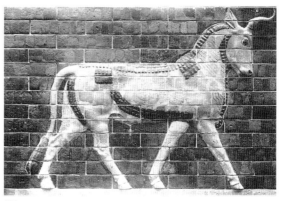

(b)

Writing on Clay

Pottery was not the only use to which fired clay was put in Western Asia. In Sumer, for example, literacy was linked to soft clay. Indeed, it undoubtedly influenced the manner in which writing developed there. The characteristic Sumerian cuneiform script, pressed into damp clay tablets using special tools, was made permanent by firing, and thousands of baked clay tablets have been found in excavations, adding to our knowledge of this ancient civilization. By deciphering these tablets, scholars have learned about treaties between governments, how clerks kept track of warehoused supplies, how trade was carried on, and even what kinds of medicines doctors prescribed about 4,000 years ago (see 2-9).

Ceramics in Architecture

Although for centuries building in western Asia had made use of sun-dried bricks, fired clay bricks and tiles were a great improvement. They were often used to cover the thick sun-dried brick walls; their less perishable surface protected the more fragile building materials of royal palaces, city defenses, and religious buildings. Later, as ceramics technology improved, glazed clay tiles were used both to protect the walls and to provide decoration (2-10). Such molded tiles brought colorful and symbolic reliefs to Babylon's massive defensive walls and processional gateway.

CRETE AND THE MINOANS

The island of Crete is located in the Mediterranean Sea between Egypt and western Asia, so it naturally developed a seagoing society. With a well-disciplined navy, the island was safe from invasion, so it enjoyed the peace that made it possible for its inhabitants to develop a sophisticated culture based on commercial relations with its mainland neighbors. Influenced by artistic and religious ideas from both Egypt and western Asia, this culture, called Minoan after Minos, one of its kings, lasted from around 2500 to 1100 B.C.

The early Cretans worshipped a goddess, made images of her in clay, left offerings to her on decorated ceramic platters, and sculpted clay figurines of her priestesses dancing a sacred dance (2-11).

The nobility lived in large palaces whose rooms were decorated with colorful murals. They enjoyed such comforts as baths hooked up to **terra-cotta** drainage systems, some of whose pipes can still be seen under the palace of Knossos. Grain, oil, and other foodstuffs for the palace were stored in large jars (2-12), or **pithoi** (singular *pithos*). The maze of underground storerooms that held these pithoi may have been the basis of the Greek legend about a labyrinth where the half-bull, half-human Minotaur roamed, demanding human sacrifice in the form of a yearly tribute of young men and women from mainland Greece. The Greek hero Theseus killed the Mino-

taur and rescued the captives by unwinding a ball of string as he penetrated the maze. Then, following the string back out, he led them to safety. In a folk dance that is still popular in Greece, a line of dancers winds in and out, supposedly representing Theseus leading the young men and women of Athens out of the Minotaur's labyrinth (see 2-11).

Enduring Traditions

The ancient pithoi that survived the fire that destroyed the palace in 1450 B.C. are still in place in the storerooms (see 2-12). In the nearby village of Thrapsanon some potters continue to use techniques similar to those in use on Crete around 1400 B.C. Thrapsanon has been a potter's village for generations; fifty or sixty years ago more than 100 potters were building pithoi there, but today only a few still work in the traditional way, moving out into the fields in summer to make smaller versions of the thick-walled ancient pithoi (2-12). Once the jars have dried in the sun, they are fired in vertical kilns similar to the ancient ones (see 2-14).

Revolved by an assistant seated in a trench at the potter's feet, the turntable on which a modern jar is built consists of a disk of moisture-resistant plane tree wood that rotates on an axle of olive wood. Wrapped in leather and held by an ingeniously knotted rope, it becomes smooth from the friction and revolves quite easily (2-13).

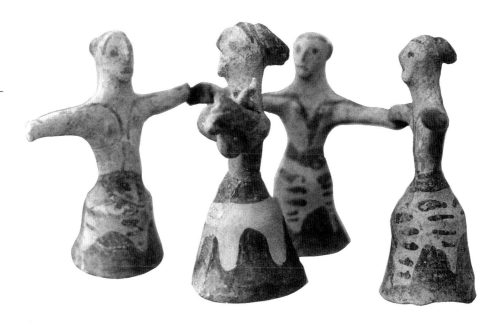

FIGURE 2-11
Homer described a circular dance, comparing the velocity of the whirling men and women to the motion of the potter's wheel. These Minoan dancers—noblewomen or perhaps priestesses—may also portray the revolutions of the turntables that potters used to form Minoan pottery. Palaikastro, Crete, 1400–1100 B.C. *Photo taken courtesy of the Archaeological Museum, Heraklion, Crete.*

The design of these turntables may well have been based on ancient models. A similar Cretan potter's wheel in the Heraclion Museum dating from 1700–1450 B.C. consists of a clay disk with a socket in the underside into which a wooden axle would have been fitted, probably revolving in a stone socket just as the ones in Thrapsanon do today.

Thrapsanon potters work in teams. After a row of pots has been started, an assistant moves along

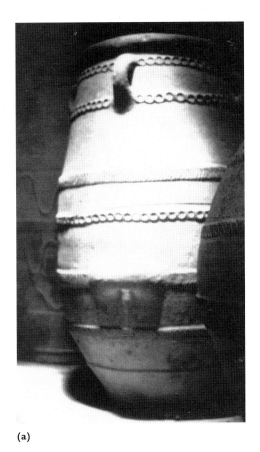

(a)

(b)

FIGURE 2-12
(a) Storage jars, called *pithoi,* still in place in the storerooms of the royal palace at Knossos, Crete, once held grain, oil, or honey. According to legend, the young son of King Minos died by falling into a similar jar of honey; he was found with only his legs sticking out. The pithoi were built up with coils in six bands, with applied coils pressed on with the potter's thumb to mark and strengthen the joints. Knossos, Crete, c. 1400 B.C. *(b)* A potter who lived on Crete about 1,400 years ago left the enduring mark of his thumb in the damp clay of a large pithos. Mallia, Crete. *Photo: James McGann.*

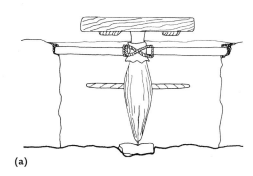

(a)

FIGURE 2-13
(a) Detail of the wheel and axle of a turntable used today on Crete. Braced by a crosspiece of wood resting on the sides of the trench, the axle passes through a notch in the plank. *(b)* The assistant, sitting at the bottom of the trench, turns the wheel. As the jar rises, the master potter sits higher, finally standing to shape the last band. *Based on observation and on the article "The Potters of Thrapsano," by Maria Voyatzoglou, in Ceramic Review (November–December 1973). Drawings by John M. Casey.*

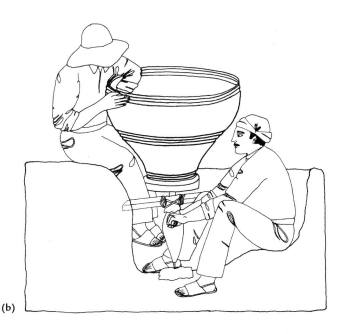

(b)

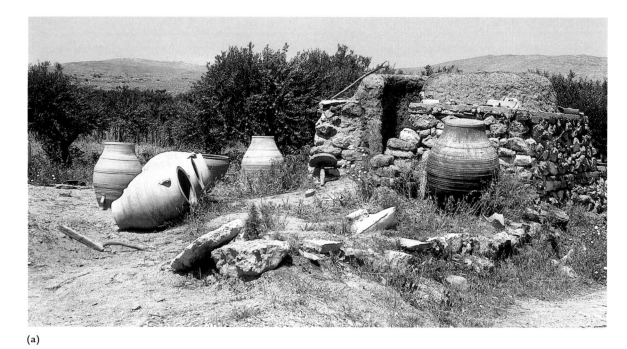

(a)

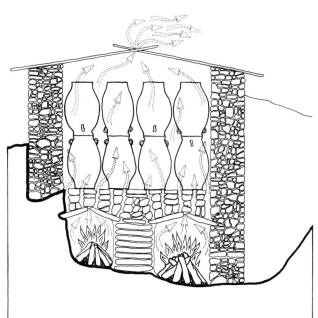

(b)

FIGURE 2-14

(a) Built of stones covered with clay, this Cretan kiln is basically a vertical cylinder sunk into the ground. The opening in front, through which the jars are loaded, will be closed with stones and clay after the kiln is full. The heat rises from the fire pit through holes in the floor. A stoker adds wood through a hole at the back during the firing. The duration of the firing depends upon the size and number of jars. Thrapsanon, Crete.

(b) A schematic diagram of a kiln in use today on Crete. It shows the cylindrical form typical of the kilns of the Mediterranean area that were derived from those in ancient Mesopotamia. Minoan potters who made the pithoi in the palace at Knossos probably fired their jars in kilns like this, using shards of pottery instead of sheet metal to close the top.

Based on observation and on information in the article "The Potters of Thrapsano," by Maria Voyatzoglou, in Ceramic Review (November–December 1973). Drawing by John M. Casey.

from one turntable to another, adding new coils to each pot as the first section hardens somewhat. Then the master potter progresses along the row and works on each jar in turn, sitting on the edge of the trench while another assistant turns the wheel. These wheels do not revolve fast enough to allow the clay to be **centered** and the wall to be raised by centrifugal force, so the master must pull up and smooth out the coils, form one section on a jar, then move along the trench to another wheel. When he has completed a section on all the jars, the first ones are usually stiff enough for him to start over again and add another section. Just as the ancient pithoi were built in six sections, so are the present-day versions, with an extra coil added at each seam to strengthen the wall at that vulnerable point (see 2-12).

When a row of jars is completed, handles are added and designs may be scratched into the walls. The pots are then left to harden, and by the next day they are usually stiff enough to be removed from the turntables. Placed in the hot sun, they are left until they are thoroughly dry and ready for firing in the kiln.

Cretan Kilns

As soon as enough jars have been made to fill a kiln, they are fired in a vertical kiln that is basi-

FIGURE 2-15
The Minoans on the Mediterranean island of Crete were a seafaring people, and their pottery often displayed sea creatures (see 2-16). The potter decorated this jug with abstract wave-like swirls, and what may be jellyfish with floating tentacles. Minoan. *Courtesy Nimatallah/Art Resource, NY.*

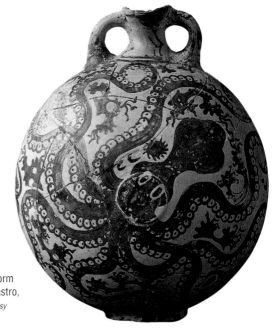

FIGURE 2-16
Octopuses encircle and emphasize the curving form of a vessel. From Palaikastro, Crete, c. 1500 B.C. *Courtesy Scala/Art Resource, NY.*

cally the same as those used in most ancient Mediterranean cultures (2-14) and later introduced to northern Europe. Made of rocks smeared with heavily tempered refractory clay, the modern kiln is sunk into the ground with a perforated clay floor above the **firebox.** Access to the firebox is down a sloping trench at the back, giving the stoker access to feed dry brushwood through an opening in the wall. The fire is started in the early afternoon and tended carefully until the firing is complete around sunset.

This method of building and firing the large jars is the result of empirical knowledge built up over generations, possibly dating back as far as 2000 B.C.

Minoan Decorated Pottery

The potters of ancient Crete not only made tall storage jars using these techniques but also created elegant utensils and containers in great variety, forming clay into objects for purposes that ranged from "teapots" with strainers for preparing infusions of herbs, to low tables on which offerings were left for the sacred snake who protected the household, to graceful vases decorated with paintings of plant forms or sea creatures (2-15, 2-16).

The nature-loving Minoans drew inspiration from living forms, translating them into decorations that were freely drawn and painted with black, white, and earth pigments. The palm trees, octopuses, flowers, leaves, dolphins, and shells serve to accentuate the curves of the vases and jars. Although the decoration is sometimes so overwhelming that it distracts the eye from the shape of the vessel, at its best it is flowing and harmonious.

MYCENAE

Around 1450 B.C. the sophisticated Minoan civilization either fell to invaders or was destroyed by a natural disaster. After Knossos was destroyed by fire, Crete was unable to maintain its powerful position. Mycenae, on the mainland of what is now Greece, became the dominant state in the Aegean for the next 200 or more years.

The Mycenaeans, named for one of their massive palace-citadels on the Greek Peloponnesus, were influenced by the art of the Minoans, but the essence of their aggressive military society is probably best illustrated by the lines of marching soldiers on the *Warrior Vase* (2-17). Mycenaean potters also produced storage jars and

FIGURE 2-17
The Mycenaean *Warrior Vase* shows soldiers marching in full war gear with shields, spears, and plumed helmets. Compared with the Minoan urns, this vessel's decoration illustrates the profound contrast between the peaceful Minoan culture and the aggressive Mycenaean society. 1300–1200 B.C. *Courtesy Scala/Art Resource, NY.*

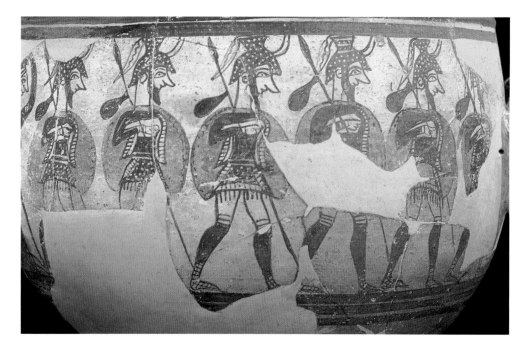

accompanying inscribed clay labels for the palace storerooms. The powerful Mycenaeans held territorial and trading rights throughout what later became Greece, as well as on the mainland of western Asia. But in about 1200 B.C. the great Mycenaean citadels fell to Doric invaders, and the area that later became Greece entered a period of disruption characterized by waves of migrations. The armed men painted on the *Warrior Vase* vividly portray the type of soldiers who tried with little success to hold back these invasions. Life became unsettled. From the chaos, however, a new civilization emerged—a civilization that was to have a profound effect on the history of the Western world: Greece.

GREECE

It is apparent from Greek legends and mythology that clay held an important place in early Greek life. According to legend, the first ceramic wine cup was molded over the breast of the beautiful Helen of Troy. Mythology also tells us that the goddess Athena was the inventor of many useful articles, including the earthenware pot, and that she became the patroness of Greek potters. Clearly, the early Greeks recognized clay's special qualities, and Athenian potters lived up to the reputation of their goddess, for

under her patronage they created some of the world's most admired pottery.

The Geometric Style

More than four feet tall, Geometric-period urns are a testament to the shaping and firing skills of early Greek potters (see 2-18, 2-19). Called Geometric because of their stylized painted decoration, these vessels are a remarkable technical achievement. We do not know exactly when the true wheel was introduced into Greece, but turntables were efficient enough by 800 B.C. for the potters to build these huge vases.

It is clear that the potters now had the technical knowledge and skill to produce magnificently shaped pottery. Once mainland Greece began to recover from the general disruption, Corinth, which was located near beds of white and cream-colored clay, became the first big ceramic center. By around 550 B.C., however, the potters of Athens had surpassed those of Corinth, and Athens became the main Greek ceramics center. From that time on, through the classical period of Greek art to the last days of the Roman Empire, the Greeks were the greatest vase makers in the Mediterranean world, and their wares were transported throughout the Eastern world and into Europe. Greek **amphorae** (singular *amphora*) containing wine have been

The decoration painted on the Geometric urns was totally different from the flowing, natural forms on Minoan ceramics. Deceptively simple, it showed a new sense of discipline and an intellectual approach to design. Alternating bands of abstract decoration and human figures were carefully chosen to emphasize the impressive shape and size of the vessel. No decoration could have accomplished this better than the linear patterns and rows of severe figures that encircle these urns. The paintings of funeral processions in the areas between the bands of meanders, zigzags, and diamond patterns project a strong emotional quality, but its expression is subordinated to the structure of the vessel. This rational, carefully thought out Geometric pottery (2-18, 2-19) offers a preview of later Greek art.

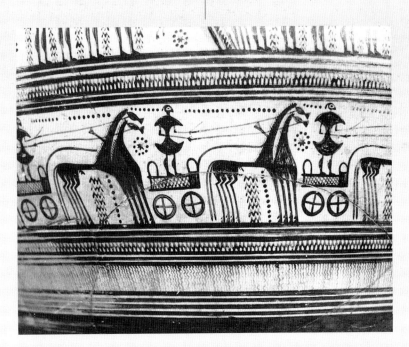

FIGURE 2-18
This detail of painting on a Geometric-style urn depicts warriors and chariots in a funeral procession. Such tall urns were placed on graves in the Diplyon Cemetery in Athens, where they served as memorials as well as vessels used during funeral rites. Eighth century B.C.
Courtesy National Archeological Museum, Athens.

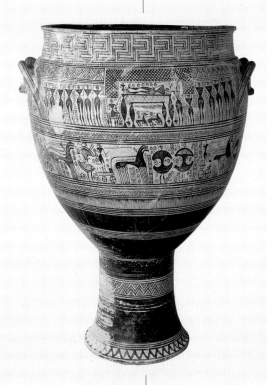

FIGURE 2-19
On this huge Geometric *krater* the figure of a dead warrior is shown lying in state, surrounded by followers with their arms raised in the characteristic mourning pose. These vessels, which are often more than four feet tall, illustrate a long tradition of forming and firing. 42⅝ in. Attributed to the Hirschfeld Workshop. Eighth century B.C. *Nimatallah/Art Resource, NY.*

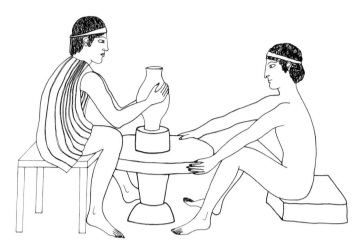

FIGURE 2-20
A Greek potter from about 600 B.C. works on a wheel rotated by an assistant. According to legend, Talos, the nephew and apprentice of the craftsman Daedalus, invented the potter's wheel, whereupon Daedalus became so jealous that he pushed Talos off the Acropolis in Athens. *Drawing by John M. Casey.*

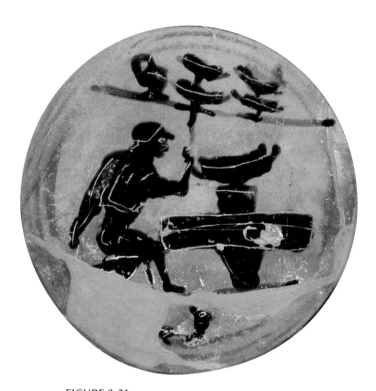

FIGURE 2-21
In this portrait of the potter at work in his shop, painted on the interior of a black-figure cup, he is shown sitting on a low stool, apparently adding handles to the wine cup on his turntable. Fifth century B.C. *Copyright British Museum, London.*

found in sunken ships off southern France, while the largest amount of Greek pottery ever found has been unearthed at various sites on the mainland of Italy, to which many of the most beautiful Athenian vases were exported.

Athenian Pottery

Athenian potters worked in a quarter of Athens called the Kerameiskos, which was located near large deposits of clay, or **keramos,** from which our word *ceramics* is derived. Most of the master potters who worked there were foreigners. These potters, who came from many cultures, melded ideas and styles from many sources, thereby enriching the craft of pottery in Greece, as well as influencing the art of painting on the vessels. In the Kerameiskos, pottery production was organized in a factorylike system—in some of the potters' shops as many as seventy assistants worked under the master potter, who owned the business. Working on a wheel propelled by an assistant, the master potter probably filled the most important orders for nonutilitarian vases himself (2-20, 2-21). If they were to be especially large, he would make them in sections and then attach the parts with slip—a process called **luting.**

The celebrities of the day—politicians, athletes, and actors—would visit the most famous potters' shops to order vases depicting a ritual dance, commemorating a victory or the death of an important person, or honoring the winner of an Olympic contest. Now, for the first time, individual artists signed their pottery, and because many vessels bear inscriptions such as "Exekias made and painted this," we know that some of the accomplished painters were also master potters (see 2-25). We also know that although the commemorative vases and cups were made by men, some of the painters who decorated them were women.

The type of vertical kiln in which early Greek ceramists fired their wares probably was brought there by potters from western Asia. The Greeks improved the earlier kilns by adding a side tunnel for the fire so that the heat, but not the flames, reached the ware (2-22). As the potters' skills developed and their kilns became more advanced, new influences reached them from western Asia, quite likely via immigrant potters; now the shapes and decoration of Athenian ware were greatly refined (see 2-23 to 2-25).

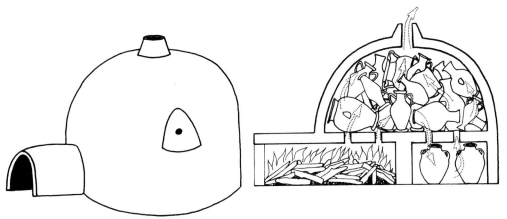

FIGURE 2-22
Greek kilns were built in a beehive shape with a tunnel at the side for the fire and a vent on the top that was covered with a potshard to damp down the fire and create a reduction atmosphere. Paintings on pottery show potters opening or closing the vent to change the kiln atmosphere in order to create the black and red decoration on the pottery. They could watch the progress of the firing through the spy hole in the side of the kiln.
Drawing by John M. Casey.

Black-Figure Pottery

Developed originally in Corinth, the decorative style called **black figure** became popular by the end of the seventh century B.C. In this style the figures were painted on the light-colored clay body with a specially formulated slip that fired black. The artist drew in details of clothing and features by scratching lines through the slip with a sharp instrument, revealing the lighter color of the clay beneath. The new style was soon taken over by Athenian potters, who refined it and quickly captured the export market for this type of pottery (see 2-24).

The firing process used to achieve the contrast between the black figures and the buff or reddish background was a complex one. The fine, purified slip with which the figures were painted contained iron oxide, which turned black when fired in a reduction atmosphere. Reduction occurs when a fire is smothered and the flame does not get enough oxygen to burn freely. Put simply, in an attempt to get more oxygen the flame will draw oxygen from the metal oxides in the clay and in so doing will release the metal and change its color. **Oxidation** refers to the atmosphere prevailing in a kiln when the fire is receiving enough oxygen to burn cleanly. The black and red colors that decorated the surface of Greek pottery were the result of the particular clay body and slip used and a single controlled firing in which reduction and oxidation were produced alternately.

To achieve black-figure decoration, the potter painted the figures with special slip and then fired the pottery in an oxidizing atmosphere in which the flame burned freely, firing the clay body to its natural reddish color. The potter then closed the vents, smothering the kiln chamber to create a reduction atmosphere, which turned the painted-on slip black. If the slip had been correctly formulated and the firing was not too high, the slip-covered areas remained black when the kiln was returned to an oxidizing atmosphere. The areas not covered with slip retained the reddish or buff tone of the earthenware clay. If the natural color of the clay body was not red enough, the potter might have washed it over with a coat of iron oxide before firing. The glossy brilliance of the black that is such a prominent feature of these decorated vessels resulted from the illite content of the fine-grained slip and its near vitrification under the action of an alkali such as wood ash, along with the action of the reduction atmosphere, which converted the iron oxide into magnetite. The black slip was so fine and dense that it did not allow oxygen to penetrate to the clay body under the slip as the kiln returned to an oxidation atmosphere, while the coarser unpainted red clay body allowed the oxygen to enter its pores. The purple-red used for hair or details of clothing was achieved by mixing red iron oxide with the black slip. (See *Expertise,* Chapter 1C for slip and body composition.)

Obviously, this firing method requires great care and control of the kiln atmosphere and temperature, since the pot can turn completely black if the kiln is not oxidized at the right time. The Agora Museum in Athens displays a series of fired **test tiles** excavated from a potter's shop. These show how the potter tested the slip in the kiln, continuing to draw out tests from the kiln during firing in order to control the complex

The master potters of Greece in the classical period refined the traditional Geometric shapes and developed new vessel forms. These included flasks to contain the oil that athletes rubbed into their skin; flaring bowls, or *kylix*, used for drink-ing wine mixed with water; and *oinochoe*, jugs used for pouring. The thousands of vessels pro-duced by Greek potters rarely varied from these basic forms, and potters concentrated on refining them (2-23). Most of the decorated Athenian pottery was intended not for its original utilitarian use but for memorial, display, or commemorative pur-poses. The paintings them-selves, at least those by the best artists, respected the shapes of the vessels, enhancing rather than disrupting their forms (2-24, 2-25).

(a) (b) (c) (d)

FIGURE 2-23

Some of the many shapes so skillfully formed by the potters of Greece. *(a)* The *amphora*, generally oval-shaped, with a narrow mouth and a small lid, was used for carrying liquids and was also awarded as a prize to winners of athletic and drama contests. *(b)* The *kylix*, a drinking cup, was used for serving wine mixed with water. *(c)* The *krater*, whose shape and handle position varied, was used for mixing wine and water. Its wide mouth made blending easy. *(d)* The *cantharus* was a drinking globlet with high, curved, exaggerated handles. *Drawing by John M. Casey.*

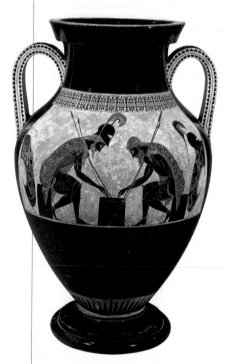

FIGURE 2-24

This black-figure amphora by the renowned Athenian potter-painter Exekias illustrates the ultimate refinement of shape and decoration in Greek pottery. Note how the bending figures emphasize the belly of the pot and how the negative space between their intent heads leads the eye up to the neck and lip. Vessels by name potters and of such elegant shape and decoration were often used as presentation pieces, often to famous athletes. The decoration shows Achilles and Ajax playing a game during a lull in the siege of Troy. Exekias drew the detail on their flowered cloaks and the curls of their hair by scratching through the slip with a fine point 540–530 B.C. *Scala/Art Resource, NY*

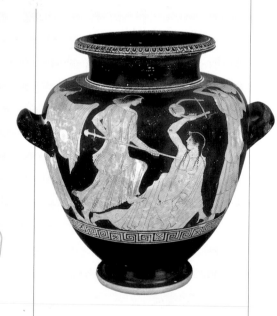

FIGURE 2-25

A *stamnos* attributed to the artist Hermonax. The reserved red figure decoration illustrates the death of the legendary musician Orpheus. He was attacked by maenads, who were followers of Dionysus, the Greek god of wine. Ht. 12⅜ in. (31.5 cm.). Fifth century B.C. *Reunion des Musees Nationaux/Art Resource, NY. Photo: Herve Lewandowski.*

process. A **peephole** in the kiln wall allowed the potter to peer in and observe how the color on the pot was developing during firing. By gaining an understanding of this complex method, we can better appreciate the skill, tenacity, and empirical knowledge of the Greek potters.

Red-Figure Pottery

Around 525 B.C. vessels painted in a new style appeared in Athens. The decoration was applied using a method called **reserve,** in which the black-firing slip was painted around the figures, thus reserving the color of the red clay for the skin tones of the figures (see 2-25). To intensify the skin tone, the painter sometimes first coated the vase with a wash of iron oxide or a thin iron-laden slip that fired to a rich orange-red. Within the red figures, the details of faces, bodies, clothing, and armor were painted with thin black lines, for which the painter used a single-haired brush. Once it was painted, the pottery was fired in alternating reduction and oxidation atmospheres—the same technique as that used for black-figure pottery.

Greek Architectural Ceramics

Greek ceramists did not limit themselves to producing elegant presentation vessels; they also used clay for more practical purposes. To protect the wooden structure of early temples, builders sheathed the ends of the wooden roof beams with terra-cotta tiles that were vertically grooved to allow rainwater to run off them. Between the beams, and alternating with the grooved tiles, ungrooved terra-cotta tablets displayed painted designs. Both of these features were copied in marble in the sculptured details on temples of the classical period. The gable fronts of the early temples were also decorated with sculptures modeled in clay—forerunners of later marble sculptures—and the cult images inside the temples representing the gods or goddesses to whom the temples were dedicated were also made of clay. Built up with coils and wads, these sculptures were fired, then painted in realistic colors. The painted terra-cotta sculptures at the apex of the roof, called *acroteria,* and the brilliantly painted figures in the gable ends would later be copied by Etruscan sculptors (see 2-29).

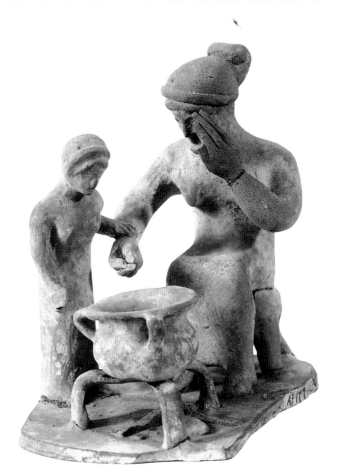

FIGURE 2-26
Woman Cooking with Young Girl Looking On, which shows a kitchen pot on a stand over a fire, illustrates that cooking methods had not changed much from the earlier Anatolian pot and stand shown in Figure 1-5b. Tanagra, fifth century B.C. © *2002 Museum of Fine Arts, Boston.*

Terra-cotta reliefs that were mass-produced in **molds** apparently played much the same role for the Greeks as inexpensive art reproductions do today, for they were used in homes as decorations, as well as in temples as votive offerings. Fired clay decorations were also applied to furniture.

Terra-Cotta Figurines

For centuries Greek potters created a profusion of small terra-cotta figurines that vividly portray life in Greece (2-26, 2-27). The figures were made by hand at first and later produced in quantity through the use of **press molds**. These were molds made by stamping a fired original into a damp clay slab. The resulting negative impression was then fired to harden it, making a porous

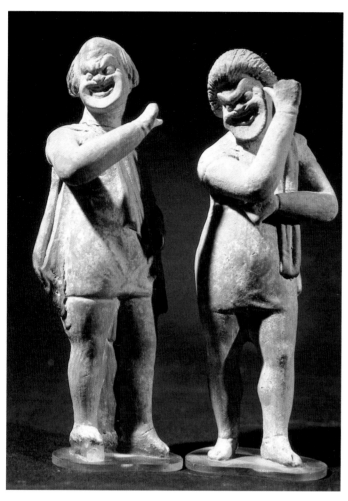

FIGURE 2-27
Characters from the theater were extremely popular subjects in Greece, where comedies were broad and earthy. Actors' figures were often distorted with padded tights and jerkins. Here two actors portray drunken old men. Terra-cotta. Second half of the first century B.C. From Myrina, Isle of Lemnos, Greece. *Erich Lessing/Art Resource, NY.*

where the ones made by well-known mainland potters and sculptors were sold for extremely high prices. Thus, a potter in Sicily using molds sent from Athens could produce figurines of popular actors playing in a theater in Athens in the latest comedy by Aristophanes (see 2-27).

In addition to comedy figures, graceful figurines of women dancing, arranging their hair, gossiping, and caring for children were in demand.

Greek Influences Abroad

Greece extended its colonies and trading networks throughout the Mediterranean, sending Athenian pottery, soldiers, traders, and colonists to distant ports. Contact with Italy had begun early, and Greek traders were attracted to central Italy's mines and forests. Greek ships carried in them the best products of the Corinthian and Athenian potteries, and officials in far-flung colonies proudly added these works to their collections. Greek potters also sailed aboard the ships, carrying with them their knowledge of clay techniques, which they spread in the colonies. In southern Italy these potters developed a flourishing industry, and the vases and sculpture they produced were traded throughout the Italian peninsula. In this way Greek ceramics were brought in quantity to the Etruscan inhabitants of central Italy and greatly influenced potters and artists there.

mold. Next, a slab of damp clay was pressed into the mold to create a positive reproduction of the image. Sometimes as many as fourteen molds were used to make one figurine, and parts of figurines were often interchanged to vary the pose. All the figures were brightly painted after firing, and some still show traces of color—white, blue, and bright pink.

From the fourth century B.C. on, quantities of these figures, made in the mainland pottery centers of Boetia, especially Tanagra, were sent to the Greek colonies in Italy, Sicily, and western Asia, where there was a large market for them. Often the molds themselves were sent abroad,

THE ETRUSCANS

The origin of the Etruscans has long been a mystery. Some scholars believe that they emigrated from western Asia; others, that they were Indo-Europeans who came from the north; and still others, that they were indigenous to Italy. Whatever their origin, the Etruscans adopted and profited from ideas and techniques from many different sources, including the local peoples of Italy—called Villanovans for the name of the town where objects from their culture were first excavated. These farmers used clay molds to produce metal tools and agricultural implements, buried the ashes of their dead in clay pots with helmetlike covers, and also used earthenware clay for domestic vessels. The vig-

This early sculptural Etruscan funerary urn dates from around 700 B.C. The large figure on the lid may represent the person whose remains were interred in it, while the small figures are demons and mourners. *Courtesy Superintendent of Antiquities, Florence.*

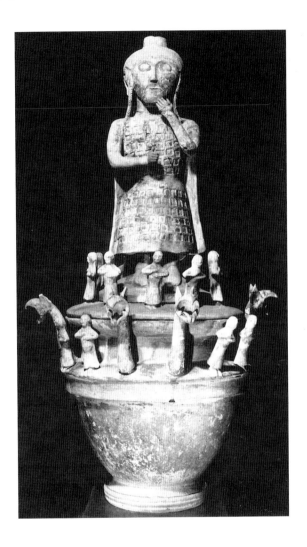

orous, commercially oriented Etruscans also exploited Italy's rich natural resources, developing a metal industry whose smelting furnaces polluted the air around their industrial towns. Drawing inspiration from Greek religion and mythology, they also absorbed Greek ceramics technology, as well as adapted the imaginary animals, sphinxes, winged bulls, and griffons of western Asia to their own uses (2-28). The Etruscans merged these influences with their own inventive and artistic vitality, creating a characteristic art that reached its peak between 700 and 400 B.C.

Etruscan Sculpture and Architectural Decoration

The local clay from the fertile earth of Etruria was regarded by the Etruscans as a noble material. Perhaps because clay is a medium that encourages spontaneity and immediacy, it was particularly well suited to the exuberant Etruscan temperament. Because fired clay was an excellent material on which to paint, the Etruscans used it to exhibit their love of color and surface decoration. Always brightly painted, their sculpture was sometimes heroic, sometimes comic, sometimes tender (see 2-30).

Etruscan architectural sculpture, like the early Greek sculpture from which it developed, was used to cover the wooden structure of temples and other buildings. At the excavations of the Etruscan town of Misa, outside present-day Bologna, excavators unearthed the terra-cotta facings of a building that had enclosed a sacred spring. These architectural components probably were made in a nearby potter's shop that was also excavated. The well-organized shop contained storage bins for clay and pipes that brought water

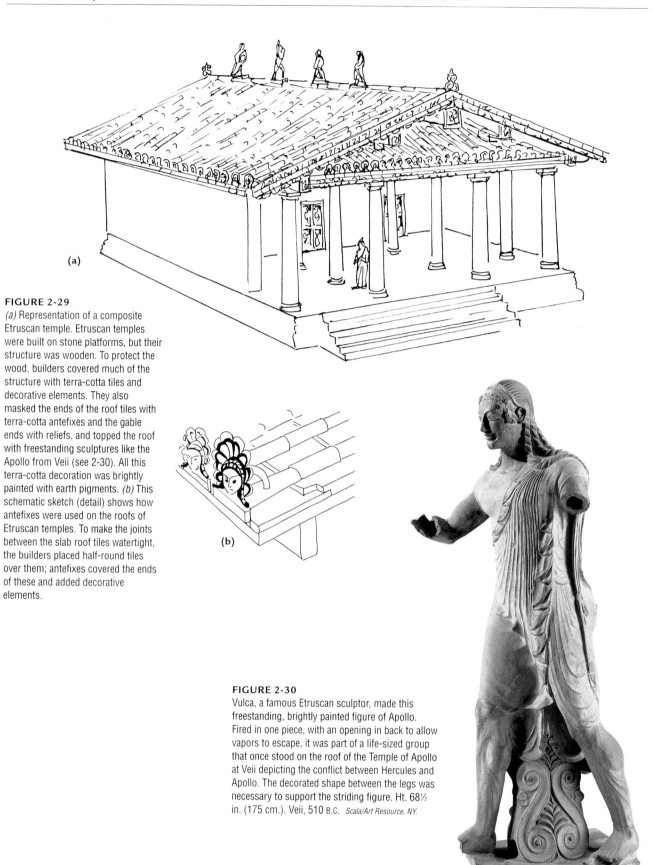

(a)

FIGURE 2-29

(a) Representation of a composite Etruscan temple. Etruscan temples were built on stone platforms, but their structure was wooden. To protect the wood, builders covered much of the structure with terra-cotta tiles and decorative elements. They also masked the ends of the roof tiles with terra-cotta antefixes and the gable ends with reliefs, and topped the roof with freestanding sculptures like the Apollo from Veii (see 2-30). All this terra-cotta decoration was brightly painted with earth pigments. *(b)* This schematic sketch (detail) shows how antefixes were used on the roofs of Etruscan temples. To make the joints between the slab roof tiles watertight, the builders placed half-round tiles over them; antefixes covered the ends of these and added decorative elements.

(b)

FIGURE 2-30

Vulca, a famous Etruscan sculptor, made this freestanding, brightly painted figure of Apollo. Fired in one piece, with an opening in back to allow vapors to escape, it was part of a life-sized group that once stood on the roof of the Temple of Apollo at Veii depicting the conflict between Hercules and Apollo. The decorated shape between the legs was necessary to support the striding figure. Ht. 68½ in. (175 cm). Veii, 510 B.C. *Scala/Art Resource, NY.*

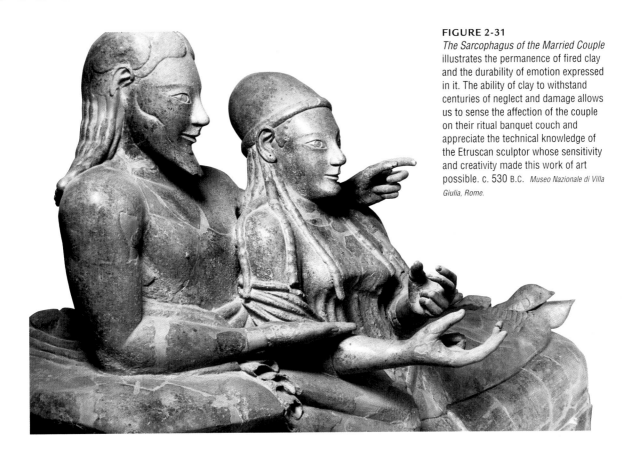

FIGURE 2-31
The Sarcophagus of the Married Couple illustrates the permanence of fired clay and the durability of emotion expressed in it. The ability of clay to withstand centuries of neglect and damage allows us to sense the affection of the couple on their ritual banquet couch and appreciate the technical knowledge of the Etruscan sculptor whose sensitivity and creativity made this work of art possible. c. 530 B.C. *Museo Nazionale di Villa Giulia, Rome.*

into the shop from a distance, an investment in equipment indicating the importance of pottery production to the community.

A typical Etruscan temple would be decorated with rows of standing figures along its roofline, a figure on horseback or in a chariot, human or demon faces on **antefixes** at the ends of the roof tiles, and a sculptured group in the pediment, all painted with blue, purplish black, and liberal amounts of red (2-29, 2-30).

In addition to the temple figures, the sculptors modeled life-sized terra-cotta figures of the dead for the coffins (sarcophagi) of the rich. These figures were painted realistically, while the side panels frequently carried mold-formed reliefs of battles and heroic deeds. Some of the figures on the sarcophagi were obviously mass-produced in molds, personalized only by an added portrait head, but many were individually sculpted, portraying the deceased on a banquet couch.

For an Etruscan who could afford to have an individually made sarcophagus, the sculptor Vulca of Veii made one of the great works of Etruscan art, now called *The Sarcophagus of the Married Couple* (2-31). On it a man and his wife recline on their banquet bench in an affectionate pose that suggests not only their close relationship but also the equal position of men and women in Etruscan society.

Later Etruscan sculptors, influenced by Hellenistic Greek art, became increasingly interested in portraiture, and lifelike representations of bald, obese individuals occur frequently on the coffins. Etruscan sculptures, dug up during the Renaissance search for antiquities, influenced Italian sculptors such as Donatello.

ROME

The Etruscans, who settled before the Latins in what is now Rome, were the first rulers of that area, and just as the Etruscans drew on Greek technology, so the Romans drew on the Etruscan knowledge of art, engineering, and ceramics. In fact, they hired the famous Etruscan sculptor Vulca (see 2-30), to create the sculpture for Rome's most important temple, the Temple of

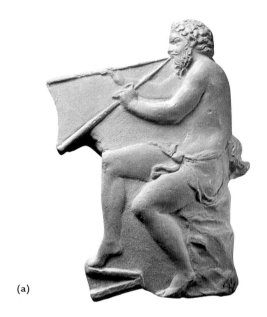

(a)

(b)

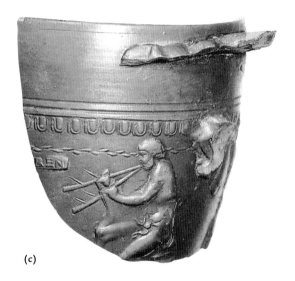

(c)

Jove. The Romans also continued to use clay for portrait sculptures, frequently casting them in bronze from the clay models.

Roman Pottery Factories

The Romans adapted much of their pottery techniques from the Etruscans and the Hellenistic Greeks, and with their characteristic organizational skill, they transformed their pottery workshops into factories. The most characteristic Roman ceramics—domestic red earthenware with decorations in relief—was of a type originally produced by the Hellenistic Greeks. This ware was made in molds into which sculpted, fired stamps were impressed while the mold was damp, thereby forming reverse molds that were then fired. Next the mold was placed on a wheel, and damp clay was thrown inside it so that the formed pot reproduced the decoration in **bas-relief** (or low relief; 2-32). The Roman factories produced this type of pottery in great quantities, fired it in large batches in multiple flue kilns, and shipped it throughout the northern colonies for use by the legions there. Even-

tually potteries were established to make the ware in the colonies, but the pottery produced in Rome was especially admired (2-32).

Roman Terra Sigillata

This Roman ware was coated with the same type of extremely fine slip as was used in Greece for the red and black pottery, however, in Rome it was known as **terra sigillata** (literally, "sealed earth"). Although some potteries were noted for their all-black ware, fired in a reducing atmosphere, the most famous of the Roman ware was fired in an oxidizing atmosphere so that it came out a rich red, whose glossy finish is largely the result of a micalike material in the clay that made up the slip (2-33). This red ware, with or without its molded reliefs, was produced in Italy but was copied in other areas of the Roman Empire—workshops in Switzerland, Gaul, and England also produced typical terra sigillata–finished pottery. The fine slip created a surface that was popular for tableware.

Like the Greek potteries, the Roman factories made tiles and ceramic plaques to decorate their elaborate public buildings and luxurious homes. Particularly in the early days of Rome, buildings were frequently made of brick and faced with stone, but at the height of the Roman Empire brick and terra-cotta were no longer in fashion, and Emperor Augustus could boast, "I found Rome of brick, I leave it of marble." In less highly developed areas of the empire, however, it was the use of clay building materials—bricks, roof tiles, ceramic floor coverings, and ornamentation—that often differentiated the homes of the well-to-do Roman conquerors from the simpler wooden houses of the local inhabitants. The Roman colonists also built such luxuries as public bath houses whose rooms were heated by hot air sent from wood-burning furnaces through terra-cotta pipes in the floors or walls.

The Roman empire depended on an efficient shipping service in which amphorae carried grain, oil, and wine to Rome and from there to conquered northern territories (2-34). So many of these amphorae were brought to Rome filled with foodstuffs from the colonies that there is still a hill in Rome, *Il Testaccio*, that was gradually built up from the broken amphorae thrown away after their contents had been transferred to warehouses along the Tiber River.

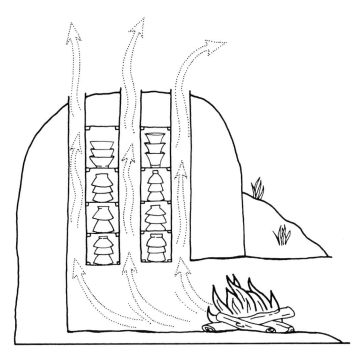

FIGURE 2-33
Representation of a Roman terra-sigillata kiln. Originally developed in Greece, the process of using fine terra-sigillata slip to coat the surface of pottery was adapted by Roman potters, who used it to make their relief-decorated red ware (see 2-32). This ware required oxidation firing to achieve its characteristic color, so the potters fired it in special kilns with built-in flues to protect it from the smoke and ash of the fire.

FIGURE 2-34
The Greeks, Etruscans, and Romans shipped millions of amphorae filled with wine, oil, and grain throughout the Mediterranean area. Fitted into the holds of merchant ships, as seen in the drawing, these containers became the unit of measure by which the capacity of a vessel was calculated. *Drawing by John M. Casey.*

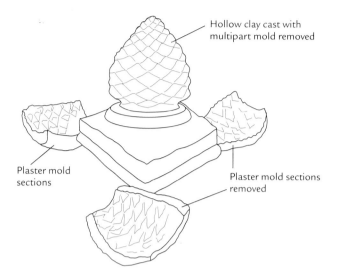

Hollow clay cast with
multipart mold removed

Plaster mold
sections

Plaster mold sections
removed

FIGURE 2-35
In a terra-cotta pottery in Italy, a multipart plaster mold is removed from the original model after forming a garden or architectural ornament. The pine cone finial will be given finishing touches by hand. This pottery is crafted in Petroio in Tuscany, once the land of the Etruscans, whose heritage can still be felt there.

Wherever they settled, the Romans introduced the use of the potter's wheel and the technique of firing in vertical **parallel-flue kilns,** both of which had been unknown in northern Europe before the Roman legions arrived. When the Roman Empire crumbled and Europe settled into the Dark Ages, the knowledge of the potter's wheel and the Roman kiln were lost. In England their use was not reintroduced until the ninth to the twelfth centuries A.D.

ENDURING TRADITIONS

In the town of Petroio in Tuscany, some of the ancient skills of forming and firing clay are still a viable part of the town's economic life. Several potteries continue to function in the vicinity of the town. Over the generations, dating back to Roman and Etruscan days, the potteries there have exhausted the clay in the immediate vicinity. Potters now use clay brought from a few miles away.

Instead of making vessels for oil storage, charcoal burners, drainpipes, and other functional products, as potters there once did, the modern potters now produce decorative flower pots and architectural decorations. The ware is formed in molds—sometimes using only base molds and handbuilding but more often by hand-pressing entire sections. The molds are two-part or multipart, depending on the complexity of the original (2-35). After removal from the mold, the clay surface is hand-finished by artisans who take pride in their skills. Now fired with oil fuel rather than with wood, much of the ware is shipped out of Italy, with about 60 percent going to the United States.

A few years ago regional middle school students researched the potteries—their history; the techniques used, both ancient and modern; their present-day aesthetics; and their economic effects on the community. Here, as has happened so often throughout history, potters had adapted and changed as they were faced with new social and economic conditions. The students' published report includes drawings of historical pieces, mostly from the nineteenth century, and interviews with inhabitants about earlier days in the potteries.

3

Asia

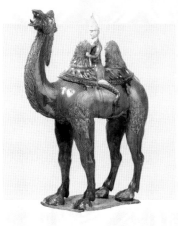

Based on the archaeological record at hand, scholars were once convinced that the deliberate firing of clay to create ceramics began only when people settled permanently in villages. In some areas, however, pottery from more recent excavations predates the pottery from settled cultures. These more recent finds date ceramics to the hunter-gatherer phase of several cultures, including Japan (3-1). In fact, the oldest pottery found so far is the Japanese Incipient Jomon. This early ware is part of a tradition that continued for several thousand years through a number of periods. It was originally divided into the categories Early, Middle, and Late Jomon, but recent excavations have pushed the dates of Jomon pottery ever earlier and thus necessitated new categories. There are now six periods of Jomon pottery, from Incipient Jomon (c. 12,700 years before the present [B.P.]) to Final Jomon (3,700 years B.P.). The early potters who made Jomon ware were not farmers; they gathered edible plants, caught fish, and hunted animals, living a seminomadic life.

EARLY JAPAN

The early ware, formed of low-firing clay, was apparently made by melding small slabs together. It is quite thin and well fired. The name Jomon—meaning "cord pattern"—comes from the rows of decoration on the pots. The potter decorated the ware by using fibers, a fingernail, or the split ends of bamboo to impress patterns into the surface, or he rolled a **roulette**—probably a notched stick—over the damp clay. Some of the pots are decorated with raised, cord-like patterns.

The earliest Jomon potters produced the first known fired vessels that appear to have been used for cooking (3-2). Many of the pots have

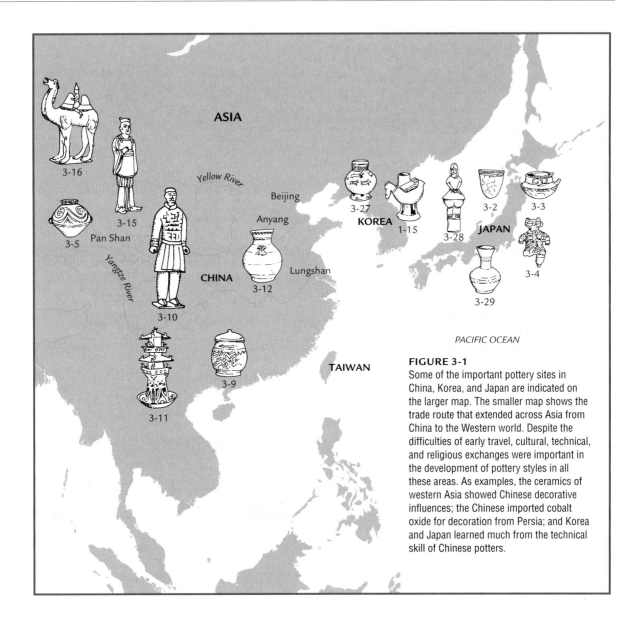

FIGURE 3-1

Some of the important pottery sites in China, Korea, and Japan are indicated on the larger map. The smaller map shows the trade route that extended across Asia from China to the Western world. Despite the difficulties of early travel, cultural, technical, and religious exchanges were important in the development of pottery styles in all these areas. As examples, the ceramics of western Asia showed Chinese decorative influences; the Chinese imported cobalt oxide for decoration from Persia; and Korea and Japan learned much from the technical skill of Chinese potters.

Trade Routes between Asia and the West

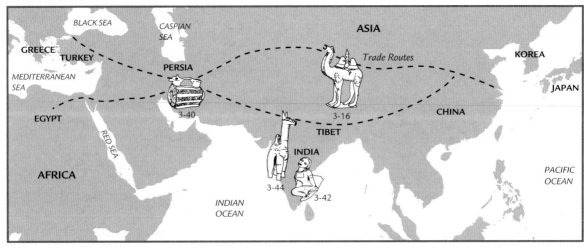

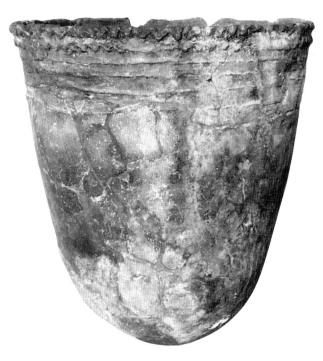

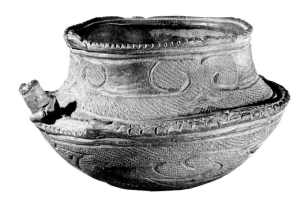

FIGURE 3-3
The name *Jomon* is applied to a type of Japanese pottery that was decorated, as is this small pot, with incised lines and applied clay "cords." Jomon pottery was produced over a long period from c. 10,000 B.C. to c. 300 B.C. Ht. 3⅞ in. (10 cm.). Japan, Late Jomon, first millennium B.C.
Copyright British Museum, London.

FIGURE 3-2
This vessel is among the most ancient pottery yet found—it dates from about 10,000 B.C. The pottery of this period is called *Incipient Jomon* because it pre-dates earlier finds and displays the beginnings of the characteristic decoration of Jomon pottery. The word *jo* means "straw rope" or "mat," while the word *mon* means "design," indicating that the designs were derived from cord patterns. Unearthed from Ishigoya cave in the city of Suzuka, Nagano prefecture, Japan.
Courtesy Museum of Archeology, Kokugakuin University, Tokyo, Japan

FIGURE 3-4
Like the Late Jomon pottery, Jomon sculptured figures were carved with swirls and textured areas alternating with highly polished sections. Full of vitality, they may have had a fertility significance. Aomoni prefecture, Japan, Late Jomon, first millennium B.C. © *Seattle Art Museum, Floyd A. Naramore Memorial Purchase Fund*

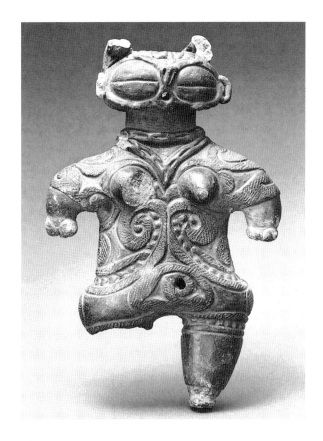

been found in caves or other sheltered sites, along with stone tools, and near mounds of shells left by early fisher-hunters.

The later, coil-built Jomon ceramics (3-3) were more varied in shape and more sophisticated in decoration than the early ware. By the Middle Jomon period the object, whether pottery or a sculptured figure, is vigorously formed and deeply carved. Like all early ceramics, it was low-fired, either in open fires or in simple pit kilns. Although much of the utilitarian ware was made in domestic settings, it appears that as time went on there were specialists who produced elaborate vessels and figures for the elite or for ceremonial use. The later ware was created in a wide variety of forms, from low bowls with handles, to incense burners, to vessels with pouring spouts, to figures with staring eyes and decorated clothing (3-4).

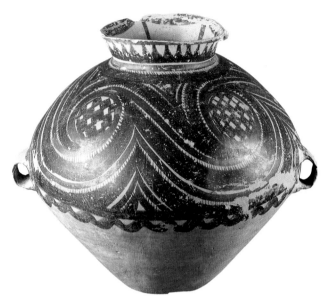

FIGURE 3-5
Neolithic potters in China made urns, low bowls, and jars of red earthenware clay on turntables, burnishing them before firing. After firing, they painted the vessels with mineral oxides in geometric patterns and flowing spiral designs in red, purple, and black. Ht. 13 in. (33 cm.). Found in a grave, Panshan, China, 2500–1500 B.C. *Courtesy Collection Haags Gemeentemuseum, The Hague.*

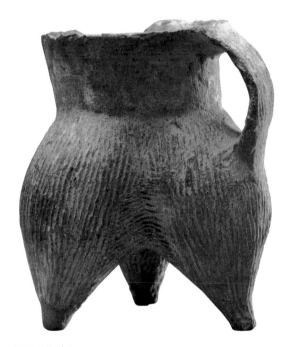

FIGURE 3-6
Called a *li*, this early tripod shape may have developed from three pots joined together. The potter paddled the outside of the walls, thinning and texturing them. Gray pottery. Ht. 6 in. (15.2 cm.). China, c. 2000 B.C. *Courtesy Asian Art Museum of San Francisco, The Avery Brundage Collection, B60P2074. Used by permission.*

The early Japanese potters believed in supernatural beings called *kami* who breathed life into everything that existed—trees, rivers, plants, and also the hands of a fisher, hunter, or potter. This vitality seems to have passed into the clay itself, animating Japanese ceramics in a characteristic manner throughout later centuries despite influences from China and Korea. In many areas, where mountains and deep valleys separated villages, artisans making domestic ware lived quietly on the same land for generations, digging clay from the same bank, firing their kilns on the same hillsides, and maintaining an intense personal relationship with clay that has continued to this day. (We will pick up the thread of Japanese ceramics later in the chapter.)

CHINA

The term *Neolithic,* once used to denote a settled community that farmed and made pottery, is now also used for earlier cultures that farmed and made stone implements of an advanced type but did not make pottery. These cultures are also called *pre-ceramic.* When we use the term *Neolithic* here it refers to the ceramic period.

An important site that has given us considerable information about early ceramics technology was discovered at the village of Panpo, on the Yellow River in central China. Excavations have shown that between 6,000 and 4,000 years ago hunters settled there and created a farming civilization, founding villages in which people lived in permanent houses, maintained a cemetery, and fired pottery.

Skilled in the crafts, these Neolithic villagers made tools from stone, and pottery from *huang tu,* a local yellow clay rich in alumina that they tempered with sand. They ornamented their pots with fingernail- and tool-impressed textures and also painted them with decorations consisting mainly of geometric shapes and lines composed with great sensitivity to the form of each pot.

By about 2000 B.C. potters in Gansu (Kansu) province were shaping clay into thin-walled pottery, which they usually painted with **hematite** powder (red iron oxide) and manganese oxide in a variety of line designs—bands of circles, crosses, dots, and triangles. They painted other vessels with elegant spiral patterns or fluid lines that suggest waves or the currents of a river (3-5).

Around 4,000 years ago potters at various places in central and eastern China also made vessels in a tripod shape with three hollow legs, their form probably based on three pots joined together (3-6). Called a *li,* this shape may have had fertility significance or may have been derived from pots originally designed to boil liquids on an open fire. The example shown in Figure 3-6 is decorated only with striations. Its form is rather squat, but some of these pitchers are well proportioned, with graceful long spouts and swelling legs tapering down to pointed feet.

Advancing Technology

At about the same time (2000 B.C.), another clay culture called *Lungshan,* on the lower Yellow River, was making extremely thin-walled black pottery fired in reduction. From marks on the vessel walls, archaeologists have deduced that this pottery was made with a relatively advanced wheel—apparently a true potter's wheel that turned at least 100 revolutions per minute.

The early Chinese "kilns" were pits dug into the ground with a fire below (3-7). They were small—able to fire only three or four large pots and about ten smaller ones up to a temperature of around 1470°F/800°C. Nevertheless, they represented an advance from open firing or shallow pits, in which the wind could cause uneven firing.

The Shang Dynasty (1700–1027 B.C.)

The first true Chinese dynasty, the Shang, placed a central ruler above the local landed lords, and from then on dynasty succeeded dynasty. There is no need for us to dwell on the intricacies of China's political history, but since certain dynasties were more significant in the history of ceramics or contributed particular innovations to its technique, we will emphasize their contributions to China's long history and skim over other dynasties.

By now cities were built with large religious centers and palaces where the rulers and nobles lived. When they died they were buried, along with the bodies of their sacrificed slaves and horses, in elaborate tombs that contained ritual bronze urns and pottery fired in more advanced kilns (3-8).

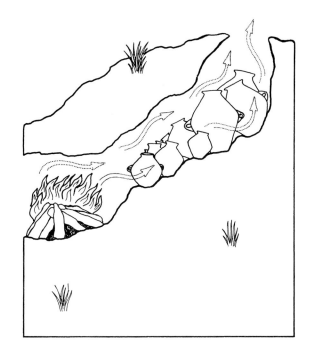

FIGURE 3-7
Most of the earliest Chinese kilns were pits dug into the ground; the ware was heated by a wood fire built below. At times they were more complex, with a fire tunnel placed somewhat to one side.
Drawing by John M. Casey.

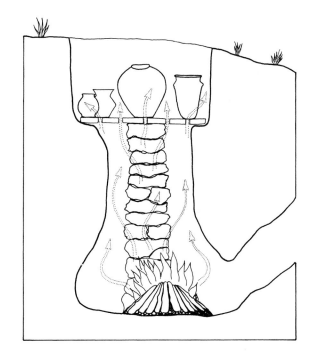

FIGURE 3-8
By the end of the Shang dynasty, the Chinese had developed a simple updraft kiln. The firing chamber was larger, and the ware was placed above the fire on a permanent grate supported on a pillar. The fire was stoked through a tunnel at the side, and the potters may have built domed roofs over the top opening each time they fired. *Drawing by John M. Casey.*

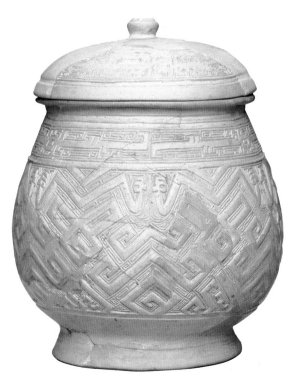

FIGURE 3-9
Made of almost pure kaolin, this fine white urn was fired to around 1832°F/1000°C. Too fragile for ordinary use, it probably was reserved for ceremonial occasions. Excavated potter's tools include stamps from this period with dragons and squared spirals like the decorations on this jar. Ht. 8 in. (20.3 cm.). Anyang, Henan, China, late Shang dynasty, 1300–1028 B.C. *Courtesy Asian Art Museum of San Francisco, The Avery Brundage Collection, B60P538. Used by permission.*

SHANG KILNS As a thriving pottery industry developed, kiln design changed somewhat. Shang kilns were vertical, about four feet (1.22 m) in diameter, and had a central pillar or wall that supported a perforated clay floor on which the pots were placed (see 3-8). As kiln technology improved, potters learned to fire at temperatures of up to 2190°F/1200°C. By around 1400 B.C. the Chinese had made the first high-fired pottery, known as **proto-porcelain** (a form of what we call stoneware), which requires **kaolin,** a white primary clay found in large deposits in China. Kaolin gets its name from Gaoling, a mine site near Jingdezen.

SHANG GLAZES Along with the technical advances Shang potters made in kiln building and firing, they also discovered how to cover their pots with glaze. This knowledge probably developed from observing the accidental ash glaze that formed when ashes from the wood fire fell on the shoulders of vessels in the kiln. Wood ashes contain alkalies, such as potash and soda, as well as silica and alumina, and the high kiln temperature caused the minerals in the ash to fuse with the silica in the clay, forming a glaze. Noticing how the ashes formed a shiny coating on the shoulders of the pots, the potters undoubtedly began to experiment with different materials, eventually creating a deliberately applied high-fire feldspathic glaze that fused with the proto-porcelain clay body to make a coating that became an integral part of the fired pottery. This yellowish-brown or greenish glaze marked the first step in the long search for refinement in glazes, a search that occupied potters in China for many centuries.

In the later days of the Shang dynasty, some very fine white vessels were made of almost pure kaolin, in shapes similar to those of Shang bronzes (3-9). Decorated with designs that show probable influences from Southeast Asia and the cultures in western Asia that used animal decorations, these rare, fragile vessels were made from a clay body that was the direct predecessor of the true porcelain of the Song (Sung) period.

The Zhou (Chou) Dynasty (c. 1100–722 B.C.)

The ceramics of the Zhou dynasty continued along the lines established in the Shang dynasty. Potters formed proto-porcelain into wine vessels, bells, and footed basins, as well as domestic earthenware. Building on Shang technical knowledge, they improved the stoneware body and learned to cover it with a smoother, more translucent, and more resistant glaze. These developments resulted partly from a more advanced kiln design that now distributed the heat around the firing chamber through complex duct systems, achieving a more uniform firing temperature throughout the kiln.

Clay and Bronze Casting

As in other early cultures, metallurgy and ceramics were interrelated in China, where the bronze industry flourished. Clay also played an important part in the production of the impressive bronze objects made by artisans. For example, excavation of fifth-century B.C. bronze work-

shops have revealed more than 30,000 clay models and fired-clay molds used for casting bronze vessels.

The Influence of Confucianism and Daoism

After the decline of the Zhou dynasty and the Warring States period (480–222 B.C.), China entered a time of chaos as well as great intellectual ferment. Two influential scholars were propounding two quite different philosophies, initiating a moral and intellectual conflict that was reflected in China's later social, political, and artistic history. Both the scholarly orderliness of Confucianism and the mysticism of Daoism (Taoism) revealed themselves in the art of China. Moreover, Daoism would later become an important influence on certain segments of Japanese society and their ceramics.

The Qin (Ch'in) Dynasty (c. 221–202 B.C.)

The Qin emperors conquered all of China, unifying it under a powerful central government and ruling through fear. Until recently they were seen as ruthless tyrants who made little contribution to Chinese culture. Certainly they were ruthless—they created an early police state, exploiting the labor of thousands for their own glorification. An example is the army of terra-cotta soldiers and horses that was buried with the First Emperor Qin shi huang di (3-10). Arranged in battle formation, the army took thirty-six years and an estimated 700,000 workers to create.

These are the earliest realistic Chinese clay sculptures yet found, and they reveal a highly developed ceramic-sculpture building and firing technology. Research has shown that the figures were built solid up to the waist, coil-built from there up, and then beaten with a paddle. The hands and ears were made in molds, and the individualized heads were fired separately. Finishing details were done by hand. Chinese ceramists have replicated and fired similar figures in an attempt to understand the early technology. Built with the same methods as the originals and dried slowly, these replicas were fired for several days, reaching 1800°F/1000°C. Because this reconstruction of the early technique showed a failure rate of 10%, the mind boggles at what was involved in building and successfully firing the

(a)

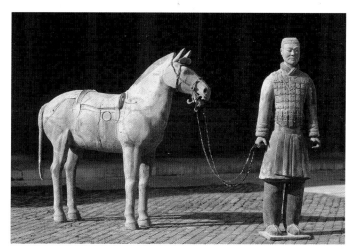

(b)

FIGURE 3-10

(a) Excavations in Shaanxi Province in China unearthed the terra-cotta army guarding the tomb of the Emperor Qin shi huang di (221–206 B.C.). Thousands of life-sized foot soldiers, bowmen, their officers, and horses were sculpted in the earthenware clay of northern China. Disposed in ranks on paved floors, they reveal a remarkable ceramics technology. *(b)* A cavalryman and horse from the emperor's bodyguard. The soldier is 5 ft. 10 in. (1.79 m.) tall, while the horse stands 5 ft. 7½ in. (1.79 m.) high. From the Emperor Qin's tomb in Lintong, Shaanxi Province, China. 221–206 B.C. *(a) Daniel Schwartz/Lookat, Zurich. (b) The Metropolitan Museum of Art, Asian Department (cat #19,102).*

more than 6,000 figures that have been found so far. The soldiers were originally painted after firing with mineral pigments that were mixed in a binder made of animal blood or egg white, but most of the paint has worn off.

The Han Dynasty (c. 206 B.C.–A.D. 220)

Under the Han, China again enjoyed a period of comparative peace, but the life of ordinary people probably changed very little. Much of what we know of their lives comes from the countless ceramic grave models made for the ruling class. These models were buried with the dead—instead of live slaves and horses—for use in the afterlife (3-11).

HAN LEAD GLAZE Made of earthenware, most of the grave models were unglazed and painted with unfired pigments that have largely worn

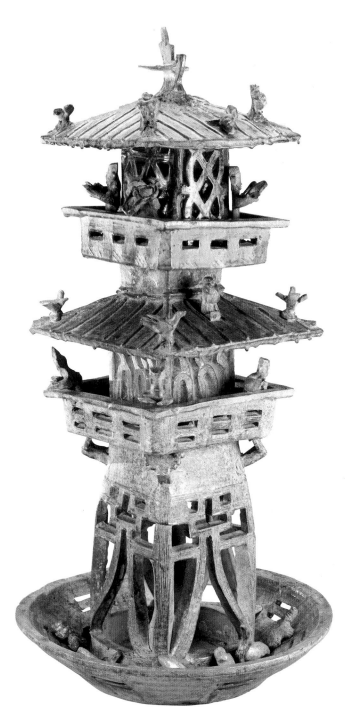

FIGURE 3-11
Peasant rebellions were frequent in the Han period, so landlords and their families took refuge in watchtowers like this one guarded by archers and sentries. Note the glazed tiles on the roofs. Grave model, green lead glaze. Ht. 33¼ in. (84.4 cm.). Han dynasty, second century A.D. *Courtesy Freer Gallery of Art, Smithsonian Institution, Washington, D.C., Gift of Charles Lang Freer, (F1907.68a-d).*

FIGURE 3-12
During firing, wood ashes fell on the shoulder of this Han stoneware jar, fused with the silica in the clay, and formed an accidental glaze. Stoneware. Han dynasty, 200 B.C.–A.D. 221. *Courtesy Royal Ontario Museum, Toronto, Canada, © ROM.*

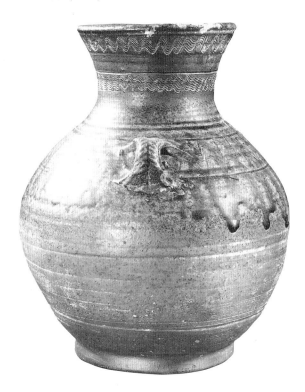

FIGURE 3-13
Later kilns in China were built with permanent domes designed to direct the heat up over the stacked ware and then downward before it went up the chimney. This type of kiln—called a **downdraft kiln**—could reach a temperature of 2192°F/1200°C. Because the chamber was open to the smoke and ashes of the fire, the combination of ash, silica in the clay, and high temperature usually caused an ash glaze to form on at least part of the ware. *Drawing by John M. Casey.*

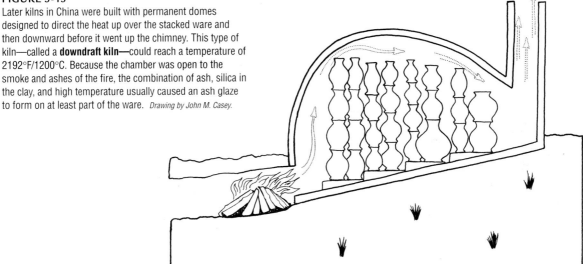

off, but some were coated with a newly developed **lead** glaze. Lead glazes had been in use in Mesopotamia since the sixth century B.C., leading to speculation that knowledge of these glazes was brought to China by traders following the Silk Road. Established in the second century B.C., this caravan route led from China through Afghanistan to western Asia and on to Rome, carrying China's fine silks and lacquerware to the West. From about 550 B.C., when the Persians conquered large areas of western Asia, they traded with Chinese silk merchants, selling them gold and silver vessels. When Chinese potters saw these, they adapted many of the Persian metal shapes to clay. Whether or not Persian potters traded their ware to China and taught Han potters their glaze techniques, lead glazes did appear in China, and Chinese pottery was traded across large areas of Asia, further spreading glaze technology.

HAN TECHNOLOGICAL IMPROVEMENTS Kilns and glazing techniques continued to improve during these centuries and in the following periods as potters continued to experiment with high-firing glazes (3-12, 3-13). By the end of the Han dynasty, potters in southern China were making a type of high-fired glazed feldspathic stoneware called Yue ware, whose greenish glazes came close to the famous green **celadon** glaze of the later Song period (see 3-17). In fact, so many kilns were being fired with wood in the

ancient kingdom of Yue that a ninth-century poet wrote:

> In autumn, in the wind and dew, rises the
> smoke of the kilns of Yue
> It robs the thousand peaks of their kingfisher
> blue.

Legend tells of a hard-working Han potter whose firing of a large and precious pot had failed. Distraught because his work was destroyed, the potter jumped into the kiln and died in the flames. After that sacrifice, miraculously all the pots fired perfectly, so from then on potters worshipped him as the god Tung, "Genius of Fire and Blast."

Toba Wei (A.D. 386–617)

After the fall of the Han dynasty, northern China was overrun by waves of nomadic horsemen. Living on the edges of this stratified society were the herd-tending nomadic tribes of central Asia who moved constantly through the mountains, steppes, and deserts of that vast area. Periodically they appeared on their swift horses to raid the more settled Chinese communities, sometimes destroying them, sometimes assimilating into them and passing on new artistic styles they had absorbed in their nomadic wanderings. Eventually the Toba Wei, a Turkish tribe, took control in A.D. 386. These invaders ruled through

FIGURE 3-14
This northern Wei period tomb model illustrates how architectural roof tiles and ornaments were used on palaces and temples. China's ceramics industry turned out quantities of molded or stamped bricks and glazed tiles decorated with scenes of farm life, craft shops, hunters, and processions of notables. Northern Wei, A.D. 386–534. *Giraudon/Art Resource, NY.*

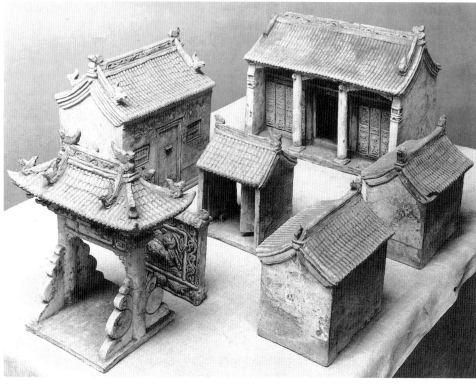

FIGURE 3-15
The Toba Wei, a Turkish tribe, conquered northern China in A.D. 386, ruling through military officials. These officials were realistically depicted in painted earthenware. Ht. 35 in. (88.9 cm). *Courtesy Asian Art Museum of San Francisco, The Avery Brundage Collection, B60S498. Used by permission.*

military officials who became part of the Chinese bureaucracy, abandoning their nomadic lives and adopting Chinese language, building styles (3-14), and dress, along with the Buddhist faith. We can see their Western faces reflected in the ceramic sculpture of the time (3-15).

Architectural Ceramics

The making of roof tiles had long been part of the ceramics industry in China. The decoration was made by stamping patterns into the clay with fired-clay stamps, or the tiles were made in negative carved molds lined with cloth to keep the clay from sticking, thus transferring the design in positive to the damp clay. Decorated bricks, tiles, and architectural ornaments became an integral part of the wooden buildings, even before the knowledge of glazes made brightly colored clay tiles possible. Once the knowledge of lead glazes reached China during the Han period, the greenish lead glaze was adapted to cover earthenware tiles as well. From then on, as more colors became available to the potter, glazed ceramic tiles and roof ornaments became characteristic of Chinese architecture.

The Tang Dynasty (A.D. 617–906)

Tang ceramics reflect the cosmopolitan aspect of this period in China's history. Along with the camels and their drivers from the silk caravans, foreigners appear in the clay figurines that were glazed with polychrome lead glazes (3-16). Made by mixing copper, iron, or cobalt with lead silicate, these blue, green, brown, and yellow glazes were often applied over a white slip. They tended to be runny because of the action of the lead flux, and the potters applied them freely so that they ran down the sides of the figures, color over color. The Tang potteries also produced many unglazed sculptures of female musicians, dancers, and court ladies, reminding us that during this dynasty China was governed for fourteen years by the Empress Wu. During her reign, upper-class women were educated, wrote poetry, and played polo. It was a tolerant society; foreign religious groups were allowed to build temples and churches in the capital—among them were the Buddhists, whose religion eventually became dominant.

Western shapes continued to be popular in Chinese ceramics. These ranged from pilgrim bottles from Persia, to pottery copies of metal ewers, to Hellenistic amphorae. All were absorbed into the Tang potter's repertoire but adapted to local taste and materials.

The First True Porcelain

Under the Tang the ware from the Yue kilns became more refined, until finally a true porcelain was attained and perfected. Porcelain clay body is composed of kaolin, feldspar, and silica, and when fired to a temperature of 2370–2440°F/1300–1450°C or more it becomes vitrified and translucent. China's fine porcelain was described by a Muslim merchant as so thin that one could see the sparkle of water through it; it was this translucence that caused it to be treasured by Chinese connoisseurs, poets, and the court. This fine white clay body was made possible by the discovery of deposits of both the white primary clay, kaolin, and **petuntze,** a white feldspathic rock essential to the making of porcelain. During high firing, the petuntze (China stone, or **Cornish stone**) melts and surrounds the particles of kaolin so that they can fuse. Official Imperial Kilns were established in Jingdezhen (Ching te

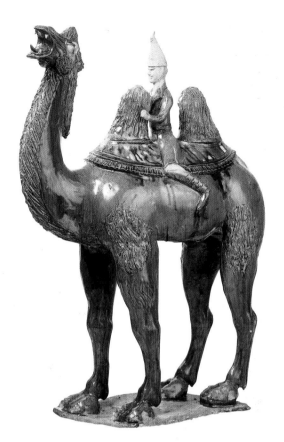

FIGURE 3-16
Chinese potters made many models of the western Asian camels and their drivers who traveled the Silk Road. First the potters modeled the camels; then they made their humps and packs and drivers, attaching them before glazing the pieces with yellow, green, and brown lead glazes that were allowed to run down the sides. Buff earthenware, brown and green glazes. China, Tang dynasty, A.D. 618–907. *Courtesy Victoria & Albert Museum, London/Art Resource, NY.*

chen) near deposits of kaolin. The finished ware was shipped by boat to Nanjing (Nanking) and then through the Grand Canal to the Imperial Palace in Beijing (Peking).

The Song (Sung) Dynasty (A.D. 960–1279)

The ceramics of the Song dynasty, like those of the Tang, reflected the taste of the court, where every educated person studied painting and calligraphy and even the emperors were painters and poets. In this atmosphere of culture and artistic accomplishment, ceramics were elegant, formal, and exquisitely crafted. Produced in several pottery centers, some of which had as many as 200 kilns, much Song porcelain was formed

FIGURE 3-17
A celadon glazed ceremonial jar from the Song dynasty, fired in
the northern kilns. The famous celadon glazes of China varied in
color from one area to another due to variations in the minerals
used and in the firing temperatures of local clays, but they all fired
to shades of green—from bluish green to greenish brown.
Eleventh century A.D. *Courtesy Asian Art Museum of San Francisco, The Avery
Brundage Collection, B60P147. Used by permission.*

in carved molds that transferred their designs
onto the damp clay.

SONG GLAZES When Westerners think of Song
ceramics, a soft green glaze usually comes to
mind. In Europe it was named *celadon* for a
character in French theater who was dressed in
that shade of green (3-17). The soft green was the
result of centuries of experimentation in an at-
tempt to achieve the color and surface of sacred
jade. In fact, celadon glaze may fire to many
shades because the iron oxide in the glaze, when
fired in reduction, can create a wide range of
tones from leafy green to watery bluish green, de-
pending on the oxides present in the clay body

and in other glaze materials. Potters were limited
to local materials, so the results varied greatly
from one area to another and from one period to
another. For example, the celadon from northern
China was formed of a gray porcelaneous body
on which the glaze was first fired in reduction at
a high temperature, then in an oxidizing atmo-
sphere as it cooled. The glaze emerged from the
kiln a greenish brown. By contrast, at the south-
ern Longquan (Lungchuan) potteries the glaze
was used on a grayish white stoneware body, and
when fired in reduction on that clay body it pro-
duced a pale olive green.

Rice-straw ash was a popular ingredient of
Song glazes because it is high in silica, thus con-
tributing to the stability and hardness of the
glaze. Its mineral content varied according to the
soil in which the rice was grown, so another
variable was introduced to the glazes.

Chinese ceramics continued to be in demand
abroad; Arab countries bought it in great quanti-
ties. Thousands of shards of both Yue ware and
white porcelain were found in the ruins of the
summer palace of the caliphs. Celadon was also
popular among rulers who feared assassination;
it was believed the ware would crack and change
color if exposed to poison. This idea may have
been prompted by the low-silica **crackle glaze**
that was deliberately **underfired** to create a dec-
orative effect. This finish resulted from the acci-
dental discovery by the Chinese potters that the
glaze would crack if not properly formulated to
shrink along with the clay body. The effect was
popular, so the potters exploited and controlled
the crackled surface deliberately.

The porcelains made from the excellent clays
of China were envied by potters in Persia, who
used white **tin glazes** to cover their coarse red
clay in an effort to compete with the white
porcelain Chinese imports. This use of white tin
glaze later spread to Europe, where it formed the
background glaze for **maiolica** decoration. (See
Chapter 6.)

In northern China, however, Tang-style glazes
continued to be used into later periods. The
earlier low-fire glazes were used there with
particular success on a group of remarkable
large Buddhist figures sculpted between the
tenth and eleventh centuries (3-18). In addition
to making the classic white-glazed porcelain
and soft green celadon and crackle glazes, the
Song potters produced the brilliant *Jun (Chun)*
glaze with purple and red splashes (3-19). This
was fired in long chambered, or "snake kilns,"

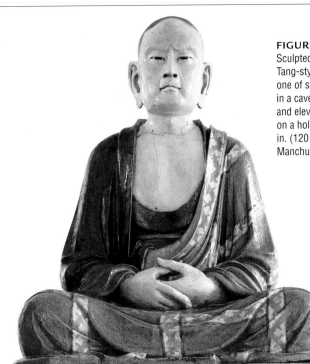

FIGURE 3-18
Sculpted in light-colored clay and covered with low-fire Tang-style green and warm brown glazes, this *Lohan* is one of sixteen images of the apostles of the Buddha found in a cave near I-chou (Hopei). Sculpted between the tenth and eleventh centuries A.D. The heavy clay figure was built on a hollow base that was supported with arches. Ht. 47½ in. (120 cm.). China, Song dynasty or Liao kingdom, Manchuria. *Courtesy British Museum, London.*

FIGURE 3-19
This stoneware Jun ware bowl made in the Song dynasty shows a cobalt blue glaze splashed with copper. Diam. 7½ in. (19 cm.). © *Victoria & Albert Museum, London/Art Resource, NY.*

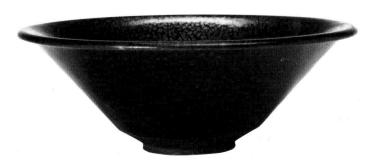

FIGURE 3-20
Often mottled with "oil spots" or streaked as "hare's fur," this glaze was developed by Song potters. In Japan it was known as *tenmoku*. Bowl, Jian (Chien) ware. Ht. 2¾ in. (7 cm.). China, Song dynasty, tenth to thirteenth century A.D. *Courtesy Asian Art Museum of San Francisco, The Avery Brundage Collection, B60P1718. Used by permission.*

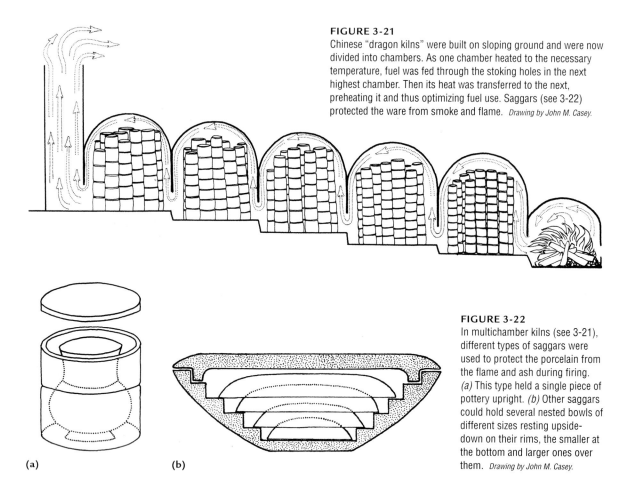

FIGURE 3-21
Chinese "dragon kilns" were built on sloping ground and were now divided into chambers. As one chamber heated to the necessary temperature, fuel was fed through the stoking holes in the next highest chamber. Then its heat was transferred to the next, preheating it and thus optimizing fuel use. Saggars (see 3-22) protected the ware from smoke and flame. *Drawing by John M. Casey.*

FIGURE 3-22
In multichamber kilns (see 3-21), different types of saggars were used to protect the porcelain from the flame and ash during firing. *(a)* This type held a single piece of pottery upright. *(b)* Other saggars could hold several nested bowls of different sizes resting upside-down on their rims, the smaller at the bottom and larger ones over them. *Drawing by John M. Casey.*

(a) **(b)**

which produced alternating oxidation and reduction. The colors achieved would vary according to the iron, copper, and other materials present in the glaze.

Another glaze developed in the Song period was exported to Japan, where it became popular with Japanese potters and eventually, through them, with Western potters. This was the blackish brown **slip glaze** that later was named **tenmoku** in Japan. This is the name by which we still know it (3-20). A thick, oily-looking glaze that often collects in rolls and drops at the bottom of a piece, its surface may show "oil spots" or "hare's fur," effects that were deliberately sought. These glazes perfected during the Song dynasty represented a developing expertise and aesthetic sensibility that would cause a sensation when they became known in Europe.

SONG KILNS The kilns that now fired the ware were much more advanced, often built into a hill in a series of stepped levels and sometimes

as much as 165 ft. (50 m) long (3-21). The firing kilns were vividly portrayed by Chinese writers as giant dragons spitting fire. Most of these **chambered kilns** were fired with wood, although some smaller ones used coal, and the potters had to prevent the free-floating ashes from spoiling the celadon glaze. Their solution was to fire each separate piece in a fire-resistant container, or **saggar** (3-22), that would protect it from the wood ash. The Longquan kilns could fire as many as 20,000 saggars at one time.

UNDERGLAZE DECORATION One result of the trade that Persia and China carried on across Asia was an influx of Persian decorative motifs to China. These were adopted first by silk weavers and then by potters. Partly due to Persian influence, toward the end of the Song dynasty the potters had also become increasingly interested in colorful, high-fire glazes and other methods of surface decoration. This led them to experiment with painting floral designs in black

under a transparent glaze. This type of painting, called **underglaze,** had been used in western Asia since the ninth century (see 3-34), and now Chinese potters tried it, initiating a new phase of pictorial decoration that would influence later Japanese and European ceramics. In the fourteenth century they experimented with copper oxide to paint red underglaze on their porcelain, but the copper bled into the white or lost its color when fired. Giving up on the copper, they began to use cobalt for underglaze decoration. To apply underglaze, the artist first allowed the body to dry, then painted the pigment on the unglazed body, and finally covered the vessel with a semiopaque glaze. This method allowed the painter to apply detailed decoration. After a single firing, the underglaze became suspended in the translucent glaze between the outer surface and the body, acquiring luminosity and brilliance (3-23). The Chinese cobalt, however, contained a high proportion of both manganese and iron impurities, so it fired to a dull blue; Persian cobalt, on the other hand, contained no manganese and fired to a clear blue. To satisfy the Chinese demand for brilliant color, the trading caravans brought Persian cobalt to China, where it was called *Mohammedan blue*. Cobalt is a strong pigment that resists porcelain-firing temperatures and is not affected by oxidation or reduction atmospheres in the kiln.

Eventually the Chinese learned to refine the iron out of their own cobalt, but they could never completely eliminate the manganese, so they mixed local cobalt with some of the expensive imported oxide, using this mixture for the bulk of the blue and white ware. Only the court porcelain, made in the Imperial Kilns, was underglazed with the pure imported Persian cobalt.

BLUE AND WHITE EXPORT WARE Chinese blue and white ware became popular all over Asia. As the demand for it grew, much of this ware was made for export to Persia, and to increase its popularity potters decorated it with Persian inscriptions. Near the turn of the seventeenth century, however, Chinese potteries began to export a thin, rather brittle blue and white porcelain ware to Europe. Because the European potters were unable to produce such a fine, white clay body, its appearance created a sensation there. Soon the Dutch were importing the ware by the shipload, and to satisfy Western customers the Chinese factories adapted their shapes and decorations to European taste. The arrival of this ware

FIGURE 3-23
A Chinese "blue and white ware" dish with underglaze blue decoration and porcelain glaze. When this ware first appeared in the Arab countries, potters tried to copy it with low firing clays and glazes. Later shipped to Europe, its arrival there led to efforts by European potters to achieve the high standard of Chinese porcelain bodies and glazes. The ware was also copied in low-fire clay in Holland and became known as *Delftware* (see 6-20). Hongzhi mark and period. A.D. 1488–1505. *Courtesy Percival David Foundation of Chinese Art, London.*

led to a competitive effort by European potters to formulate a porcelain body and find the necessary materials to make it. (See Chapter 6.)

The Ming Dynasty (A.D. 1368–1644)

The Ming rulers liked to consider themselves the heirs to the refinement of the Song dynasty, but in reality they preferred elaborate decoration rather than the simplicity of Song design.

Lovers of rich, luxurious living, Ming officials commissioned highly decorated ceramics—the *three-color* and *five-color* wares painted with **china paint,** or **overglaze enamel.** These **overglazes** were colored with metallic oxides and contained a great deal of lead so that they would melt at a low temperature, around 1470°F/800°C.

The three-color overglaze enamels were painted over the high-fired body glaze, and when the pottery was given a final low-temperature firing, the lead in the main body glaze softened enough that the overglaze fused into it. On the

FIGURE 3-24
A porcelain vase made in China between the late seventeenth and early eighteenth centuries shows the famous red copper glaze called in Europe *ox blood*, or *sang de boeuf*, that was originally developed in the fifteenth century. A.D. 1662–1722. © *Victoria & Albert Museum, London/Art Resource, NY.*

five-color ware, high-firing cobalt provided a blue underglaze. The other four colors were added as overglazes. Eventually an overglaze blue was developed, as well as an opaque white glaze that provided a good background for the overglazes. This many-colored type of decoration became so popular and the demand for enamel-decorated ware so great that the potters had to speed up production and potteries were organized like factories.

We know a good deal about the Imperial Kilns, where the export porcelain and overglaze-decorated ware were produced, from the writings of a European priest who visited the kilns between 1698 and 1741. In letters sent back to Europe, he wrote that one decorator would paint only one type of leaf, flower, or figure, and as many as seventy potters might work on one piece of porcelain.

The Qing (Ching) Manchu Dynasty (A.D. 1644–1912)

Under the Manchu, Tsang ying-hsuan, the director of the Imperial Kilns, was responsible for the development of a group of glazes that became extremely popular with connoisseurs of fine porcelain, first in China and later in Europe. The kilns during this period produced colorful glazes—clear yellow, spotted yellow, turquoise, and rich black. The kilns were also famous for the **sang de boeuf** ("ox-blood"; 3-24), *peach bloom,* and *claire de lune* ("moonlight") glazes, which were exported to Europe and the United States. There, they became famous under those names. Often the glazed porcelain was shaped into boxes to hold the red paste with which affluent scholars stamped their names on their calligraphic scrolls, as well as pots for washing or holding their brushes. These classic pieces were the envy of European collectors, who spent fortunes to buy them.

KOREA

Although moving back and forth in our discussion between Japan, Korea, and early China can become confusing, it is necessary in order to understand how these cultures influenced one another. The original prehistoric people of Korea, the Yemaeks, who settled the peninsula in a time known to historians as the Plain Coarse Pottery period, apparently came from the north. Documented Korean history begins at the end of the second century B.C., when the Han dynasty armies from China invaded and occupied an area of the northern Korean peninsula, holding it until A.D. 313. Buddhism arrived with the invaders and eventually became the main religion in Korea, whence it was taken to Japan. While the Chinese invaders settled in the north, the native Koreans established a series of states farther south—the Three Kingdoms—of which the Silla is the most interesting to us because of its characteristic ceramics. Along with clay figures and objects made to be placed in tombs (3-25, 3-26), the Silla potters produced gray urns (3-27), frequently composite, made in several parts.

By the time of the Tang dynasty in China (A.D. 617–906), the Silla rulers had unified the three kingdoms and formed an alliance with the imperial Chinese court. At this time Chinese ceramics

FIGURE 3-25
An ash-glazed stoneware tomb model of a Korean warrior wearing leather-plated armor. The funnel on the back of his horse and the spout on the horse's chest suggest that this was a ritual vessel for pouring libations. The ring on the spout probably held a "dangler" of clay links, a characteristic decoration on such vessels. Ht. 9¼ in. (25.5 cm.). North Kyongsang province, Korea, Old Silla dynasty, fifth to sixth century A.D. *Courtesy National Museum of Korea, Seoul.*

FIGURE 3-26
This stoneware chariot model from a tomb of the Old Silla dynasty in Korea reproduces all the details of the carts in use at that time. It has movable wheels. North Kyongsang province, Korea, Old Silla dynasty, fifth to sixth century A.D. *Courtesy Kyongju National Museum of Korea.*

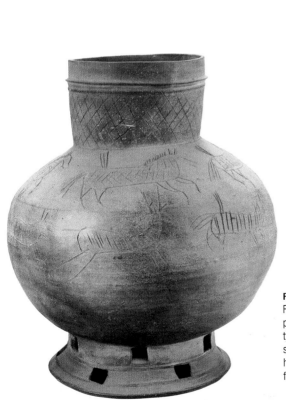

FIGURE 3-27
Fired to stoneware hardness, the gray clay of this jar is covered in places with a natural ash glaze. The openwork pedestal base is typical of Old Silla pottery, and the incised line drawings of deer suggest a relationship with the northern tribes, which used deer horns in shamanistic practices. Uljn-gun, Korea, Old Silla dynasty, fifth to sixth century A.D. *Courtesy National Museum of Korea, Seoul.*

techniques such as intentional glazing reached Korea and were adopted by the Korean potters. Later, during the Song Dynasty in China (A.D. 960–1279), because their relations with northern Korea were unfriendly, Chinese trading ships came across the Yellow Sea to the southern part of Korea, bringing ceramics, along with paper, silk, books, and ginseng. Thus, Korean potters learned how to make Chinese glazes, and it was through Korea that Chinese ceramics knowledge reached Japan.

LATER JAPAN

The Old Tomb Period (c. A.D. 300–600)

During this period, named for its many tombs, entire communities of potters came or were brought to Japan from Korea. The ware they made—a pottery known as Sue—was fashioned of a high-firing, dense gray body into what was undoubtedly a luxury item. At the same time, Chinese-influenced proto-porcelain was being brought to Japan from Korea, and with it arrived the technique of applying glazes.

Although the Japanese potters, like the Chinese and Koreans, now became dedicated to refining clay and glaze, some of the vitality of the earlier Jomon period was maintained in the vigorously modeled *haniwa* sculptures made during the Old Tomb period (3-28). The *haniwa*, literally "clay circles," were derived from the simple cylinders that were embedded in the ground around the mounded earth of the tombs, possibly to keep the earth from sliding. The Old Tomb *haniwa* sculptures portrayed people, ani-

FIGURE 3-28
The cut-out eyes and mouth of this Japanese *haniwa* warrior give his face expression, but they also served as vents to allow vapor and gases to escape during the sculpture's firing. The *haniwa* were originally simple clay cylinders sunk in the ground around the mounded royal tombs. Later they were modeled to depict dancers, singers, farmers, warriors, and animals. Earthenware. Fujioka, Japan, late Tumulus period, c. sixth century A.D. *Courtesy Asian Art Museum of San Francisco, The Avery Brundage Collection, B60S204. Used by permission.*

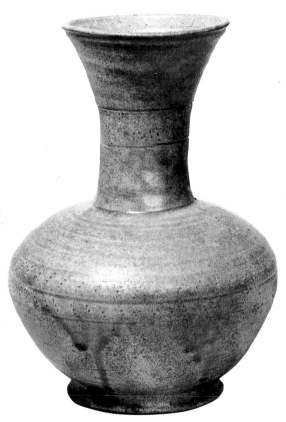

FIGURE 3-29
When we compare this ash-glazed Japanese stoneware jar with a similar Han jar (see 3-12), it is clear how much the early stoneware of Japan owed to Chinese influences. However, the lively, almost awkward way in which the narrow neck sits on the swelling body exemplifies the direct and vital Japanese attitude toward clay. Ninth or tenth century A.D. *Courtesy Board of Trustees of the Victoria & Albert Museum, London/Art Resource, NY.*

FIGURE 3-30
An early Japanese snake kiln, modeled on similar Chinese and Korean kilns. The pots were packed on top of one another on circular stands with slanting bases to keep them level on the sloping floor. Sometimes saggars were used to protect the ware from the flames and ash in the kiln.
Drawing by John M. Casey.

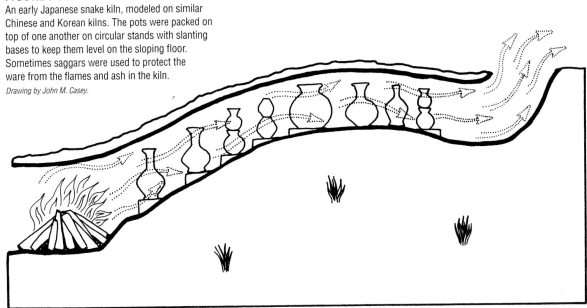

mals and objects of everyday life in Japan: warriors, farmers, singers and dancers, houses, horses, and other animals.

A thirteenth-century Japanese Buddhist priest, Toshiro Kato Shirozaemon, went to China to learn more about ceramic techniques and when he returned in 1227 he carried some Chinese clay with him. Later he discovered good clay in Japan, and he was said to have founded the Japanese pottery industry in the Seto area. This is still the largest pottery-producing area in the country.

Japanese Kilns

From the mid-1200s on, the ceramics industry in Japan expanded, and crafts guilds became part of Japan's highly organized class system. The workshops now fired their stoneware (3-29) in kilns, sometimes known as snake kilns because of their length and form. These kilns were built to climb up a hill in one long tunnel with no interior dividing walls (3-30). Called *anagama*, they were modeled on the sloping kilns of China and Korea. In them the Japanese potters fired pottery whose glazes were meant to imitate the celadon and other Chinese glazes of the Song period. But because the Japanese lacked the centuries of accumulated knowledge of the Song

potters, their ware was coarser and coated with a greenish and sometimes yellow glaze that did not attain the quality of the Chinese glazes.

As Buddhism became the dominant religion in Japan, Japanese sculptors created temple figures that reflected the restrained spiritual quality of the religion. Some of these, made of clay mixed with straw, were unfired, built over wooden forms. These figures were coated with fine clay and then painted; incredibly, some survive today.

Zen Buddhism and the Tea Ceremony

During the Song dynasty in China, the Chan sect of Buddhism emerged; like the Daoists, they emphasized self-cultivation and meditation. Called Zen in Japan, this sect developed a highly ritualized ceremony, in which the drinking of tea and its attendant rituals became a means of acquiring nobility and purity of thought. Brought to Japan by returning Buddhist monks around A.D. 1200, Zen Buddhism became an integral part of the search for enlightenment in Japan. Chinese tea bowls were introduced, along with tea houses, where the tea ceremony was performed. Japanese potters began to make the ceramics that accompanied the tea ceremony in their own way, creating forms and surfaces that expressed the Zen ideal of simplicity.

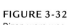

Tea Ceremony Ceramics

An influential Japanese tea master, Sen no Rikyu (1521–1591), preferred to use the simple rice bowls of Korea and the brown and black iron glaze (called *tenmoku* in Japan) for his tea bowls. Others followed his lead, and soon there was a demand for these *chato,* or tea ceramics, which included tea caddies, bowls, jars, and flowerpots, along with the tea bowls (3-31). These roughly shaped tea bowls were first made in the sixteenth century in Kyoto by a Korean. Following his death, his Japanese widow and then her son, Chojiro (1515–1592), carried on the tradition, as did a grandson, who was given the right to mark the character *raku* ("pleasure") on the bottom of his bowls. From then on, successive generations of the family made **raku** tea bowls in Kyoto into the twentieth century.

These *chawan* (tea bowls) were pinched from a solid lump of clay, then carved into their final shape. This method produced a bowl with no joints and was done for aesthetic as well as practical reasons, because the bowls were subjected to damaging temperature changes when they were placed in and quickly removed from the red-hot raku kiln. This firing, done in a special small kiln, generally created cracks, pits, and other sought-after variations in the glaze, individualizing each bowl.

The coarse clay body from which the tea bowls were made did not conduct heat quickly, and part of the enjoyment of the ceremony was the gentle, slow warming of the hands by the hot tea served in them. The tea ceremony experience included an appreciation of the rough surface of the bowls as they were held in the hands. Each piece of *chato* expressed the character of the master potter who made it; some famous bowls were given names and are now classified as National Treasures of Japan.

Bizen Tea Pottery

Among the most famous of the tea ceramics were those that came from the **Bizen** kilns, where a rustic type of pottery greatly valued by tea mas-

ters was fired in a deliberate effort to achieve accidental fire markings (3-32). To create a wide range of surface effects on one pot—rosy red, matt black, greenish glaze, with areas of opalescence—the potters packed the *cha-ire* (tea containers) inside other pots lined with straw, or placed bags of straw next to them in the climbing *anagama* kilns. As the straw burned, it produced areas of local reduction that were responsible for the variations on the surface.

Both the raku method of placing tea bowls in the hot fire and the Bizen use of local reduction firings have had an influence on contemporary Western pottery, especially since the resurgence of interest in Zen Buddhism. Potters all over the world now use tenmoku glazes, fire in wood-burning kilns of Japanese-derived style, and practice variations of the raku firing process, some of which the early tea masters might have difficulty recognizing.

Japanese Porcelain

Japanese potters did not limit themselves to these deliberately rough wares produced in the Tamba, Tokoname, Bizen, and Shigaraki kilns. At the beginning of the sixteenth century a Japanese potter visited China to study the porcelain industry there, hoping, without success, to find the necessary ingredients for making a porcelain body in Japan. Finally, around 1605, an immigrant Korean potter named Ri Sampei did find kaolin in the Arita district of Japan. The porcelain industry founded there grew so rapidly that by 1664, 45,000 pieces of porcelain were being shipped to Holland each year. Japan quickly outpaced China in the export trade, and so many trees were cut down to fuel the kilns that the government restricted the building of new ones. By this time the Japanese kilns were divided into chambers.

Decoration

Potters had also learned from China the techniques of underglazing with cobalt blue and using brightly colored overglazes. With a natural sense of design and skill with the brush, Japanese potters created some enameled ware of great beauty. However, like Chinese potters, they often had to satisfy the Western taste for garish

FIGURE 3-33
Ogata Kenzan, the potter, signed this square tray on the base, and the painter, Ogata Korin, his brother, signed it above his brush painting of irises. Stoneware tray by Ogata Kenzan, decorated by Ogata Korin. 8⅝ in. square (21.7 cm.). Edo period, 1615–1868. *Courtesy Freer Gallery of Art, Smithsonian Institution, Washington, D.C. Gift of Charles Lang Freer, F1920.220.*

colors and overelaborate forms. To speed production, many people worked on each piece, which meant that although the ware was popular in Europe, it did not meet the high aesthetic standard demanded by collectors in Japan.

The Edo Period (1615–1868)

Despite the emphasis on mass production of export ware, there were potters in Japan who maintained a close personal relationship with clay, forming their restrained pottery themselves and decorating it with graceful underglaze brush paintings. In the seventeenth century the capital of Japan moved from Kyoto to Edo, from which city the period takes its name. Two brothers, potter Ogata Kenzan (1663–1743) and painter Ogata Korin (1658–1716), remained in Kyoto, however, applying their highly developed taste and visual awareness to ceramics (3-33). Inspired by nature, they often worked together, and both signed the pieces on which they collaborated.

The decoration consisted of simple shapes brushed on with masterly strokes in brown or black on a white clay body or a colored clay covered with a white slip. Throughout the years the name Kenzan has been bestowed to honor potters considered worthy of it, and in the twentieth century one Western potter, Bernard Leach of England (see 8-2), was honored with the name Kenzan VII (see 8-2).

Today Japanese ceramics encompasses an active industry and a vigorous, honored craft; it also includes many artists working with a contemporary approach to both pottery and sculpture (see 16-5).

WESTERN ASIA

At the other end of the Silk Road that led from China to the West (see 3-1), the Persians had expanded their empire and created a new style of art called Sasanid, or Sasanian (A.D. 226–651). Persian cities became the meeting places of two worlds—central Asia, India, and China to the east and Syria and Rome to the west. Potters working in Persia during earlier dynasties had experimented with glazes and refined the white opaque tin glaze that covered the reddish color

of their earthenware clay (3-34), creating an excellent background for inscriptions or decoration. Through continued experimentation the potters learned to give color to the opaque glazes they used on pottery and tiles (see 3-39, 3-41). These glazing techniques were handed down through generations, and by the seventh century A.D., when Arabs conquered Persia and other eastern territories, the Sasanid taste influenced Islamic ceramics. Based on the Persian knowledge of alkaline and lead-tin glazes, glaze technology was passed on and refined wherever Islamic ceramics were made (see 3-36, 3-39–3-41).

Islamic Ceramics

The rich glaze tradition of the Islamic world can be traced back to the glaze experimentation by early potters in Egypt and Mesopotamia. Firing was done in updraft kilns capable of attaining temperatures between 1000 and 1200°C.

The Abbasid, who came to power in A.D. 750, established their capital in the new city of Baghdad, where palaces and mosques were decorated with tiles. Pottery was now decorated for the first time with lead glazes, some of it with green, brown, and yellow splashes under a transparent lead glaze. Possibly this ware was influenced by

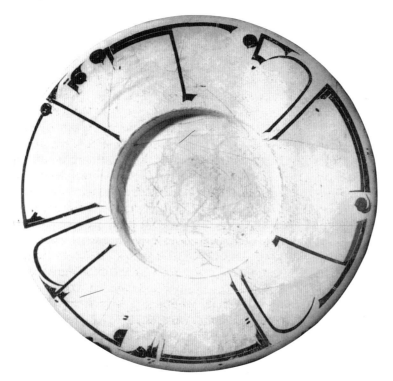

FIGURE 3-34

The inscription in Kufic script on this Iranian plate creates an abstract design but also preaches a lesson: "Deliberation before work protects you from regret." The potter decorated the plate with underglaze on white slip-covered earthenware in an attempt to copy the underglaze-decorated porcelain of Song China. Diam. 14⅝ in. (37.2 cm.). Persia (Iran), Samanid period, tenth century A.D. *Courtesy Saint Louis Art Museum, purchase.*

FIGURE 3-35
The characteristic tile mosaics of the Seljuk period were glazed mainly with turquoise, which contrasts with the black, cobalt, and violet glazes used in the remaining tiles. Cut into stars, leaf patterns, and interlacing designs, the pieces were set in a light-colored background mortar. The domes, walls, and niches covered with these tiles meld into an overall blue tone, evoking the sky. Tile mosaic in the former Karatay Medrese (an Islamic law school, now a museum), Konya, Turkey. Anatolia, c. A.D. 1251.

the Chinese Tang three-color ware. Other Chinese influences were evident in Samarra, where potters tried to imitate contemporary Chinese white porcelain by painting cobalt designs and inscriptions over an opaque tin-glazed ware.

One factor of great importance in the development of Islamic art that also applied to ceramics was the prohibition in the Koran, the Muslim religious text, against the portrayal of human figures in mosques or on pottery used for religious purposes. These strictures also limited much ceramic decoration to abstract patterns, floral motifs, and stylized calligraphic proverbs or quotations from the Koran, although human images did appear on some pottery made for secular use. Far from limiting the creativity of potters, however, the regulations forced them to develop a rich style of floral decoration called *arabesque.* This type of decoration was widely used to decorate tiles for mosques.

TILE DECORATION The tile makers of the Muslim world used their artistry to apply ceramic decoration to mosques, minarets, prayer niches, and palaces (3-35; see also 3-40, 3-41) throughout the Islamic world, from Persia to Anatolia, Turkestan, Afghanistan, and Spain, encompassing a wide variety of styles that flowered during an equally wide span of time—from about the ninth to the eighteenth centuries A.D. A few very early tiles survive from the ninth century; they are decorated with **luster** glaze painted over the base glaze and refired in a reduction atmosphere. In the thirteenth century tiles were often cut into rectangular, floral, circular, and triangular shapes that were carefully fitted together to create mosaics. Over the centuries tile makers produced tile decorations ranging from simple turquoise and cobalt designs on religious buildings to elaborate multicolor panels that created a gardenlike atmosphere in the palaces and harems of the

FIGURE 3-37
Opaque white tin glaze makes an excellent background for colored glazes and iridescent yellow luster overglaze decoration on a bowl from Kahr, near Teheran, Persia (Iran). Diam. 7½ in. (19.1 cm.). Late twelfth to early thirteenth century A.D. *Courtesy Board of Trustees of the Victoria & Albert Museum, London/Art Resource, NY.*

FIGURE 3-36
Persian potters often used black, white, and blue glazes on pottery or tiles. The inscriptions on such bowls might read "Sovereignty is God's" or "Blessings and beneficence." Kashan, Persia, thirteenth century A.D. *All rights reserved, The Metropolitan Museum of Art, Bequest of William Milne Grinnell, 1920 (20.120.34).*

FIGURE 3-38
Earthenware tiles coated with opaque tin glazes decorated palaces, mosques, and tombs in Persia and throughout the Muslim world. The tiles were often cut in the shapes of stars, leaves, and flowers. Vines and flowers twine in interlaced decorations called *arabesque,* while Arabic script is used as decoration. 21 in. square (53.4 cm.). From a tomb, Persia, thirteenth century A.D. *Courtesy Board of Trustees of the Victoria & Albert Museum, London/Art Resource, NY.*

FIGURE 3-39
The decoration on this plate is typical of that used on pottery ware and tiles made in the ceramic town of Iznik, Turkey during the Ottoman period. The red underglaze color on the ware was often applied so thickly that it created a relief design. Similar motifs are seen on the tiles in palaces and mosques. Ottoman dynasty. Sixteenth century. © *Giraudon/Art Resource, NY.*

Ottoman Turks. In the sixteenth century tile makers in Turkey discovered that an iron-rich clay (called *Armenian bole*) would produce brilliant red accents, and they applied it thickly, creating an actual relief.

LUSTER WARE Since the Koran taught that the faithful would be rewarded in paradise with vessels of gold and silver, it was forbidden to use precious metals on earth. In addition, in Sasanid Persia there was a shortage of silver, so silver vessels became even more expensive. It has been suggested that potters therefore looked for a substitute material that would give the appearance of metal but would still allow its owners to remain good Muslims; this led them to develop a form of overglaze called *luster.* This iridescent decoration was made with metallic salts—copper or silver, for example—mixed with a paste of **gum** or clay and painted on top of the glaze. The piece was then given a low firing at 1112°F/600°C in a reducing atmosphere, after which the kiln was sealed and allowed to cool. Although the Egyptians had used luster earlier, it was the Islamic potters who perfected it, using

it with rich effect on pottery and tiles throughout the Islamic world. Styles of luster decoration varied from one place to another and from one century to another (3-36–3-41).

FRIT WARE At the beginning of the fourteenth century, Abu'l Qasim, who lived in Kashan, wrote a ceramic "how-to" book that gave, among many recipes, one for a clay body that became a popular substitute for Chinese porcelain. It consisted of a glass **frit,** quartz, and white clay and was formed on the wheel. Because the clay was not very plastic, vessels had to be made in small sections. Later sections would be either thrown onto the already leather-hard first section or made separately and luted to it when it, too, became leather hard. Then, when the entire vessel was leather hard, the potter would thin it by gradually scraping away clay from the walls as the vessel turned on the wheel. Vessels made of this frit body, if thinned enough, could become translucent like Chinese porcelains.

When the religious climate of Islam grew less strict for a time, potters did portray the human figure (see 3-37), along with animals and birds,

FIGURE 3-40
Copper luster overglaze decorates a water jug used for washing hands at table. Known as *aquamaniles,* these jugs had tubes inside to direct water through the animal's mouth. Earthenware, coated with white glaze, then painted with luster, it was reduction-fired at a low temperature to create the coppery glow. Persia, late fifteenth to early sixteenth century A.D. *Courtesy Board of Trustees of the Victoria & Albert Museum, London/Art Resource, NY.*

sometimes combining them into fantasy creatures or using animal shapes for ceramic jugs or other objects. But the human figures never appeared on the tiles that enhanced the walls of the prayer niches. These continued to display pious inscriptions and arabesques of plant forms.

Flowers, leaves, abstract designs, and inscriptions painted in bole red and blues on a white background are characteristic of the pottery and tiles made in Isnik and Bursa in Turkey, during the Ottoman period (seventeenth century A.D.). Their vibrant colors and all-over floral designs created a vision of paradise in the interiors of palaces and mosques. The same motifs were also used on the pottery of this period made in Isnik (see 3-39) and Kütahya.

As the Islamic styles in art spread westward through the Mediterranean and along the northern coasts of Africa, pottery techniques and designs from the East changed the native art wherever local inhabitants were converted to Islam. When the Moors crossed to Spain around A.D. 700, Islamic art reached the European continent, influencing styles and techniques there, especially in Spain and Italy (6-4, 6-5).

FIGURE 3-41
In the seventeenth-century Safavid period in Persia, tile-makers covered the exteriors of mosques and other religious buildings with tile designs featuring stylized natural forms. Intricate when viewed closely, the overall effect of the blue glazes and elaborate patterns suggest the depths of the heavens. The tile patterns also reflect the designs seen in other applied arts such as weaving. Luftullah Mosque, Isfahan, Iran, A.D. 1602–1616. *Courtesy Ann & Bury Peerless Picture Library, Birchington-on-Sea, Kent, UK.*

India

Despite the oceans and mountains that ring the vast territory of India, the land has received numerous waves of migrating peoples, ranging from the invasions of the Aryans in about 1500 B.C. through those of the Iranians, Greeks, Arabs, and finally the British in 1815. As a result, there has always been great diversity in the peoples of India, and the three main religions—Hinduism, Jainism, and Buddhism—have offered artists a rich heritage of images with which to decorate the elaborate temples.

The best-known temples in India were built of stone, but in areas where stone was rare, itinerant bands of terra-cotta craftsmen made and decorated brick temples well into the nineteenth century. Because clay was a symbol of the earth's fertility, potters considered the clay they used on these temples sacred. Working under a master, the potter-sculptor conferred with representatives of the different religions, who instructed him in the complex symbolism of the cults so that he might depict the deities with their proper attributes and in the proper attitudes. To the Indian viewer, the sensual and erotic images are always religious, expressing spirituality through the beauty of the human form and its sexuality (3-42, 3-43).

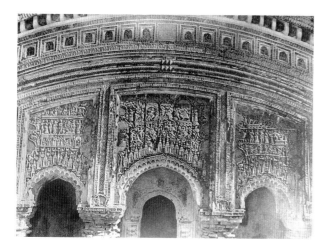

FIGURE 3-43
In India, well into the nineteenth century, groups of artisans
traveled from village to village erecting temples using local clay for
the rich decorations on the facades. The decorations showed
religious figures, as well as scenes from the epics and from daily
life. The mid-nineteenth-century terra-cotta facade of the Lakshmi-
Janardana Temple in Surul, Bengal, illustrates the epic *Ramayana*.
Photo courtesy Lalit Kala Akademi, New Delhi.

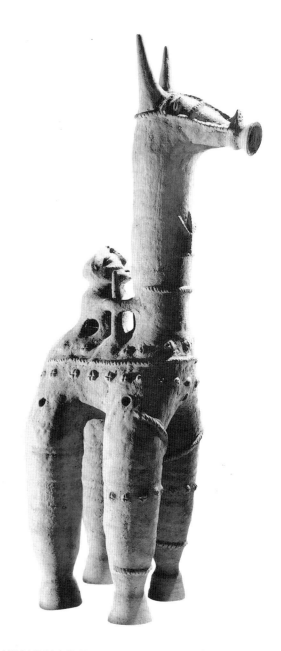

FIGURE 3-44
The tradition of modeling votive images from the earth is a
long one in India, and the horse has been a favorite image
there since the remote past, symbolizing hope and
protection. Shown here is the protective steed with its Spirit
Rider, guardian of the villages. Votive horse and rider, terra-
cotta. Bhil tribe. Ht. about 3 ft. (91.4 cm.). India, twentieth
century. *Courtesy Philadelphia Museum of Art: Purchased with funds
contributed by Henry Dofinger, 1929.*

Traveling groups of clay artisans were active in
Bengal into the eighteenth century, moving from
place to place to build and sculpt temples using
the local clay. Working under a master, the guild
members made the bricks and built the temples,
while the modelers made the sculptures of fertil-
ity deities and mythological personages that dec-
orated the temple facades. Generally, the sculp-
ture was made in molds and then worked over
when leather hard. The clay was frequently bur-
nished, and the decorative details were incised
with pointed instruments made of bone or bam-
boo. Finally, the reliefs were fired in kilns built at
the site and then were installed on the temples.

ENDURING TRADITIONS

In traditional India, village shrines were deco-
rated with deities and protective spirits of fired
clay. The Spirit Riders, who were believed to
protect the village fields, riding their boundaries
at night, were often depicted in clay (3-44). Rang-
ing in size from small votive sculptures to huge
fired-in-place horses and life-sized human fig-
ures, these images express the hopes and fears of
an agricultural society dependent on the weather
for the success of its crops. The tradition of form-
ing shrine figures from local terra-cotta clay con-
tinues in villages today.

4
Africa

The African continent encompasses many different natural environments and peoples. Wide-open grasslands, hot, dry deserts, deep rain forests, cool mountain highlands—each is part of Africa's rich natural heritage. Just as the land is infinitely varied, the continent has seen a procession of peoples moving across it for thousands of years, hunting its wild animals, driving domestic herds to new grazing lands, moving on in search of a better place to live. For these reasons, the lifestyles, beliefs, ceremonies, legends, and arts of the African peoples have varied greatly from one group to another and from one place to another, so we cannot speak of African art or African ceramics as if they were the products of a single culture (4-1). Nor is it possible to establish any one area where ceramics were first made and used.

Since there has been much less excavation in Africa than in western Asia, archaeologists have not been as successful in documenting the course of developing ceramics technology on the continent. In addition, the ancient routes of the early peoples that moved across the continent have not been mapped. We do know, however, from widespread discoveries of small fired clay shards, that the craft of forming and firing pottery has been known in various parts of the African continent since about 10,000 years ago. For example, pottery shards from the Sudan have been dated to about 10,000 years ago, and a larger number found in other areas to about 9,000 years ago.

Based on the excavated shards, much of the ware was well formed with thin walls and simply but pleasingly decorated. The early ware was often covered with rows of impressions made with combs, cords, or natural tools. By about 6,000 years ago burnished ware appeared (4-2); later, in the Nile valley and other areas of northern Africa, painted decoration was applied.

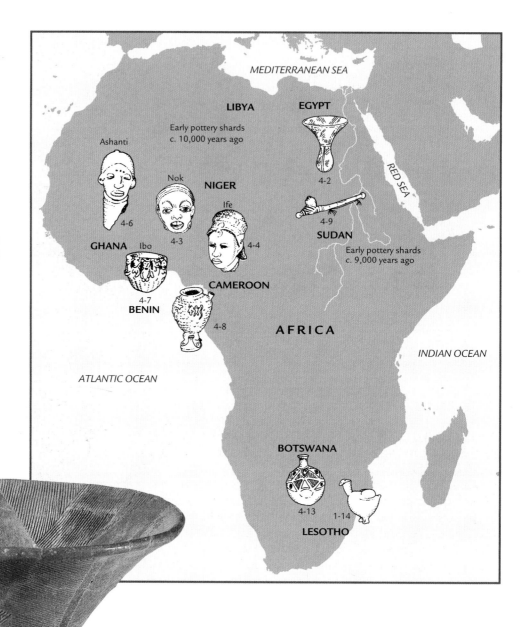

FIGURE 4-1
The continent of Africa is so varied in its natural environment that the peoples who have populated it have developed differing ceramics techniques and styles to suit their ways of life. Ceramics there have ranged from life-size sculptures to tiny figurines, from elaborately decorated ritual pots to plain domestic ware. This map shows a few of the areas where pottery or clay sculpture developed, but much excavation remains to be done if the whole story is to be known. In some areas, all that has been found are shards of fired pottery.

FIGURE 4-2
Called *calciform beakers,* the actual purpose of these elegantly shaped pots is not clear. The pots are thin-walled, well-crafted, and the burnished surface is decorated with incised designs. Excavated in a neolithic cemetery at Kadada on the upper Nile River in Sudan, this style of pot is believed to have been made for funerary use. It is not known if there was a functional purpose in giving the vessels such rounded bases—imposible to set upright, unless they were partially buried. *Courtesy the British Museum, London.*

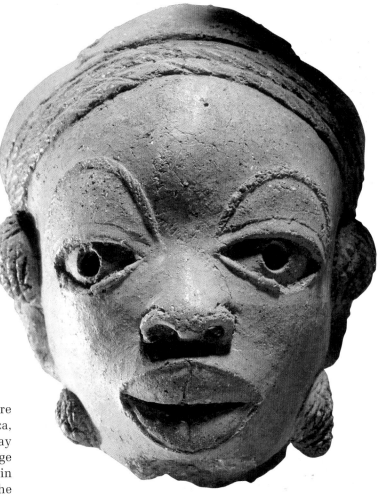

FIGURE 4-3
Nok sculptors in the second century B.C. shaped clay into images that express a sense of urgent life. The faces appear carved, suggesting that their forms may have been based on wood carving. Almost life-size, the figures reveal remarkable technical skill in building and firing clay. Nok culture, 900 B.C. to A.D. 200. *Courtesy Werner Forman/Art Resource, NY.*

NOK (c. 500 B.C.–A.D. 200)

Archaeologists have unearthed a later culture that shows that, at least in some areas of Africa, there must have been a long tradition of clay sculpture. In northern Nigeria, near the village of Nok and at Taruga, iron-working furnaces, tin mines, and iron tools dating from around the fourth or fifth century B.C. have been found along with fragments of almost life-sized terracotta sculptures of humans and animals (4-3).

The technical knowledge required to build and safely fire such large, thick-walled sculptures suggests that people must have been working with clay here for some time. The clay body used for these sculptures is coarse, containing inclusions that opened the pores. These, along with the punctured eyes and open mouth, allowed the vapors to escape in the firing.

As in most other early cultures, clay and metal working developed here simultaneously. In Upper Nigeria, for example, the wives of iron workers were the potters. The expressive ways in which the sculptors indicated human feelings suggest a rich artistic heritage, and the sculptures exhibit a sophisticated simplification of form. Nok was one of the cultures in Africa that developed a court art centering on the king or chief, and sculptor-potters in these societies were often retained by the king to create cere-

monial and status objects, in addition to ancestor figures. (Ancestors were of the greatest importance among many peoples in Africa.)

In recent years women in some of the small groups living in this area have made pottery similar in shape to ancient Nok pottery and have also occasionally made sculptures for grave memorials and ritual use. It is possible that they are the inheritors of the Nok culture, but like so much in the story of African ceramics, this is only conjecture.

IFE (c. A.D. 800–1400)

One of the royal courts of Africa was centered in the city of Ile Ife in southwestern Nigeria, where from around A.D. 800 to 1400 the Yoruba people produced a rich and lively art. No ar-

FIGURE 4-4
Ife sculptures are more realistic than Nok sculptures, but some of the details of clothing and hair are similar. The dates of Ife sculptures are uncertain; some scholars date them at A.D. 600–1200 and others at A.D. 800–1400. Terracotta. *Nigerian Museums. Copyright British Museum, London.*

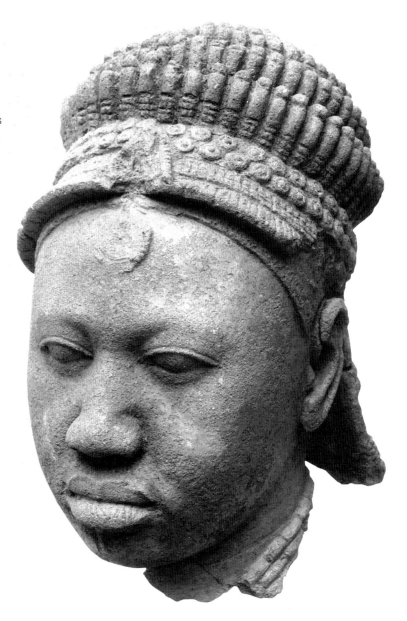

chaeological finds have yet been made that can fill the gaps in our knowledge about the years between the end of the Nok culture and the flowering of the Ife culture. It is possible that the two cultures were not connected, but some similarities between them suggest that Nok sculpture may have influenced Ife sculptors (4-4). Both cultures made large, almost life-sized terracotta sculptures on which the forms were simplified, and some of the detailing of beaded decorations and hair on the bodies is similar. But the Ife sculptures are more realistic than those

of the Nok sculptors, and in many ways they are closer to Benin sculpture.

By the eleventh century A.D. the sculptors of Ife were skilled in bronze casting, a craft that relied on clay for the crucibles in which the metal was melted, the molds in which bronze objects were cast, and the original images from which the terra-cotta molds themselves were made. In African cultures the artist was never divorced from the people who used his or her creations, and although some individuals may have achieved the highest skill at weaving or pottery

making, their work was considered to be a reflection of normal human activity. That beauty was part of everyday life is testified to by a Yoruba poet who celebrated equally the beauty of fast-running deer, children, a rainbow, and a well-swept veranda, saying, "Anybody who meets beauty and does not look at it will soon be poor."

BENIN (c. A.D. 1250–1897)

In Benin as in the Nok culture, sculpture was a court art focused on the king, who, it is said, brought a talented Ife sculptor, Iqu-igha, to Benin to teach local sculptors the craft of working in bronze and other metals. For each metal sculpture cast in bronze, there had to be a clay original from which to make the mold, and a number of these have survived in fired terra-cotta (4-5). We cannot attach names to these individuals, but in these ceramic sculptures we are likely to see the faces of court officials and other notables—and possibly even one of the kings of Benin. Although the Benin culture probably dates back to the thirteenth century, the fifteenth century marks the flowering of its sculpture.

RITUAL CERAMICS

Preserving the memory of historic happenings and the images of royalty and their ancestors was one of the main assignments of sculptors in these royal courts. What we call *art* has served ceremonial and ritualistic functions in many cultures throughout the world, and in Africa ceramic objects were essential to religious ceremonies and burial rituals (4-6, 4-7). These ritual objects were made for use and were associated with the passage from one period of life to another, with death, and with ancestors. In Ashanti graveyards terra-cotta sculptures of heads were given an honored place, probably as memorials to the deceased. Many ceremonial objects and ceramic vessels were used by the secret male societies that governed the initiation of youths into manhood, while others were related to women's puberty rites. Still other pots were used in ceremonies, festivals, and rituals dedicated to the spirits of crops and fertility or to bringing good fortune.

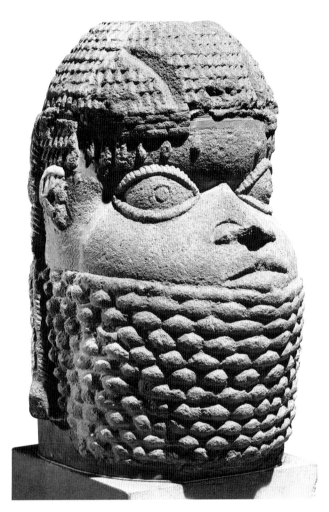

FIGURE 4-5
In Benin, foundries that served the king and court required terra-cotta original portraits from which to make sculpture molds. Many of the terra-cotta heads found there could have served that purpose. On the other hand, originals tend to be damaged and discarded when the molds are removed, so these may have been less-expensive substitutes for bronze portraits commissioned by lesser officials. Terra-cotta. Ht. 10½ in. (26.4 cm.). Benin. *Copyright Field Museum, Chicago, IL. Neg. #A99506.*

An outstanding group of sculptured pots from the Ibo village of Osisa, on the west bank of the Niger River, was made to be placed in the village shrines dedicated to Ifijiok, the yam spirit. In Ghana, the Ashanti placed a type of ornamented pot called the *abusua kuruwa,* along with a cooking pot, utensils, and hearthstones, beside each new grave. In it was placed hair that all the blood relatives of the deceased had shaved off their heads during mourning.

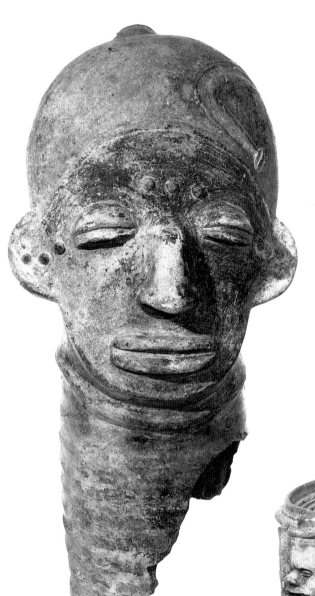

FIGURE 4-6
Ashanti terra-cotta heads like this one were apparently used in funeral ceremonies or as memorials to the dead. This one was sculpted more than 100 years ago by a craftsman of the Kwahu, an Ashanti group. Ht. 15 in. (38 cm.). Kajebi, Ghana. *Copyright British Museum, London.*

FIGURE 4-7
The Ibo, who lived west of the Niger River, placed sculptured pots on altars dedicated to Ifijiok, the yam spirit. This pot shows images of the chiefs, their wives and children, and attendant musicians. Ht. 13¾ in. (35 cm.). Ibo, Osisa, Nigeria. *Copyright British Museum, London.*

FOREIGN INFLUENCES

Just as China and Japan absorbed and modified the Buddhist art that came from India, so Africa absorbed and modified many artistic ideas that came to the continent through invasions, migrations, and trade with other peoples. The Cretans, Greeks, and Romans all came to northern Africa. The extent of trade across the continent is indicated by the shards of celadon export ware from seventeenth-century China found in excavations in the ruins of Zimbabwe, the stone citadel in the southern African country of that name. In addition, the Muslims brought to Africa their religious prohibitions against representing human forms, which changed the styles of ornament in areas that were converted to Islam; and from the time the Europeans arrived, in the 1600s, local art often reflected the teachings of Christianity.

CERAMICS IN ARCHITECTURE

Like many other peoples in warm climates, Africans have for centuries built storage buildings, houses, and mosques with mud and clay. Where clay was plentiful, it was plastered over a framework of wood or brush and then built up into thick walls that kept out the heat. Another traditional use of clay in certain areas of Africa was for building granaries to store and protect the grain that was needed to reseed the fields the following year (see 4-16). After the beginning of the nineteenth century, the walls of many such buildings were decorated with sculptured clay reliefs, and the sun-dried mud bricks with which the walls were built were often set in decorative patterns. Alternatively, the walls were often painted with brilliantly colored designs (see 4-15).

EARLY TECHNIQUES

Among the African ceramic treasures in the storerooms of the British Museum is a modest box labeled "African female potter's tools," collected in the 1880s. The tools are few and simple: The box contains only a piece of metal for scraping, a wooden tool for making designs, smooth stones for polishing, a pointed shell for punching holes,

a dried corncob and smooth seed pods for impressing designs—reminders that potters all over the world have shaped, smoothed, and decorated clay pots in very much the same fashion for thousands of years (see 5-20). The methods used in Africa today may have been changed by contact with other cultures, so we cannot take them as "living archaeology"; rather, we must see them as only suggestions of some of the traditional methods that have been handed down from one generation to another. Although there are some similarities in technique among artisans across the African continent, there are also great variations in the traditions of the widely separated groups that have lived there.

One factor does remain the same throughout all African cultures. Until recently, pottery in most of Africa has always been handbuilt and fired in open fires. Only in Egypt were turntables on axles, kick wheels, and permanent kilns known and used.

Low-fired earthenware pots were used for all domestic needs—cooking; storing food, beer, or honey; carrying water (see 4-12); and dyeing fibers. Because there was no need for a higher-fired ware, none was developed; in fact, earthenware was better adapted to the rural African life than high-fired ceramics would have been. Earthenware is, for example, better for cooking over an open fire due to the coarse texture of the clay, which allows the pots to withstand the shock of the heat and reduces the likelihood of cracking. Earthenware is also excellent for storing drinking water in a hot climate; the porosity of the clay body allows the water to cool by evaporation.

DIVISION OF LABOR

Traditionally, African men and women have had distinct roles, and in areas where domestic pottery making has continued, it is still usually done by women. As in the American Southwest, African women potters handed down the empirical knowledge of generations. The hands of African women traditionally dug the clay, prepared it for use, and shaped it, often according to rules and taboos. For example, the Mongoro potters of the Ivory Coast sacrificed a goat or rooster before digging clay as a way of asking forgiveness from the gods.

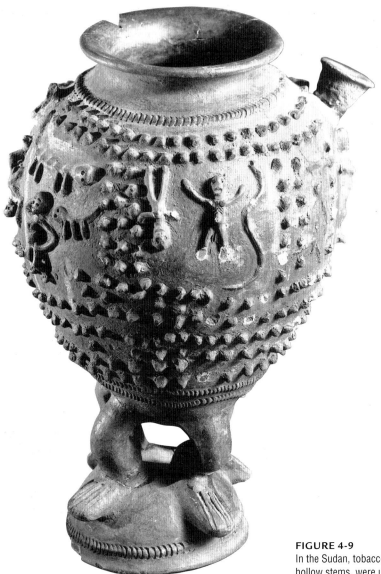

FIGURE 4-8
Naa Jato, who was active in Cameroon in the 1930s, handbuilt this palm wine container, depicting on it scenes of village life. She applied the relief figures while the clay was damp; once the wall was leather hard, she burnished the area between the reliefs with a smooth stone. Earthenware. Ht. 16½ in. (42 cm.). Cameroon, Northern Mfunte, Lus group, 1936. *Courtesy Portland Art Museum, Portland, Oregon. The Paul and Clara Gebauer Collection of Cameroon Art.*

FIGURE 4-9
In the Sudan, tobacco pipe bowls, attached to long hollow stems, were used in male ceremonies, so often the men made them. They rubbed white chalk or ash into the incised crosshatching typical of their decoration to emphasize it. Length of bowl 3⅛ in. (8 cm.). Shilluk, Sudan. *Copyright British Museum, London.*

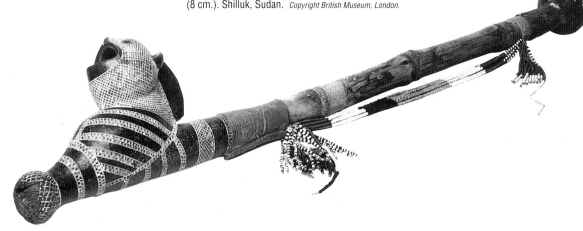

FIGURE 4-10
An Ashanti potter making a series of large pots. She builds the upper sections first. When these sections are stiff enough to support more clay, she turns them over and completes the bottom sections. Ghana. *Photograph by Eliot Elisofon, The National Museum of African Art, Eliot Elisofon Photographic Archives, Smithsonian Institution.*

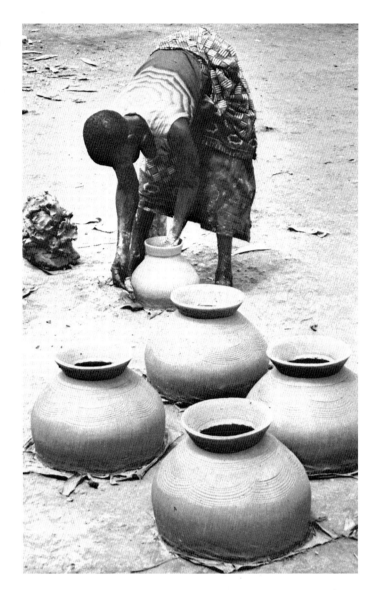

Although women have been potters for centuries in Africa (4-10), only comparatively recently have the names of women potters become known. One such potter, Naa Jato, lived in a village in Cameroon, where she made palm wine containers commissioned by the male clubs and local chiefs (4-8). Hers were not domestic pots; the relief decoration she added to the clay of the handbuilt walls was lively and humorous.

Where men have been involved in pottery in Africa, they have frequently made a special type of pottery or object (4-9) or used techniques that differed from those used by the women. In Ghana, for instance, taboos forbade men to make domestic ware. On the other hand, among some peoples today the men make pottery and the women are forbidden to come near them during certain parts of the process. In some traditional cultures, ceremonial ceramics—objects associated with men such as ritual drums, pipes (see 4-9), and bellows tips for smelting—were created only by men.

CLAY FORMING METHODS

Almost every type of handbuilding technique is still employed in Africa today, but often the traditional methods are used to produce ware for the tourist rather than for local domestic use. Today's villagers tend to use plastic or metal containers, while it is the art market that supports the potters' craft, keeping the handbuilding techniques alive.

A potter might start by pressing the clay into a base mold, leaving it to stiffen somewhat and then building the rest with coils. Conversely, sometimes potters start by forming the upper section of a pot, letting it stiffen, and then, when it is firm enough, building coils onto it to form the lower section upside down (4-10). Others, however, may build the whole pot by pulling up the sides from one lump of clay, walking around

it backwards as they do so. Elsewhere, a potter may form the base of a pot by hollowing out a lump of clay with her fingers and then building the wall. Still others start the base by pressing clay into or over a mold or old pot that has been lined with leaves or ashes to keep the clay from sticking; as they build the wall, they pound the clay with a wooden beater while holding a stone inside. The base may be part of a dried gourd, the bottom of an old pot turned with the hands or feet as the pot is built, or an old broken pot set on another pot (4-11). Generally, where coils are added to the wall, they are pressed together with the fingers, then melded by beating them with a paddle or by scraping them with a shell

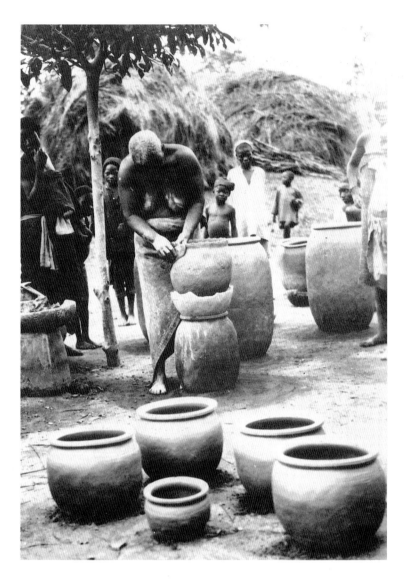

or a piece of dried gourd used as a **rib.** After the coiling is completed, the surface may be burnished with a smooth stone or a piece of leather.

Finishing

There seem to have been as many methods of finishing pots as there are peoples in Africa, and these traditional methods are still used in some areas. One of the simplest treatments is functional—combing a pot to give it a rough surface, thus making it less slippery to hold or carry when wet (4-12). If the surface of the pot has not been textured, it may be burnished with smooth stones or seed pods until the leather-hard surface be-

FIGURE 4-11
Using a large pot as a stand and a broken one as a base, a potter scrapes and smoothes her pot, using a rib and one hand inside to support the wall— a characteristic gesture any potter will recognize. *Courtesy Field Museum of Natural History, Chicago, CSA70034.*

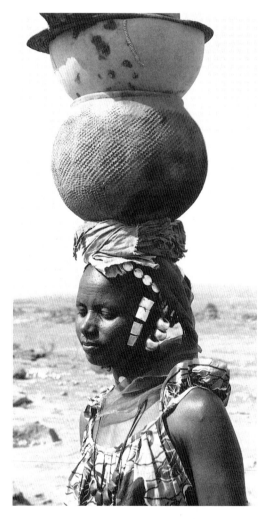

FIGURE 4-12
A woman, probably Fulani, carries pots in the Sanga region of Mali. The rough texture on the lower pot was probably added to make it less slippery when it was wet. *Courtesy National Museum of African Art, Eliot Elisofon Archives, Smithsonian Institution. Photo: Eliot Elisofon, 1970.*

comes smooth and the clay's pores are tightened; or the potter may alternate burnished and textured areas. Sometimes the clay body is tempered with mica or covered with a mica-containing slip so that after it is fired, the surface of the burnished pot sparkles as the mica reflects the light. Some potters apply a paste of graphite before firing, achieving a glossy dark finish, whereas potters elsewhere cover their pots after firing with resin, palm oil, or other vegetable mixtures to close the pores. Sometimes the vegetable mixture is splashed on while the pot is hot, creating a marbled effect. Occasionally the coating is varnish or shoe polish.

Decoration

Depending on the local pottery tradition, African potters have used a great variety of techniques to decorate their pots, impressing designs or textures into the surface with a natural object such as a corncob. The potter might roll repeat designs onto the clay with a carved wooden wheel, called a roulette. Water or milk pots from Botswana are decorated with patterns in which dark-toned graphite triangles contrast with areas of untreated clay body, while the Ibo color only the raised bands of clay that they attach around their large-bellied vases in undulating patterns.

Some of the decorative techniques may have had their origin in particular functions. For example, impressed, carved, or raised designs make it easier to lift a heavy, slippery pot full of water. In Uganda, some potters copy in clay the shapes of calabashes used as containers and carve lines on the pots to duplicate the patterns originally made on gourds by the carrying sling made of fiber or leather thongs (4-13). Until recently, each region or group of peoples stayed within its own tradition, repeating its designs consistently over time, but now there is greater interchange of influences.

FIGURE 4-13
Burnishing, incising, textured lines, and a black post-firing coloring material were used to decorate this pot. Pottery coloring materials in Africa were often the same as those used for body decoration—oil, kaolin for white, and soot for black. The lines suggest those used on calabashes, where the colors were separated by rows of white beads attached with resin. The Tswana people, Botswana. Ht. 9¾ in. (25 cm.). *Courtesy the British Museum, London.*

Firing

Once the village potters complete their pots, the pots are left to dry. If the weather is too hot, the **greenware** is placed in a cool spot, with fired pots placed over them to keep them from drying too quickly. Before firing, the potters might heat and dry them by burning grass inside them.

Almost all pottery firing in Africa is done in an open fire or pit, using the most readily available fuel (4-14). The length of firing time varies from one place to another, and according to the size, number, and thickness of the pots. It may last for several hours or only a few minutes.

ENDURING TRADITIONS

Large numbers of pots are still produced in Africa using traditional methods, but there, as all over the world, the rich heritage of ceramics techniques is being eroded as the continent becomes more urbanized. Since plastic and factory-

FIGURE 4-14
Ashanti women of Ghana arrange their pots for firing, alternating several layers of pots with fuel. Sometimes they fire as many as 300 pots at one time; at other times they may fire just one large pot, using wood, grass, millet, or straw for fuel. In a few places in western Africa, a low wall is built around the pots to deflect the wind and hold in the heat, in effect creating a rudimentary kiln. Ghana. *Photograph by Eliot Elisofon, The National Museum of African Art, Eliot Elisofon Photographic Archives, Smithsonian Institution.*

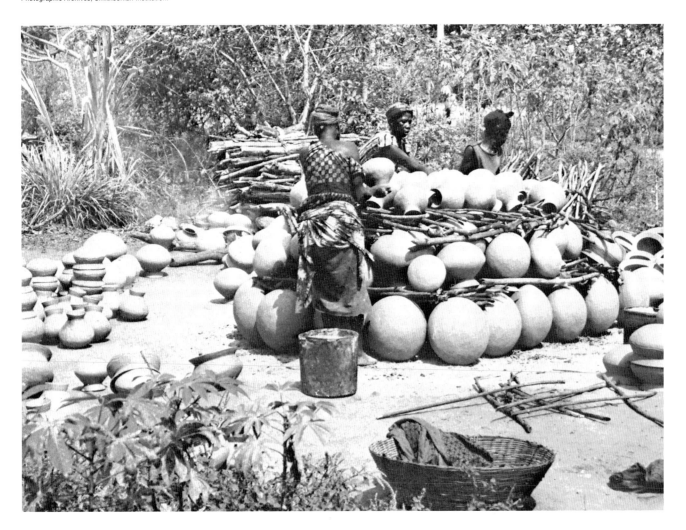

produced domestic ware now take over much of the market, the future of traditional pottery is uncertain.

A number of African potters have worked to preserve their heritage and to develop a respect for the old crafts among younger potters. Among them, David Cobblah, who broke his tribe's tradition that only women could make pots, worked with British potters Harry Davis and Michael Cardew in ceramics training programs, and when Ghana became independent he devoted his energies to preserving some of the older ceramics traditions.

Just as potters have been influenced throughout history by ideas, styles, and technologies from other cultures, in Africa those who work in clay are generally open to new ideas. As an example of how aesthetic frontiers have become less rigid, a collaboration between a potter in the Netherlands and two women from the land of the Ndebele was arranged by a Dutch museum (4-15). Franzina Ndimanda and her daughter, Angelina,

FIGURE 4-15
Franzina Ndimanda and her daughter, Angelina, from Kwa in the land of the Ndebele, decorate vessels with paintings based on the traditional designs that women apply to the walls of houses in their homeland. In an international collaboration, the artists were invited to Holland to decorate the walls of the Hetkruihuis Museum in 's-Hertogenbosch, the Netherlands, and to paint these designs on pottery forms that were thrown by local ceramist Norman Trapman. The artists say that the only goal of their art is *the creation of beauty which gives joy. Courtesy Hetkruihuis Municipal Museum of Contemporary Art and The European Ceramic Work Center, 's-Hertogenbosch.*

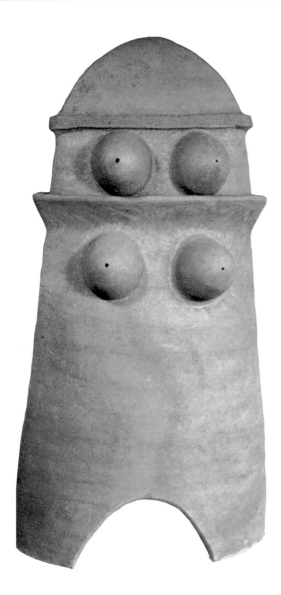

normally use clay to plaster their hut walls, on which they paint traditional decorations. They came to Holland to apply their sense of design to the decoration of pottery formed by ceramist Norman Trapman. Ernest Aryee, originally of Ghana, brought his own interpretation of his heritage to the United States, where he now lives.

FIGURE 4-16
Ernest Aryee of the United States has his roots in Ghana, and his sculpture echoes the forms and methods of African pottery and architecture. His concern with the preservation of our earth's sustenance is seen in his coil-built sculptures with their forms that often echo Africa's clay storage granaries (see also 11-34). *Courtesy the artist.*

5

Indigenous America

It is now generally accepted that the arrival of humans in the Americas occurred between 30,000 to 28,000 years ago; this new time frame, which is earlier than scholars previously estimated, is based on the fact that the land bridge they must have traversed was later flooded by the melting of the Ice Age glaciers (5-1). The arriving groups apparently moved slowly through the North American continent, spreading out as they pushed into Mesoamerica and South America. Some groups found livable environments along the way, while others continued southward. We can only guess at the time frame of their progress by the fact that a seasonal camp excavated in southern Chile yielded charcoal radiocarbon-dated to 14,000 to 12,000 years ago.

These early arrivals did not produce ceramics, but excavations in what is now Brazil have shown that by about 7,000 to 6,000 years ago humans remained settled near the mouth of the Amazon River long enough to form and fire rough pottery—the earliest ceramics yet known in the Western Hemisphere. Pottery shards with incised decorations were found in shell middens near the river's mouth. These ceramics were made of a rough sand- or shell-tempered clay body, and they slightly predate the early ceramics produced in Ecuador—once considered to be the earliest in the Western Hemisphere.

As time went on and humans lived a more settled life on the American continents, potters in almost all cultures formed domestic ware, along with burial and ritual urns, using handbuilding techniques (see 5-2, 5-3); the true potter's wheel was not known in the Americas until the Europeans arrived. Instead, potters in the indigenous cultures shaped their pots with coils (see 5-17); some may have used simple turntables to smooth the ware.

Figurines were usually modeled by hand, although in some areas, especially as the demand for ceramics increased, terra-cotta molds

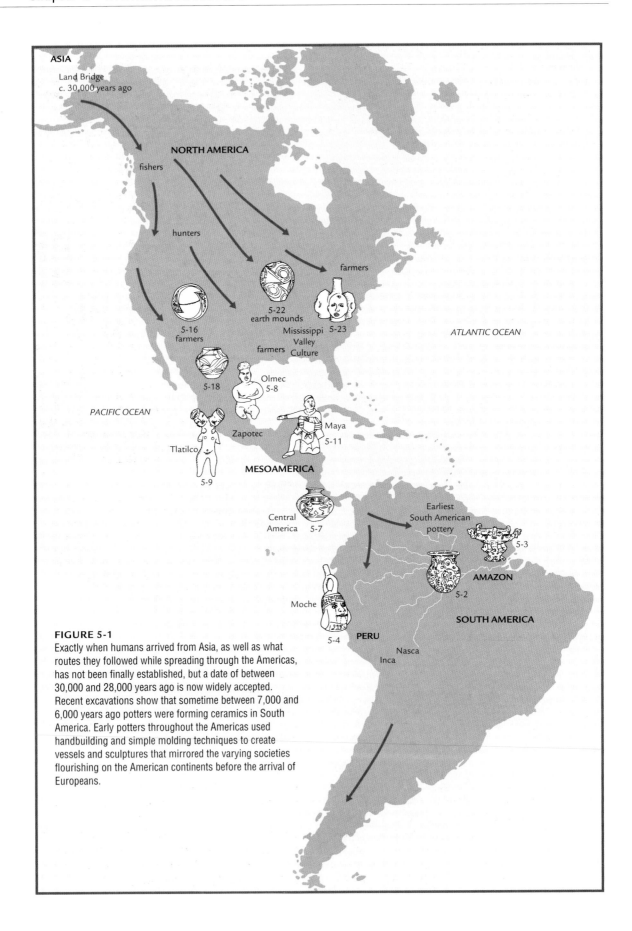

FIGURE 5-1
Exactly when humans arrived from Asia, as well as what routes they followed while spreading through the Americas, has not been finally established, but a date of between 30,000 and 28,000 years ago is now widely accepted. Recent excavations show that sometime between 7,000 and 6,000 years ago potters were forming ceramics in South America. Early potters throughout the Americas used handbuilding and simple molding techniques to create vessels and sculptures that mirrored the varying societies flourishing on the American continents before the arrival of Europeans.

were used to form figurines or face vessels (see 5-4), as well as the relief decoration applied to elaborate ritual vessels (see 5-13). Firing was accomplished in an open fire or in a pit (see 5-21), and it was not until after the arrival of the Europeans that updraft kilns were adapted for local use.

From about 500 B.C. to the arrival of Europeans in the 1500s, potters throughout the Americas developed various styles of decorated pottery that maintained local characteristics (see 5-2–5-7). Despite these differences, however, a number of the applied, incised, or painted motifs on ritual or burial vessels made in the various areas of the Americas show some stylistic similarities.

SOUTH AMERICA

The exact route taken by humans finding their way into the vast continent of South America is untraced, but we now know that some groups must have developed a semisettled lifestyle in the Amazon Basin and Ecuador by at least 7,000 to 6,000 years ago in order to have produced the local ceramics that have been dated to that time. It is uncertain at present whether the advancing ceramics technology in the various areas of South America developed independently or was the result of diffusion through migration or trade.

The Amazon

A number of pottery-producing cultures throve on the western and eastern coasts and in the mountains of the Andes from early in the common era until the arrival of the Europeans (see 5-2, 5-3). Judging from ceramics found in burials, a series of peoples developed complex societies along the Amazon river and its tributaries between c. A.D. 500 and 1500. The pottery and sculpture found at several sites in the river valley show high standards of technical and artistic sophistication; clearly, therefore, the potters in these groups had inherited a long tradition of ceramics knowledge. The burial urns and other ceramics vary in style and decoration, but the same Amazon fauna appear on many of the vessels—snakes, scorpions, turtles, birds—along with representations of humans. In some areas these motifs are portrayed quite realistically,

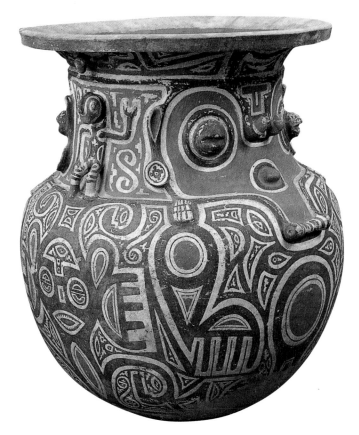

FIGURE 5-2
Between c. A.D. 500 and 1500, Marajoara potters working near the mouth of the Amazon River in what is now Brazil created handbuilt burial urns that exhibit a high level of ceramics knowledge and a sophisticated sense of design. The surface treatment on the pottery combines applied three-dimensional forms and painted decoration in red, black, and white. The human faces and abstract curvilinear patterns may have had a ritual significance whose meaning may now be lost to us. Ht. 33 in. (84 cm.). A.D. 900–1600. *Courtesy Museo Paraense Emilio Goeldi Belém, Brazil.*

and in others the people, animals, and reptiles are highly stylized.

The Marajoara people, who lived during that period on an island in the lower Amazon area, were part of this flowering of ceramics-producing cultures along the river and its tributaries. The Marajoaran potters created burial urns that display considerable technical mastery—handbuilding, applied modeling, painting, carving, and firing of large vessels. At the same time, the designs on the urns, which included humans and animals in both naturalistic modeling and stylized painting, made sophisticated use of the visual environment in which the potters lived (5-2).

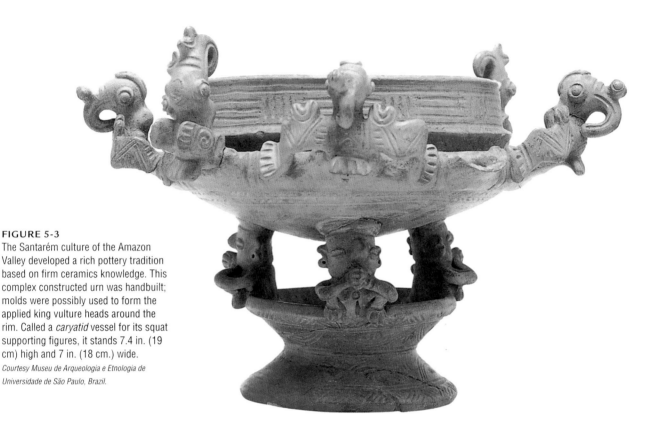

FIGURE 5-3
The Santarém culture of the Amazon Valley developed a rich pottery tradition based on firm ceramics knowledge. This complex constructed urn was handbuilt; molds were possibly used to form the applied king vulture heads around the rim. Called a *caryatid* vessel for its squat supporting figures, it stands 7.4 in. (19 cm) high and 7 in. (18 cm.) wide.
Courtesy Museu de Arqueologia e Etnologia de Universidade de São Paulo, Brazil.

The ceramics found at Santarém, a center in the Amazon Valley, include numerous figurines —some in informal poses, others more formal— and some of the portly male figures are actually bulbous vessels. Among the most remarkable Santarém ceramics, however, are a group of composite vessels with supporting figures holding a wide upper bowl—the so-called *caryatid* vessels (5-3).

The epidemics, disruptions, and slave trade inflicted on Native Americans by Europeans in the sixteenth century decimated the communities living in the Amazon Basin, and the lifestyles of the remaining inhabitants were drastically changed as a result. Later European explorers who discovered examples of Amazon pottery found it difficult to believe that the ancestors of the surviving population could have developed the technology to produce such elaborate ceramics. More recent scientific excavation at sites in the river valley and a reevaluation of museum collections have made it clear that a large population did at one time live in communities throughout the Amazon, supporting expert potters who worked with technical facility and sensitivity. Thus, not only was pottery created very early in the Amazon area, but the later preconquest ceramics produced there are of a standard equal to that of other, better-known cultures in South America.

Moche (c. 200 B.C.–A.D. 600)

The Mochica ceramics showed a strong sculptural sense. By around A.D. 400, at their most productive and creative, the talented sculptor-potters working in and around Moche, on the west coast of present-day Peru, modeled stirrup-spouted drinking vessels into realistic portrait heads (5-4), made models of houses and temples, and modeled figurines portraying aspects of daily life. Many of the spouted Peruvian vessels were "whistling" jugs—they emitted a variety of tones that imitated bird and/or animal sounds when they were blown into or when liquid moved from one chamber of a double pot to another. A whistle chamber and the air duct that created the

sound can be seen in radiographic images of the interior of the ware. These whistling jugs may have been used in rain-making or other agricultural fertility rituals.

The sculptors formed the face vessels by handmodeling, building with coils, pressing clay into two-part molds, or using a combination of these methods. The process of making and using molds required that the artist first shape a clay original of the sculpture to be replicated. The original would then be fired; following that, slabs of damp clay would be pressed onto it to form an impression of each side. Perhaps some form of natural coating would have been used on the fired original to make it easier to remove the stiffened clay mold. The mold would be fired and used as a press mold to make impressions of each side of the head. These sections would be joined while still damp, and in this way more than one replica of the original could be made.

To make the spouts, the potter-sculptor wrapped strips of clay around wooden rods; when the clay stiffened enough to allow the rods to be removed but was still pliable, he bent the spout to shape and attached it to the pot. After the spouts and handles were attached, the potter would add the details of face or body by carving them into the clay or adding additional clay to form the detail of features. The multiple images produced with this method were often changed sufficiently to create lifelike portraits of individuals. On some pots, details were drawn with applications of an organic black pigment. The pots would then be slip-painted, burnished, and usually fired in an oxidizing atmosphere, although occasionally they were deliberately reduced in order to turn them gray or black.

There is no doubt that many of the pots were individual portraits, and by studying large numbers of these pots it is possible to recognize the work of individual artists. We may even see what the artists looked like, for sculptured pots depicting potters have been found. Most of them portray potters carrying bags over their shoulders, probably containing their tools: burnishing pebbles, pointed sticks, molds, and stamps. The liveliness and skill with which the Moche potters modeled their sculptured vessels were outstanding, and it is small wonder that later artists, notably Paul Gauguin (see 6-25), have been influenced by the creations of these skillful and sensitive potters.

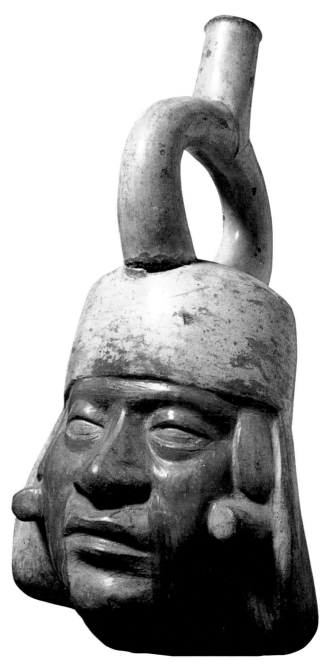

FIGURE 5-4
A stirrup-spouted jar from Peru is also a portrait, possibly of the person with whom it was buried. Paint or tattooing on the face may indicate rank. Most Mochica jars were made with a combination of handbuilding and molds. Ht. 12 in. (30.5 cm.). Mochica culture, Trujillo, Peru, A.D. 200–600.
Copyright Burstein Collection/CORBIS.

FIGURE 5-5
The Nasca culture, which was centered on the coast of Peru, used various mineral coloring pigments to decorate the characteristic spouted pots. This painted design combines a human face with feline characteristics, and a snake-like body. Nasca, Peru, A.D. 50–200. *Courtesy the Art Institute of Chicago, Kate S. Buckingham Endowment, 1955.2100.*

Nazca (200 B.C.–A.D. 600)

Another local culture centered on the Nazca valleys along the southern coast. The people who lived there slip-painted their pottery with symbolic decorations. Less interested in realism than the Moche, they outlined their flat, stylized painting with black lines around each area of colored slip, sometimes using as many as nine colors. Mythological creatures, masklike faces, and catlike images appear on the bridge-handled pots.

Chancay (c. A.D. 1000)

At this point, the story of the groups who lived in what is now Peru becomes even more complex. Between A.D. 600 and 1000, centers of power shifted frequently. Cities gained and then lost dominance, and new regional cultures developed. One of many regional cultures—that of the Chancay Valley on the central coast—produced pottery with decorative geometric and stylized animal designs, sometimes painted on a layer of plaster, in black or brown and white (5-5). At times decorations were combined with three-dimensional modeling, and the painted animals were abstracted to squares, rectangles, and triangles.

Chimu (mid-1300s)

The Chimu rulers on the north coast conquered territory far beyond the boundaries of the Moche sphere of influence, placing their court in the city of Chan Chan. The ruins of this extensive city are surrounded by enormous walls of sun-dried bricks plastered with clay and carved with stylized animals and geometric designs. The Chimu also made highly burnished vessels that were fired to blackness in reduction (5-6). Although they may have learned the technique of forming whistling jars from the Moche, they rarely used color on them.

Inca (c. A.D. 1400–1533)

The Inca empire developed in a single century from a small, unimportant group of people fighting with its neighbors to an awesome power that maintained military and administrative control over a huge area extending from Chile to Ecuador. The Inca nobility generally used bronze and silver vessels, while the poor and the large army that policed them used clay pots. Although Inca potters were highly skilled, much of the pottery that survives was apparently government issue for military posts, and it is rather standardized.

The Inca splendor and dominance over other cultures in South America abruptly ended in 1533, when the Spaniard Pizarro entered Cuzco and looted its famous treasuries to send gold back to the rulers of Spain.

CENTRAL AMERICA

In the narrow neck of land between the two Americas, in what is now Panama, Costa Rica, and parts of Colombia, rich gold mines yielded large quantities of gold. Clay was used to make simple pottery there by around 2000 B.C. and it was also used in the fabrication of gold artifacts; the goldsmiths used two-part ceramic molds to cast their solid-gold ornaments.

There has been considerable speculation about whether ceramics technology in this area was influenced from the north, was based on knowledge of considerably earlier pottery from southern American cultures, or developed independently. It has also been noted that ceramics in this area appear to be linked more to ritual or prestige production than to domestic use (5-7).

FIGURE 5-6
Whistling jars were popular with Chimu-Inca potters. The water made a whistling sound when the jug was tilted. The highly polished black ware comes from the Chancay Valley, central coast, Peru.
Courtesy Fine Arts Museums of San Francisco, Gift of Herbert Fleishhacker, 52.39.51

FIGURE 5-7
The stylized crocodile god on this Panamanian vessel is painted on a cream slip. Ht. 9¾ in. (24.8 cm.). Veraguas, Panama, A.D. 1000–1500. *Courtesy National Museum of the American Indian, Smithsonian Institution (22/9500).*

Whatever answers eventually emerge, there is no question that elegantly shaped bowls, jars, and pedestaled urns were created in the province of Veraguas in Panama before the arrival of the Europeans. Potters there obviously had become highly skilled, decorating their ware with forceful, stylized figures of animals and gods painted in red, black, and purple in a rhythmic style unlike that of other Mesoamerican or Peruvian pottery but with some resemblance to Amazon Valley decoration (see 5-2).

MESOAMERICA

Mesoamerica is a term used by archaeologists to refer to central and southern Mexico, Guatemala, El Salvador, and parts of Honduras. Several cultures that developed in this area shared a number of features: Most of the peoples there learned to cultivate maize, used hieroglyphics, built large stone monuments, created calendars, and understood and used some form of mathematics. In parts of both American continents, the domestication and cultivation of maize preceded the growth of large urban centers and a highly developed lifestyle—at least for the upper strata of the society. For this reason, the seasonal rebirth of the maize came to have a religious significance that was reflected in the ritual ceramics of these cultures.

The bulk of the ceramics that have survived in Mesoamerica have come from tombs, where they were protected from breakage. Thus, it appears that most of the ceramics activity was devoted to religious objects. We know, however, from wall paintings that Mesoamerican potters also made ceramic vessels for domestic use—for storage, cooking, and drinking.

FIGURE 5-8
Olmec terra-cotta figures with the typical pouting mouth were usually coated with white or cream-colored slip. Since the Olmec religion saw the jaguar as the source of all life, some authorities believe that the sculptures represent werejaguars, legendary offspring of the union of a woman and a jaguar. *Copyright North Carolina Museum of Art/CORBIS NC002011.*

Olmec Influences (c. 1200–500 B.C.)

Many of the features shared by the Mesoamerican cultures are believed to have come originally from the Olmecs, who lived in the eastern coastal regions of what is now Mexico. Their advanced agriculture and crafts, their astronomical observations, and their irrigated or drained coastal lands indicate that they had developed sophisticated technology. The Olmecs also built ceremo-

nial centers, which contained courts for a ritual ball game. They traded kaolin and shells with other groups, at the same time passing along their religious concepts, which included the cult of a jaguar god who they believed controlled the rain and fertility. Some scholars believe that the typical "Olmec mouth" is based on the shape of a jaguar's mouth (5-8). This pouting mouth with downturned lips appears in the sculpture of many areas in Mesoamerica and in the Mexican highlands as well.

Tlatilco (c. 1300–900 B.C.)

One culture in which the Olmec style of mouth is particularly prevalent in clay figures is known as Tlatilco, which means "the place where things are hidden." The name is appropriate, because high on the Central Plateau near present-day Mexico City, at the site of a village named Tlatilco, archaeologists have found large numbers of graves in which innumerable clay figurines and pottery were buried. This large and wealthy village seems to have been the center of a culture that borrowed technology and artistic ideas from the Olmecs while creating its own characteristic style. The Tlatilco potters scraped, polished, and stamped their pots or decorated them with textures made with the edges of shells traded from the coastal areas. They also painted their pottery with red, yellow, and white geometric designs—predominantly stylized snakes or jaguar claws, another Olmec influence.

The sculptors who worked the abundant clay of the Tlatilco region also modeled it into human figures—the bulk of which portray large-hipped women. They are usually painted with lines suggesting tattoos, clothing, or body paint. All have elaborately styled hair, and the most unusual ones have two heads (5-9) or two faces that share a third eye. Among these figurines is the earliest clay representation of a ball player, wearing the characteristic padding used in the ritual ball game depicted in paintings and sculptures throughout early Mesoamerica.

The Maya (c. 1000 B.C.–A.D. 900)

Like other Mesoamerican cultures, the Maya worshipped nature gods and recorded past history in hieroglyphics on stone monuments. They developed an accurate calendar and created impressive stone pyramids and temples in Mexico and Guatemala.

According to the *Popul Vuh,* the sacred book of the Quiche Indians in Guatemala, the first humanlike creatures were modeled out of clay by the gods. The gods are said to have destroyed these clay people, however, because they could not think, and finally, says the sacred manuscript, "only maize was used for the flesh of our first fathers."

The ceremonial pottery of the Maya was simple in shape; the potters seemed more interested

FIGURE 5-9
Clay figures of two-headed or double-faced women with carefully styled hair are frequently found in burials at Tlatilco; according to some authorities, they represent the duality of nature. This one shows traces of the color that usually decorated them. Tlatilco, Mexico, 1300–800 B.C. *Courtesy Museo Nacional de Antropología, Mexico.*

in producing a smooth painting ground than elaborate pottery shapes. These cylindrical vases were often covered with plaster to give the painters a better background on which to compose figurative paintings. These stylized paintings show priests, warriors, and nobles wearing ornate headdresses and vividly depict rituals, including the traditional ball game (5-10).

FIGURE 5-10
This cylinder vase from the central lowlands of the
Maya area in Mesoamerica was used as a painting
ground on which to depict the ritual ball game of
the Mayan culture. Ceramic with slip. 8.06 × 6.25
in. (20.3 × 15.9 cm.). Found at the Ik Emblem
Glyph site, A.D. 650–800. *Courtesy Dallas Museum of Art,*
gift of Mr. and Mrs. Raymond D. Nasher. 1983. 148. Photographic
materials copyright 1994, Dallas Museum of Art.

FIGURE 5-11
Mayan players in the ritual ball game wore
protective belts, helmets, gauntlets, and knee pads;
players were usually forbidden to use their hands
or feet, so they kept the ball in motion with their
bodies. Reliefs on the Toltec ball court at Chichén
Itzá show the decapitation of a ball player; possibly
the losers were sacrificed, although some scholars
suggest that it was the winners who had the honor
of being sacrificed. Ht. 6 in. (15.2 cm.). Jaina,
Campeche, Mexico, A.D. 700–800. *Courtesy Museo*
Nacional de Antropología, Mexico.

The kings, and often the queens, were expected to participate in ritual self-bloodletting, during which they had herb-induced visions that they believed were brought by the Vision Serpent. Many such acts are represented on Mayan pottery.

MAYAN TERRA-COTTA FIGURINES One of the best sources of information about Mayan life—at least the lives of rulers and priests—is the large number of terra-cotta figurines buried with the dead on the island of Jaina, opposite Yucatán. Beautifully crafted, these clay sculptures show us kings and notables in huge headdresses, statuesque court ladies wearing heavy jewelry, and ball players in ritual costume (5-11).

The so-called ball game in which these padded Mayan players contended was played in courts outside the temples, where many spectators watched and bet on the outcome. The ball may have symbolized the sun, and the "game" often ended in sacrifice—probably to the gods of sun and rain.

Despite the rituals requiring sacrifice or autosacrifice and the slave economy that supported the nobility and the priesthood, some of the figurines show a gentler side of Mayan culture.

Women weaving, cooking, and caring for children, the old, and the ill come alive in these small clay sculptures.

The ancient Mayan civilization eventually lost its vitality; its cities declined, and the jungle grew over them, but the influence of the Mayan culture, like that of the Olmec culture, was felt in other parts of Mesoamerica and continues to this day.

Veracruz—Remojadas (c. 500 B.C.–A.D. 900)

On the Gulf Coast, in central Veracruz, a culture that centered in Remojadas and later in El Tajin produced a large number of clay figures, many of them children at play (5-12). Cheerfulness is rarely represented in Mesoamerican art, but the thousands of figures found there—many of them captured in clay in the middle of a belly laugh—give the impression of a fun-loving people who faced life and death with a smile.

Some of the figures have emblems of life and movement on their headdresses; others depict priests playing musical instruments. They therefore may have had a connection with ritual dance. The earliest of these lively figures were

FIGURE 5-12
The Remojadas culture, centered in Veracruz, was one of the few to depict happy people—many of the figurines show laughing children. It is not known whether there is a special significance to their expressions. This sculpture of two children swinging is also a whistle. Veracruz, c. A.D. 500.
Courtesy National Museum of the American Indian, Smithsonian Institution (22/6374).

FIGURE 5-13
Elaborate urns like this grayware Zapotec funerary urn held food, incense, or water offerings for the gods in the small containers held between the figure's hands. Ht. 13½ in. (34.3 cm.). State of Oaxaca, Mexico. *Courtesy National Museum of the American Indian, Smithsonian Institution (23/4236, move image).*

modeled individually by hand, whereas the later ones were made in molds or built up hollow into nearly life-sized figures.

Teotihuacán (c. 100 B.C.–A.D. 850)

On the Central Plateau north of Mexico City, rising steeply from the flat plain, loom the ruins of the sacred city of Teotihuacán. Its immense pyramids stand as mute reminders of the bustling ritual city that once flourished there. Teotihuacán was not only a religious center—the focus of rituals dedicated to the deities associated with water, fertility, and agriculture—it was also a residential center. At its height, the potters and sculptors lived in a special area given over to the crafts. There they shaped large, three-footed ritual cylinders decorated with jaguars or human heads or coated with plaster and painted with images of the gods in brilliant color.

According to an anthropologist who has studied the fingerprints of the potters of Teotihuacán, the prints on the earliest clay artifacts—mostly

simple domestic pottery—are women's. Later vessels, made at a time when pottery was no longer produced solely for domestic use, show male prints, and in the final period, when the culture was declining, the prints are female again, suggesting that the craft was once more mainly directed toward supplying the needs of the home.

The Zapotecs (c. A.D. 300–900)

Twelve hundred feet up the mountain at Monte Albán, near present-day Oaxaca, the Zapotecs built a great ceremonial center. Some dispute exists about earlier settlements there—some scholars argue that the Zapotecs were strongly influenced by the Olmec culture; others, that the Olmec civilization itself actually began in the valley below and radiated outward from there.

The most characteristic ceramics created by the Zapotecs are large sculptured urns representing human or jaguar figures (5-13). The humans often hold small containers with offerings of fire, incense, food, or water for the gods. Orig-

inally the Zapotec urns were handmodeled, but later many were formed in separate molds, with the various components assembled before firing, as was the urn in Figure 5-13.

The Aztecs (c. a.d. 1325–1520)

The Aztecs, whose city at Tenochtitlán astounded the Spaniards when they arrived in 1520, built their great ceremonial center on an island where Mexico City now stands. Known for their skill in building aqueducts, draining marshes, and creating a network of canals, the Aztecs dominated their neighbors, demanding tribute and a constant stream of victims to be sacrificed in religious rites that guaranteed the daily return of the sun.

Aztec artists owed much to the surrounding cultures, especially the Mixtecs of Oaxaca, from whom they learned the craft of painted pottery— a delicate orange ware decorated with gray, yellow, or white. Aztec trade was extensive, and paintings in codices show the arrival of foodstuffs, often carried to the city in pottery vessels. Babies were baptized in pottery tubs; elderly people drank their daily allotted ration of *pulque,* the Aztec liquor, out of wide, shallow pottery cups; and all the usual domestic pots appear, giving us a clear idea of the importance of ceramics in the daily life of early Mesoamerica.

Western Cultures

In the western areas now comprised by the states of Michoacán, Guanajuato, Jalisco, Colima, and Nayarit, the villages were isolated from other Mesoamerican cultures and show only a few traces of Olmec and Teotihuacán influences. What has remained of early cultures here is a wealth of small clay figurines that suggest that artists were more concerned with portraying life on earth than with pleasing the gods (5-14, 5-15). From around A.D. 300 to 900, sculptors in western Mexico modeled clay into figures that depicted nursing mothers, musicians, dancers, priests or shamans, children at play, animals, and birds, along with houses, temples, and ball courts. In comparison with, say, the stylized, elaborated figure on a Zapotec funerary urn (see 5-13), the sculpture from this area is lively and human.

FIGURE 5-14
Grinding corn on a *metate,* unaware of her child trying to steal a tortilla from her lap, this figure shows us an aspect of family life in the Colima area of Mexico around A.D. 300–900. To an anthropologist, a clay figure like this also tells much about the culture's agriculture, cooking and eating habits, clothing, and jewelry, as well as its custom of binding the heads of babies in order to achieve an elongated skull. *Courtesy Museo National de Antropologiá, Mexico.*

Although there is great similarity among these small sculptures from various parts of western Mexico, regional differences tell us about local customs. For instance, we learn that the women of Nayarit usually went naked or sometimes wore short skirts but always dressed their hair carefully and wore large earplugs and, usually, necklaces. The men wore light armor woven from fibers, carried clubs, and threw spears. Many of the Nayarit figurines are almost caricatures. In Jalisco, on the other hand, despite some

FIGURE 5-15
A group of figures from Jalisco, about 7 in. (18 cm.) tall, recreates a scene in which a man wearing a snake and feather headdress, possibly a priest or shaman, beats time with paddles as he accompanies the dancers. Since we can only guess at their original grouping, this recreated assemblage may suggest relationships that never actually existed. Jalisco, Mexico, A.D. 300–900. *Courtesy National Museum of the American Indian, Smithsonian Institution (#31198).*

exaggeration of the deliberately deformed heads, people are shown more realistically—a woman preparing tortillas (see 5-14), a young man looking into a mirror, an old man carried in a litter—bringing us close to everyday life as it was lived in this part of the Central Plateau of Mexico.

NORTH AMERICA

Ceramics of the Southwest

Some scholars believe that the new arrivals to the North American continent who settled in the areas of present-day New Mexico, southern Colorado, and Arizona may have been influenced by pottery from Mexico, for there was a connection in living styles between the areas. For example, the adobe clay houses in New Mexico and Col-

orado were almost identical to those in northern Mexico. Whether pottery followed a similar path has not been proved, but the decoration on some early pottery from Arizona does show similarities to motifs used on Mexican pottery.

"HOW POTTERY CAME TO THE SOUTHWEST" Legend often tells more colorful stories. For example, according to the Cochita legend "How Pottery Came to the Southwest," Clay Old Woman was sent to the village from Shipap, the underworld, to teach the villagers how to make pots. She mixed the clay with sand, softened it with water, and began to coil a pot while her husband, Clay Old Man, danced and sang. When the pot was about a foot and a half high, Clay Old Man grabbed it, smashed it, and ran off with it. Clay Old Woman retrieved the smashed pot, built another, and gave each person in the pueblo a piece of clay from the new pot. That is

FIGURE 5-16
Responding to the "contemporary" appearance of bowls like this one from the classic Mimbres period, we tend to forget that the artists who painted them had different cultural and artistic motivations from ours. This bowl, though broken and mended, has no "kill hole"—the hole usually made in the bottom of bowls intended to be buried in graves. Found on the Pruitt Ranch, Mimbres Valley, New Mexico. *Copyright Richard A. Cooke/CORBIS.*

how the people in Cochita started to make pottery.

However they learned to make pots, the craft of pottery making has played an important part in both the sacred and domestic life of the peoples in this region. Between A.D. 700 and 1100, the first villages were built in the area where New Mexico, Colorado, Utah, and Arizona meet, and at various times in different villages or groups of villages, pottery production reached a peak of creativity, declined, and then was renewed. Generally the potters were women, but men sometimes made the ceremonial vessels needed for the religious life of the village. These were shaped in forms dictated by their use in the sacred rituals. Nowadays, however, pottery is generally formed more for display, or often it is made for sale to museums, galleries, and collectors.

MIMBRES (C. A.D. 700–1100) One outstanding ceramic tradition that developed in the Southwest was that of the people the Spanish called Mimbres (meaning "willows"), who settled in the southwestern area of New Mexico near what are now the Arizona and Mexican borders. Originally they built their homes on the heights above the valley, perhaps for defense, but after about A.D. 550, when they became dependent on agriculture, the group moved down to the Mimbres River plain, founding small villages near their crops. It was after this move to the valley that the inhabitants began the custom of carefully placing bowls over the heads of the dead, with a small hole broken through the bottom of the bowl. Interpretations of this custom differ—some say the hole allowed the spirit of the dead to be released.

Coil-made, scraped smooth, and thin-walled, the Mimbres pottery of the earlier years was coated with a layer of iron-rich slip, burnished, and fired to a rich red. By around 750 A.D., the pottery was fired in reduction, and bowls, small jars, and large jars were enhanced with characteristic black and white decoration (5-16). By about 1150 A.D. the Mimbres had mysteriously

FIGURE 5-17
A Hopi woman making pottery outside her home in Arizona around 1900 needed only her hands and simple tools to create beauty from the earth. She would take a lump of clay, mix in some type of temper, and rest the clay on her lap or in a handmade basket, or *puki*, to form the base, perhaps using a half circle of dried gourd to smooth and thin the wall as she shaped the pot. Then she would use a smooth stone to burnish its leather-hard surface. *Courtesy Field Museum of Natural History (#CSA133).*

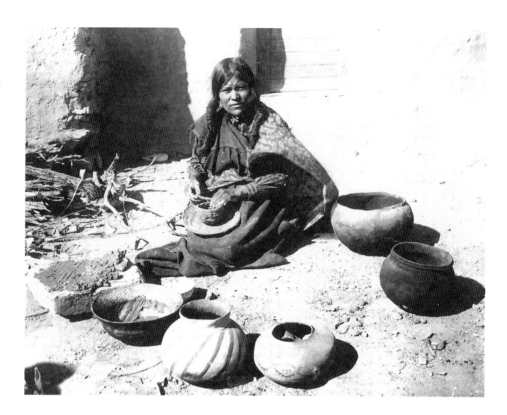

given up their homes, and by 1400 A.D. large areas of the Southwest had been abandoned by the indigenous groups of peoples, possibly owing to many years of drought. At that time the population became more concentrated in the Hopi, Zuñi, and Rio Grande areas.

OLD AND NEW INFLUENCES From around 1600—when the Spaniards first arrived—until the present, so many new ways of life, new power structures, and new religious influences came to the area that the native peoples had to struggle to maintain their traditions. But whether these influences came from Mesoamerica, from the Spaniards, from contact with other native peoples, or from the tourists who began arriving when the railroad came in 1880, the potters in the pueblos usually took the new ideas and adapted them to fit their own way of life. The local potters continued to use ancient techniques (5-17) and forms and to create designs that were well adapted to the form of each pot and to their own traditions.

TRADITIONAL SOUTHWEST TECHNIQUES In the Southwest it was the women who were the potters, handing down the skills from mother to

daughter to granddaughter. In different villages the potters varied in how they dug, prepared, and shaped the clay. Generally, however, the potters dug the clay out with sticks, speaking to the earth and asking its permission, for they felt that the clay had life and feelings deserving of respect. Sometimes they had to travel a long distance to find the right clay (see 1-1). In Santa Clara, for example, the clay—*Na p*—was gathered at a place called *NA Pii we,* about a mile west of the pueblo, while the tempering material, *Shunya,* was found about seven miles away. Once dug, all materials had to be carried in a basket or a hide container back to the village, where the clay was pounded into granules and stones and other impurities were removed. Often the clay was ground on a stone, like corn for tortillas, until it became fine-grained.

Tempering Next, some form of temper was mixed in. This might have been a gritty material such as volcanic sand, or organic material, depending on what was available. The Zuñi, on the other hand, have always added ground-up discarded pottery to newly dug clay; each generation thus incorporates some of the past in their pots. The potters of Taos and Picuris, however,

FIGURE 5-18
A water jar made in an Acoma village in the nineteenth century. The flowing bands that swing around the swelling shape are painted in two shades of orange. Ht. 9¾ in. (25 cm.). McCartys, New Mexico, c. 1890. *Photo: Arthur Taylor. Courtesy Museum of New Mexico.*

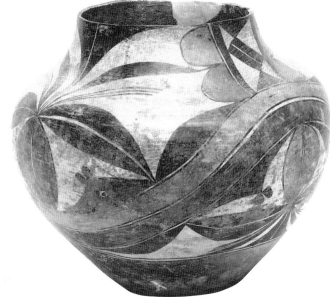

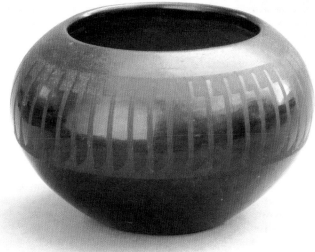

FIGURE 5-19
In the 1940s Maria Martinez and her husband, Julian, who lived in the San Ildefonso Pueblo, pioneered a return to the tradition of forming and decorating pottery, perfecting the technique in the process. Maria formed the pottery with coils and burnished it; then Julian painted it with designs. Fired in reduction, the pot itself became shiny black, while the painted design remained matte. On Julian's death Maria's son, Popovi Da, decorated the pots. Ht. 3½ in. (9 cm.). Painted by Popovi Da, c. 1957. *Private collection. Photo: Mark Preu.*

needed no temper, for there was abundant mica in the local clay. Other pueblos used volcanic sand or laboriously ground lava-rock into a powder, mixing it in with their hands or sometimes their feet. Once the potters had mixed in the temper, they wrapped the clay in a damp cloth or sometimes buried it in the ground to keep it out of the sun until they were ready to use it.

Building with Coils Coiling was the traditional method of pot building in the southwestern pueblos. The bottom of a pot was formed in some sort of base mold—a basket, a broken pot, or a *puki,* a specially made shallow bowl (see 5-17). Potters kept a set of base molds shaped to suit different types of pots; they started water jars, for instance, in molds that had convex bottoms so

that the base of the water jar would be concave to fit the bearer's head for carrying. The coiled wall was built up straight, carefully pushed outward to the desired shape, and scraped while being shaped.

Finishing the Pots After a pot had been shaped, it was dried away from the sun and watched by the potter for cracks. Little cracks were mended with damp clay, but pots with large ones were discarded. The exterior was then smoothed again and coated with slip to cover the rough, coarse texture of the clay body and provide a smoother base for painted decorations (5-18, 5-19). The slip was usually red, white, or off-white and made from a fine clay that could be found only in certain places. The white slip was basically

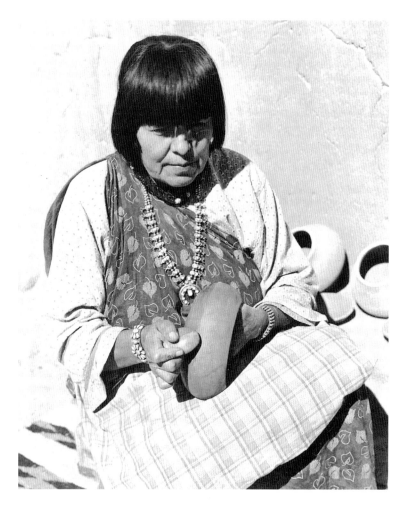

FIGURE 5-20
One of the most influential individuals in the revival of the ancient craft of ceramics in the Southwest was Maria Martinez. Here, she burnishes a slip-painted pot with a smooth stone to give it a rich, glossy finish. San Ildefonso, New Mexico, c. 1940. *Photo by Wyatt Davis. Courtesy Museum of New Mexico, neg. no. 68353.*

kaolin, the cream slip was largely bentonite, and the red was iron-bearing clay. After the slip was applied, the pot was burnished with smooth, rounded stones or pieces of leather or rags (5-20). Collections of rubbing stones in various shapes and sizes were handed down through generations of potters, and it was considered bad luck to lose one.

Decoration Various types of pigment, such as fine mineral-colored slips and vegetable pigments, were used for the design. The mineral slips usually fired to shades of dark brown, black, and sometimes red. The matt black decoration, which contrasts so handsomely with the glossy finish of many contemporary Santa Clara and San Ildefonso pots, is produced by painting designs with fine slip on top of the polished surface, then firing in a reduction atmosphere, which turns the pot black. The slip comes out of

the fire with a matte surface, while the burnished part of the pot stays shiny (see 5-19). Some potters used a vegetable paint that turned black during firing. Called *guaco,* it was made by boiling new shoots and leaves of the Rocky Mountain bee plant into a syrup. Hardened and formed into a block, the paint could be kept for years and mixed with water when needed. Traditionally, the artist applied the paint with a brush made from yucca leaf or other vegetation.

Decorative motifs have varied throughout the years and in different areas, from geometric or symbolic motifs painted in black on white (see 5-16) to flowing polychrome designs. The decorations might consist of stylized clouds, rain, lightning, feathers, or the plumed serpent. Other pieces were decorated with what appear to be totally abstract patterns, but these may have had some secret symbolic meaning.

FIGURE 5-21
Julian Martinez removes a burnished double-spouted wedding jar from the open firing, whose reducing atmosphere turned the pots black. San Ildefonso, New Mexico, c. 1940. *Photo by Wyatt Davis. Courtesy Museum of New Mexico, neg. no. 30932.*

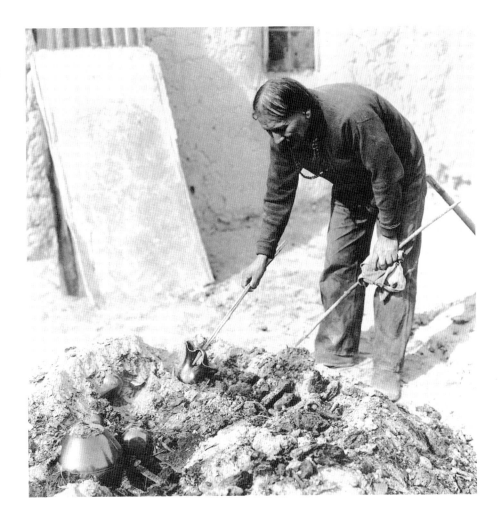

Firing The traditional methods of firing have remained very much the same to the present day, except that today's pottery—most of which is made for decorative purposes and not intended for domestic use—is fired at a cooler temperature than in earlier times. Potters in pueblos such as San Ildefonso and Santa Clara still fire in open fires, using available local fuels—cow or sheep dung, wood, or even, in the Hopi areas, soft coal. Nowadays the pottery is placed on sheet metal or a metal grill and covered by sheet metal, but the method is still basically the same as that which has been used in the Southwest for centuries (5-21). The firing is mostly done in the evening or early morning to avoid any wind that could cause the fire to burn unevenly, and it usually takes from around thirty minutes to an hour and a half. Some potters leave the pottery to cool in the fire, while others rake away the coals and remove the still-hot fired pots with long sticks.

SCULPTURE IN THE SOUTHWEST Clay sculpture was not as common in the early Southwest cultures as it was in South America, although a few pots were made in the shape of birds or had sculptured animals on them. But by around 1890, when tourists began to travel to the Southwest and buy curios, some potters started to make small sculptures, and this tradition continued in several pueblos.

Today an increasing number of Native American artists in the Southwest are creating clay sculpture in traditional styles and as individual expressions that continue to honor their peoples' myths, beliefs, and values while sometimes incorporating contemporary images and methods.

Northern Indigenous Cultures

Recent excavations in Virginia indicate that humans occupied campsites in eastern North

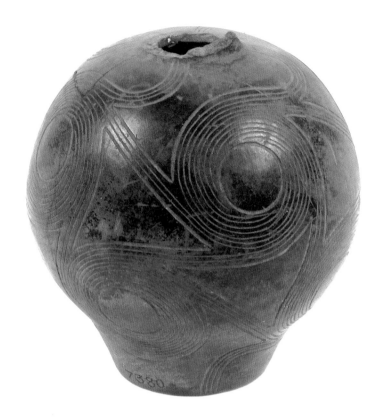

FIGURE 5-22
Dark, burnished pottery, usually with incised decoration, was typical of the Mississippi Valley culture. Its spiral design is remarkably like designs on pottery from Egypt (see 1-18), China, (see 3-5), and Panama (5-7). *Courtesy National Museum of the American Indian, Smithsonian Institution (00/7380, move image).*

America much earlier than had once been established. White pine charcoal found at what is believed to be a campsite has been dated at 15,000 years ago. This has given rise to an unsubstantiated suggestion that there was possibly an ocean crossing of people from the Iberian Peninsula to eastern North America as early as 24,000 to 16,000 years ago.

But indications of early camps do not mean that ceramics were made in them, and the development of ceramics in various cultures in North America came much later than the early camp in Virginia. One group of Mississippi Valley peoples, once collectively called the Mound Builders and now known as the Mississippi Valley cultures, made large earth mounds along the river valley and also formed some of the most advanced pottery found in the northerly part of the continent (5-22). According to one theory they were migrants from the south, influenced by group memories of Mesoamerican pyramids, but there seems little connection between these earth mounds and the stone pyramids of Mesoamerica.

The Iroquois in the North and the Florida Cherokee also made black or gray pottery and modeled animal figures as bowls for ceremonial use. Other eastern peoples (5-23) also made pottery, but many of the northern groups led hunting and foraging lifestyles, moving to seasonal camps according to the movements of their prey, so those groups naturally did not develop as complex a ceramics culture as the southwestern farming groups had. Pipes, however, could be easily carried, so ceramic pipe bowls have been found in various areas (5-24).

FIGURE 5-23
A three-headed vessel known as the *Triune Vessel,* found before 1883 near Caney Fork Cumberland River, is an example of the skill of the indigenous potters in eastern North America. Ht. 17 in. (43 cm.). Chestnut Mound, Smith County, Tennessee. *Photograph courtesy of the National Museum of the American Indian, Smithsonian Institution (#33747).*

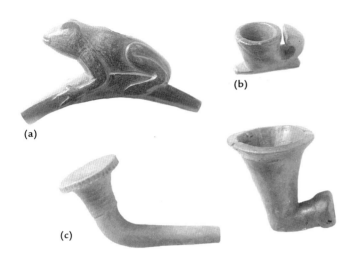

FIGURE 5-24
Pottery pipe bowls from various tribes. *(a)* Pipe bowl representing a frog, from Illinois. *(b)* Pipe from Cayuga County, New York. *(c)* Pipes with flaring bowls from the Nacoochee Mound, White County, Georgia. *Courtesy National Museum of the American Indian, Smithsonian Institution (N00775).*

FIGURE 5-25
A group of potters from North America founded Potters for Peace in an effort to help potters in several areas of the Americas adapt their traditional craft and indigenous designs to new markets. The pottery being made by this potter in Nicaragua is destined for the international market. Additionally, the organization has developed a ceramic filter for drinking water designed to help counteract water-borne diseases in the area. It has also suggested alternative firing methods that conserve wood in order to help preserve local forests. *Courtesy Potters for Peace.*

ENDURING TRADITIONS— CONTEMPORARY INTERPRETATIONS

The changes that occurred in the Americas with the arrival of the Europeans disrupted the indigenous traditions of unglazed ware and slip-coated ritual vessels in much of North and South America. New technologies—the potter's wheel, colorful lead glazes, and updraft kilns—modified older ceramic methods as native potters learned to reproduce the imported glazed Spanish ware.

Today, where metal and plastic have often replaced the traditional wares and indigenous ceramic techniques have been in danger of being lost, many individual potters have honored their traditions, using the old methods of working as a way to keep their traditions alive. In addition, some local potters' cooperatives, art museums, and native art traders have encouraged potters to return to earlier methods. Ancient designs, new interpretations of old patterns, and contemporary images now appear in hand-formed and mold-made pots and sculpture. The growing market for traditional art has fueled these efforts, so it is not unusual to meet a potter in a Mexican village who brings a yearly truckload of figurines to urban California for sale. Others sell their ware through cooperatives or galleries in cities nearer their homes. There is also a North American potters' group—Potters for Peace—that since 1986 has helped potters in Nicaragua and other areas design and make ware for the art market (5-25).

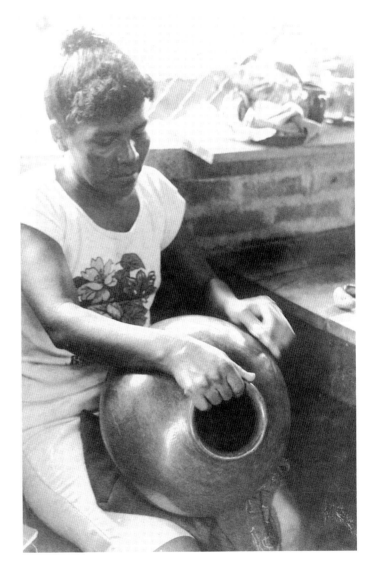

In northern America, new interpretations of traditional ware grow out of pride in continuing and contributing to the history of indigenous pottery, while contemporary attitudes, artistry, and techniques are now incorporated into local traditions of pottery and ceramic sculpture (5-26).

FIGURE 5-26
Warrior Woman, by Reuben Kent, U.S.A. Kent, who is of Kickapoo/Otoe/Iowa descent, makes use of Native American motifs combined with personal imagery. The final image goes beyond the traditional; Kent says, *the ultimate goal of all this technical knowledge is an object which hopefully speaks to the spirit or soul of the individual viewing the piece.*
Courtesy the artist.

6

Europe

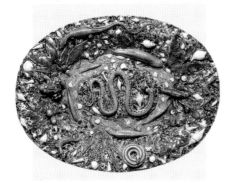

Prehistoric potters in the northern areas of Europe and Britain (6-1) had learned to make handbuilt vessels by about 6,000 years ago. Decorated with patterns of incised lines and textures, the pots were coilbuilt and sometimes paddled. Handbuilt black vessels with incised lines often emphasized by white chalk, funerary urns painted with swirls, rough pots with fingernail textures—all of these had been made in early periods from Scotland (6-2) to Denmark, from Switzerland to Hungary. Many of them, especially the pots of the La Tène (6-3) and Halstatt cultures, were shaped with a fine sense of the relationship between form and decoration. But in northern Europe a tradition of pottery making had not developed into a full-scale pottery industry like that of Crete, Greece, or Rome, probably because large urban centers such as those in the Mediterranean had not yet developed there.

The Romans brought potters and their advanced Mediterranean ceramics technology with them when they conquered Britain and parts of northern Europe. They influenced local potters and passed onto them technology they had learned from Greek potters. Later, after the legions withdrew, the Roman technology was largely forgotten.

As the Roman Empire waned, new ideas and influences appeared and were spread throughout Europe. The expanding Christian religion created an art that incorporated styles and motifs from classical Greece and Rome, while at the same time influences transmitted through Byzantine art from India, Egypt, Persia, and the ancient Mesopotamian cultures merged with the art of medieval Europe. The influence of Islamic art also spread as the Arabs thrust westward.

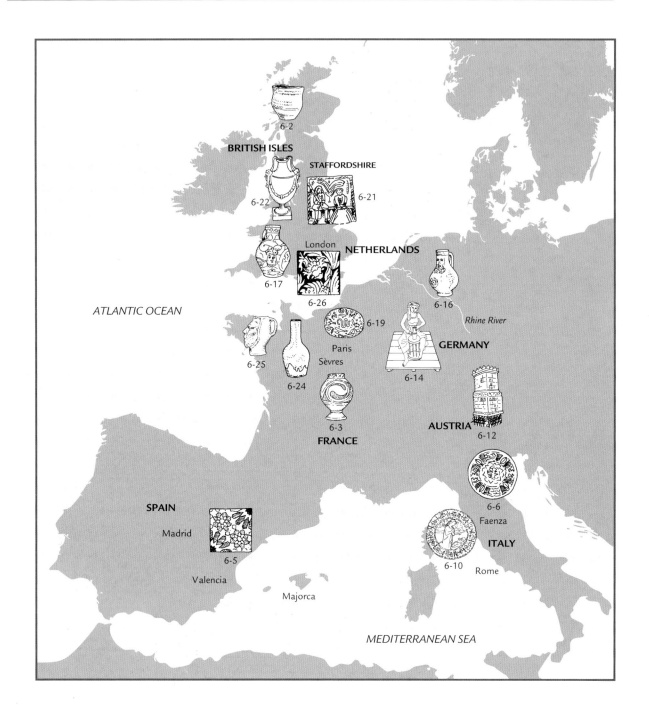

FIGURE 6-1
The early peoples living in what later became the countries
of Europe made pots with simple scratched and incised
decoration. Then came waves of immigrants from various
regions who brought with them new techniques and
aesthetic attitudes. For example, the Celts and the Moors
left their diverse influences on European pottery, and
separate traditions developed on the continent as national
identities became differentiated (see 6-3 to 6-6).

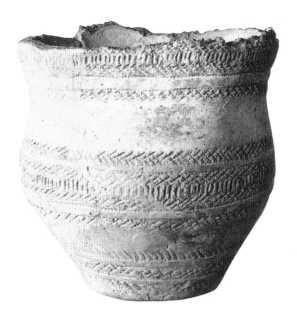

FIGURE 6-2
Prehistoric pottery in Europe, such as this Bronze Age urn from Scotland, was made of local clays fired to a low temperature and decorated with scratched lines. Similar linear decoration, scratched or impressed into the walls while the clay was still damp, appeared on early pots around the world. Ht. 5¾ in. (14.6 cm.). Terradale, Scotland, Bronze Age (1700–1300 B.C.). *Courtesy Board of Trustees of the Victoria & Albert Museum, London/Art Resource, NY.*

FIGURE 6-3
The black *palmette* decoration on red clay on this urn was characteristic of continental La Tène ceramics, as was the fluid shaping of the vessel itself. The culture was named for a place on a lake in Switzerland where nineteenth-century excavators discovered artifacts that pious Celts had thrown into the water to placate the gods. The name *La Tène* was then applied to these Celts, who spread widely throughout Europe and the British Isles, influencing the arts of metal and clay wherever they appeared. From an excavation at Caurel (Marne), France, second half of the fourth century B.C. *Réunion des Musees Nationaux/Art Resource, NY.*

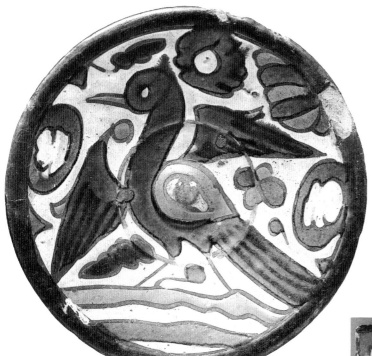

FIGURE 6-4
The dark green, yellow, and gray-blue glazes on a Hispano-Moresque tin-glazed plate are separated by lines painted with a mixture of manganese and grease in a technique called *cuerda seca*, used to keep the glazes from running into each other. Tin-glazed earthenware. Diam. about 9 in. (22.9 cm.). Spain, fifteenth century. *The Metropolitan Museum of Art, Rogers Fund, 1930 (30.53.11).*

FIGURE 6-5
Hispano-Moresque tiles such as this one glazed in black, yellow, and green were decorated using the *cuenca* technique, in which designs were first impressed into the damp clay and then filled with glaze. The indentations kept the colors separate in the firing. Glazed earthenware. Spain, seventeenth century. *Courtesy Cooper-Hewitt, National Design Museum, Smithsonian Institution/Art Resource, N.Y. Gift of Eleanor and Sarah Hewitt, 1929-17-20-a, b.*

MEDITERRANEAN TECHNIQUES

When the Islamic Moors invaded Spain from North Africa around A.D. 700, potters came with them, bringing their knowledge of glazes and lusters, as well as the characteristic Muslim style of decoration. The Moors occupied a large part of Spain for nearly 800 years, developing a particular type of decoration that combined local and imported motifs into a new, hybrid art style known as **Hispano-Moresque** (6-4). Islamic and Spanish decoration and ceramics techniques were blended; Arab calligraphy and scenes from Christian tales might both appear on the same painted ware. This style of decoration spread far beyond Spain and, with the new technical information, influenced pottery and tiles throughout Europe and eventually Hispanic America.

Luster Glazes

In addition to the tin glazes, to give the ware a rich metallic sheen, potters in Spain often fired gold and copper lusters onto the glazed surfaces, using a reducing atmosphere in the kiln. In the words of a fourteenth-century Islamic writer on ceramics, "Everything which has had a fire of this kind glistens like red gold and shines like the light of the sun." Even after the Moors were expelled from Spain, many of the traditional potters there continued to decorate their pottery with Islamic glazes, lusters, and Moorish-influenced designs, as do contemporary potters in Spain today.

Spanish Tiles

The characteristic Islamic use of tiled surfaces first appeared in Spain on the walls of Moorish palaces and mosques around A.D. 1300. The tiles were made with two techniques, called **cuerda seca** and **cuenca,** whose purpose was to keep the multicolored glazes from running into each other when they were fired. In the *cuerda seca* technique, the potter drew lines around the areas of the design, using a mixture of manganese and grease, and then filled in each area with a glaze. This separation method was also used on pottery, where it gave dark outlines to the designs (see 6-4). Later the *cuenca* method became more popular for use on tiles. In this technique the potter used stamps to impress designs into the damp clay, forming indentations and ridges that kept each color of glaze from spilling over onto the neighboring areas (6-5).

Majolica (Maiolica)

Even though travel both by sea and by land was dangerous and difficult, people and goods moved constantly across the Mediterranean and overland throughout Europe. Italian potters, for instance, are known to have worked in Spain in the late medieval period. Conversely, much of the tin-glazed decorated pottery made in the Valencia area of Spain was exported to other parts of Europe via the island of Mallorca in the Balearic Islands. The term *maiolica,* the historical Italian name for decorated tin-glazed pottery, is believed by some to come from a corruption of the place name Mallorca, whereas others say that it is derived from *obra de mélica,* a term used as early as 1454 to describe the pottery made at Manises, near Valencia. Whatever its derivation, the term *maiolica* (or **majolica**) is still used for this type of pottery (see 6-6).

ITALY

The know-how to make lead glazes, which had come to western Asia from China, had then spread via Byzantine potters throughout southern Europe. Lead glazes had been used in Italy since at least the ninth century A.D., and tin-glazed ware had been made in Sicily and southern Italy by the eleventh or twelfth century A.D., but the brilliant color and luster of the maiolica that came from Spain had greater appeal. Maiolica arrived in northern Italy at an opportune time, when a rich ruling and mercantile class that could afford the luxury of this imported ware was emerging in the Italian city-states. By the thirteenth century decorated pottery from Spain was traded to Italy, and it, along with glazed and decorated Byzantine pottery imported through the port of Venice, exerted a strong influence on Italian ceramics. Local potters soon began to copy this ware, hoping to get a share of the luxury market for themselves. That the Italians treasured glazed and lustered pottery bowls from Spain and the Byzantine Empire is clear from the place of honor they gave to those bowls by setting them into the brickwork of the towers and facades of their Romanesque churches. These lustered bowls, which may still be seen in church facades and towers in Italy, were placed there, it is said, to glorify God as they reflected the first rays of the sun in the morning and the last in the evening.

The potters in numerous ceramics towns in Italy eventually produced white and colored maiolica and learned how to apply luster as well. The Italian cities of Faenza, Deruta, Vicenza, Siena, and Perugia all developed pottery industries that embodied the new aesthetic ideas of the Renaissance (6-6).

Because it could be easily washed, the tin-glazed ware was at first especially popular in pharmacies for jars containing herbs, medicines, oils, and ointments. The earliest Italian maiolica had been decorated with geometric designs—

FIGURE 6-6
Potters in northern Italian ceramic towns such as Deruta, from which this plate came, were influenced by glazed and decorated pottery imported from the Byzantine workshops in Constantinople, by Hispano-Moresque ware from Spain, and finally by Gothic decorative motifs from northern Europe as seen on this plate. Lead-tin-glazed plate. Diam. 8 in. (20.6 cm.). Deruta, Italy, c. A.D. 1530. *Courtesy Indiana University Art Museum. Photo by Michael Cavanaugh, Kevin Montague.*

FIGURE 6-7
Kick wheels are shown in an Italian potter's shop of the sixteenth century. Piccolpasso states that the diligent artisan must work as carefully on the outside surface as on the inside, smoothing out the ridges of clay that appear on the wall of the vase. Cipriano Piccolpasso, *The Three Books of the Potter's Art,* Italy, c. 1556.
Courtesy Board of Trustees of the Victoria & Albert Museum, London/Art Resource, NY.

crosshatching, circles, and dots—but soon other types of ornament appeared: Asian motifs traceable to Persia and designs and motifs from medieval illuminated manuscripts from northern Europe, along with classical and Renaissance ornament. Now the maiolica was considered elegant enough to be given as a gift to the Medici ruler, Lorenzo the Magnificent. In 1490, acknowledging a gift of what was likely luster-enhanced ware, he wrote, "They please me by their perfection and rarity, being quite novelties in these parts, and are valued more than if of silver. . . ." In fact, by the turn of the fifteenth century, as their knowledge of glazing techniques was being perfected, potters in Italian ceramics towns were producing luster-glazed ware.

Improved Techniques

Pottery workshops were now run on the apprentice system, with assistants working under the supervision of a master potter. One of these potters, a sixteenth-century Italian named Cipriano Piccolpasso, wrote *The Three Books of the Potter's Art,* which described his methods and those of other potters. For example, Piccolpasso tells potters to make the pivot of the wheel axle from steel, to set it to revolve on a flint socket or steel plate, and to wrap the bearing near the top of the axle with oiled leather to make it turn more easily. He also describes how to mix clay, how to form pots on the wheel (6-7), how to finish them, and how to build a kiln and fire it (6-8). Bowls, Piccolpasso said, were often finished upside down on the wheel. The wall was thinned and smoothed by a **template** held against the side wall while the piece was turned on the wheel. In the same way, he stated, the wheel could be used while decorating pots.

Decoration

Toward the end of the fifteenth century, presentation pieces—*piatti di pompi*—became an important part of the Italian potter's output. These consisted of souvenirs and gifts such as wedding bowls displaying portraits of the betrothed (see 6-18). As time went by and the techniques of painting with glazes improved, the decorators used the white-glaze surface of maiolica more and more as a painting ground on which to display their

FIGURE 6-8
Piccolpasso captures the tension of firing as the master potter urges assistants to load in wood to keep the fire going while he times its duration with an hourglass. This sixteenth-century kiln was built of brick, with flues in the floor that allowed the heat to rise through the stacked pottery; after the arched door had been bricked in, the smoke and heat escaped from vents in the roof. Cipriano Piccolpasso, *The Three Books of the Potter's Art,* Italy, c. 1556. *Courtesy Board of Trustees of the Victoria & Albert Museum, London/Art Resource, NY.*

knowledge of the new Renaissance aesthetics. Now the pottery decorators copied engravings of paintings by famous artists such as Raphael and used perspective and shading to create illusionary space and three-dimensional form. As a result, the biblical and mythological figures in landscapes and architectural settings often appeared to be three-dimensional, with little relation to the shape of the vase or the flat plane of the plate.

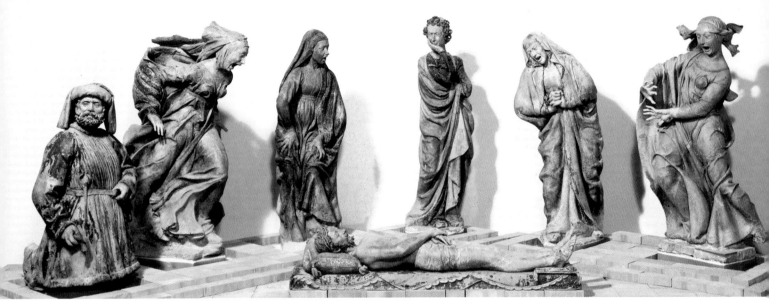

FIGURE 6-9
Almost life-sized mourning figures surround the figure of the dead Christ in this terra cotta *Pietà* by Italian sculptor Niccolò dell'Arca from the church of Santa Maria della Vita in Bologna, Italy. Created in the last twenty years of the 1400s, the work was orginally painted in polychrome, but little color remains. Tradition has it that the kneeling figure on the left is a self portrait of the sculptor. *Courtesy Scala/Art Resource, NY.*

Renaissance Clay Sculpture

While Renaissance painters were producing the illusion of space on the walls and ceilings of palaces and religious buildings and ceramic painters were following their lead in their commemorative plates, a number of sculptors were modeling the human figure in the round instead of in bas-relief. The tradition of using clay for sculpture had continued in some areas of Italy since the days of the Etruscans (see 2-28–2-31). For example, in the late fifteenth century in northern Italy, sculptors in Ferrara, Modena, and Bologna created almost life-sized religious works from the abundant local earthenware clay, painting them with realistic colors after firing. Niccolò dell'Arca, an artist who worked in this manner in northern Italy in the late fifteenth century, created large fired clay works depicting saints, Madonnas, and other religious figures posed in dramatic scenes or as realistic portraits. The city archives of Bologna contain records of the amount of clay allotted to him for various sculptures he created there in the late fifteenth century. The most impressive of his works is the painted terra cotta *Pietà,* from the church of Santa Maria della Vita, in Bologna (6-9). These expressive, almost life-sized figures were originally painted after firing, but little of the polychrome color remains.

During the height of the Renaissance, however, most sculptors used clay (as well as wax) to make the originals from which bronze statues were cast. But some, such as Donatello and Verrocchio, used terra-cotta clay to create portraits that were apparently intended not for casting but as works of art in themselves. Indeed, Verrocchio

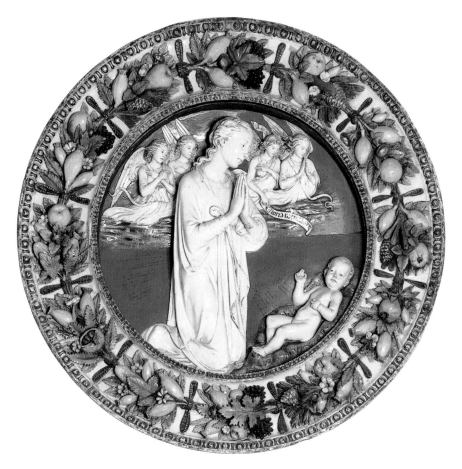

FIGURE 6-10
The Virgin Worshipping the Child, by Luca Della Robbia (1399–1482). He was the first to apply brightly colored tin glazes to large terra-cotta reliefs and freestanding sculptures. Three generations of his family carried on the tradition into the sixteenth century. His nephew, Andrea Della Robbia (1455–1525), made the frame, decorating it with fruit and flowers in the typical family style. Luca Della Robbia, fifteenth century. *Courtesy Philadelphia Museum of Art, purchased by the W. P. Wilstach Collection, 1930 (#30.1.1).*

had some of his sculpture glazed in the workshop of the Della Robbia family so that its surface would be more durable than the paint formerly applied to terra-cotta sculpture after firing.

Architectural Ceramics

Like the Islamic countries, various Italian cultures, from the Etruscan to the Renaissance, traditionally used ceramics in architecture. In some areas of northern Italy, where there was little good stone for building, decorative unglazed bricks were molded for use around windows, doorways, and sometimes even the whole facades of buildings. With the development of maiolica, the tiles, which can still be seen on the floors of churches and palaces, were glazed with blue, orange, green, and purple.

In the mid-fifteenth century, Luca Della Robbia, impressed with the colors that could be obtained with opaque tin glazes, saw the possibility of applying them to sculpture. After much experimentation, he succeeded in developing richly colored glazes, which he and his son and nephew used on terra-cotta panels and medallions modeled in relief, many of which can still be seen on buildings throughout northern Italy (6-10). Della Robbia **rondelles** depicting Madonnas are usually surrounded by wreaths of flowers and fruit that display the colorful glazes to great advantage. The composition of the glazes remained a secret that was handed down through three generations of the family but was eventually lost. According to legend, it was hidden in the head of one of his freestanding sculptures, and more than one Della Robbia figure, the story goes, was later smashed in the attempt to learn the composition of the glazes. Although many Della Robbia wall pieces were small enough to be fired in one piece, many were so large that they had to be fired in sections; a crucifixion scene in the Franciscan monastery of La Verna, in Italy, is made up of 720 pieces and is 18 ft. (5.65 m) tall.

FIGURE 6-11
For the castle museum in Lenzburg, Switzerland, Ernst Häusermann and Peter Schmid reconstructed a medieval heating stove. The firebox is built of brick, coated with layers of local low-fire clay mixed with straw, sand, and weed seeds. The unfired exterior is painted with whitewash. Wood-fired pots set into the rounded top radiate heat even when a small fire is lit, and steps at the side provide a warm sitting space. The stove is stoked through the wall from behind. Ht. 71 in. (180 cm.). *Courtesy Ernst Häusermann. Photo: Hans Weber.*

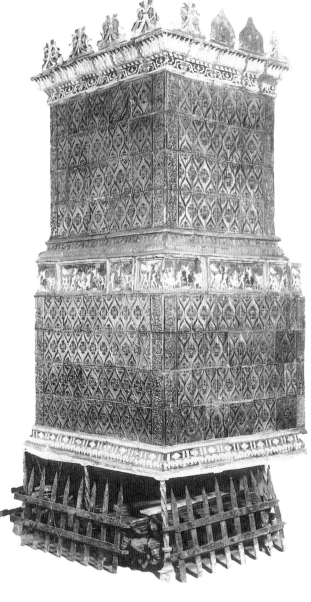

FIGURE 6-12
By the sixteenth century, heating stoves in Europe were covered with tin-glazed tiles molded in relief that served to radiate heat from the wood fire and provide a decorative surface. The repeat-pattern tiles are green, while the middle border of figures and the top decorations are multicolored. Austria, 1589. *Courtesy Philadelphia Museum of Art: Purchased with funds contributed by Henry Dolfinger, 1929 (#29.56.1).*

NORTHERN EUROPE

Northern potters had learned from Rome how to use the true potter's wheel and to build more advanced kilns such as the parallel-flue kiln, but once the Romans left, they gradually forgot these techniques. It was not until sometime between the mid-ninth and the twelfth centuries that advanced technology was once more known in the north.

Some medieval kilns were basically the same as the simple Mediterranean updraft types—circular, vertical, having some sort of perforated floor resting on a central pillar, the fire underneath, and a vent at the top. However, by the thirteenth century double-flue kilns were used in which the pots were stacked on the floor of the firing chamber and a temporary vault of turf or clay smeared on a wicker support was built over them. Eventually, in the fifteenth and sixteenth centuries, potters fired their ware in circular, multiflue updraft kilns with fires built in each of five or six radiating flues. At the same time, simple versions of the Roman parallel-flue kilns were reintroduced (see 2-33).

Architectural Ceramics

These parallel-flue kilns meant that potters could make large quantities of bricks, as well as tiles, chimney pots, drains, water pipes, and decorations to be placed atop gabled roofs. A characteristic use of clay for architecture during the medieval period in England was for tiles for the floors of churches and large homes. These tiles were made by *tyghlers,* men who traveled around the country and made tiles near the site at which they were to be installed. Made of earthenware, the tiles often had white clay lines inlaid in the red clay, depicting floral motifs, animals, saints, bishops, and nobles.

Another use of clay at this time was for stoves to heat the cold homes of northern Europe. Early medieval stoves were built of ordinary bricks and then coated with layer upon layer of coarse, wet clay mixed with straw and sand as temper (6-11). In many of the early stoves, earthenware pots were set into the sides or top to conduct the heat outward.

When Protestant potters in Faenza, Italy, experienced religious persecution, some went north, taking their knowledge of glazes with them. They applied their knowledge to stove building and influenced northern stove makers, who embraced the idea of decorating the tiled stoves. The stoves were constructed with special hollow glazed tiles that radiated the heat while serving as colorful decoration (6-12, 6-13). Potters from the Italian ceramics town of Faenza also went to France, and it was from the French spelling of the name of their town that the word **faience** came to be applied to tin-glazed earthenware.

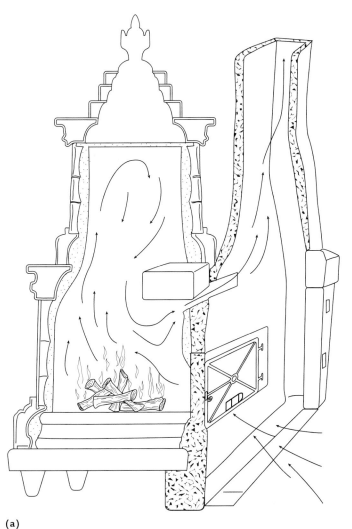

(a)

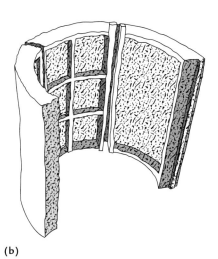

(b)

FIGURE 6-13

(a) Ceramic-tile heating stoves were generally located next to a wall so that the flue could be carried into the wall and then into a chimney. The stoking port for wood, with its metal door, opened from a room or hall behind the stove. In northern Italy the ceramic tiles of which the stoves were built were formed in terra-cotta molds.
(b) The tiles are three-dimensional and structural, insulated with highly porous local calcareous stone, and are still in place in many old stoves. Once the fire was going and the door was closed, a small air vent allowed enough oxygen to enter the firebox to keep the fire going, so the warmed ceramic tiles radiated a steady heat. Similar but less-decorative tile stoves are still being built for use today. *Redrawn from* L'Arte del Calore, *by Memmo Caporilli. Editoria, Trento, Italy. Courtesy the author.*

Jugs

The potters who supplied the domestic ware for Europe were especially proficient in making jugs (6-14–6-18). At a time without metal or plastic containers or auto transport, people needed jugs for carrying water, wine, or beer by hand from nearby sources. Although no longer essential ware, jugs as decoration have remained an important part of the potter's output since that time. The earliest medieval jugs were rough and crude but strong and bold in shape. They were wheel-formed (see 6-14), with varied decoration—stamped and combed designs, trailed slip decoration, human and animal figures and faces in relief. The main glaze used in northern Europe at this time was made from a lead powder called **galena** (see 6-15); it was dusted onto the ware, where it adhered to the surface to create a yellowish transparent glaze. This lead glaze could be colored with oxides—copper to make it green and iron to make it reddish—but the addition of these oxides did not make the glaze opaque, so it did not cover the body color completely.

By the end of the thirteenth century, in addition to making jugs, potters were making cooking pots, bowls, skillets, lamps, cups, weights for spinning wool, mortars—the list is a long one. Potters settled near sources of clay, digging their clay from pits near their cottages. An indication of how much ware they made is that when they dug the pits deeper and rains filled them with water, the pits became dangerous to travelers; in England in the fifteenth and sixteenth centuries, the courts ordered potters not to dig clay within eight yards of the highway.

FIGURE 6-15
Jugs made in medieval England were glazed with a lead powder (galena) that was sprinkled onto the surface of the clay. During firing, the lead combined with the silica in the clay, forming a glaze. The incised lines on this jug, made with a notched tool (see 6-14), were typical decorations, as were designs made with stamps and small wheels called roulettes. Ht. 14⅝ in. (37 cm.). Lead glazed, England, c. 1300. *Reproduction by permission of the Syndics of the Fitzwilliam Museum, Cambridge.*

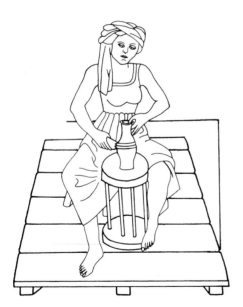

FIGURE 6-14
A medieval potter finishes a characteristic earthenware jug on a kick wheel. Rotating the wheel with her foot, she uses a notched tool to decorate the jug as the wheel turns. The wheel head was supported and attached to the base with several wooden posts. Redrawn from a fifteenth-century playing card. *Drawing by John M. Casey.*

FIGURE 6-16
A salt-glazed "Bellarmine" stone-
ware jug with face. The potters
along the Rhine River in Germany
found that their local clay became
vitreous and impervious to liquid
when fired to high temperatures,
and the further development of salt
glazing gave their ware even greater
imperviousness. The faces on these
jugs were generally press-formed in
molds and then applied to the jugs
in a technique called *sprigging*. This
one represented the well-known
Cardinal Bellarmine. *Courtesy the
Smithsonian Institution.*

FIGURE 6-17
A brown earthenware "Harvest jug." To decorate
such jugs, the artist trailed white slip over the
surface and then scratched lines into it, re-
vealing the fired clay below and thus creating
the detail. This one includes the royal coat of
arms (the lion and unicorn) and an inscribed
motto. White slip over earthenware, decorated
with **sgraffito** decoration, made by scratching
lines into the slip. England, 1775. *Courtesy Royal
Albert Memorial Museum, Exeter City Museums, England.*

FIGURE 6-18
Belle donne (beautiful women) pitcher. This late-fifteenth-century wine
pitcher from Italy is an excellent example of the presentation ware thrown,
glazed, and painted in northern Italian potteries. Made in Faenza, or possibly
by a potter from Faenza working in Venice, and decorated by a Venetian artist,
its "Amore" slogan and the arrow piercing the lady's breast are symbolic; the
decorated ware was often given to honor a betrothal. The unknown painter
created an evocative message and, unlike some other ceramics painters of
the period, respected and even emphasized the form of the pitcher through
restrained use of three-dimensional painting style and perspective. 1499.
Copyright © Scala/Art Resource.

German Stoneware

While the potters of Britain and France were making lead-glazed jugs from local earthenware, the potters working along the Rhine Valley in Germany were discovering that the abundant local clay could be fired to a high temperature (2218°F/1250°C), making it dense, impervious to liquid, and resistant to acids; this resulted in a great improvement in domestic ware. In addition to the large supplies of stoneware clay, the forests of northern Europe provided ample wood for the kilns, and the river provided a means of shipping the pottery easily. The first stoneware was made near Bonn in the middle of the twelfth century, and from then on potters along the Rhine made jugs whose basic form remained the same for several centuries. From about A.D. 1300 on, the use of stamped, applied decoration was particularly characteristic of jugs made along the Rhine River Valley. Many of the jugs were decorated with medallions in bas-relief (see 6-16). To create these medallions, the potter first carved an original into stone, which allowed precise details. The stone carving was then pressed into damp clay to create a positive stamp that was fired at a low temperature. From this clay positive, any number of negative clay molds could be made, and it was from these that the relief medallions were created. The low-fired clay molds were porous so that the medallions could be removed easily when the mold had absorbed water from the damp clay. Once the medallions were made, they were luted to the jug, the stoneware jugs were single-fired without a preliminary **bisque firing.** The clay body fired to a dull gray color, so the jugs were often coated with an iron wash to give them more color, then they were salt-glazed. The process of applying separately formed relief decoration is known as **sprigging.** The method is still used today, although often in a less traditional manner.

Salt Glazing

The potters found that the lead glaze they had used on earthenware was unsatisfactory for glazing stoneware, for it would melt and run off at the high temperature needed to fire that heat-resistant ware. Although the discovery of **salt glaze** may have been accidental, potters learned at some point that if salt were introduced into the kiln, it would vaporize in the heat, and as the sodium in the vapor settled on the stoneware, it would combine with the silica in the clay body to create a shiny, transparent coating on the pottery (see 6-16).

Salt-glazed ware became extremely popular, and the Rhine Valley potteries were organized to produce it in large quantities. Many barge loads of jugs were exported down the river to western Europe and on to England, even reaching the American colonies. Because the industry was important economically, the stoneware potters kept their techniques secret, causing ill feelings and envy among the earthenware potters.

The stoneware potters in Germany continued to guard the secret of the salt glazing zealously; it was not until the mid-sixteenth century that French potters learned to make salt-glazed stoneware, and not until 1671 was a patent taken out in England for the manufacture of this product. Even then, country potters continued to make slip-decorated earthenware jugs (see 6-17) into the nineteenth century. Ceramists today still reinterpret the jug shape (see 12-73).

The Spread of Tin Glazing

In the fourteenth century some potters from Spain had brought the technique of opaque tin glazing to Italy, where maiolica decorators became adept at enhancing plates, bowls, and tiles with Gothic and Hispano-Moresque designs (see 6-6). Then, as art styles changed, so did the style of painting on ceramics; three-dimensional images on presentation plates, bowls, and jugs made for special occasions became fashionable (6-18). French potters learned their methods of glazing, painting, and firing, and with this colorful tin-glazed ware, the French took over a large part of the European market.

One individualistic artist in France whose work was quite different from the usual decorated tin-glazed pottery was Bernard Palissy (1510–1590). Originally a glass painter whose work led him to an interest in glazes, Palissy created sculptural work—figurines colored with lead glazes—and a distinctive series of display plates modeled in brightly colored relief with faces, fish, eels, and fruit (6-19), which became popular with the aristocracy. Palissy was so fascinated by glaze experimentation and so determined to develop new glazes that at one time he sat up for six days and nights tending his kiln. Palissy wrote that after

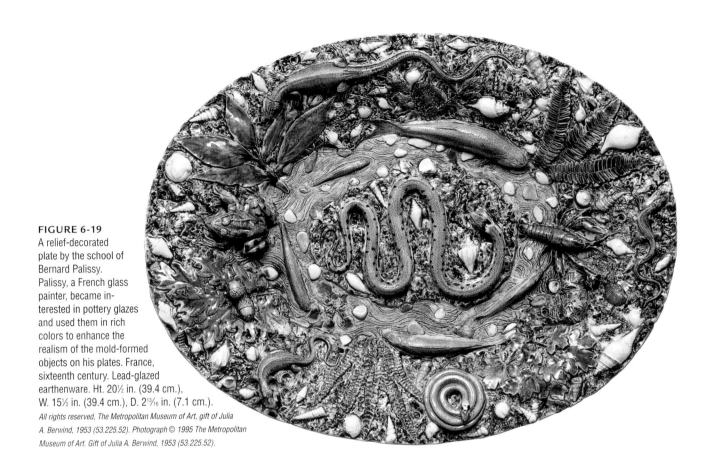

FIGURE 6-19
A relief-decorated plate by the school of Bernard Palissy. Palissy, a French glass painter, became interested in pottery glazes and used them in rich colors to enhance the realism of the mold-formed objects on his plates. France, sixteenth century. Lead-glazed earthenware. Ht. 20½ in. (39.4 cm.), W. 15½ in. (39.4 cm.), D. 2¹³⁄₁₆ in. (7.1 cm.).

ten years of this intensive work, "I became so thin that my legs had no roundness of shape left about them. . . . as soon as I began to walk, the garters with which I fastened my stockings used to slip down." Palissy used molds for his forms, often making them from life, and when he died his followers continued to use his molds to produce copies of his work—a customary procedure in traditional potteries.

Various factors affected the way the expanding ceramics industry developed in each country. In France, for example, two quite different motives gave impetus to the industry: royal pride and French taste in food. In 1709 King Louis XIV was in need of money, so he had the royal gold and silver bowls, cups, and plates melted down, leaving himself with no elegant tableware. He then commissioned the potters of Limoges to make *faience* of the Italian type to replace it. Meanwhile, expanded mustard manufacturing in Dijon kept the potters there busy making the earthenware jars in which the mustard was shipped.

European Blue and White Ware

European *maiolica* pottery was thick, not translucent like porcelain, and despite the glaze coating was not totally impervious to liquids or resistant to acid. When the first shipments of blue and white Chinese porcelain arrived in Europe around 1600, it caused a sensation due to its fine clay body and rich decoration (see 3-23). Collectors accustomed to the European white tin-glazed ware were stunned. In order to compete with the imported porcelain, the potteries in Italy and the Low Countries immediately attempted to imitate it, but since they did not know the secret of making porcelain, they made their imitations in earthenware. The opaque white glaze on earthenware did provide a good background for cobalt blue decoration, so the European potters were able to produce a relatively inexpensive copy of the Chinese porcelain with the general appearance of the fine white Oriental ware, although it lacked its delicacy and translucence.

FIGURE 6-20
After Chinese blue and white porcelain became popular in Europe, the potters in Delft, Holland, began to copy the style on tin-glazed earthenware, decorating it with Chinese-inspired motifs. This style of Delftware spread across the continent, and on this pitcher, *chinoiserie* decoration was combined with European figures. A pitcher with openwork like this one would have had an interior wall behind the cut-outs to allow the user to pour liquids. Late eighteenth century. *Courtesy Musee National de Ceramique, Sevres, France.*

DELFTWARE Although low-fired blue and white ware was produced throughout Europe, the town of Delft in Holland became especially noted for it, and, as with Faenza, its name became synonymous with its product. A great variety of tin-glazed earthenware objects were made there; apothecary jars, tiles, mugs, barber's dishes, and pitchers were all decorated with cobalt blue, reflecting the rage for Chinese-inspired decoration called **chinoiserie** (6-20). The Dutch became expert in making tiles, and blue and white glazed tiles became especially popular in Europe.

The Search for Porcelain

Despite the popularity of the local tin-glazed blue and white ware, potters continued to search for the secret of porcelain. As early as the late sixteenth century, Italian potters had made what is known as **soft-paste** porcelain, which, unlike true porcelain, can be scratched with a sharp steel instrument. Finally, around 1710, Johann Friedrich Böttger, a chemist and alchemist in Germany, discovered how to make the true high-fired, translucent material known as **hard paste.** On the orders of the king of Saxony, Böttger had been trying to make gold from less expensive materials to fill the depleted royal treasuries. It was in the course of research for this purpose that he experimented with clays and discovered how to make a fine stoneware that was so hard it could be cut on a lathe. His discovery led to the founding of the Meissen ceramics factory. Then, when he found kaolin in Saxony, he succeeded in making true porcelain, which became a status symbol throughout Europe.

In Denmark the ceramics industry was at first supervised by French and German technicians, who brought their techniques and even their clay with them because the local clay did not fire well. In 1779 a factory was established that became the Royal Copenhagen Porcelain Factory, and a French potter who had come to work for the Danish king was ordered to teach two of the local technicians his porcelain-making secrets before he was allowed to return to France.

After production of porcelain began in Germany, a race was on among other countries to discover its secret so that they could compete with the flood of imports from China and the output of the German factories. Eventually other European potteries did learn how to make porcelain and found the kaolin supplies needed to make the fine, translucent ware.

BRITAIN

In 1689 William of Orange became king of England, as well as king of the Low Countries. At this time potters from Delft went to England, taking their knowledge and techniques with them; thus blue and white ware crossed the Channel.

Along with the blue and white porcelain, tea was being imported from China, and Chinese tea and Arabian coffee became the fashionable drinks in English drawing rooms and coffee houses. English potters responded to this new social habit and developed special shapes for pouring the popular beverages. As a result, teapots and coffee-

pots now constituted a large part of the potter's output, and both porcelain and tin-glazed, low-fired teapots became popular.

Slip-Decorated Earthenware

While the blue and white tin-glazed ware gained popularity among the wealthy and fashionable, simple earthenware vessels were still used in most rural areas throughout Europe and Britain. Potters continued to make large quantities of lead-glazed earthenware decorated with slip (see 6-17), and traveling pot sellers marketed the ware from village to village, selling it directly from their carts. The slip-decorated pottery was made with techniques that remained very much the same in country areas in the eighteenth century and well into the nineteenth century—and these techniques are still used by some studio potters there today. In one technique, the decorative slip was **trailed** onto wet slip of a contrasting color; then a comb or other tool was dragged across it in a technique called **feathering,** which created a marbled effect (see 7-2). In another technique, sgraffito, the ware was covered with an overall coating of light-colored slip; then, when the slip was dry, lines were drawn through it with a sharp instrument, revealing the darker body clay below it (see 6-17).

Earthenware plates, often formed by draping a slab of clay over a carved **hump mold** or in a concave press mold that formed relief decoration, now appeared in many homes. Made for display or as wedding and christening gifts, they also had dates, mottoes, and other decorations trailed onto them through cow horns or small pots fitted with quills through which the slip was trailed. The pottery first shipped to Plymouth and to other early American colonies was of the simple undecorated type.

Kilns remained basically the same, except that now the ware to be fired was often stacked on thin stone shelves, and in order to keep the pots from sticking to the saggars or shelves when the glaze melted—a problem that had resulted in many ruined pots and saggars in the past—small pellets of heat-resistant clay were placed under each pot. Although the potteries were still basically family-run workshops, a much-expanded ceramics industry would soon appear.

English Stoneware

In the seventeenth century some English potters had learned to make high-fired, nonporous, acid-resisting stoneware—a big improvement over earthenware pottery—and potters experimented with different types of stoneware bodies. In 1671 a Fulham potter, John Dwight, developed a fine white stoneware body that was widely used for domestic ware but also successfully used to make small figure sculptures, on which he used salt glaze. The salt glaze **fitted** the clay body well and did not obscure sculptural details by filling up indented areas. By the eighteenth century, in Staffordshire, where large numbers of potters had settled because of the availability of good clay, white stoneware was used in a combination of mold and handbuilding techniques to make small sculptures (6-21).

FIGURE 6-21
In the early eighteenth century, potteries in Staffordshire, England, adapted German salt-glazing techniques to small sculptured groups made of a dense, white stoneware body. The figures were made with rolls of clay, with thin slabs added for clothing. The faces were mold-formed. Details of faces and clothing were accentuated with dark-brown clay slip. Pew group, Staffordshire, c. 1745. *Reproduction by permission of the Syndics of the Fitzwilliam Museum, University of Cambridge, England/Bridgeman Art Library.*

FIGURE 6-22
Influenced by Greek pottery shapes and mythology, the black Basalt ware of the Wedgwood pottery was made of a stoneware body colored with manganese—so hard it could be cut and polished on a lapidary wheel. This urn is decorated with sprigged satyr masks and garlands. Wedgwood Basalt ware, c. 1775, marked "Wedgwood and Bentley." *Courtesy Trustees of the Wedgwood Museum, Barlaston, Staffordshire, England.*

These were built with thin rolls of clay that acted rather like the skeletons of the figures; over these, thin slabs of clay were draped to form the clothing.

Ceramics and the Industrial Revolution

In the process of experimenting with clay bodies, the potters in England developed a type of soft paste that fused at a lower temperature than porcelain because it contained **bone ash,** which acted as a flux. Still in use in England for making **bone china,** this soft-paste clay body would have a profound effect on the world's tableware.

One potter, Josiah Wedgwood (1730–1795), probably did more than any other person to transform English potteries from small family workshops into a mass-production industry. This transformation made it possible for ordinary people to afford attractive, easily washable tableware. In addition, Wedgwood experimented with a variety of clay bodies and developed a specialty called **Basalt ware,** which was formed into classically inspired vase shapes for more affluent clients (6-22).

The development of better transportation played an important role in the ceramics industry. By 1777 a new canal permitted cheap water transport to the door of Wedgwood's newest factory, and Wedgwood urged other pottery owners to join him in improving roads so that wagons could carry their ware easily. On the negative side, in the process of manufacturing large amounts of tableware the pottery-producing areas of England became polluted with the fumes and smoke that poured from the kilns; one pottery alone might have had two dozen **bottle kilns** in operation at a time. Widely used in the industrialized pottery towns during the eighteenth and nineteenth centuries, bottle kilns were of the common updraft design; the bottle-shaped outer structure both increased the draft to the inner kiln and protected the men from inclement weather as they loaded the saggars into the kiln.

The potteries' goal was to make more and sell it cheaper, so steam power was harnessed to turn the mixing machinery, improved potter's wheels were sped by mechanical means, molds were used in order to form the ware faster, and workers were organized into assembly lines. One person no longer could participate in all aspects of the ceramic process, so a separation developed between the individual potter and the product.

Before this separation, the men and women who worked with clay had filled basic needs of their communities, whether producing vessels to be placed on religious altars, simple cooking pots, or even rabbit hutches or cricket cages (6-23). However, in an industry that was rapidly becoming machine-oriented, there seemed to be little place for the individual clay worker who took pride in his or her own work—who was an artist as well as an artisan. This led to a revolt

FIGURE 6-23
Despite the popularity of porcelain and china, potters throughout rural Europe continued to make utilitarian objects of earthenware. Clay provided the material for ovens, chamber pots, jugs, money jars, perforated jars to hold snails while they were prepared for human consumption, and cages, such as this one, made to hold crickets to amuse children. *Courtesy Museo Nacional del Pueblo Español, Madrid.*

FIGURE 6-24
The French potter Ernest Chaplet experimented with Oriental glazes, which he used on simple shapes reminiscent of those of Chinese porcelain. His glazes influenced many other European potters to experiment with colorful high-fire glazes. Ernest Chaplet, France, porcelain, 1906. *Courtesy Museum of Decorative Art, Copenhagen.*

against the factory system by some art-school-trained potters, along with other artists.

STUDIO POTTERY

By the 1880s a new category of potter had appeared—the studio potter. The term *studio potter* can be applied to a variety of artists. For example, the Frenchman Ernest Chaplet (1835–1909), worked for two large pottery companies, but he also maintained his own workshop, in which he used both stoneware and porcelain, covering his creations with glazes that rivaled those from China (6-24). It was in this shop that painter Paul Gauguin (1848–1903) first made ceramics—coil-built and press-molded pots and sculptures that he considered to be an important part of his artistic output (6-25). Gauguin glazed his work with some of Chaplet's glazes, but he applied them in his own distinctive, painterly manner, creating pieces that were expressive of his sense of form and surface. On the other hand, some studio potters both in Europe and in the United States at this time did not form the ware themselves but created paintings or decorations on pieces made by professional potters. This approach was not new—many Renaissance potteries hired painters to copy popular paintings onto their ware.

The Arts and Crafts Movement

In the 1880s a number of artists and art critics, rebelling against the spread of machine-made objects, preached a return to handcrafts. Led in England by William Morris (1834–1896) and William Frend De Morgan (1839–1917), this group urged craftspeople to respect the materials they worked with and join in a revival of

FIGURE 6-25
Self-portrait, by Paul Gauguin, France. This portrait jug was executed in
stoneware by Gauguin when he worked at Ernest Chaplet's workshop at
Choisy-Le-Roi in 1889. Gauguin was influenced by the early face pots made
in the Peruvian Moche area (see 5-4). Made of stoneware, it was covered
with a grayish-green feldspathic glaze that in places changed to red. 7.5 × 7
in. (19.3 × 18 cm.). *Courtesy Museum of Decorative Art, Copenhagen. Photo: Ole Woldbye.*

handcrafts that would beautify the surroundings and help the human spirit survive in a materialistic world. Morris and his followers became influential in leading many craftspeople back to the small workshop situation of preindustrial days.

Tiles

Many of these artists took their inspiration from the Middle Ages, Persia, and the art of the early Italian Renaissance. Morris and De Morgan designed panels of maiolica tiles (6-26), using flowing floral forms and the greens and blues of Persian pottery. The tiles were also set into the backs of chairs, buffets, and washstands.

In Spain another believer in the medieval craft guild system was the Catalonian architect Antoni Gaudí (1852–1926). His work is of particular interest to today's ceramists because of his collagelike use of glazed pottery shards to surface many of his buildings. He entrusted the execution of the mosaics to a young architect, Josep Maria Jujol (1879–1949), who was responsible for supervising the tile setters at the sites as they covered the facades of buildings, roofs, fountains, benches, and ceilings with pottery rejects, broken tiles, and other found objects.

Although the members of the Arts and Crafts movement attempted to restore the past by returning to earlier styles of art and craft methods, it was clearly impossible for an art-school-graduate studio potter to become once more an unsophisticated village potter. The studio potter was now faced with questions that would never have occurred to an early African village potter: how to resolve the conflict between the machine and human hands and how to choose between the desire to form clay with honesty and integrity and the need to compete with cheap machine-produced goods. Some potters resolved the conflict successfully by designing handsome ceramics for industrial production while creating their own individual pieces in their studios. A number of Scandinavian factories even gave ceramics artists the opportunity to work in this way at the factories.

These various approaches to the fabrication of ceramics—the factory setting for mass production

FIGURE 6-26
William Frend De Morgan, who was active in the Arts and Crafts movement in England, started a ceramic factory in London to produce vessels and tiles designed by himself and other artists. Their designs, frequently based on plant forms, were generally glazed in blue and green, sometimes with luster overglazes. Earthenware tile. Sand's End Pottery, 1898–1907.
Courtesy Cooper-Hewitt, National Design Museum, Smithsonian Institution/Art Resource, N.Y. Purchase in memory of Georgiana L. McClellan, 1953-104-4.

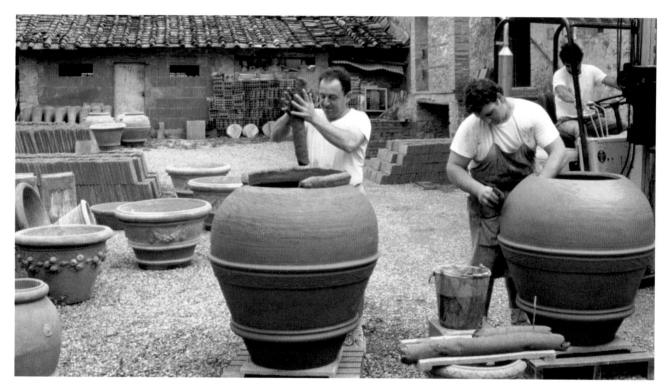

FIGURE 6-27
In Italy, potters have formed clay from the hills and valleys of Tuscany into useful and decorative ware since the days of the Etruscans. Today, there are still potteries there where ancient building methods are used with care and pride to make giant urns and architectural decorations. The ware is built by hand; by a combination of molds and hand building; or as sculpted originals used to produce press-molds for forming multiples (see 2-35). Here, large damp coils wait to be attached to one pot, while the worker on the right uses a gesture any potter will recognize—one hand supports the wall from the inside as he smooths the outside. A pottery in Imprunta, Tuscany, Italy. © *Vittoriano Rastelli/CORBIS.*

of china and pottery, the smaller workshop for handmade domestic ware, and the studio or workshop situation where one-of-a-kind pieces are created by individual artists—still account for the bulk of ceramics produced around the world.

ENDURING TRADITIONS

By the mid-nineteenth century the small pottery workshop tradition of Europe was increasingly disrupted by the arrival of the Industrial Revolution, although small country potteries continued to supply basic domestic ware in Europe into the twentieth century, keeping alive the knowledge and techniques of hand-formed pottery (6-28). But as the gap between industrially produced ceramics and folk ware grew wider, it caused a break in the continuity of ceramics tradition. There were factories that pro-

duced historical styles—generally decorated ware such as Italian Renaissance maiolica—but this was a self-conscious copying, not a true enduring folk tradition. A few ceramics factories in Europe and the United States opened special programs in which individual potters could contribute their artistic and technical skills, and at factories such as the Sèvres factory in France and others in Germany, Denmark, England, and the United States, artists were brought in to paint on ware that they did not throw themselves. In fact, it was largely through the influence of sophisticated art-school-trained potters that an appreciation of folk tradition was kept alive. These potters sought inspiration in countries such as Japan, which was not yet industrialized, and regions such as Africa, parts of the Middle East, and the southern United States, where there was a direct connection to past traditions. The effect of these living traditions on some twentieth-century potters are discussed in Chapters 7 and 8.

7

The United States

When Europeans first founded settlements in North America (7-1), they generally depended on potters in their homelands to ship pottery to them for domestic use. In the Plymouth, Massachusetts, settlement, for example, there were at first no potters in the village. Although the indigenous inhabitants—the Wampanog people—made handbuilt pottery, the tableware and other domestic ware used by the settlers came by ship from England. Recent excavations in western England, near Barnstable, have unearthed a kiln used to fire the type of earthenware brought to the first English settlements. Later, when potters did come to work in North America, some came as free farmer-potters, some came as indentured workers, and others were later brought as slaves. Existing records, as well as excavated kilns, indicate that in parts of New England and the South, potters were at work in the colonies by the mid-seventeenth century and that by the time settlements were well established, most villages and plantations had resident potters supplying the local needs.

COLONIAL CERAMICS

Over the years, potters arrived from different countries, bringing with them diverse styles and differing techniques. They continued to work in these familiar ways in the New World, adapting their methods to the available clay and to the needs of local buyers.

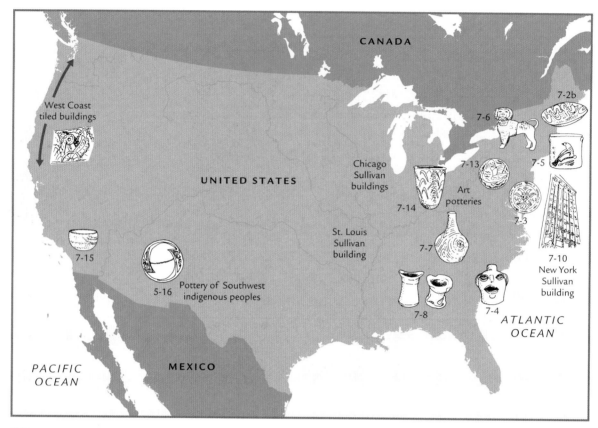

FIGURE 7-1

As settlers from Europe penetrated the vast North American continent, they brought their own ceramics traditions with them. Over the centuries, newly arriving potters and sculptors continued to bring their cultural attitudes and ceramics techniques with them, and as a result no single American tradition has ever existed. Now, with growing appreciation of the country's indigenous cultures, combined with influences from every part of the world, American ceramics exhibits a vigorous energy but no single identifiable style.

New England

Since most of the potters who first settled in New England came from England, the pottery they made reflected that background, and because their ware was produced for utilitarian use, they made it as they had made earthenware at home—slip-decorated and lead-glazed (7-2, 7-3, 7-6). The wealthier colonists could afford to import tin-glazed tableware from Europe, so the local potters concentrated on making simple earthenware utensils. For this reason, colonial ceramics in New England was not greatly influenced by European maiolica ware.

The New England potter was usually a farmer or fisherman who dug clay in the fall, dried it in the winter, reconstituted it in the spring, and made pottery whenever he could spare the time. The master potter, generally the father of the potting family, would do the throwing; a couple of assistants, often his sons, would do the rest of the work.

The earthenware was thrown on a kick wheel and then glazed with red lead, which was ground with sand and water in a glaze mill consisting of two millstones. The potter added cobalt, manganese, or iron to the transparent glazes, depending on which oxides were locally available, frequently applying the glaze in spots, streaks, or splatters. Slip decoration was popular; the jars, tubs, wash basins, pie plates, crocks, and porringers were trailed or painted (see 7-2). None of the decoration was elaborate, probably because of the Puritan strictures against frivolity. Nevertheless,

FIGURE 7-2
This slip-decorated platter illustrates how English potters who came to New England brought with them the techniques of ceramics they had used at home. Earthenware, slip-trailed and feathered. *Courtesy Shelburne Museum, Shelburne, Vermont.*

potters in New England tried to make their products as attractive as the material and the social and religious mores allowed.

Although pottery making was generally a male occupation, women did a good deal of the decorating and glazing, and apparently some women were potters as well. In 1716, for example, an advertisement offered the services of women potters who had arrived as indentured servants, and there are records of widows who ran potteries after their husbands died.

Pennsylvania

The distinctive pottery made by the Germans who settled in Pennsylvania reflected the traditions of country pottery in their homeland, where decorated plates commemorated important events. Dates, names, proverbs, and other inscriptions circled the edges of earthenware display plates (7-3). The plates were covered with slip or a glaze, with many of the design motifs—such as the Hapsburg double-headed eagle—taken directly from decorative motifs used in Germany. These designs were slip-trailed, painted, or scratched on in the style of northern European peasant art.

FIGURE 7-3
Another type of European decoration—from Germany—was used in Pennsylvania. First covered with a white overall slip, this earthenware plate was then decorated with slip-trailed tulips and Hapsburg eagles. George Hübner, Pennsylvania, 1786. *Courtesy Philadelphia Museum of Art: given by John T. Morris (#00-21).*

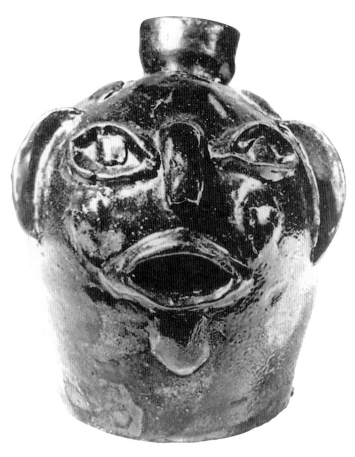

FIGURE 7-4
Face vessel from Bath, South Carolina. When Africans came to the New World, they brought with them the ceramics traditions of their homelands, which they integrated with the European techniques to which they were exposed. Along with utilitarian ware, the plantation potters created these lively, expressive face pots. Red earthenware with ash glaze. Ht. 8 in. (20 cm.). Early nineteenth century. *Photographs and prints division, Schomburg Center for Research in Black Culture, The New York Public Library, Astor, Lenox and Tilden Foundations.*

African American Pottery

Recent discoveries and reevaluations have shown that in the very earliest colonial days in Virginia and Maryland a few African Americans worked as indentured servants and craftspeople rather than as slaves. Not until later—at the end of the seventeenth century as slavery became widespread—did they become primarily fieldworkers, whose pottery skills were not used until the nineteenth century.

Some decorated clay tobacco pipes, once believed to be Native American, have been recognized by anthropologists as having been made by these African American craftspeople. Apparently the pipes—made between 1650 and the end of the century—were made on European molds, but the incised and applied designs were African, and they bear a striking resemblance to those on the pottery and pipes of West Africa. For example, one such design included tiny circlets of applied clay that can be seen on Ife sculpture (see 4-4), while other designs were scratched into the clay and then emphasized with white clay rubbed into the lines.

Later, when the potters were no longer indentured but were slaves, some of them used their skills to make pots that combined European vessel forms with African imagery, including sculptured "face pots" (7-4). A few slave potters were

FIGURE 7-5
New York and Vermont potters specialized in simple jugs, stoneware crocks, and pots decorated with chickens, shore birds, and eagles. Sometimes stacked 6 ft. (1.82 m.) high in the kilns, the cylindrical crocks were thick-walled enough to support the weight of those placed on top of them. Firing and salt-glazing the utilitarian stoneware in wood kilns required six to eight days. Ht. 11½ in. (29.2 cm.). *Courtesy New York State Historical Association, Cooperstown, N.Y.*

well known and sold their functional work at nearby market towns, earning income for their masters.

Colonial Stoneware

When, as early as 1730, English and European potters who knew the technique of firing stoneware arrived as settlers in the mid-Atlantic states, they found local stoneware clay and began to use it to make a wide variety of utilitarian ware. By the end of the eighteenth century, stoneware had for the most part replaced earthenware in domestic ceramics in the new country. By then English potteries were shipping the fine products of their **china** factories to the colonies to grace the tables of wealthier residents, and clipper ships were bringing the treasured blue and white ware from China (see 3-23). American potteries concentrated primarily on producing utilitarian stoneware such as containers in which to store pickled vegetables, salted pork, vinegar, and homemade beer. Stoneware was perfect for these uses, as it was impervious to acid as well as water, and its salt glaze contained no lead (7-5).

Stoneware clay did not exist in New England and upper New York, and the potters who made the ware in lower New York, New Jersey, Pennsylvania, and Virginia guarded the secret of its manufacture jealously so that they could sell finished pottery in the northern areas. When potters in other parts of the colonies finally learned how to salt-glaze stoneware, raw stoneware clay from New Jersey was shipped via waterways to northern potteries.

THE DEVELOPING CERAMICS INDUSTRY

These early stoneware potteries began as simple workshops, but they turned out a remarkable amount of ware. As time went on and the workshops became small factories, the work of the potter became more specialized. Using a kick wheel, the master potter would throw the basic stoneware shapes, making tall, wide-mouthed cylinders for meat tubs; low ones for butter pots; tall, narrow cylinders for butter churns; and smaller cylinders with an added neck and spout for jugs. Next, a finisher smoothed the inside and outside and sometimes impressed decorations in the damp clay using a roulette. A third person would add the handles, and yet another worker would decorate the crock with slip of a contrasting color.

The stoneware was stacked in the kiln rim to rim and base to base. As a result, the vaporized salt did not penetrate to glaze the interiors of the crocks and pots. For this reason, the inside of the ware was generally coated with **Albany slip,** made from a fine clay mined near Albany, New York, that fired to a dark brown or black slip glaze.

Earthenware potteries also increased their output. For example, a pottery mentioned in the 1850 census was described as making 100,000 pieces of earthenware a year with a staff of only three men, a woman, and a horse—which probably turned the **pug mill** that mixed the clay and also pulled the cart that carried the ware to market. The pug mill was usually a wooden tank with iron spikes set on its inside walls. When the tank was filled with dry or damp clay, sand, and water, a central shaft with spikes turned by horse or water power agitated the clay-and-water **slurry.** After the ingredients were thoroughly mixed, the semiliquid clay was screened to remove impurities and larger particles, then set aside to age.

Decoration

Much of the decoration of both earthenware and stoneware was done by drawing designs directly on the damp clay with a **slip trailer**—a small pottery flask with a thin neck into which a quill was inserted. The low-fire slip ran out through the hollow quill onto the unfired earthenware. Laid down in separate lines and dots, the slip flowed together in some places to form solid areas and in others to form lines that stood out in relief. The same type of slip trailer was used to flow on oxides such as the cobalt that produced the characteristic blue decoration on many stoneware country crocks.

Salt Glazing

The technique of firing salt-glazed stoneware used in the colonies was basically the same as that used in Europe. The ware was fired in a

single firing, which meant that the kiln operator had to regulate the wood fire carefully, increasing the temperature slowly to be sure the pots would not burst as the water left the clay. When the kiln was firing at 2300°F/1260°C, the worker shoveled ordinary rock salt down into the kiln and closed the opening. The salt vaporized almost instantly, and the vapor covered the ware (as well as the kiln interior), forming a glaze as it combined with the silica in the clay body. A local potter's instruction manual advises, "When fit to glaze, have your salt dry. Scatter it well in every part of your kiln, during this act you must keep a full and clear blaze so as to accelerate the glazing and give the ware a bright gloss. Stop it perfectly tight and in six days you may draw a good kiln of ware."

The kiln would be kept at high heat for about three days, using many loads of wood in the process. Then the temperature would be reduced so that the kiln would cool slowly to avoid damaging the ware. Finally, after about six to eight days, the door would be unbricked and, with

FIGURE 7-6

The deep brown glaze colored with manganese that was used on stoneware such as this poodle originated at the Rockingham China Works in Swinton, England. When nineteenth-century American pottery and animal figurines were coated with a similar glaze in America, it was usually deliberately mottled and runny. Ht. 8¼ in. (21 cm.). 1849–1858. *Courtesy Brooklyn Museum, H. Randolph Lever Fund. Acc. #74.19.3.*

luck, a kiln full of perfectly glazed ware would be revealed. But mishaps did occur, and many **wasters**—pieces of pottery that had buckled or cracked in the kiln—have been found at pottery sites. Wastage was not the only problem facing the potters: When salt vaporizes, it gives off a dangerous chlorine gas, and some citizens living near salt kilns complained about the gases that were released as the salt vaporized.

Potters followed the westward movement as settlers moved into Ohio and beyond, establishing potteries in the new territories to provide the utensils needed in the farming communities.

In southern workshops, an almost unbroken tradition has produced the functional ware needed in a rural community—bread pans, jugs, butter churns, and the usual storage crocks. By the nineteenth century most of the ware made in these workshops was salt-glazed stoneware like that made in New York and Vermont. In the South, however, the potter stood, rather than sat, at the wheel to throw the pots. Kilns were built of bricks made of the local earthenware clay, and the firing chambers were partially set into the ground, with the earth piled up around the sides of the arch to brace it. These kilns were called *groundhog kilns,* a type that is still used today by some potters in that area.

Other traditional methods survive today in small potteries in rural areas. The potter's wheels and mixing mills may now be run by electricity rather than turned by the family mule, and the jugs, churns, and crocks the potters make are likely to be sold to collectors.

Popular Figurines

Later, when many Americans had settled into small-town or urban life, a market developed for small figurines that could be displayed in middle-class parlors or placed on the kitchen dressers of humbler homes. Many of these, such as the Rockingham-glazed ware, were lively animal sculptures (7-6).

For wealthier people, there were more self-consciously elegant figures made of a white material called *Parian marble*—actually porcelain. This material was modeled or cast into sentimental statues of children or miniature sculptures of draped women in classical poses that imitated in small scale the work of noted nineteenth-century sculptors.

Art Pottery

By the end of the nineteenth century a growing leisure class had become interested in the arts, and many potteries began to hire artists to design vases, lamps, and decorative tiles. Some of the old pottery companies that were scattered across the country began to produce "art pottery" in styles influenced by contemporary art movements in both the United States and France. The Grueby Faience and Tile Company of Boston and the Rookwood Pottery in Cincinnati were in many ways representative of these art pottery companies. These potteries and other makers of art pottery produced distinctive wares for which they soon became famous (7-7, 7-8).

THE GRUEBY FAIENCE AND TILE COMPANY Inspired by the French pottery shown at the Columbian Exposition of 1893, the Boston pottery run by William Grueby (1867–1925) made handmade semiporcelain ware decorated with reliefs and coated with distinctive **matt glazes.** Like most of the art potteries, Grueby's depended on young women to do the decorating, in this case graduates of art schools in the Boston area. The designs were usually based on natural forms—flowers and leaves. These reliefs were formed separately, applied to the ware, and then hand-detailed.

ADELAIDE ALSOP ROBINEAU Like numerous other women art potters in this period, Adelaide Alsop Robineau (1865–1929) came to pottery through china painting—a popular activity considered acceptable for well-bred women. Frustrated with decorating other people's work, she began to cast her own ware and then learned to throw forms on the wheel. Greatly influenced by the glazes of Taxile Doat of the Sèvres Porcelain Factory in France, Robineau and her husband, who did the firing, began to experiment with glazes, many of which were **crystalline glazes.** Robineau was, however, particularly proud of her carved pieces, on which she often worked for hundreds of hours. These were either incised (7-7) or excised. In the latter method she cut out the background, leaving raised patterns and, in at least one case, a lacy openwork.

THE ROOKWOOD POTTERY Founded in 1880 by the wealthy Mrs. Maria Longworth Nichols Storer, the Rookwood Pottery grew out of its owner's

FIGURE 7-7
Carving was characteristic of the work of Adelaide Alsop Robineau and was often more elaborate than the swirling lines on this vase. The carving was done before firing, when the ware was dry. Ht. 14½ in. (36.8 cm.). 1913. *Copyright © The Detroit Institute of Arts, gift of George G. Booth, acc. no. 19.101.*

interest in china painting. The earliest Rookwood output was largely the work of Mrs. Storer and her "lady amateurs," but once the company was put on a business basis, professional artists, at least one of whom came from Japan, were hired to design its ware. The Standard Ware of Rookwood, frequently decorated by women students from the Art Academy of Cincinnati, was painted with colored slips and then coated with glazes. This use of colored slip under the glazes

FIGURE 7-8
Chief Joseph of the Nez Perces, a vase by
W. P. MacDonald made and decorated at the
Rookwood Pottery in Cincinnati, Ohio, in
1898. Slip-painted with underglaze, earthen-
ware. Ht. 14 in. (36.6 cm). *Courtesy
Metropolitan Museum of Art, Gift of Wells M. Sawyer.*

created a depth and richness that made the ware
famous (7-8).

GEORGE E. OHR In contrast to the pottery stu-
dios dedicated to creating beautifully decorated
vases and bowls, George E. Ohr (1857–1918), an
unusual but widely known figure in the ceram-
ics scene, made vases and pots that expressed
his unique personality. He produced his ware at
his Biloxi Art Pottery in Mississippi and adver-
tised himself on signs outside as "the greatest
potter on earth." Ohr, who saw himself as a ge-
nius and emphasized his similarity to Bernard
Palissy (see 6-19), was the most innovative pot-
ter of his time, anticipating in his work an atti-
tude toward clay that would not surface again
until the 1950s (7-9).

ARCHITECTURAL CERAMICS

In the mid-nineteenth century architects in the
rapidly expanding American cities began to dec-
orate buildings with details made from terra-
cotta. Easier and cheaper to model than carving
stone, clay was especially appropriate when used
along with the brick of which so many U.S. build-
ings were constructed. Although terra-cotta was
often surfaced to resemble more expensive stone
facing, it was also used for construction details—
for example, as fireproof tiles for ceilings. The use
of terra-cotta in architecture became widespread
after the devastating Chicago fire of 1871, which
destroyed many iron and stone buildings. After
that disaster, builders realized that these materi-
als were not as fireproof as was once believed.
Many of these buildings, presumed to be fire-
proof, had actually collapsed in the heat of the
Chicago fire; older ones with terra-cotta or brick
exterior facing survived. Builders now faced
many of the new metal-frame buildings with
ceramic "curtain walls" (non-load-bearing walls).
The use of malleable clay for the components
also made it easy to cast ornament for their
facades (see 7-10).

Louis Sullivan

The innovative American architect Louis Sulli-
van (1856–1924) exploited the aesthetic possi-
bilities of ceramics as part of this new structural

FIGURE 7-9
Six O'Clock in the Evening and *Three O'Clock in the Morning,* by George Ohr. Much of Ohr's work was totally outside the decorative studio-pottery tradition in America at the turn of the twentieth century, and foretold the attitudes of some convention-breaking potters of the 1950s and 1960s. Glazed earthenware. c. 1900.
Courtesy Smithsonian Institution, photo no. 78-2604.

system by using terra-cotta to face the metal frames of his buildings, successfully using richly detailed terra-cotta decoration to contrast with the thin piers and columns. For many years designer George G. Emslie and sculptor Kristian Schneider designed and modeled the plaster originals from which the molds were made for the distinctive terra-cotta decoration, marked with Sullivan's highly individualistic style. The Bayard Building in New York, erected between 1897 and 1898, exhibits a combination of plain terra-cotta sheathing and cast ceramic ornament based on natural forms (7-10).

FIGURE 7-10
The Bayard Building in New York City was designed by architect Louis Sullivan and built between 1897 and 1898. Sullivan often used ceramics to clad metal-framed buildings, working with his designers to create the elaborate, naturalistic ornamentation that became characteristic of his architecture. Cleaned and refurbished, the facade still shows the Sullivan atelier designs.

FIGURE 7-11
This tile, entitled *Persian Antelope,* was made at the
Moravian Pottery and Tile Works in Pennsylvania in
1937. Founded by Henry Chapman Mercer in 1898,
this tile factory reflected its founder's interest in
historical ceramics, using designs such as this one,
influenced by Persian as well as medieval and early
Pennsylvania-German pottery. Glazed earthenware.

FIGURE 7-11
This tile, entitled *Persian Antelope,* was made at the
Moravian Pottery and Tile Works in Pennsylvania in
1937. Founded by Henry Chapman Mercer in 1898,
this tile factory reflected its founder's interest in
historical ceramics, using designs such as this one,
influenced by Persian as well as medieval and early
Pennsylvania-German pottery. Glazed earthenware.

*Courtesy Cooper-Hewitt, National Design Museum, Smithsonian
Institution/Art Resource, N.Y. The Eleanor and Sarah Hewitt Fund,
1937-62-3.*

FIGURE 7-12
The 1930s was a busy decade for American ceramics
factories; architects often specified panels and tiles to
clad buildings, taking advantage of the colorful
surfaces of glazed ceramics. This Oakland, California,
movie "palace" displays brightly colored tile murals
depicting sports and entertainment.

Art Tiles

Expanding the use of ceramics in architecture,
many of the art potteries—the Grueby Company
and Rookwood among them—made decorative
tiles. A tile factory that was particularly famous
at the turn of the twentieth century and is still
producing tiles today, the Moravian Pottery and
Tile Works of Doylestown, Pennsylvania, was
founded by an archaeologist, Henry Chapman
Mercer. Many of his tile designs were influenced
by the Arts and Crafts movement in England,
while additional inspiration came from Persia
(7-11), from Moravian iron stove decorations,
from Pennsylvania earthenware pottery (see 7-3),
and from the decorations on French, Italian, and
English pottery and tiles.

Art Deco

Cast or extruded clay lent itself well to the low-
relief decoration characteristic of Art Deco orna-
ment, and designers soon realized its color po-
tential. In the late teens and early twenties of the
twentieth century, interest in the use of color in
architecture developed. At first, color was used
only on small areas, contrasting with the solid

beige or white of the building, but as time went on, ceramic was used on larger areas until eventually the entire front of the building was faced with glazed terra-cotta (7-12). Some of the most colorful and fantastic decoration was applied to the "movie palaces" built throughout the country, many of which showed the influence of Hispano-Moresque (see 6-5) in their architecture and tile decoration.

U.S. POTTERY, 1920s–1940s

Now that the production of everyday dinnerware and other utility ceramics had become largely industrialized, many art-oriented ceramists chose to work in small workshop/factories such as the Cowan Pottery in Ohio, where they created art pottery and figurines. At the same time, in some rural areas, such as Appalachia, the tradition of utilitarian wheel-thrown pottery was still alive—though on the verge of dying out. It took the De-

pression of the 1930s and the cottage-industry relief programs—including a project started by Eleanor Roosevelt—to turn regional crafts into viable commercial ventures with markets outside local areas.

Painter-potter Henry Varnum Poor (1888–1971), on the other hand, approached the rural earthenware tradition from the viewpoint of a sophisticated artist, aiming for an alternative to what he despised about the American ceramics tradition—which he called "sanitary hotel china." Searching for a new tradition, he decided that the answer was to develop a warm relationship with the material and to live close to the natural forms from which his images evolved (7-13). From 1920 on, Poor made his living as a potter in then rural Rockland County, New York, decorating much of his utilitarian earthenware with images based on native animals and birds.

During these years, emigrating European potters brought with them new perspectives and technical expertise. Among them were Marguerite Wildenhain, from Germany; Maija Grotell,

FIGURE 7-13

Painter-potter Henry Varnum Poor began to make pottery in 1920, building his own wheel, digging clay from his land, and learning to make pots and glazes through experimentation and persistence. He believed that *a good design is a living thing. . . . It is evolved out of a way of life* (quoted from *A Book of Pottery, From Mud Into Immortality,* Henry Varnum Poor, 1958). Earthenware, with yellow, brown, and green decoration under a transparent glaze. Diam. 11 in. (28 cm). *All rights reserved, The Metropolitan Museum of Art, Edward C. Moore, Jr., gift (29.130.2).*

FIGURE 7-14
Maija Grotell was noted for her imaginative use of glazes and textures. Grotell emigrated from Finland in the 1920s and became an important influence, through her own work and her teaching, in the development of ceramics in the United States. Stoneware, superimposed and inlaid glaze in turquoise and blue-gray. Ht. 12 in. (32 cm.). 1949. *Courtesy Everson Museum of Art, Syracuse, New York; Purchase prize given by G. R. Crocker and Co., 14th Ceramic National, 50.641.*

FIGURE 7-15
Earth Crater Bowl. Gertrude and Otto Natzler came to the United States from Vienna, Austria, in 1938. They worked together, Gertrude throwing the pots and Otto formulating the glazes for use on her simple forms. The Natzlers were also influential teachers, passing on their aesthetic philosophy, as well as their knowledge of glaze chemistry. Earthenware, green-gray glaze. Ht. 8¾ in. (22 cm.), diam. 12¼ in. (31 cm.). 1956. *Courtesy Everson Museum of Art, Syracuse, New York; Purchase prize given by United States Potters Association, 19th Ceramic National, 59.26. Photography © Courtney Frisse.*

from Finland (7-14); and Gertrude Natzler and her husband, Otto, from Austria (7-15). Grotell, who came to the United States in 1927, became head of the ceramics department at Cranbrook Academy of Art, a school that was ahead of its time in teaching the crafts on an equal footing with painting, sculpture, and architecture. Grotell's dedication to ceramics as an art, her disciplined craft, and her years of research into glazes resulted in rugged surfaces and brilliant color.

CLAY SCULPTURE, 1920s–1940s

Influenced by Europeans who emigrated to the United States, some American potters began to go to Europe to study. One of them was Viktor Schreckengost. He had been raised in an American pottery-making family and had worked at the Cowan Pottery in Ohio—a center of small ceramic sculpture making. Impressed with the Austrians' respect for clay, he created sculpture that frankly displayed the material from which it was made, using images that were often bitingly humorous (7-16). He also created some large architectural wall pieces that were rare at the time.

Other artists who were using fired clay for their work in the United States during the 1930s and 1940s believed that ceramics was a medium deserving of respect and that ceramic sculpture should have a place as a fine art. Among them was Weylande Gregory, who also had worked at Cowan. Gregory's large-scale ceramic figures on the *Fountain of the Atoms* were a feature of the 1940 World's Fair and represented a technical expertise that was unusual for the time (see 11-14). Other artists—painters and sculptors such as Elie Nadelman, Reuben Nakian, Isamu Noguchi, and

FIGURE 7-16
The Dictator, by Viktor Schreckengost. Of this 1940 piece the artist says, *Hitler, Mussolini, Stalin, and Hirohito seemed to be following the old pattern of Nero, who fiddled while Rome burned. They are represented by little cupids trying to crawl up into the throne while the British Lion lies sound asleep at his feet.* Red clay, black **engobe,** white, turquoise, yellow, and black glazes. In the permanent collection of the Everson Museum, Syracuse, 1940. *Courtesy the artist and the Everson Museum.*

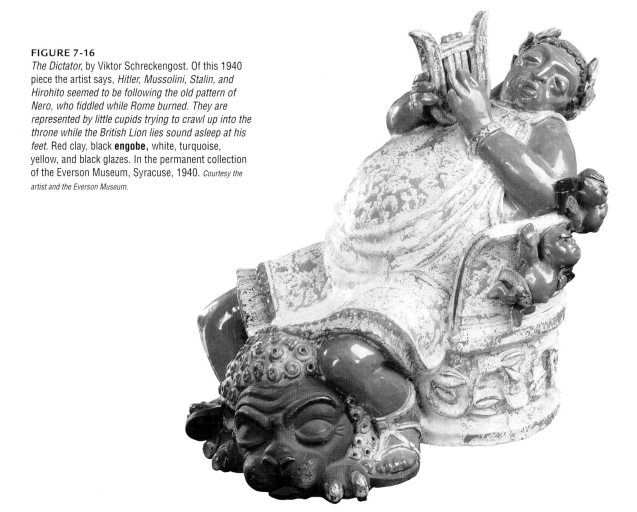

FIGURE 7-17
Moving-Static-Moving Figures, by Louise Nevelson. Sculpting from clay in 1945, when most
sculptors used clay only to make originals for bronze casting, Nevelson assembled these slab
sections of abstract figures on metal rods after firing. Terra-cotta. 1945. *Courtesy Collection of The
Whitney Museum of American Art, New York; gift of the artist. 69.159.1-15. Photo: Geoffrey Clements.*

Louise Nevelson (7-17)—used clay on occasion,
in the same way that they might use any other
medium to express their concepts. It is interest-
ing to speculate what course American ceramic
sculpture might have taken if World War II had
not disrupted what was promising to develop
into a vigorous American use of clay. But al-
though some artists did work in the material
after the war, clay did not reemerge as a widely
used sculpture medium until the 1950s.

8

Worldwide Interaction

Historically, potters have attempted to keep their glazes and other techniques secret, usually without success as other potters often figured out how to replicate them. In the twentieth century, however, a more open attitude developed, and today ceramics chat groups freely share ceramics knowledge on the Internet.

Aesthetic and interpersonal interactions occurred in the ceramics world in the 1950s and 1960s, along with worldwide interest in both new and old ceramics technologies (8-1–8-5). This global spirit of artistic exchange is strikingly symbolized by a series of meetings that took place between four potters—a Japanese folk potter, a British art school graduate who went to Japan and fell under the spell of raku, an innovative Californian potter, and a Tewa potter from a village in the American Southwest.

When Shōji Hamada (see 8-1), who worked in Mashiko, a traditional pottery village in Japan, met the British potter Bernard Leach (see 8-2), the two became good friends. Later, in 1952, Leach and Hamada met two Americans who also became influential in the world of ceramics—potter Maria Martinez (see 8-5), from San Ildefonso in New Mexico, and the late potter-sculptor Peter Voulkos from California (see 8-4). These interchanges between artists from such diverse cultures emphasized the common interests of all who work in clay.

Bernard Leach came to pottery because of the fascination he felt when he attended a raku party in Japan at which each artist and poet present decorated and fired a plate. Seeing what happened when the plates were fired in a red-hot raku kiln, and then plunged into water immediately on withdrawal from the kiln, Leach decided to become a potter himself. Maria Martinez and her husband, Julian, were instrumental in revitalizing traditional pottery in the American Southwest (see Chapter 5). At the same time in Italy, potter-sculptor Leoncillo

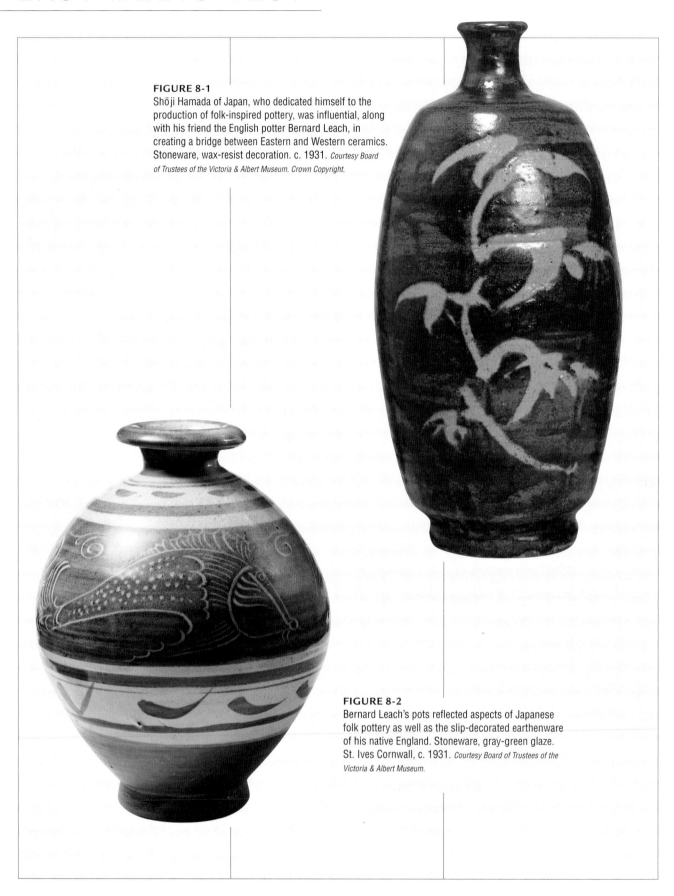

FIGURE 8-1
Shōji Hamada of Japan, who dedicated himself to the production of folk-inspired pottery, was influential, along with his friend the English potter Bernard Leach, in creating a bridge between Eastern and Western ceramics. Stoneware, wax-resist decoration. c. 1931. *Courtesy Board of Trustees of the Victoria & Albert Museum. Crown Copyright.*

FIGURE 8-2
Bernard Leach's pots reflected aspects of Japanese folk pottery as well as the slip-decorated earthenware of his native England. Stoneware, gray-green glaze. St. Ives Cornwall, c. 1931. *Courtesy Board of Trustees of the Victoria & Albert Museum.*

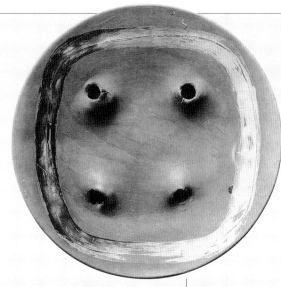

FIGURE 8-3
Italian painter-sculptor Lucio Fontana also worked with clay, and his innovative ceramics influenced other Europeans to approach clay with greater freedom. Maiolica fired at 1650°F/900°C. Black background with blue and gold metallic luster, fired in reduction. Diam. 16½ in. (42 cm.). *Courtesy, Collection Carlo Zauli.*

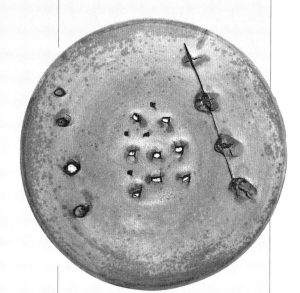

FIGURE 8-4
In the United States Peter Voulkos, influenced by the Abstract Expressionist movement, led the "clay movement" of the 1950s and 1960s. Slashing, puncturing, and altering his plates, he initiated a new approach to working in clay. Stoneware and porcelain. Diam. 18 in. (46 cm.). 1973. *Courtesy Toki Collection.*

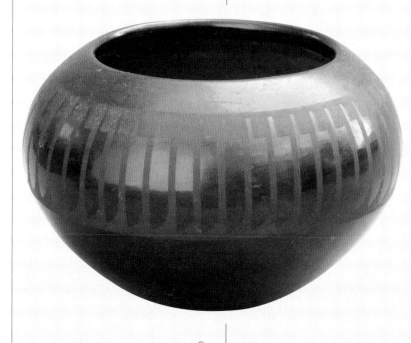

FIGURE 8-5
In the early 1950s Shōji Hamada and Bernard Leach visited Maria Martinez in the pueblo of San Ildefonso, New Mexico; they were also together at a lecture-demonstration at the opening of the folk museum in Santa Fe, New Mexico. This pot, made by Maria Martinez in the late 1950s, was painted by her son Popovi Da, who decorated much of her pottery after Julian, her husband, died. *Private Collection.* *Photo: Mark Preu.*

FIGURE 8-6
Chop Dish with Moon and Grasses, by Kitaoji Rosanjin of Japan, was made from a slab and fired with straw or other organic material introduced into the kiln to produce local reduction in the traditional Bizen firing technique. *Gift of Miss Margaret O. Gentles, 1969.697. Photograph*

(known only by his first name) and painter-sculptor Lucio Fontana (see 8-3) brought influences from twentieth-century painting and sculpture to clay, while in California Peter Voulkos (see 8-4) responded to postwar art movements and developed his own innovative approach to clay. Shōji Hamada formed his pots with local clay, using ash from trees in the nearby woods for his glazes, to create pottery that reflected Japan's rich ceramic traditions of *mingei,* or Japanese folk art (see 8-1). Leach drew on the background of English slip-decorated folk pottery (see 8-2) and played an important role in teaching a generation of potters in England and the United States.

When Leach returned to England, Hamada helped him set up his kiln and workshop and stayed as his partner for three years. Leach's writing in *A Potter's Book* inspired ceramists around the world, and his Cornwall workshop became a place of pilgrimage and training for young potters. In Japan he was honored as the seventh Kenzan, while Hamada was designated a National Living Treasure by the Japanese government.

One of Leach's assistants in Cornwall for a time was Michael Cardew, who became internationally influential in the 1960s and 1970s. Cardew spent several years in Ghana and Nigeria, where he set up pottery training centers to teach local potters to make stoneware in an attempt to improve their economic situation.

Another potter who was active in the global interchange in the 1950s was Kitaoji Rosanjin of Japan (8-6), who lectured and gave workshops in the United States demonstrating Japanese ceramics techniques. Rosanjin became a master of diverse styles of ceramics—Bizen, Oribe, Shino, Seto, and porcelain, decorated with his famous calligraphy in blue. Rosanjin came to pottery from a different orientation than Hamada, and it is revealing that when he made his trip around the world he visited Picasso and Chagall rather than other potters.

TWENTIETH-CENTURY ART INFLUENCES

In fact, an important worldwide influence on twentieth-century ceramics came from a number of European painters and sculptors who occasionally turned to the medium of clay for expression. Pablo Picasso and Henri Matisse were among the artists who responded to the innate character of clay, each in his individual style: Picasso sculpturally, by altering or combining professionally thrown forms (8-7), and Matisse by using ceramic forms as painting grounds.

Still another impetus came from the Bauhaus School, founded in Germany in 1919 and influential worldwide until it closed during the Hitler regime. The school taught that "form follows function" and that applied decoration had no place on any contemporary product. Bauhaus ideas were seen in the design of many factory-produced objects in the late 1920s and 1930s,

and ceramic factories such as Arabia in Finland and Wedgwood in England reflected these changing attitudes with simple, cleanly designed functional tableware.

During the 1930s a number of potters left their native lands due to political or artistic repression. Among them were Lucie Rie, Hans Coper, Maija Grotell (see 7-14), and Gertrude and Otto Natzler (see 7-15), who emigrated either to England or the United States from Austria, Germany, or Scandinavia.

Lucie Rie, who worked as a potter in Vienna before she went to England, set up a studio in 1939 and hired Hans Coper as an assistant. His work exhibited an intense interest in the formal, as opposed to the decorative, aspects of ceramics, and he created pottery that combined the classical and the innovative.

Given Italy's ceramic tradition, it is not surprising that artists there—among them Leoncillo—brought twentieth-century painting and sculpture influences to clay. In the 1930s the Italian painter Lucio Fontana had made three-dimensional still lifes in clay that prefigured the gestural quality of Abstract Expressionist paintings; later, Fontana made a group of works he called "Spatial Ceramics," punching holes and creating craters in the flat surface of his plates (see 8-3).

FACTORY STUDIOS

After World War II a number of European ceramics factories, such as De Porcelyne Fles in Holland, Bing and Grøndahl in Denmark, and Arabia in Finland, set up experimental studios where artists had a working relationship with the factory and were also given the freedom to create their own work. The establishment of these programs helped studio ceramists during

the difficult postwar recuperative period in Europe. Others, among them the Kohler Company in the United States and the Sèvres factory in France, as well as a number of brick and pipe factories in various countries, have welcomed artists into their workshops to use their facilities and technical expertise.

CONVERGING INFLUENCES

In the 1950s and 1960s many influences motivated emerging figures in ceramics, as well as in various other media, to begin to use clay as their medium of expression. In ceramics these influences included the work and attitudes of Leach, Hamada, and Rosanjin, as well as a growing interest in Zen Buddhism; an awareness of the indigenous cultures of the Americas, Africa, and other less well-known areas; in the painting and ceramics of artists such as Picasso and Fontana; and New York's Abstract Expressionist painting and constructive sculpture. The renewed interest in color in sculpture among nonceramic artists also led artists working in clay to expand their color pallettes by using postfiring paint and enamels on their work (see 8-16, 8-19).

The Clay Revolution

These currents in the art world affected the work of a number of potters and sculptors in the United States and Europe. The late Italian sculptor Carlo Zauli (8-8), who started as a young potter in the ancient ceramic town of Faenza, collected pottery shards and slumped, overfired wasters from the fifteenth-century kilns that had produced the town's famous maiolica. Influenced

FIGURE 8-8
Crollo di Cercope, by Carlo Zauli. To suggest the landslides that occur on the clay soil of the Apennine foothills outside Faenza, Zauli allowed the clay to collapse in response to gravity. He then reworked the surface of the forms. Black stoneware with touches of black glaze. 33 × 17 in. (85 × 45 cm.). 1980. *Courtesy the artist. Photo: Antonio Masotti.*

by these twisted wasters and the innovative work of Leoncillo and Fontana, Zauli began to alter his vessels, crushing them or letting the soft clay take on its own forms as it slumped. By the 1970s Zauli was creating large sculptures and murals that reflected many of the natural earth forms of his native province, Emilia Romiagna (see 13-11–13-15).

Just as the work of Fontana, and later Zauli, influenced potters and ceramists in Europe to work in a freer manner, the iconoclastic approach of Peter Voulkos, who set up the ceramics department at the Otis Art Institute in Los Angeles in 1954, led to a new approach to clay in the United States (see 8-4). Originally a painter who followed the contemporary art movements of Europe and New York, Voulkos was already known for his skill in throwing. He altered, paddled, and slashed his vessels as the clay responded to his gestures, and by painting bright colored, low-fire glazes on his sculpture, he said, he was using color not to enhance the form but rather to violate it. Voulkos's vital personality attracted other artists and students, who gathered around him at Otis. Among these were John Mason (8-9), Paul Soldner, (see 8-23); Jerry Rothman, Kenneth Price (8-10), and Billy Al Bengston, all of whom went on to become influential in the 1960s and 1970s.

John Mason had been a potter, but he began to alter his vessels, and by 1957 he was building large sculptures and walls of clay, using the medium freely to record his spontaneous gestures. By the 1960s Mason's work had become simplified into large forms, many of them variations of the cross, almost monochromatic, and at times seeming closer to Color Field painting than to sculpture.

Kenneth Price created brilliantly colored, egglike forms with erotic overtones. By 1970 he was creating installations containing curios inspired by Mexican folk pottery, prefiguring ceramic installations to come in the 1980s.

In Northern California during the 1950s and 1960s the term *Funk* was applied loosely to the work of several artists whose only real similarity was their irreverence toward established art concepts. One such artist, Robert Arneson, originally worked in the vessel form, but in the 1960s he switched from using high-fired stoneware to low-fired earthenware and low-fire glazes. In the 1970s he began a series of self-portraits that expressed his satirical ideas—political, artistic,

FIGURE 8-9
Red X, by John Mason, U.S.A. In the 1960s Mason coated his cross forms with monochromatic glazes that created fields of color. Stoneware. 58½ × 59½ × 17 in. (148.5 × 151.1 × 43.2 cm.). 1966. *Courtesy Los Angeles County Museum of Art. Gift of the Kleiner Foundation.*

FIGURE 8-10
The brilliant, almost fluorescent *S. L. Green,* by Kenneth Price of the United States. An influence in American ceramics in the 1960s, Price focused on contained organic forms. The surfaces, frequently painted with car enamel, are brash and startling, but the overall effect is elegant. Clay and paint. 9⅝ × 10½ in. (24.45 × 26.67 cm.). 1963. *Collection of Whitney Museum of American Art, N.Y. Gift of the Howard and Jean Lipman Foundation, Inc., 66.35.*

and psychological. In his later work Arneson commented grimly on the nuclear arms threat and militarism in general (see 8-18).

Other artists on the West Coast also expressed their irreverence in sculpture that tended to startle, frequently using everyday images. Richard Shaw used playing cards, letters, books, and soup cans to cast components for still-life assemblages (8-11). Clayton Bailey, who with Chris Unterseher and other artists called their work Nut Art, juxtaposed his highly personal clay images with found objects, as when he surrounded a banal electric lamp with cast ceramic noses (8-12).

A New Use of Color

A new appreciation of the color possibilities of ceramics spread throughout California, influencing both sculptors and ceramics students such as Ron Nagle (8-13), who studied with Peter Voulkos and later worked as his assistant. The appeal of the ceramic surface brought a new approach to color as well as to form and scale—all used as expressive tools rather than for decoration. Kenneth Price and Richard Shaw used color in widely differing ways (see 8-10, 8-11), while David Gilhooly (8-14) covered his satirical sculpture with lus-

FIGURE 8-11
What Can Parents Do? created by a master of slip casting, Richard Shaw, of the United States. Shaw also makes his own decals, and used both skills to create a precarious looking playing card tower. 10½ × 8¼ × 5½ in. 1994.
Courtesy the artist.

FIGURE 8-12
Clayton Bailey, a leader in the California clay revolution, made his *Nose Lamp* by combining a functioning electric lamp with glazed ceramic noses. Earthenware, low-fire glazes. Ht. 11½ in. (29.2 cm.). 1968. *Courtesy M. H. de Young Museum Art School. Photo: Robert Hsiang.*

FIGURE 8-13
A multifired pot by Ron Nagle of the United States. Nagle's work requires many firings to build up its rich glaze surfaces. After firing, he might add acrylic paint to further enhance the surface, as on this altered cup form. 20 × 14 × 18.5 in. (51 × 36 × 47 cm.). *Courtesy the artist and Rena Bransten Gallery.*

FIGURE 8-14
David Gilhooly of the United States created a mythological Frog Land whose shiny green inhabitants engaged in a spoof of human foibles. The base of this portrait of *Mao Tse Toad* displays biographical drawings of the Chinese dictator as a frog. 31 × 19 in. (78.7 × 48.3 cm.). 1976. *Private collection. Courtesy the artist.*

cious low-fire glazes. Nagles's pots grew ever smaller, while Viola Frey's figures grew larger; each artist exploited the impact of size and glaze in widely different ways. Others, including Louise McGinley (see 8-16), Beverly Mayeri (see 8-19), and M. C. Richards, fired their sculpture and pots without glaze but used postfiring paint to achieve quite different but equally expressive surfaces.

Fantasy and Narrative

As more and more potters and sculptors used clay as an expressive medium, some, such as Charles Simonds (8-15) and David Gilhooly (see 8-14), turned to narrative. Simonds chose crevices in dilapidated buildings or crannies under city curbs to leave traces of a mysterious miniature civilization. Gilhooly brought to life an imaginary world in which frogs worshipped a frog god and

FIGURE 8-15
Charles Simonds of the United States works on one of his *Dwellings*. In the 1970s Simonds traveled the world, creating groups of buildings in unusual sites. He used miniature unfired bricks, leaving them to disintegrate in weather or traffic. This one was built in the Passage St. Julien La Croix, Paris, 1978. *Courtesy the artist. Photo: Jacques Faujour.*

FIGURE 8-16
Summit Conference. In this political commentary produced in the 1970s by American sculptor Louise McGinley, the artist joins her sinister group of traders as they bargain for spoils over a campfire. McGinley fires her work at a very low temperature and paints the surface with acrylics after firing. Life size. *Courtesy the artist.*

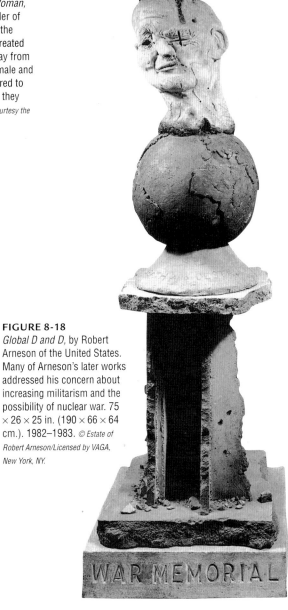

goddess. The multitude of shiny green-glazed creatures that emerged from his hands, though amusing, actually constituted a serious commentary on human society. Californian, Louise McGinley (8-16), also used fantasy creatures to comment on the human condition; her half-human, half-bird figures warned of lurking dangers, as in *Summit Conference,* an early installation made while the world waited to see whether the Soviet Union and the United States would avoid global destruction through nuclear war.

Figurative Sculpture

Through the 1970s and 1980s and into the early 1990s, the popularity of figurative ceramic sculpture grew. Stephen De Staebler built tall columnar figures composed of disassembled and reassembled body parts that evoke both the strength and fragility of the human body and spirit (8-17). Robert Arneson continued to depict his own portrait, but now his work took on a more menacing tone, commenting on nuclear fears (8-18).

FIGURE 8-19
In *Checkered Woman* Beverly Mayeri of the United States created a compelling figurative sculpture, heralding the return to the figure. She painted her clay sculpture with acrylics—a startling idea in ceramics at the time. 1978. *Courtesy the artist. Photo: Colin C. McRae.*

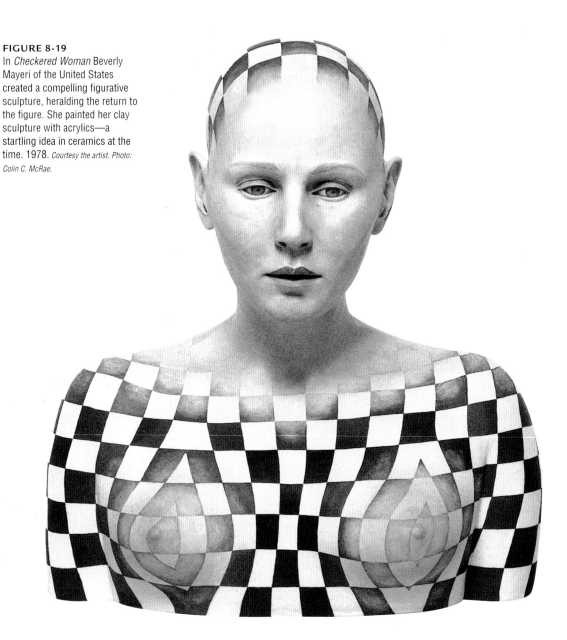

In addition, continued interest in surface color led clay sculptors such as Viola Frey to apply glazes to figurative sculpture, while others experimented with different coloring methods—both Louise McGinley (see 8-16) and Beverly Mayeri (8-19) used acrylic paint rather than glazes.

The late Mary Caroline Richards (known by her pen name M. C. Richards) wrote a seminal book, entitled *Centering,* that influenced a generation of potters. She was also known for her mastery of the craft of pottery—exhibiting a poetic sensibility that became ever more experimental over the years; finally she used acrylic paint on her pots instead of glazes.

Now, ceramics confronted the art world.

CERAMICS AND THE ART WORLD

For many years art critics and historians in the West had tended to place any object crafted of clay in the category of "decorative arts" or "minor arts." In contrast, in Japan fine pottery was hon-

ored, along with other products of the human hand and spirit, while in Italy people still venerated the ceramic altar pieces and other works of Niccolò dell'Arca (see 6-10) and Luca Della Robbia (see 6-11) as expressions of religious faith.

As the ceramics world exploded with innovative ideas, sculptors found that the malleability of clay and the brilliant color of glazes and acrylics provided them with a versatile medium. As a result, they made use of clay as they would any art medium. It took some time, however, before art galleries would display ceramic sculpture or art critics would consider it serious art. This left those who worked in clay at that time few places to display their work. But with artists like Voulkos (see 8-4, 8-20), De Staebler (see 8-17), Mason (see 8-9), and Zauli (see 8-8) leading the way, the art world eventually accepted the importance of clay as a sculptural medium. With the wide acceptance of fired clay sculpture today it is difficult now to realize that it was considered a breakthrough when clay sculpture was displayed as art rather than craft.

Performance

One way clay sculptors did enter the art scene was to become involved in happenings or performance: Dancers wallowed in slithery slip (see 16-1). A sculptor formed works by shooting bullets into chunks of clay. American ceramist James Melchert staged a production in Holland in which he and other participants dipped their heads in slip, allowing it to drip down over their bodies as they sat in a room that was hot at one end and cool at the other; a camera recorded the clay drying unevenly on their bodies.

Conceptualism and Minimalism

Given the fact that clay and ceramic are material and object-oriented, it is not surprising that Conceptualism and Minimalism had less effect on ceramics than on other contemporary art movements. Since the "pure" conceptual artist did not create an object beyond a written statement or plan, few ceramic sculptors—who by definition are involved with a basic material, clay—could be said to have created conceptual works. Nevertheless, a sculptor such as Johannes Gebhardt shows the influence of Minimalism. Oth-

ers, such as Rosa Verhoeve (see 16-6), Paul Astbury (see 9-17), and Ann Gazelle (see 9-12, 9-13) can be said to have been concerned primarily with the concept despite the fact that they constructed an object in clay.

Installations

Another route to the art gallery—and perhaps one better adapted to ceramics—was the installation. A number of ceramists entered the art scene in the 1970s and 1980s by creating installations. For example, Bernard De Jonghe and friends carried his cobalt-blue-glazed columns to the top of a Provençal mountain and videotaped the event (see 16-3).

Installations continue to intrigue ceramic artists today, as well as offer them a wider opportunity for self-expression than single pieces (see Chapter 16). Whether a clay sculptor creates an installation in a gallery for a few days or weeks or a short-lived setup against an unusual background for a photo shoot, installations have the ability to move ceramics out of the kitchen and into the art world. On the other hand, some artists prefer to connect directly with viewers—Frans Duckers placed a clay figure at a bar in Holland to interact with the patrons (see 9-9), while Antony Gormley involved hundreds of people in forming the tiny figures for his *Fields* (see 9-10) and Charles Simonds built houses for tiny people in unexpected places (see 8-15).

Judy Chicago used a ceramic and mixed media installation to comment on the history of women artists and other feminist issues (8-20).

CERAMICS IN ARCHITECTURE

Ceramics has played an important part in the decoration of architecture throughout history (see 2-10, 2-29, 3-14, 3-35, 7-10), but the functional architecture of the post–World War II period offered little opportunity for its use. By the early 1960s, however, some architects in Europe, and later in the United States, became concerned with the dehumanization of buildings; they began to work with tile-makers and clay sculptors to bring color and human scale back to building design. Clay sculptors won commissions for wall pieces, as well as freestanding sculpture in

FIGURE 8-20
Judy Chicago, of the United States, used ceramic plates in her installation, *The Dinner Party,* honoring thirty-nine outstanding historical women—among them a number of artists. To create her feminist statement, the plates are sculpted with vaginal images—what Chicago saw as a shared symbol. The names of almost a thousand other famous women were inscribed on the tiled floor. Hundreds of women worked in cooperation on the installation, painting the china, doing the needlework—using their historically "feminine skills." It toured museums and galleries in the United States and abroad. Mixed media. 48 ft. (14.6 m.) on each side.
© Judy Chicago, 1979. Photo: © Donald Woodman.

architectural settings. Stephen De Staebler in the United States, Carlo Zauli in Italy, and Kimpei Nakamura (see 16-5) in Japan all created site-specific works both indoors and outdoors.

THE VESSEL

During these years of change and innovation, some potters looked at their work with new eyes and began to create one-of-a-kind pieces for gallery display—what had been called *studio pottery* in the nineteenth century now was called *the vessel* to distinguish it from domestic ware. Others followed the examples of painter Paul Gauguin (see 6-25) and potter George Ohr

(see 7-9) and created highly personal pottery made more for viewing than for using. This was nothing new in ceramics. One has only to look at early Greek commemorative vases honoring Olympic games winners to see parallels.

Peter Voulkos continued to create massive altered pots that blurred the line between the vessel and his sculpture (see 8-4, 12-134). Influenced by techniques of the past, many potters, such as Paul Chaleff (see 8-22), altered their work less drastically, using wood firing in individual interpretations of earlier firing methods.

Also influenced by history and distant cultures, Richard Hirsch saw his tripod vessels as *celebrations of containers, with their fundamental characteristics and cultural manifestations* (8-21). Hirsch used terra sigillata and many lay-

ers of glazes to create the ancient-appearing surfaces on his work. After a trip to the ceramics town of Yixing in China, Richard Notkin began to create highly individual interpretations of the town's traditional teapots, expressing his feelings on contemporary political and humanitarian issues (see 13-75).

In the 1980s and 1990s the strong sense of continuity with the past that leads potters to identify with historical work brought Karen Karnes, Paul Chaleff (see 8-22), and others to refer, however freely, to ancient cultures or use modified historical methods. While innovation in ceramics continued to attract attention and many vessels were made with gallery exhibition in mind, Janet Mansfield (see 12-6), Michael Casson (see 12-2), Steven Hill, (see 12-73), Catharine Hiersoux (see 12-44), and Ben Owen, to name only a few, continued to create beautiful pots for use, striving for perfection of form, glaze, and decoration.

These and many other potters and sculptors around the world adapted ancient or diverse cultural techniques or forms to their own work, while at the same time others pushed the boundaries of ceramics under the influence of contemporary art movements. All these currents helped to prepare the way for a sense of freedom and experimentation that continues today in ceramics.

MATERIALS AND PROCESS

Potters have always experimented with new materials and methods and have been open to learning from migrating potters or ware brought from other countries through trade, and today potters still welcome the new ideas and technology exchangedthrough Web chat groups. For example, experimentation with clay additives such as nylon fiber or steel wool, or with firing clay and steel together in one firing, have opened up new ways of working. Others have found satisfaction in developing personal interpretations of historical methods as far apart in time and place as prehistoric Asia, medieval Germany, seventeenth-century Japan, and the American South of the late nineteenth century. This has led to new interpretations of methods from around the world, including Paul Chaleff's adaptation of Japanese wood firing (8-22); and Paul Soldner's use of postfiring smoking (8-23).

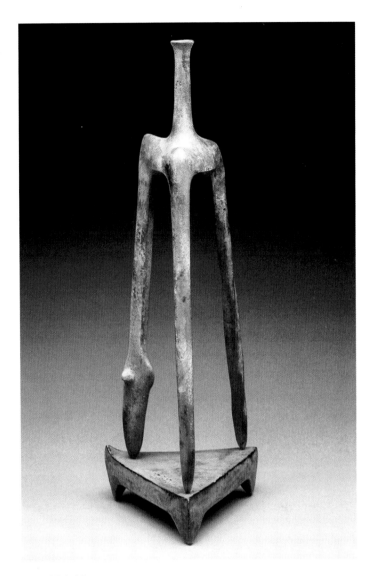

FIGURE 8-21
Vessel and Stand #15, Coper-Metti Series, by Richard Hirsch of the United States. Hirsch achieved the ancient-appearing surface with layers of terra sigillata, low-fire glazes, and raku firing. 22½ × 10½ × 10½ in. (57 × 27 × 27 cm.). *Collection Museum of Contemporary Ceramics, Ghent, Belgium. Photo: Dean Powell.*

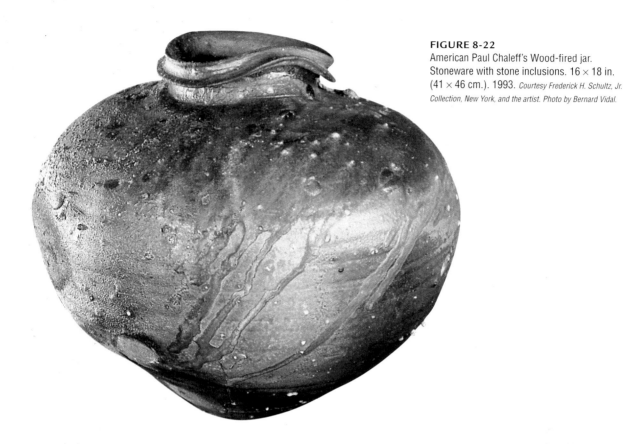

FIGURE 8-22
American Paul Chaleff's Wood-fired jar.
Stoneware with stone inclusions. 16 × 18 in.
(41 × 46 cm.). 1993. *Courtesy Frederick H. Schultz, Jr.*
Collection, New York, and the artist. Photo by Bernard Vidal.

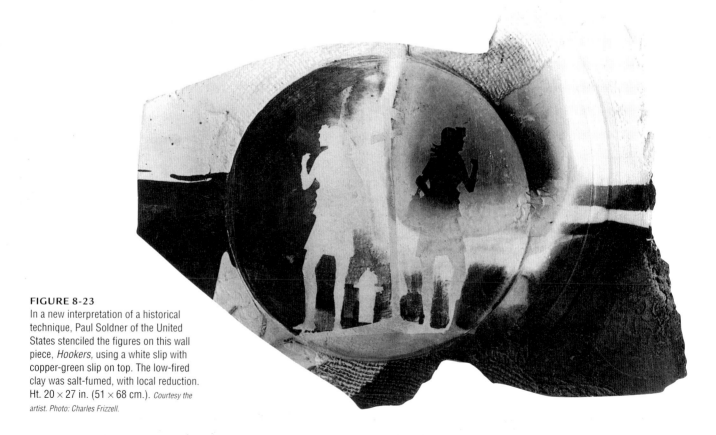

FIGURE 8-23
In a new interpretation of a historical
technique, Paul Soldner of the United
States stenciled the figures on this wall
piece, *Hookers,* using a white slip with
copper-green slip on top. The low-fired
clay was salt-fumed, with local reduction.
Ht. 20 × 27 in. (51 × 68 cm.). *Courtesy the*
artist. Photo: Charles Frizzell.

Part Two
SHAPING THE PRESENT

OVERLEAF

Figure Column III, 2001, by
Stephen De Staebler. 78 × 13½
in. (193 × 34 cm.). *Courtesy the*
artist. Photo: Ira Shrank.

9

The Artist's Vision

What *is* the "artist's vision"? What makes it different? Isn't the urge to make an object or an image innate in all of us? Listening to what artists have to say about how their images arise and their ways of working may give us some insight into the creative process.

THE CREATIVE PROCESS

Psychologists have often puzzled over creativity, over why some people and not others have the desire and the need to express their creativity through art, as well as the ability to do so.

Perceptions, the basic components from which we form our concepts, refer to any insight, intuition, or knowledge gained through any of the senses—visual, tactile, or aural. What the brain makes of these perceptions depends on each person's accumulated experiences and background; each of us perceives objects and experiences somewhat differently, so what each of us makes of those perceptions will, of course, differ. Creativity, and the individuality that fosters it, seems to develop in part from an acute sensitivity to one's perceptions and an honest effort to express the concepts or feelings that those perceptions generate. Just why a person may be motivated to express these concepts or feelings in visual art, music, or words is another matter. Science does not explain this.

Many artists refer to the importance of intuition, improvisation, and dreams that lead them toward their creative solutions. Others speak of the importance of learning about themselves as they create. In a way that may not be clear even to the artist, the ability to objectify inner issues and feelings can clarify them for the maker as well as for the

(a)

(b)

FIGURE 9-1

Four slab-built figures by Gail Rushmore of the United States chronicle the lives of women in mythic images. On them, mixed-media additions increase the impact of the imagery, serving as decorative and evocative symbols of the stages of woman's life. The pieces are all raku-fired, with post-firing additions of various materials glued on with epoxy. *(a) Eve—Under Construction:* The young girl holds Adam's rib, set in her abdomen. She is slab-constructed and assembled after firing. The bones are coated with diluted white glue to seal them. 28 × 7 in. (71 × 18 cm.). *(b) Out of the Garden:* The young girl, approaching womanhood, carries a box containing an apple enhanced with gold leaf and a branch. Raku-fired. 27 × 7.5 in. (69 × 19 cm.). *(c) Fertile Fields* depicts a mature woman with child. The raku-fired sculpture is richly colored with red and gold glaze. 27 × 7 in. (69 × 18 cm.). *(d) Eve of Destruction* depicts the crone. The woman, in the last stage of her life, is slightly shrunken with age. Here the additions are rusted metal glued on with epoxy. 26 × 6.5 in. (66 × 16 cm.). *(a–d) Courtesy the artist. Photos by Scott McCue.*

viewer. This aspect of the creative process may explain why myth and legends have had such power throughout human history.

Stages of a Life

Gail Rushmore uses the human figure and references to myth and legend to examine the stages of a woman's life. Her four companion pieces begin the story with *Eve—Under Construction* (9-1a), in which Eve holds Adam's rib in a box. The rib, set in her abdomen, is not, however, part of the structure of Eve; as Rushmore explains, *she is still only spirit and still forming.* The next sculpture in the series, *Out of the Garden* (9-1b), portrays the youthful girl welcoming womanhood. As she leaves the security of the Garden, she carries the forbidden fruit, her sex-

(c)

(d)

uality. In the third sculpture of the series, *Fertile Fields* (9-1c), Eve is depicted as a mature woman nurturing the generations to come. The final figure, *Eve of Destruction* (9-1d), represents an aged crone. Of her, Rushmore says, *She is weathered and wears her many badges of life's rewards. Her structure is shrinking, and she silently carries the rusting framework of her life.* Rushmore feels that she knows what each of the women is thinking. She says, *I enjoy creating personalities in my figures. They have life stories. These are not always evident, leaving some interpretation to the viewer.*

Human Connectedness across Time

Since the last Ice Age humans have used the malleable quality of clay to express their deepest emotions. Humans' long association with clay may be one reason many people who work with the material today often refer in their work to the lives of those who lived decades or centuries ago. Perhaps it is this distancing from the contemporary world that allows the artist to deal with issues that are common to all humanity.

Frank Steyaert, who lives in Belgium and works in a studio overlooking a highly traveled river, has understandably become interested in boats and those who work on them. Steyaert's ceramic boats, however, are different from the mechanized craft he sees passing his studio (9-2). His ceramic boats appear to be ancient, disintegrating, as if they have lain ashore for years in a salt marsh. Complete in every rotting detail, under their decks they hide reminders of the people who lived and worked on them. Steyaert sees the boats as symbolic of individuals with

FIGURE 9-2
Frank Steyaert of Belgium builds ceramic boats that might have been found in an archaeological dig. Before he adds the decking, he reproduces in exact detail the deteriorating belongings of the people who once lived and worked on them. To Steyaert, these rotting hulks, with their disintegrating artifacts belowdecks, symbolize human beings exposed to the vicissitudes of life. Made of black clay, the boats are colored with oxides and slips. 48 × 21 × 23 in. (123 × 53 × 59 cm.). *Courtesy the artist. Photo: Jan Pauwels.*

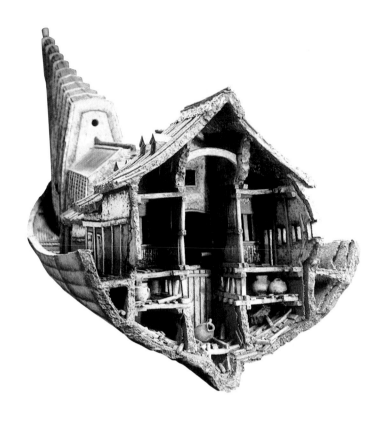

bruised inner lives, evoking vulnerability, fear, and pain. To him their message is also metaphorical: By their very structure boats are built for moving forward, but the voyage of life, although it is a forward movement, ends, as he says, *in saying farewell* (see also 11-55).

An African Heritage

Another example of influences from the past can be seen in the work of Ernest Aryee of Ghana. The rich heritage of ceramics in Africa is so diverse that one cannot generalize about its forms or decorative approach (see 4-2–4-8). Yet Aryee's work immediately brings to mind that vast continent and the enduring relationship between its peoples and the earth material, clay. Speaking of clay, Aryee says,

> I find tremendous potential in using this vital, sensuous, docile material to express or replay themes associated with African culture: migration, pride, sophistication, religion, politics. . . I use granary form as a source of metaphor: In

> these structures one keeps seed (life in a state of waiting) waiting to be planted.

The Ga society in Accra, from which Aryee comes, is patrilinear. It is organized in this way, Aryee says, to help ensure the society's continued existence. This social organization is referred to in Aryee's *Metropolitan Series*, a sculpture that symbolizes the African clay granaries that preserve the crop seeds.

> We preserve our names and customs by drawing from our "granary" by the combined effort of male and female, as paid tribute to by the overtly sexual references in the piece. Reference is made to this by use of the container, and the dominance of the phallic image references to the patrilinear inclinatation of the society.

Since it is the clay walls of the granaries that preserve the seed, Aryee finds clay a natural material in which to express these ideas, referring to it as *this vital, sensuous, docile medium.* He also says, *I use the granary form as a source of metaphor related to the continuity of life, [and] the red reduction-fired color of the fired clay is*

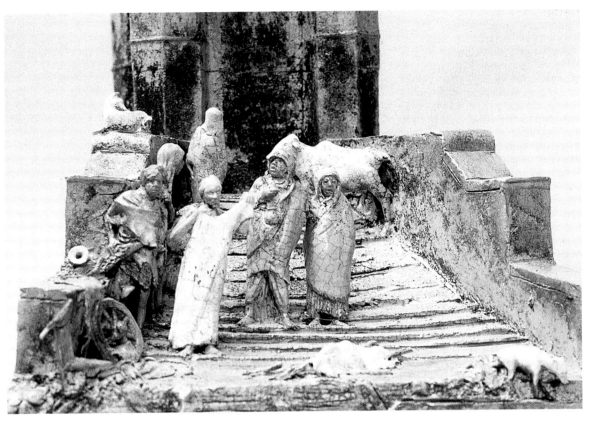

FIGURE 9-3
Detail of *Temple Ghat, India 2012,* by Stuart Smith of England, was created on his return from a trip to India, an experience that inspired him to adopt a new approach to sculpture. To capture what he saw, he worked in new ways, modeling directly to express the emotional impact India had on him, then raku-firing his work to achieve the surface that best evoked what he had seen there. Raku clay with porcelain detail, underglaze with crackle overglaze; bisque-fired to 2012°F/1100°C. Ht. 30 in. (76 cm.).
Courtesy the artist.

appropriate to the subjects of the works (see also 11-34).

Cultural Influences

The African Ibo potter who sculpted the yam pot in Figure 4-8 drew on a heritage of shared myth, ritual, and belief. So too, no doubt, did the Moche potter when forming the portrait jar in Figure 5-4, knowing just where in the scheme of shared experience the image of ruler, god, or priest belonged. And with a complete lack of self-consciousness, the Indian sculpting the sensuous woman in Figure 3-42 worked with mythological or religious meanings that were part of his everyday life.

Today's artists are generally more self-conscious than those of early societies, but exposure to an ancient culture through travel may have such an impact on a sculptor that he will change the method with which he works. English sculptor Stuart Smith, for example, took a trip to India, and what he saw there changed his attitude toward clay and toward his ceramic career (9-3):

> *I was overwhelmed by the wonderful richness and yet at the same time appalling images that confronted me. I could have burst into tears a hundred times a day, yet in Calcutta I found such a sense of warmth and vitality.*

Smith had spent most of his working life handling clay in a workshop/studio situation in which the work was produced in molds and the original was destroyed during the process. He was so taken with the surfaces he saw in India—eroded by time and grime, but showing sudden flashes of color—that when he returned he decided to model directly with clay and raku-fire

FIGURE 9-4

Seed and Sprout, a wall piece by Juan Granados of the United States. Granados says that while working in the fields as a child of immigrant workers, he found much in nature that was fascinating, *such things as bugs, animals, fungus, algae, fish, birds, and manufactured items, as well as the overall environment and dynamics of a field and how it all works.* On first viewing, Granados's individual wall pieces suggest only the budding life within the natural forms—until one notices the metallic, pipelike openings that suggest the irrigation systems that water rows of plants. Low-fire earthenware clay, cone 04. 27 × 14 × 10 in. (69 × 36 × 25 cm.). *Courtesy the artist.*

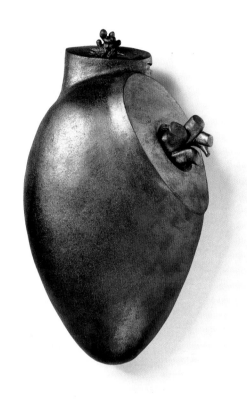

the pieces. The body of work he created on his return is a vivid example of how travel and one's response to new places can affect the creative spirit. In order to recreate some of what he felt in India, Smith learned a totally new, more direct technique of building with clay. It is through such stretching experiences that an artist may grow in vision, creativity, and technique.

Smith's sculpture of the steps that lead down to India's sacred Ganges River suggests the presence and movement of the crowds of bathers, animals, worshippers, and mourners who gather there.

It shows how an artist can create a new "reality" from a perception or group of perceptions to give us a totally new experience—provided that it is believable within its context no matter how "unreal" it actually may be.

Childhood Experiences

For a work to be successful, the viewer must be able to accept the new reality created by the artist. Juan Granados's work, for example, is based on close observation of agricultural crops from early childhood. Although no actual plant looks like those in *Seed and Sprout* (9-4), seeing

the emerging life through his eyes, we accept it and grasp its symbolism.

An artist's childhood experiences and memories of particular places may lead to images that are transformed by the adult artist's eye. Granados has created installations based on days spent in the fields when his parents were migrant agricultural workers throughout the southern half of the United States. Of these experiences, he says,

My interest in observing nature was a very important part of my childhood experiences growing up doing migrant labor for ten to twelve hours a day, six days a week. This type of mundane labor allowed me to be fascinated by watching plants grow through their various cycles of transformation throughout the growing season.

In his large installations Granados frequently develops themes based on remembered images of cultivated crops (see 11-41–11-46), while in his individual pieces he tends to focus on single, budding, organic forms swelling with life, but with details that suggest the pumps and pipes of irrigation systems. In this way we see how the familiar early surroundings and childhood experiences of an artist may feed creativity in later life.

Signs of Nature

Juliet Thorne often uses fired clay stamps to impress symbols into the moist clay of her sculptures (9-5; see also 11-23–11-32). She says,

I suppose I'm looking for links between us all. I'd like my work to evoke a sense of connection with the spectator. I suppose using my own stamps is part of the way I try to get this across.

Her fired clay stamps include

a series of symbols that express aspects of how we relate/respond to nature and the garden, such as growth, fecundity, and renewal. Rhythm is a strong theme, referring as it does to the seasons, as well as the rhythm set up by the repetition present in nature, like the petals of flowers and cells in the body. Some of the different stamps symbolize seed, the spiral of harmonious growth (a Fibonacci number series proportion), plant shoots, a man with an erection, a ladder, and an eye. I also enjoy the sensuality of clay's amazing "printability," the way it can take impressions.*

Although we do not know exactly what the spiral meant in early cultures (1-17–1-20), many ceramic objects from prehistory to the present have been decorated with spiraling lines; it appears to have carried a universal meaning. Today, however, the spirals in the work of Juliet Thorne (see 9-5) and Peggy Prichett (9-6) have more personal meanings. Prichett sees the spiral as a metaphor for life and the cycle of the seasons: birth, death, and rebirth. When her first spiral pot emerged, she had been a wife and

FIGURE 9-5
Juliet Thorne likes to garden, and many of her works are made for outdoor settings, to be placed in beds of flowers (see 16-27) or among trees or hung on branches. She makes her stamps with clay, fires them, and then presses them into damp clay slabs, incorporating meaning and surface enhancement in her sculpture. *Courtesy the artist.*

*Mathematician Leonardo Fibonacci, born in Pisa, Italy, in 1175, discovered the number sequence that governs logarithmic spirals in shells, flower petals, pine cones, and other natural forms. The sequence is also the basis for the Golden Section, or Golden Rectangle, that fascinated Italian Renaissance painter Leonardo DaVinci.

FIGURE 9-6
One of Peggy Prichett's *Woman Pots* emerged as she was finding a new life for herself. Like so many potters throughout the ages and around the world, Prichett, of the United States, sees the spiral as an enduring symbol. She says, *It is a journey that has a beginning and an end and yet is endless.* She coil-built the pot, drew the design on the bisque-fired earthenware surface and masked out the spiral design with tape, and then applied black underglaze. After firing it to cone 06, she waxed the pot. *Courtesy the artist.*

FIGURE 9-7
Paula Winokur of the United States, develops the forms of her wall pieces using slabs of porcelain that she drapes over a variety of supports, allowing the clay to stiffen before she removes them from the mold for further work. This method, although carefully calculated, gives her sculpture a sense of random geological forces at work (see also 16-15). 31 × 35 × 10 in. (79 × 88 × 25 cm.). *Courtesy the artist.*

mother for many years, and she saw the pot and its symbol as a declaration of freedom.

> It was, she says, *a declaration of freedom and a recognition that through this pot I had somehow found out who I was. When the first one was completed, it shouted to me, "here I am." The spiral, coiled or curved, is inherent in the female body and is used in the process of building these pots. So the infrastructure is spiraled, and the design follows the shape of the pot.*

Mountains, Rocks, and Clay

Although some of Paula Winokur's wall pieces and fireplace surrounds take their imagery from the country around her Pennsylvania home, others are suggested by the mountains, rivers, and land forms she has seen while driving or flying over the United States. Her white porcelain wall sculptures contrast areas of unelaborated clay with surfaces that echo the ancient folded and weathered surface of the earth—the source of clay itself (9-7; see also 16-15). In these works we see gnarled tree roots that seem to split ancient rocks, or we sense the earth spread out below a plane's wings, as if whole mountain ranges are contained in a few feet of porcelain.

Earth Textures

Back home in Italy after being released from a German labor camp in World War II, Carlo Zauli became a potter. It was the young Zauli's return from this enforced exile that led him to see the

rolling hills and plowed fields of the Italian countryside with fresh eyes and to apply these perceptions to his work in clay. While working as a potter, Zauli explored the war-torn ruins of his native Faenza, collecting distorted wasters from bombed-out potteries. These slumped pots inspired him to deform his own wheel-thrown work. Later, he incorporated these shapes with the textures of his native earth when forming his large sculptures (see 8-10, 13-11–13-15).

People and Society

Although political action and social concern are not among the most frequent sources of imagery in contemporary ceramics, there are those, such as Richard Notkin, who use clay to comment on pressing social or political issues. Notkin believes that humanity has a choice between using its abilities to destroy or better our world. It is artists, he believes, who *provide and nurture the warm spark of our creative human spirit that keeps hope alive.* Notkin's own work often ad-

dresses vital contemporary issues. He says that by defending the artist who chooses social criticism and commentary, he does not

> *intend to understate the role of the abstract sculptor or dedicated potter. Every act of creativity is a positive statement in itself, benefiting the creator and those around him. The ripple effect of many creative acts—our collective creativity—eventually reaches, touches, and benefits the whole of humanity. In this lies our power as artists.*

Jessica Abbott of the United States was inspired by a book published in Holland titled *The Work of Man,* which depicted tile-makers in etchings by the artist Jan Luyten. The tile piece shown in Figure 9-8 evolved as she thought about her own work as an artist today, as contrasting with that of the tile workers in seventeenth-century Holland. She also began to see herself as a worker among others—mechanics, florists, and parking lot attendants.

As she walked around Oakland, California, Abbott talked with people and photographed

(a)

(b)

FIGURE 9-8
An installation, *Tilemaker,* by Jessica Abbott of the United States, includes *(a)* the tile wall piece by Abbott, depicting seventeenth-century Dutch tile-makers, and *(b)* photos she took of a variety of workers in Oakland, California, along with etchings by seventeenth-century artist Jan Luyten depicting other traditional Dutch work roles. *Courtesy the artist.*

FIGURE 9-9
Hump, by Frans Duckers of the Netherlands. Duckers permanently installed *Hump* in a café, where he sits either alone or as part of a group of guests who may choose to interact with him or ignore him. Here, the artist plays bartender and treats *Hump* to a drink. Pinched-coiled figure, colored with stains and glazes. Life size. 1991. *Courtesy the artist.*

FIGURE 9-10
Field, by Antony Gormley of England, is one of several such installations made up of small hand-formed figures arranged in masses of several thousand. The individual figures comprising this work, at the Salvatore Ala Gallery in New York, were made in Mexico, with brickmakers and their families forming each figure by hand. The figures have no faces, but their punched-in eyes stare back unnervingly, mutely allowing viewers to make what they will of the confrontation. Brick clay, fired in brick kilns.
Courtesy the artist and Jay Topling/White Cube. Photo by Josephe Coscia.

them as they worked. By combining ceramics, photography, and etchings, her sculptured tile piece became an extended exploration of her own life in art, of how people worked in Holland's Golden Age, and of how people work today.

On the other hand, Frans Duckers, who lives in the southern part of the Netherlands, refers to a quite different aspect of local life—the cafe. Commenting on this socially important institution in his sculpture *Hump* (9-9), he says,

Cafés are a part of life here, the extension of the living-room, a place to socialize, to meet people. In the café you can see both pleasure and loneliness at the same time. The sculpture is placed so that if the café is crowded it's just one of them. The moment there are only a few people, it just sits there by itself, isolated. Hump *embodies both aspects.*

Antony Gormley, who is well known for his iron figurative sculpture, says *Field* (9-10) *is like a living organism, like water, it settles in place, it doesn't organize it.* His *Fields*, Gormley says, are also a reminder that *there is only one humanity.* Gormley's Fields have been made and shown in museums and galleries in numerous countries, each installation creating a new grouping that depends on the configuration of the space.

With her singing and dancing figure, entitled *On Top of the World* (9-11), Susan Shelton uses the evocative imagery of the Dia de los Muertos to give us a glimpse into an important Mexican celebration. In both Mexico and parts of the United States, this is the day when families meet at the graves of family members to picnic and celebrate the lives of the departed. Children are given molded sugar images of skeletons, and the gulf between the living and the dead is bridged for this day.

Another View

Although clay artists are generally more tactile in their perceptions and responses than painters, whose images are more likely to be based on visual input, most potters and clay sculptors are visual people who tend to speak of how they "see" their own work or that of others. However, sculptor Ann Gazelle, who lost her sight at the age of 16, reminds us that *when I speak of looking at a work, of course I mean by touching it.*

FIGURE 9-11
On Top of the World, by Susan Shelton of the United States, evokes the molded clay and candy images sold for Mexico's Day of the Dead (Dia de los Muertos). Made of low-fire clay with colorful underglazes and clear overglaze, the skeleton in a colorful skirt, carrying a basket of fruit on its head, conveys a message of cheer along with sorrow and horror. Ht. 42 in. (107 cm.). *Courtesy the artist. Photo by Terry Novelozo.*

Some time after losing her sight, Gazelle picked up a lump of clay while waiting for a friend to finish throwing a pot. She was immediately drawn to the material and decided to take some pottery lessons. After she had spent a frustrating time at the wheel, a perceptive teacher

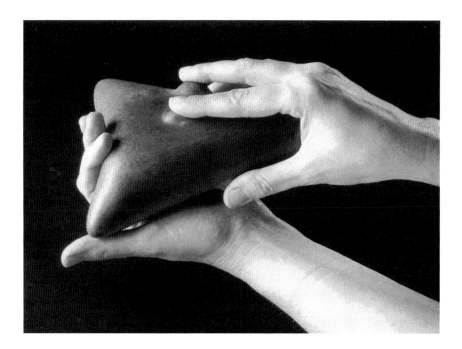

FIGURE 9-12
The genesis of Ann Gazelle's sculpture was her love of natural forms. It also grew out of frustration: Blind since the age of 16, she tried to work on the wheel, but one day in disgust she slammed an unsuccessful cylinder down and then became intrigued by its distorted forms. Encouraged by her teacher to try sculpture, she now draws on what her fingers and memory tell her about natural forms, creating sculptural pieces that others may experience with their own hands. *Courtesy the artist. Photo: Elaine Comer Shay.*

encouraged her to handbuild. Gazelle then switched to making small hand-held sculptures (9-12). She says,

Sometimes it gets a bit tough, with no visual stimulus to draw on. On the other hand, it means I'm not overwhelmed by too many images and ideas. But I often have to dig down deeply inside myself to come up with inspiration.

To introduce viewers to her work and increase their awareness of their own sense of touch, Gazelle created a provocative installation at the Acme Art Company in Columbus, Ohio. Titled *Another View* (9-13), the installation grew out of her experience as an artist who perceives through touch rather than through vision. Wanting the public to understand how people who are sight-impaired experience the world, she drew on her own frustration during visits to galleries and museums where a "do not touch" attitude prevails. She designed a freestanding wall covered with empty frames that represented the paintings she cannot see. Openings in the wall allowed viewers to reach their hands in and feel, but not see, the sculptures placed behind in display cases. Once they had explored the sculptures with their hands, viewers could go behind the wall and see the objects they had just perceived by touch alone. Through this experience the installation not only gave viewers a new un-

derstanding of what it means to be without sight, but many who saw it recognized how little they use and appreciate their own sense of touch.

Integrating Imagery

A number of other artists refer to the importance of reveries, dreams, and daydreams in the creative process. William Daley (see 13-2), who makes vessels that are pleasing to the eye and appealing to the tactile and kinetic sense, says that he dreams them in a state of reverie. For Margaret Ford, dreams or daydreams are not only a source of material but also subject matter in themselves. Dreamlike reveries can unite our physical perceptions, intuitions, and intellectual concepts, stimulating the creation of sculpture, painting, pots, or poetry.

Although the enigmatic quality of Ford's *The Bower* (9-14) allows the viewer to see and interpret it, Ford is specific about the sources of her imagery. The image of *The Bower,* she says, refers to the bower bird, so named for the elaborate structure the male bird builds to court the female. The work also references a traditional English maze that Ford had read about called The Bower that was said to have served as a secret meeting place for the lord of a manor and his mistress. This bower image added its

(a)

(b)

FIGURE 9-13

Another View, an installation by Ann Gazelle. *(a)* Gazelle designed a wall that would block sighted viewers from seeing her work, forcing them to explore it as she makes it—through touch alone. *(b)* After touching the objects through the wall, viewers could go behind the wall, see them, and watch other hands experiencing them through touch. Installation at the Acme Art Company, Columbus, Ohio.

Courtesy the artist. Photos: Russ McKnight.

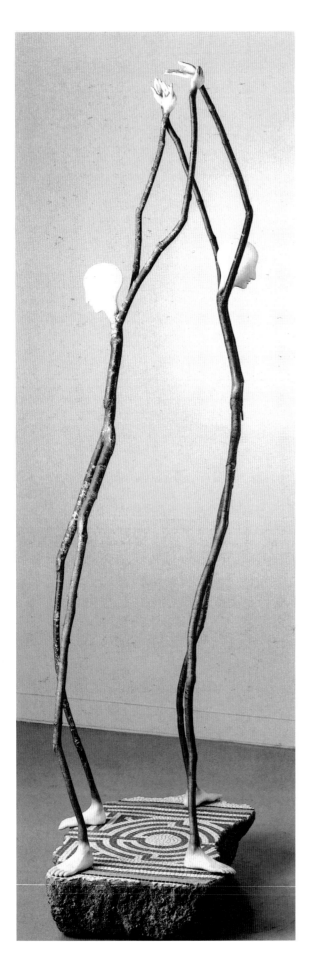

FIGURE 9-14
The imagery of *The Bower,* by Margaret Ford of the United States, grew from many sources—including autobiographical and psychological, ones—but it originated in historical references that captured her creative imagination. It took an artist's vision, however, to bring these elements together in a work of art that is dense in references but leaves viewers the space to bring their own interpretations to it as well. Clay, wood, and mosaic. Ht. approx. 7 ft. (2.1 m.). *Courtesy the artist.*

own symbolism to the zoological, botanical, and personal references evoked by the bower bird. Then, rather like the bird itself, Ford transformed her collection of treasures—references from history as well as her own experiences—into a new image that comments on interpersonal relationships.

Ceramics History as Inspiration

Historical references abound in ceramics. The fact that there are only a certain number of forms that can be employed in making utilitarian ware may be the main reason for this, but there are other factors as well. There is also the fact that people who work in clay are still using exactly the same material that has been used for thousands of years; it comes from the earth and has not changed over the centuries, despite new ways of decorating and firing it.

Most potters feel a sense of continuity in relation to those who for thousands of years supplied the everyday needs of people for beer containers, cooking vessels, jugs to pour wine, or ritual vessels. The fact that industry has taken over most of this work from potters has not disrupted this sense of connection—if anything, it has grown stronger. Now, when buyers feel the need to own a hand-thrown bowl or jug to escape the impersonality of machine-made ware, they are not looking as much for useful cooking pots or storage vessels as for ware that is decorative and suggests the touch of its maker's hand. Potters, too, though sometimes accused of romanticism, are glad to continue coiling or throwing, for through this activity they feel a link to the thousands of potters who have made pots before them.

Janet Mansfield has set herself the task of creating new and fresh pots within the craft's ancient traditions (see 12-6). Speaking of her sources, she says,

Looking at Cypriot pottery in museums, the forms, the mellowness of the decoration, the aptness of the decoration to the form, the purpose for which the pot was made, the mystery of the unknown people that needed those wares, one can only hope for similar relevance for the pot we make today.

Michael Casson of England says, *History is for me the great teacher, but I hope to interpret the forms for today's function.* To do this, Casson has taken a traditional form—the jug (see 6-16–6-19)—and, like Mansfield and Steven Hill (13-73), sees the form's long history not as a limiting restriction but as a source from which to draw inspiration.

My sources? Well, mainly European, from Cretan (great jugs), Cypriot (even better), and Medieval (best?) times.

Richard Hirsch of the United States is fascinated by the form and surface of ancient vessels (9-15; see also 8-21). His own vessel forms are reminiscent of ritual objects; they are containers for the spirit as well as for ritual liquids. To create a patina of age on his work, he undertakes what might be termed a ritual itself, first coating them with terra sigillatas, next covering them with low-fire glazes, and finally sandblasting the surfaces.

Some potters use historical techniques, such as salt firing, but alter them to alleviate today's environmental concerns; for example, American potter Mary Law often fires ware in a low-sodium vapor kiln to minimize emissions from the volatilizing salt. A production potter, much of Law's domestic ware is traditional in form, but on occasion she shapes containers that are reminiscent of temple or house models from ancient China or Peru (9-16). British potter Walter Keeler,

FIGURE 9-15
Pedestal Bowl with Weapon Artifact, Richard Hirsch, U.S.A. Hirsch achieves ancient patinas on his vessels by using a layering technique of colored terra sigillatas and low-fire glazes. He then sandblasts the surface, giving it additional textural interest. 44 × 31 × 13 in. (48 × 79 × 33 cm.). *Courtesy the artist. Photo: Geoff Tesh.*

FIGURE 9-16
House Pot, by Mary Law of the United States, has parallels in ancient ceramics traditions—models of temples or houses used in burial rites or large granaries constructed in Africa to protect crops or seed from destruction. Stoneware with high-kaolin slip. Sodium-vapor-fired at cone 11.
Courtesy the artist. Photo by Richard Sargent.

(a)

FIGURE 9-17
In an exploration of the basic ceramic material, Paul Astbury of England presents an installation of commonplace ceramic objects—teapots, teacups, vases, and figurines—in the unfired state. Left damp and sealed in plastic containers, their moisture is drawn out to veil them in condensation—or alternately returned to the clay, leaving a clear view of the objects. *(a)* A teapot, still wet, inside a clear plastic container. *(b)* The teapot collapses. *Courtesy the artist. Photos: Tim Fieldstead.*

(b)

FIGURE 9-18
Cup, by Lidia Zavadsky of Israel, consists of intriguing slab pieces in which two-dimensional drawings and three-dimensional slab constructions interact—in reality and illusion—leaving the viewer to decide what the reality actually is. Porcelain, underglaze pencil drawing. Ht. 1.5 in. (38 mm.).
Courtesy the artist's estate.

FIGURE 9-18
Cup, by Lidia Zavadsky of Israel, consists of intriguing slab pieces in which two-dimensional drawings and three-dimensional slab constructions interact—in reality and illusion—leaving the viewer to decide what the reality actually is. Porcelain, underglaze pencil drawing. Ht. 1.5 in. (38 mm.).
Courtesy the artist's estate.

on the other hand, combines the tradition of salt firing with functional ware that he has radically altered before firing, in a complete break with tradition (see 12-133). Walter Keeler says that many of his forms *spring from a boyhood obsession with collecting fragments of ancient pots on the shores of the Thames in London.*

Concepts and Concretions

Although Paul Astbury is best known for his sculpture and installations, for a number of years he has depicted everyday ceramic forms in colored drawings; cups and saucers are almost obscured within the background. Over the years he has also become especially interested in the material itself, creating work using clay with metal, clay with paper or cardboard, clay with cloth, clay with tree branches, and pen-and-ink notes on fired clay. Astbury has once more dealt with clay in relation to another material—this time, damp clay and plastic (9-17). His purpose, he says, was

> *to present familiar commonplace domestic images usually made from clay, e.g., cup and saucer, teapot, jug, figurines, etc., in a different light. From our familiarity with these things we always preconceive their function, quality of appearance and in some ways even the geographical position within the domestic environment. Tradition and familiarity have taught us what to expect.*

But in this installation the clay objects are isolated from our touch, enclosed within containers, and shrouded in plastic. Inside the plastic, the clay remains damp, and as the moisture leaves the clay it forms condensation that veils the object from our view. This damp nature of the clay body is usually perceived only by those directly involved in making ceramic objects.

This interplay between the clay's moisture and the atmosphere is a vital aspect of the work; depending on surrounding conditions, the object may eventually become dry and brittle, revealing yet another aspect of the material. On the other hand, clay's long tradition in the making of containers for liquids or dry foods also plays a part in the work. Astbury points out that

> *although the wet clay images of drinking cup, water jug and teapot forms, etc., cannot be used to contain liquid in the usual sense, they nevertheless do involve liquid in their actual material and structural make-up. They can, therefore, be interpreted as containers supporting liquid.*

Astbury also sees the partially obscured, secretive objects inside the plastic as suggestions of a fetal or embryonic condition as well as projections of a supernatural remoteness.

The late Lidia Zavadsky of Israel, who also created large works based on the vessel form and life-sized figurative works (see 11-62), also used images of pottery conceptually: She presented everyday domestic ware in *trompe l'oeil* drawings and paintings combined with actual three-dimensional construction on porcelain slabs. Her installation, *Cup*, explores cups and saucers and other objects as forms in space, animating them through portrayal in unusual perspectives (9-18).

AESTHETICS AND TECHNIQUE

The manner in which creative people translate their perceptions into pottery or sculpture varies from one person to another, but as in all creation, there is originally a vision, an idea, or a concept, which, through skillful use of technique, has been transformed into an actual object that we can perceive in space, look at, touch, or use.

Never in the history of ceramics has the person working in clay had such a wide choice of techniques or such an extensive range of available materials. Ceramics can be a seductive medium in which to work, offering processes that in themselves are fascinating. The alternatives available today demand aesthetic choices as well as new techniques for forming, coloring, and firing clay. Thus, for the ceramics artist, nurturing creativity, fostering imagination, and developing aesthetic awareness are as much a part of ceramics as is mastering the process.

10

Getting to Work with Clay

Today's ceramics artist is exposed to a flood of information and stimuli from history, from other cultures, and from other craftspeople. A multitude of techniques are on display in museums, galleries, and books, not to mention the ceramics magazines, Internet that can share new work of contemporary potters and sculptors almost as soon as they open their kilns. As you look at others' pottery and sculpture and as you watch people working in clay in so many ways, remember that only you can find your *own* way of working.

The technical information offered in the remaining chapters of this book is intended to help you develop and perfect your own working method, not to dictate absolute rules. *For an artist,* says American sculptor Stephen De Staebler, *the most valuable motto would be "No rules."*

THE WORK SPACE

The chapters that follow are generally concerned with the technical aspects of ceramics, but throughout we have included examples of work by dedicated potters and sculptors using those methods. We include these examples to show how the particular techniques we've discussed of forming, finishing, and firing can be utilized to give reality to a variety of concepts and emotions. Choosing the method that works best for you may take considerable time and thought, or perhaps you will find that technique immediately.

If you are new to the ceramics studio, this chapter will introduce you to the considerable amount of equipment that is available for a variety of uses. A well-equipped studio designed for teaching often

FIGURE 10-1
Walnut Creek Civic Arts' 7000-sq.-ft. (653-sq.-m.) ceramics studio, managed by Peter Coussoulis
(with beard). This well-equipped studio contains electric pottery wheels, a slab roller, wedging tables,
gas and electric kilns, displays of artwork, a library, and a television for showing videos. *Courtesy the City of
Walnut Creek, California, Civic Arts Education Program, Walnut Creek Civic Arts Center. Photo: David Hanney.*

provides access to mechanical aids as yet unknown to you (10-1, 10-2). If you are already experienced enough to set up your own studio, Chapter 17 will help you decide what equipment you need to start out and the order in which to add to it as you can afford it.

You may, however, prefer to work the way potters have for centuries, digging clay at some nearby source (10-3) and forming pots or sculpture using the simplest methods (see 1-8, 5-17). If you are able to set up your own work space, even if only in your backyard (see 10-7), there are some aspects of ceramics that you should take into consideration when you arrange your space (see Chapter 17). But even if you are a student working in a studio over whose arrangements you have no control, it is essential that you become aware of health and safety considerations, as well as the ecological impact of working with ceramics materials.

HEALTH AND SAFETY

Before working in ceramics, it is important to realize that many ceramic materials are toxic in varying degrees and that they present hazards to those who work with them. In the past, when potters unknowingly worked long hours without proper ventilation and were continuously exposed to toxic materials of various sorts, chemical poisoning and silicosis—a lethal disease of the lungs—were common. Today, however, basic health and safety standards and precautions, along with safety equipment, have

FIGURE 10-2
This chart illustrates most of the equipment you will encounter in a school ceramics studio. If you are a beginner, you will not be using all of these items immediately, but you will feel less of a stranger in the studio if you learn to recognize these basic types of ceramics equipment.

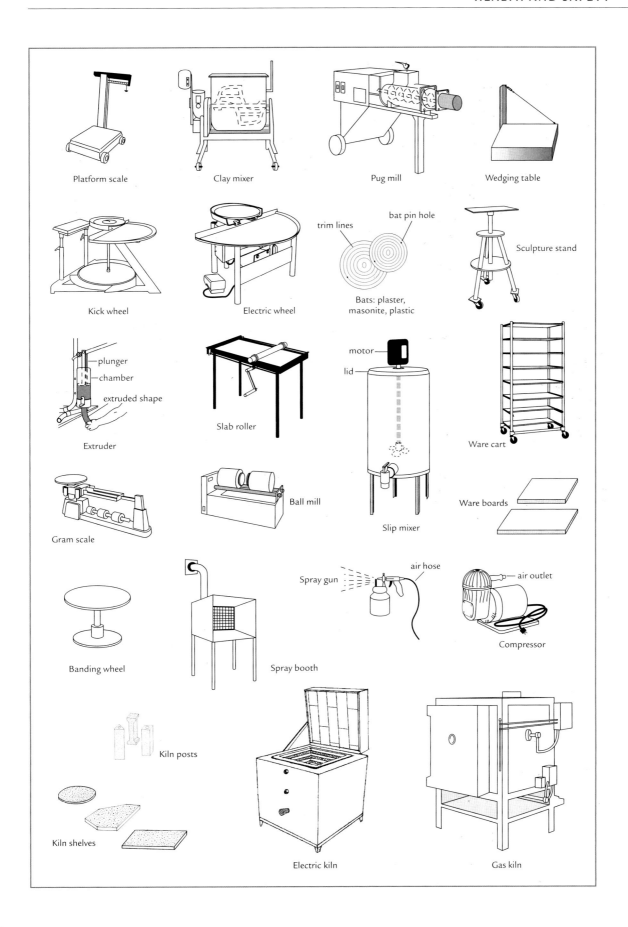

Platform scale

Clay mixer

Pug mill

Wedging table

Kick wheel

Electric wheel

trim lines

bat pin hole

Bats: plaster, masonite, plastic

Sculpture stand

plunger

chamber

extruded shape

Extruder

Slab roller

motor

lid

Ware cart

Gram scale

Ball mill

Slip mixer

Ware boards

Banding wheel

Spray booth

Spray gun

air hose

air outlet

Compressor

Kiln posts

Kiln shelves

Electric kiln

Gas kiln

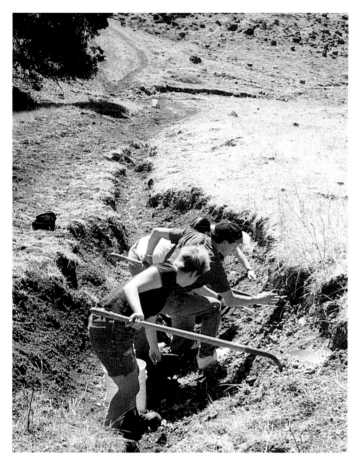

FIGURE 10-3
Natalie Cartwright, Jennifer Atkins, and Jennie Canning, students from the California College of the Arts, dig clay samples in a ravine that was cut into a hillside by water runoff in Santa Rosa, California. They unearthed and tested different colors of clay at this site (see 10-6).

FIGURE 10-4
Since exposure to some toxic ceramics materials is unavoidable, this chart shows you some of the devices that will protect you against hazards while working. Many variations of these devices are available commercially, but you can make many of these systems yourself. Precautions that you should take include careful monitoring of studio cleanliness, use of exhaust fans and hoods close to the source of contamination (with strong enough suction to remove contaminants before you become exposed), and protection against injury and eye damage. In handling the kiln, you need to wear special protective equipment and remain alert to hazards. These hazards and what you should do to protect yourself are discussed in greater detail in the appropriate process sections, and throughout the book the alert symbol will warn you when safety or health hazards exist.

been developed to minimize the dangers to all who work in this field. Wherever you work, whether at school, in a recreation facility studio, or your own studio, it is imperative that you familiarize yourself with and follow these health and safety regulations. **It is up to you to protect yourself.**

Precautions and Safety Equipment

 The composite safety chart (10-4) has drawings of the safety and health equipment that can be used in different situations to protect you as you work. Chapter 1E in *Expertise* lists the ceramics materials you are likely to use, along with their

degree of toxicity. Become familiar with this list, and whenever possible, substitute less hazardous materials. For example, you can eliminate a lot of clay dust by using damp, premixed clay, but if you do wish to mix dry clay, try to choose clays that contain only small amounts of free silica, and use an asbestos-free talc as well as personal protection when you mix dry clay (see 10-6).

Not only should you protect yourself against immediate exposure to toxic substances, but you should also take into account the many other pollutants we are all exposed to in our daily lives; so you must also consider the total burden of toxic substances to which your body is exposed. That burden is increased substantially if you smoke.

Schools and public art centers can call on various government agencies and private organizations to make health-hazard surveys of their facilities or offer short courses for teachers and professionals in safe studio design and management. Individuals may call on the same agencies for advice or information. (Some of these agencies are listed in *Expertise,* Chapter 5A.) Books and, in particular, newsletters are excellent sources of up-to-date safety and health information (see Further Reading). Remember that new research is constantly being published and that it is up to you to stay informed of all available *current* information. Also be sure that your protective equipment meets government standards.

It goes without saying that your work space should be efficient and safe. For example, all electric equipment should be properly wired and grounded to prevent electrical shock. Heavy materials should be placed so that you can reach and lift them without straining your muscles. If

Take care!

Symbol will alert you to take precautions.

Exhaust systems

Fans and hoods for venting toxic fumes, mists, heat, and fumes from kiln.

Air purification

Room-sized air cleaner collects fine airborne dust particles.

Dust collector

Collector close to source picks up heavy dust particles; for mixing, grinding, sanding, carving clay, and sandblasting.

Spray booths

Vented booth with exhaust fan for spraying glazes, lusters, china paint, or booth with water curtain.

Supplied air

Mixing large amounts of clay, toxic materials, chemical powders, grinding clay, and sandblasting requires filtered supplied air.

Respirators

Use correct filters rated for dusts, mists, and toxic vapors. Use when no adequate local exhaust venting present and for salt firing.

Special vacuum

Vacuum with special filters for microscopic particles for dust pick-up. Or wet mop.

Goggles/Shields

Shaded goggles or hand-held welding shield for looking into kiln. Clear goggles for grinding clay and keeping dust from eyes and contact lenses.

Face shields

Clear for grinding, hazardous liquids, clay mixing. Shaded for looking into kiln.

Heat-resistant gloves

Aramid fiber gloves for unloading kiln and protecting hands and arms from heat of raku kiln.

Protective gloves

For handling glaze chemicals, rubber molding compounds, and toxic adhesives.

Ear protection

Ear muffs and ear plugs for use when grinding or using noisy machinery.

Fire extinguisher

Keep near all fire and heat sources and combustibles.

First aid kit

Complete kit with eye wash, burn treatment, and first aid instruction.

you have to lift heavy sacks of clay, bend your knees and lift with your entire body so that the weight is distributed and the force comes from your knees, not your back. Proper seating should be available when working on the wheel to avoid strain on the back. Sometimes, raising the wheel and standing to work will relieve back strain (see 12-9). If physical limitations prevent you from using a regular wheel, check with supply companies for specially designed wheels, such as those that are wheelchair-accessible.

In addition to using common sense in setting up the work space, it is important to inform yourself about the materials you work with and to avoid any whose composition and degree of toxicity you do not know. (See *Expertise,* Chapter 5A and Chapter 17.)

Safe Studio Procedures

- Do not smoke, eat, or drink in the ceramics studio. Keep your hands away from your mouth while working.
- Before starting to work, and periodically thereafter, make sure that the ventilation systems are working properly, that the filters within the systems are clean, and that they are cleaned or changed on a regular basis.
- Use all required and recommended protective equipment.
- When respirators are not in use, store them in a plastic bag in a clean area. Do not hang them in the open, where dust and pollutants can collect inside the face piece.
- Respirators will not function properly without a good seal between the face and the face piece. Beards and sideburns interfere with the seal.
- Clean up tables and floors with a special vacuum that filters out the microscopic ceramics material particles; if such a vacuum is not available, use a damp mop and damp sponges. (Sweeping with brooms and brushes merely sends the particles into the air.) Wear a respirator while cleaning.
- When you have finished working, clean off dusty or dirty clothing while still wearing the respirator. Shower and shampoo dust particles from your hair following any extensive use of clay or glaze materials.

ECOLOGICAL CONCERNS

Ceramists are becoming increasingly aware of the impact of their working situations and their materials on the environment. They realize the necessity of eliminating hazardous wastes and finding ways to reprocess ceramics materials. For example, Bill Roan and Clayton Bailey developed a method for reprocessing ceramics materials in a nonpolluting manner (see *Expertise,* Chapter 1C), and many artists use a substitute compound (see *Expertise,* Chapter 1C) for **vapor firing** instead of salt, which emits hydrochloric acid into the atmosphere. At the European Ceramic Work Centre in Holland, the entire studio was set up to handle all toxic wastes. In addition, every bit of material is recycled and disposed of in an ecologically responsible manner.

For some time, Kimpei Nakamura of Japan has been incorporating industrial ceramic objects into his sculptural works. As part of an installation at the Ishikawa Prefectural Museum of Art in Kanazawa, he covered the floor with hundreds of porcelain waste parts reclaimed from a renovated transformer substation. In a noteworthy example of the reuse of ceramic materials, Nakamura says, *After the exhibition they are further broken down and then ground. The powder is mixed with clay and reused.*

You may not be able to grind down porcelain insulators to mix with your clay, but nevertheless you should recycle as much toxic material in as ecologically proper a way as possible. It is important that ceramists everywhere stay up to date on current recycling and disposal methods for the toxic materials they use in their studios. The time has come when the air we breathe, the land on which we live, and the water we drink must be treated with respect. (See *Expertise,* Chapter 5A or contact local recycling agencies.)

TOOLS

When throwing on the wheel or handbuilding, limit yourself at first to exploring the clay with your hands and fingers. This can teach you a considerable amount about the material. Although a wide variety of useful tools are commercially available (10-5), only your imagination can limit you in finding or making others. Most people who work in clay adapt a variety of

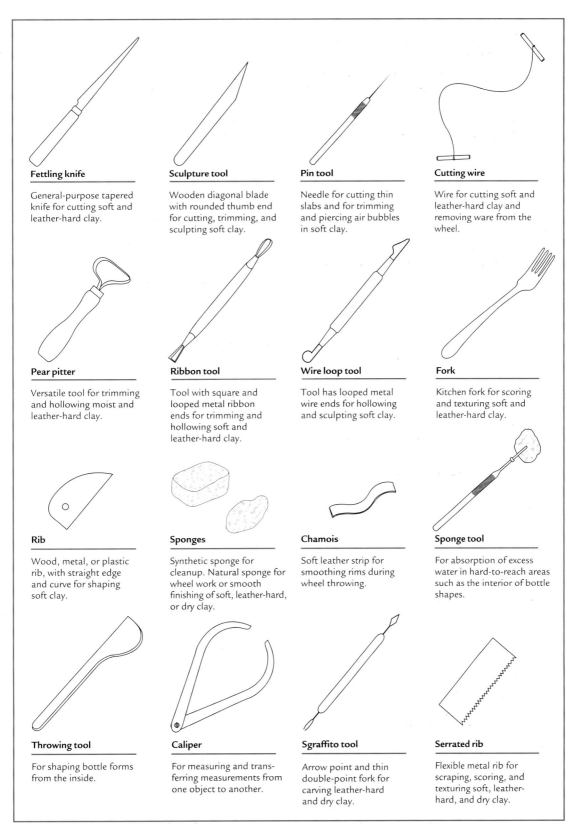

Fettling knife

General-purpose tapered knife for cutting soft and leather-hard clay.

Sculpture tool

Wooden diagonal blade with rounded thumb end for cutting, trimming, and sculpting soft clay.

Pin tool

Needle for cutting thin slabs and for trimming and piercing air bubbles in soft clay.

Cutting wire

Wire for cutting soft and leather-hard clay and removing ware from the wheel.

Pear pitter

Versatile tool for trimming and hollowing moist and leather-hard clay.

Ribbon tool

Tool with square and looped metal ribbon ends for trimming and hollowing soft and leather-hard clay.

Wire loop tool

Tool has looped metal wire ends for hollowing and sculpting soft clay.

Fork

Kitchen fork for scoring and texturing soft and leather-hard clay.

Rib

Wood, metal, or plastic rib, with straight edge and curve for shaping soft clay.

Sponges

Synthetic sponge for cleanup. Natural sponge for wheel work or smooth finishing of soft, leather-hard, or dry clay.

Chamois

Soft leather strip for smoothing rims during wheel throwing.

Sponge tool

For absorption of excess water in hard-to-reach areas such as the interior of bottle shapes.

Throwing tool

For shaping bottle forms from the inside.

Caliper

For measuring and transferring measurements from one object to another.

Sgraffito tool

Arrow point and thin double-point fork for carving leather-hard and dry clay.

Serrated rib

Flexible metal rib for scraping, scoring, and texturing soft, leather-hard, and dry clay.

FIGURE 10-5
These are the basic tools you will use for shaping and trimming pottery and sculpture or for finishing your work.

objects to their work—ordinary odds and ends that they have found in nature, in the house, or on the scrap heap. These may include a smooth stone or the back of a spoon for burnishing, a hand-shaped piece of wood or metal, or scraps of leather, twigs, or shells.

TYPES OF CLAY

Chapter 1 explains how clay is formed through the action of geological forces and the weathering of the rocks that make up a large part of the earth's crust. Figure 1-1 shows how some clays remain in place as the feldspathic rocks of which they are largely formed decompose. It also illustrates how other clay components are moved by the action of rain, streams, and rivers and deposited in beds of different types of clay. Some clays can be dug up and used as they come from the ground because they are naturally plastic and can be worked without additional chemicals. However, contemporary ceramists who mine their own clays often find it necessary to add other ingredients to form a satisfactory body. For example, adding **fire clay** (or refractory clay), increases the clay body's resistance to heat and, depending on the type of fire clay, may also add plasticity to the body. Adding **grog** will also modify the natural quality of a body. Grog, made from fired clay that has been ground to various particle sizes, can add body strength and will also open the pores of the clay. Various oxides, such as iron, chrome, or cobalt, may also be added for color.

This chapter introduces you to different types of clays and explains how to mix and test clay bodies for your own use (see 10-6–10-10). If you have not run clay body tests before, we suggest that you study this material in conjunction with later chapters.

Primary Clays

Clays that remain at their original site of decomposition are known as primary clays. These deposits supply the white china clay, or kaolin, that is used in porcelain, bone china, and glazes. The chemical formula of kaolin is the closest to "theoretical clay"—a completely unadulterated clay that is never actually found in nature. Kaolin's formula includes mineral oxides in the following proportion:

$$Al_2O_3 \cdot 2SiO_2 \cdot 2H_2O$$

Secondary Clays

Secondary clays are clays that have been washed away from the feldspathic rocks and deposited in beds that may be far from their place of origin. Over millions of years, as the rocks of the earth's crust broke down, the particles were weathered into increasingly smaller sizes and were continually moved by rain and streams. As the movement continued, larger particles were dropped first, and increasingly smaller particles were carried farther by the water to become mixed with other minerals and organic matter. Finally deposited in river bottoms, on plains, or below the ocean, similar-sized particles were deposited together, and each deposit had a particular mineral and physical composition that determined the type of clay and its individual properties. Among the secondary clays are the fire clays—made up of coarse and heavy fragments that were usually dropped ahead of the smaller particles—and the common earthenware clays and the stoneware clays (see 1-1).

LOW-FIRE CLAYS Earthenware clay is a low-firing secondary clay found throughout the world. It was the first type of clay widely used to create ceramic objects hardened in fire, because the considerable amount of iron contained in this natural clay meant that it could reach maturity at the comparatively low temperatures achievable with early firing methods. Made up of decomposed rocks along with organic material and iron, earthenware clays remain porous when they are fired to mature temperatures that range from **cone 010 to cone 1** (1675°–2109°F/913°–1154°C). (Explained more fully in Chapter 16, **pyrometric cones** are devices that indicate when a particular clay is reaching maturity. Here, and throughout the book, when cones are referred to, the temperature reference is to large Orton cones. The small cones used in **kiln sitters** fire to maturity at a different rate. A chart of cone temperatures of both American Orton cones and English Seger cones appears in *Expertise,* Chapter 2A.)

Natural low-fired earthenware varies in color from reddish to yellowish, depending on the

amount of iron or lime it contains. It is commonly used for flower pots. Some earthenware clays can be dug up and used just as they come from the ground, with very little preparation beyond cleaning out large impurities. Such clays were used by early potters to make pots and ritual objects, and they are still used by village potters today. Many specialized low-fired earthenwares have now been commercially developed, including white earthenware containing only small quantities of iron.

HIGH-FIRE CLAYS The natural high-firing clays were first used in China (see 3-9, 3-12); later, after boatloads of Chinese stoneware and porcelain objects arrived in Europe, potters there searched for and eventually found the necessary materials with which to make their own high-fired ceramics. Used for domestic ware as well as sculpture, these clays are still popular with many contemporary potters and sculptors.

FIRE CLAYS Because fire clays are heat resistant, they are used to make bricks for lining furnaces or fireplaces, or to build kilns. They are also used as ingredients in stoneware clay bodies. Fire clays can be used pretty much as they come from the ground.

STONEWARE CLAYS Stoneware clay is a secondary clay made up of finer particles than those of fire clay. This clay was formed when the rock particles became mixed with small particles of iron and with decayed plants containing potassium, a mineral that acts as a flux. When stoneware clay is fired to maturity—depending on its composition, anywhere from cone 1 to cone 10 (2109°–2377°F/1154°–1303°C)—it becomes dense, vitreous, and resistant to water and acid. It generally fires to a buff or brown color, although it is possible to mix white stoneware. Your coffee mug and dinner plate are probably made of stoneware. Large deposits of stoneware in the Rhine Valley made it possible for German potters to develop the salt-glazing techniques that gave them a competitive edge over potters in other areas (see 6-16).

BALL CLAY **Ball clay** is a secondary clay that contains little iron. When fired, it turns a light gray or buff color. This clay is used in both low-firing and high-firing clay bodies that require plasticity.

FORMULATED CLAY BODIES

Mixed for a particular use, a clay body may be made up at the factory and packaged either in dry bulk or damp in plastic bags. It may also be mixed from dry ingredients in the studio. In either case, it will contain a variety of components that have specific functions in the clay body. An example of a clay body might be a white earthenware mixed without iron in order to produce a low-firing body that can take color well. Another example, porcelain, is a mixed body made up of high-firing components that will fire to the pure white, translucent ware so esteemed in China. When fired to maturity at a range from cone 8 to cone 13 (2316°–2455°F/1269°–1346°C), porcelain is impervious to liquids. Because of its density and imperviousness, porcelain is also used for sinks, toilets, and electrical insulators. For additional information about blended clay bodies, mixing, and testing, see *Expertise,* Chapter 1A.

CHOOSING A CLAY BODY

It is important to choose the correct clay for the type of work you intend to do. If you are a beginner in a school situation, it is likely that you will be using a premixed clay body developed commercially or by the school for a particular use and firing range. If you are working on your own, you will have to choose which premixed clay body is correct for the type of work you plan to do and the firing method you prefer. For example, coiled pots to be fired at a low temperature require a somewhat porous earthenware, not a high-fire porcelain clay, which would not mature at the low temperature and might break during handling. If you were planning to throw on the wheel, you would prefer a plastic clay. Very fine clays shrink more when they dry than those that are coarser or contain more temper or filler, so you probably would not use a fine body such as porcelain for building large, thick sculptural forms. (This does not mean that this cannot be or has not been done, however. There are always exceptions.) If you wanted to fire a large piece of sculpture to a higher temperature than earthenware will stand, you would likely use a stoneware body containing a lot of temper (grog, or **chamotte**), which would make it less likely to crack. Clays to be thrown on the wheel, however,

must be more plastic than sculpture clays, so they are made with as little nonplastic material—flint or feldspar—as possible, and with additional plastic materials such as ball clay or small quantities (1–3%) of bentonite or macaloid.

There is usually a trade-off to be made in choosing a clay body, yet it is possible to push the limits of a particular clay in a remarkable way. As with everything else in ceramics, there are no rules that cannot be challenged, and some people choose clays for their aesthetic properties, such as texture or color, rather than for their usual material function or specification. One would not expect to use porcelain for a large sculpture, yet Carlo Zauli used it to create a thick wall relief about 30 feet long (9.1 m.). Asked why he used porcelain for such a large piece, he replied that it was partly to see if he could do it and partly because he wanted the porcelain's whiteness on which to use color (13-15).

Despite the fact that clay can sometimes be pushed beyond the limits one would expect, there are certain considerations to bear in mind in choosing a clay for specific applications. For example, for sculpture placed outdoors in a climate with wide seasonal fluctuations, the type of clay used is critical. In such conditions, moisture collecting in the open pores of low-fire clay will alternately contract and expand as it freezes and thaws, eventually causing the piece to crack. Therefore, water must not collect in open cavities or pockets and must drain off the ceramic. For that reason, a coarse, heavily grogged clay such as stoneware, fired to vitrification, is essential in exterior applications where there is a danger of subfreezing temperatures. A low-fire clay piece, though not as strong as stoneware, can, however, be used safely outdoors in a mild climate in a spot where it would not be easily broken.

Low-fire, stoneware, and porcelain clays can all be used in the production of utilitarian ware. Each, however, possesses unique characteristics that will affect how it is used. For example, low-fired clay tends to be either reddish or buff (although white is also available), and because it is not watertight, it usually requires glaze to form a waterproof surface. To make a piece watertight, the ceramist will often glaze the whole piece, including the **foot,** so it is necessary to place the ware on **stilts** during firing (see 15-17).

Low-fired dinnerware does not take stove-top or oven temperatures well; the ware may crack and the glaze can **craze.** For this reason, stone-

ware clay is usually chosen for dinnerware because it is strong and durable and takes handling well. It is also water- and acid-proof. Depending on the composition of the body, some stoneware clays can accept oven temperatures or even low stove-top temperatures. Stoneware colors range from white to brown.

Porcelain is also especially popular for dinnerware because of its smooth white surface. On it, glaze colors can achieve brilliance and depth, and when it is fired to maturity (in a range from cone 8 to cone 13, or $2316°–2455°F/1269°–1346°C$), porcelain is waterproof without glaze. Cherished by the aristocracy of China, where the most precious creations of the official potteries were reserved for the emperor's household, porcelain has always had an aura of elegance.

Firing each clay to its maturity is especially critical in the production of dinnerware. Equally critical is the proper fit of the glaze to the clay body. As will be discussed in Chapter 15, each glaze must be carefully chosen to match the shrinkage rate of the particular clay body on which it is used. Otherwise the glaze may craze, or **crawl** and separate from the ware. Crazing is not acceptable in cooking or tableware, because food can collect in the cracks and pose a health hazard.

Suiting the Clay Body to Your Needs

Sometimes, finding the right clay body can take considerable effort. For example, potters on Crete must dig their clay, crush it, saturate it with water, and leave it in the sun to let the water evaporate (see 1-7). In the days when the early potters in the American Southwest dug their clay, they sometimes had to walk miles to find the right type of clay and carry it home on their backs. You may wish to dig local clays and test them yourself as a way to understand the empirical methods potters used through the centuries (10-6).

Why Mix Clay Bodies?

Since a natural clay body or a commercially mixed body may not always meet an individual's needs, many potters and sculptors prefer to mix their own bodies or have them mixed to their recipes.

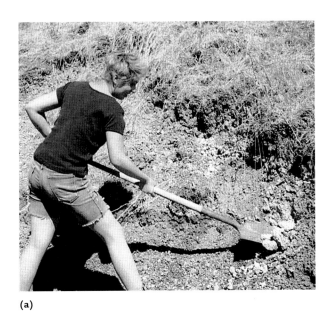

(a)

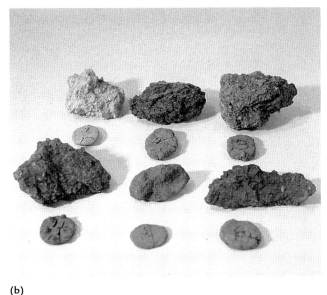

(b)

FIGURE 10-6
(a) Natalie Cartwright digging natural clay samples. After separating the clay by color and placing each raw sample in a bucket, she then added a small amount of water to each sample. *(b)* She pinched small round test tiles and then dried and fired the tiles to cone 05 (1915°F/1046°C). After firing, the tiles ranged in color from light to dark brown to reddish.

For example, American sculptor Richard Notkin (see 13-75) says that although porcelain is one of his favorite clays:

> *. . . for the Yixing Series, I have developed a range of fine-particled cone 5–6 stoneware bodies from a combination of ingredients available commercially: stoneware and earthenware casting slips, various dry clays, Mason stains, etc.*

On the other hand, Janet Mansfield (see 12-6), who has a studio in an area of Australia that is rich in clays and other minerals useful to potters, says,

> *In my pots I use all these materials, hoping to discover the qualities in them that will direct my work and give it distinctiveness. Wanting to work in this way means that I need to do much experimenting with the clay bodies, and also with how the clay will serve the forms.*

American Patrick Siler (see 10-12) likes the process of blending his clay body:

> *One of the things I enjoy most about starting a group of pieces is the process of making my batch of clay. Although really I haven't varied the kind of clay I use for years, I enjoy the initiation rites of the process.*

One reason for learning to mix at least a few basic clay bodies is to become familiar with the ingredients and how they act in the clay. Even if you do not plan to make your own clay bodies in bulk, some knowledge of formulating, mixing, and testing clay bodies will add to your understanding of how the different ingredients affect the body and how a particular clay will respond to your hands, to drying, or to firing.

Learning to develop superior clay bodies especially formulated for one's own needs in sculpture or wheel forming can add to your satisfaction with the results in firing and glazing or postfiring finishing; for example, you may wish to formulate a clay body with a particular color or texture to suit your concept. Perhaps you will need a casting slip with an especially fluid property to fit the intricacies of your plaster mold; if so, by mixing your own slip you can gain control over the water content, the consistency, or the shrinkage rate, thus making the slip suit your particular needs.

Another consideration in mixing clay is understanding how clay body formulas can affect the quality of the results you get from glazes. Early potters had little or no theoretical knowledge of the chemical components of clay, of *why*

different clays responded to the heat or atmo-sphere of the kiln in different ways, or *what* made one clay more plastic than another. They could only observe what happened when they used certain materials and experimented with different types of clay. Throughout history, it was this experimentation that led to the success-ful development of new ceramics techniques or materials, as potters learned just what each glaze would do on certain types of clay under certain firing conditions. Now ceramists can turn to chemistry for help, but empirical knowledge and testing are still as important as ever.

For these reasons, we have compiled and tested some clay bodies, listed in *Expertise,* Chapter 1, that have only a few components so that as you test them you will not have to deal with too many variables. The same chapter also lists recipes for somewhat more complex clay bodies, shared by potters and sculptors, that you can mix and test as you progress in experience and knowledge (10-10).

MIXING CLAY BODIES

Dry clay should be mixed with care. The haz-ards of breathing clay dust were not known in the past, so potters who were constantly ex-posed to the dust—those who mined dry clay in-gredients and those who worked in dusty pot-tery factories—often developed the fatal disease silicosis.

Protection against Clay Dust

Since breathing clay dust is harmful to the res-piratory system, proper protection is essential. It is not the particles you can see floating in the air that are most dangerous; rather, it is the mi-croscopic particles that can penetrate an ordi-nary paper mask that are harmful.

One way to protect yourself against breathing clay dust is to keep the studio as clean as possi-ble. Cleaning with the proper type of vacuum cleaner or damp-mopping or hosing the work space at the end of each work session will help keep clay from being tracked around the studio and its dust from entering the air (see 10-4). Clay dust can also be spread through a studio from the bits and pieces of clay that dry on tables, wheels,

and the floor; sponging off these surfaces at the end of each work session is also important.

Active Local Ventilation

In addition to being kept clean, the studio should provide proper ventilation. Do not rely only on general studio ventilation. A studio should also have local exhaust systems that capture the dust at its source—that is, where dry clay is mixed, dry ware is carved, or dry clay objects are sanded. Although most studios now have active local ventilation systems that vent the dust from near the source, if you find that you have to mix clay in a situation where such a system has not been installed, wear a respirator rated by the Occupa-tional Health and Safety Administration (OSHA) to protect yourself against the microscopic clay particles. Wear protective goggles as well. If you are going to be mixing large quantities of dry clay materials, the ultimate protection is a supplied-air system in which your head is completely en-closed and filtered air is supplied through a hose. All general and personal protective equip-ment is shown in Figure 10-4.

HOW TO MIX CLAY

Mechanical Mixers

Once you are properly protected against clay dust, there are several ways to mix your clay (10-7–10-9). Your first experience will probably consist of mixing relatively small batches in order to make test tiles, which you will then fire at vary-ing temperatures and in different atmospheres.

Dough mixers can be used to mix clay—in fact, many aspects of clay or glaze mixing are similar to certain kitchen procedures. To use a dough mixer, simply weigh out the dry materi-als, usually just over half the capacity of the dough mixer; then turn the mixer on, blend the ingredients while they are dry, and slowly add the water.

Commercial clay mixers are basically the same as dough mixers, but they are larger and designed specifically for mixing clay. The type of mechanical mixer you are most likely to find in a school studio is illustrated in Figure 10-8. Recommended mixers have blade guards and

safety shut-off switches. Never put your hands in a functioning mixer, but if an accident should occur, first reach for the switch and turn it off.

Used in the same way as a dough mixer, a clay mixer is probably the most useful piece of equipment in a studio, because in addition to mixing clay it can be used to recycle clay that has been discarded in the process of making pots or sculpture. Putting dry scraps directly into the mixer is not recommended, because hard chunks usually find their way into the processed clay. Rather, the dry scraps should first be moistened in a bucket; then fresh, dry clay ingredients and additional water should be added and the mixture blended. The recycled clay can then be **wedged** to eliminate air bubbles and make it more homogeneous (see 10-15–10-18).

Pug Mills

Pug mills are machines that are used for mixing and sometimes for **de-airing** clay (10-9). The process of pugging (putting the clay through a pug mill) can eliminate the need for wedging (see 10-13–10-14), although many potters and sculp-

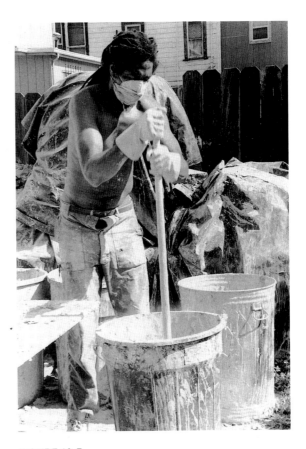

FIGURE 10-7
You don't have to have an elaborate studio to work in clay. If you live in a temperate zone, you can set up a work space outside, at least in the summer. Ptah, who lives in California, mixes his clay in buckets and bins, wearing gloves and a respirator.

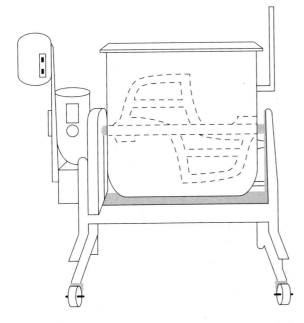

FIGURE 10-8
Mechanical clay mixers have revolving blades or paddles (indicated by the dotted lines) that mix large quantities of clay in a tilting container. The clay is first dry-blended, and then the water is added.

Clay

FIGURE 10-9
A pug mill has an auger blade inside and will mix, homogenize, and recycle clay. The clay is extruded in a solid mass. Some mills will also de-air the clay.

tors still prefer to wedge their clay even after it has gone through a pug mill. Since pug mills will also accept and process dry scraps, they can be used for recycling clay as well. However, if you use a pug mill to reprocess clay scraps, make sure the scraps are not so large that they bind in the blades, possibly damaging the machine. Producing a high-quality recycled clay from dry chunks usually requires that the clay be pugged two or three times. As a rule, it is better to dampen any scraps before reprocessing them; this is easier on the machine and cuts down on processing time.

Some pug mills are equipped with a de-airing system that produces a clay body that is free of air, is well compacted, and in which the particles are pressed close together. The pre-mixed clays in plastic bags sold in ceramic supply stores have been processed in this way.

To blend porcelain clay, use a pug mill with stainless steel blades and a stainless steel or aluminum barrel hopper (mixing container) to avoid rust contamination of the clay. Also, stainless steel is much easier to clean than non-stainless.

Commercially Mixed Clay

Many ceramists use commercially mixed clay with great success. They include prize-winning Canadian potter Susanne Ashmore, who makes her teapots from a premixed porcelain, which is also used by many other Canadian potters. American sculptor Richard Notkin, who uses porcelain clay (see 13-75), says,

> I generally use a good commercial cone 6 vitrified porcelain (which porcelain "purists" may scoff at), but it works quite well for my purposes, in compatible plastic clay and slip-casting batches.

TESTING CLAYS

Mixing and testing are among the most important skills to learn. Not only will testing show you how to vary a clay body (and, later, a glaze), but it will introduce you to the many variables in commercial clay materials and to the varying conditions that can exist in a kiln. Testing can also suggest how to use coloring materials with greater success.

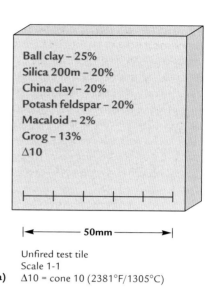

Ball clay – 25%
Silica 200m – 20%
China clay – 20%
Potash feldspar – 20%
Macaloid – 2%
Grog – 13%
Δ10

|◄─────── 50mm ───────►|

Unfired test tile
Scale 1-1
(a) Δ10 = cone 10 (2381°F/1305°C)

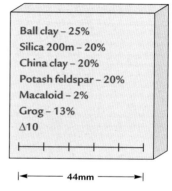

Ball clay – 25%
Silica 200m – 20%
China clay – 20%
Potash feldspar – 20%
Macaloid – 2%
Grog – 13%
Δ10

|◄─────── 44mm ───────►|

(b) Fired test tile

FIGURE 10-10
(a) This drawing shows an unfired tile cut from a plastic template 2¼ × 2¼ × ¼ in. (57 × 57 × 6 mm). For testing purposes, and for ease and accuracy of calculations, all measurements were in millimeters. A 50-mm horizontal line was drawn along the bottom of the tile and crosshatched with lines every 10 mm using a sharp knife or safety razor. A metal stamp was used to label the tile. *(b)* After firing, the tile was checked for color and shrinkage. Shrinkage in this test averaged approximately 12% for a stoneware porcelain fired to cone 10 (2377°F/1303°C).

Making Tiles for a Shrinkage Test

To make clay test tiles, dry-blend 100 g of clay and then add water until it becomes soupy. Then pour the solution onto a plaster **bat** and leave it for 3 to 4 minutes or until most of the water is absorbed. Scrape the clay off the bat using a rubber rib, and blend by hand. Roll out a thin slab ¼–⁵⁄₁₆ in. (6–8 mm) thick and cut it into a 2¼-in. (57-mm) square. Label the tile using metal stamps, or

mark it with a tool. The label should include chemical formulation information and the firing cone. The cone symbol is a pyramid and comes before the cone number. Draw a 50-mm line on the tile using a sharp knife or safety razor blade, with crosshatching marks every 10 mm. After firing the tile, calculate the shrinkage (10-10) by subtracting the difference in the line length, multiplying by 100, and then dividing by the original length (50 mm). The shrinkage formula is

$$\frac{\text{original length} - \text{fired length}}{\text{original length}} \times 100$$

Clay Recipes to Mix and Test

Some simple clay body recipes are given in Chapter 1A in *Expertise* for use in the testing process. Since a clay body affects the glaze you put over it, we suggest that you use these clay bodies, formulated for *Hands in Clay,* to make the tiles on which you will test the glazes that were also specially formulated for testing. Make and fire enough tiles to set aside for later use.

Ceramics is all variables. Even those who know a good deal about what clay ingredients do are not able to visualize exactly what will happen when the clay goes through the fire. And when glazes are formulated to fit a particular clay body, you can expect even more variables (10-11). In dealing with clay and glazes, one can be specific only up to a point. The sooner you recognize and accept this, the sooner you will feel at home with the process.

Each time you change the type of work you are doing, you may have to do more clay body tests. In fact, in some cases you may have to continue testing for many months to get the clay body that suits your particular needs exactly.

Evaluating Clays

After you have mixed test clay bodies, you may want to modify them to suit your needs. Ask yourself the questions in the following checklist to help you to arrive at the best formula to suit your purposes.

- *Does the clay crack too easily?* Try increasing the amount of clay or decreasing refractory materials in the clay body, or increase the water content to the original formula.
- *Do I need to add more texture to a smooth clay body?* Try adding 5–20% 20–30 mesh grog (chamotte) or 30–70 mesh sand. The lower the mesh size number, the coarser the material.
- *Is my porcelain clay body* **short** *(or non-plastic) and does it need more plasticity?* Try adding .5–2% bentonite or macaloid, or a combination of them.
- *Do I want to build a thick sculpture (3–6 in. [8–16 cm.]) and need to add bulk materials to reduce weight or open up the body to make it more porous?* Try adding 1–5% Pearlite (dry weight), sawdust, or vermiculite.
- *Will aging the clay body increase its plasticity?* Aging clay for a week or longer can increase plasticity and help to reduce cracking during modeling or throwing.
- *Do I need to add grog to a clay body made for burnishing?* For a small, hand-held size sculpture or small bowls, it is best to use a smooth clay. For larger pieces, use clay with very fine grog so that if the particles come to the surface they will not cause scratching during burnishing.
- *Can I make my white clay body colorful?* Try adding glaze or body stains in amounts of 1–10% or .5–5% oxides.
- *What can I add to the clay to strengthen it when making paper-thin slabs?* Try adding .1% nylon fiber (½-in. [13-mm] long strand type).
- *What should I do if my clay slumps when made into a tall slab or an elongated form?* Try adding grog or sand for larger slabs, or reduce the percentage of **colloidal clays** such as macaloid or bentonite. Or increase the silica or feldspar added to the clay body.
- *How can I achieve dark brownish/black spots on the surface of my clay?* Try adding granular rutile, ilmenite, or silicon carbide.
- *What should I do if my clay body cracks easily?* Make sure that all the chemicals in the formula were weighed accurately, blended thoroughly, and wedged properly.
- *My clay bodies have been working well for years, but now the clay is a slightly different color, is cracking easily, and*

CLAYS

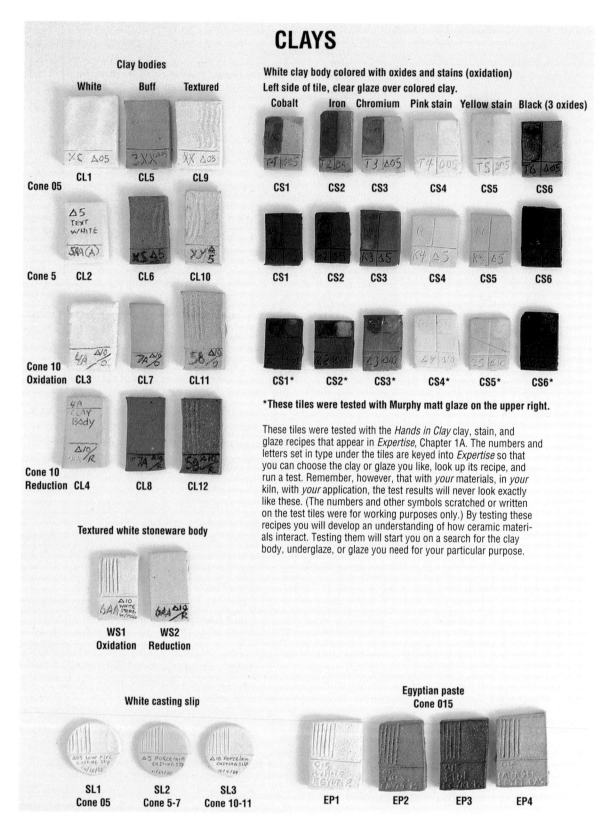

Clay bodies

White | Buff | Textured

Cone 05 CL1 CL5 CL9

Cone 5 CL2 CL6 CL10

Cone 10
Oxidation CL3 CL7 CL11

Cone 10
Reduction CL4 CL8 CL12

Textured white stoneware body

WS1
Oxidation

WS2
Reduction

White casting slip

SL1
Cone 05

SL2
Cone 5-7

SL3
Cone 10-11

White clay body colored with oxides and stains (oxidation)
Left side of tile, clear glaze over colored clay.

Cobalt | Iron | Chromium | Pink stain | Yellow stain | Black (3 oxides)

CS1 CS2 CS3 CS4 CS5 CS6

CS1 CS2 CS3 CS4 CS5 CS6

CS1* CS2* CS3* CS4* CS5* CS6*

*These tiles were tested with Murphy matt glaze on the upper right.

These tiles were tested with the *Hands in Clay* clay, stain, and glaze recipes that appear in *Expertise*, Chapter 1A. The numbers and letters set in type under the tiles are keyed into *Expertise* so that you can choose the clay or glaze you like, look up its recipe, and run a test. Remember, however, that with *your* materials, in *your* kiln, with *your* application, the test results will never look exactly like these. (The numbers and other symbols scratched or written on the test tiles were for working purposes only.) By testing these recipes you will develop an understanding of how ceramic materials interact. Testing them will start you on a search for the clay body, underglaze, or glaze you need for your particular purpose.

Egyptian paste
Cone 015

EP1 EP2 EP3 EP4

FIGURE 10-11
Hands in Clay test tiles. *Copyright © 1989, 1995, 1999, 2003 by Charlotte F. Speight and John Toki.*

sometimes slumps while being modeled.
Has my source or supply of clay changed?
There can be variations in the quality, mineral content, and particle size of materials mined from the earth. If you substitute a chemical, you will probably need to test and adjust the clay body chemically.

- *Does the type of water I use have an effect on my clay?* Yes, water mineral content varies from one place to another. Higher levels of salts and other trace minerals can affect the plasticity and the surface quality of a clay after it is fired. This is especially critical when making casting slip clay bodies. If you suspect that water is a problem, try using distilled water, and compare the physical properties to a test clay using your local water.

Color in Clay Bodies

You will want to consider the color of the clay body in relation to what you are planning to make with it. If, for instance, you are using stoneware or earthenware for unglazed sculpture, or if you want to leave sections of a pot unglazed, you will probably want to use a clay body with a rich color. On the other hand, if you want to mix a dark brown or black clay to use unglazed in a sculpture, you will need to add iron and manganese and possibly other oxides or **stains** to the clay body. It is the amount of iron and/or other coloring oxides in natural earthenware and stoneware that gives them their earthy tones. Because the iron acts as a flux, earthenware containing a large amount of iron can be fired at the low temperatures commonly achieved with an open or a pit firing. This fluxing action of iron is what made it possible for early cultures to develop pottery. Since earthenware clay contains considerable iron, it fires to buff, brown, or reddish brown, and potters, first in the Middle East and then in Spain, Italy, and the rest of Europe, used opaque tin glazes to cover the reddish-brown tones to provide a white background on which they could paint with cobalt blue or other colors.

Once the technology of firing clay to a high temperature was developed in China (see Chapter 3), clay bodies high in feldspar could be brought to maturity, and feldspar became a valuable flux. Feldspar, such as Cornwall stone (*pe-tuntze* in China), or a medium-firing flux such as nepheline syenite, has a higher maturing range than iron and can be used as a flux in porcelain, avoiding the color imparted by the iron.

Because the maturity of a clay body is related to the type and amount of fluxes in the clay and since some coloring oxides also act as fluxes, when you mix colored clay bodies you should be aware of the temperature and time needed in the kiln to bring the clay to maturity. Maturity, or immaturity, will also affect the color and surface of the fired clay (sheen or matt), as well as the texture (porous or vitrified).

Learning to manipulate clay materials takes time and experience. For example, if you want to fire a white, high-firing stoneware clay at a slightly lower temperature than usual, you can add some extra flux to fuse it at the lower temperature. But if you want to lower the maturing temperature a great deal, you should not use stoneware but a low-fire body such as earthenware. However, if you want to keep the clay body white, you should not use a color-imparting flux, and you need to know how the different fluxes affect the color of the clay. Since the maturing temperature of the clay can also affect its fired color, a change in just one component can alter a clay body considerably (see 10-11, as well as Chapter 1A in *Expertise*).

Variations in Materials

Clay materials themselves can vary a good deal, thus affecting the results you may get with different batches of the same clay body. When the availability of materials changes or a specific vein of material is exhausted, a supplier might substitute a similar material but one that produces somewhat different effects. For example, when miners of Kingman feldspar hit a new vein that had considerably more iron in it, stoneware potters had to adjust their firing and glazes. Eventually, when Kingman was mined out, they shifted to Custer feldspar, which is similar in chemical composition yet differs subtly in color and texture.

American potter Eileen Murphy says that she uses her own mixture of clay because after years of trying different prepared clay bodies she became tired of finding

some dunted, some with too little silica, some very dry, some with too much iron, some too

brown, some with too much shrinkage and on and on.

But even now, using her own recipe, she says,

the clay still varies year to year due to changes in the natural materials. The clay I just had mixed according to my recipe has more iron in it than two years previous. This strongly affects my work, because in salt firing the body is exposed, not glazed over.

Using Local Clays

Instead of using commercially produced dry ingredients to mix your clay body, you might search for local clays, dig them, clean them, and test them for color and other qualities. Sometimes you can use such a clay just as it comes from the earth, or with twigs or large pebbles removed by hand and some form of temper (probably grog) added, but if there are too many large impurities in it you will have to screen them out.

At road construction sites, cuts into the earth often reveal soil striations that contain various types of clay. A creek bed or a ravine cut by flooding is another good place to search for clay. Natalie Cartwright, Jennie Canning, and Jennifer Atkins, students from the California College of the Arts, discovered clay after learning about a site in Santa Rosa, California, owned by Walter Byck. After a road was cut through Byck's property his auto tires became clogged with a very sticky dirt; this was a good sign that there would be clay on the property. The students decided to dig near the road (see 10-1, 10-6a). After they had dug soil samples and fired them, they evaluated the several types of clay and found them to have varying properties.

Availability of Materials

Because clay is widely available on earth, we tend to think of ceramics materials as inexhaustible. This is not true; certain feldspars—such as Kingman feldspar—have already been mined out and substitutions made. Natural Albany slip is no longer being mined in upstate New York, and substitutes are now used. As time goes on, there probably will have to be other substitutes for depleted materials. Some of the materials we may need for ceramics are fi-

nite, so our attitude should be one of respect for what the earth provides.

AGING CLAY

Once you have mixed a batch of clay, you can set it aside like bread dough, not to rise but to age. Clay, like bread, is improved by the action of bacteria. These bacteria develop acids and gels and secrete enzymes that help break down the clay into smaller particles, increasing its plasticity. Adding organic materials such as vinegar, red wine, or stale beer to the clay can help in this process. Some potters and sculptors consider two weeks to be adequate time to ripen the clay, but others say that the longer the clay ages, the better it becomes. English potter Michael Cardew, for example, buried some clay in a hole because it did not throw well. He left it there while he traveled for ten years, tried it again without success, and then forgot it for another ten or fifteen years. An apprentice found it and, Cardew said, used it to make fabulous unglazed terra-cotta garden pots.

WEDGING

To carry the kitchen parallel further, the action of wedging is like kneading bread (10-12). It eliminates the lumps and drives out air that may be trapped in pockets or bubbles in the clay. But most important, wedging homogenizes the clay. You can eliminate small air bubbles on the wheel or slab by puncturing them with a pin, but if you have skipped the wedging and are throwing a pot and you find a moist area on one side and a stiff, hard lump in the clay on the other, you have encountered an insurmountable difficulty. Even if a commercial body has been premixed, it may not be thoroughly homogenized; perhaps the bag it came in had been sitting on a shelf for a long time; there may have been a small, undetectable puncture in the bag; or the clay may have been left exposed to the air for a while so that although the interior seemed moist enough, the exterior might have stiffened. Therefore, it is wise to wedge any clay prior to use, especially for throwing on the wheel.

You can see if there are air bubbles in a chunk of clay by cutting through it with a wire and

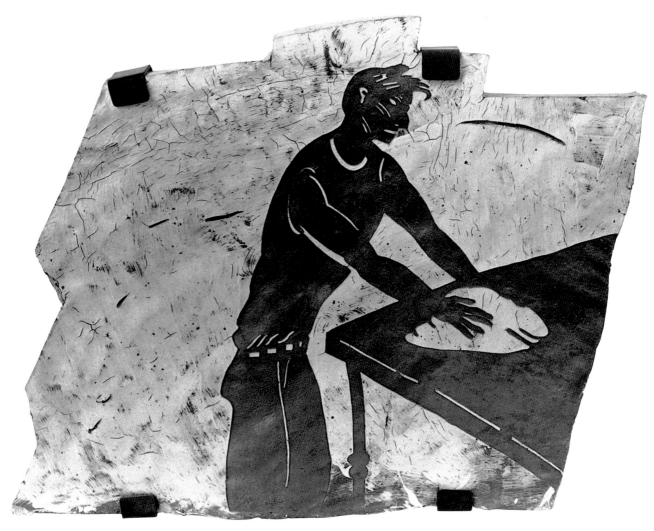

FIGURE 10-12
Wedging the Clay, a wall panel by Patrick Siler of the United States, part of a series of panels titled
Clayworks. 22 × 26 × 2½ in. (56 × 66 × 6 cm.). *Courtesy the artist.*

looking at the exposed areas, but that will not tell you about the clay's consistency. One way to see firsthand how wedging blends clay is to wedge two chunks of different-colored clay until they are completely blended.

Any wedging method is satisfactory as long as it accomplishes the objective. For some hand-building methods, it is enough to cut the clay in half and slam one section down on a solid surface and the other on top of it, but since this separates rather than tightens the clay particles, it does not make the clay cohesive enough for wheel throwing.

Spiral and Ram's Head Wedging

Two traditional wedging methods are shown in Figures 10-13 and 10-14. They should be done on as low a surface as is comfortable. Keep your body higher than the table for maximum leverage, and use your torso and legs as well as your wrists and forearms. Involve your body in the rolling action, or you will tire yourself at the **wedging table** before you even sit down to throw.

The wedging table should be firm and well anchored to keep it from moving too much as you push down and out on the clay. The surface

(a)

(b)

FIGURE 10-13
(a) To use the ram's head method of wedging, grasp a ball of clay, holding your arms extended. Push down and outward, using the weight of your body to apply steady force. With your fingers curled inward, give the clay a quarter turn on each push. Push at least five times, with a rolling motion. *(b)* Continue until the clay becomes thoroughly blended—that is, homogenous—and resembles a ram's head.

can be plaster, which will soak up a lot of moisture from the clay. Some potters, however, cover the plaster with a light cloth or use a canvas-covered board as a surface to prevent picking up bits of plaster from the table and mixing them into the clay. Tiny bits of plaster in the clay will expand as they moisten and will eventually pop the fired glaze from the surface.

Either of these two frequently taught methods of wedging, the "ram's head" and "spiral" methods, will prepare the clay for throwing. Both methods not only de-air the clay and take out lumps and bubbles, but they also tighten the clay into a firm, compact ball ready to throw. Some potters feel that the spiral method does a better job because it lines up all the particles of clay in one direction (see 10-14b).

Whatever method you use, wedging serves another purpose: It brings you into contact with the clay you are going to use, and to some potters and sculptors this is a very important part

(a)

FIGURE 10-14
(a) To wedge the clay in the spiral method, you need to give it a slight twist of the hands. This will open up all parts of the clay ball and allow any bubbles to escape. *(b)* Spiral wedging also lines up the clay particles in the direction in which the pot will be thrown on the wheel. *Courtesy Ron Judd.*

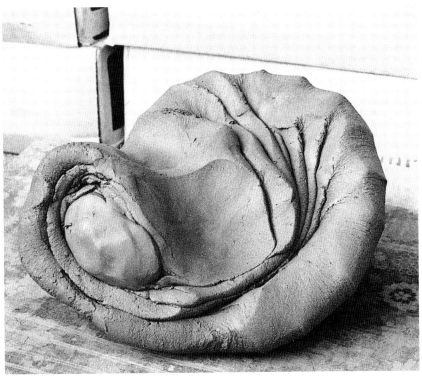

(b)

of the process. The rhythmic action of the body and the time spent wedging the clay allows them a chance to think about how they will work the clay, and the intimate contact wedging sets up between their hands and the clay estab-lishes the best mood for working. Stephen De Staebler, who once tried having someone assist with wedging and preparing his slabs, said, *I discovered that it was helping me in terms of time, but hindering me in terms of thinking.*

FIGURE 10-15
Mark Messenger removes reclaimed wet clay scraps from a bucket where they have been soaking and fills a plaster trough with slurry. The slurry will be left to dry in the trough for three to five days, depending on weather conditions and the absorption rate of the plaster.

FIGURE 10-16
When the clay has pulled away from the plaster trough by about ¼ in. (6 mm) and the center is no longer wet, the entire block of clay can be lifted out and placed on a wedging table.

FIGURE 10-17
Using a cutting wire, Messenger cuts the clay into manageable chunks. *If the clay is too wet,* he says, *flatten it on the plaster table with a paddle or your fist to expose a larger amount of its surface to the absorbent plaster and the open air. In half an hour or so it will be ready to wedge.*

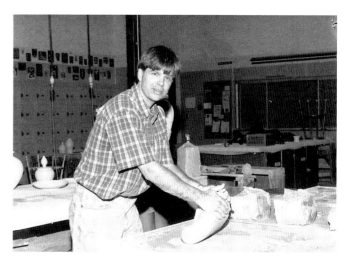

FIGURE 10-18
Messenger wedges a lump of clay until it is consistently blended and homogenous throughout. This removes air bubbles and blends all the clay scraps together. He then bags it and leaves it for one or two weeks to age. This will increase its plasticity for throwing on the wheel.

RECYCLING CLAY

Unfired clay trimmings and waste can be recycled using an effective method employed at Diablo Valley College in California. The system does not use any dangerous machinery, and it can easily be set up in the home studio (10-15–10-18).

Taking scraps of clay one type at a time, saturate the dry or damp clay with water until it becomes a wet slop, or slurry. Then place the slurry on a plaster or wooden bat or on a concrete surface. (Plaster absorbs best, followed by wood and concrete.) The moisture in the clay will be absorbed by the porous surface, leaving the clay ready for wedging.

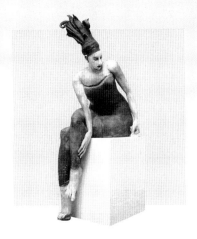

11

Handbuilding

Much of the appeal of clay as an art medium may be the intimate and direct relationship the potter or sculptor can develop with it. Unlike stone or metal, clay can be modeled with few tools or intermediate processes to separate the maker from the work. Speaking of clay's malleability, Stephen De Staebler (see 11-60, 11-61) says, *I can't think of another sculptural medium that has such a vulnerability to force.* Sensitive hands using handbuilding techniques—building solid clay sculpture, pinching, coiling, working with clay slabs—can create vessels built for storage or display or sculpture that is expressive of human joy or pain.

If you take some time to explore pottery and sculpture with your hands, closing your eyes so that you can rediscover your tactile sense, you will find that such exploration can bring a new perspective and new vitality to your clay forms. Your hands are an extension not only of your arms but of your whole body—indeed, of your entire being. It is that being, that individuality, that will give a pot or a sculpture its expressive quality, for clay captures and holds not only the imprint of the maker's fingers but also the imprint of human creativity.

It is often difficult to tell just what method an artist has used to handbuild a particular pot or sculpture. A piece may have been built solid and then hollowed; shaped by pinching; shaped by pinching with added coils; constructed with slabs; constructed with slabs and pinched forms; or built with any combination of these methods. Although these building methods are discussed separately for clarity, they are frequently used in combination, and the finished works do not always reveal the method used.

WORKING IN THREE DIMENSIONS

Whatever handbuilding method or combination of methods you decide to use, the process will require an awareness of working in three dimensions. If you are not used to visualizing forms this way, handbuilding can be an exasperating experience at first. For instance, when handbuilding a large pot or figure you may concentrate on one section, only to step back and discover that the area you have been focusing on fails to work well with other parts of the piece. Most people have to make a conscious effort at first to consider their work from all angles. In order to turn a piece frequently, place it on a **banding wheel** or a revolving sculpture stand. If the work is too large to fit on either of these, make a point of walking around it often to ensure that working too long on one part will not totally change its relationship to other sections of the piece. In addition, before starting a complex sculpture or vessel, it is wise to make some sketches of the projected piece from different angles or to make a few clay **maquettes** (three-dimensional sketches).

Exploring different arrangements of the work's masses in this way can sharpen your perception of the whole composition in space. Notice, for example, how tension develops between flat and curved shapes, how jagged forms suggest one type of emotion while swelling, soft ones project an entirely different feeling. Be alert as well to what the negative space between the forms contributes to the expression of your idea or emotion.

BUILDING SOLID

Generally a clay sculpture is built hollow, not for the purpose of building a container but rather to ensure that the clay forms are not too thick. There are reasons, however, why it is sometimes better to build solid, even if it then is necessary to hollow the sculpture out. Hollowing evenly is essential because the walls of a pot or sculpture that are unusually thick—1–5 in. (2.54–13 centimeters)—release moisture more slowly than thin walls. Thick pieces must be given extra drying time, because if there is still water in the clay's pores when it is heated in the kiln, the water will turn into steam, which, in the process of leaving the clay walls, may cause the

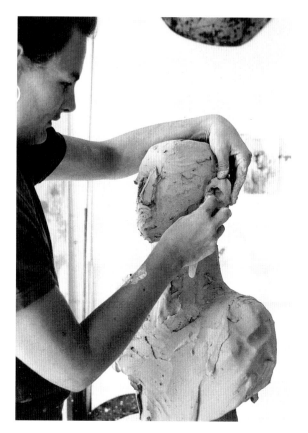

FIGURE 11-1
Michelle Gregor of the United States builds her portrait heads solid, working quickly and surely as she defines the forms. If a live model is not available, she takes photos of the subject from every angle to use for reference while she works.

work to blow up. Small, solid sketches or figurines can be fired safely if they are totally dry before firing; otherwise they too can explode, damaging other work in the kiln as well.

On the other hand, sculpting larger work solid has certain advantages over building hollow: Compared to a thin-walled piece, a solid one is in less danger of collapsing, becoming distorted, or tearing while it is being worked on. Also, when working solid it is often easier and more spontaneous to visualize and build a solid mass in space than to develop the forms by building *around* empty space. In addition, the heavy, dense foundation of clay that working solid produces will allow you to use more pressure on a piece, whether you work with your hands or with a tool—there is less danger of the whole thing collapsing than when building hollow. It is also easier to experiment when working solid by adding or subtracting clay.

At times it is best to build solid, cut the piece apart, and hollow out the interior when it is stiff but still damp, as Michelle Gregor did when modeling a bust (11-1–11-5). Again, an important rule

FIGURE 11-2
Gregor slices the sculpture with a strong wire when it is leather hard, choosing the least conspicuous area for the cut—often along the hairline. She has two pieces of foam ready on which to rest the sections to protect the freshness of the sculptured surface while she hollows them.

FIGURE 11-4
Finally, Gregor reassembles the hollowed-out piece by pressing the sections together well after scoring the edges and painting them with slip. During joining she is careful not to damage the surface; she reworks the join to eliminate the joining line and to bring back any lost detail. Gregor uses slips or sometimes a wash of acrylic paint to color her sculpture.

FIGURE 11-3
Resting each section on the foam, Gregor starts to hollow it out, using a ribbon tool. She scoops out the excess clay until the walls are between ¼ in. (6.35 mm) and ½ in. (12.70 mm) thick. To be sure she is not getting the walls too thin, Gregor uses a needle tool to test their thickness.

FIGURE 11-5
Crow Boy (detail). Michelle Gregor built this full-size figure using coils and slabs for the body, but she made the head using the same solid/hollowed-out technique that she demonstrates in Figures 11-1–11-4. Sculpture mix body, colored slips. 52 × 26 × 13 in. (132 × 66 × 33 cm). 1992. *Courtesy the artist. Photo: Amy Franceschini.*

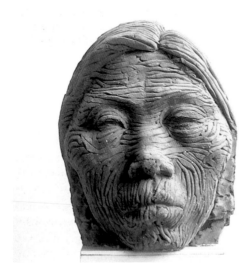

FIGURE 11-6
Root, by Yau Yongkang of the People's Republic of China. This handbuilt head, the artist says, is a portrait of *a typical peasant woman. It expresses the feeling I have thinking of the "Source."* Built of stoneware clay, fired in reduction in a gas kiln, 2372°F/1300°C. *Courtesy the artist.*

to keep in mind when hollowing out a solid form is to make the wall as even in thickness as possible so that the drying rate of all areas will be the same; otherwise the piece can warp or crack as it dries or in the firing. (And remember to recycle the clay that was dug out.)

Modeling a Head or a Bust Solid

There is a long tradition of modeling figures in clay that goes back at least to the Etruscans (see 2-31) and the Romans and extends through the Renaissance in Europe (see 6-9) to the present. And in Africa, in the Benin culture (see 4-5), solid terra-cotta heads were often sculpted as originals for casting in metal.

In some cases, the walls of a large, thickly built sculpture can have holes drilled or punched into them to release the steam while the piece is still damp so that it will not blow up in the kiln (11-6, 11-7). This is usually done when the sculpture has been built in thick sections, allowing the holes to be easily drilled or punched (11-8).

Cutting, Hollowing, and Rejoining Solid Sculpture

If you build solid, you can either hollow out the piece totally with a loop tool, pierce the clay with a pin tool, or drill into the solid clay using an electric drill with a flat-blade wood auger bit, creating a honeycomb pattern. Or you can use a core tool to make holes in the clay that will aid in drying, give moisture a chance to escape, and also reduce the mass and weight of the clay. Piercing the clay will also help shorten the firing time and lessen the chance of a piece blowing up in the kiln.

If you plan to slice a sculpture to hollow it out in order to fire it, wait until it is leather hard. Plan the cut carefully, placing it where it will be easy to rejoin the sections, and use a strong wire for cutting because it can take considerable strength to slice through a solid chunk of leather-hard clay of this size. Proceed with the hollowing, using a ribbon tool (see 11-3).

After you have hollowed out all sections and made sure that the walls are of a consistent thickness, score the edges well and coat them with slip, then press the sections firmly together (see 11-4). Once they are firmly joined, work

FIGURE 11-7
Solid clay pierced with holes using different tools in order to allow moisture to escape during drying and firing. *(Left back)* Hollow core tool. *(Right back)* Needle tool. *(Front)* Drill bit.

over the joint to obliterate any mark and sharpen smeared details. Then complete the sculpture and fire it. Firing a sculpture built in this way should present no problems if the piece has been hollowed evenly and dried thoroughly before firing. (See Chapter 15.)

BUILDING HOLLOW

Building hollow, especially for larger work, offers advantages that should be weighed against those of building solid: Building hollow eliminates the effort and difficulty of hollowing out solid clay sculpture without damaging the form or surface, but a hollow damp clay piece is more delicate than a solid one. (See pages 208–213 for information about supporting damp clay while you work.) Building hollow also uses less clay. For obvious reasons, vessels generally are unlikely to be made from solid clay, although in Japan small teacups were often carved out of a solid chunk of leather-hard clay to better withstand the shock of raku firing. Once the decision to build hollow has been made, there are several ways to go about it, and you probably will find that at times you need to use these methods in combination.

FIGURE 11-8
Transmutation Series #1, by Rita Sargen-Simon of the United States, is first in a series representing, she says, *the simbiotic relationship between humanity and the natural environment.* Built solid and then hollowed out, the piece also had holes punched in the interior as vents to allow moisture to escape during firing. Ht. 17 in. (43 cm). *Courtesy the artist.*

PINCHING

Pinching is one of the most basic and useful techniques in handbuilding—indeed, the gesture of pinching clay between fingers and thumb seems to be a natural human response to the material. Pinching a ball of clay into a hollow form is a direct way to work, adaptable for forming both pottery and sculpture. If you experiment by pinching a pot (or any hand-sized open form), turning the clay ball in your hands, you will quickly discover just how stiff the clay needs to be to hold its shape as you pinch up the wall and how thin it can become without tearing. You will also discover how moist the edges must be kept

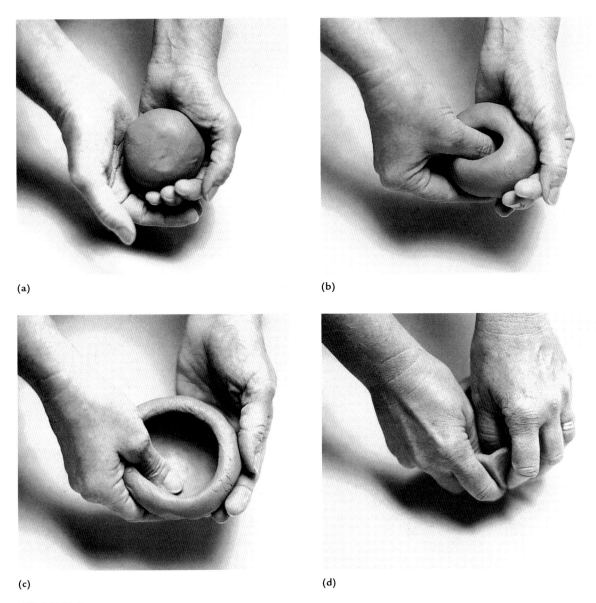

(a)

(b)

(c)

(d)

FIGURE 11-9
(a) Barbara Walch of the United States starts her pinched ware by slapping or patting the clay into a ball.
(b) She then opens the pot by pushing her thumb into the center of the clay ball. *(c)* Using gentle, even
pinches, overlapping each other, she turns the clay, continuing to open the pot as she turns. *(d)* She
begins to form the ridges by pinching the clay between her fingers. *Courtesy the artist. Photos by Charlie Krause.*

to avoid cracking and at what point the clay will
collapse if you push it beyond its limits. (Figures
11-9–11-11 show one method of pinching a pot,
and Figures 11-12 to 11-14 illustrate vessels and
figures made by pinching or a combination of
pinching with other handbuilding methods.)

Remember that it is especially important to
keep the wall even in thickness as you pinch;
otherwise the thick and thin sections will dry at
different rates, creating tensions that can cause
warping or cracking during drying and firing.

Pinching Domestic Ware

Barbara Walch of the United States uses the pinch-
ing method to make teapots, complete tea and
coffee sets (see 11-12), goblets, plates, demitasse
cups, trays, and bowls—any ware that is used on
the table. She starts her pinching process with a
handheld ball of clay, opening it with the age-
old thumb-and-finger pinching gesture (11-9).
As she continues opening and developing the
shape while at the same time refining its form

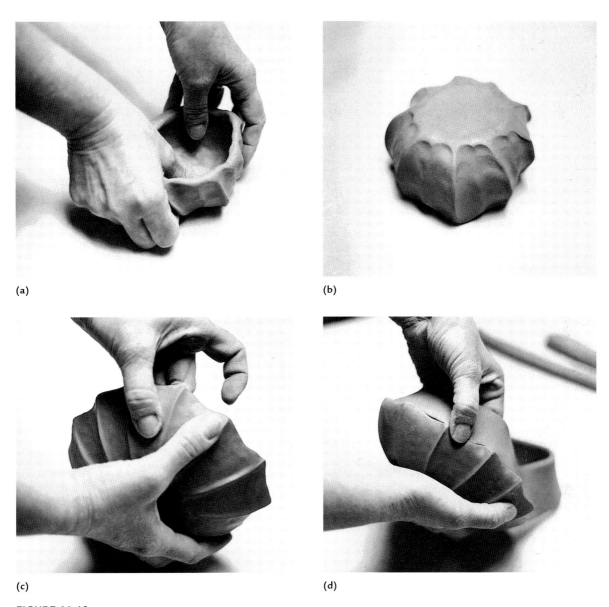

(a)

(b)

(c)

(d)

FIGURE 11-10
(a) Walch continues to open her pot and thin the wall, keeping the ridges intact. At this point she flattens the bottom between her thumb and a smooth board or tabletop. *(b)* Now she turns the pot upside down and lets it stand. At this point she refines the bottom, then allows it to stiffen enough so that she can finish the rim or add clay for height without the bottom collapsing. *(c)* Walch refines the ridges and the areas between them. *(d)* Adding flattened coils, she enlarges the pot, moistening the rim before pinching a flattened coil onto it.

and surface, she begins to delineate her ware's characteristic flowing ridges. As she works, Walch uses gentle pinches to thin the pot, keeping the ridges sharp and graceful (11-10). Then, if she wishes to enlarge it, she lets the clay stiffen for a while before adding a flattened coil. After attaching the coil securely (11-11), she pinches this added section, continuing the established ridges until she has completed the desired size

and form of pot. Her working method represents the epitome of handbuilding—she uses only her hands to shape and smooth the clay. Figure 11-12 illustrates a tea set formed by Walch's pinching and coiling method that is illustrated in Figures 11-9–11-11. This method can be adapted for shaping pots (11-13) or sculpture, or used in combination with other building techniques.

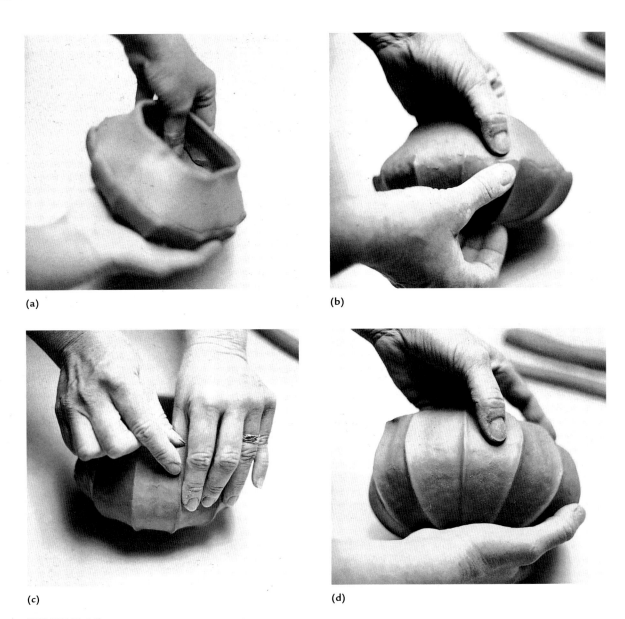

(a)

(b)

(c)

(d)

FIGURE 11-11

(a) Walch is careful to smooth the interior join, making sure the two parts are well blended. *(b)* She then repeats the pinching and smoothing on the outside, further strengthening the join. *(c)* Next, she pinches the newly added flat coil so that it conforms to the ridges of the base. *(d)* She continues pinching the ridges and valleys on the added clay until the addition becomes a continuation of the base pot. She sets the growing bowl aside periodically to stiffen so that it can be completed without sagging or deforming.

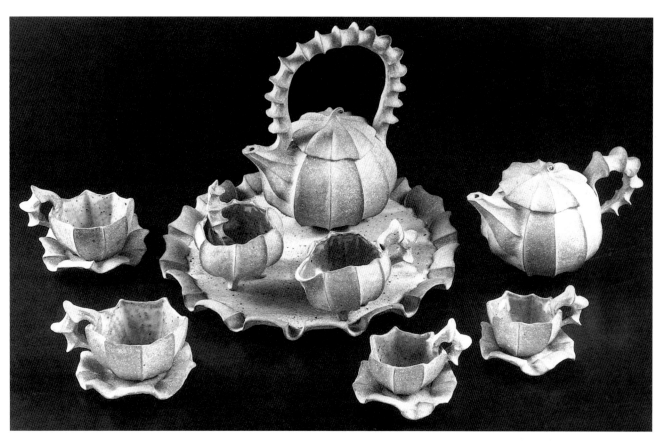

FIGURE 11-12
Pinched-coiled tea set by Barbara Walch of the United States. Walch uses two handbuilding methods for all her domestic ware. She starts with a basic pinched pot and adds coils for height, melding them onto the basic pinched form and continuing the ridges and valleys of the surface. Using this method, Walch built an entire tea set with tray, cups and saucers, cream and sugar bowls, spoon, and hot water pot. Stoneware, clay. *Courtesy the artist. Photo: Tommy Olof Elder.*

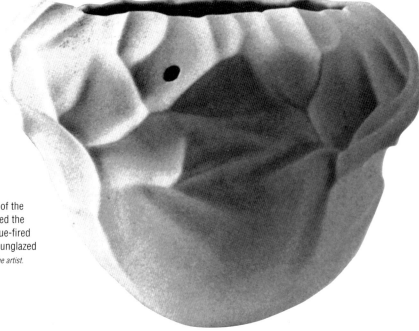

FIGURE 11-13
Harvest Moon, by Paulus Berensohn of the United States. After Berensohn pinched the clay into this thin-walled pot, he bisque-fired it and then sanded it, creating a soft, unglazed surface. White earthenware. *Courtesy the artist. Photo: True Kelly.*

SUPPORTS FOR CLAY WHILE BUILDING

It is difficult to build a vertical form of damp clay without some sort of support. When the early Greeks and the Etruscans used clay for large free-standing figures, they strengthened them by building supports of clay between the legs, disguising them either as decorative motifs—as in the Apollo from Veii (see 2-30)—or as rocks, tree trunks, or other natural supports. To be sure that any large sculpture has sufficient support, both as you build it and later during drying and firing, you can include built-in clay supports as part of its basic construction.

Weylande Gregory, who worked at Cowan Pottery in Cleveland designing small, limited-edition figurines, later became known for the large clay sculptures he did during the late 1930s and the 1940s. At that time few artists were making ceramic sculpture, and even fewer were creating such large pieces. Gregory developed his own method of building sculpture over a clay framework—a sure, but painstaking, way to support the clay while building up the wall and shaping the final form (11-14).

There are a variety of methods to support the clay while working on a sculpture. Frans Duckers, for example, used a wooden rod as a temporary support while building up a figure, but in addition he built a network of clay supports inside the figure that became part of the fired structure of the piece (11-15).

Wooden sticks and dowels or metal pipes can be removed or pulled out of the clay when it has stiffened enough to hold its shape. If you use a solid support that has little give, such as wood, pad it with something that will compress as the clay shrinks, such as newspaper, cellulose sponges, and cotton batting. Another type of removable support can be made by filling a plastic bag with polystyrene beads, vermiculite, or sand. This will give you a rounded support, which is useful if you want to shape a pot or a sculptured head or similar form. But do not pack the bag too tightly. It should be able to give a little as the clay shrinks. Also, make sure the opening of the bag is easily accessible, because as the clay stiffens you will want to pour out the contents, leaving the clay to support itself. A balloon will also work as a removable support; it can be deflated and pulled out when the clay is stiff enough to support itself.

To give additional support to the clay, you can use a simple **armature**—a support—made with a wooden dowel nailed or fitted into a drilled hole in a board, or a piece of PVC pipe screwed into a metal flange wrapped in plastic, newspaper, or other material that will allow the clay to shrink; then, when the clay stiffens, the piece can be lifted off the support (11-16).

Almost any kind of removable support that will help defeat the enemy—gravity—is worth a try (see 11-17). The support may consist simply of wads of clay that hold up an extended form while it stiffens enough to support itself. Or it may be made of crumpled newspaper, cardboard boxes, paper towel rolls, a brick or a stone, straw, tin cans, sticks of wood, a pillow, pieces of wire, bundles of cloth, foam—anything that works and can be removed as the clay stiffens. Wadded or rolled paper taped or tied to hold the approximate form you wish has the advantage that the paper will compress somewhat, allowing the clay to shrink as it stiffens and thus avoiding cracking. The paper can be pulled out before firing or, if it is impossible to pull it out without damaging the piece, if the work will be fired in a gas kiln it can be left in to burn out in the firing (see 11-40–11-46).

REINFORCING MATERIALS IN CLAY

For thousands of years people have been reinforcing clay by adding natural fibers. In Babylon, brick makers mixed straw into the clay used for sun-dried bricks. This additive strengthened the clay during both building and drying, but if fired, the straw burned out, resulting in a weaker, porous brick.

Although potters still use similar natural materials, a variety of more modern ones—nylon fiber, **fiberglass** screening, fiberglass fibers, and woven fiberglass—can now be added to clay to strengthen it; they will melt into the clay on firing. (Be sure to use protective measures, including goggles, gloves, and a respirator, when you work with fiberglass, since the floating fibers can be inhaled, may irritate the skin, or may damage the eyes.) Some sculptors use a fiber mesh developed for concrete to reinforce their sculpture as they build. The mesh burns out in the kiln. (Again, a warning: This type of reinforcement should not be fired in an electric kiln unless vented.)

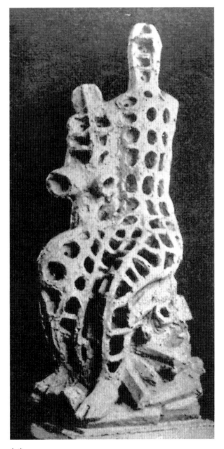

(a)

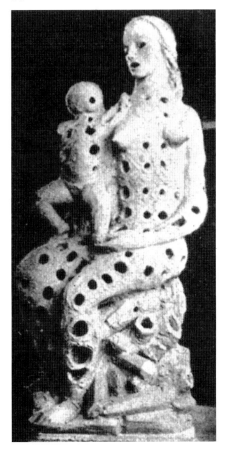

(b)

(c)

FIGURE 11-14

Weylande Gregory of the United States created large fired clay figures in the 1930s and 1940s, at a time when few sculptors considered clay as an art medium except to make originals for molds used for casting in bronze. *(a)* To make his fired clay works, he built a honeycomb clay support system. *(b)* He blocked out the entire figure first and then covered it with clay, gradually developing the finished sculpture over this support. *(c)* The finished sculpture in the kiln. c. 1944. *Photos from American Artist, September, 1944.*

(b)

FIGURE 11-15

(a) The Girl with Hat, by Frans Duckers of the Netherlands. Built hollow with thin clay slabs, this sculpture was strengthened on the inside with a network of clay supports; the forms are mainly pushed out from inside. Duckers says that, after making a series of hyperrealistic figures, he searched *for a way to accentuate the inside—the spirituality of human beings.* Stoneware clay, colored with oxides and stains and sprayed with clear glaze. Ht. 39 in. (1 m). *Courtesy the artist. (b)* Duckers supports the figure with a wooden dowel attached to a wood platform to keep the sculpture from tipping over. He scores the edge of the figure, adds slip, and then attaches a coil flattened into a slab. As the figure gets taller, Duckers lets the lower section stiffen slightly so that it can support the weight of newly added clay. *Courtesy the artist. Photo: Veronique Jean.*

(a)

(a) Solid clay

Moist clay
or foam

Concrete block
or brick

(b) Solid clay

Fabric sling

Tape

(c) Hollow clay

Foam
Plywood
Washer
All thread
Wingnut

(d) Hollow clay

Lower flange

(e) Hollow clay

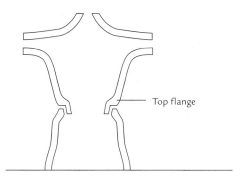

Top flange

(f) Hollow clay

FIGURE 11-16

These schematic drawings show various supports for
damp clay and connection methods as well as joins
between sections. These can be used when making
sculpture or pottery, either solid or hollow. *(a)* Plastic
sheeting makes a good separator between solid or hollow
clay sections. *(b)* To keep an extended or cantilevered
form from sagging, prop it on foam or moist clay placed
on any support such as bricks or a block. *(c)* Tape around
a form keeps the clay structure from bursting or sagging.
A sling attached to a rigid support holds an arm in place
while drying. *(d)* Foam, plywood, and a metal rod through
the plywood can be tightened as the section shrinks. (Use
stainless steel hardware to prevent rust and corrosion.)
This keeps the piece compressed and prevents it from
sagging or slumping outward. *(e)* A tapered lower flange
creates a support for the upper section of a sculpture or
pot—a good method for a large work. *(f)* A tapered top
flange rests on a lower section—this method is useful for
small or medium-sized sections.

Clays for Handbuilding

Chapter 10 presents additional information about choosing clays and tempering material appropriate for handbuilding, as well as information about other additives that can change the workability or strength of clay. Juliet Thorne, for example, mixes paper pulp into her clay for the added strength it gives her coiled torsos (see 11-23–11-32), and Juan Granados incorporates nylon fibers into the clay body he uses for his sculpture (see 11-40). (See also *Expertise,* Chapter 1C.) The type of clay used will depend on how thick the walls of the piece will be and the temperature at which it will be fired. If the clay has already been put through a pug mill (see 10-9), wedging will

not be as necessary for coiling, but it is still important to make sure the clay contains no lumps or air bubbles. If you will be melding the clay together as you work—by pressing the coils together with your fingers, smoothing them with a rib, or paddling the walls—wedging the clay before use is not as vital as it would be if you were planning to leave the coils unmelded.

ARMATURES

From the Renaissance until quite recently, sculptors generally used clay to build a figure up on an armature to provide a model from which to make a mold for casting metal sculpture. A

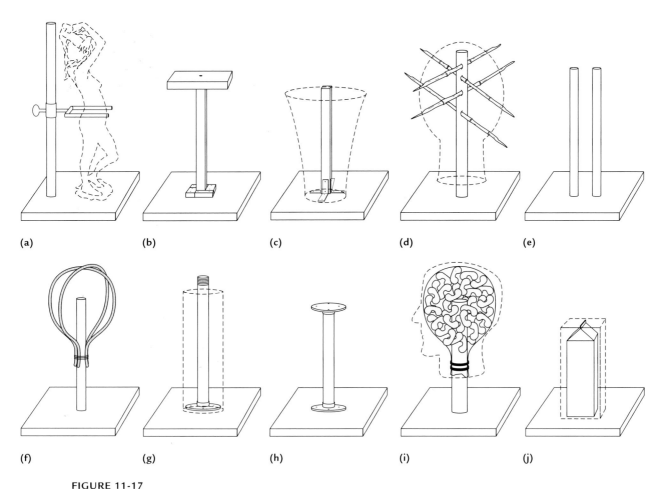

(a) (b) (c) (d) (e)

(f) (g) (h) (i) (j)

FIGURE 11-17
Simple armatures for small work can be made from various common materials. All the bases are wood.
(a) Pipe, brace, and dowel. *(b)* All wood. *(c)* Metal angle braces holding wood. *(d)* Dowel pierced by bamboo skewers. *(e)* Two dowels. *(f)* Dowel and copper piping. *(g)* Metal flange and pipe. *(h)* Flanges at top and bottom of pipe. *(i)* Pipe and plastic bag filled with packing "peanuts." *(j)* Milk carton.

sectioned mold was made from the model, and the casting of the bronze figure proceeded.

The clay pressed onto such an armature must be kept damp, however; otherwise it will shrink as it dries and, since the armature itself cannot shrink, the clay will crack and fall off the framework. Except in rare cases, this type of permanent armature is not used for clay sculpture that will be fired (11-17, 11-18).

Armatures for building solid are generally made of wood or metal in order to support the heavy clay while a sculpture is being built up (see 11-18). Sometimes solid works are clad in metal mesh or other material that will help support the clay and make the armature lighter. The method of making a mold from a clay original has been used for centuries to cast sculptures in bronze and is still used today for that purpose, but it now can be used to make models for molds to cast in fiberglass or concrete. For example, when Tony Natsoulas was commissioned to build a series of fiberglass sculptures for an atrium space in a shopping mall, he began by welding large steel pipe armatures. After each original model was finished, he made plaster molds and cast the pieces in fiberglass (see 11-59).

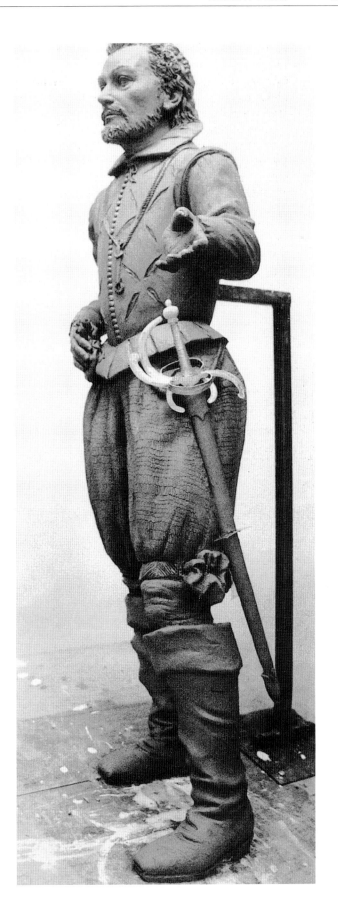

FIGURE 11-18
Ship's Captain, by Stuart Smith of England. Created as an original model for casting a sculpture, this figure was built on a metal pipe armature to support it as it was constructed. Using this type of armature meant that the figure could not be fired, only used to make a mold in which the final sculpture will be cast. *Courtesy the artist.*

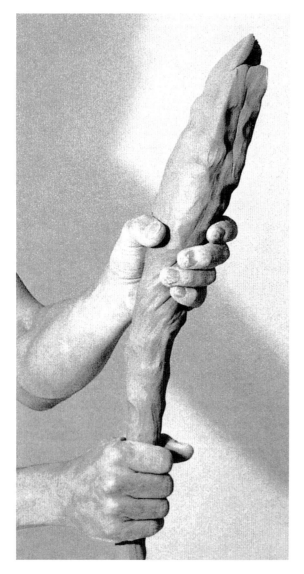

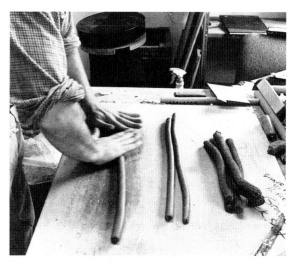

FIGURE 11-20
To build his large coiled sculptures, Graham Marks of the United States formed his coils with an extruder, then rolled them out on a table, readying them for applying.

FIGURE 11-19
You can make large coils easily by squeezing them in your hands. Thick coils are useful for large pots or sculpture (see 11-33). However, the uneven pressure of your fingers makes it difficult to keep the coils smooth.

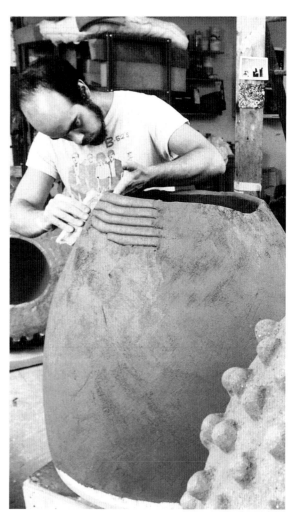

FIGURE 11-21
Marks then built the coils up over a polystyrene form, scraping and refining the surface as he built.
Courtesy the artist and Helen Drutt Gallery.

COILING

Throughout history coils have been used to build vessels such as the tall, thick-walled pithoi made to hold oil in the cellars of the Minoan palace on Crete (see 2-12); Tewa potter Maria Martinez, on the other hand, made elegant thin-walled pots using the coiling method (see 5-19). Coiling is an adaptable method for forming both sculpture and pottery, allowing one to achieve almost any shape, size, or surface.

Making the Coils

Experiment with making various thicknesses of coils, and decide what type of coil is most appropriate to the piece you plan to make (11-19–11-22). If you are rolling out coils on a table, it helps to roll with the base of the hand, rather than with the fingers, and to roll the coils from the middle out. The length of the coils depends on what you find easiest to handle and on the aesthetic concept of the work. Some potters and sculptors prefer to use coils that are long enough for only one ring at a time, while others build by spiraling a long coil up several times to create the diameter of the form (see 11-23).

Extruding Coils

Studio clay **extruders** efficiently produce round coils, squared tubes, and hollow shapes (see 11-22). They are useful for making coils for hand-built vessels or for adding coils to wheel-thrown vessels. Extruders can also produce handles for pottery, tubes for containers, and forms that can be altered for sculpture. If you plan to work in white clays or porcelain, it is advisable to use an extruder with a stainless steel or aluminum chamber and **dies** that clean well to avoid contamination after extruding colored clay.

Coiling Up the Wall

If you are building a container, obviously it will need a base. To make a convex base, press lumps of clay into the bottom of an old broken pot, a plastic kitchen bowl lined with cloth or plastic wrap, or a specially made plaster base mold. To make a flat base, pound or roll the clay out on a board or table sprinkled with grog or sand or

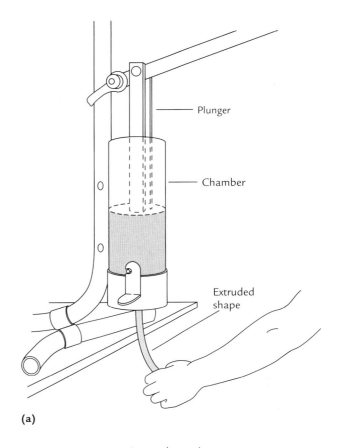

(a)

Assorted extrusions

Solid round Solid square Flat ribbon Round tube Square tube

(b)

FIGURE 11-22
Clay extruders will produce various solid and hollow shapes.
(a) The machine contains a steel, plastic, wood, or ceramic die at the end of a hollow steel chamber that holds about 5–15 lb. (2.3–6.8 k) of soft clay. At the top of the chamber is a plunger attached to a lever arm. When the arm is pulled down, the plunger pushes the clay through the die, resulting in an extruded shape.
(b) Assorted dies will make solid extrusions, such as coils for coiling pots or for shaping cup handles, and hollow tubes to be made into containers. Other dies will make wide clay ribbons for forming slab containers, or smaller ribbons for flat loop handles on casserole lids.

covered with cloth or plastic, then cut the base to any shape you want. Another alternative is to shape the base by rolling a coil into a flat spiral and then smoothing it. When building sculpture, however, there is no particular need for a base; in fact, it is often best to leave the bottom

open so that you can reach in later and remove excess clay from the interior if the wall becomes too thick while you are building (see 11-28).

Placing the Coils

One advantage of coiling is that it gives you considerable control over the shape of the pot or sculpture as you go along. To start a piece of coiled sculpture, either lay out the first coils in an approximation of the form of its base and develop it as you build it up, or start with a cylinder that you can push or paddle into shape as you go along. Whether you are building a pot or a sculpture, it is extremely important to revolve your work on a turntable or move around it yourself to see how it is progressing on all sides (see 11-29).

Joining the Coils

Because a coiled pot or sculpture is made up of many separate pieces (unlike a pinched one, in which the clay is actually melded together), the joins between coils must be properly made. If they are not, the coils may pull away from each other as they dry, and cracks or breaks may develop at those points when the piece is fired. Whether you add coils while the clay is quite wet or let it stiffen somewhat between rings, be sure that each coil is firmly attached to the one below it. If you plan to smooth the coils with a rib or to paddle the outside while you hold your hand or a smooth rock inside to support the walls, you may not need to do more than push them together with your thumb, because the smoothing or paddling will also meld them together, constricting the clay and strengthening the walls. Many potters and sculptors meld their coils completely as they go along to ensure that the joins are strong or to achieve a smooth surface (see 11-21 and 11-36). Others, like Juliet Thorne (see 11-23–11-32), may keep the coils distinct in order to create a surface that emphasizes or contrasts with the form of the piece.

When coiling up a small pot or sculpture, keep the wall pretty much the same thickness throughout, but if the piece is to be large, with a quantity of clay built on top of the lower coils, it is a good idea to use somewhat thicker coils toward the bottom and gradually make the coils thinner as you continue. The difference in coil

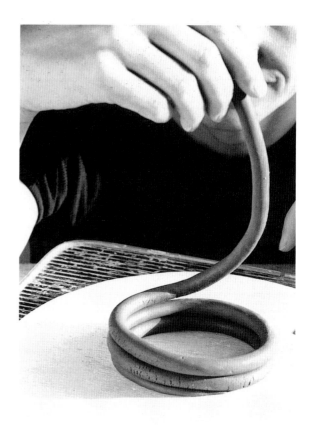

FIGURE 11-23
Juliet Thorne slants the first coil's end, establishing a secure base for the torso. She leaves the base open, allowing moisture to escape during firing. *Courtesy the artist. Photos: Robin Brown.*

thickness might not be more than a fraction of an inch, but even that can reduce the weight of the added clay considerably.

Coiling a Torso

British sculptor Juliet Thorne developed her meticulous coil building technique in order to build sculpture, but the technique could also be applied to pottery. She works on her clay torsos this way so that the coils appear continuous, giving her figures a sense of movement and rhythm.

Thorne begins to build up the form with the first coil, leaving the base open. Using coils no more than two feet long, she joins them as she builds, maintaining the contours of the torso while leaving the coils showing on the surface. She does this by carefully attaching the coils and melding them only on the inside as she builds. After attaching the two ends of the coils so that they appear continuous, she periodically sets the figure aside and covers the last series of

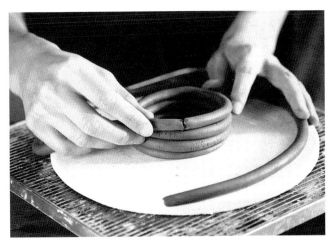

FIGURE 11-24
Thorne moistens the coil ends slightly, then adds slip before joining them. To keep a continuous line, she may add some clay and smooth it in.

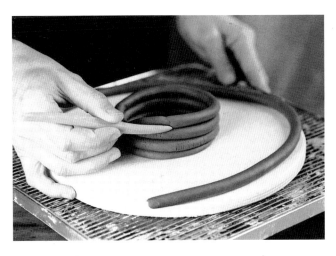

FIGURE 11-25
Thorne keeps the coils well defined as she builds. The continuous line of the coils give her torsos movement and rhythm.

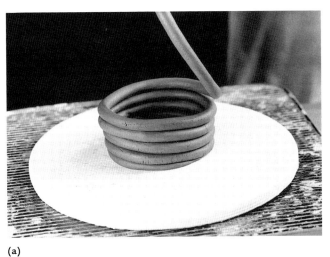

(a)

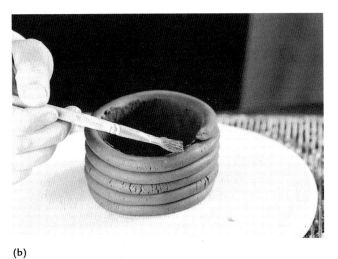

(b)

FIGURE 11-26
(a) Continuing to coil up the wall, *(b)* Thorne builds up the wall without melding the coils until the piece reaches a height of about 3 in. (77 mm).

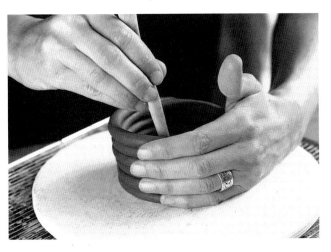

FIGURE 11-27
With plastic over the clay, the coils will stiffen until they can support additional weight. Thorne often works on an other piece in the meantime.

FIGURE 11-28
Using a small curved sculpture tool, Thorne scoops up clay to meld the coils together on the inside. This will ensure a good bonding of the coils.

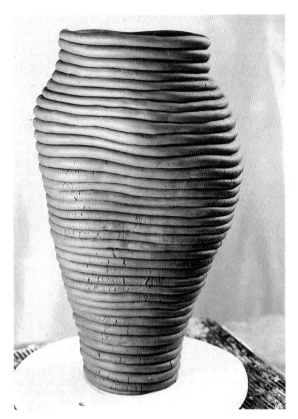

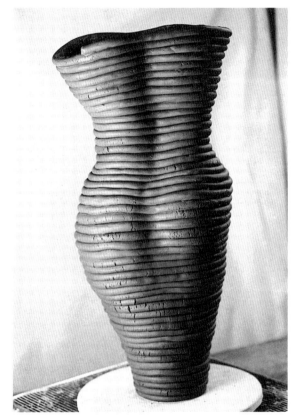

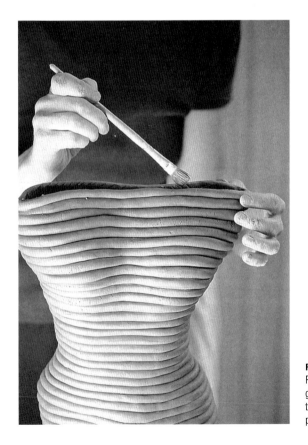

FIGURE 11-29
Thorne turns her work frequently, ensuring that all its forms flow together rhythmically. Each coil is placed so as to emphasize the form.

FIGURE 11-30
With its open top and spiraling form, the torso now suggests a container—echoing the ceramics terms used to describe the parts of a vessel: *body, waist,* and *neck.* Shown here is a back view of the torso.

FIGURE 11-31
Reaching the top of the torso, Thorne gradually brings the coils together. When they meet, the top row will be moistened, painted with slip, and closed.

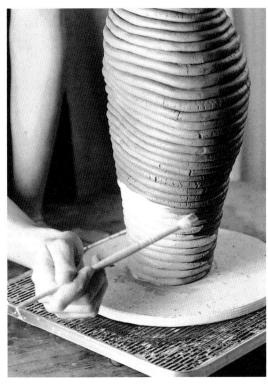

(a)

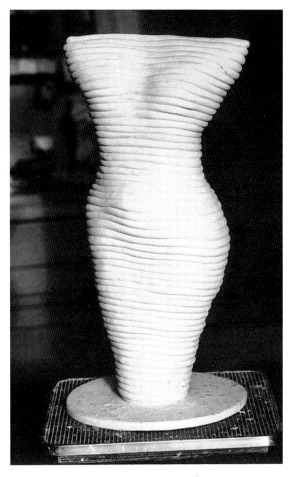

(b)

FIGURE 11-32
(a) Thorne paints white slip on the torso before firing. Because the base is open, there is no need to leave vents to allow for moisture to escape during firing. *(b)* The torso is finished and set aside to dry. Note how the spiraling coiled surface carries the eye upward and around the body.

coils with plastic so that the clay will stiffen enough to carry the weight of additional clay.

To ensure that the torso is equally effective on all sides, Thorne turns it frequently. Viewing the forms from every aspect, she works on a revolving sculpture stand or walks around the piece frequently. On completion of the torso, she applies a coating of slip that provides a smooth ground for the glaze (11-32).

Various Coiling Methods

Norbert Prangenberg built his massive coiled pots as sculptural forms rather than for utilitarian use (11-33). He kept the coils unmelded. This coiling method is also used by Ernest Aryee to create large sculptures (11-34). He uses extruded coils, melds the coils together to create a relatively smooth surface, cuts the work up into

manageable pieces to fire them and then reassembles them after firing.

Aryee, who came from Ghana to the United States via the Netherlands, where he lived for three years, spent nine months at the European Ceramics Workshop in 's-Hertogenbosch. There he found much to draw on for the development of his large-scale sculpture, but his work remains largely African in its roots, images, and working methods. Although he also builds sculptures from wheel-thrown sections (see 9-3), he forms others with coils, using the extruder to make them. His pieces are earth-toned, formed with red, coarse clay, and fired in reduction.

Jun Kaneko (11-35) also builds with coils, but he melds the coils together to create semismooth surfaces suitable for decoration. S. H. Chen, on the other hand, smoothed the surface of his pot shown in Figure 11-36 and coated it with glaze, making the coiling process invisible.

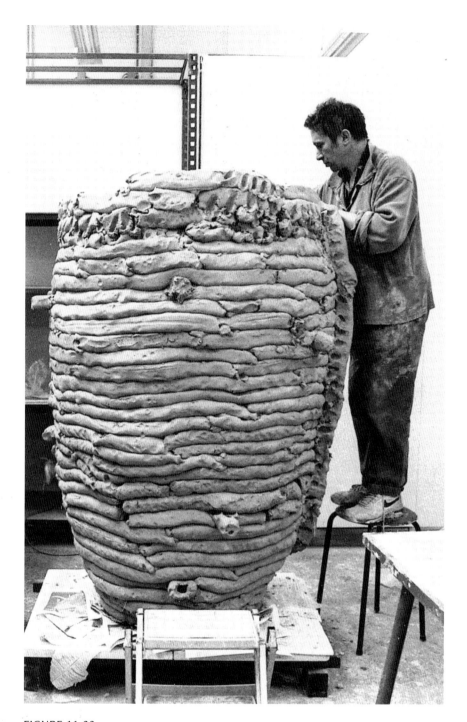

FIGURE 11-33
Norbert Prangenberg of Germany, working on one of his tall coiled vessels. As he develops the vessel form, the texture created by the thick coils brings vitality to the surface. *Courtesy European Ceramic Work Centre, the Netherlands.*

(a)

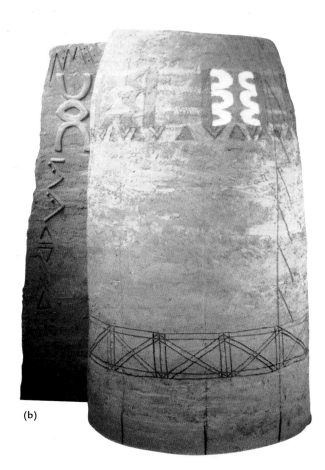

(b)

FIGURE 11-34

(a) Ernest Aryee, originally from Ghana, building his coiled piece *Left Over of the Spirit*. Influenced by the granaries that hold seed in Africa, he sees his work as dealing metaphorically with fertility and the continuity of life. He built this piece *(b)* with extruded coils; then, when the entire piece was complete with relief and slip decoration, he cut it into sections *(c)* to prepare it for firing. Red, coarse-grained earthenware clay, fired in reduction.

Courtesy the artist.

(c)

FIGURE 11-35
A group of *Tall Dangos* by Jun Kaneko of the
United States. These variously decorated forms
were coil-built of stoneware clay. 70 × 22 × 30 in.
(178 × 56 × 76 cm). *Courtesy Dorothy Weiss Gallery.*

FIGURE 11-36
Teapot, by (Bob) S. H. Chen of Taiwan,
Republic of China. Chen built the pot by
coiling, but to achieve its elegance of
form, he refined the shape and surface
so that no suggestion of the coiling
technique remains. White glaze, fired at
2246°F/1230°C. *Courtesy the artist.*

In a quite different style of work, Stuart Smith used coils to build his *Porter* (11-37) hollow, then added clay to allow him to detail the figure and model the face.

SLABS

The constructive method of building pots and sculptures from slabs of clay is a relatively new development in ceramics. It is true that small slabs of clay were used in the past to build pots (see 1-10) or pressed into molds to make figurines, but the method of building up forms from slabs as it is often done today grew out of the changes that took place in twentieth-century sculpture when constructive, as opposed to cast-metal, methods became popular.

Making Slabs

Slabs can be made by slamming the clay on alternate sides on a table or floor until it flattens, by rolling it out flat with a rolling pin (11-38), by combining small slabs to make large ones, or by putting the clay through a **slab roller** that produces a slab of even thickness (11-39). Casting slabs by pouring slip onto a flat plaster bat or into a two-part mold is another technique. Pouring the slip onto a bat works well for making thin slabs—say, $^3/_{16}$ in. (5 mm) thick—to be used for small works such as jewelry or for test tiles. To make thicker slip-cast slabs, $^1/_4$–1 in. (6 to 25 mm) thick, a two-part mold will do a better job of forming them and will make an even slab that will not warp. It is also possible to extrude a tube, slice it lengthwise, and flatten it into a slab.

Whether slapped, rolled, pressed, or extruded, slabs generally provide a structurally strong and dense building material. This is because the pressure exerted on the clay to form the slabs tightens the clay's microscopic structure, thereby strengthening the slab.

Soft Slab Construction

Working with soft slabs allows considerable spontaneity in construction. Paula Winokur, for example, drapes clay over molds or in slings made of plastic or fabric, removes it while still

FIGURE 11-37
Porter, by Stuart Smith of England, was inspired by street life he saw on a trip to India. Unlike Smith's piece shown in Figure 11-18 that was built solid for casting, this sculpture was built hollow with coils and then detailed with added clay. Since achieving a worn look of poverty was important to the concept of the work, Smith painted the white stoneware clay with underglazes and a white crackle glaze, then raku-fired it. *Courtesy the artist.*

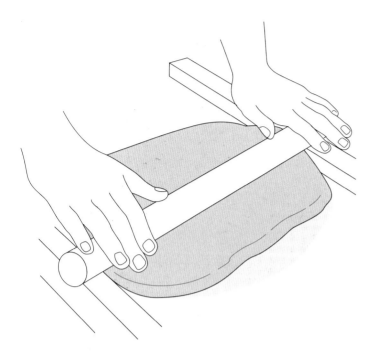

pliable enough to detail, and refines the rocklike or organic forms (see 9-7, 16-15). This method of working with soft slabs often takes advantage of gravity, allowing the clay to slump and find its own resting place over or in a form.

Juan Granados drapes his soft slabs over bundled newspaper, adapting the method used in Mexico to shape piñatas (11-40–11-46). Granados has been fascinated by the process of growth in plants since childhood, when with his parents he worked in the fields as an agricultural laborer. His background led him to a lifetime study of shoots, seed pods, and other organic shapes, which he incorporates into his wall pieces (see 11-46) and in his large installations (see 13-7, 16-8). Laying the soft slabs over bundles of newspaper, he paddles the surface, modeling the pods, stems, leaves, and other botanical shapes and adding texture and detail.

FIGURE 11-38
Using a kitchen rolling pin or a dowel to roll out the clay between two strips of wood is an easy way to make slabs of even thickness for pots or small sculptures. The wooden strips guide and control the thickness of the slab.

FIGURE 11-39
A slab roller is useful when evenly thick slabs and well-compressed clay are appropriate for the building method to be used. Here Glenda Castain rolls out a thin, dense slab. After removing the soft clay from the roller, she will store it overnight to stiffen before cutting it to shape. *Courtesy Richmond Art Center Ceramics Studio, Richmond, CA. Photo: Carl Duncan.*

FIGURE 11-40
Juan Granados works with clay into which he mixes nylon fibers, an additive that gives greater strength to the clay slabs.
Courtesy the artist.

FIGURE 11-41
Granados bundles and securely tapes newspaper into an approximation of the form for one of his wall pieces.

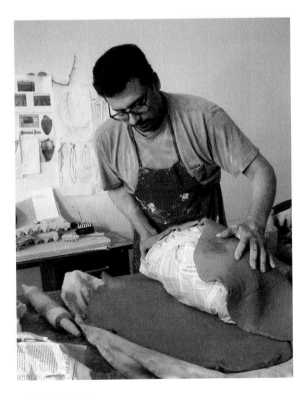

FIGURE 11-42
After careful preparation of the paper support, Granados lays a soft slab over it, shaping the clay as he proceeds, then joining the slab edges to complete the basic organic shape.

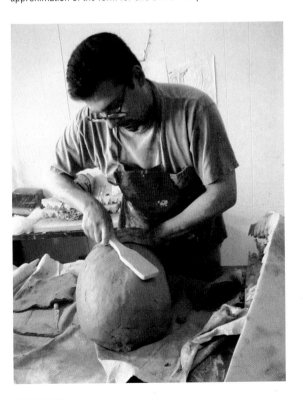

FIGURE 11-43
After the slab edges have been joined, Granados paddles the slab, shaping and refining the form. This process also tightens the pores of the clay.

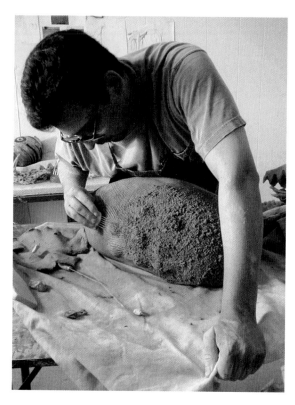

FIGURE 11-44
Once formed, the clay can be textured or clay can be added or pushed up from within to create variations on the surface.

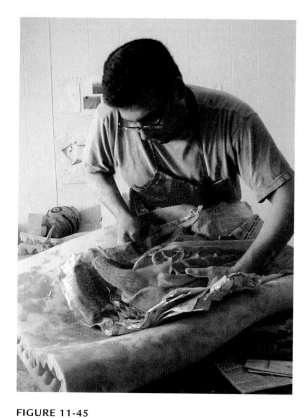

FIGURE 11-45
Once stiffened enough to move, the completed piece is placed to rest on foam rubber, where it can safely dry before firing. Granados cautions that a work built over a paper support *must not* be fired in an electric kiln unless the paper has been removed by pulling it out through a hole left for that purpose. The hole can be plugged up before firing.

FIGURE 11-46
Growth, a wall piece by Juan Granados of the United States. Using a method that comes from his Mexican heritage, Granados's sculpture is based on his early study of emerging shoots, seed pods, and other organic forms while working in the fields. Red earthenware clay, glazes. 30 × 23 × 10 in. (76.2 × 58.4 × 25.4 cm).
Courtesy the artist. Photo: Jon Q. Johnson.

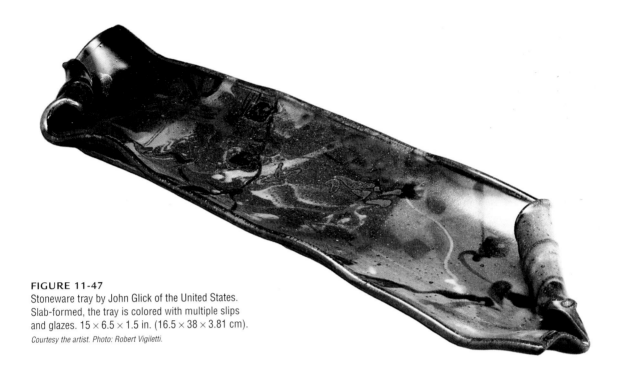

FIGURE 11-47
Stoneware tray by John Glick of the United States. Slab-formed, the tray is colored with multiple slips and glazes. 15 × 6.5 × 1.5 in. (16.5 × 38 × 3.81 cm).
Courtesy the artist. Photo: Robert Vigiletti.

 Granados warns that any sculpture formed over paper must not be fired in an electric kiln before the paper is removed through a hole made in the sculpture. This hole can then be plugged up before firing.

Soft slabs are adaptable to many situations and molding methods. John Glick, for example, used a slab to shape a free-form tray (11-47), while Paula Winokur drapes soft porcelain over or in a variety of objects and molds to create her geologically inspired sculptures (see 9-7, 16-12–16-15). Soft slabs can even be formed over parts of a living body if the model is willing to sit still long enough for the clay to stiffen a bit. The judicious use of a hair dryer at a low setting can speed up the process. Soft slabs can also be adapted to forming pottery, using **drape molds** or hump molds (see 13-3, 13-7), and pottery can also be shaped using semi-stiff slabs (11-48).

FIGURE 11-48
Mountain Charm, a handbuilt slab vase by Chen Songxian of the People's Republic of China. Its flowing tricolored glaze suggests a waterfall reminiscent of the scenes portrayed in classical Chinese paintings. 24 × 11 in. (61 × 28 cm).
Courtesy the artist.

FIGURE 11-49
Larissa Martin of the United States built a series of slab boxes and then assembled them around a ceramic tree trunk. Her untitled sculpture was built in three sections, then assembled and glued with silicone. Finally, it was colored with ceramic stains. Ht. 67 in. (1.7 m). *Courtesy the artist.*

Working with Stiff Slabs

Working with stiff slabs requires advance planning. If you work with a hard-edge slab method, you will use leather-hard slabs, joining them carefully with scoring and slip (11-49–11-56). If the slabs are complex in shape, it is a good idea to have a pattern or template to use when cutting out the slabs. This will ensure that the edges of the clay shapes will match, and if you bevel (slant) the edges, the joins will be even sharper

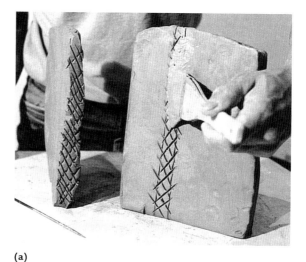

(a)

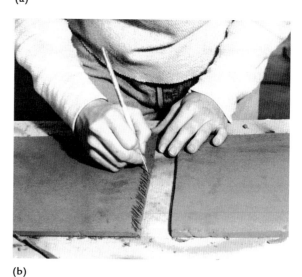

(b)

FIGURE 11-50
(a) Construction with stiff slabs calls for careful planning and precise craft, since the structure of a piece depends on the strength of its joins. If the image calls for hard edges, building it carefully with leather-hard slabs and strong joins is essential. *(b)* Martin first scores the edges. If the slabs are too stiff, painting vinegar on the edges will soften the clay.

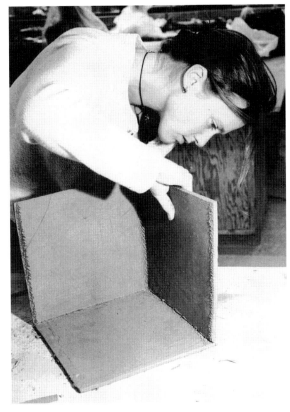

(a)

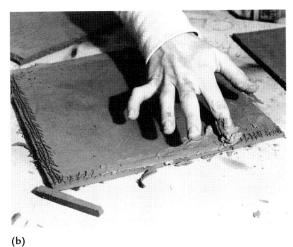

(b)

FIGURE 11-51
(a) As Martin constructs a hard-edge form, she test assembles her cut slabs to be sure they will fit tightly at each corner. *(b)* She continues scoring, coating the edges with a thick mixture of slip and scoring them again before assembly.

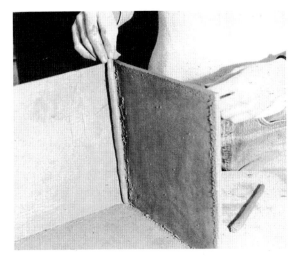

(a)

(b)

FIGURE 11-52
(a) To strengthen each join, after scoring it once more on the inside, Martin places a thin coil of clay along the join. *(b)* She then presses down on the coil, melding it to the wall and base.

FIGURE 11-53
With all four sides and the base assembled, a leather-hard slab can be fitted for a lid. After scoring and slip-coating the box edges and the lid, Martin will carefully press down on the top to seal it. *Courtesy the artist.*

FIGURE 11-54
These drawings show the process of joining two slabs, progressively increasing the strength of the join. The principles of each technique work at all scales; however, for small slabs technique *(a)* and *(b)* may be sufficient. For larger work, an additional coil at the join as well as corner braces will help make the connection more rigid. *(a)* To join two slabs, score both slabs (1, 2) and add slip. *(b)* Push slab (1) into position on the base (2). *(c)* Score the back of the join and smooth. *(d)* Add a clay coil to the join for additional strength. *(e)* Smooth out the clay coil and blend into both slabs (1, 2). *(f)* Add corner braces for strength.

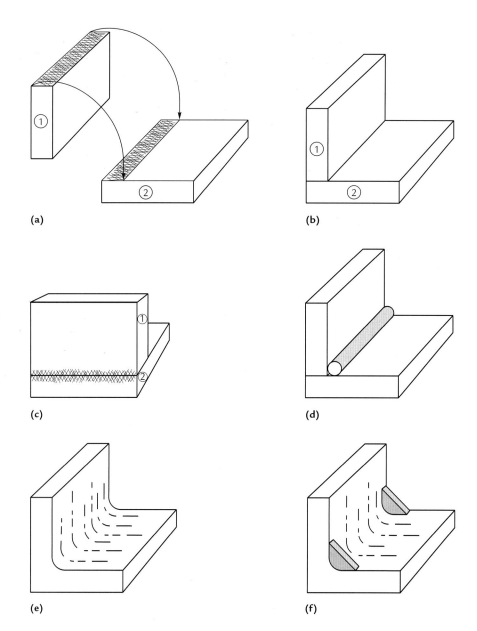

and tighter. Once cut, the edges of the leather-hard slabs should be scored and painted with water or slip or both. Larissa Martin even scores twice, before and after applying slip (see 11-51).

The slab edges should be pressed tightly together, and as an added support a small roll of clay can be inserted along the joins to strengthen them. This precise method of cutting and assembling leather-hard slabs allows for careful control (see 11-54). Building with stiff slabs takes patience and care, but it is well worth the effort because leather-hard slabs can be used to construct a variety of ceramic objects: A tall slab-built form can become a vase to display an elaborate glaze or decorative treatment (see 11-48); stiff slabs can

also be used to build a palace, a tower (see 3-11), an ancient-appearing boat (11-55), or two mysteriously journeying houses (11-56). Although this technique of slab building may not allow as much freedom as building with soft slabs, a creative attitude will lead to new ways to use the method freely.

Frank Steyaert lives in Belgium and works in a studio on the heavily traveled river Dender. Unlike the modern working boats that go by his studio window, his ceramic boats have a mysterious ancient appearance, as if dug out of the depths of a marshland.

Steyaert works on his boats only in winter, when he can keep the approximately 4 ft. long

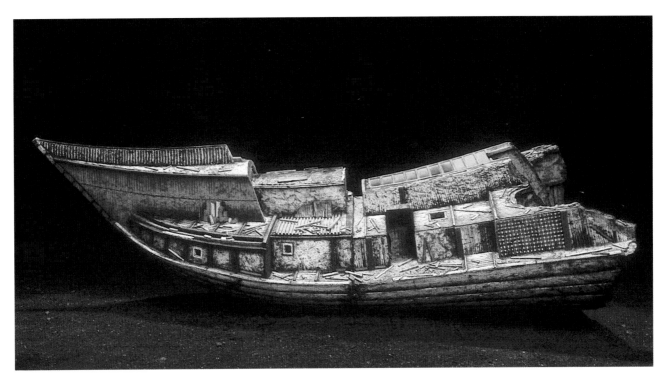

FIGURE 11-55

Frank Steyaert of Belgium constructs his apparently wrecked and rotting boats in a plaster mold—used
only to support the hull while he builds it with coils. Before he starts to build, Steyaert draws a careful
architectural plan. All the details both inside and out are cut from slabs and attached with slip. Black
clay with grog; colored slips and oxides applied before firing. 48 × 21 × 23 in. (123 × 53 × 59 cm).
Courtesy the artist. Photo: Jan Pauwels.

FIGURE 11-56

The Passing of Two Houses, by Robert Winokur of the United States. Winokur has constructed a series
of slab-built houses, shops and churches. Empty and dilapidated in what may be a deserted frontier
town, their worn surface is imparted by the salt firing. Brick clay, salt-glazed. 12 × 31 × 6 in. (30 × 79
× 15 cm). *Courtesy the artist.*

(125-cm) hull damp for the two or three months it takes to complete it. Before he begins to build, he draws a detailed architectural construction plan for the interior and exterior of each boat. He builds each boat in an individual plaster mold, not to reproduce the hull but to support it; the plaster also helps keep the clay damp. In addition, he keeps the work covered with plastic except for the section on which he is working.

Using coils to build the hull in the mold, he then cuts the details out of slabs and attaches them with slip. Before closing in the deck, he installs hatches and other details and places miniature replicas of objects such as half-decayed fishing baskets and broken clay vessels inside the hull.

Steyaert increases each boat's ancient appearance through his surface treatment; both before and after the bisque firing, he paints on layers of oxide-colored slips and oxides and finally the dark color. Each boat may be given as many as five firings (see 11-55, 9-2).

KEEPING WORK-IN-PROGRESS DAMP

It is often necessary to keep a partially completed pot or sculpture damp between work sessions. There are various ways to do this. For example, if you do not mind a certain measure of coarse texture on your handbuilt pot or sculpture, you can add 1–5% pearlite to the clay before you start work. This will help keep the work at a consistent moisture level. The usual way to keep your work damp, however, is to wrap it in moistened—but not dripping wet—cotton rags, blankets, or towels and then cover it completely with plastic.

A misting spray bottle is also useful for keeping your work from drying out too fast. Rather than spraying the clay itself, use it to dampen the wrapping cloths to keep them moist but not too wet. Be careful, however, not to overspray a piece or to redampen a too-dry one. Just how damp you will want to keep your work depends partly on how you work. For instance, if you intend to attach new wads of clay to a pinched sculpture, you will need to keep it moist in order to meld in the new parts. If you are adding soft clay coils, you will also want to keep your work quite damp. If, however, you are working with stiffer clay, scoring and painting with slip to attach new

coils, you do not need to keep it so damp. For stiff slab construction, leave the clay to stiffen to leather hardness before proceeding.

Some studios have damp rooms where the humidity is carefully controlled to maintain the dampness of objects or dry them slowly (11-57). If such a facility is not available to keep your work damp, you can use a covered canister or tin for small work or an old camping refrigerator or an inexpensive polystyrene cooler for somewhat larger pieces. But if you do not have access to a damp room, the best method for large sculptures or thick-walled pots is to wrap them tightly in plastic between sessions.

DRYING POTS OR SCULPTURE

The thoroughness and care with which you dry a pot or sculpture are as important to the total process as the forming; hours of work can be destroyed by careless drying. The thicker you make the wall, the more slowly you should dry the piece before it is safe to expose it to the warm air of a studio. This is because as clay dries and moisture leaves its pores, the clay particles move together and shrinkage occurs (generally 5–10% and sometimes as much as 20%). If this happens too fast, it can warp or cause cracks or even breaks in the wall or joins. This is another reason for making sure the wall of a pot or sculpture is fairly even throughout. A very thin section will dry much more rapidly than a thick area, causing uneven shrinkage. If this happens, you may face discouragement as the work of hours or days warps or pulls apart.

It is best to dry all clay objects slowly and evenly in circulating air. It *is* possible to use a hair dryer or heat lamp to help stiffen the clay, or to place the work near a warm kiln to speed up the stiffening. If you place your work near a heat source, however, don't forget to turn the piece often to prevent one side from drying faster than another; one ceramist sets his work on a slowly revolving electric wheel with a hair dryer directed at it. The key to successful drying is to let the clay dry slowly until the surface changes from a damp to a dry, matt look. When you see that the surface has changed in this way, you will know that the clay has shrunk about as much as it will before being fired. Up to this point, any heat used to accelerate the drying must be applied only with great care. Once your

FIGURE 11-57
Many school studios have a facility for keeping work moist between sessions, like this damp room. Here, Peter Coussoulis, manager of the Walnut Creek Arts ceramic studio, looks for the best spot to place a large vase. The room is equipped with an electrically controlled and pressurized steam-generated humidifier that keeps the pottery and sculpture damp between class sessions. *Courtesy the City of Walnut Creek, California, Civic Arts Education Program, Walnut Creek Civic Arts Center. Photo: David Hanney.*

work seems dry to the touch, it can safely be exposed to the air to continue drying, but it must be completely dry before it is fired. One easy way to determine whether a piece is dry enough to place in the kiln is to hold your cheek to the clay. If it feels cool to the touch, chances are it still contains moisture and needs additional drying time.

Drying Tents

One method of drying clay evenly, used successfully at the European Ceramics Work Centre in Holland, is to construct a newspaper tent. Tape or staple a single layer of newspaper into a shell that conforms loosely to the shape of your work, and place the tent over it. Unlike plastic sheeting, the newspaper breathes so that the clay dries evenly, and you can slow the drying process even further by adding additional layers of paper.

Another simple and economical method for accelerating the drying process of pottery or sculpture is to construct a drying tent out of plastic sheeting or a tarp. This kind of tent offers flexibility, especially for drying oddly shaped work (11-58). To do this you will need a small 1000 to 1500 watt electric heater with fan and thin, lightweight clear plastic sheeting, along with a number of bricks or weights. Cut the sheeting about 50% larger than the area to be covered. Loosely drape it over the leather-hard work, and place bricks or weights every 1 to 3 ft. (.5 to 1 m) around the perimeter to hold down the plastic. At one end of the tent, build up a small brick chamber in which to place the heater, with enough room around it so that it is not touching the plastic. Be sure that all combustible material is at least 1.5 ft. (.46 m) away from the heater.

Turn the heater on low, and let the hot air fill the chamber. Once the plastic tent has expanded, cut three or four small openings into

FIGURE 11-58
Made with bricks, cinder blocks, a kiln shelf, and thin plastic sheeting and equipped with a heater, a plastic drying tent will dry large pots or sculpture. Place the plastic over the work, the heater between two cinder blocks, and the kiln shelf on top of the blocks to keep the plastic away from the heat. Then place four or five bricks as heat baffles about 15–20 in. (38–51 cm) in front of the heater. After you turn on the heater and the tent puffs up with warm air, make about four or five slits about 2 in. (5 cm) long in the top of the plastic to allow the heat and moisture to escape.

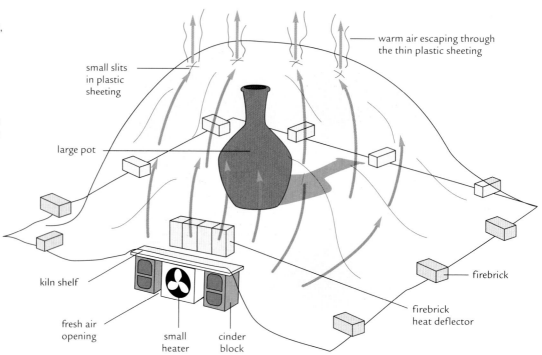

warm air escaping through the thin plastic sheeting

small slits in plastic sheeting

large pot

kiln shelf

fresh air opening

small heater

cinder block

firebrick

firebrick heat deflector

the top of the sheeting to let out the damp, warm air. The heated chamber creates an evenly pressurized drying system that can be adapted to work of any size. A tent is especially useful in damp climates or during winter, when there is a tendency for work to dry too slowly. As the pot or sculpture begins to dry, moisture begins to collect on the interior of the plastic—a clue that the work is drying. When you put your hand in the tent and cease to feel moisture, you will know that the work is dry.

Drying in the Kiln

Once a large piece of sculpture (or sections of a large work) is dry, you can place it in a gas kiln to preheat, leaving one burner on low and the kiln door slightly open (3–10 in. [7.62–25.4 cm]) for 24–48 hours until you are *sure* that all moisture has been driven out of the clay. For an electric kiln, leave it overnight with the lid propped open 3–5 in. (76–127 mm), all the spyhole plugs open, and the heat on low. There is no way you can *overdry* your work before firing it, so give it some extra time and slow warmth rather than risk having your piece blow up in the kiln.

Now the pot or sculpture—called *greenware* at this stage—is ready for firing, an exciting, challenging, and sometimes frustrating process that is covered in Chapter 15.

REPAIRING DRY WORK

Sometimes an arm or a finger may break off a totally dry figure, or the handle may come off a pitcher. Do you have to throw the whole thing away? No. With care you can dampen the dry sections to be mended enough to reassemble them. Wrap the dry sections with moist (not wet) rags overnight. The next day, remoisten the rags and rewrap, repeating the process until both parts become damp enough to be scored, painted with slip, and reattached. To prevent the sections from crumbling, don't rush the redampening; for a large piece of sculpture, redampening both parts equally may take two or three days.

You may decide, however, that redampening a broken pot or piece of sculpture is not worth the effort. In that case, go ahead and fire the main section along with the broken-off part and use an adhesive to glue them together after the final glaze firing. To do this, use a method employed by industrial ceramics companies: Mix **epoxy** with ceramic stains to match the glaze. If your clay body is coarse, you may want to mix a

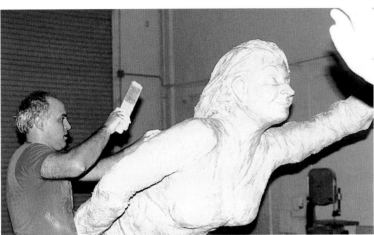

(a)

FIGURE 11-59

(a) When Tony Natsoulas of the United States was commissioned to build a series of large sculptures to be cast in fiberglass, he made the originals in clay. Here, he paddles the thick clay figure, which is supported by a metal armature. When the original was finished, a mold was made from it in which to cast the fiberglass figure. *(b)* The sturdy armature used to support the large original clay model. After welding a 1½-in. (38-mm) diameter pipe armature, Natsoulas attached plastic foam with wire and then covered the entire support with chicken wire. The chicken wire mesh kept the clay in place as he embedded a total of 1,100 lb. (500 k) of clay in the wire. *Courtesy the artist.*

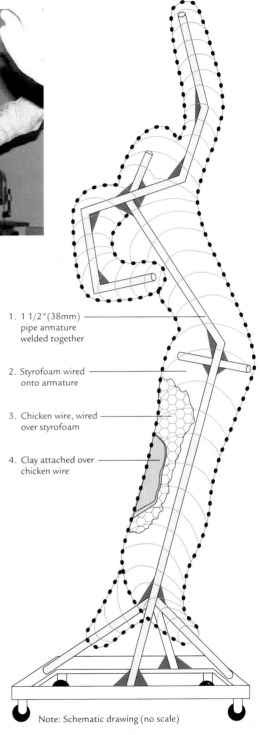

1. 1 1/2"(38mm) pipe armature welded together

2. Styrofoam wired onto armature

3. Chicken wire, wired over styrofoam

4. Clay attached over chicken wire

(b) Note: Schematic drawing (no scale)

little grog into the epoxy to give it texture. (For additional information about repair and adhesives, see page 245 and *Expertise,* Chapter 4C.)

LARGE-SCALE SCULPTURE

There is nothing new about using clay to build large-scale sculpture. Large ceramic sculpture was created during the Greek and Etruscan periods (see 2-31, 2-32), in the Nok culture in Africa (see 4-3), in areas of Asia (see 3-28, 3-40), and in northern Italy during the late medieval and early Renaissance periods (see 6-9).

Even in the 1930s, when ceramic sculpture was generally small, there were at least a few sculptors working on a large scale. Weylande Gregory of the United States, for example, built works that were very large for the time (see 11-14). Today, however, there are numerous sculptors working on a large scale either consistently or on occasion when they receive commissions for such works (see 11-60–11-64, and 16-16, 16-33).

Applying the basic handbuilding methods to large sculpture requires slow building of the walls, patience while waiting for the lower sections to stiffen enough to carry the weight of added clay, and often strong supports while building (11-59). Depending on the configuration

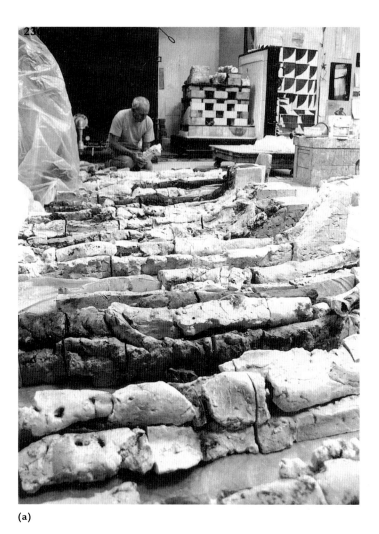

(a)

FIGURE 11-60
(a) Stephen De Staebler in his Berkeley, California, studio with sections of newly fired work spread out before assembly. *Courtesy the artist.*

FIGURE 11-61
Figure Column III, 2001, by Stephen De Staebler. Assembled after firing, the sections of his finished sculptures are permanently attached. These towering sentinels are permanently assembled with epoxy glue. 78 × 13½ in. (198 × 34 cm). *Courtesy the artist. Photo: Ira Shrank.*

FIGURE 11-62
Ephraim . . . Ephraim, by the late Lidia Zavadsky of Israel. Zavadsky's life-sized green donkey was featured in her last one-woman show in the Haaretz Museum, Tel Aviv, Israel.
Courtesy the artist's estate.

of the piece and the preferences of the creator, the inner strengthening supports can be built as clay frameworks and under certain kiln situations and temperatures can be fired as part of the piece (see 11-71).

Kiln size will dictate the size of the sections in which the piece can be built or into which it will be cut before firing. Even cut into sections, the placement of the work in the kiln can take considerable care and planning (see Chapter 15).

The methods used to attach the sections of the work require serious consideration, since large clay masses are so heavy that their poten-

tial collapse could cause damage to people or property. Before a large sculpture is placed in any public area, the installation plans should be designed or at least reviewed by a qualified engineer. (See Chapter 16 for additional information on supporting and installing large works.) Clearly, there are many considerations to take into account when creating large clay works.

Sculptors who work on a large scale, including Stephen De Staebler (11-60, 11-61; see also 8-17), develop their own methods for either building in sections or cutting the work before firing (11-61–11-64).

(a)

(b)

FIGURE 11-63

(a) Michelle Gregor of the United States builds a large figure hollow, using thick flat coils. As the lower section stiffens enough to support the added weight of the upper clay, she slowly develops the upper figure. *(b)* Gregor's *Shy Girl*. Completed and fired at cone 05, the coil-built sculpture is imposing, yet its pose successfully suggests the shyness referred to in the title. *Courtesy the artist. Photos: Helga Sigveldadotir.*

(a)

(b)

FIGURE 11-64

(a) Sybil Series, by Danae Mattes of the United States. Mattes is intrigued with the action of water on geological formations and on clay, which she says suggests a metaphor for the soul's journey through life. *(b)* Studio view with completed work and work in progress. Mattes builds her sculptures in sections, using colored clays, and adds engobes and stains for additional color. The sections are once-fired and assembled after firing with epoxy glue. *Courtesy the artist.*

POSTFIRING CONSTRUCTION

With expanding concepts of what constitutes ceramic sculpture or vessels, numerous artists have turned to postfiring construction methods. Postfiring construction gives the artist greater freedom to put together forms that would be unlikely to survive the fire intact, to make larger pieces, or to combine several materials in mixed-media constructions. The sections can be assembled permanently after they have been fired, or they can be designed to be demountable, making a large piece easier to move or ship. Given the popularity of mixed media and of constructive methods of forming sculpture, it is helpful to become familiar with adhesives (see *Expertise,* Chapter 4C). Always follow the manufacturer's instructions when using new products.

MIXED MEDIA

Although "mixed media" grew out of the twentieth-century experimental approach to sculpture, clay, one of the earliest sculptural media, has always lent itself readily to use with other materials. Holes poked into the damp clay could hold feathers or grasses after firing or allow objects to be tied onto the fired sculpture. For instance, an ancient Egyptian terra-cotta sculpture of a hippo had holes around the base in which reeds probably were stuck to suggest the rushes along the Nile. In New Guinea, clay, straw, and hair were combined in a fertility object, and throughout Africa many materials were commonly used along with clay. There the artist chose whatever material best suited his or her idea. This attitude toward materials and clay is continued in the work of some African American artists. It is seen, for example, in the work of the anonymous artists who made the "mixed media" grave markers in nineteenth-century cemeteries in the American South.

Sculptors now use every conceivable material with clay to create sculptures that may or may not be conventional ceramic works but that make use of clay for at least part of the work (11-65–11-72). Many of these works depend on assembling sections after firing is completed. Gail Rushmore (see 9-1), for example, builds her figurative, mixed-media sculpture with slabs, frequently incorporating metal, wood, and bones into the composition. These nonceramic additions are added after firing and attached with epoxy glue. She raku-fires, using glazes as well as gold leaf applied after firing. The turkey bones on *Eve—Under Construction* are coated with thinned-down white glue.

ADHESIVES

Silicone

This type of adhesive is generally used to temporarily or, in some cases, permanently glue together ceramic sections. Silicone is flexible and can also fill relatively large gaps between sections. When used in small amounts, the adhesive can be pried loose or cut apart with a knife, so it

FIGURE 11-65
Ya Mei Kuo of Taiwan, Republic of China, combines clay with finely crafted wood and metal in her slab constructions.
Courtesy the artist.

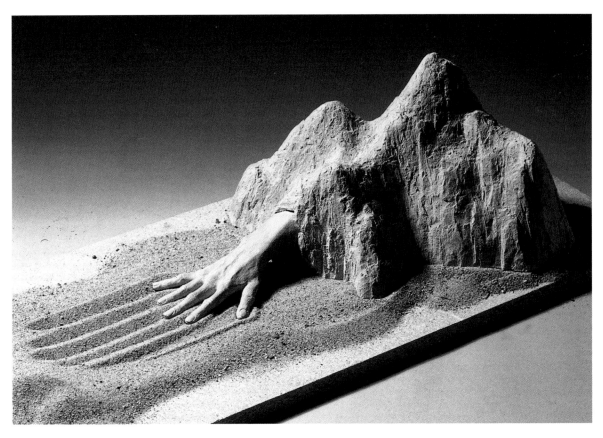

FIGURE 11-66
Transmutation Series #4, by Rita Sargen-Simon of the United States, is a mixed-media piece built of earth materials—clay, travertine, and sand—in a plea for respect for the natural environment. Sargen-Simon spread sand on the travertine, sprayed the sand with a fixitive to hold it in place, and topped it with loose sand. *Courtesy the artist.*

can also be used for gluing ceramic to concrete, to wood, or even to tile floors for temporary installations. You can also use silicone to glue glazed sections or to repair functional pottery if it is to be used in the oven or on top of the stove: Silicone glue can take some oven heat without disintegrating, but if used on top of the stove it must not come in direct contact with the flame.

Epoxy Glues

Ceramists use two types of epoxy. The five-minute-setting epoxy is valuable for quick repairs that will set while you hold the parts to-gether, but it usually does not hold up when exposed to excessive moisture or direct contact with water. Overnight-setting epoxy is generally stronger and more resistant to weather. Neither of these types of epoxy can take direct-flame, oven, or kiln heat. Both types can be combined with glass fiber for additional strength and can also be thickened with silica (flint) to form a puttylike glue that will not drip. These can be colored with ceramic stains, clays, or even tempera paints to match clay or glaze colors for patching or filling cracks. *Expertise,* Chapter 4B contains a list of color additives that can be used to color epoxy for repairing fired work, along with other information on adhesives.

FIGURE 11-68
Buddhist in the Clouds, by Luo Xiao Ping of the People's Republic of China. Luo used the purplish local clay of Xyching to sculpt a symbolically headless figure and placed it on marble clouds. It shows, he says, *the Buddhist in the clouds detached from worldly concerns.* 19 × 10 × 23 in. (48 × 25 × 59 cm). *Courtesy the artist.*

FIGURE 11-67
Clayton Bailey of the United States used clay, light, sound, and imitation fire in his *Drop Coin, Fight Satan.* Bailey has been creating innovative ceramics combined with other materials for some time (see Chapter 8). 30 × 24 × 12 in. (76 × 61 × 30 cm). *Courtesy the artist.*

FIGURE 11-69
Sea Life, by Shi Guo of Taiwan, Republic of China. In the artist's words, this mixed-media sculpture *symbolizes the vitality of the ocean.* Handbuilt clay forms combined with artificial fiber. 63 × 23.8 × 24.6 in. (160 × 68 × 88 cm). *Courtesy the artist.*

Polyurethane

This type of adhesive has excellent gripping strength and weather-resistant properties. Use polyurethane to adhere ceramic to ceramic, to stainless or galvanized metals, or to wood (see *Expertise,* Chapter 4C).

Acrylic Additives

There are now acrylic emulsion additives for mending and patching cracks in greenware or in bisque-fired or high-fired pieces. To patch or bond a broken piece, mix the chemical with the same clay body as your ceramic piece and then refire the piece. This ensures accurate and compatible color and shrinkage.

POSTFIRING REINFORCEMENT

Frequently a piece of sculpture or large pot comes through the fire successfully, but the ceramist may be concerned about whether it will take the stresses and strains of shipping, hanging, or other installation procedures. In this case, it is wise to reinforce. For example, Marylyn Dintenfass reinforced all the thin porcelain slabs of her work for the Connecticut State Court Building before installing them, and John Toki reinforces his large sculptures with fiberglass (see 16-16, 16-17). In earthquake-prone areas, strengthening with epoxy and fiberglass and inserting neoprene pads between the sections is essential and may help a piece survive a quake. This epoxy-and-fiberglass combination can also be used to glue wires or metal brackets to pottery or sculpture for hanging it. Additional methods for reinforcing sculpture are discussed in *Expertise,* Chapter 4C.

FIGURE 11-70
A ceramic and wood sculpture by Kevin Nierman and Harry Siter, both of the United States. The artists designed the sculpture collaboratively and fabricated the parts separately. Nierman threw the ceramic shape and fired it in a raku kiln. Then, after firing, he broke it into pieces and glued it back together. Siter carved the base from a single chunk of cypress wood using a chain saw. Together they assembled the piece. The cracks and fissures in the clay relate well to the natural qualities inherent in the wood grain and the knots, while the saw marks are reminiscent of scarification marks on figurative African wood sculpture. Ht. 60 in. (152 cm).
Courtesy the artists. Photo: Jock McDonald.

FIGURE 11-71
Art Warrior, by Tom Stamper of the United States.
Stamper uses molds to create the porcelain clay forms
in his mixed-media sculptures. He combines them
after firing with found scrap steel to form figures that
create an ominous expression of the human struggle.
72 × 36 × 24 in. (183 × 91 × 61 cm). *Courtesy the artist.*

FIGURE 11-72
Water, by Margaret Realica of the United States,
appears to be a mixed-media piece, or it could be
one of her *trompe l'oeil* works, in which thrown
pieces and slabs are glazed and coated with metalic
lusters and then cemented together. It is impossible
to know by the eye alone whether a section is
actually metal or porcelain. *Courtesy the artist.*

12

Throwing on the Wheel

The true potter's wheel was developed over centuries. It evolved from the many types of turntables that potters used throughout the world to rotate their handbuilt pots in order to form and smooth them evenly (see 2-2–2-5). The true potter's wheel must spin at a speed of at least 100 rotations per minute (rpm); below that speed, the centrifugal force responsible for the fast rising of the clay wall in the potter's hands will not operate effectively. It is that force acting in relation to the potter's hands that makes the pot rise. Wherever the new, true wheel was known and used, potters could shape the clay more easily and quickly into thin-walled pots of a consistent size.

The gradual spread of the true wheel changed the nature of pottery as a craft, allowing for a semifactory production and trade of surplus pots. To this day, however, as earlier chapters have shown, many potters around the world prefer to use their handbuilding skills to create sensitively crafted pottery.

WHEEL FORMS

In this chapter and throughout the book there are examples of wheel-thrown pottery made by potters who throw with such experienced skill that their concern and thought now go into the design of their forms rather than their throwing technique. Study their work critically, not to copy it but rather to see how they used the wheel to bring vitality and strength to classic forms (12-1). Such study is an important part of any potter's development; by studying others' pottery—and your own—with a critical eye, you will learn over time how to

FIGURE 12-1
Pierre Bayle of France stresses that technique is only one aspect of a work of art; the spiritual is equally important, and the two must remain in balance. White earthenware bowl, coated with fine, local red clay slip. Oxidation and reduction firings. *Courtesy the artist. Photo: J. P. LeFevre.*

incorporate your individual ideas into the design and process of forming pots.

In many languages, pottery forms are named for parts of the human body, and often the vessel has a symbolic meaning—a bowl encloses or holds the spirit, a bottle pours offerings to the gods, a teapot suggests warmth and friendship, a pitcher pours refreshing water, and an urn stores grains or oils for sustenance. Thus, when we speak of the *lip,* the *neck,* or the *foot* of a vessel, our words carry meaning on several levels.

The development of the true potter's wheel gave potters a new way of working that influenced the forms of vessels. Although perfection of form is possible with coiling or pinching, the wheel gave speedier results and greater fluidity to pottery forms. The potter's skillful hands can work in tune with the spinning wheel to give the ultimate touch to the rim of a pitcher (12-2) or

the profile of a vase or a bottle (12-3), or to make the components of an assembled teapot (12-4). Study how a low cylinder can be widened and thinned into an elegant bowl (12-5), or what can be created by refining a cylinder to create a tall urn (12-6). Experienced potters use the wheel creatively; they have spent years mastering the skill of throwing, and they continue to practice it with joy.

The French potter Pierre Bayle, for example, has been working on the wheel since the age of 14. For years he has spent ten days twice a year working in a pottery factory in order to recover and refine his throwing skill. Bayle says that a pot's appearance on his wheel does not come as a free gift—there are years of work behind it (see 12-1). But, he stresses, technique is only one aspect of the potter's work; the spiritual aspect is equally important, and the two must remain in balance.

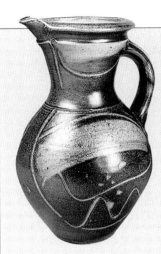

FIGURE 12-2
This pitcher by Michael Casson of England is feminine in the curve of its body and the narrowing of the neck, while the base sits solid, giving the pitcher a strong visual base. The lip is well shaped for pouring but also elegant as it completes the curve. Stoneware, salt-glazed, wood-fired to cone 10. Ht. 17 in. (43 cm). *Courtesy the artist. Photo: John Coles.*

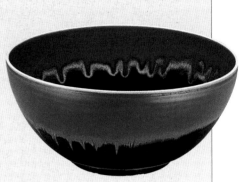

FIGURE 12-5
Bowl by Ross Spangler of the United States. How do you make a bowl that becomes a source of joy? Throw it thin, carefully shaping the curve inside and out; finish the rim with an artist's touch; give it a proportionate base; and glaze it with a painter's eye. It's magic! Porcelain, cone 10, 4¾ × 9¼ in. (12 × 23.5 cm). *Courtesy the Toki Collection.*

FIGURE 12-3
A bottle by Steve Branfman of the United States combines a bulbous body with a slender neck, creating a form that is bold yet elegant. Note how the swelling body flows with a graceful curve into the elongated neck—a visual transition that requires a masterful touch. Poured glaze. Ht. 20 in. (50.8 cm). *Courtesy the artist.*

FIGURE 12-6
A pot glazed with salt by Janet Mansfield of Australia becomes an evocation of history (see Chapter 6) as well as a useful container. The tactile surface is compelling—you feel that you *must* run your hands over it to sense the texture and follow the curve of the belly as it slopes to a straightforward base. *Courtesy the artist. Photo: Jutta Mainic.*

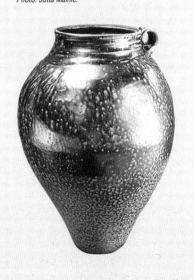

FIGURE 12-4
Teapot by Susanne Ashmore of Canada, is almost a sphere—a shape that displays Ashmore's complex glazes well and gives it the cozy feel that teapots need. The spout is honest and direct, its function clear, but the handle, a burst of fancy, lifts the piece to the decorative. *Courtesy the artist.*

TYPES OF WHEELS

Before making a pot, you will need to learn to control the wheel, center the clay, and throw a basic cylinder. If you master this part of the process, your persistence will pay off, and the day will come when, with sensitive, skillful fingers, you will throw a pot or vase that pleases you.

There may be both electric and kick wheels in the studio where you learn to throw (12-7–12-12). Perhaps the electric wheel looks easy, whereas the kick wheel seems difficult to manage. Some beginners, however, learn more quickly and feel more in control of the wheel's speed by learning on a kick wheel. Others are more comfortable working on an electric wheel. The type you use will be a matter of personal preference or availability.

Kick Wheels

In general, the methods for working on both types of wheels are the same, but there are a few extra factors to consider in using a kick wheel (see 12-7). Wearing rubber-soled shoes, practice getting the wheel in motion before starting to throw. Kick

from the inside near the shaft, thrusting out with a rolling motion and making use of the favorable gear ratio close to the shaft. You will find that you can get the wheel moving and keep it going with less effort by working this way than by trying to keep up with the faster-moving outside rim.

The action of kicking the wheel results in the transfer of movements to other parts of the body, including your arms. For this reason it is not a good idea to kick while your hands are on the clay, as the movement in your arms could shift it off-center. It is best to get a rhythm going, take a breath every couple of seconds, remove your hands from the clay, and give the wheel a couple of kicks to keep the wheelhead moving.

Electric Wheels

The photos of the basic wheel processes in this chapter (12-13–12-26) were made of a potter working on a type of electric wheel that most schools provide. One advantage of this type of wheel is that it can be used by both right- and left-handed individuals. Such wheels are popular because they are powerful enough to handle

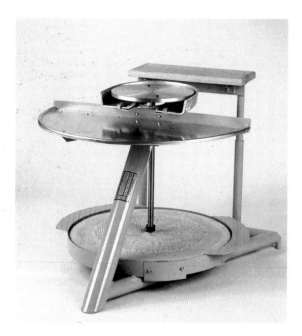

FIGURE 12-7
A kick wheel gains speed by foot power and wheelhead torque through the centrifugal force of the heavy concrete flywheel. The wheelhead on a kick wheel can rotate either clockwise or counterclockwise.

FIGURE 12-8
Electric pottery wheels can operate at variable speeds, with an average top speed of up to 200 rpm. Most are available in tabletop or splash-pan styles and with motor size options ranging from ¼–1½ horsepower.

(a)

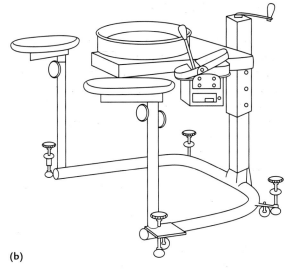

(b)

FIGURE 12-9
(a) People with backpain may find comfort from standing at the wheel. Diane Heart (see 12-74–12-85) raises her wheel when her back is bothering her so that she can throw with less strain. The only problem, she says, is that then her feet hurt. *(b)* A wheelchair-accessible electric pottery wheel is available with a hand-operated speed control, armrests, a splash pan, and a crank handle to adjust the wheelhead height.

FIGURE 12-10
Kick wheels generally have a large table space for tools and a water bucket. They are quiet to operate and turn smoothly at low speeds for trimming or for banding oxides or stains on pottery. Some motorized kick wheels are available.

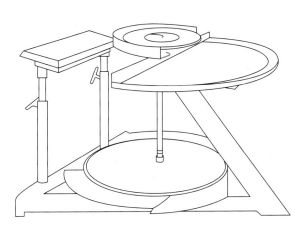

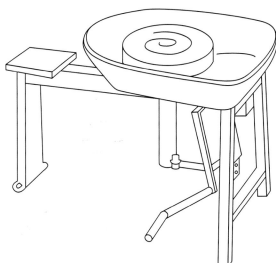

FIGURE 12-11
Treadle wheels use foot power to swing a lever attached to the wheelhead shaft. This in turn rotates the wheelhead. Some treadle wheels are equipped with a concrete or cast iron flywheel for added wheelhead torque and spinning ability.

Wheel head: A 14 in. (355 mm) wheel head is an all-purpose size for thowing medium to large work. Large wheel head is especially useful for throwing pots with large bases.

Bat pins: Bolted to wheel heads for attaching and removal of bats.

Splash pan: Protects user from clay slurry and water spinning off the wheel head or from trimmings falling onto the floor.

Work area: Space for water bucket and tools.

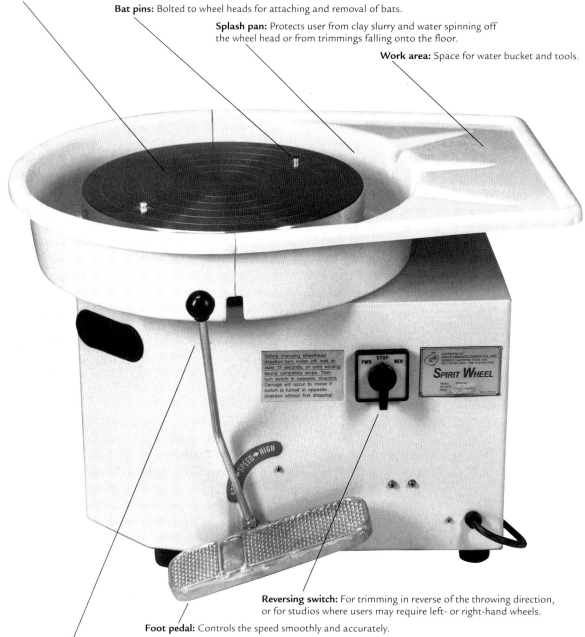

Reversing switch: For trimming in reverse of the throwing direction, or for studios where users may require left- or right-hand wheels.

Foot pedal: Controls the speed smoothly and accurately.

Arm lever: Gives low sped control when trimming or refining and allows speed control for wheelchair users.

Motor size: Motor size and torque affect the amount of clay you can throw.

Size: Smaller than kick wheels, more electric wheels will fit in a studio, and they are also lower and easier for short adults and children.

FIGURE 12-12

Individuals or schools with limited work space often prefer the small size of electric wheels; since they are smaller than kick wheels, more electric wheels will fit in a studio. They are also lower and easier for short adults or children to use. For left-handed potters, a reversing switch is a necessary feature, and bat pins make attaching and removing bats convenient. The wheel's motor size and torque affect the amount of clay that can be thrown.

projects of almost any size, and they are semi-portable since they are considerably smaller and weigh less than foot-driven kick wheels. Some people find throwing on an electric wheel easier because they can concentrate on the throwing rather than on kicking the wheel. Many teachers also find it easier to teach using an electric wheel because they can help their students adjust the speed of the wheel while they learn to judge its speed in relation to the throwing process. Most electric wheels are available with a plastic splash pan that fits around the wheelhead and shields the potter from flying clay slurry or trimmings, and some have drains built into the table-top for easy draining of clay slurry into a bucket. Electric wheels operate on 120 volts (European wire, 230 volts) and can be plugged into any household electrical outlet. Some models have reversing switches that will allow the wheelhead to rotate clockwise or counterclockwise—especially useful if you are left-handed.

WORKING ON THE WHEEL

Health and Safety Considerations

 Although throwing on the wheel does not expose the potter to the same hazards as mixing clay, it is important to remember to clean up the wheel and the floor daily at the end of the work period, using a damp sponge and mop and wearing a mask. This avoids spreading dust around the studio. Another health consideration when throwing is the physical strain of leaning over the wheel for long hours. Two ways to eliminate this strain are to do conditioning exercises to strengthen back muscles and to use an appropriate type of seat in the proper position. As already mentioned, another way to reduce back strain is to stand at the wheel. Some traditional potters in the South used wheels at which they stood, and adaptations of these wheels are available to potters today. For individuals in wheel-chairs, there are specially designed wheels that have hand-operated speed controls and hand-adjustable wheelhead heights (see 12-9b).

Another physical condition that can cause the full-time potter pain is carpal tunnel syndrome, which is caused by a pinched nerve in the wrist. This usually develops as a result of repeated actions involving the hands and wrists held in a strained position—for example, while wedging

FIGURE 12-13
Kevin Nierman of the United States prepares to throw a cylinder with 5 lbs. (2.27 kgs) of clay, throwing with the wheel turning counterclockwise.

or throwing. If you are aware of these potential physical problems and learn to minimize them from the beginning, you should be able to avoid them if you do become a full-time potter.

Preparing to Throw

During the first step on the wheel—centering—the wheel should be turning rapidly. The centrifugal force created by the speed will help you center the uneven lump of clay. Then, with each succeeding step, you will slow down the wheel gradually, until at the end of the process of finishing the lip the wheel will be barely moving. Once you can control the wheel reasonably well, you are ready to center the ball of clay (12-13).

Preparing to Center

One dictionary defines *center* as "the point around which something revolves; an axis," while another defines it as "the point toward which any force, feeling or action tends, or from which any force or influence takes its origin." Both definitions have meaning in relation to centering clay. Although centering is a physical process involving how you place your hands, where you press the clay, and how fast the wheel turns, it also has other meanings. We think of a centered person as being steady, in balance. It is this inner steadiness that you will want to draw on as you start to center the clay on the wheel.

The principle behind centering is that if an uneven lump of soft clay turning around the fixed point in the middle of the wheel comes into contact with a steady force pressing against it—your hands—it will become evenly centered on the wheel and perfectly round (12-14–12-18). The importance of centering cannot be overemphasized, for if the clay is not perfectly centered, there is no way you can throw an even pot.

Centering

Centering the clay on a rotating wheel takes steady hands and forearms, so you need to anchor your arms in some way. One way to do this is to press your elbows inward tightly against your body. Or you can press them against your upper legs, your sides, or even the wheel frame—whichever is most comfortable and gives them the best support (see 12-17). Your hands should be joined in some way to keep them steady, functioning together as one tool. Whatever method of joining them you use, be sure that they are not working independently. One hint is to use soft clay when you practice centering; you don't want to have to fight the clay.

Opening

The next step to learn after centering is opening the clay mass (see 12-18). This is not difficult, but it takes concentrated force. In order to open the centered clay evenly, you will need to con-

FIGURE 12-14
To make a ball of clay stick to the wheelhead before starting to center, Nierman lightly dampens the wheelhead and then slams the clay down.

tinue bracing your arms, keeping your hands working together. As you press your finger or thumb down into the clay, you will be forming a centered lump of clay with a deep indentation in the middle. Do not throw from this doughnut-like lump; the clay is not fully opened until you have formed the bottom of the cylinder and straightened the wall. To do this, move your finger or fingers across the bottom of the clay parallel to the wheelhead in accord with the speed of the wheel. Leave enough clay on the bottom to form the base of the cylinder. Only now are you ready to pull up the wall.

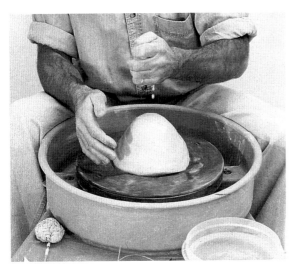

FIGURE 12-15
Nierman pats the ball of clay into a low cone, then squeezes a little water onto it before starting the wheel. Nierman suggests using a clay that is soft enough to handle easily.

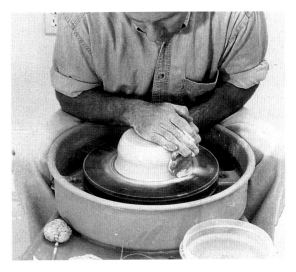

FIGURE 12-16
To begin centering he runs the wheel at a medium-fast to fast speed. At the same time, he applies downward pressure with his right hand while the left hand steadies the mass.

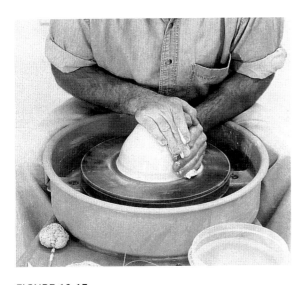

FIGURE 12-17
He continues to center with even pressure of his left hand pushing inward while his right hand pushes downward. He scoots forward while centering and anchors his arms against his body or thighs for greater control. If necessary, he lubricates the clay with a little more water.

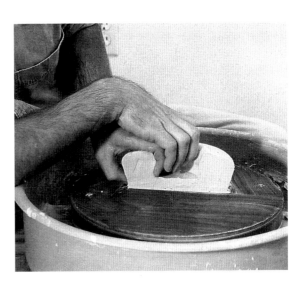

FIGURE 12-18
A cutaway view of a centered mound of clay shows the hand positions for opening and widening the well. Nierman locks his thumbs in a crossed position and curls his fingers downward. He pulls toward his body to open the well, not too far past the diameter of the base. The base should measure ⅜–½ in. (9–13 mms) thick, measured with a pin tool to avoid making a significant hole in it.

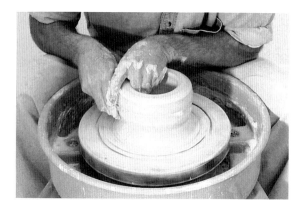

FIGURE 12-19
To begin pulling up the wall, Nierman lubricates the clay and sets the wheel at medium speed. He crosses his thumbs for greater control and sets his fingers in a slightly curled position. Starting at the base of the cylinder, he applies firm pressure inward with both fingers while slowly pulling up.

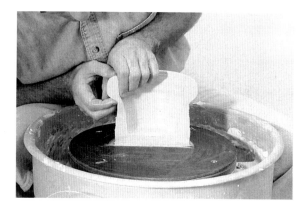

FIGURE 12-20
A cutaway view demonstrates Nierman's hand position for pulling up a wall. His right hand pushes inward gently while the left hand pushes out and up in one motion. Pulling up a wall usually takes three to four pulls.

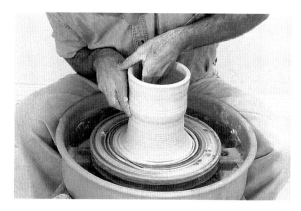

FIGURE 12-21
As the cylinder gets taller, he locks his arms against his body for increased leverage. The thumb of his left hand is steadied on the edge of his right hand. He pulls up the wall at a steady and methodical pace and adds water to keep the clay lubricated.

Pulling Up the Wall

If you have centered and opened the clay well properly, pulling up the wall will not be difficult. But if you have not performed the earlier steps with care, it will be almost impossible to pull up the wall evenly. When you pull up the wall, you will find that it rises more easily if you vary the speed at which you pull in relation to the wheel's speed: As the wheel turns fast, you can pull fast; as the wheel begins to slow down, pull up the wall more slowly.

To pull up the wall, place the fingers of both hands opposite each other on the inside and outside of the wall of the low, opened cylinder. It is the even pressure you exert on the clay between your fingers that makes the wall rise. If you place your hands so that they force less clay to pass between them than the thickness of the opened wall, the extra clay will respond by moving, and it has nowhere to go but up (12-19–12-21).

The opened clay that is revolving on the wheel is being subjected to a centrifugal force that tends to make its wall flare out. To counteract that thrust and make the wall grow straight up, press your hands slightly inward as you form a cylinder. Continue practicing making a cylinder even longer than seems necessary, for if you can throw the three basic types of cylinders perfectly (see 12-28a), there is no shape that will daunt you; just start with one of the cylinder forms and go from there.

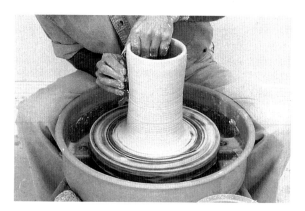

FIGURE 12-22
Nierman uses a rib to straighten the wall. His left hand on the inside of the cylinder gently pushes against the wall into the rib, which he holds with his right hand. As the cylinder nears completion, he slows the wheel speed down.

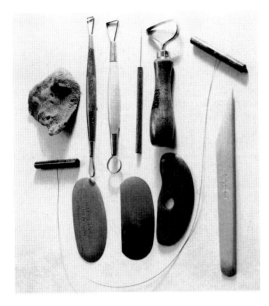

FIGURE 12-23
Basic tools used for throwing on a pottery wheel and for trimming, cutting, and sponging excess water from a pot.

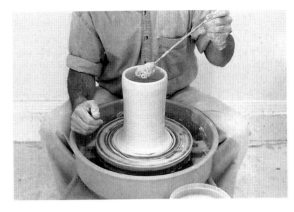

FIGURE 12-24
Here, Nierman uses a sponge tool to absorb and remove excess water that has collected at the bottom of the cylinder. This step helps to avoid cracking on the bottom of the pot during drying.

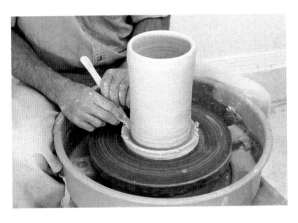

FIGURE 12-25
Nierman uses a wooden diagonal tool to trim excess clay from the base. With the wheel at medium-slow speed, he holds the tool firmly with both hands at about a 45-degree angle and cuts the extra clay off the wall. Then he uses the tool flat against the wheelhead to remove the excess clay.

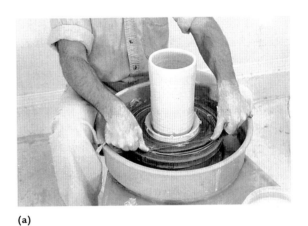

(a)

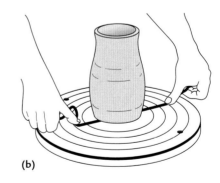

(b)

FIGURE 12-26
(a) With the wheel slowly rotating or at a stop, he holds the left end of the cutting wire tightly down while pulling the other end toward him, keeping it taut against the wheelhead. *(b)* This drawing shows the correct finger position.

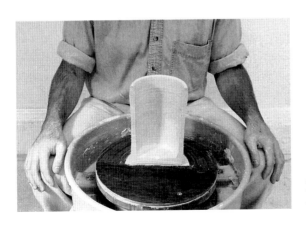

FIGURE 12-27
A cutaway view of the cylinder shows the even wall thickness and adequate clay at the base, which is left as is, for minimal trimming later.

Shaping a Cylinder

Shaping a pot on the wheel can be approached in a number of ways, each of which will affect the aesthetics of the piece. Finger marks pressed into the wall of a pot can add rings that give rhythm to the piece; the size and spacing of the rings and whether they are concentric or slightly off-center will affect how the piece feels when it is handled. A cylinder made from a coarsely grogged clay body that is shaped into a bulbous form will often develop a textured surface when the body is stretched from the inside with a rib.

An experienced potter who knows what technical problems he or she must contend with can give attention to both the throwing of the cylinder and the shaping at the same time, but less experienced throwers may need to separate the two and deal with them as distinct processes (12-22–12-27).

Here is a helpful tip: Do not weaken the clay by adding too much water or stretching it. Remember that clay loses its plasticity if it is overworked, so if your desired shape does not appear after a reasonable amount of time, discard that clay and start over with a fresh ball. Do not count on correcting a badly designed or clumsily thrown pot by trimming it, although doing so may improve it somewhat. When you have completed a good cylinder, remove it from the wheel with a wire (see 12-26), and set it aside until it is leather hard so that you can trim it.

(a)

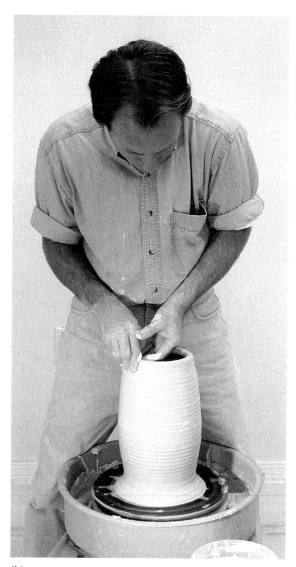

FIGURE 12-28
(a) You can make a bottle, teapot, or bowl from a basic cylinder shaped as outlined in dark lines. *(b)* Kevin Nierman throwing a 15 lb. (6.81 k) cylinder that he will shape into a bottle. He stands up for more control while throwing the cylinder.

(b)

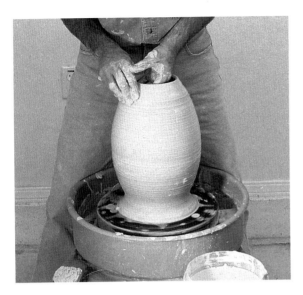

FIGURE 12-29
As the bottle form begins to take shape, he keeps the top collared in as he pushes out and pulls up the wall. To bulge out the body, his inside hand pushes out while his outer hand pushes up. After each pull, he steadies the rim of the pot to keep it true and centered.

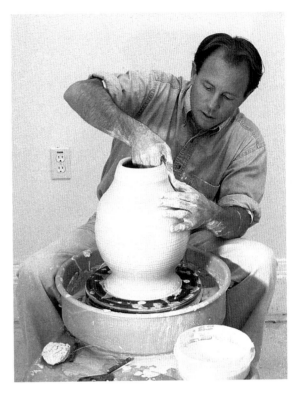

FIGURE 12-30
Nierman gently collars in the shoulder while pulling up the wall to form the neck. In one motion, his left thumb pushes the wall out while his right hand lifts the clay from the inside.

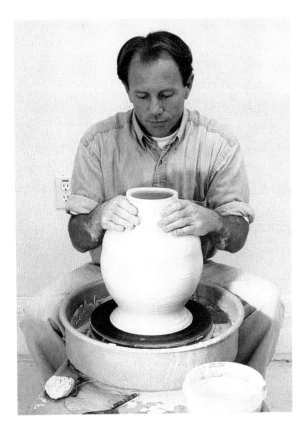

FIGURE 12-31
When collaring in the neck, his thumbs and fingers are in a triangular position. As the wheel spins slowly, he gently collars in the wall and pulls his hands upward.

THROWING A BOTTLE

When throwing a tall cylinder (12-28a) in preparation for throwing a bottle, it is important to taper the wall inward to keep it true. Then, to form the bottle you will need to push outward from the inside with a rib or your hand. Therefore, it is important to throw a cylinder with an extra thick wall because the wall will be stretched, becoming thinner as you push outward (12-28–12-34). Useful for shaping bottle forms is a throwing tool (see 10-2), which can shape the inside of deep cylinders, vases, or narrow-necked containers, reaching places where hands and fingers cannot. Changing the wheel speed from fast to slow or very slow as you pull up a wall can develop an uneven undulating lip similar to those of Japanese tea bowls, which often have walls of different thicknesses. These are made by gently squeezing the wall of a cylinder with uneven pressure as the wheel turns, slowly forming the wall into an organic form.

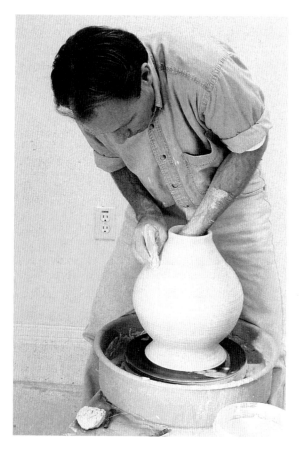

FIGURE 12-32
In the final shaping, Nierman stands up and locks his arms against his body to provide greater stability. His left hand supports the clay on the inside of the pot while his right hand pushes in and pulls up the wall to shape the neck.

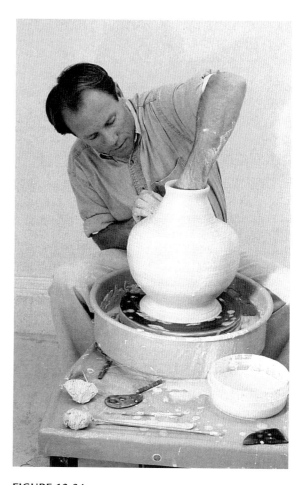

FIGURE 12-34
He refines the bottle form by pushing the outside wall with his right hand against the left hand inside to create the desired curve between the shoulder and the neck. Nierman says, *I find using a variety of clay bodies fun because each clay body wants to throw a somewhat different form.*

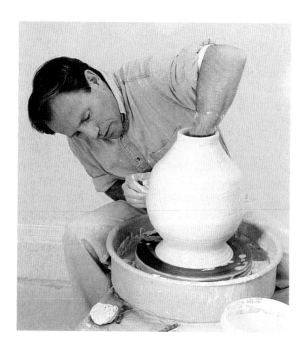

FIGURE 12-33
For final shaping he uses a metal rib in his left hand and pushes the belly of the bottle outward against a rib in his right hand on the outside.

THROWING A LARGE BOWL

When throwing a large bowl (12-35–12-43), it is easier to center the clay mass if you use soft clay. You will also have more control if you steady your forearms by pressing your elbows close to your body during this process. Kevin Nierman uses 15 lbs. (6.81 k) of clay when he throws his large bowls, so the consistency of the clay and the position of his arms, as well as his posture while throwing, are all extremely important (see 12-35–12-38).

The diameter of the bowl you will make is directly related to the size of the base; therefore, for a large bowl, center the clay with a wide base. The purpose of this wide base is to support the wall as the clay is raised and pulled outward.

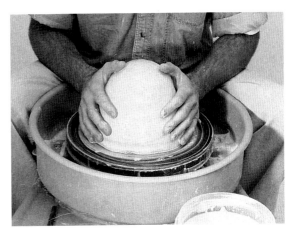

FIGURE 12-35
After slamming a 15 lb. (6.81 k) ball of clay onto the wheelhead, Nierman pats it into a rounded cone shape, dribbles a little water onto the mound, and is ready to throw a large bowl.

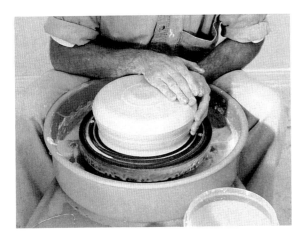

FIGURE 12-36
Nierman advises: *When centering a large ball of clay, rely on your entire body to help provide the extra force necessary to center the large mass. With the wheel set at a medium-fast speed and thumbs locked together, apply concentrated pressure on top of the mass with the right hand while the palm of the left hand pushes into and up the wall. This will form the clay into a domed conical shape.* He performs this process two or three times.

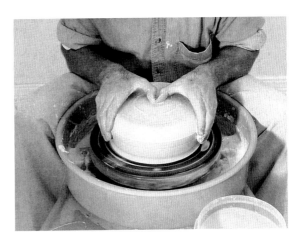

FIGURE 12-37
To begin opening the well, Nierman lubricates the clay lightly and gets the wheel going at medium speed. With both thumbs he pushes down into the clay to make a hole, stopping at ⅝–¾ in. (13–20 mm) from the bottom of the clay mass.

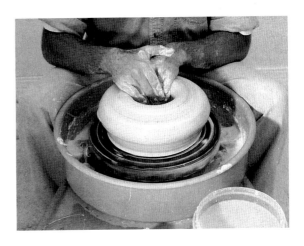

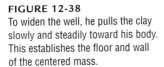

FIGURE 12-38
To widen the well, he pulls the clay slowly and steadily toward his body. This establishes the floor and wall of the centered mass.

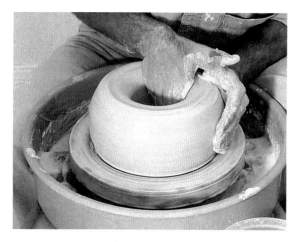

FIGURE 12-39
Nierman's left hand pushes the clay up while his right hand, in a slightly curled position, lifts and steadies the inside of the wall. At this stage, both hands are braced with the thumbs touching for greater stability and support.

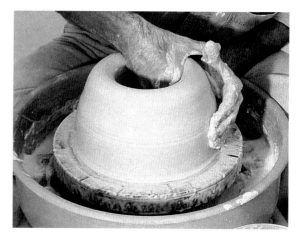

FIGURE 12-40
The wall begins to grow as he pushes it on the outside and lifts it on the inside. Even pressure must be applied by both hands as they move together, raising the wall. He pulls up the wall in three or four pulls, depending on the final thickness desired.

FIGURE 12-41
As he shapes the bowl, Nierman slows the wheel. To widen the wall, he pulls the clay in an upward and outward motion, going slower with each successive pull.

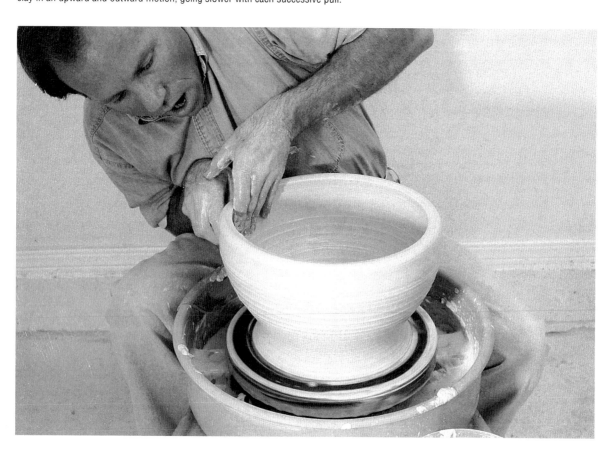

THE PRODUCTION POTTER

Historically the term *production potter* has been applied to potters who make a full range of domestic ware, while potters who make decorative ware for display rather than for use have been called *studio potters*. Nowadays, this distinction is not as clear as it was in the past, and many potters produce both types of work.

Making domestic pottery calls on all pottery skills, requiring aesthetic decisions in using color, texture, and glaze as well as firing a kiln. In addition, a production potter must consider marketing, building up a clientele, producing items to order, repeating these items to a certain standard, formulating glazes, procuring materials, often living on an uncertain income, constructing kilns, maintaining a studio, managing the business, controlling overhead, and paying taxes. At the same time, production potters must continue to grow as artists, improving their forms and glazes and exploring new ones. If you are considering becoming a full-time potter, it is a good idea to become aware of all its aspects. You can form a relatively realistic idea of what might lie ahead by reading ceramics magazines, which frequently

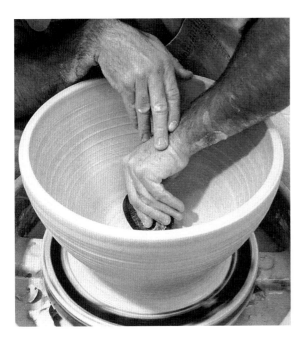

FIGURE 12-42
Nierman uses a wooden rib to smooth and shape the inside of the bowl. He holds the rib at a slight angle as he shapes, resting his arm on his thigh to help steady his hands.

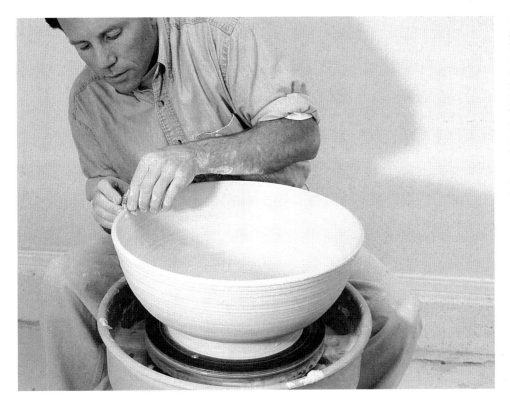

FIGURE 12-43
After thinning the wall and widening the bowl, Nierman uses a wet piece of newspaper folded over the rim to smooth the edge of the lip as the wheel turns very slowly. Sometimes he leaves a big bowl on the wheel for several hours or overnight to let the clay dry and stiffen so that he can resume shaping the bowl without fear of it sagging. He says, *This is especially critical if the wall of the bowl has a wide flair, which is susceptible to collapsing.*

FIGURE 12-44
A porcelain plate by Catharine Hiersoux of the
United States. The bold brush design on the plate
is offset by the elegant glazed white porcelain
background and is achieved with various glazes
and a copper-red glaze splash. The plate was fired
in a gas kiln in a reduction atmosphere to attain
the reddish colors. Diam. 18 in. (46 cm). *Courtesy
the artist. Photo: Richard Sargent.*

publish profiles of potters who have made this choice. Or you may be able to talk with potters in your area about their lives or, even better, work as an apprentice to a potter. This would enable you to see firsthand the daily operation of a pottery workshop and experience making ware, glazing it, loading and firing the kiln, as well as marketing. Another alternative would be to work in a pottery factory—more than one potter represented in this book has worked in a factory situation, learning some of the realities of that life and finding it an excellent way to develop or refresh throwing skills.

THROWING A PLATE

It is best to attempt throwing a plate only when you feel that you have mastered the basic skills on the wheel. In throwing a plate, one of the most important requirements is confidence. Keeping the clay alive and fresh is vital, perhaps more so than with other objects because the flat bottom of a plate is subject to many stresses and strains as it is formed, dried, and fired. Thus, assured and practiced hands are particularly important in throwing plates, because one cannot go back and make corrections. For this reason, it is wise to have the form of the plate in mind before you start and to think ahead to the motions and actions you will have to perform as you work.

Design considerations are equally important in forming a plate. These include the relationship of the curve to the base, the appearance of the rim and foot in relation to the whole, as well as the design of the rim detail. For example, a precisely tooled rim can create a frame around the plate. On the other hand, you might prefer to leave the rim neutral, rather like an unframed painting. Also, it is important to keep in mind the type of decoration, if any, you intend to apply to the plate. If you keep all these factors in mind, your plate can become a work of art (12-44).

Throwing a plate entails using the basic wheel skills, but there are also special factors to take into account (12-45–12-52). For example, you must be sure to compress the clay thoroughly in the horizontal area of the plate; otherwise it may warp or crack during drying or firing. Another area that requires special care is the curve between the base and the sides. It is important to maintain a smooth concave curve and to gradually decrease the wall's thickness as you pull it

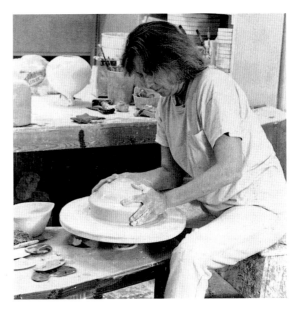

FIGURE 12-45
Hiersoux centers a 15-lb. (6.81 k) lump of clay. As she brings it down, she takes care not to trap air under the extended edge.

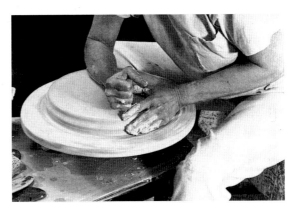

FIGURE 12-46
Using her forearm with a tight fist for added force (and to avoid muscle cramping), she flattens the clay.

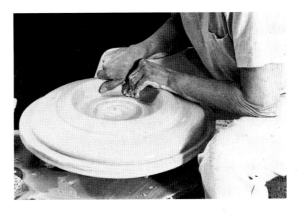

FIGURE 12-47
Once the clay is flat, Hiersoux starts to open it, using both hands.

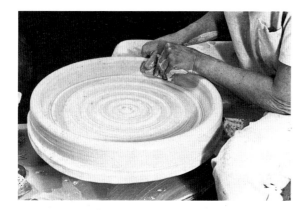

FIGURE 12-48
She begins to pull up the sides, with the clay opened as far out to the edge as possible but still supported by the bat.

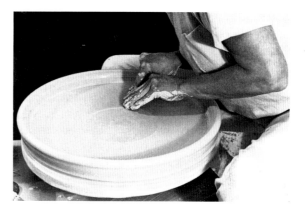

FIGURE 12-49
It is extremely important at this point to compress the clay with a wooden or hard rubber rib to strengthen the plate and prevent cracks. Because the flat area can't take a lot of handling, Hiersoux prefers to finish the bottom completely before thinning the walls.

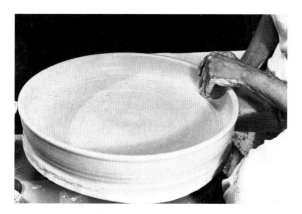

FIGURE 12-50
Now she can begin to work on the wall before extending it to develop the form of the large plate.

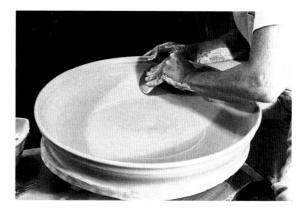

FIGURE 12-51
She gradually decreases the thickness of the wall, paying attention to the visual impact of the curve and maintaining its profile while supporting the rim with one hand as she works.

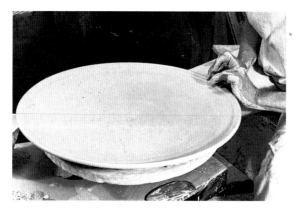

FIGURE 12-52
Hiersoux makes sure she maintains the curve as she gives the rim its finishing touches.

out. Take care that the wall does not become too thin or extended, or it may crack or collapse.

Catharine Hiersoux throws plates on a plaster bat. She prefers a plaster bat to a wooden one because the absorbent plaster helps the base dry and allows the plate to be lifted off the wheel without the use of a wire. This is important because she has found that removing plates with a wire can increase the chances of the porcelain warping or distorting. She fits the bat to the size of her planned plate.

Drying and Trimming

Drying a plate can be tricky. It must dry from the inside outward, but in the process the curve and rim must not dry too quickly. For this reason, depending on how humid or dry the studio atmosphere is, you may need to wrap the rim. Hiersoux dries a plate like the one illustrated for about an hour right-side-up until it is stiff; then she removes it from the bat and turns it upside-down to continue drying. Once the base is leather hard, she will trim it, turn it right-side-up again, and let it finish drying.

Trimming is especially important in the base area of a plate, because that is where the weight is (12-53–12-55). Not only does an excessively thick base make a plate heavy, but it is also visually clumsy. On the other hand, if the base becomes too thin, it may warp, so the potter must learn from experience just how much clay to remove.

Placing the Foot

The placement of the foot determines the size of the ring of clay Hiersoux will attach. The best size to choose is related to the curve of the sides; the greater the curve, the narrower the foot can be. On a large plate, she uses a double foot, making the middle ring slightly lower than the outer one (see 12-54). She does this when the plate is turned right-side-up, the base will sink and the inner ring will be lower.

Hiersoux says that she used to throw, then bisque-fire her plates, then look at the blank plates and decide on the decoration. Now she has the decoration in mind before she starts to throw. That way, she says, she can make adjustments while throwing that will make the decorating easier (see 12-44).

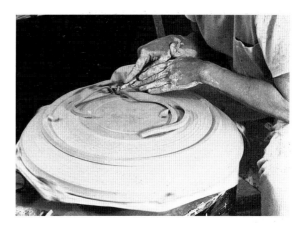

FIGURE 12-53
With a leather-hard plate centered on the wheel, Hiersoux starts to trim the bottom, removing the excess clay and forming the foot.

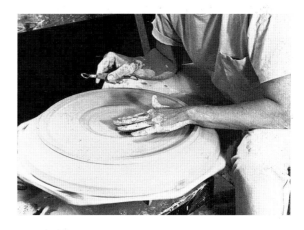

FIGURE 12-54
Tapping the bottom to be sure it is not becoming too thin, she completes the double foot needed to support the plate's diameter.

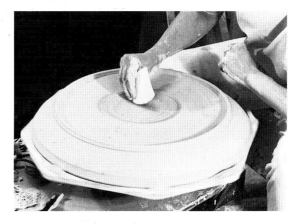

FIGURE 12-55
Hiersoux finds that bleach bottles cut into a variety of profiles work well for finishing her porcelain plates.

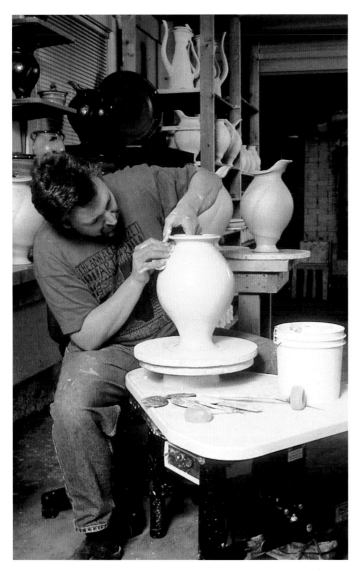

FIGURE 12-56
Potter Steven Hill of the United States refines the form of a pitcher, using a metal rib on the curve of the body.
Courtesy the artist. All process photos by Al Surratt.

DESIGNING AND THROWING A PITCHER

Throwing an elegant pitcher requires a combination of throwing and handbuilding skills. A potter who makes domestic ware needs to be able to throw a well-proportioned vessel, shape a functional but graceful pour spout, and pull a comfortable handle, as well as be adept at assembling them. Timing is essential in the assembly of the parts to be sure that they dry and shrink evenly, without cracking or separating where they are joined. Because the separate parts must be combined to make a functional pitcher, it is important to maintain a keen sense of form and utility as you throw the body and form the additional parts (12-56–12-73). For example, how a pitcher feels when it is picked up by the handle is important to its functional aesthetic, as is its weight in relation to the volume it contains. A well-executed pitcher can provide a satisfying experience when pouring liquids, whereas a badly designed one can be a disaster.

Detailing and Decoration

Graceful handles, subtly curving spouts, unusual glaze treatments, incised designs, scarification, carving, or other embellishments on a piece of pottery add visual excitement to the finished ware. For example, the detailing that Steven Hill gives to his pitchers enhances their flowing quality (see 12-61). Patterns or ridges trimmed into the rim, lip, or base can add to the aesthetic pleasure of a well-detailed pot. These ridges and sgraffito areas provide valleys for the glaze to settle into during firing. The effect is especially pleasing when certain transparent glazes are used; when fired, the glaze may remain light on the ridges, but it becomes darker in the crevices.

Another method of adding decoration to the surface is to cover the pot with a white or colored engobe (or slip) and then draw through it with a needle tool to expose the clay beneath, or carve designs through the covering slip into the clay. Studying large numbers of pots as they come from the kiln allows a potter to see how a sgraffito or carved surface reacts to different glazes and to develop a personal style of detailing and decoration. Through further study and experience you too will learn to exploit these effects as you see how the glaze interacts with the texture of the clay. (See also Chapter 14.)

FIGURE 12-57
As the wheel turns slowly, Hill tools a spiral into the neck.

FIGURE 12-58
Using a metal rib, he flattens the rim and gives it a subtle ridge line.

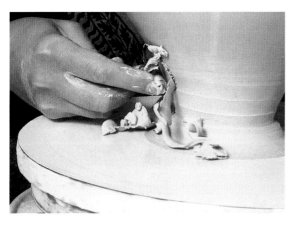

FIGURE 12-59
Now he trims the base into a spiral pattern, enhancing the overall form of the pitcher and giving it a visual lift.

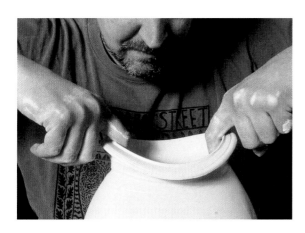

FIGURE 12-60
Using his index fingers, he pulls up on the rim, shaping an oval in preparation for adding a spout.

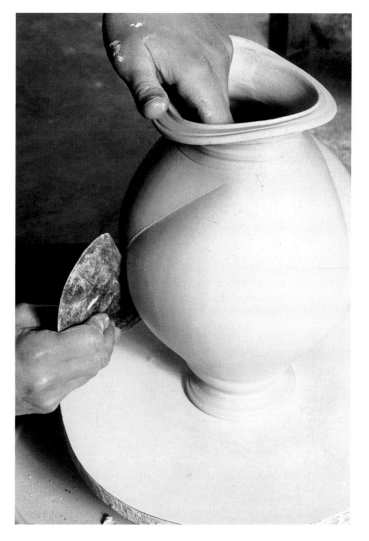

FIGURE 12-61
Hill steadies the pitcher with his left hand as he indents the belly with a large rib, giving it a melonlike appearance.

Throwing the Lip and Spout

Making an attractive and functional pouring lip on a thrown pitcher takes skill and practice; it is an essential skill to learn if you wish to make a full range of domestic ware. Once you have shaped the body of a pitcher—whether a delicate porcelain creamer or a robust stoneware jug—it will need a lip that is an extension of the body form. In addition, it should pour without dripping.

It requires practice, as well as attention to detail, to develop a personal style that will give character to a pitcher—to its swelling body, its rim, and its spout and handle. Be direct as you stroke the moist clay, giving shape to the spout trough and the lip so that the pitcher spout will not only pour properly but be consistent with the form of the pitcher itself (12-62–12-68).

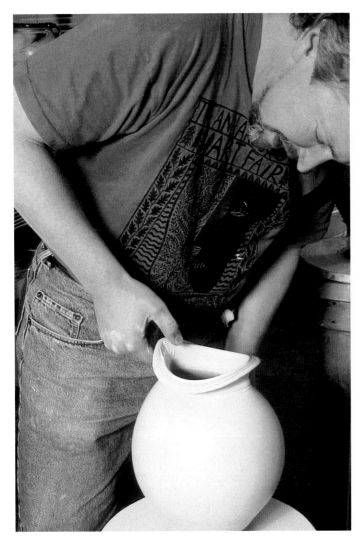

FIGURE 12-62
Hill stands up to gain stability and a better view of the pitcher as he begins to prepare the tip for attaching the spout.

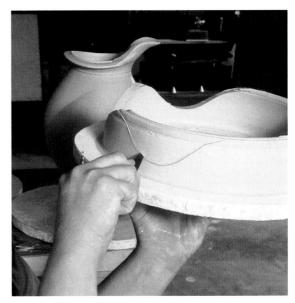

FIGURE 12-63
From a wheel-thrown ring of clay, he cuts the wedge of clay that will become the spout. Note that he cuts several spouts from one thrown ring.

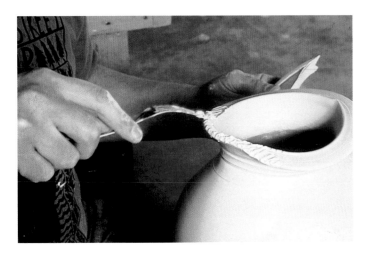

FIGURE 12-64
Before attaching the spout to the pitcher, he scores the rim well with a fork, and adds slip.

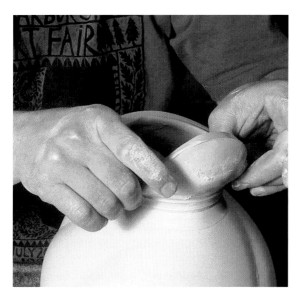

FIGURE 12-65
After scoring and adding a small amount of slip to the rim, Hill carefully attaches the spout.

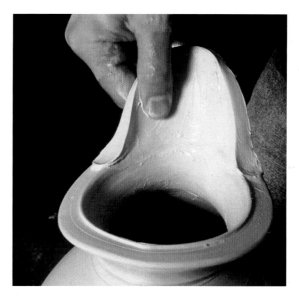

FIGURE 12-66
After lubricating the spout with a little water, he makes multiple pulls to shape it.

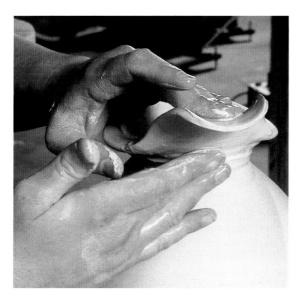

FIGURE 12-67
Using both hands on the top and underside of the spout, he refines the trough to create an elegant, free-flowing form as well as a functional pouring shape.

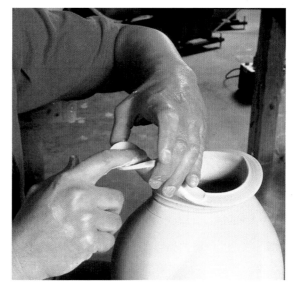

FIGURE 12-68
In the final stage of shaping the spout trough, Hill's left thumb and fingers gently support the spout as he pulls his right index finger across the trough, adding definition to the lip.

FIGURE 12-69
After moistening a slug of clay with water, Hill begins to pull a tapered handle for his
pitcher, making about fifty strokes to achieve the correct handle length and shape.

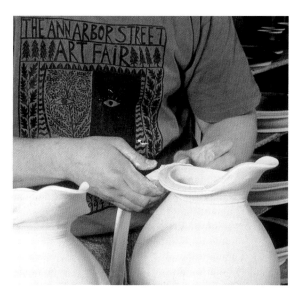

FIGURE 12-70
After scoring the rim of the pitcher at the point of handle attachment, he adds a little slip to the scored area and pushes the handle into position.

Designing, Pulling, and Attaching the Handle

The handle is an important design element in the construction of a pitcher or a teapot. In addition to its size and shape, as well as the negative space it defines, its placement in relation to the body not only is crucial to the pitcher's visual composition but also its main function—pouring (12-69–12-72). Hill's pitcher handles are flowing and organic, seeming to grow naturally out of the body of the pitcher (12-73). At the same time, they provide a comfortable grip for holding and pouring.

When attaching a handle, be sure that the clay making up the body of the pot is stiff enough so that its shape will not be deformed when you hold it and start to pull. On the other hand, if the body is too dry when you attach the damp handle, the difference in shrinkage rate between the handle and the body could cause the handle to crack around the edges of the join or to fall off during drying. Scoring the body and applying viscous slip at the points of attachment should create a positive bond between the body and the handle, ensuring the continued strength of the bond during drying, glazing, firing, and, ultimately, years of pouring.

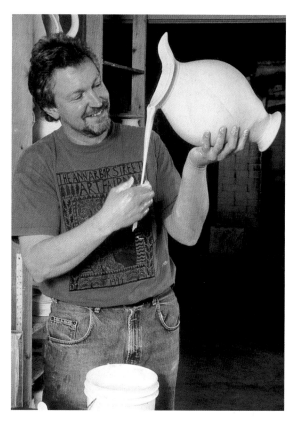

FIGURE 12-71
He prepares to rotate the pitcher to study the shape of the handle in relation to the curve of the body.

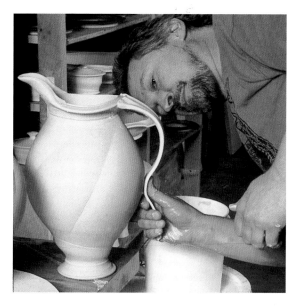

FIGURE 12-72
When attaching the tail of the handle to the body of the pitcher, Hill does not score the clay but relies on the softness of the handle to bond it to the damp body.

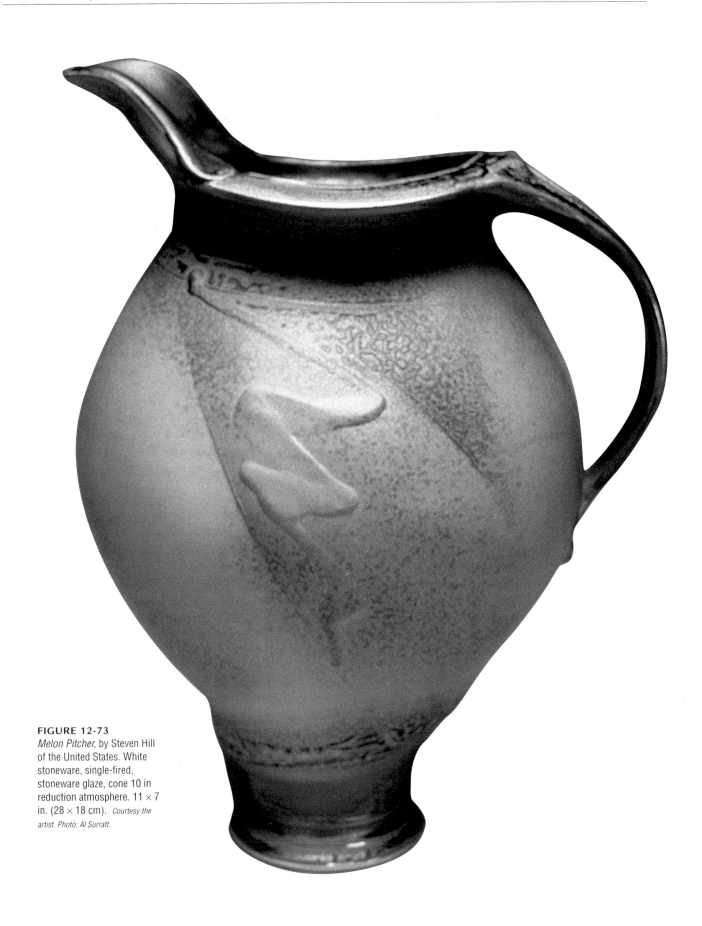

FIGURE 12-73
Melon Pitcher, by Steven Hill of the United States. White stoneware, single-fired, stoneware glaze, cone 10 in reduction atmosphere. 11 × 7 in. (28 × 18 cm). *Courtesy the artist. Photo: Al Surratt.*

THROWING AND ASSEMBLING A TEAPOT

It is a challenge to make a teapot that looks inviting, is easy to handle, and pours well (12-74–12-85). A teapot must have a wall that is thick enough to hold the heat and keep the tea warm, but the pot must not be too heavy to lift comfortably. It needs a lid that sits solidly in the top of the pot so that it will not fall out, with a knob that fingers can grasp easily. In addition, the spout must be well attached to the pot and designed so that it does not dribble when pouring. If the teapot is made with a pulled clay handle, the handle should fit the hand and allow the pot to tilt at an easy angle for pouring. After these separate elements have been completed, they must be assembled with sound knowledge of ceramics construction. There are also, of course, aesthetic concerns to consider. Whatever the functional design of the pot, its handle, spout, and lid, as well as their relationship to one another, should be pleasing to the tea drinker's eye, hand, and spirit (see 12-85).

Diane Heart, who uses her teapots frequently, says, *I like making teapots. I like to think of the character of the pots, and I like putting all the parts together. Also, I've always been fascinated by the tea ceremony.* Heart has given much thought to the functional design of her teapots.

(a)

FIGURE 12-74
(a) Diane Heart of the United States served her apprenticeship in two pottery factories, throwing thousands of pots; so when she set up her own workshop and store in a busy summer tourist town, she had the experience to make it a success. *(b)* Tools used for throwing and constructing a teapot: Ribs and sponge for throwing; ruler and calipers for sizing components; tools for trimming and cutting; a bucket of slip for construction; and a wire tool for removing it from the wheel. See Figures 10-5 and 12-99 for drawings and explanation of tools. *Diane Heart photos by Mark Preu, courtesy the artist.*

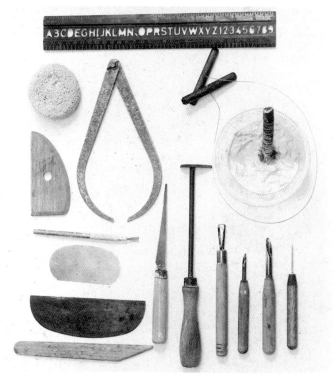

(b)

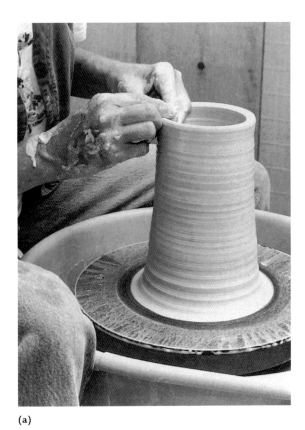

(a)

Throwing Off the Hump

Throwing off the hump is a technique used by potters around the world, from a village workshop in Turkey to a modern studio on Cape Cod. Some potters use this method because they feel that it is important to throw the teapot, spout, and lid from the same cohesive lump of wedged clay, and throwing off the hump is a convenient way to do it (12-76–12-78).

Even if you are not planning to make teapots, throwing off the hump is a good skill to learn. For example, if you have a series of similar

FIGURE 12-75
(a) Heart throws 4½ lbs. (1.7 k) of porcelain clay into an extra-tall cylinder to form a four-mug, six-cup teapot. The height allows her to pull the wall thin and, thus, avoid making the pot too heavy. *(b)* She shapes the clay into a rounded belly, using the pressure of her hand inside the pot against a flat wooden rib held on the outside. *I like to get a nice rounded form that gives me a good surface for brushwork or carving.* *(c)* Halfway up the pot she reverses the pressure so that the flexible rib is pressing in. *I like a nice shoulder. I use a flexible rib on the shoulder so there are no flat spaces on the curve.* Continuing to detail the rim, she finishes the pot and sets it aside to trim when it is leather hard. *All photos courtesy the artist, © Mark Preu.*

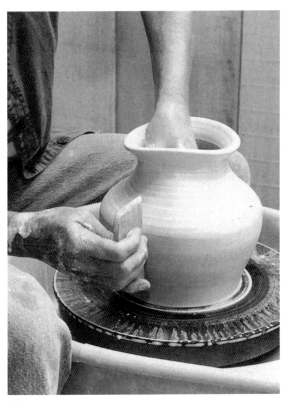

(b)

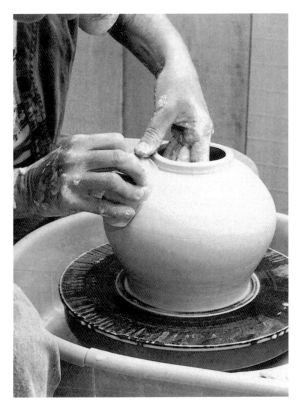

(c)

pieces to throw, it saves time; you can center the top section of the hump, throw the piece, cut it off, and continue throwing without stopping to center another lump of clay.

Throwing the Lid

Heart uses the hump method for her lids and spouts because she usually throws six teapots at a time. That way, she says, *I get to match the lids, spouts, and pots up at the end, and I can really play around.*

Heart's teapot lids are generally 3 or 3¼ in. (76.2 or 82.6 mm) wide, depending on the size of the pot. The size of the opening gives her room to reach in to clean the inside, as well as ensuring the correct placement of the handle in relation to the lid.

FIGURE 12-76
(a) Heart opens the lid on the hump from the center, leaving enough clay to form the knob. *(b)* She pulls the lid side up. *(c)* Heart notes that *laying down the rim gives plenty of room for holding the knob.*

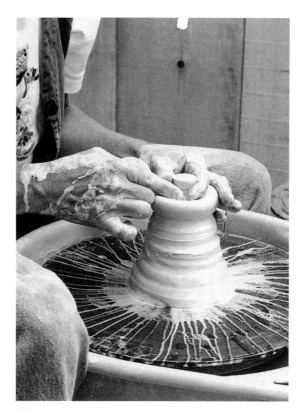

(a)

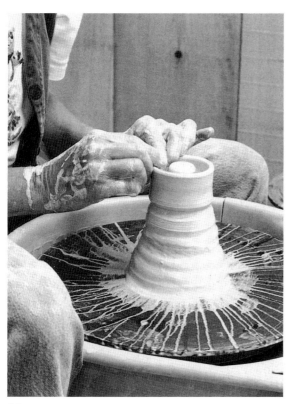

(b)

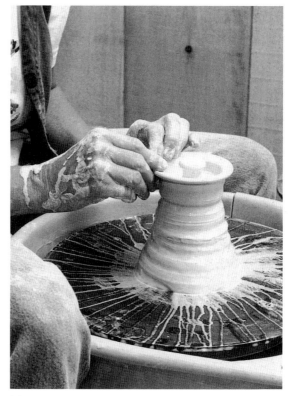

(c)

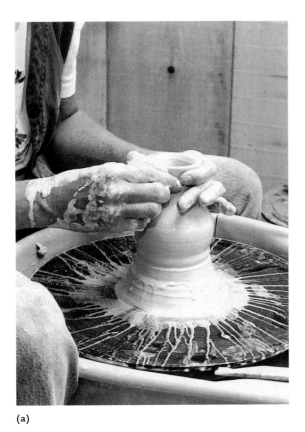

(a)

Throwing the Spout

The form of a spout can change the appearance and function of a teapot. Spouts can be elegant or perky; they can pour successfully, or they may dribble or spurt. The trick is to make a spout as functional as possible so that the tea pours easily, and to design it so that it is appropriate to the character of the pot (12-77). Heart says, *I used to make spouts that flared out, and they looked cute, but they dribbled.*

When all the separate parts of the teapot are finished, Heart sets them aside until they are leather hard, ready for trimming.

FIGURE 12-77
(a) She pulls up and collars in the neck of the spout after throwing it larger than needed; she will cut part of it off when she has finished pulling. *(b)* She pulls up more clay to give the spout needed height. *(c)* She ribs the tip of the spout with pressure against one finger.

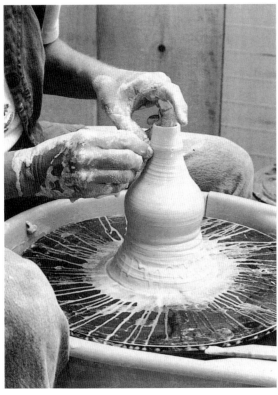

(b)

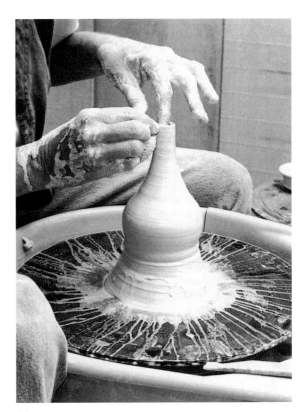

(c)

Finishing the Spout

Once the spout has been thrown and its lip carefully shaped, Heart shapes the spout tip (12-78a) and bends it slightly to ensure that it will be at the correct pouring angle (12-78b). (She usually does this while it is on the hump, but for the photos she removed it.) Cutting the spout at the correct angle is the secret to attaching it to the teapot so that it pours well (12-78c). Heart says, *I used to spend a lot of time trying to get it cut at the right angle. Then I saw a potter in North Carolina who did it like this with a rib. Now I just eyeball it and slice it through at a 45-degree angle.*

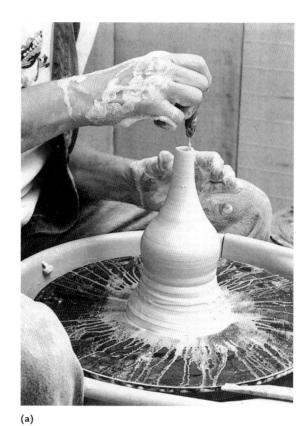

(a)

FIGURE 12-78
(a) Using a needle tool, Heart sharpens the inside tip of the spout while it is still damp on the hump. *That's really important,* she says, *so that the teapot doesn't drip. (b)* She bends the spout to ensure dripless pouring. *(c)* She slices it when leather hard at a 45-degree angle for correct attachment to the teapot.

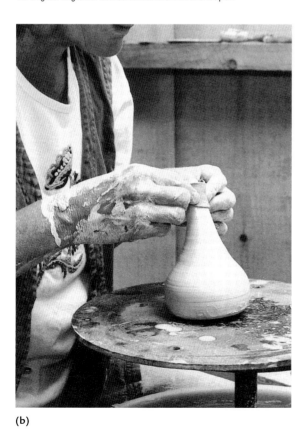

(b)

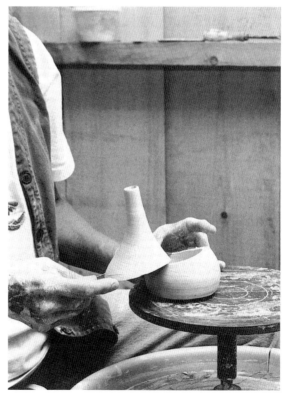

(c)

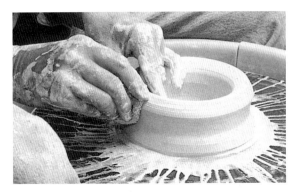

(a)

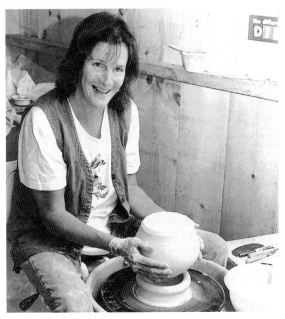

(b)

FIGURE 12-79
(a) Heart throws a damp chuck for trimming the lid first, then the spout, and finally the teapot. *(b)* She places the leather-hard teapot in the damp clay chuck.

Trimming the Teapot

Trimming the body of a leather-hard teapot is basically the same as trimming any pot (12-80), but if the body has been thrown thin enough to ensure a lightweight teapot, there is probably not much excess clay to trim. **Chucks** designed to hold pots when trimming on the wheel are available commercially (see 12-105a), or you may throw and bisque-fire one (12-105b). Heart, however, prefers a wet clay chuck (12-79) because *the pot stays better in damp clay, and if your pot is at the right dryness, it won't get goopy.* Also, by using a damp chuck, she can first throw the chuck small to fit the lids, then enlarge it as she trims the spouts and finally the pots. Whatever type of chuck you choose, the pot should sit securely in it.

If Heart plans to carve the surface of a teapot, this is the point at which she will do it.

Assembling the Teapot

Assembling a teapot requires careful construction and meticulous care (12-81–12-83). Using her own teapots has taught Heart to place the spout so that it pours well, without drips and dribbles, and at the same time complements the form of the teapot. In addition to cutting the curve of the spout to fit her pot, she gives the

FIGURE 12-80
(a) She trims the bottom curve of the pot. *(b)* Cutting in the foot reduces the pot's weight and lets it shrink in the kiln with minimum friction. A well-trimmed foot also lifts the form visually.

(a)

(b)

(a)

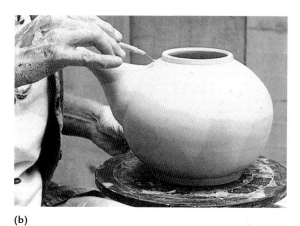

(b)

FIGURE 12-81

(a) Heart holds the thrown spout against the trimmed pot, placing the top edge of the spout a little below the rule, melding the clay well. *(b)* To cut the strainer holes, she uses a ½-in. (12.7 mm) punch tool (or hole tool). Marking the center hole first, then the top and bottom holes, she punches a circular pattern of seven holes. Heart says, *If the opening for the [pouring] tip is its smallest diameter and the spout is long enough, after pouring, the tea should flow back into the teapot without dribbling.*

inside of the spout a 45-degree angle, which helps attach it firmly to the belly.

When attaching the spout, in addition to scoring the pot and spout, Heart says, *I've found that if I use really old slip that has a lot of molds growing in it, it tends to adhere my pieces together better. If I use new slip I get more cracks.*

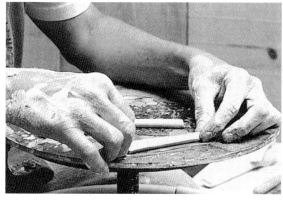

(a)

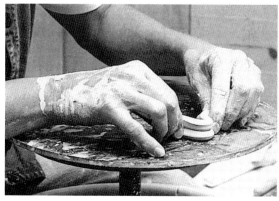

(b)

FIGURE 12-82

(a) Heart pulls a clay slug long enough to allow for the 15% shrinkage of her porcelain clay. *Otherwise,* she says, *you won't be able to get the bamboo handle into the lugs. (b)* She then cuts it in half down the middle and bends both sections together so that they have the same curve. She puts them aside to set up slightly, and later she pulls them apart and attaches them. *(c)* She places the lug next to the spout first. *That way,* she says, *I get the lugs on straight across from each other.* After attaching the lugs she presses a small ball of clay on the outside of each lug, strengthening the attachment. An added incised design gives the lug an individual touch.

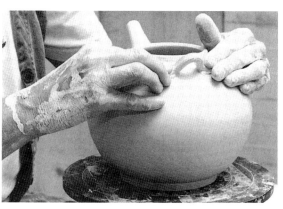

(c)

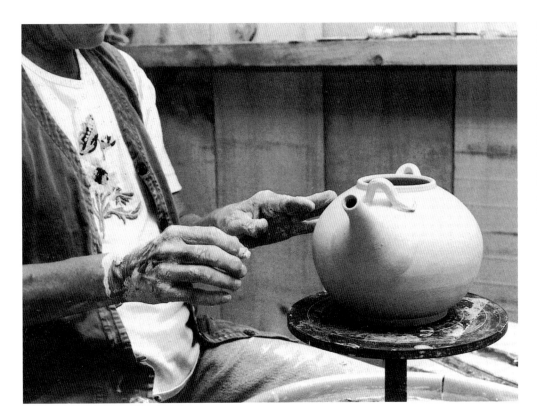

FIGURE 12-83
Finished! The pot has already taken on a life of its own, but drying and sanding are still ahead. After she has constructed her teapots and let them dry slowly, Heart puts on a mask and runs a scouring pad over the teapots to eliminate sharp edges. Then comes bisque firing, glazing, decorating, and glaze firing. Heart uses thinned glazes to achieve her watercolor wash glaze effects.

Making and Attaching the Handles and Lugs

Handles, in addition to being functionally essential, are aesthetically important to the design of a teapot. A clay handle may rise high over the pot, visually lifting it, or it may spring from the side, providing a secure handhold.

Heart, however, uses bamboo handles because she feels that clay handles make a teapot too heavy, and she also likes the way the bamboo handles look on her pots (see 12-85). She used to make the lugs to hold the bamboo handles from coils of clay, but she has found that pulled lugs make stronger connections for the handle (see 12-82).

FIGURE 12-84
Heart holds the glazed pot that she demonstrated making over these pages. This teapot was first glazed with a white glaze, then decorated with brushwork. Of her teapots, Heart says, *Each reminds me of an individual creature. They're my pals.*

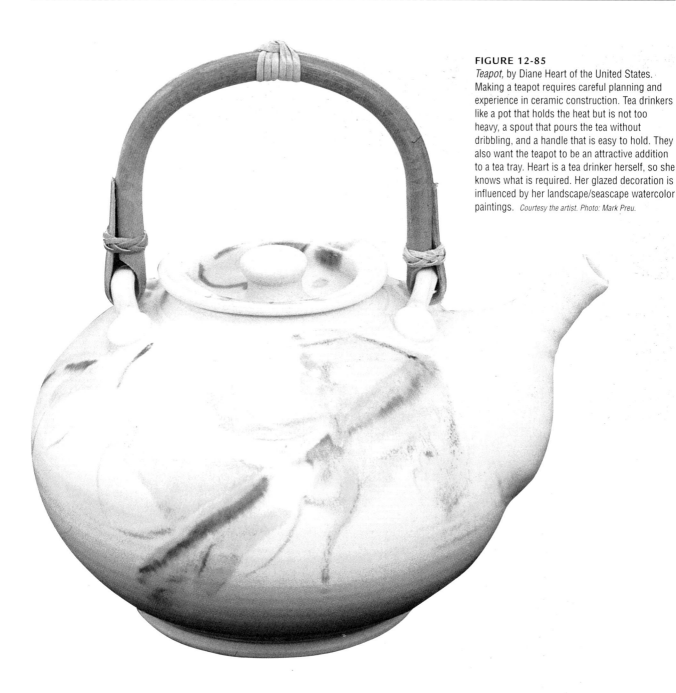

FIGURE 12-85
Teapot, by Diane Heart of the United States. Making a teapot requires careful planning and experience in ceramic construction. Tea drinkers like a pot that holds the heat but is not too heavy, a spout that pours the tea without dribbling, and a handle that is easy to hold. They also want the teapot to be an attractive addition to a tea tray. Heart is a tea drinker herself, so she knows what is required. Her glazed decoration is influenced by her landscape/seascape watercolor paintings. *Courtesy the artist. Photo: Mark Preu.*

The Finished Teapot

After she finished school, Heart worked in two pottery factories, perfecting her skills. *It was tremendous,* she says. *When we counted up the number of pots we made at the end of the year, I found I had thrown 30,000 pots.* Now that she has her own shop, she feels lucky that she can experiment with teapot design and decorative effects without restrictions.

There's nothing like making pots, Heart says. Recently she took some watercolor classes that gave her a new approach to decorating her work, and when she and her husband, photographer Mark Preu, go hiking or boating, she paints while he takes landscape and wildlife photos. Although she does not copy her watercolors onto her pots, many of her teapots are decorated with quickly brushed sea and landscape impressions (12-84, 12-85).

FIGURE 12-86
Soup Tureen, by Carol Temkin of the United States.
Glazed and fired with matching ladle, the tureen's
quiet color and functional shape belie the skill and
thought that went into its construction. Wheel-
formed of porcelain, fired at cone 10 in an electric
kiln in oxidation, with a turquoise magnesium-
based combination glaze. *Courtesy the artist. Photo:*
Robert Arinda.

THROWING AND ASSEMBLING A TUREEN

A soup tureen that is simple and well designed,
with carefully detailed handles and lid, can sug-
gest comfort, home, and chicken soup (12-86).
On the other hand, an elegant, highly decorated
tureen may evoke an elaborate celebration with
exotic cuisine.

Making any tureen requires a number of
throwing, trimming, handle-making, and fitting
techniques. After throwing a cylinder and shap-
ing it into the body, Carol Temkin gives it a
sturdy, well-rounded rim that will accept and
hold a lid firmly in place (12-87–12-90). A struc-
turally sound rim resists cracking during firing,
or damage from frequent use. A thin rim not
only is susceptible to warping during building
and firing but also is easily chipped in use.

Rhythmic throwing rings can add to the over-
all strength of a tureen and provide a place for
the glaze to settle and develop during firing. In
addition, these throwing ridges and valleys help
create a variegated surface that can enhance the
glaze.

Whatever type of tureen a potter throws, it
should be well designed, drawing the eye to its
shape, color, and detailing. At the same time, it
should be built strongly enough to provide years
of satisfying use on the table.

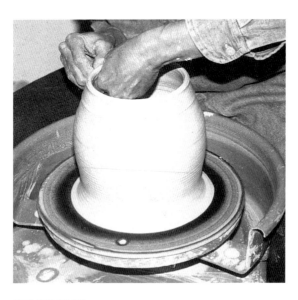

FIGURE 12-87
Temkin pulls up the wall of a cylinder that will be shaped into a
tureen. She throws on a bat so that the piece can easily be
removed from the wheel without distorting it.

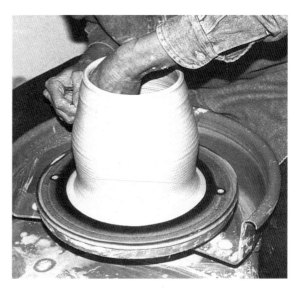

FIGURE 12-88
Temkin pulling up the wall another time.

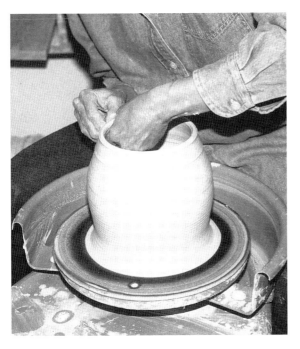

FIGURE 12-89
The belly of the tureen begins to swell as the clay is stretched further. She then slows the wheel speed as she forms the wall into a sturdy rim that helps counteract warping and resist damage. It also emphasizes the visual quality of the tureen.

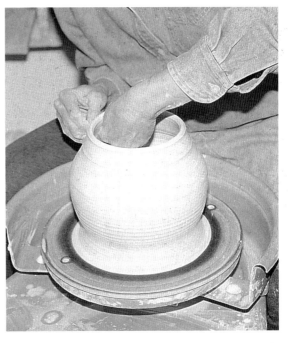

FIGURE 12-90
Temkin says, *Visually and functionally, a strong, rounded rim is important to the form.* Here she gives the tureen its final shape.

FIGURE 12-91
Temkin uses a Giffin Lidmaster tool for measuring the inside and outside of a pot.

Using Calipers

Calipers are useful instruments for measuring the inside and outside diameters of wheel-thrown pieces (12-91–12-93). Ceramists use a variety of calipers, made of wood, plastic, or metal. If you have only one pair of calipers, you can measure the inside of a container, transfer that measurement to a piece of paper, and then open the calipers to the outside position. Some potters choose to use a unique tool called a Giffin Lidmaster (see 12-91), which gives both the inside and outside measurements of a container or vessel. When using this tool to transfer measurements from the inside of a container to the outside of a lid, it is important to hold the piece in a fixed position so the measurements can accurately be transferred from one object to another. Transferring a measurement from a vessel to a newly thrown lid requires accurate records to attain correct dimensions. These measurements are especially important when you are fitting a lid to a container.

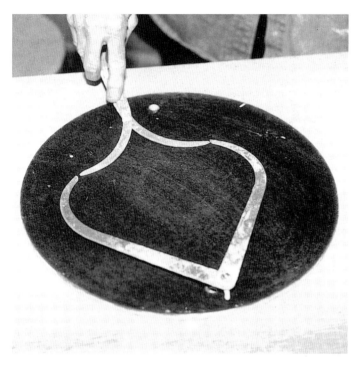

FIGURE 12-92
To determine the lid size, she transfers the inside rim measurement to the outside flange measurement of the lid (see Figure 12-93) by criss-crossing one caliper and aligning it against the inside of another caliper.

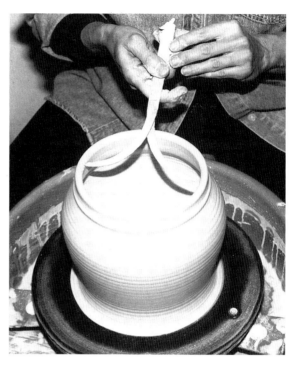

FIGURE 12-93
Temkin measures the inside diameter of the tureen with a caliper to calculate the size of the lid. This piece measured 5½ in. (139.7 mm).

Throwing the Lid

Throwing a lid (12-94–12-98) requires a technique similar to that used in making a shallow bowl or a plate (see Catharine Hiersoux, 12-44 to 12-55). It is a good idea to throw the lid on a bat so that it will stay flat during drying without distorting. Some potters throw extra lids when fitting a lid to a container because there may be variations in shrinkage as the lids dry. This is especially important if the lid is being matched to a container that has already dried and shrunk. Usually one lid is matched to the inside diameter of the container or flange while the second is made slightly larger in case the smaller one shrinks too much. Be careful not to cut too much clay off the bottom of the lid when you cut it from the bat with a wire, or you may end up with too thin a lid.

After slicing through the bottom of the lid with a wire tool, leave the lid in place to stiffen on the bat until it is damp and leather hard or until it does not slump or bend when handled.

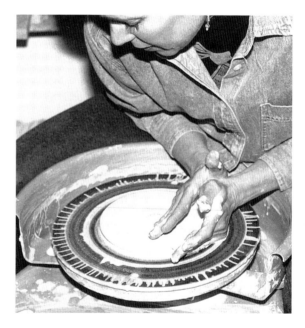

FIGURE 12-94
Temkin centers 1½ lbs. (681 g) of clay on a bat, which keeps the piece true while she throws. Here, she throws a flat, wide disc for the lid.

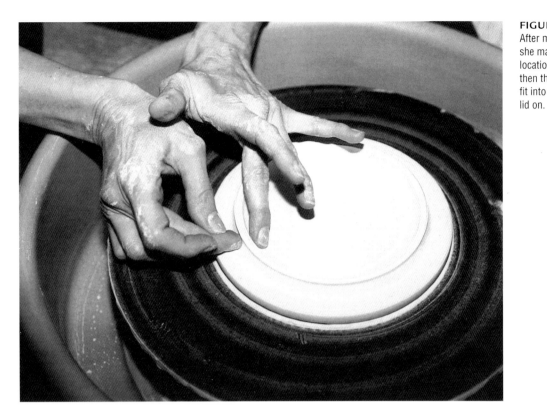

FIGURE 12-95
After measuring with a caliper, she marks the disc, indicating the location of the vertical flange, and then throws a low flange that will fit into the tureen to help keep the lid on.

FIGURE 12-96
Temkin makes a slight depression in the lid: This concavity will help seat the lid over the curve of the tureen rim.

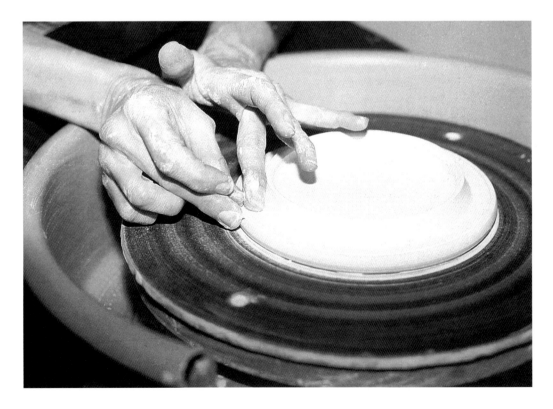

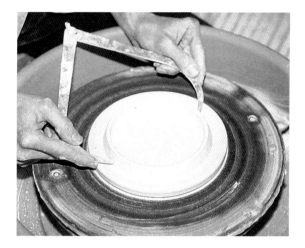

FIGURE 12-97
To ensure that the lid will fit the tureen properly, she uses calipers to measure the outside diameter of the low flange.

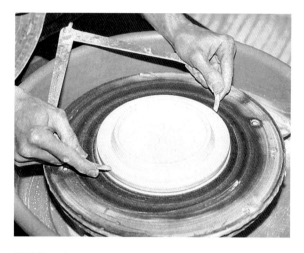

FIGURE 12-98
Temkin measures the outside of the lid to make sure it will rest on the tureen rim, matching the outside edges. She uses a chamois or sponge to round the edge of the lid.

(a) (b) (c) (d) (e) (f) (g)

FIGURE 12-99
Assorted tools for trimming: *(a)* combination curved and straight-edge pear pitter trim tool; *(b, c)* flat-blade ribbon tools; *(d, e)* Japanese style trim tools; wire-end tools for trimming soft clay.

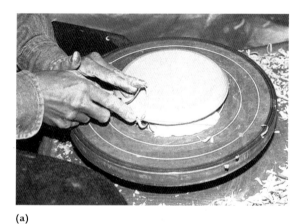

(a)

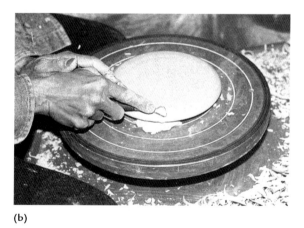

(b)

FIGURE 12-100
(a) After securing the lid to the wheelhead with soft clay, Temkin begins trimming, using the flat, broad surface area of a pear pitter tool. She trims the lid in a spiral pattern, which helps determine the depth of the cut. *(b)* Temkin switches to a ribbon tool to trim the curve of the lid.

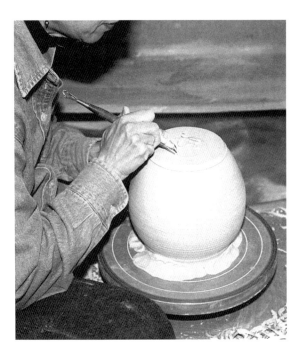

FIGURE 12-101
Trimmings from the base release cleanly when the clay is trimmed in the leather-hard state. For added stability, Temkin holds the trim tool with both hands: With the wheel turning fast, she positions the tool at the center of the base and steadily cuts down into the clay while simultaneously pulling it toward her body.

Trimming the Tureen

When inverting the tureen on its lip for trimming, it is important that the clay be damp enough to trim yet stiff enough (leather hard) so that the rim will not distort or be damaged; this is especially important if the tureen will require a fitted lid. The clay is at the correct degree of dampness for trimming when it cuts easily and the trimmings look like flat ribbons. If, however, the trimmings come off in small flakes or as dust, the clay may be too dry. In this case, mist the clay with water to soften the surface, then trim the ware in stages, alternating between moistening and trimming (12-99–12-105).

Some potters place a piece directly on the wheelhead for trimming, attaching it to the wheelhead with a damp ring of clay (see 12-101). Another method is to flatten a ¼-in. (6-mm) soft slab onto the wheelhead, then place the work on this slab and attach a ring of clay or tabs at three points.

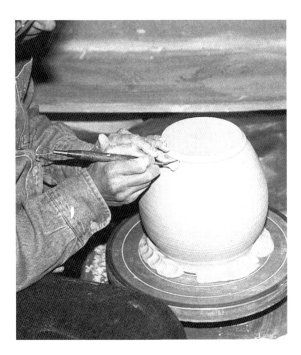

FIGURE 12-102
Temkin says, *The foot should extend the contour line of the tureen in a graceful manner but at the same time provide a solid base for the pot to rest on the table so it can be used securely.*

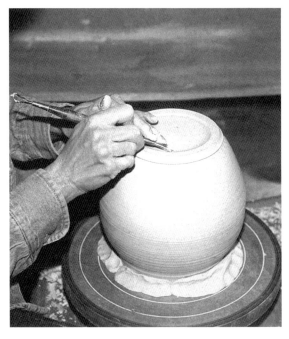

FIGURE 12-103
She trims the foot to a depth of 1⁄16–1⁄8 in. (1.5–3.0 mm). The thickness at the base after trimming is 3⁄16–1⁄4 in. (4.80–6.20 mm).

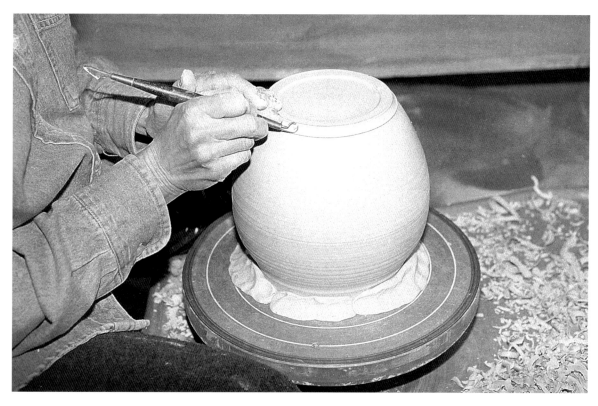

FIGURE 12-104
Temkin trimming, with the pot held on the wheel with damp clay. She uses the rounded end of a ribbon tool to cut a shallow depression into the rim of the foot. This acts as a design feature.

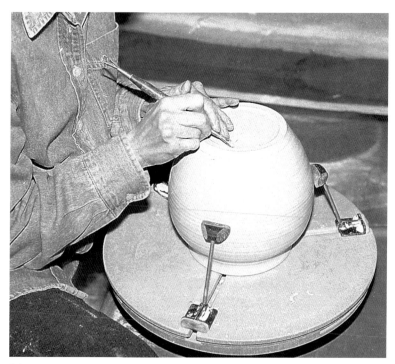

(a)

(b)

FIGURE 12-105
(a) Temkin uses an adjustable commercial chuck called a Giffin Grip to trim her pottery. (b) A thrown and bisque-fired chuck can also be used to hold pots on the wheel.

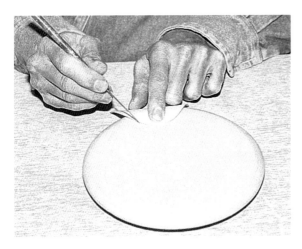

FIGURE 12-106
Temkin positions a paper template sized to make a large enough hole to accommodate the spoon handle. She marks the damp, leather-hard lid and punctures numerous holes through it with a needle tool. This makes it easier to cut the handle notch.

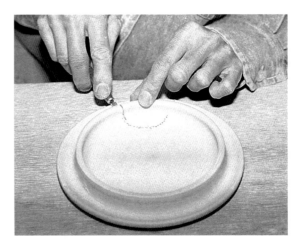

FIGURE 12-107
With the lid inverted, she cuts the spoon handle notch, using a sharp, tapered knife.

Cutting the Spoon Hole

A spoon hole must be cut large enough to accommodate a serving spoon or ladle and allow it to sit at a pleasing visual angle (12-106, 12-107). If the hole is too large, however, air can enter the tureen and cool the soup.

After cutting the spoon hole, beveling or rounding the edges will help keep them from chipping, especially if a metal spoon will be rattling around in the hole (12-108, 12-109).

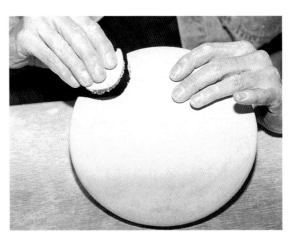

FIGURE 12-108
She carefully removes the spoon handle notch cutout.

FIGURE 12-109
She holds the trimmed lid ready for a handle.

FIGURE 12-110
Temkin begins to pull a handle, taking a slug of clay in her left hand and lubricating it with water.

FIGURE 12-111
She completes a pulled handle to be used for either the lid or the sides of the tureen. Temkin pulls extra handles and chooses those that best fit the shape of the tureen both aesthetically and functionally.

FIGURE 12-112
Pulled handles are hung on a shelf and left to dry until they are stiff enough to keep their shape yet soft enough to bend and attach to a lid or bowl. Temkin sometimes covers the handles with plastic sheeting to prevent them from drying too quickly.

Pulling the Handles

Pulled handles are popular with many potters because they can result in fluid and elegantly finished decorative features. Pulled handles are also structurally sound and resistant to cracking or distorting because they are seamless, pulled from a single thick coil of clay.

Clay used for pulling handles is usually smooth earthenware, porcelain, or stoneware, or one that contains fine grog (30–70 mesh). Clays that are heavily grogged and coarse may pull adequately but may not bend or curve easily. For pulling, the clay should be wedged and of a consistency stiff enough not to come apart once water is added to assist in pulling (12-110–12-112).

Sizing the Lid Handle

Accurately sizing a handle to a container is important for a number of reasons. A handle must visually interact with the overall form of a piece, as well as fit the hands of the user. Structurally, the handle must be attached firmly and be strong enough to take daily use, especially if the container will be put in the dishwasher or the oven. It is wise to make extra handles before sizing a lid handle in case you change your design and want a longer handle or one that is thicker or thinner; also, if you cut one too short, you'll have extras on hand. Measuring a handle with a ruler or calipers will ensure accurate alignment and fitting (12-113, 12-114).

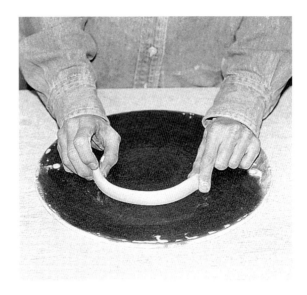

FIGURE 12-114
She bends a handle into a curve and then dries it on a board until it is stiff enough to pick up and attach to the lid. The handle is curved high enough so that lifting fingers will fit easily between the handle and lid.

FIGURE 12-113
The lid is placed on the bowl to help determine the handle placement. Temkin marks the position of the handle using a wood scribe tool.

Attaching the Lid Handle

Consider the aesthetic as well as the functional aspects of the lid before attaching a handle. The visual quality of a handle and its fit can enhance the overall shape of the tureen. Remember to make the curve of the handle high enough for adequate gripping: If the handle is too close to the lid, you may burn yourself if the container has hot food inside. The handle must be damp but stiff enough to hold its shape without slumping when you begin to attach it to the lid. With a pin tool or a fork, score both the lid and the handle at the points of attachment or just slightly beyond to ensure a positive bond. Then apply a small amount of slip to the joins and press them together (12-115–12-119).

(a) Sculpture tool

Wooden diagonal blade with rounded thumb end for cutting, trimming, and sculpting soft clay.

(b) Pin tool

Needle for cutting thin slabs and for trimming and piercing air bubbles in soft clay.

FIGURE 12-115
(a) A pin tool (or needle tool) used for marking and scoring. *(b)* A wood sculpture tool used for applying slip, trimming, and shaping. Here, it is used for pressing the ends of handles into the bowl. The thumb end is used for sculpting soft clay.

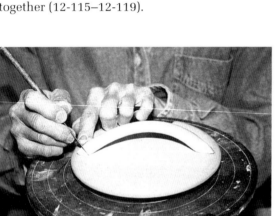

FIGURE 12-116
With the handle resting in place, Temkin uses a pin tool to mark the lid, determining where to score and add slip. The ends of the handle are cut at an angle so they fit flush to the surface.

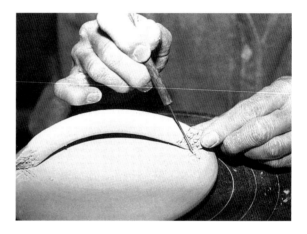

FIGURE 12-117
Using a pin tool, Temkin scores the lid and handle heavily in a crosshatched pattern.

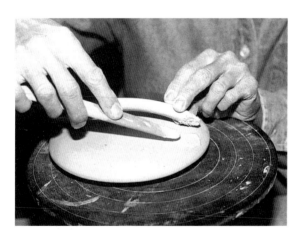

FIGURE 12-118
She applies slip to both surfaces, scores them again, and then attaches the handle.

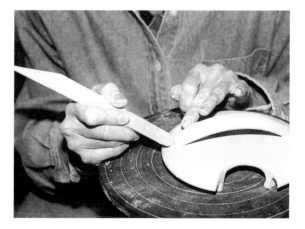

FIGURE 12-119
She uses the rounded end of a wooden sculpture tool to apply pressure to the points of attachment to ensure a positive bond.

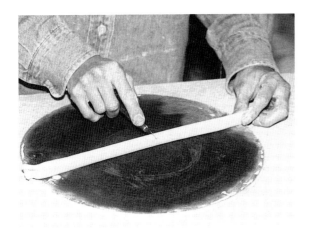

FIGURE 12-120
Temkin selects a long handle and cuts it evenly into two pieces.

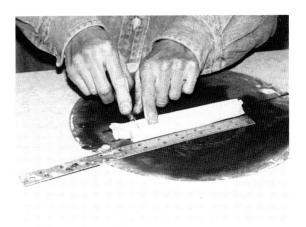

FIGURE 12-121
Using a ruler, she cuts two handles the same length for the sides of the bowl.

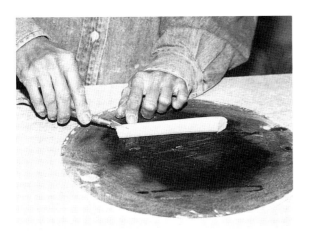

FIGURE 12-122
She uses a knife to cut the ends of the handles on a diagonal so that they fit the curve of the wall.

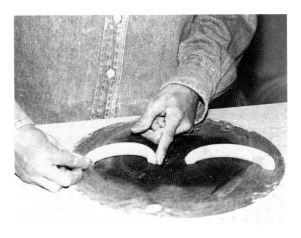

FIGURE 12-123
The side handles are shaped into a slight curve and left to dry and stiffen until they hold their shape without deforming when picked up. If they become too dry, they will not bond properly to the bowl.

Making the Side Handles

Side handles can be pulled, rolled as coils and flattened, or extruded. They can be kept plain or embellished with light carving, which will add to the aesthetic interest of the tureen. Cutting a damp clay handle on a smooth, flat, porous surface such as a bat ensures that the handle will release from the work surface. For accurate measuring, use a ruler or calipers to record the exact size that will be needed to match the pair. You can also mark the size on a piece of paper (12-120–12-123).

Attaching the Side Handles

When positioning side handles, be aware of the form of the tureen and how the design of the handles will affect its appearance. The side handles also need to be large enough so that one can easily pick up and carry the tureen, and strong enough to hold the weight of both the container and its contents without breaking off. The side handles are generally attached to the upper half of a tureen for visual and structural stability.

After measuring the pulled and cut side handles with a ruler or calipers, place each handle

on the tureen to check its position before attaching it permanently. Mark the placement of both with a needle tool, score the handles and the body where they will be attached, apply a little slip, and then attach each handle and press the ends onto the scored and slipped surface of the tureen (12-124–12-126).

FIGURE 12-124
After scoring the handle and bowl, Temkin applies even pressure to the handle as she joins it to the bowl.

FIGURE 12-125
She uses the curved end of a wooden sculpture tool to compress the join between the handle and the bowl.

FIGURE 12-126
Temkin places a ruler on top of the bowl to align the second handle, then measures down from the rim 2–2½ in. (51–64 mm) and makes a mark with a pin tool to designate the handle position. (See Figure 12-86 for the completed tureen.)

COMPOSITE POTS

What do you do if you want to throw a pot that is taller than your arms? Eileen Murphy, who is not very tall and whose arms are short, has had this problem. Since it is impossible for her to reach in to throw as large a pot as she wants, she solves the problem by throwing a series of rings on the wheel and then luting the sections together. Others use various methods to combine several wheel-thrown sections. Catharine Hiersoux makes all the sections of her tall jars on the wheel and then attaches the sections with slip before firing (12-127–12-129).

There is nothing new about combining forms or methods. The Etruscans did it long ago (see 2-29). Traditional potters everywhere made pots in sections; many of the jugs that were the mainstay of a medieval European potter's livelihood were made in two parts. In his "how-to" book published in 1556, the Italian potter Piccolpasso explained both how to attach separately thrown forms while they were damp and how to "glue" parts after the bisque firing by using glaze that would melt and fuse the parts together in the

FIGURE 12-127
Catharine Hiersoux of the United States makes a large jar in sections. Here, she prepares to add the second leather-hard section. Note the flange on the inside, made to fit securely over the scored and slip-painted lower section.

FIGURE 12-128
Hiersoux lowers the upper section, thrown upside-down and still attached to its bat, onto the lower section.

FIGURE 12-129
After melding the join with her thumb and cleaning off the excess slip, Hiersoux uses a rib to smooth and shape the tall jar. The third section will provide the neck and lip.

FIGURE 12-130
Paul Chaleff of the United States uses coils to construct jars that are more than 6 ft. (1.83 m) tall. He works outside his studio, using an electric wheel only to turn the jar as he builds. *Courtesy the artist.*

FIGURE 12-131
The wheel rotates the jar as Chaleff smooths the wall. Chaleff says that he tries *to preserve that respect for history throughout my work in concept, process and in form.* His wheel-and-coil method is a modernization of traditional techniques used around the Mediterranean and in Korea and Japan. *Courtesy the artist.*

second firing. One method of making large pieces, probably used since the days of the Minoan potters on Crete (see 2-12a), has been given a modern touch by Paul Chaleff. He built up and smoothed his 6-foot (1.83-meter) jars outside his studio, coiling them on an electric wheel (12-130, 12-131).

ALTERED WHEEL-THROWN FORMS

Until comparatively recently, most altered vessels stayed within the general category of containers even if, like Palissy's plates (see 6-19), they were unlikely to be used for anything but display. For example, Hans Coper, who altered and recombined wheel-thrown forms, made vessels that *could* contain, although his work is usu-

ally treasured for its appearance rather than its usefulness. Many other ceramists continue this tradition of maintaining the basic vessel form while altering it enough to impose on it a new quality or individual style (12-132–12-138).

Artists approach the vessel in a variety of ways. Warren MacKenzie's lidded jar (see 12-132) is a fluid wheel-thrown form that he altered slightly, then unified with a Shino glaze. MacKenzie says, *in the firing, carbon gets under the glaze and develops the range of color variation from dark grays to the traditional Shino glaze salmon color.*

Basic wheel-thrown shapes luted together, altered, or combined with other components made from slabs or coils or with the extruder can bring new and unexpected relationships of volume and profile to thrown vessels. The English potter Walter Keeler, who has moved back and forth between making useful pots and making nonfunctional ones, says, *Function, though,*

has remained a vital catalyst for me in creating new pots (see 12-133).

Painter Nathan Oliviera and Peter Voulkos collaborated on a thrown and altered vessel that became a sculpted head. Deeply gouged, textured, and painted with glazes, it creates its impact through their combined approaches to form, surface, and color (see 12-134). For his larger pots, Peter Voulkos used a wooden mallet to alter their forms (12-135).

As illustrated further by three works, altered wheel forms can vary widely—from Woody Hughes's *Steam Iron* teapot (see 12-136) that could never pour, to Sadashi Inuzuka's assembled pieces that he calls "exotic species" (see 12-137), to Don Reitz's tall *Teastack* (see 12-138), which he threw, coiled, tore, and reassembled.

FIGURE 12-132
A lidded jar by master potter Warren MacKenzie of the United States reflects the thrown pottery tradition, with its altered form aesthetically unified by the addition of a Shino glaze. Ht. 4 in. (10 cm), diam. 8½ in. (22 cm). *Courtesy the artist. Photo: Peter Lee.*

FIGURE 12-133
Walter Keeler of England threw his *Angular Teapot* upside-down, added a slab base, struck the pot and spout with a metal file to make the score lines, extruded a handle, and assembled the parts when leather hard. Keeler's collection of tinware utensils influenced his choice of forms. Stoneware, cone 10, oxides and stains mixed with engobe, salt-glazed. Ht. 8 in. (20 cm). *Courtesy Aberysthwyth Arts Center and the artist. Photo: Keith Morris.*

FIGURE 12-134
American painter Nathan Oliviera decorated this thick-walled abstract expressionist vessel thrown by Peter Voulkos. Their bold approach to the figurative vessel incorporated the marks of the artist's hands as an important aspect of its aesthetics. The vessel was high-fired, then refired with low-fire glazes to attain bright red and orange colors. *Courtesy Toki Collection.*

FIGURE 12-135
Peter Voulkous inserts chunks of clay into cutouts in the wall of one of his wheel thrown composite pots. Then, using a wood mallet he paddles the surface of the vessel to alter the shape of the piece. After drying, the sculpture is fired in a wood kiln. *Photo: John Toki.*

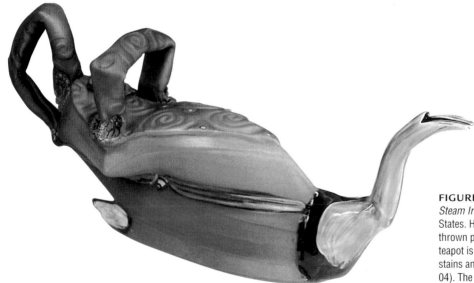

FIGURE 12-136
Steam Iron teapot, by Woody Hughes of the United States. Hughes assembled his teapot from wheel-thrown pieces when they were leather hard. The teapot is decorated with terra sigillata, slips, and stains and fired at earthenware temperatures (cone 04). The low firing temperature allows Hughes to use a wide range of colors when he decorates his pottery. He seeks to attain an overall balance between decoration, gesture, rhythm of form, and structure. Hughes says, *I am particularly interested in the formal aspects of creating; in getting each piece to work aesthetically.* 14 × 5 × 9 in. (36 × 13 × 23 cm). *Courtesy the artist. Photo: Woody Hughes.*

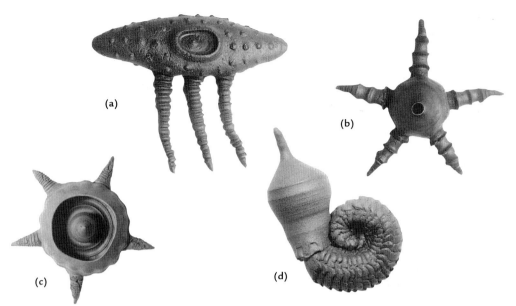

(a)

(b)

(c)

(d)

FIGURE 12-137
Sadashi Inuzuka of Canada generates his sculptural forms *(a to d)* from the potter's wheel by altering cylinders, cones, plates, and other vessel shapes. He then assembles the parts and builds them into sculptures that he calls his magical world of "exotic species." Inuzuka says, *I use the metaphor of the insect or microscopic organism to talk about the natural world and our place within it.* Courtesy Davis Art Center, Davis, California. Photo: Stuart Allen.

FIGURE 12-138
Teastack, by master potter Don Reitz of the United States. This piece was made with two wheel-thrown sections, joined, as the lower half. Then a coil 24 × 6 in. (61 × 15 cm) was attached to form the neck. Reitz pushed a broom handle into this thick neck coil and rotated it to open and shape it. He then tore off parts of the "skirt," leaving a ragged edge, and applied various appendages to the neck and rim. Ht. approx. 42 in. (107 cm). Stoneware, fired in a wood kiln to cone 12, with oak and walnut wood. Courtesy the artist.

POSTFIRING CONSTRUCTION

Making constructed objects out of a number of fired parts has been speeded by the development of modern adhesives. For example, Kevin Nierman intentionally breaks up his vessels in a process that, he says, *suits a part of my personality, my destructive side.* He then reassembles them, creating a personal statement that he sees as a healing process (12-139). Whether you want to fire and reassemble a shattered pot, or attach the components of a wall piece to a plywood panel, you can use adhesives (see *Expertise,* Chapter 4B).

This means that you are freed from many restraints and have available a wider range of methods or combination of methods with which to work than at any time in the history of ceramics. It is still of vital importance, however, to master the basic forming skills so that you can develop your *own* way of working.

FIGURE 12-139
This sawdust-fired pot by Kevin Nierman was torched after firing to achieve additional color. Then the piece was deliberately broken with a hammer and glued back together.

13

Molds

WORKING WITH MOLDS

For several thousand years potters and sculptors have been creating images and useful objects by pressing or pouring clay into molds (see Chapters 2–7). Molds have also been continuously used in ceramics factories to mass-produce a variety of objects such as dinnerware, decorative figurines, plumbing fixtures, and insulators.

Thus, like so many contemporary ceramics processes, the technique of pressing, pounding, or pouring clay into a mold is an ancient one; what *is* new is that the use of molds to create images is no longer confined to mass production. Contemporary ceramics artists now regularly use molds to make one-of-a-kind vessels (13-1, 13-2) or sculptures, as well as to make multiples, tiles, and other types of modules.

This chapter covers various molding techniques using hump, press, and drape molds, as well as a step-by-step explanation of how to make a multipart **slip-cast** vase mold. A wide variety of molding applications are also discussed, including a wood press mold used for making a tall container and the press mold process used by Carlo Zauli to build one of his large porcelain architectural wall sculptures.

HUMP MOLDS

The first mold may have been a rounded stone over which someone pressed clay to make a simple container. A so-called *hump mold* can be made of any material over which clay can be draped. An inflated plastic bag, a balloon, a bag of sand or vermiculite, crumpled up newspaper, a polystyrene form, or a specially made plaster or terra-cotta

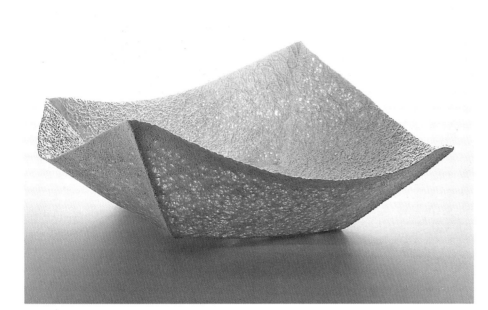

FIGURE 13-1
Porcelain vessel by Nagae Shigokazu of Japan, formed by layering thin sheets of porcelain slip in a mold. Fired at 2336°F (1280°C) for 30 hours in a gas kiln.
Courtesy the artist and Yufuku Gallery, Tokyo.

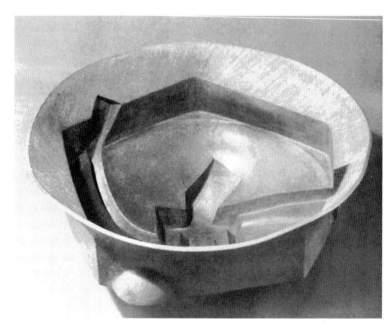

FIGURE 13-2
In *Pentagonal Destination,* William Daley of the United States created a sculptural vessel that refers back to the Shang bronze-vessel makers and the Anasazi Native Americans, whom he sees as his masters. Unglazed stoneware. Ht. 15¼ in. (39 cm). *Courtesy Helen Drutt Gallery.*

hump mold will allow you to support the clay as it stiffens and takes on the shape of the mold. Low-fired clay and plaster are, however, particularly useful as mold materials because their porosity allows them to absorb moisture from the clay, causing it to stiffen quickly.

You can place the clay over a hump mold in the form of slabs, wads, or coils, patting it on with your hand, paddling or scraping it to compress the particles or make it smooth. Whatever method you use to apply the clay, by working on a hump mold you can easily make a wide-mouthed form (13-3), as long as the mold is not shaped to curve inward, causing an **undercut.** On a mold that curves in, as the stiffened clay shrinks it will be held tightly around the inward-curving area and have to be cut to be released from the mold.

Hump molds can be used in a variety of ways—for example, to support the wide, flaring

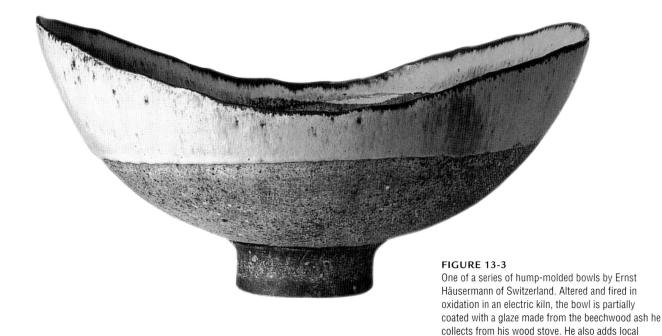

FIGURE 13-3
One of a series of hump-molded bowls by Ernst Häusermann of Switzerland. Altered and fired in oxidation in an electric kiln, the bowl is partially coated with a glaze made from the beechwood ash he collects from his wood stove. He also adds local earth materials to the clay to give it a rich, roughened surface. 9½ × 21 in. (24 × 53 cm). *Courtesy the artist.*

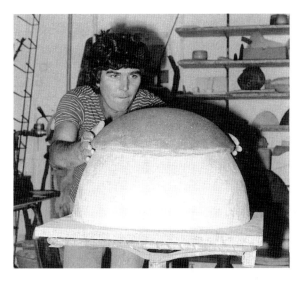

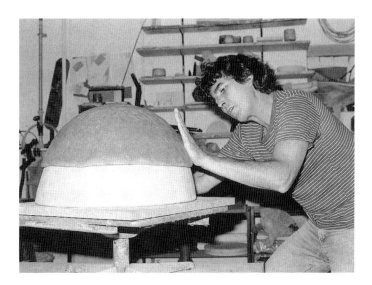

FIGURE 13-4
Häusermann shapes a bowl on a porous bisque-fired hump mold. As the mold absorbs moisture from the clay, the bowl will stiffen enough to be removed. Notice that the mold does not curve inward, which would cause an undercut that would make it impossible to lift the stiffened bowl off the mold. *Courtesy the artist.*

FIGURE 13-5
Slapping the stoneware clay, Häusermann thins the wall while extending it farther down the mold. Once he has thinned the wall he will attach the foot. Then, when the clay has stiffened enough, he will be able to remove the bowl and finish the shaping process. *Courtesy the artist.*

form of a bowl that might be difficult to keep from collapsing while being handbuilt right-side-up (13-4, 13-5). As mentioned, coils can also be formed over a large mold and scraped smooth (13-6), or slabs can be shaped over soft forms such as bundled and taped newspaper.

Juan Granados uses the latter method to form his organic sculptures for wall pieces and installation modules (13-7; see also 11-41 to 11-46).

The newspaper can be left in to burn out if a piece is fired in a well-ventilated gas kiln, but it must be pulled out before firing in an electric

kiln, unless it is vented to draw the paper smoke out to the open air. Other soft materials, such as bags of plastic peanuts or foam shreds can also be used as hump molds; in those cases, however, the plastic or foam *must* be removed before firing in any type of kiln.

Clay placed over a stiff hump mold of plaster or bisque-fired clay can be applied as wads, coils, or slabs. Patting it on, paddling it, or using some other method to apply the clay, you can form a vessel or a section of hollow sculpture on a stiff hump mold. This technique will be successful, however, only if the mold does not

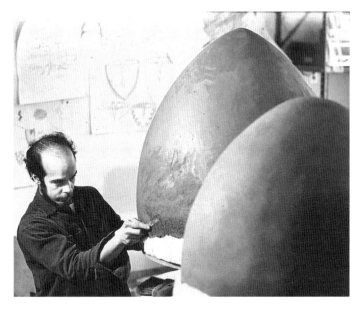

FIGURE 13-6
Graham Marks of the United States uses coils to build his sculpture upside-down over polystyrene foam hump molds. He melds the coils together by scraping the surface. *Courtesy Helen Drutt Gallery.*

FIGURE 13-7
First Harvest, by Juan Granados of the United States. Drawing on his rich Mexican heritage and his experience as the child of migrant workers, Granados uses clay as a medium to access and transform his memories. To create his individual sculptures and installations, he builds forms of wadded-paper to make hump molds, then lays clay slabs over them. Earthenware, grog, stains, and oxides; oxidation firing. 12 in. × 8 ft. × 14 ft. (30 cm × 2.43 m × 4.26 m). *Courtesy the artist. Photo: Jon Q. Thompson.*

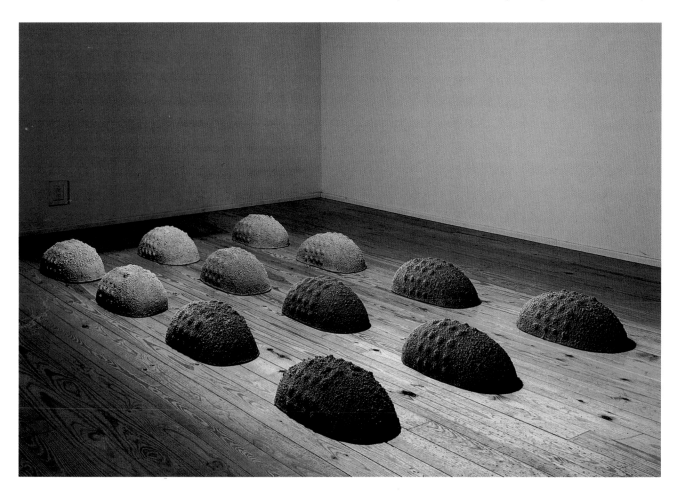

curve inward, as noted earlier. Another precaution when using inflexible hump molds: Watch the clay carefully as it stiffens and remove it before it dries too much. As the clay shrinks on a rigid hump mold, it cannot contract against the mold and can crack or even form breaks in the wall if left on the mold too long.

PRESS MOLDS

In contrast to hump molds, press molds are usually low-relief or concave forms into which the damp clay is pressed. The interior of almost any concave form can serve as a press mold as long as the surface of the object is smooth enough to release the damp clay or is covered with plastic sheeting or coated with **mold soap,** vegetable oil, or petroleum ointment.

Press molds do not have to be elaborate. A kitchen mixing bowl lined with a piece of plastic wrap or cloth or even a milk carton or cardboard box will work, as long you can press slabs, wads, or coils of clay into it. As with hump molds, press molds must not permit undercutting.

A bisque-fired press mold has advantages: As compared to using a metal or glazed china bowl as a mold, a bisque-fired mold will release the clay more easily; it can also be reused hundreds of times. Early potters from a variety of cultures understood the advantages of terra-cotta molds, as we can see in a relief-decorated vessel from Rome (see 2-32) and in the face vessel from Peru (see 5-4).

A press mold made from plaster, however, also has its advantages. It is especially useful for drawing the moisture evenly out of the clay; with proper care the stiffened clay can be removed from a plaster mold in one piece (13-8). It also has the advantage of allowing you to reproduce your own work, or a section of it, as part of a mural, architectural facade (13-9), or large sculpture. And like a bisque-fired clay mold, a plaster mold can be reused if it is stored in a dry place between castings.

To make a one-part press mold, you must choose an object to cast that has no undercutting. For example, the simple mold shown in Figure 13-10 into which Gunhild Aberg pounds clay with a stone will release the stiffened clay with no problem. Pressing clay into this type of mold will result in a simple, open, concave form.

FIGURE 13-8
In a hill town in Italy, potters make large decorative urns in simple, two-part ceramic press molds; they then hand-tool the surface to refine the details. They work much as their Etruscan ancestors did, except that the modern molds are plaster. The lower bowl keeps the mold from rocking.

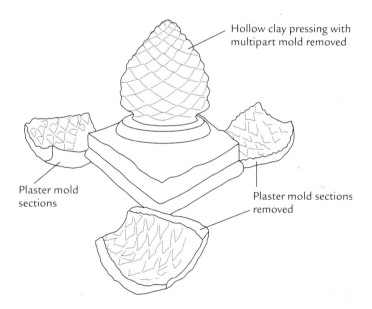

Hollow clay pressing with multipart mold removed

Plaster mold sections

Plaster mold sections removed

FIGURE 13-9
This cast of a large terra-cotta pineapple for architectural or garden decoration was made in a multiple plaster mold in a pottery workshop in Petroio, Italy, where architectural ornaments and large decorative vessels are pressed into plaster molds and then finished by hand. At one time the potteries in this area made all functional storage vessels, troughs, pipes, and kitchenware for the surrounding villages, carrying on the ancient Etruscan and Roman terra-cotta heritage. (See also Chapter 2.) *Photo: Le Terrecotte di Petroio, researched by the Middle School, Trequanda, Italy, Editori del Grifo.*

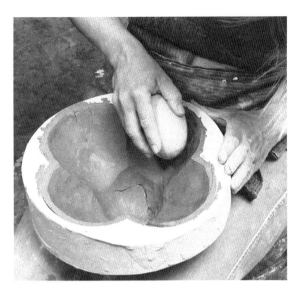

FIGURE 13-10
Gunhild Aberg uses a smooth, rounded stone to press a slab of clay gently into this one-part plaster mold. *Photo: Mogens S. Koch, Denmark.*

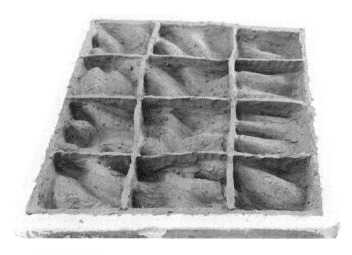

FIGURE 13-11
Carlo Zauli of Italy frequently used press molds made from plaster to build sections of his sculpture. This small press-molded section shows the network of clay ribs that gave added support to the section without too much added weight. *Courtesy the Zauli Estate.*

FIGURE 13-12
To make some large sections for his sculptural pieces, Zauli used simple open-face wooden molds. He pressed new clay into the mold, somewhat altering the form as he built up the clay against the mold. As the mold was slowly filled, the earlier parts were kept moist under plastic. When the mold was removed, the piece was sectioned while still damp, then dried and fired. *Courtesy the Zauli Estate.*

A plaster mold used as a press mold can last for hundreds of reproductions, so you can make many copies from the mold. If you wish, you can alter the copies, creating one-of-a-kind pieces from the same mold. By adding clay, carving or tooling the surface, or altering the vessel or sculpture's shape, you can use a press-molded form as the basis from which to develop a series of new works (13-11, 13-13).

Press molds can also be used for more complex projects. Robert Arneson, for example, formed much of his sculpture in plaster molds into which terra-cotta clay was pressed to form one-half of a portrait head; then both parts were joined (see 8-18). Carlo Zauli often used wooden molds or plaster molds reinforced with steel pipes and sisal fiber to make large wall reliefs, pressing clay into them and then firing the sections separately to be assembled later (13-13 to 13-14). He also combined groups of damp-clay sculptural sections generated from hump or press molds into new composite pieces.

FIGURE 13-13
The full-scale model for a Zauli wall mural. After the piece was sculpted, he made a multipart press mold over the entire wall. *Courtesy the Zauli Estate.*

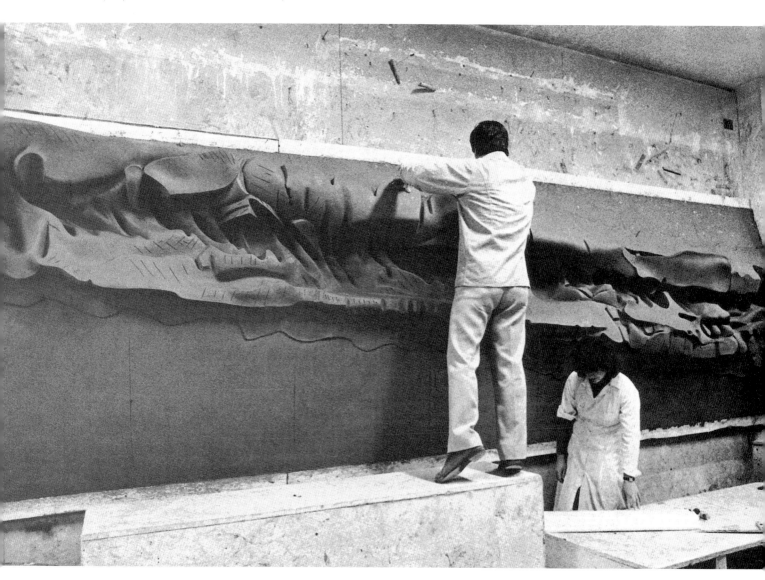

FIGURE 13-14
Zauli inspecting the plaster, steel, and fiber reinforced press mold constructed over the wall mural.
Courtesy the Zauli Estate.

FIGURE 13-15
Zauli checking on the results of a porcelain wall mural drying in his studio. To construct the piece, he pressed porcelain clay into large press molds (see 13-13). Clay ribs and supports (see 13-11) built into the back of each unit increased the structural strength and reduced the weight of each section. *Courtesy the Zauli estate.*

FIGURE 13-16
Sadashi Inuzuka used a heavy-duty plaster, steel, and polyester-fiber-reinforced six-part press mold to make his series of *Spirit Boat* sculptures. Terra-cotta was pressed into the mold, beginning at the bottom and progressing up to the rim in a spiral direction. After the piece was completed, the side walls of the mold were unbolted and removed, and two 10 in. (254 mm) wide by 5 in. (127 mm) high tapered plaster wedges located at both ends of the mold were also removed, leaving the clay piece sitting on a thick plaster pad. The spaces left open after removing the wedges accommodated the forklift forks, which were driven underneath the ceramic boat, picking the piece up on its corners to load into the kiln. *Courtesy the artist.*

FIGURE 13-17
Spirit Boat, by Sadashi Inuzuka, is made from press-molded terra-cotta clay coils with wheel-thrown inserts. This piece was part of a series of pieces arranged to represent a group of boats traveling down a river. *Courtesy the artist.*

FIGURE 13-18
Sadashi Inuzuka in his studio with the large *Spirit Boat*
press mold and a greenware boat. *Courtesy the artist.*

In the creation of his *Spirit Boat* series,
Sadashi Inuzuka pressed terra-cotta clay into a
6-part, 5-ft. (152-cm) press mold. Due to the size
and extreme weight of each ceramic boat, the
mold was constructed in a way that made it pos-
sible to remove the plaster side walls and the
wedges that supported the base ends. This left
the boat sitting on an oval-shaped base with
room on the ends to accommodate the studio
forklift that was used to move the boat. The fork-
lift forks were carefully spread by hand to fit just
under the ends of the piece, and the sculpture
was then raised off its base and transferred to
the kiln (13-16–13-18).

Lisa Lee models clay against a granite boul-
der and uses the face of the rock as a natural
press mold for her large sculptural forms (13-19).

FIGURE 13-19
Lisa Lee uses the face of a large granite boulder as a press mold
for forming the front of her sculpture. The sloping granite rock
form, which has no undercuts, keeps the tall piece from tipping
over, and because of its porous surface the clay slab will easily
release from the boulder. *Photo: John Toki.*

FIGURE 13-20
Danielle Ashton found the bark of a large tree to be an ideal natural press mold. She pressed two clay slabs against a tree to capture the bark texture and let them dry for about 1 hour, until they became stiff enough to remove from the tree without deforming. Then she joined them at the seam to form a rectangular box construction.

Danielle Ashton used the bark of a tree as a press mold for a rectangular box construction (13-20).

MAKING TILES IN A PRESS MOLD

One way to make tiles is to press clay into a mold. The tiles shown in Figure 13-24, for example, were made for a floor as decorative ac-

cents between large Mexican tiles. The following sections outline how a precise mold was made from a plastic original; the resulting tile mold yielded a tile $4\frac{1}{4} \times 4\frac{1}{4} \times \frac{5}{16}$ in. (108 × 108 × 15 mm) when fired (13-21, 13-22). Although the tiles were intended for use as floor tiles, they could work equally well on outdoor or indoor walls, kitchen countertops, or splash boards. These tiles were made to be extra thick because they were to be laid in a heavily trafficked area.

Making the Original Tile Model

To make the mold, you will need an original tile **model.** This can be machined out of plastic, enlarged by 13% to compensate for clay shrinkage.

The mold illustrated here was designed to be thick ($8\frac{1}{2} \times 8\frac{1}{2} \times 2\frac{1}{4}$ in. [216 × 216 × 57 mm]) so that it would not break when the clay was pounded into it. To achieve a flat clay surface on the tile, the top edge of the mold was made $1\frac{3}{4}$ in. (44 mm) wide.

Made wider at the base, the original should taper slightly inward. This tapered angle of the wall (called **draft**) is necessary so that the plaster mold will release from the original model. (It also provides extra space for grout between the tiles when installing them; it is easier to push the wet grout between the tiles if they are slightly angled.)

Preparing the Model for Casting

After the original model and wood base are constructed, lightly apply mold soap to the model and allow it to dry for about 5–10 minutes. Give it only a very thin coating of soap. (If you are pouring plaster onto a model coated with sudsy soap, the resulting mold will become pitted and will transfer the rough texture to the tiles.)

Pouring the Plaster Mold

The model is now ready for pouring the plaster. For the mold illustrated here, Pottery Plaster #1 was used because it will last longer and make more tiles than a mold made with ordinary casting plaster. After pouring the plaster, it is important to wait until the top of the plaster is hot to

FIGURE 13-21
This original tile model was made of plastic, machined to be 4⅞ × 4⅞ × 2¹/₃₂ in. (124 × 124 × 17 mm) high, tapering to 4¹³/₁₆ × 4¹³/₁₆ in. (122 × 122 mm). This plastic original was attached to a larger base plate (8½ × 8½ × ¾ in. [216 × 216 × 19 mm]) with five flat-head machine screws (each ³/₁₆ × ⅞ in. [6 × 22 mm] long) countersunk to fit flush with the base. A pair of right angle form boards (11½ × 8½ × 3 in. [292 × 216 × 76 mm]) are clamped around the model and a clay coil is placed along all the seams where the plastic meets the wood. This will ensure that the plaster does not seep through.

FIGURE 13-22
To make a tile mold, mix the plaster in a two-gal. (7.6 l) bucket in a ratio of 5 lb. 2 oz. (2,325 g) plaster to 3 lb. 10 oz. (1,644 g) water. This will yield one mold of the size shown. After measuring out the ingredients, slake the plaster into cool, clean water and wait until all the plaster becomes moist. Wait 1 minute more, then mix the plaster by hand for 2 minutes. Before pouring, wait a few minutes or until the plaster becomes like a fluid cream. At that point, mix the plaster with your hand a few times, then pour it into the mold, starting from one edge of the mold. Let the plaster flow around and over the model.

the touch before removing it from the original plastic model. After removing the plaster, let the mold dry thoroughly, otherwise the clay will stick to the damp surface. The drying process usually takes about one week in a warm room. You can tell if the mold is dry by weighing it on a scale. If it weighs close to 5 lb. (2,270 g), it is dry enough to use. Be aware that new molds sometimes work best after a few clay pressings, because the initial clay pressings pick up the mold soap. (For more information on working with plaster, see *Expertise,* Chapter 4.)

Pressing the Tiles

Once the mold is dry, you can begin to make the tiles (13-23). Pressing the clay into the mold must be done quickly and with very soft, damp clay, because the clay begins drying as soon as it touches the plaster mold. A flat piece of wood called a **screed** is pulled across the clay to level it (13-24). Screeding should be done while the clay is sticky soft. Otherwise, if the screed is run

FIGURE 13-23
To start pressing, quickly throw enough clay into the center of the tile mold so that it comes above the top of the mold by about ⅝ in. (15 mm). Pound the center slightly. While cupping your hand, pull the clay from the center of the mound to the four corners of the mold to fill it.

(a)

(b)

FIGURE 13-24
(a) Dip the screed into water and scrape it across the back of the tile. With a textured rib, score the tile back. Let the piece stay in the mold until it shrinks a little. To get the tile out of the mold, tap on the back of the plaster mold with a rubber mallet. This will help to vibrate the tile out. *(b)* A press-molded porcelain tile was made especially thick to increase its strength for use as a floor tile. It was fired to cone 10, with a cobalt blue transparent glaze.

over the top of the clay as it is drying, the tile will not stay square and will likely become distorted. If the clay it too dry, dip the screed in water and then drag it across the top of the mold to lubricate the clay; this makes the leveling process easier. Be aware that after the tile is fired to cone 10 it will shrink 11–13%, depending on the type of clay used.

Karen Koblitz (13-25) uses a flat plaster slab press mold to impress dimensional patterns on her tiles. To make her molds, after making a low relief design in a slab of wet clay, Koblitz uses the mold to press low-relief tiles.

Drying the Tiles

There are various ways to dry tiles to avoid cracks and warping. If you make tiles using a slab roller, it is best to move the slab on a board to keep it absolutely flat as it dries. If you do not have access to a slab roller, you can also form a slab by placing the clay on a piece of canvas and flattening it with a rolling pin or pounding it with your hand. The porous canvas evenly absorbs moisture from the clay as it dries. Cutting a clay slab into tiles while it is soft or damp leather hard

helps relieve any stresses on the clay that could develop into cracks as the slab dries.

For large or thick tiles (12 × 12 in. [305 × 305 mm] or larger), wrapping the edges in thin plastic sheeting, damp paper towels, or a combination of the two will keep them from drying out too quickly. Small tiles can be sandwiched between layers of plaster board or between plaster bats. This creates equal absorption throughout the tile, while the weight of the board or bat keeps the tiles flat as they slowly dry.

Warping can occur if a moist clay tile is picked up, bent out of shape, and reflattened. The reflattened tile may appear flat throughout the drying period; however, in the firing the tile may warp badly. Slide tiles onto the palm of your hand or a board to ensure that they remain as flat as possible. Tiles of uneven thickness are also susceptible to warping, which can occur during drying and firing. Ceiling fans, wind, or a light breeze can also cause tiles to dry unevenly, resulting in cracks and warping. Force-drying tiles by placing them in a kiln or near a heater is best done after the tiles have stopped shrinking. Placing the tiles on wooden slats or on kiln posts to dry will let air circulate around them for even drying.

(a)

(b)

FIGURE 13-25

(a) Shown here are some of the steps taken by Karen Koblitz of the United States to make a tile for a mural. The original drawing; the drawing transferred to a clay original; a plaster press mold made from the clay original; and the final low-fired tile ready for glazing. Mural commissioned for the Securities Commission, Cranston, CA. *(b) Arts and Crafts Still Life #2,* by Karen Koblitz. A wall relief combining glazed tiles and three-dimensional still life. Low-fire clay and glaze. 31 × 35¼ × 5 in. (79 × 91 × 13 cm). *Courtesy the artist.*

DRAPE MOLDS

A drape mold is any support that will hold a draped clay slab while it stiffens to shape. Examples include a sling made from canvas or a bed sheet stapled to a wood frame, a plastic bucket with a plastic bag draped into it (13-26, 13-27), a metal wok lined with thin plastic sheeting or cloth, a reinforced metal and sisal fiber plaster mold (13-28), or a wood frame mold (13-29).

Some drape molds are similar to press molds except that instead of being pressed into a concave form, the weight and flexibility of the soft clay slab relies on gravity to conform it to a depression. After laying a slab into a drape mold, you can press it into the form by patting it gently with your hand or with a soft sponge. If the clay is especially wet, a thin plastic sheet or cloth over the top of the slab will act as a separator, keeping your hand from sticking to the clay when pressing it into the form.

Of course, you can also take advantage of gravity alone and allow the clay to slump and find its own resting place. The range of possibilities for forming clay is almost endless.

There are a number of ways to manipulate slabs in a more direct manner than allowing them to drape over a hump mold or a canvas sling while they stiffen. Once you learn just how stiff the clay has to be to stand up, you can build vertical forms (see 13-29). Edward Persike found from experience that building a 27-in. (69-cm) tall slab vessel requires careful handling. He shapes his slab vessels in a ¾-in. (19-mm) thick plywood mold. After the wood mold is removed, Persike refines the corners by filling in any depressions or cavities and straightens the edges with a wooden rib and a trim tool. The top rim is added last, and then the piece is left to dry for two weeks. He bisque-fires it slowly over a period of 15 hours and then brushes glaze onto the vessel and fires it for 12 hours in a computerized electric kiln.

FIGURE 13-26
A 5 gal. (19 liter) plastic pail with a plastic bag pulled over the top works well as a simple drape mold. This type of mold can also be made by covering the pail with a cotton T-shirt, a burlap bag, or even a towel.

FIGURE 13-27
A damp clay slab is placed in a plastic bag drape mold (see 13-26) and left to dry for 3 or 4 hours, or until it is stiff enough to remove without distorting.

FIGURE 13-28

(a) A 1½-in. (38-mm) thick plaster drape mold reinforced with sisal fiber and welded-steel reinforcement rods is used for making large rectangular platters. *(b)* The drape mold, shown upside-down, was cast over an oil-based clay form. For structural reinforcement it has a welded-steel cage made with a ⅜-in. (5-mm) reinforcement rod that is embedded in the plaster about ¾ in. (19 mm) and reinforced with sisal fiber. Six riser rods welded to the oval frame raise it to a comfortable working position while helping to maintain the mold's stability when used for draping large clay slabs. *(c)* Sisal fiber, also known as hemp fiber, is an excellent plaster reinforcement material. It is used to strengthen the walls of plaster molds and make them lighter. After a few layers of plaster (called a *splash coat*) have been applied to a form and built up to about ½–¾-in. (13–16 mm), the sisal fiber is dipped into the plaster solution and then stretched out to draw the fibers into an elongated shape. While the plaster-wetted sisal fiber is still damp, it is applied to the mold and around the steel frame. *(d)* To make a large oval platter, a 25-lb. (11.35-kg) slab of clay was draped into the mold and left to dry overnight to stiffen. After it was removed from the mold and turned upside-down on a piece of foam padding, four large clay balls were attached to the bottom to form feet.

(a)

(b)

(c)

(d)

(a)

FIGURE 13-29

Jade, by Edward C. Persike of the United States. *(a)* Persike's thick (⅜-in. [10-mm]) slab-built vase shows formal influences from Chinese jade containers. *(b)* It was built in two wooden molds, or **jigs** *(b, c, d).* The jigs maintained the walls upright during fabrication, drying, standing, and joining. *(d)* Persike cut a base slab, inserted it into the end of the mold, and then placed a paper towel along the inner mold join to keep the slip from sticking (detail). Next, he cut a 45-degree angle along the edges to be joined, placed one slab in the mold, and then pushed it up against the slipped base *(d).* After connecting all the slabs, he scored the inner join with a fork, pressing a thick coil along the seam for extra reinforcement *(e).* A hair dryer accelerated the drying, and when both sets of walls were stiff enough to stand up in the jigs without deforming *(f),* he scored the edges, painted them with slip, stood the mold up, and joined them. The mold was removed after a few hours' drying, when the vessel could stand alone without distorting *(g).* The neck and rim were added, and then the vase was fired and glazed. Stoneware glaze, a solution of copper oxide dripped down the sides; cone 6, oxidation firing. $8 \times 8 \times 24$ in. ($20 \times 20 \times 61$ cm). *Courtesy the artist. Photo: Scott McCue.*

(b) Wood mold. Two molds required.

3/4" (9mm)
90°
11" (28cm)
27" (68.58cm)

Score edges
of walls and
apply slip

Trim edges
of walls at
45° angle

Lay paper towel
under slabs

#1 mold

(c) Clay **L** slab in mold.

Score base and
edges of walls
and apply slip

Trim edges
of wall at
45° angle

Lay paper
towel
under
slabs

#2 mold

(d) Base slab added in mold.

1. Score, crease, end,
and apply slip
2. Add coil along
entire slab and
meld together

Paper towel

(e) Detail shows construction of **L** slabs in
(**c**) and (**d**). (section view)

(f) Both slabs ready for joining.

(g) Completed slab vase.

PLASTER, TOOLS, AND EQUIPMENT

 There are a few cautions to note before you begin working with plaster. Although not hazardous like clay dust, plaster dust can irritate the respiratory system if inhaled, so be careful when you use it in dry form. Also, never pour plaster down a sink! Your plumbing will be totally blocked up if you do; when water is added to plaster, it sets up into a solid mass that cannot be washed out of the pipes. If you are planning to make plaster body casts or face masks, you must be aware that plaster gets very hot, especially when a large mass is poured. Do not let the plaster cast remain on the person being cast for too long. Dangerous burns can occur. When the plaster begins to set it will get warm, then hot. Remove the cast just after the material begins to get warm. Casting body molds should be performed with an experienced person present.

Store bulk plaster of Paris in a bag in a dry place, preferably on wooden slats for adequate air circulation. If it becomes damp in the bag, the plaster will be useless.

Mixing plaster and pouring it into a form to make a mold requires several tools (13-30). Accurately weighing plaster and water on a precise scale and timing the mixing with a clock or watch will give you more control over the setting time of the plaster (13-31). Taking these steps will ensure a plaster mold that absorbs moisture evenly and that lasts through many castings, or pressings. Although plaster can be mixed by hand, using an electric drill with a mixing blade is faster and more thorough.

There are various materials used as separators in forming molds. Mold soap is an excellent separator for plaster because it will not reduce the absorbency of the plaster. A high-quality natural sea wool sponge is the best tool for applying mold soap to the plaster. Separating walls when casting plaster can be made from very thin brass or aluminum flashing material called **shim** material. Clay wall dams to contain the liquid plaster can be used in conjunction with an adjustable mold form box made from four pine boards held together with L-brackets.

Added materials can strengthen the plaster, especially when the walls are made thin to reduce the weight for press, hump, and drape molds. Sisal fiber is a strong natural fiber reinforcing material, but polyester fibers used in concrete are also effective.

FIGURE 13-30
Materials and tools most often used in making molds. ▶

A ribbon loop tool will be needed to carve registration sockets for **keys** into plaster molds, and a series of scrapers, rasps, and files are important tools when performing the final trimming, cleanup, and shaping of a mold. Turning tools are useful for trimming hard plaster or for turning on a plaster machine or pottery wheel when shaping the mold before it has completely set.

For holding small- to medium-sized molds together, rubber bands or tire inner tubes cut into rubber bands work well. A large mold should be cinched tight with a mold strap that has a metal clasp, which ensures that the mold will not burst open from the extreme pressure that can build up inside it from the weight of the slip.

MAKING PLASTER MOLDS

Plaster is a fascinating and versatile material. The most common type of plaster used for making molds, plaster of Paris, is made from one of a group of gypsum cements, essentially calcium sulfate, a white powder that forms a viscous solution when mixed with water and hardens into a solid mass. It is best to use a specially formulated plaster; with it your mold will last almost twice as long as one made with ordinary plaster. The mold used in the following demonstration (see 13-33–13-38) is made from Pottery Plaster #1.

Mixing a Test Batch of Plaster

By mixing a small test batch of plaster, you will learn how a fluid plaster solution is transformed into a solid mass in 25 to 40 minutes. And by following the steps in Figure 13-31 for making a block of plaster cast in a ½-gal. (1.89-l) milk carton, you will learn the correct way to mix and pour plaster. This test is recommended before attempting to make a complex multipart plaster mold.

For this small test batch, the ratio of Pottery Plaster #1 is 2¾ lb. (1,249 g) mixed with 2 lb. (907 g) of water, which will yield approximately 81 cu. in. (1,327 cu. cm). Begin by filling a ½-gal. (1.89-l) bucket with 2 lb. (907 g) of cool, clean water. As a general rule of measurement, the

Bag of Plaster

Pottery Plaster #1 is a high-quality fine-grain plaster for making slip-cast molds, wedging tables, and bats. Casting plaster is good for press and waste molds, or slip-cast molds for limited editions.

Spring Scale

Portable scale for weighing plaster and water.

Buckets

Plastic or metal bucket for mixing plaster.

Electric Mixer

Variable-speed hand-held drill with mixer blades of various sizes for mixing plaster.

Mold Soap

Water-soluble soap used as a plaster separator.

Natural Sponge

Natural sponge for applying mold soap to plaster when making molds.

Shim Material

Thin brass or aluminum flashing material is used as a separator between mold sections. Linoleum or tarpaper works as an outer case form or thick shim material.

Adjustable Mold Form Box

Adjustable mold form box made with four boards cut the same size and L-braces screwed to the top edge of the wood, with enough space to allow for the boards to snuggly slide through each other.

Plaster Reinforcement

Sisal (hemp) fiber embedded into plaster strengthens plaster walls, especially thin sections and long spans or large surface areas.

Loop Tool

Metal loop ribbon tool used for cutting registration socket into plaster.

Spatula

Metal spatula for shaping clay and trimming plaster, or for use as a wedge to separate cast plaster sections that are stuck together.

Plaster Rasp

Coarse open-tooth rasp is excellent for shaping or trimming damp or dry plaster.

Planing Tool

Hand-held planing tool, called a Surform tool, has an open-tooth grate that resists clogging and is excellent for shaping or trimming damp or dry plaster.

Turning Tool

Sharp metal tool available with either half-round, triangle, or straight end for shaping plaster on a pottery wheel or plaster machine.

Rib

Flexible metal rib for smoothing and scraping plaster.

Mold Bands

Heavy-duty rubber bands or synthetic straps with clamps for securing molds. Old car tire inner tubes cut into 1/2-1 in. (13-25 mm) strips make for durable mold bands.

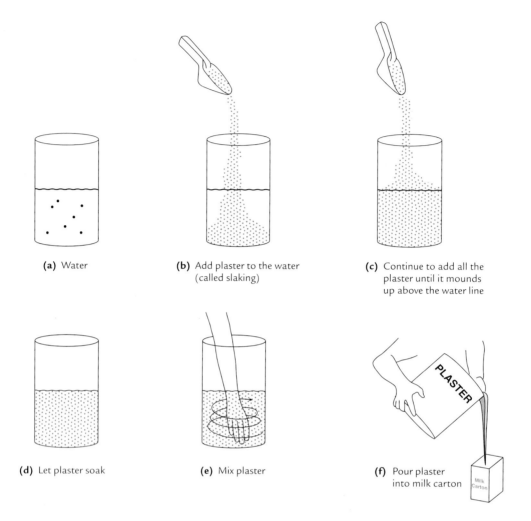

(a) Water

(b) Add plaster to the water (called slaking)

(c) Continue to add all the plaster until it mounds up above the water line

(d) Let plaster soak

(e) Mix plaster

(f) Pour plaster into milk carton

PLASTER

Milk Carton

FIGURE 13-31
Mixing and pouring a small batch of plaster into a milk carton with the correct proportions of water to plaster will teach you the basic plaster mixing method. *(a)* In a ½-gal. (1.89-l) pail or bowl, add 2 lb. (907 g) of cool, clean water. *(b)* Add 2¾ lb. (1,249 g) of plaster by **slaking** (sifting by hand or with a scoop) it into the water. *(c)* Let the plaster mound up. *(d)* When the plaster becomes moist, wait 2 minutes. *(e)* Mix the plaster by hand for 2 to 3 minutes. *(f)* Pour the mixture into a half-gallon (1.89-l) milk carton. Wait about 25 to 40 minutes, or until the plaster becomes hot to the touch, before peeling away the carton, revealing a small plaster block *(g)*.

(g)

mixing bucket should be twice the volume of water. By the time you add the plaster to the water, the solution will fill about three-quarters of the bucket, which should leave enough room to keep the mix from spilling over the side. It is also helpful to use a pliable plastic bucket or basin for mixing plaster so that after pouring, when the residue hardens, you will be able to squeeze the container's walls and shatter the remaining plaster into fragments to remove it.

Now weigh out 2¾ lb. (1,249 g) of Pottery Plaster #1 and pour it quickly into the water (this is called *slaking*). Continue adding all the plaster until it mounds up in the center. When all of the plaster becomes moist, let it sit *untouched* for 2 minutes. This saturation period helps eliminate air bubbles in the plaster. With your hand submerged to the bottom of the bucket, begin mixing the plaster solution with a gentle swirling motion. Mix the plaster for 2 to 3 minutes, and then pour it into the milk carton.

For precise control, measure the mixing time with a timer—a kitchen timer or a photographic lab clock will work. Using a timer will help you avoid overmixing, which can result in a mold with walls of unequal density. This factor is most critical for multipart molds: If different sections of a multipart mold are of unequal density, they will absorb water unequally. This may cause the slip-cast object to crack at the mold seam while it is still in the mold after the slip has been drained.

Watch the plaster in the milk carton for the next 10 to 20 minutes; you will see it begin to get creamy. Wait another 5 to 10 minutes, and the plaster will begin to harden. If you can press a fingernail into the plaster and make a dimple or if the plaster feels spongy, it is still setting up. Wait another 5 to 10 minutes or until it begins to get warm. When the plaster gets hot to the touch, it is set strong enough to be removed from the milk carton. Peel the carton away, and you will have a solid block of plaster (5½ × 3¾ × 3¾ in. [140 × 95 × 95 mm]).

Water temperature makes a difference in the setting-up time of plaster; cold water will set up at a slower rate than hot water. (This setting-up demonstration was based on an approximate water temperature of 72°F/22.2°C.) About 25 to 40 minutes is an average setting-up time, depending on the type of plaster used, the presence or absence of **retardant** (see below), and atmospheric conditions in the work area. Ask your supplier for the setting time of the specific plaster you buy. Some plasters are manufactured for 20-minute setting and others for 30-minute setting. The latter is good if you need more time to apply or pour a mix into or onto a form.

It is possible to add **sodate retarder** to the plaster if you feel that the mixture will set up too quickly for your purposes. This chemical slows the setting time. Adding ¼–2 tablespoons (approximately 1.33–15 g) of retardant can delay the setting-up time from 10–60 minutes. Vinegar also works as a retardant.

Plaster Molds with and without Undercuts

Now that you have mastered mixing and pouring plaster, you have experienced how a fluid solution becomes a hard mass within an hour. To make a mold it is possible to smear an object (with no undercutting) very lightly with vegetable oil, motor oil, or soap, pour a couple of inches (51 mm) of plaster into a cardboard box, place the original on this layer, pour more plaster around the original up to but not over its top, and end up with a one-part mold that will work reasonably well. However, a more carefully constructed mold will last longer.

If you plan to make a one-piece or multipart mold, you will need to understand how an undercut affects the number of parts that make up a mold (13-32). A bowl has no undercuts and can be cast in a one-piece open-face mold (see 13-33, 13-34). A bottle has an undercut along the shoulder and must be made with at least a two-part mold. If it has an inset foot, it will require a three-piece mold: two halves and a bottom. An easy way to understand the concept of an undercut is to place your index finger on the center of your scalp. Now slide your finger down the side of your cheek and stop at your jawbone. From this point on, moving down and under your jawbone, is an undercut.

Making a One-Part Mold for Slip Casting

If you follow the directions given here, you will be able to make an even-walled mold that can be used for slip casting as well as for press molding. Plaster slip molds do not last as long as press molds because the sodium silicate and soda ash in the slip are absorbed into the plaster

This bowl without undercut
is made into a one piece mold

This vase with undercut
requires two piece mold

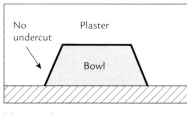

(a) No undercut

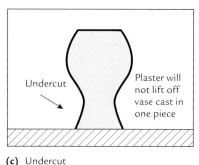

(c) Undercut

Plaster mold sections
pull out sideways

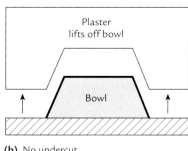

(b) No undercut

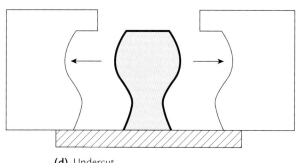

(d) Undercut

FIGURE 13-32
Before making a mold, it is important to evaluate the object to see if it has undercuts. This will
determine the number of **parting lines** necessary for the mold. The drawings compare a bowl *(a, b)*
without undercuts and a vase *(c, d)* with undercuts. The sloping wall of a bowl *(a)* has no undercuts.
Plaster poured on top of the inverted bowl *(b)* will make a mold that will lift off the bowl. The wall of a
vase that curves inward and then outward has undercuts, which will require a two- or three-part mold
for the mold to separate from the vase.

and accelerate its deterioration. In industrial settings, where the highest-quality casting and high-speed production are called for, a plaster slip mold is used only 50–150 times, owing to the need for perfect replicas and the established production schedule per eight-hour work shift. A studio potter, however, can often use a mold for up to 200 casts. Once you have learned how to make a good one-part plaster mold, you will have mastered the basics of mold making and can go on to make a multipart vase slip mold or other, more complex molds.

To demonstrate making a one-part mold, a simple stoneware bowl with no undercutting or details was chosen (13-33). Remember that your final clay cast will turn out to be considerably smaller than the original as a result of shrinkage during drying and firing. One refinement to learn in making a mold for slip casting is the **slip reservoir.** The purpose of this reservoir is to form a chamber that will hold extra casting slip, which will increase pressure on the slip in the mold during casting, thus ensuring that the slip will be pressed against the plaster walls. This in turn will ensure the formation of even clay walls that replicate the mold exactly and can be especially important in the casting of a thick slab. The reservoir is made by attaching an extra clay mass to the object from which you make the mold, forming it to follow the contour of the ob-

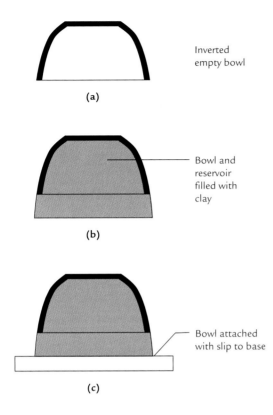

(a)

Inverted empty bowl

(b)

Bowl and reservoir filled with clay

(c)

Bowl attached with slip to base

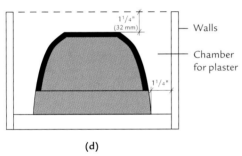

(d)

1¼" (32 mm)

1¼"

Walls

Chamber for plaster

FIGURE 13-33

Steps in preparation for making a mold. *(a)* The empty bowl from which the mold will be made. *(b)* The bowl filled with clay, with the reservoir mass extending below it. This reservoir will hold extra slip that will exert pressure to produce an evenly walled cast. The reservoir must have a minimum slope of 1 degree in order to release the mold easily. *(c)* The soaped bowl and reservoir attached with slip to a plywood base. *(d)* A wall made from flexible linoleum, metal, clay, or plastic should be placed about 1 to 1¼ in. (2.5 to 3.2 cm) away from the original, and it should also extend high enough to allow a solid plaster base of that thickness to form. Seal any cracks where plaster might run out with wads of clay. The dimensions on the drawing are those used for the mold shown in Figures 13-34–13-38.

FIGURE 13-34

Before making a mold from a bowl, soap the original so that it will release easily from the plaster mold. Carefully brush out any soap bubbles. The clay reservoir mass already has been formed at the base of the bowl, and both are set on a plywood base.

ject (see 13-33b). The reservoir and the object to be cast must have a slope of at least 1 degree to make it possible to remove the mold.

After the clay for the reservoir has been shaped, the object should be set on a base. Plywood will do for this purpose. Attach the object to the base with sticky clay or nail cleats to keep it from lifting as the plaster is poured around it. Next, soap the original to keep the plaster from sticking to it (13-34). The clay reservoir mass does not need to be soaped (if the original you are going to cast is made of damp clay, you do not need to soap that either), because you can remove it and wash the damp clay out of the mold. The best thing to use for soaping is a water-base mold soap, diluted 2 to 1 with water.

The drawings in Figure 13-33 show the preparations for making a mold. Surround the original and the reservoir with a wall made from linoleum, tar paper, sheet metal, clay, or plastic. For this demonstration a strip of floor linoleum was bent into a circle and secured with a mold-form clamp, but you can secure yours with duct tape, a metal strip with a turn buckle, a strip of an inner tube, a mold strap, or a large rubber band. The wall should be placed about 1–1¼ in. (2.5–3.2 cm) away from the original and extend 1–1¼ in. (2.5 to 3.2 cm) above it. This spacing

will create a plaster mold of optimal thickness. A thicker-walled mold would not be any more absorbent, although if the mold were a large one, thicker walls *would* add to its structural strength. On the other hand, too-thin walls would become saturated with moisture too quickly, and the casting slip would not set up.

To be sure that the wet plaster does not leak out around the base of the wall or at its seam, plug these areas with damp clay pressed firmly into the cracks. Before mixing and pouring the plaster, be sure to soap the wall and the plywood base to keep the plaster from sticking to them, using the same solution of soap you used on the original. Coat the wall first; then sponge the absorbent plywood with water and soap it as well.

Mixing Plaster with a Scale

Although it is possible to measure out and mix plaster by eye, it is more accurate to measure the ingredients with a scale. The ratio is based on the water-absorption capacity of the plaster. The mold demonstrated here was made with the following ratio:

2¾ lb. (1,249 g) plaster
2 lb. (907 g) water
———————————————————————————————
Yield = 81 cu. in. (1327 cu. cm) plaster

Mixing Plaster without a Scale

Measuring plaster without a scale and mixing it by hand is not as accurate as using a scale to measure ingredients. For slip casting it is important to weigh the plaster carefully and mix it with the right amount of water in order to produce consistency in the absorptive properties of the mold. Mixing by hand can, however, work for making hump or press molds, or for **splash coats** when building up layers of plaster. Remember, though, that if you have trouble making a satisfactory mold using the hand method, switch to the scale method.

To mix by eye, fill a pliable container about half-full with water. This amount of water will yield about two-thirds of a bucket of mixed plaster. Instead of weighing the plaster, add it relatively quickly by sifting handfuls into the water above the water line; the result will resemble

a steep, mountainous island rising above the ocean (see 13-31 b, c). When the last bit of plaster that shows above the water line becomes moist, let it remain untouched for 2 minutes. This will help eliminate air bubbles and keep the mixture from setting up too quickly. After 2 minutes, begin mixing slowly, with your hand submerged to the bottom of the container to avoid creating air bubbles in the plaster. If air bubbles do form, rock the bucket on the floor or tap its side to help make the bubbles rise to the top. Continue mixing for 2 to 3 minutes; then pour immediately.

To mix the same formula of plaster with an electric mixer, measure as just described, add the plaster to the water, and when the last bit of plaster becomes moist, wait 2 minutes without touching it. Then mix with the mixer for 1 minute and pour.

Pouring Plaster

Pour plaster carefully around the reservoir into the space between the original and the wall, always starting at the lowest point (13-35, 13-36). Let the plaster rise up and over the original to the top of the wall or to the point at which it is 1¼ in. (3.2 cm) thick above the bowl. Avoid splashing or dripping plaster on the original as you pour around it; splashes or drips will cause hard spots in the mold that could create unequal density in the wall at those points and prevent the casting slip from releasing from the plaster. If the wall of the mold is uneven in density, different parts of the mold will absorb water from the slip unequally, creating an uneven wall in the final cast. If you lightly agitate the plaster with your fingers after pouring it into the mold, you can break up any air bubbles.

Before trying to remove the original from the mold, let the plaster stand for 25–40 minutes, or until the mold begins to get hot (13-37). Removing the original from the mold before the plaster has set properly can damage the mold severely, possibly creating a distorted mold or causing cracks or fractures. Once the plaster starts to get hot, it has expanded to its farthest point and will separate from the original more easily. If the plaster cools down, a slight amount of moisture may develop between the plaster and the object, causing the plaster to bond to the original through condensation suction. If this happens,

FIGURE 13-36
Roslyn Myers pours the plaster into the space around the reservoir mass, taking care not to spatter or drip any onto the original.

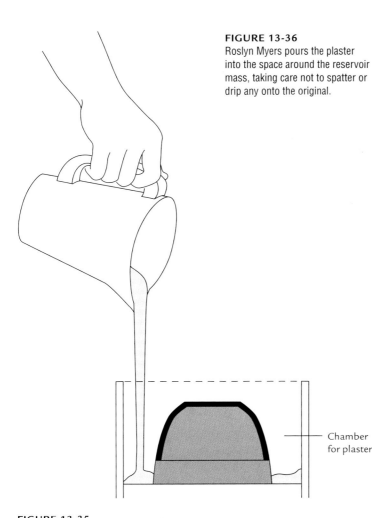

Chamber for plaster

FIGURE 13-35
Pour plaster, starting at the lowest point around the reservoir; let it rise up and over the original. A metal or plastic pitcher with a tapered, pointed lip gives a controlled plaster flow and will break up any bubbles in the plaster as they flow over the lip.

the two should be easier to separate if you place the mold and the original in very hot water for 10–15 minutes, then remove the mold from the water and tap the bottom of the plaster with the palm of your hand or a rubber mallet to loosen the original ceramic bowl.

Drying the Mold

Dry the mold for a few days. You will then be ready to make a copy of the bowl by casting with liquid slip (see 13-38). Dry the mold slowly in a warm atmosphere or place it near a heat source. Place the mold on wooden slats for more even heat circulation, or on kiln posts if the mold is

FIGURE 13-37
Before removing the original, leave it and the completed mold untouched until the plaster starts to get hot—usually between 25 and 40 minutes. With the clay reservoir removed, you can see the space above the rim of the bowl for the extra slip.

placed near a warm kiln. The drying temperature should not rise above 120°F/48°C because excessive heat may cause the mold to crack and deteriorate and thus lose its absorbtive properties. Circulating heat is best. The mold must be thoroughly dry for the best results when slip casting, otherwise if the mold is saturated with too much water the cast may not release from the mold. After drying the mold for a few days, you are ready to make a copy of the bowl by casting with liquid slip.

SLIP CASTING

When you are ready to start casting with slip, you will have to decide whether to mix your own slip from the particular type of clay you wish to use or to use a commercial slip. Unlike the clay used for handbuilding, for which it is important that the clay particles flock together, the clay used for slip casting should consist of particles that stay separate and suspended in water. The slip must remain fluid and pourable

(a)

(b)

FIGURE 13-38
(a) Myers pours colored porcelain slip into the mold, taking care not to splash the rim. When the slip level drops, she will top it off with more. *(b)* Once a wall of the desired thickness has formed around the edge of the mold, she pours the extra slip out into a basin. *(c)* She upends the mold and places it over a basin to drain out the excess slip. *(d)* As the porous plaster absorbs moisture from the clay, the slip-cast wall begins to pull away from the mold. *(e)* The porcelain cast bowl is removed from the mold, and Myers removes the extra clay of the reservoir mass from the cast. *(f)* The cast bowl is finished, with its rim smoothed, ready for firing. The difference in size between the original and the cast will become even greater when the cast bowl shrinks during drying and firing.

(c)

for at least 1 hour. For this reason, specially formulated casting slips contain **deflocculants.**

Deflocculants

A deflocculant, such as soda ash or Darvan #7, is added to slip to keep the clay particles in suspension and reduce the amount of water needed to make the slip. It is important to keep the proportion of water as low as possible; if the casting slip contains too much water the clay and fluxes will settle in the bottom of the container. But if you add too much deflocculant you will also get settling. The proportion of deflocculant added to the clay and water must be exact, and the type of clay used also makes a difference. It is not easy for a beginner to make successful casting slip, and since commercial slips are for-

mulated to avoid most of these problems, we suggest that you use them at first to learn the correct viscosity of slip. However, if you want to try making your own slip, a formula for low-fire slip is provided in *Expertise,* Chapter 1A.

Variations in water quality can also affect the composition of a slip, and evaporation can cause the slip's consistency to change. Remember that some water and deflocculant will have been drawn into the mold during casting, so if you plan to reuse the extra slip drained from the mold, the proportion of water and deflocculant in the remaining slip will vary from the original formula. To compensate for this change, you can add very small amounts of water plus a few drops of sodium silicate. To determine whether you have the correct amount of water and chemical additives in the slip, you can insert a hydrometer to measure its specific gravity. This

(d)

(e)

(f)

measurement will tell you if you have too much or too little water and if the chemicals are balanced correctly to maintain a pourable slip.

The type of slip to use and its firing range depend on what you plan to cast. Low-fire slip is the easiest to use because of its greater flexibility and minimal warping problems as compared to a high-fire slip.

Pouring Slip

Before pouring the slip into the mold, stir it gently for a few minutes until it becomes well mixed and fluid. If you pour it without stirring it, the moisture may not be absorbed evenly into the plaster mold. This may result in a weak or sagging wall. In addition, the extra slip can become too thick to drain easily from the mold.

Pour the slip into the mold carefully, trying not to spill any on the mold (13-38). Soon after filling the mold, you will notice that some of the water from the slip is being drawn into the mold.

As more water is drawn from the slip into the mold, a clay wall begins to form around the edge. Remember that the wall will become thinner when the water evaporates from it as it dries. Wait until the wall reaches the appropriate thickness for what you are casting—thin for a small porcelain bowl, thick for a large sculpture. When casting a thin porcelain piece, dipping the mold in water for a second immediately before casting will slow down its absorbing properties by letting the slip flow more smoothly along the mold wall without setting up too fast. This technique is used when casting doll arms, feet, and other delicate parts. When casting thick slabs or pottery, a small amount of fine grog (about 5%) added to a slip body will reduce the shrinkage and potential cracking that could occur if you were using a fine-grained clay. Once the wall reaches the desired thickness, pour out the extra slip into a bucket, slip-casting drain table, or basin (see 13-38b). Then upend the mold over a basin, resting it on two wooden slats, and let the extra slip drain thoroughly out of the mold, usually for 5–20 minutes (see 13-38c).

Once the extra slip has drained out, turn the mold upright and wait until the clay wall begins to pull away from the mold wall before trying to remove the cast (see 13-38d). Blowing a little compressed air carefully around the edge will speed up the process, as will using a handheld

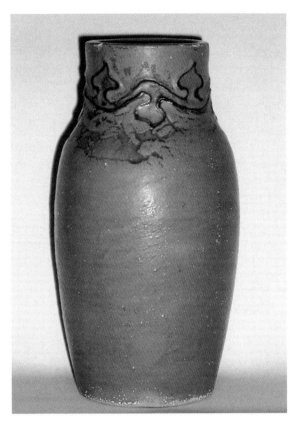

FIGURE 13-39
A vase made in 1915 at the Arequipa Pottery, a sanatorium for women recovering from tuberculosis in San Anselmo, California, serves as an original model for the demonstration of making a four-part mold for slip casting.

electric dryer to blow warm air into the casting, but be sure to dry it evenly. Remove the cast from the mold with care, and carefully trim off extra clay from the reservoir (see 13-38e). Note that the cast is slightly smaller than the object from which the mold was made (see 13-38f); it will become even smaller as it dries and is fired.

MAKING A MULTIPART MOLD FOR SLIP CASTING

By mastering the process of making a multipart plaster mold for slip casting, you will be able to utilize the methods learned in this section to make other, complex multipart molds for cups, teapots, pitchers, or sculpture. The vase used in the following demonstration was produced at the Arequipa Pottery in Marin County, California, in 1915 (13-39).

The glazed ceramic vase makes a good model from which to make a plaster mold because it is impervious to moisture and will not distort, shrink, or move under the heat generated by the plaster as it sets (13-40). The mold was made for an educational display at the Oakland Museum. The vase dimensions (13-41) determined the size of the mold.

To determine the number of parts for a multipart vase mold, you need to evaluate the piece to arrive at the number of parting lines needed to allow the original vase to come out of the mold. The vase is fired ceramic, so it will not flex when the plaster is set and therefore may not come out from the mold easily. To avoid damaging this antique vase, it was best to make a mold in four parts, instead of three, ensuring the vase's easy removal.

The size of the mold serves two functions. The mold needs a wall thick enough to absorb the water from the slip without becoming saturated, and the plaster wall must be physically strong. It must also be resistant to cracking when rubber bands, metal or synthetic straps, or clamps are used to secure the mold.

Marking the vase with guidelines, using an indelible pen, helps in determining the parting lines when sectioning the mold. (The indelible ink can be safely removed later with acetone.)

(a)

FIGURE 13-40
(a) The finished four-part plaster mold of an Arequipa vase secured with rubber bands ready for casting. *(b)* The Arequipa vase mold opened to show the base and three side sections forming the wall. The shallow concave shape at the top of each section forms the reservoir, which holds extra casting slip. The small concave depressions are called *keys* and align with the registration key locking the mold together into the original position.

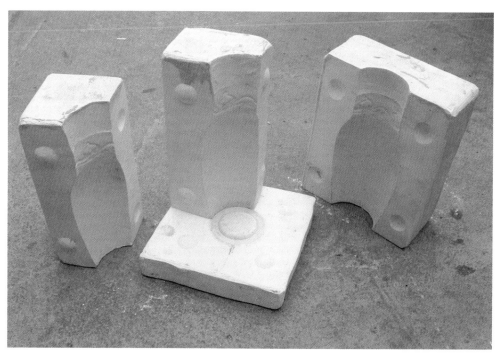

(b)

FIGURE 13-41
To determine the mold size for the Arequipa vase, it is helpful to have exact dimensions of the original.

2¹/₂" (63mm)

7¹/₈" (188mm)

2⁷/₈" (72mm)

FIGURE 13-42
Parting lines determine the number of sections that make up a mold. These guidelines help determine the division lines between the plaster sections before the plaster is poured. The vase is divided by a parting line just below where its half mark would be. This section is again divided in half. *(a)* With an indelible pen or marker—which will not blur, smudge, or fade when damp clay or mold soap touches the fired glazed surface—draw a dashed line, A, ¼ in. (6 mm) below the center of the base. Continue this line up both sides of the vase. *(b)* Draw another line, B, that divides the first section in half, now separating the vase into two quarters and a half. Line B intersects line A.

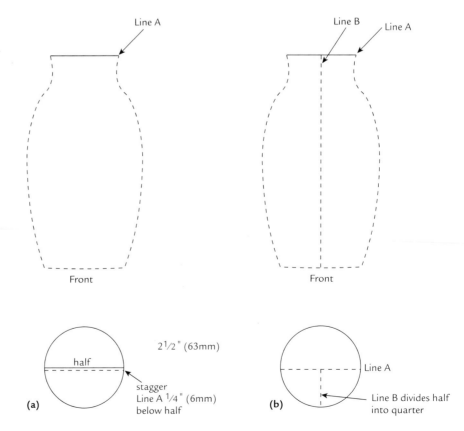

Line A

Line B Line A

Front

Front

2¹/₂" (63mm)

half

stagger
Line A ¼" (6mm)
below half

Line A

Line B divides half
into quarter

(a)

(b)

Begin by turning the vase on end and draw a short line at the halfway point (line A). Below, draw a dashed line ¼ in. (6 mm) around the vase. Draw another line (line B) that intersects line A (13-42a). Continue line B up the side of the vase and over the lip (13-42b).

Now fill the entire vase chamber with soft clay to add weight so it will not move during casting (13-43a). Place a block of clay 7⅛ in. wide × 8¾ in. long × 4⅛ in. high (181 × 222 × 105 mm) on a plywood ware board approximately 15 × 15 × ¾ in. (381 × 381 × 19 mm) or larger. Scoop out a depression in the clay block, and set the vase in the

cavity up to line A (13-43b). The bottom of the vase should line up with the end of the block of clay. Make a tapered reservoir plug with soft clay and attach it to the top of the vase (13-43c). It should taper about 10–15 degrees and resemble a low, wide cork. Place the wide part at the top, and attach the narrow tapered end to the vase. Score the attachment points well, brush them with water or slip, and secure the plug to the vase. Eventually this void, called the reservoir, will hold extra casting slip. After setting the vase on a clay block, a wood frame must be constructed to retain the plaster when it is poured.

FIGURE 13-43
(a) Prepare the vase for casting section 1 by filling the vase with soft clay. *(b)* Prepare a soft block of clay approximately 7⅛ in. (181 mm) wide, 8¾ in. (222 mm) long, and 4⅛ in. (105 mm) high. Scoop out a depression similar in profile to the vase and reservoir, and set the vase into the clay up to line A. Smooth out and flatten the clay border around the vase with a rib. *(c)* Shape a tapered reservoir plug, score the points of attachment, and join them with water or slip. The narrow end of the reservoir should connect to the vase.

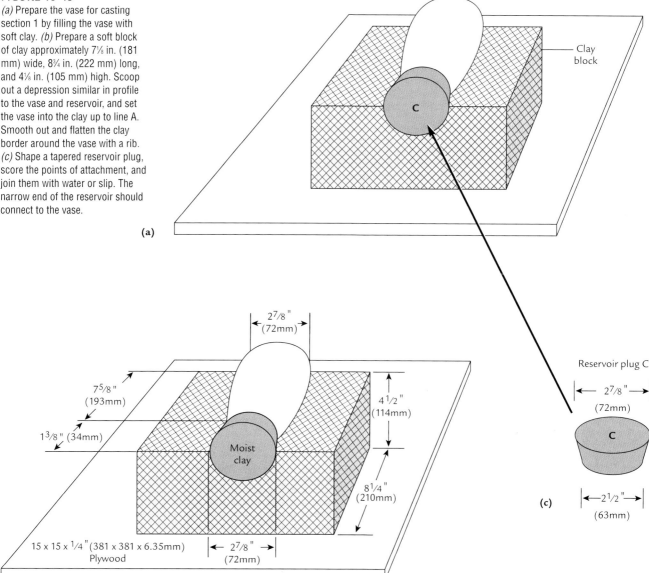

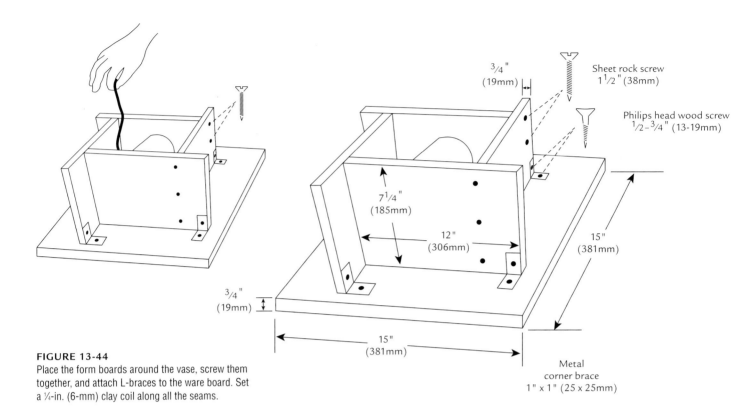

FIGURE 13-44
Place the form boards around the vase, screw them together, and attach L-braces to the ware board. Set a ¼-in. (6-mm) clay coil along all the seams.

Preparing the Mold Frame

The following materials were used to make the mold frame illustrated in Figure 13-44.

- 4 wood boards (fir, pine, or plywood) each 7¼ × 8¾ × ¾ in. (184 × 223 × 19 mm)
- 4 metal corner braces, 1 × ½ in. (25 × 12 mm) wide
- 12 wood screws or sheetrock screws, 1½ in. (25–38 mm) long
- 8 wood screws, ½–¾ in. (12–19 mm) long

Assemble the frame around the clay and vase, and seal up the seams on the four interior corners with clay coils approximately ⅜ in. (9 mm) thick (see 13-44). With a soft brush, paint a coat of 1 part mold soap diluted with 1 part water on the vase and the wood, as well as on the outside of the frame and the ware board in case extra plaster splashes or spills during casting (13-45). Do not oversoap the vase. Since the surface is glazed and impervious to water, it requires only one coat of soap. Too much soap will bubble up into the plaster, causing a pitted or irregular surface.

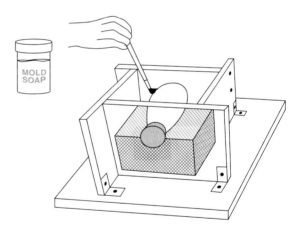

FIGURE 13-45
Dilute 1 part mold soap in 1 part water, and apply one coat to the vase and the interior sides of the form boards. Paint or sponge soap on all wood parts to prevent plaster splatters or spills from sticking.

Casting Section 1

Imagining that you are casting this vase you would fill a 2–4 gal. (7.57–15.14-l) container with 6 lb. (2,724 g) of cool, clean water. This batch will make a little more plaster than needed. Slake in 8.25 lb. (3,859 g) of Pottery Plaster #1. When the plaster becomes moist, let the material stand for

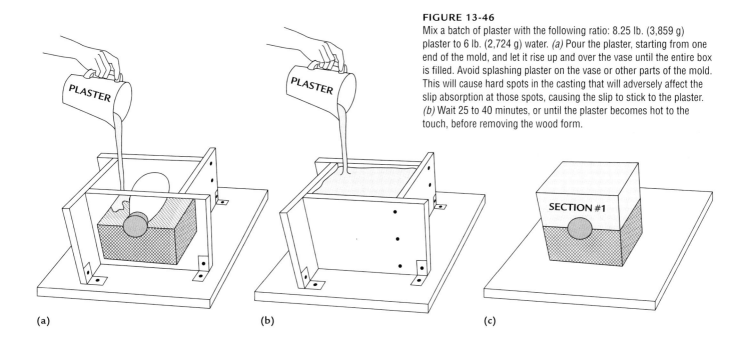

FIGURE 13-46
Mix a batch of plaster with the following ratio: 8.25 lb. (3,859 g) plaster to 6 lb. (2,724 g) water. *(a)* Pour the plaster, starting from one end of the mold, and let it rise up and over the vase until the entire box is filled. Avoid splashing plaster on the vase or other parts of the mold. This will cause hard spots in the casting that will adversely affect the slip absorption at those spots, causing the slip to stick to the plaster. *(b)* Wait 25 to 40 minutes, or until the plaster becomes hot to the touch, before removing the wood form.

(a) (b) (c)

2 minutes. Then mix the plaster for 2 minutes by hand or 1 minute with an electric mixer. Pour the mixture into the frame. When filling the frame, begin by pouring the plaster from one corner at the lowest point and let the plaster flow up and over the vase (13-46). Do not splash plaster on the vase or other parts, as this will cause small hard spots to form on the mold, reducing the absorbency of the mold at those points; this could cause areas of the clay wall to stick to the mold. After pouring the plaster, wait about 25 to 40 minutes, or until the plaster becomes hot to the touch, before removing the wood form from around the plaster. As the plaster begins to solidify, it will first become warm and then hot. If you remove the wood form or touch the plaster too soon, you will risk damaging the plaster. It will crumble and fall apart. After the plaster has set and the form boards have been removed, turn plaster section 1 upside-down. Remove the clay, except for the reservoir plug. Let it remain attached to the vase. Sponge clean any clay residue on the plaster. With a round ribbon loop tool, carve four registration sockets into the corners of the mold (13-47). Center them in the middle of the plaster face, or about ⅝ in. (15 mm) from the edge. If the plaster face is pitted or rough, use a flexible metal rib and scrape the plaster smooth. Use water as a lubricant while you scrape the plaster to attain an ultra-smooth surface.

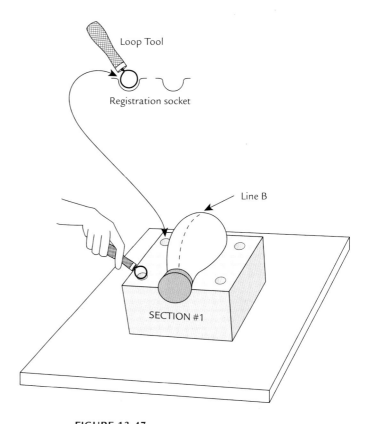

FIGURE 13-47
After removing the form board, turn mold section 1 upside-down and remove the clay. Sponge the plaster clean and scrape with a metal rib to remove any small particles. Carve registration sockets into the four corners.

FIGURE 13-48
Block up the left side of the vase up to line B with clay. It should rise at least 1½ in. (38 mm) above the side of the vase. With a natural sponge, soap the plaster three times and paint one coat of soap onto the vase. It is not necessary to soap the clay reservoir.

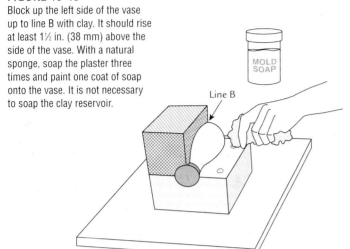

Casting Section 2

With a solid chunk of clay, build up a wall that will become the face of section 2. Soap section 1 and around the sides, including the vase (13-48). If the vase becomes loose, remove it from the mold and soap underneath the vase. This will ensure that any plaster that could possibly seep under the vase when pouring section 2 will not ruin the surface by sticking. The dry finished weight of section 2 is 4.5 lb. (2,043 g). For this batch, it is best to mix a little more plaster than you need in the event that you pour the plaster higher than the level needed, or in case any material spills (13-49). After pouring the plaster for section 2, wait until it becomes hot to the touch before removing it from the wood form (13-50). This usually takes 25–40 minutes. Remove the clay wall, sponge clean the plaster with water, and carve two registration sockets into section 2 (13-51). Then soap sections 1 and 2 and all the outer sides of the mold.

FIGURE 13-49
Set the form boards around the mold and secure them with screws. Screw the frame to the base board with the L-braces. Add a coil of clay along all the seams to waterproof the mold. Mix a batch of plaster with the following ratio: 5.5 lb. (2,495 g) of plaster to 4 lb. (1,816 g) of water. Pour the plaster, starting at one corner and letting it flow up and over the vase until the entire chamber is filled.

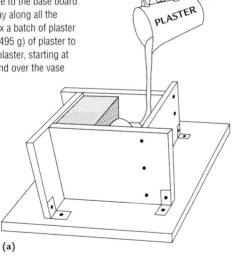

(a)

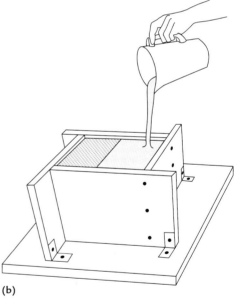

(b)

FIGURE 13-50
Leave section 2 in place and remove the mold form and the clay.

FIGURE 13-51
Damp-sponge section 2 to clean off clay residue, and scrape smooth any imperfections or small plaster particles with a metal rib. A small amount of water will help lubricate the plaster when scraping the surface smooth. Carve registration sockets into section 2 at the corners. Soap section 2 three times to ensure that the next plaster section will not stick. Soap around all the plaster parts to prevent plaster splatters or spills from sticking when the next section is cast.

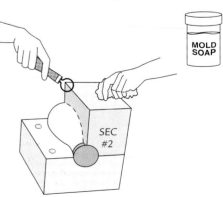

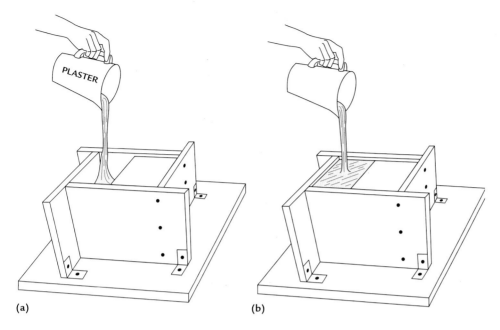

(a) (b)

FIGURE 13-52
(a) Set the form boards around the mold and secure them with screws. Screw the frame to the ware board with the L-braces. Soap the interior of the wood form, and apply one thin coat to the vase. *(b)* Mix a batch of plaster with the following ratio: 5.5 lb. (2,495 g) plaster to 4 lb. (1,816 g) water. Pour the plaster, beginning at one corner of the mold, and let it flow up and over the vase until the chamber is filled. Wait 25 to 40 minutes, or until the plaster becomes hot to the touch, before removing the form boards or plaster sections.

Casting Section 3

Reinstall the form boards, seal up the corners of the wood frame with a coil of clay, soap the boards, and pour the plaster for section 3 (13-52).

Casting Section 4

After casting section 3 (13-53), turn the mold on end and secure it with three or four ¾-in. (19-mm) wide rubber bands or with a mold strap. Carve four registration sockets on the corners of the mold, and then soap the plaster (13-54).

Preparing the Mold for Casting the Bottom, Section 4

Assemble the wood form around the mold until it is no less than 2 in. (51 mm) above the bottom of the mold. Use blocks of wood or bricks to keep the wood form from sliding down the side of the mold. Add coils of clay along all seams to waterproof the interior (13-55). The dry weight of section 4 is 2.5 lb. (1,135 g). To cast this part, mix 2.75 lb. (1,248.5 g) of plaster with 2 lb. (907 g) of water. This will make a little more plaster than you will need (13-56). Wait 25–40 minutes, or until the plaster becomes hot to the touch, before removing the wood frame. Sponge clean the

FIGURE 13-53
Remove the form boards. The mold now has three sections complete, with the bottom remaining to be cast.

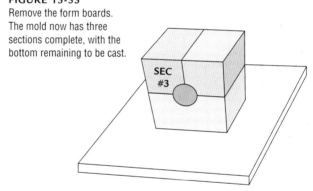

SEC #3

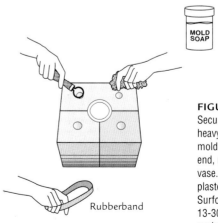

MOLD SOAP

Rubberband

FIGURE 13-54
Secure sections 1, 2, and 3 with heavy-duty rubber bands or a mold strap. Turn the mold on end, revealing the bottom of the vase. Scrape the bottom of the plaster clean with a metal rib, Surform tool, or plaster rasp (see 13-30). Carve registration sockets into the corners of the base, and soap three times.

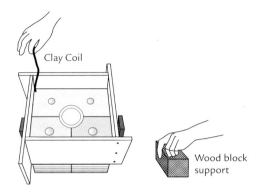

FIGURE 13-55
Raise the frame on blocks of wood or bricks so that the top is about 2 in. (51 mm) above the mold. Then secure the form boards around the mold with screws. Screwing two halves together and then attaching those two will make final assembly easier. Once the form is in place, add a clay coil along all the seams. Soap the form, and apply one coat to the bottom of the vase. To test whether the mold form is secure, lift the wood up to see if it moves. If it does not move, the mold is ready for casting. If it moves at all, or if the seam between the wood form and the plaster opens up, the form must be tightened. The lower mold sections must be absolutely secure before the final bottom section is cast.

outside of the mold, and with a knife, clean all the plaster seams that could keep the mold from coming apart. The seam line will appear as a very fine line. When it is located, carefully pull the sections apart and remove the vase.

What to Do If the Mold Does Not Come Apart

Scrape all seams clean using a plaster rasp or surform tool to reveal the mold seam lines, and then submerge the mold in a sink or tub of very hot water for 15–20 minutes. This causes the plaster to expand slightly, which also loosens the mold soap and any clay or plaster residue that

FIGURE 13-56
Mix a batch of plaster with the following ratio: 2.75 lb. (1,248.5 g) plaster to 2 lb. (907 g) water. Beginning in one corner of the mold, pour the plaster and let it flow across the mold until the entire chamber is filled. Wait about 25 to 40 minutes, or until the plaster becomes hot to the touch, before removing the form.

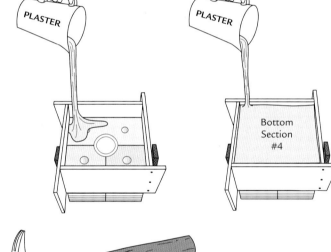

FIGURE 13-57
After all four sections are cast, the mold must be taken apart and the edges beveled. The mold should come apart easily; however, if any parts are stuck, it is best to submerge the entire mold in hot water for 15 to 20 minutes. This expands the plaster a fraction and loosens any soap, plaster, or clay residue that could be preventing the mold from coming apart. Also, any plaster that is lodged along a mold seam will prevent it from coming apart. In this case it is a good idea to use a plaster rasp or Surform tool (see 13-30) and file down the extra plaster until the seam line is revealed. *(a)* Then, tap a metal scraper or wood wedge into one of the seams between two mold sections. Next, insert a second scraper and finally a third between the first two scrapers. Tap the wedges into the seam gently. Keep adding scrapers or wedges along the mold seam, thereby increasing the force necessary to separate the parts. *(b)* Once the mold is open, bevel the outer edge of each section. Do not bevel the mold edge that touches the vase.

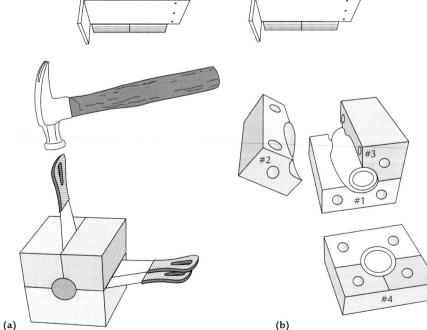

(a) (b)

could be preventing the mold from separating. After soaking the mold in the hot water, remove it from the sink and carefully pull it apart. If the mold remains stuck, insert a series of metal scrapers or spatulas, wood wedges, or ribs between the mold seams (13-57). This will increase the force necessary to separate the sections. Progressively insert one, two, or three wedges and so on along any mold seam that is stuck; spacing them approximately 2–6 in. (51–152 mm) or more apart depending on the mold size.

To open, tap a wedge gently into each seam about ¼ in. (5 mm) deep. When the mold sections begin to separate about $^1/_{32}''$ (1 mm) pour hot water into the crevice. This helps to further separate the plaster pieces. If the mold still does not come apart, increase the seam line separation force by tapping another set of wedges next to the first ones. As each additional wedge is inserted, check to see if the mold comes apart. If after inserting the second set of wedges the mold still does not come apart, insert a third set of wedges. Along each seam, gently tap a new wedge between the other two; it will appear as three wedges in a line.

This should provide more than enough force to separate a mold, barring any unforeseen problems such as undercuts, improperly soaped plaster, or crevices filled with plaster, which could also prevent the mold from coming apart. It sometimes requires fifteen wedges or more to separate a mold.

The key to separating a mold without cracking or damaging it is to insert enough wedges and to be patient while tapping the wedges into the seams. After the mold comes apart, bevel the outer edges with a 30- to 45-degree angle; this prevents excessive chipping when handling the mold (see 13-57). Do not bevel the interior edges of the mold where the vase meets the plaster.

The Completed Mold

Drying the mold will take 7 to 10 days, depending on the size of the mold and the atmosphere (13-58). It is best to dry new molds by securing them with rubber bands, clamps, or mold straps. These prevent the plaster from warping as it

FIGURE 13-58
The completed mold should be secured with heavy-duty rubber bands or mold straps and dried for about 7 to 10 days in a warm place.

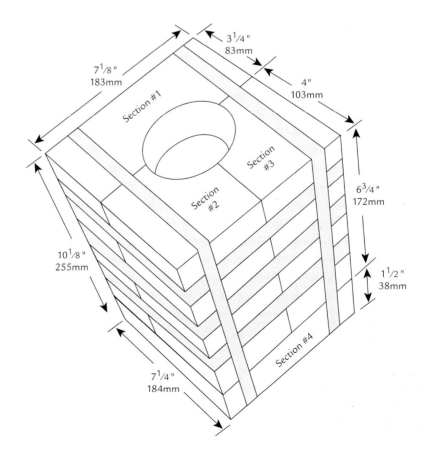

dries and are especially critical for large molds or long sections. Drying can be accelerated by placing the mold in a warm spot in the studio or near a kiln. Do not overheat a mold, or it may crack. After the mold has been cast three or four times, it will draw moisture from the slip more evenly, and the vase will also come out of the mold more easily. Figure 13-59 shows how the vase mold should look when opened after casting, with the bottom and two sides removed.

After removal from the mold, the reservoir should be trimmed off. Finally, Figure 13-59 shows the cast fired and glazed vase, showing the amount of shrinkage. By learning how to make a vase mold, you will have the necessary skills to make almost any type of slip-casting mold. If you experience any difficulties in casting plaster or slip, refer to *Expertise,* Chapter 4B, for a more detailed discussion of the idiosyncrasies of these processes.

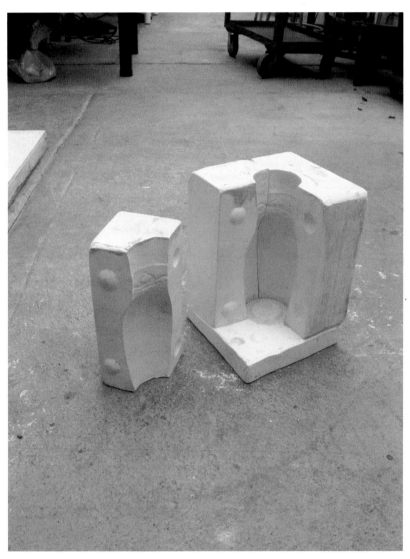

(a)

FIGURE 13-59
(a) The completed vase mold, showing section 3 removed. *(b)* A cast vase, shown with the reservoir that will be trimmed later, with sections 2 and 3 removed. *(c)* A damp slip-cast vase *(left)* and a vase glazed and fired. Note the shrinkage of the vase after firing.

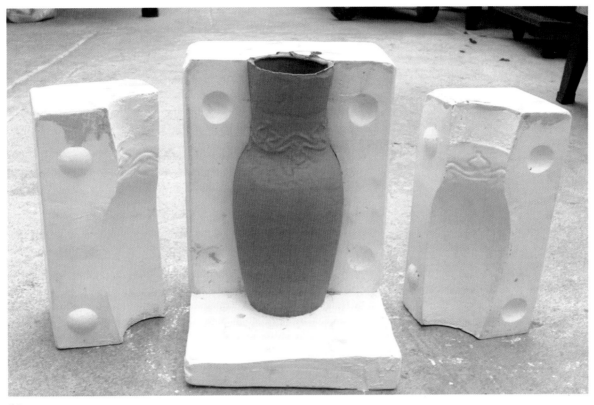

(b)

(c)

USING SLIP CASTING CREATIVELY

As you become more adept at making plaster molds, you will be able to make two-part or multipart slip-casting molds of increasingly complex originals. Slip-casting techniques can be used to create many different types of ceramic objects, from the architectural works by Nino Caruso (13-60–13-62) to *Twin Cones,* an abstract arrangement by Karen Massaro (13-64), or the futuristic piece titled *Jardow and Sytheen Together,* by Gary Molitor (13-65). Other examples include the assembled sculpture by master mold-maker Richard Shaw (see 8-11), and Jindra Vikova's portrait heads, which she made from slip-cast slabs.

FIGURE 13-60
Nino Caruso of Italy lifts off half of a two-part mold. Caruso carved the original sections of his sculpture *Homage to Tarquinia* in polystyrene foam. Because there was undercutting on the originals, one-part molds would not have released. Note the registration knobs and sockets on the mold sections. *Courtesy the artist.*

FIGURE 13-61
A detail of the sculptural sections in Nino Caruso's arch. *Courtesy the artist.*

FIGURE 13-62
Caruso utilized the slip-casting process to produce modular slip-cast sculptural sections, which he assembled into an arch. The casting process yields pieces that all shrink at the same rate, producing modules that have a precise fit. Distortion is minimized, and the weight of the piece is modest compared to handbuilt forms of the same size. *Courtesy the artist.*

FIGURE 13-63
Jackson Boone made plaster molds from plumbing pipes and fittings. Boone then cast the parts and assembled them into a teapot and cups. Low fire casting slip and clear glaze. *Courtesy the Toki collection.*

FIGURE 13-64
Twin Cones, by Karen Massaro, is an abstract arrangement reminiscent of a still life. The slip-cast porcelain pieces are dry-sanded, then bisque-fired to cone 04 and sanded a second time. Designs are painted or drawn on the pieces with underglazes and underglaze pencils, then clear glazed and fired to cone 10. Decorative accents are applied with china paints and fired to cone 017. *Courtesy the artist.*

Serge Bottagisio and Agnes Decoux developed a unique way to cast multicolored angular vessels using inlays and then backing them with casting slip (13-66). John de Fazio, on the other hand, used twenty-four molds to assemble *The Assumption of BlueBoy* (13-67), altering and interchanging parts of slip-cast figurines much as the Greeks did.

FIGURE 13-65
Jardow and Sytheen Together, by Gary Molitor, displays his mastery of multipart mold-making. Cast in porcelain slip, the piece was bisque-fired, airbrushed with matt glazes, and then refired. Ht. 13½ in. (35 cm). *Courtesy the artist and the Pence Gallery.*

FIGURE 13-66
Serge Bottagisio and Agnes Decoux of France developed a method of slip-casting inlaid colored slabs. They first cast a thin slab of colored clay, cut it in strips, lay the strips out in patterns, and pour white slip over them. This produces white-and-color-patterned slabs with an all-white lining. They then form these slabs into vessels and fire them at 2372°F/1300°C in a gas kiln. Ht. 24 in. (60 cm), diam. 14 in. (35 cm). 1993. *Courtesy the artists.*

Tony Marsh, who studied in Japan, has formal pottery training and uses the wheel as an intermediate step to generate forms that are eventually slip-cast, altered, and then combined into an assemblage (13-68). Clayton Bailey produced a series of altered shark heads made from a mold taken from an actual shark's head found on a beach near his home in California. He kept the head in his freezer until it was time to make a plaster mold for his *Pack of Landsharks* (13-69–13-71).

FIGURE 13-67
John de Fazio of the United States slip-cast *The Assumption of BlueBoy* using twenty-four molds. He made the removable lid by slicing the head off a slip-cast figurine and grafting on a cast eagle head. He then used BlueBoy's face on the hat. Other hybrid figures and birds were made by combining casts of statuettes and attaching them when leather hard. De Fazio handbuilt the cloud. Earthenware, glazes and china paint. 26 × 16 × 16 in. (66 × 41 × 41 cm). 1992. *Courtesy the artist.*

FIGURE 13-68
Tony Marsh created *Perforated Vessel,* an assemblage made from slip-cast parts that presents a delicate form that is also strong in negative space. Marsh makes plaster molds of handbuilt and wheel-thrown shapes and then casts them in low-fire slip. After perforating the units with hundreds of holes, he finishes the surfaces with engobes. 27 × 10 in. (69 × 25 cm). *Courtesy the artist.*

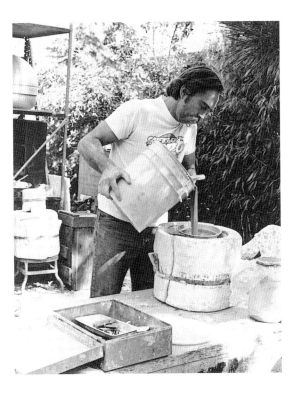

FIGURE 13-69
Clayton Bailey of the United States made a mold from a real shark's head his son found on the beach. Using slip-casting techniques, he made multiple images of the shark's head, which he then altered and individualized to create his *Pack of Landsharks* (see 13-71). Here Bailey pours slip into the mold through a strainer.

FIGURE 13-70
From a multipart mold, Bailey cast the shark head. After the piece became leather hard, he attached teeth to the upper and lower jaws, angling them inward so that it would be more difficult for the victim to get away.

FIGURE 13-71
A Pack of Landsharks, by Clayton Bailey. Although all the heads were cast from the same mold, each completed, glazed, and fired landshark has an individual personality. Slip-cast, low-fire white clay, stain and glaze. Each shark 12 × 12 in. (30 × 30 cm). *Courtesy the artist: www.claytonbailey.com.*

Phyllis Kloda throws portions of her work on the potter's wheel and then combines them with sprig, press, and multiple slip-cast molded parts to produce her work (13-72–13-74). To make her molds, Kloda says, *I use a half-and-half mixture of Hydrocal and Pottery Plaster #1. This seems to fabricate a more durable mold and increases the use of it. I always look for exact results, so I weigh out my plaster and water using the normal 7/10 ratio: 7 lb. (3178 g) water to 10 lb. (4540 g) plaster.* Kloda casts different molds and builds up an inventory of parts, which she draws on to develop her sculptures and vessel forms.

FIGURE 13-72
A Story of Passion, a pitcher by Phyllis Kloda, is assembled from cast pieces and a wheel-thrown body. Kloda says, *The slip-casting process provides for fine surface detail and patterning in the embellished areas, which I may not be able to obtain otherwise. I am always amazed at the metamorphosis the pieces go through at each stage. It's all about change and growth, and being receptive to these as an artist.* Earthenware, glaze, and china paint. 14½ × 12 × 6½ in. (37 × 30 × 17 cm). 1999. *Courtesy the artist.*

FIGURE 13-73
Kloda assembles the pitcher using a slip-cast epicalyx-designed spout, handle, and decorative elements and joins them to a wheel-thrown vessel that makes up the body of the pitcher. *Courtesy the artist.*

FIGURE 13-74
Kloda uses a banding wheel to assemble the pitcher. She generates a variety of unique shapes by throwing some parts on the wheel, slip-casting others, and pressing on decorative elements from sprig molds to embellish her fanciful vessels.
Courtesy the artist.

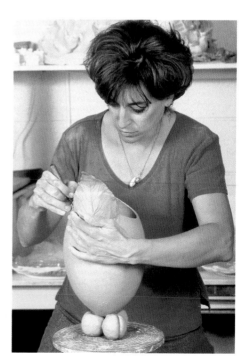

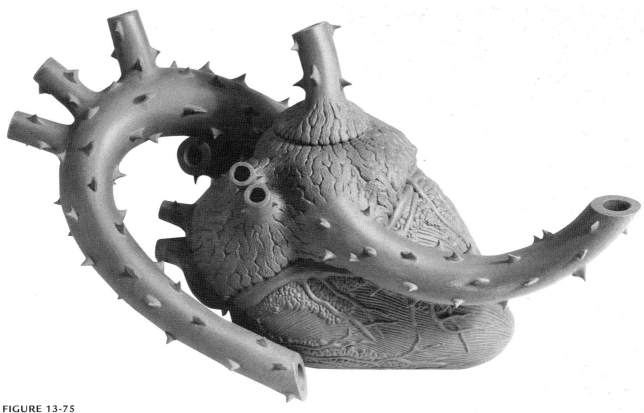

FIGURE 13-75
Heart Teapot: Sharpeville, Yixing Series. Richard
Notkin of the United States casts his stoneware
Yixing-inspired teapots in plaster molds from clay
originals that he carves with intricate surface
details. Stoneware. 6 × 10⅞ × 5 in. (15 × 28 × 13
cm). *Courtesy the artist and Garth Clark Gallery, NY.*

Richard Notkin, whose work is inspired by
the Yixing Pottery of China, combines unusual
elements such as a heart and rose plant branch
and assembles them into a teapot (13-75). Bill
Cravis, trained as a potter, utilizes the wheel to
generate unique forms. He first throws forms on
the wheel and chooses one or two and makes
molds from them. Then he casts numerous
pieces, altering them as he clarifies his idea. Fi-
nally he arranges them into narrative-derived
sculpture (13-76).

Ceramic manufacturer Bill Campbell, who
produces thousands of pieces of ceramic each
day at his Pennsylvania studio, utilizes slip cast-
ing in part of his operation to make his line of
vases, pitchers, flowerpots, casseroles (13-77),
and lidded jars. Casting has freed Campbell to
focus his attention on perfecting the surface dec-
oration and design of an original production

piece; this enables him to reproduce each with
the same quality as the original. Campbell, who
makes his own slip, screens it to remove any
large particles or debris and then ages it for one
week before using it to cast. He tests the slip
each day for specific gravity and viscosity to
maintain a properly suspended and fluid slip.

Because of the fragility of his porcelain ves-
sels, Curt Benzle forms his work directly in a
custom-made castable refractory sagger mold
that supports the ware in the kiln, preventing it
from distorting or slumping during firing (13-78).
The double-walled vessels are tinted with body
stains, which infuse the clay with a subtle color
that interacts beautifully with the undulating
edge of his pieces (13-79). Benzle says, *My work
is extremely delicate in the green stage, owing to
its thin walls and the low plasticity of the porce-
lain, which includes only 25% clay.*

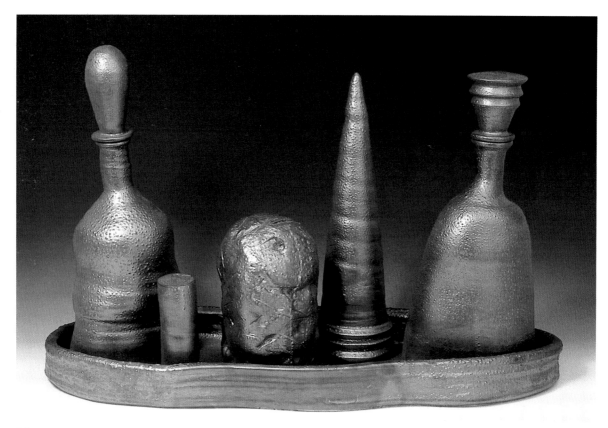

(a)

(b)

FIGURE 13-76

(a) Strange Family, by Bill Cravis of the United States, is a wheel-thrown assemblage that forms a strong narrative dialogue between the elements. Cravis often uses the wheel to generate lyrical forms, from which he selects certain pieces to mold. *(b)* Cravis makes molds of these sculptures and then alters the slip-cast parts and develops new sculptural forms. *Courtesy the artist.*

FIGURE 13-77
A porcelain casserole, by Bill Campbell of the United States, made with an ovenproof clay body formulated for slip casting. After mixing and screening his slip, Campbell ages it for a week. He tests the specific gravity and viscosity of the slip each day to maintain consistent quality. Reduction fired to cone 9.
Courtesy the artist.

FIGURE 13-78
Curt Benzle constructs his large vessels directly in a custom sagger mold made of a castable refractory material that cradles the delicate work during the firing. He applies a refractory paint to the mold surface to prevent the clay from fusing to the mold. *Courtesy the artist.*

FIGURE 13-79
Patchwork Redux, a double-walled porcelain vessel by Curt Benzle, is pigmented with body stains and fired to cone 9. The interaction between the clay and the stains creates a variegated color that is further enhanced in the kiln when the porcelain clay fluxes at the firing temperature. Nericome and slip painting, sagger-fired and gold-leafed. 18 × 18 × 4 in. (46 × 20 × 10 cm). *Courtesy the artist.*

JIGGERING AND JOLLEYING

Shaping clay mechanically using the **jiggering** and **jolleying** technique to produce utilitarian ware is an ancient process that was used by the Greeks, Romans, and Chinese. A jigger machine is similar to a potter's wheel, except that a hand-operated mechanical arm with a template shapes the pottery (see 13-81a).

Jiggering and jolleying are two processess that are generally used for making hollowware such as cups, saucers, bowls, mugs, plates, and open forms. Jiggering refers to forming ceramic ware upside-down on a spinning mold: It shapes the front and back, or inside and outside, of a piece at the same time. Pottery produced by jol-

leying is made right side up. For jiggering, the design on the top surface of a flat plate is transferred from the mold by pressure applied to the clay on the back of the plate by a profile template, which simultaneously shapes the back. The template, usually made of wood, plastic, or metal includes a profile that mirrors the plate shoulder and foot. As the soft clay turns, the profile template, which is attached to a pivoting arm, is brought down slowly by hand over the spinning clay, shaping the backside and foot at the same time. The jiggering speed is usually 150–250 rpm depending on the size of the ware being made and the type of machine.

For jolleying, the profile template forms the interior of the piece and the exterior of the mold

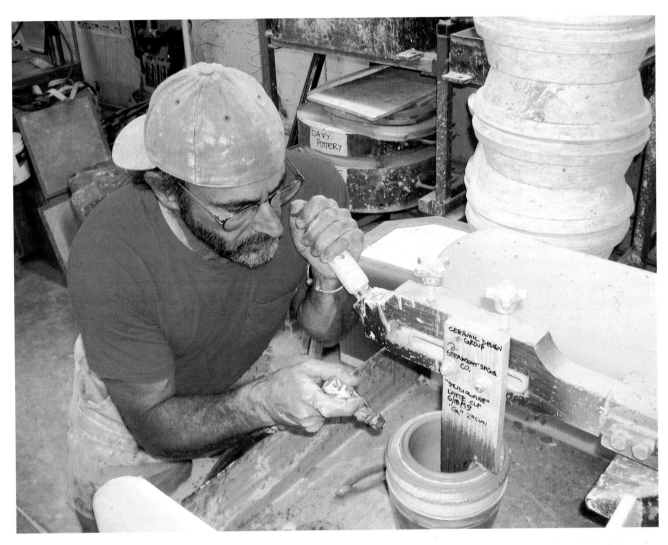

FIGURE 13-80
Jonathan Kaplan, a master mold-maker, potter, and designer from Steamboat, Colorado, uses the jiggering process to manufacture various pottery lines. The jiggering method is an efficient production process that ensures consistent quality. *Courtesy the artist.*

forms the outside wall. Jolleying is generally used to make flat objects such as plates or saucers. After a piece is turned, the mold is removed from the wheel and left to dry on a ware cart until the plate is stiff enough to remove.

Some studio potters have modified their electric or kick wheels by attaching a jigger arm assembly to the frame of the wheel. A plaster or metal chuck is bolted to the wheelhead, which accepts various jigger molds. This system works well for small to medium-sized work.

Professional jigger machines have powerful motors, and some include multiple steel rings

that can be removed to accept molds of varying diameters. They can handle molds that weigh hundreds of pounds. A switch-activated hydraulic plunger pushes the mold out from the center shaft when the piece is finished. Flowerpots are often produced using this process.

Professional mold- and pattern-maker and production ceramist Jonathan Kaplan (13-80–13-82) uses the jiggering method to produce a line of latte cups. He begins a piece by first designing it on a computer. Then he makes a prototype of the piece and a test jigger mold. When the production details are worked out, he makes

(a)

(b)

(c)

(d)

(e)

FIGURE 13-81

(a) Kaplan uses a hand-operated jigger machine to manufacture his pottery line. The machine holds custom metal chucks of various sizes that lock into place on a small spindle shaft. Tapered plaster molds fit snugly into the metal chucks that rotate on the shaft. With the wheel spinning, a metal or wood profile template affixed at the end of a counterbalanced arm pivots on a metal column. The jigger arm is pulled down by hand until the bottom tip of the cutting edge indexes perfectly to the center of the clay. Water is used to lubricate the spinning clay as the piece takes on the shape of the template. *(b)* Kaplan begins the process of making a latte

cup by placing a soft preweighed lump of clay, enough to make one cup, into the plaster jigger mold. *(c)* With the jigger machine turning, the lump of clay is lubricated with water and shaped by hand to open the well. Then the jigger arm is lowered into place to shape and trim the inside of the latte cup and the rim, all in the same motion. The outside shape of the cup conforms to the plaster wall. *(d)* Detail of the wooden latte cup template that attaches to the jigger arm. Kaplan adjusts the template to an exact distance between the mold wall and blade, which determines the wall thickness of the cup. *(e)* When the cup is competed, the plaster mold is lifted out of the metal chuck and placed on a table to dry.

FIGURE 13-82
A jiggered latte cup, with its handle attached separately, is dried and bisque-fired. *Courtesy the artist.*

a master mold in hydrocal of the latte cup mold, which he then uses to make the production jigger mold in pottery plaster.

Bill Campbell uses the RAM press technique to form his line of shallow bowls (13-83–13-85). The RAM press machine uses two steel collars that encase hard gypsum cement patterns. Clay is inserted between the molds, and the molds are brought together under tons of pressure to shape various kinds of ceramic ware.

Learning to make molds in which to press, cast, drape, jigger, or jolley will enhance your ability to shape clay into whatever you wish—from plates, cups, bowls, and sculptures to architectural ornaments. This knowledge will widen the range of your creativity in ceramics and offer you a wealth of new areas to explore.

FIGURE 13-83
Bill Campbell, who began as a studio potter, has developed his studio into an efficient production facility that turns out thousands of pieces each day using a variety of methods. Here he uses a RAM press machine to make a bowl. *Courtesy the artist.*

FIGURE 13-84
A bowl produced from a RAM press machine is shaped under tons of pressure, which forces the clay into a steel-encased hydrocal mold. *Courtesy the artist.*

FIGURE 13-85
A RAM-pressed bowl by Bill Campbell is
gas-fired in a reduction atmosphere with
multiple glazes, producing a vivid blend
of lavenders, purples, and blues that
accentuate the fluted edges of the piece.
Courtesy the artist.

14

Texture, Color, and Glaze

The very earliest potters used no more than their fingers, fingernails, sticks, fish bones, or other natural objects to scratch, impress, or carve textures onto the surfaces of their pots; their work frequently showed an innate sensitivity to the relationship of the decoration to the form of the pot (see 1-11, 3-3, 3-6). Later, before the development of glazes, potters used earth minerals to create decorations on their vessels (see 1-18 to 1-20 and the section titled "Early Glazes" in Chapter 3).

The way in which the surface of a vessel, mural, or sculpture is treated will affect the overall appearance and aesthetics of the piece. Because your choice of clay body will influence the final appearance of the surface, you need to decide on the type of surface treatment you want before choosing the clay body. Fine-grained porcelain, for example, lends itself to detailed carving or delicately colored or translucent glazes, whereas heavily grogged earthenware and stoneware are more appropriate for rougher finishes.

Clay bodies, ceramic coloring materials, slips, and glazes make use of many of the same materials, but how you use these materials in relation to each other profoundly affects the final quality and appearance of your work (14-1). Because this relationship is so important, the clay bodies formulated for mixing and testing (see 10-10) are planned as part of a series that proceeds from mixing, to coloring the clays, to finally making simple glazes to embellish them. These same clay bodies (see *Expertise*, Chapter 1A) are keyed to colorants and the specially formulated glazes in Figure 14-48 as a series of basic clays and glazes to be studied through testing. Additional information that will prove useful as you continue—concerning glaze additives; water percentages; clay and glaze colorants; frit, feldspar, and **opacifier** composition charts—is located in *Expertise*, Chapters

FIGURE 14-1
Doe in Heat, by Michael Gross of the United States. The imagery on Gross's deeply carved vessels includes hunting adventures—both human and animal—family scenes, the art and music of many cultures, and deceptively cartoonlike characters suggested by radio talk shows. Close inspection, however, reveals faces and forms that are agonized, expressing the despair of squalid city environments. The bold carved and painted surface profoundly affects the overall aesthetics by enhancing the visual and tactile sensations expressed in the piece. Clay, relief carving, glaze. Ht. 49 in. (124 cm), diam. 25 in. (63 cm). 1990. *Courtesy the Ann Nathan Gallery, Chicago. Anonymous collection.*

1A through 1F, along with some clay, slip, and glaze recipes that other ceramists have shared (see *Expertise*, Chapter 1C). If you wish to go further into analyzing glazes, read *Expertise*, Chapter 3B, always remembering that the clay body itself must be in harmony with the glazes you apply to it.

UNGLAZED SURFACES

Today many potters and sculptors explore the inherent qualities of different clays, leaving the surface in its natural unfired state. Others are interested in obtaining surface effects on unglazed clay by varying the fuel, temperature, and atmospheric conditions in the kiln. Still others add texturing materials to the clay body or deliberately develop a texture on the surface (see 14-1–14-8).

Texturing Damp Clay

Of her rough-textured vessels (14-2), Kyoko Tonegawa says,

> *Based on a special traditional technique of throwing on the wheel, I throw from the inside only, without touching the exterior of the pot. In this way I create untouched surfaces of texture and modify the shape, while allowing natural, earthen textures and colors to express themselves outwardly.*

You may find materials or objects that you can use to alter the damp surface of the clay in your home or outdoors. Almost anything, from beans to bolts or bits of bark, might help you achieve the surface you want for a particular pot or piece of sculpture (14-3, 14-4). You can also use commercial wooden or hand formed stamps to impress designs into damp clay, or you can model or carve your own stamps from clay, bisque-fire them, and then press them into the damp clay (14-5). A stamp modeled in relief will make a negative impression in the clay (see 16-24), while a concave-carved stamp will create a relief when it is pressed into soft clay (see 2-32). In addition, the method of construction you use—coils, pellets of clay pressed together, overlapping slabs—can in itself create surface interest.

(a)

(b)

FIGURE 14-2

(a) Sleeping Mountain. Kyoko Tonegawa of the United States uses a special traditional technique in which she throws from the inside only in order to preserve the natural exterior texture of the clay. Stoneware, reduction firing, cone 10 to 11. Ht. 15 in. (38 cm). *Courtesy the artist. (b)* This detail of *Sleeping Mountain* shows the natural textural qualities of the clay after it has been pushed and stretched from the inside, expressing a strong topographical feeling. *Courtesy the artist. Photo: Tom Lang.*

FIGURE 14-3

Sample textures show how easy it is to decorate soft, damp clay by scratching or pressing into it. In the past, potters used dried corncobs or shells to decorate their pots. Look for objects around your home or outside that you can use to make simple stamps or to create interesting designs and textures. *(a)* Pine branch. *(b)* Threaded pipe. *(c)* Carved plaster stamp. *(d)* Metal mesh. *(e)* Fork. *(f)* Rock. *(g)* Pencil. *(h)* Saw-cut woodblocks. *(i)* Rope.

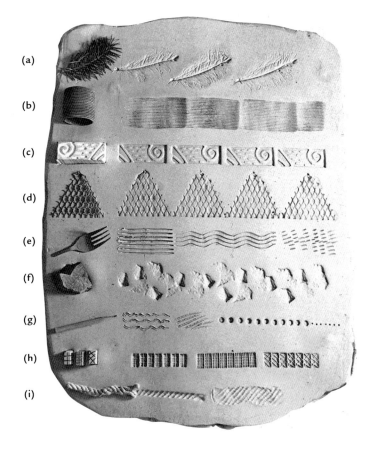

(a)

(b)

(c)

(d)

(e)

(f)

(g)

(h)

(i)

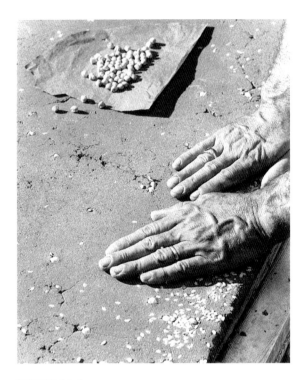

FIGURE 14-4
Pompeo Pianezzola of Italy presses beans and rice into clay. This organic material will burn out in the firing, leaving the surface pitted. *Courtesy the artist.*

Carving and Incising

The Jomon potters of ancient Japan combined impressed patterns with carving, giving a distinctive surface to the unglazed clay. They used both methods effectively on their pottery and sculpture (see 3-2–3-4).

Carving into damp leather hard clay appears easy, but as with all decorative techniques, success depends on the relationship of the carved surface to the object's clay body and to its shape and size (14-6–14-9). All these factors must be carefully planned and executed. A monumental sculpture looming over a viewer could take deep carving (see 16-18), whereas the overall patterning of a sculptured figure's dress calls for a more precise incised line (14-10).

Sprigging

Another technique from the past that is still sometimes used to create decoration in relief is sprigging (see 6-20). By applying pellets, rolls, modeled images, or cutouts of clay to the surface, you can create an overall texture or raised

(a) (b)

(c) (d)

FIGURE 14-5
(a) Bisque-fired clay texturing stamps with I- and circle-stamp ends. *(b)* An organic texture made on a tile with an I-stamp pressed into damp, soft clay and stained with a red glaze stain and fired to cone 1 with a clear glaze. *(c)* A circular and dimpled pattern, colored with a burnt-orange glaze stain. *(d)* A geometric pattern made with a circle-stamp and an I-stamp and tinted with a blue-green glaze stain.

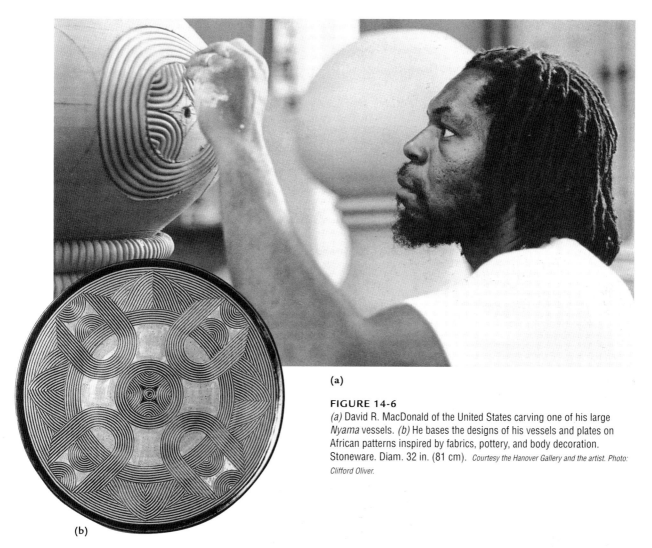

(a)

FIGURE 14-6
(a) David R. MacDonald of the United States carving one of his large *Nyama* vessels. *(b)* He bases the designs of his vessels and plates on African patterns inspired by fabrics, pottery, and body decoration. Stoneware. Diam. 32 in. (81 cm). *Courtesy the Hanover Gallery and the artist. Photo: Clifford Oliver.*

(b)

decoration on a pot or sculpture. This sprigged relief can be added to the soft clay as you build, or you can add it to a leather-hard surface after scoring it and painting it with slip. Be sure that the added relief is well attached.

Burnishing

Burnishing a clay object when it is leather hard or dry (see 1-16, 5-20) also has a long history and is a tried-and-true way of altering the surface of damp clay. To burnish, stroke the clay's surface with a river-polished stone, a curled, flexible stainless steel metal rib, or any smooth object, such as the back of a kitchen spoon. Some potters and sculptors prefer to use a piece of cloth or chamois. Burnishing works best with a clay body that is not too coarse or that has been

FIGURE 14-7
Karl Scheid of West Germany carves his delicate porcelain bowls and boxes with precise patterns that are especially appropriate to their material, size, and shape. Porcelain. Ht. 3½ in. (9 cm).
Courtesy the artist. Photo: Bernd P. Göbbels, Hirzenbain.

(a)

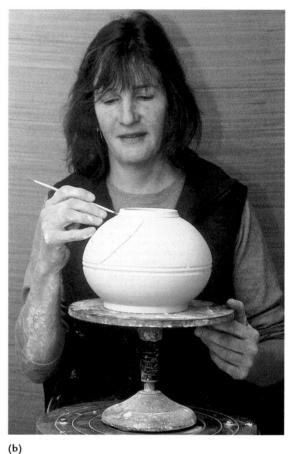

(b)

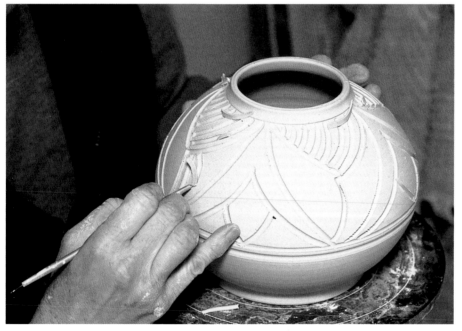

(b)

FIGURE 14-8
(a) A wheel-thrown and carved porcelain teapot by Diane Heart of the United States. The carved organic pattern accentuates the contrast in the fired glaze, which pools and becomes darker in the carved areas and shows the white porcelain body through the glaze on the ridges. Cone 10, reduction fired. *(b)* Heart carves the damp greenware porcelain body of a teapot before attaching the spout. She steadies the piece on a banding wheel while she carves a design into the shoulder of the pot. *(c)* Heart uses a ribbon tool to carve her designs into the porcelain surface. Heart carves freehand, fitting the design to the pot as she carves. She says her mind organizes her visual perceptions automatically into patterns.
Courtesy the artist.

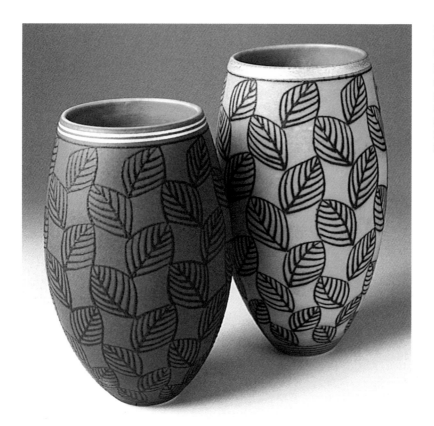

FIGURE 14-9
Two porcelain vases by Caroline Whyman of England. Her strong, simple, thrown porcelain forms carry complex abstract surface patterns, often based on grids. Her intricate decoration method utilizes carving, inlaid slips and glaze, and sometimes gold and platinum luster in a third firing. Hts. 8 and 9 in. (21 and 23 cm). *Courtesy the artist.*

coated with a fine-particle slip. Some ceramists prefer to burnish while the clay is damp leather hard or leather hard, whereas others prefer to work on dry clay. On bone-dry clay, vegetable oil can be applied to the surface and left to dry for about 10 minutes, then burnished with a smooth stone or the back of a metal spoon. A burnished piece is best when fired relatively low, around cone 015 to 010 (1501–1675°F/816–913°C; see 15-86). If fired too high, a burnished pot or sculpture will flux and lose its lustrous surface.

Texturing Dry Clay

Other surface effects can be achieved by scratching, carving, drilling, chiseling, filing, **sandblasting,** or sanding the clay when it is dry rather than leather hard. The effect differs according to the clay body or tool used (see 14-6–14-10). For example, carving dry clay that is heavily grogged may result in a slightly ragged effect, while care must be taken to avoid chipping edges when carving a smooth clay body such as porcelain. Lightly dampening the clay before carving can make carving easier.

FIGURE 14-10
Marilyn Lysohir of the United States carves a flowered pattern into the dress of one of the figures for her installation *Bad Manners* (see 16-2). The clay is leather hard and smooth, allowing her to incise the precise linear designs. *Courtesy the artist. Photo: A. Okazaki.*

HEALTH PRECAUTIONS

Clay Dust

If you sand dry clay, be sure to use a respirator. It is hazardous to breathe clay dust because the microscopic particles that carry free silica (silica that has not combined with clay molecules) can enter and clog your lungs. Although you can wear a respirator while carving, be aware that others in the studio will also be exposed to the dust, so be sure that there is adequate active ventilation to remove the dust at its source. Once you have finished sanding dry clay, check your respirator to see if dust has collected on it. Damp-sponge the casing, and dry it with a clean towel before storing it away.

If breathing through a respirator becomes difficult, check to make sure that the unit is functioning properly and replace the filter if needed. When sanding large amounts of clay, place the nozzle on a vacuum with a HEPA filter in front of the work area to suck away any dangerous clay dust, or use a battery-operated, dual-cartridge supplied-air respirator that covers your entire head.

Adelaide Robineau (see 7-7) spent more than 1,000 hours carving one of her famous pieces of pottery, unaware of the hazards of silicosis, a lethal disease of the lungs she could have developed as a result of breathing clay dust. One might reason that lots of potters lived to a ripe old age doing all the unsafe things warned against in this book, but they were not exposed to the same levels of pollutants and toxic substances in their daily lives as we are today. It is the cumulative effect of these substances that is especially dangerous to us, so be especially wary of exposure to clay dust.

Glaze Materials

Almost all coloring materials—clays, underglazes, glazes, and overglazes—pose some health risk, and if you smoke, have allergies or asthma, are pregnant, or have a heart condition, be aware that you cannot tolerate as much exposure to toxic materials as others can. In *Expertise*, Chapters 1E and 1F, we list the chemicals and ceramic materials that you will use in the studio and rate them according to their degree of toxicity. Since such information is always being updated, how-

ever, it is important that you keep up with new information as it is published. To be sure that you know what you are using, carefully read labels and any warnings and ask your supplier to give you the appropriate material safety data sheet (MSDS) that reveals any hazardous ingredients, the effects of exposure, and the necessary protection and precaution information. *Expertise*, Chapter 5A, lists sources from which you can get current information, and the Further Reading section includes publications that will keep you up to date on the latest findings. Here, we repeat some of the basic precautions you should take while working with clay and glaze materials. Ultimately, it is *you* who must actively protect yourself from danger and take responsibility for you own health.

While working with the materials used in ceramic glazes, you must protect yourself from ingesting them by breathing them as dry ingredients or absorbing them through your mouth or skin. Be especially careful if you have any cuts in your skin. If your skin is sensitive, wear protective gloves while throwing or modeling clay and while mixing glazes. If you are allergic to natural rubber such as latex, consider using vinyl, nitrile, or polyethylene gloves. Either use active local ventilation close to the dry materials you are mixing, or wear a properly fitting respirator mask with a filter rated for toxic dust. For added protection, mix glaze materials in a plastic-covered mixing bowl with a hole in the side that allows you to reach in and mix the materials. When mixing amounts of glaze under 1 gal. (3.785 l), blend the dry chemicals in a lidded plastic jar, shaking the powders together. After the dust has settled in the jar, add water and shake again to blend.

Spray or **airbrush** glazes and overglazes only in a properly vented **spray booth**, wearing a respirator rated for mists and fumes. Keep your hands away from your face, mouth, and eyes, and avoid accidental ingestion; do not eat or smoke when using glaze materials. Never hold a dirty brush in your mouth when your hands are occupied. Wear an impermeable protective apron, keep it clean of glaze materials, and leave it in the glaze room when you are finished. It is also a good idea to shower and shampoo after using glaze materials.

Ventilation is as important in glaze areas as in clay-mixing areas, so be sure that the proper standards are followed in those areas and that

you turn on the fans or dust collectors before working. The glaze area should also be kept clean. Wet-sponge all table surfaces and areas that have been splashed with glaze, and clean the floors with a wet mop, wet-dry vacuum, or shop vacuum with a filter that traps microscopic particles of clay and glaze materials. Glaze materials and glazes should be stored in covered, unbreakable well-labeled containers.

Although the chemicals and materials listed in *Expertise*, Chapters 1E and 1F, identifies certain substances as particularly toxic, remember that *all* the ingredients used in ceramics must be used with care. Take all the necessary precautions, and limit your exposure to toxic materials as much as possible through sensible work habits.

An important purpose of this book is to encourage you to work in clay, so we don't want to emphasize the precautions to such a degree that you become fearful of using ceramic materials. If you take the proper precautions, you should be able to work safely and healthily in a ceramics studio unless you have a health problem that would make you especially vulnerable. For an overview of good studio procedures and basic health and safety rules, refer to the section titled "Health and Safety" in Chapter 10.

COLOR IN CLAY BODIES

Ceramic Stains

Although the most common oxides are used as the basic colorants for clay, commercial stains offer the possibility for a wider range of colored clay bodies (14-11). These commercially prepared stains, produced primarily for the ceramics industry, are also more color-stable than oxides within specified firing ranges. These advantages make it worthwhile to buy prepared stains. If you wanted to make stains like these in the studio, you would require many materials, elaborate processing equipment to **calcine** the materials (that is, to heat to the point just below fusing in order to combine them chemically), and equipment for washing out the **soluble salts,** not to mention a great deal of knowledge and experience. So, to keep things really simple, we suggest you buy commercial stains and blend your own clays, or purchase premixed colored clay bodies. One company even offers a kit that includes small amounts of variously colored clays for testing.

Another advantage of using stains in clay bodies is the fact that the color you see in the dry stain will be similar to the color you will obtain when you blend it into the clay. By comparison,

(c)

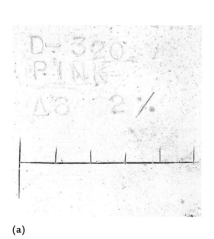

(a)

(b)

FIGURE 14-11

Hands in Clay cone 5 porcelain clay (CL2; see *Expertise*, Chapter 1A) was mixed with 15% grog to reduce shrinkage and then blended with **glaze stains** to produce color. Sometimes glaze stains are called *body stains* when they are added to clay. Although the base porcelain clay was formulated for cone 5, it actually has a firing range up to cone 10. Two-percent pink stain D-320 yielded a soft, carnation pink color, and 12% shrinkage at cone 6. Five-percent tin vanadium yellow stain yielded a pastel yellow, with a 10% shrinkage at cone 9. Three percent #62 blue glaze stain yielded a navy blue color with 12% shrinkage when fired to cone 9.

oxides such as cobalt do not show their true color until they are fired. Cobalt oxide blended in white clay appears blackish until fired, whereupon it turns blue. Until you are experienced and can predict the colors you will get from oxides, using them to color clay can be a bit like painting in the dark. As with oxides, the truest stain colors are achieved when they are blended into light or white clay bodies. The temperature at which the clay is fired can also affect a stain as it does an oxide, so testing is essential.

Mixing Stains into Clay

With stains, the color range extends beyond the basic oxide colors to encompass purples, pinks, yellows, beige, and various shades of blue, gray, green, maroon, brown, and black. In addition, the careful processing these commercial stains undergo ensures quality control and color-batch consistency. There are now deep red, yellow, and orange stains available for glaze and clay bodies that maintain their true color when fired to cone 10 in reduction.

Cadmium and selenium red and yellow stains are available, but these stains will not produce color in clay bodies, only in glazes when mixed with special lead-bearing frits.

To mix stains into clay bodies, place the dry stain powder on a wedging table or wooden bat and wedge moist clay into the color until it is thoroughly blended, or, for greater control of the color tones, mix the stain into batches of dry clay, carefully controlling the percentages of color added to the clay body. To learn about the quantity of stain necessary to add to a clay, begin by adding up to 5%. After firing the clay samples, you will be able to determine the amount needed for adjusting shades. The percentage of color to add to the clay body will be affected by the type of clay body, firing temperature, and kiln atmosphere. *Expertise*, Chapter 1A, gives the percentages of stains and oxides to add to clay bodies to test, and Figure 10-10 shows fired test tiles of clay bodies.

Wedging Different-Colored Clays

The simplest way to achieve a variety of clay colors is to thoroughly wedge together two different clay bodies. Vary the percentage of each clay to obtain the color you want. For example,

a low-fire white clay wedged with a low-fire red clay will yield a medium reddish brown, while a high-fire, iron-rich stoneware blended with a white porcelain (also high-fire) will yield a medium brown when fired in an electric kiln (it will be darker if fired in reduction). The important point here is to choose two clays that have similar maturing temperatures so that they are compatible when fired as a new clay body.

Multicolored Clay and Marbling

By combining clay bodies of different colors using a variety of methods, you can create a range of effects, extending from a braid-formed bowl to a marbled teapot (14-12). You can simply twist or braid rolls of colored clays together or use a more complex technique in which you combine blocks of colored clays and then cut, layer, and roll them, creating an agate or laminated effect. It takes a good deal of practice to make agate ware, because you must meld them lightly enough to keep the variously colored clay bodies separate, and firmly enough to keep cracks from developing where the two colors meet.

Using color in clay is not, however, simply a matter of picking any color of clay body and combining it with any other clay. Each colorant contributes certain characteristics to the clay, including different shrinkage rates, so when the clay dries or is fired, the colored clays may shrink at different rates and possibly separate. The amount of stain you add to make a color can also affect the shrinkage rate; in addition, the maturing temperatures of the different clay bodies used must be similar in order for the piece to come through the firing without cracking. On the other hand, the cracks and crevices that develop while the piece is in the kiln can become part of the surface interest, as in John Toki's large sculptures (see 16-16).

Coloring Oxides

You can develop a wider palette of clay-body colors by blending and testing various oxides in differing proportions in the clay. For example, 2–5% red iron oxide added to a clay will give you browns, and .5–2% cobalt oxide will create blues when blended into porcelain or very light-colored bodies. You will achieve the truest col-

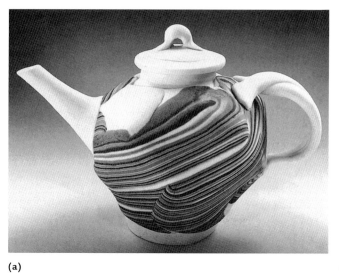

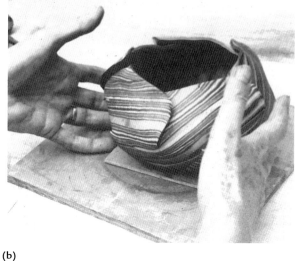

(a) (b)

FIGURE 14-12
(a) Virginia Cartwright of the United States uses a variety of folded and inlaid colored clay slabs to create the patterns on her teapots. *(b)* To form marbled slabs, Cartwright cuts thin slices from a loaf of layered clay and rolls each slab into a thicker slab from which she will build the teapot. As she rolls the two slabs together, the thin veneer becomes bonded tightly to the thicker slab, and its patterns stretch into rhythmic swirls. Porcelain, cone 10. *Courtesy the artist. Photo: Robert Stefl.*

ors when blending colorants into light or white clay bodies. Different percentages will give you various shades of color. It must be noted that high percentages of oxides in clay bodies act as fluxes in the clay, lowering the firing temperature. Remember that the temperature to which the clay is fired and the atmosphere in the kiln will also affect the colors, so *test!* You can carry these tests further to create a wider variety of colors. (See "Testing Clays," Chapter 10. For more information about clay colorants, refer to *Expertise*, Chapters 1A and 1F.)

Egyptian Paste

Egyptian paste is a self-glazing clay, so it is not strictly a clay body; yet it is not exactly a glaze, either. Originally discovered—probably by accident—by the ancient Egyptians or the Mesopotamians, it played a role in the development of glazes (see Chapter 2). The clay body used in Egypt was made from local materials that contained a number of natural ingredients, which, when fired, combined to form a fragile alkaline glaze on the surface of the clay. This ancient paste usually developed greenish blue tones due to the copper oxide in the ingredients. Now, however, the commercially available low-firing (cone

015–05) Egyptian paste is colored with glaze stains and oxides that make possible a wide range of colors. (See *Expertise*, Chapter 1A, for an Egyptian paste formula for testing). Historically used for small items, Egyptian paste has been used successfully by some sculptors for larger objects. For these pieces, the clay is frequently wrapped around steel or stainless steel wire or rods, or kiln element wire (nichrome, Kanthal, or APM wire), which remain during the low firing, generally at 1540–1800°F (838–983°C). Alternatively, one can model stiff Egyptian paste in relief on flat glaze-fired ware such as tiles or plates, then fire the ware to the appropriate temperature.

Coloring with Oxides, Slips, and Engobes

OXIDES Over time almost all the basic elements on earth have formed a chemical combination with oxygen, and the resulting oxides have proved to be of great importance in the history of ceramics. They have been used not only for coloring clay and glaze but also to provide fluxes that help fuse the clay and the glaze in the kiln.

Even if you were limited to using iron oxide (**ferric oxide**) alone, you would still be able to enhance the surface of the clay with a considerable variety of effects. By adding a second oxide,

FIGURE 14-13
Sponging a diluted solution of red iron oxide onto a bisque-fired tile is a method of staining clay that achieves a contrast on the textured surface. After the excess oxide is sponged off, the tile will be bisque-fired once more to set the oxide and keep it from rubbing off or smearing. Some ceramists, however, prefer to spray or dab on the first coat of a clear glaze—again to avoid smearing the oxide—before firing the tile.

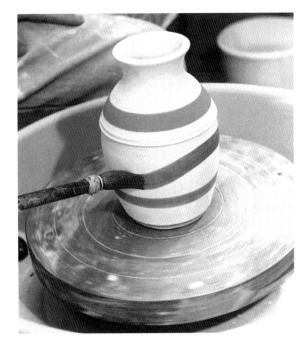

FIGURE 14-14
Bill Cravis prefers a clean, sharp-edged band around his vase when he decorates his ware. He bands his bisqued pottery with a cobalt blue glaze stain solution on a slowly turning electric potters wheel.

FIGURE 14-15
(a) Bryan Higgins applies texture to the damp clay surface of his sculptural teapot with the knowledge that when he later applies stains, oxides, and slips to the piece, they will interact with the clay, resulting in a highly tactile and rich surface after firing. *(b)* This handbuilt teapot by Bryan Higgins was constructed with thin slabs made with a slab roller. The piece was textured with a trowel and bisque-fired to cone 06. After bisque-firing the teapot, he decorated it with oxides and glazes and fired it to cone 6. *Courtesy the artist.*

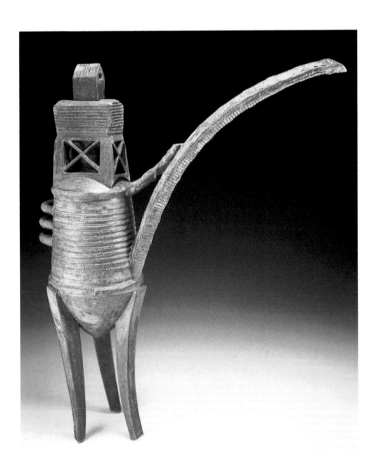

(a)

(b)

such as cobalt, copper, or manganese, to your palette and using the two oxides in combination, you could develop a considerable range of colors. If you have worked through the tests of clay bodies in *Expertise*, Chapter 1A, you already have some idea of the action of oxides in clay bodies.

In addition to their usefulness in clay bodies, these chemical compounds can be used for coloring and decorating the surface of damp, dry, or bisque-fired clay in a number of ways (14-13–14-17). Throughout history, potters applied them with brushes (14-18), feathers, twigs, or slip trailers (see 14-22).

FIGURE 14-16
Agnese Udinotti of the United States created her *Shadow Image* plates as an extension of her acrylic painted canvasses. She first covered the plate with black slip and then carefully wiped away the surface with a wet sponge or her fingers dipped in water to develop the images in a subtractive decorative process. *Shadow Images,* she says, refer to *those haunting memories which exist at the point of recollection/forgetfulness.*
Courtesy the artist. Photo: Bill McLemore.

(a)

(b)

FIGURE 14-17
St. Crow Plate. (a) Michelle Gregor of the United States, decorates her dinner ware with slip drawings under a clear glaze. Diam. 13 in. (33 cm). 1992. *(b)* She uses drawings and the name of her dinnerware—PALM Ceramics—as decoration on the back of a bowl. The black opaque slip designs painted on the plates contrast with the light color of the clay, creating striking images. Diam. in. (28 cm). 1992. *M. Gregor, sole manufacturer and creator. Courtesy the artist.*

FIGURE 14-18
A variety of brushes are available for applying slips, engobes, underglazes, stains, oxides, dry powders, and glazes. Each one has a specific use: *(a) Liner brush:* fine line decoration with glazes, stains, lusters, underglazes. *(b) Sable brush:* smooth application with lusters, metallics, china paint. *(c) Sumi brush:* painterly decoration with stains, oxides, general glazing. *(d) Camel-hair brush:* lusters, underglazes, general glazing. *(e) Fan brush, stiff bristle:* design work with dry powders, glazing decoration. *(f) Ox-hair brush:* general glazing. *(g) Hake brush:* general glazing.

There are a number of ways to apply an oxide. You can brush or dab it on with a sponge to create various textures. Another popular method is to brush or sponge it on **bisque** and then wipe it off (see 14-13); this technique is especially effective on a rough clay. Other ways to apply oxides include spraying or carefully painting it into incised lines. Or to add depth and color to textures and carved areas, you can cover the piece with oxide so that it fills the grooves, then lightly sponge it off the raised areas. You can also apply oxides with **resist** methods, covering up the parts you want to remain uncolored with masking tape, wax, adhesive paper, liquid **latex,** or a stencil (see 14-25–14-27) and then painting over them with an oxide or slip.

SLIPS AND ENGOBES A slip is basically a mixture of clay and water. With an added deflocculant, a slip mixture can become a medium for casting in plaster or bisque clay molds (see Chapter 13). In this chapter, however, the term is used in relation to water-diluted clays that are used for decoration. Grolleg china clay diluted with water is an example of a slip. The terms *slip* and *engobe* are now frequently used interchangeably. The term *slip,* however, refers to the clay-and-water mixture used for decoration or for casting, whereas the term *engobe* should be applied only to any slip that covers the whole of a pot or sculpture.

White or cream engobes are often used to cover the reddish tone of earthenware clay in order to create a light background suitable for painted decoration. White slips are often made from white porcelain clay blended into a liquid state, and white slips can be colored with basic oxides or with the wider range of colors available in commercial stains. (See *Expertise,* Chapters 1A and 1C, for several slip recipes.)

Slips and engobes do not melt and run in the same way that many glazes do, and the color does not blur. This makes slips easier to use for decoration than glazes. In addition, because slips and engobes are also made of clay, they have a natural visual relationship to the clay body, and with only a transparent or salt glaze over the whole, a slip or engobe decoration is able to maintain a relationship to the clay body. On the other hand, slip decoration can have a painterly quality when applied with a brush or fingers (see 14-16, 14-17).

Fitting the Engobe or Slip In order to ensure a good "fit" between the slip and the clay body, it is usually a good idea to make (or buy) slip or engobe made from the same clay body as that used for your pot or sculpture (14-19, 14-20). Since clays vary in their shrinkage rates, an engobe or slip made of a different clay may not have the same rate of shrinkage and therefore may peel off during drying or after firing. Early potters faced this problem when they made their white or cream engobes to cover the red earthenware body, and the pottery found in early sites frequently shows the results of this peeling, with very little of the original color left on the ware. If you use a slip of the same clay body

FIGURE 14-19
Applying a thick coat of Grollegg china clay slip with a soft hake brush to a leather-hard vase completely obscures the clay color. While the slip is still damp, a design can be cut with a sgraffito tool through the slip to reveal the clay color of the vase. To help get an even coat, the vase is rotated on a banding wheel while the slip is applied.

as that used for the pot or sculpture, this will not be a problem, but since one reason for using a slip or engobe is to change a piece's color, this is not always possible.

To mix light-colored engobes and slips, you can use light-colored clay materials such as kaolin, bentonite, and ball clays in varying proportions. Since each of these has a different rate of shrinkage, however, you may need to add flint to counteract shrinkage, or borax or frit to help the slip adhere to the pot.

If you have difficulty with a slip or engobe peeling after applying it or during firing, reformulate and test the slip or engobe and the clay body so that they fit each other better. Sometimes a slip or engobe peels off a pot due to the thickness of the applied glaze, to shrinkage, or to the shape of the vessel. An area on a pot that is especially critical to peeling or cracking is a lip that is too sharp. The tension that occurs from the shrinkage of the slip, engobe, or applied glaze often causes problems. A lip with a more rounded edge can help relieve surface tension.

You can also try adding a solution of gum to the slip. This may not solve your difficulty completely, but it will help counteract the tendency to peel. Use a solution of 196 g of **CMC** gum or gum tragacanth with 1 gal. (3.785 l) of water. If the slip is to be stored for a long time, you can add a solution to keep the gum from spoiling. Either Dowicide G or formaldehyde (¾ oz. [6 fluid drams] per 1 gal.) will do this. Since both of these products are toxic, we suggest that—in line with our recommendation to avoid using toxic materials when possible—you mix only the amount of slip you need for immediate use so that you do not have to use an antispoilant. If you do use an antispoilant, ask your supplier for an MSDS information sheet giving you handling precautions, and follow them.

Running a series of test tiles is the only *sure* way to see whether a slip or engobe will adhere to a particular clay body. *Expertise*, Chapters 1A and 1C, provide some slip recipes that you can alter and test on your clay bodies.

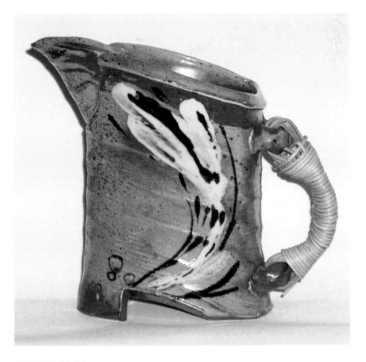

FIGURE 14-20
A wheel-thrown and altered pitcher by David Eichelberger of the United States who applied bold brushwork to the Shino-glazed surface with slips and oxides. They reacted with a finely sieved wood ash that was carefully applied to the surface and then fired to cone 10. The combination of elements reacting together in the kiln added to the decorative qualities of the organic plantlike imagery sweeping across the diagonal ridges of the wheel-thrown vessel. 7 × 3¾ × 6 in. (18 × 9.5 × 15 cm). *Courtesy the Toki Collection.*

(a)

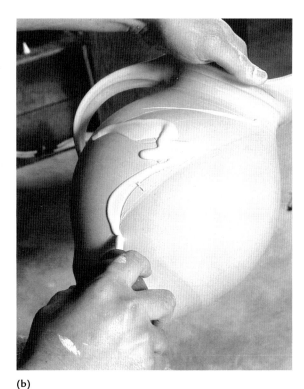

(b)

FIGURE 14-21
(a) Trailing slip from a squeezable syringe is the modern way to decorate with slip—potters formerly used a ceramic slip cup with a goose quill inserted in a small opening. Load the slip trailer with a viscous underglaze, slip, stain, glaze, or engobe, then squeeze the bulb as you draw your design. *(b)* Wielding the slip trailer with a free, sure gesture, Steven Hill of the United States adds a final touch to a pitcher. *Courtesy the artist. Photo: Al Surratt.*

FIGURE 14-22
Plate: Scarification Series by David R. MacDonald of the United States. He approaches the traditional method of slip trailing in a free manner, using slip to create patterns inspired by the scarification patterns of Africa (see also 14-6). Stoneware. Diam. 22 in. (56 cm). *Courtesy the Hanover Gallery and the artist. Photo: Clifford Oliver.*

Decorating with Slip Early potters devised a number of ways to decorate with slips and engobes. Since both are opaque, if you apply several coats you can color the whole pot or sculpture with a uniform color. In the past, an especially popular decorative method was to trail the slip onto the damp clay, creating lines, marbling, or feathered effects (see 7-2). The slip was simply trailed on in patterns, much as one would write "Happy Birthday" on a cake. Nowadays, potters use variations of the slip-trailing technique (14-21) to suggest traditional European designs. David R. MacDonald adapts the technique to create designs based on African scarification (14-22).

Les Lawrence developed a monotype method of decoration (14-23) by silk-screening an image onto a plaster slab with black slip and transferring the image to the slab of clay. Mitch Lyon invented a clay monoprinting technique using pigmented kaolin slip to transfer images from newsprint to a slab (14-24). To prepare the stoneware slab for printing, he painted three coats of china clay slip

FIGURE 14-23
To print the surfaces of his *New Visions* series, Les Lawrence of the United States, uses a photo silk-screen monoprint technique to transfer images. He screens the image onto a plaster slab, using black porcelain slip, then alters the image with various instruments—brushes, strings, erasers, stencils, or wire. Next he pours specially formulated casting slip over the slab and peels it off when it is still soft, lifting the slip decoration with it. He then uses these decorated slabs to construct his *New Visions*. Porcelain, cone 10, stainless steel, steel wire, photo silk-screen monoprint. 20 × 20 × 4 in. (51 × 51 × 10 cm). *Courtesy the artist.* *Photo: John Dixon.*

FIGURE 14-24
Mitch Lyon, of the United States, uses a clay monoprint technique to decorate the clay slabs from which he constructs his vessels forms. First he applies colored slips, oxides, and stains to newsprint with brushes and a slip trailer. Then, after letting these stiffen, he transfers the colors to porcelain slabs. Lyon also uses an assortment of graters through which he screens dried, pigmented clay onto the slab. He then transfers the entire slab onto a canvas and rolls it around a cardboard tube to form a cylinder. After joining the seam, he inverts the cylinder onto a slab cut to form the base, and then removes the cardboard tube. Finishing the piece on a pottery wheel, he trues up the wall, and may then shape a rounded base and add feet. Salt-fired, cone 10. *Courtesy the artist.*

on the surface and let each coat dry before painting on the next layer. Then, using slip-trailing syringes, brushes, and rollers, he painted design elements onto newsprint. After letting the patterns dry for about 5 to 10 minutes, or until the surface of the paint turned to dry matt, Lyon transferred them to the clay slab. Then he shaped the slabs into vases before firing them into a salt firing. To make colors, he blended oxides or ceramic stains into a viscous solution of china clay slip. Lyon has also shaped some of his slabs into sculptural vessels and fired them in a salt kiln (see 14-24). Because he uses ceramic pigments in his printing process, the pigments do not burn out during the ceramic firing process, unlike tempera or universal tints.

FIGURE 14-25
Patrick Siler cuts out one of the blotting-paper stencils with which
he created the series *Clay Works*. Siler says, *I like the contrast
between the thick slip impasto and the sharp, severe stencil edge.*
Courtesy the artist.

FIGURE 14-26
First, Siler coats the piece with a heavy covering of black slip; then
he dips the stencils in water and attaches them to the stiffened
clay with straight pins. *When I reach an arrangement I like, I will
then dip the stencils in water and carefully pat them on the
surface. Only when the edges of all the stencils are well pressed
into the dark underslip will I begin to paint on the light-colored
overslips.* *Courtesy the artist.*

FIGURE 14-27
A group of stencils are attached to one of Siler's
three-dimensional pieces in preparation for
brushing on the second coat of slip. On the left
side, the thick, light slip has already been
applied over the stencils, and after drying for
about 5 to 10 minutes, they have been peeled
off. *I like to apply the overslip thick enough to
be stucco-like and crack a little in drying. . . .
When the piece is thoroughly dry, I will spray
on a simple clear glaze and fire the piece up to
cone 5.* *Courtesy the artist.*

SGRAFFITO The early use of white slip over reddish clay led to the sgraffito technique. In this process, lines were scratched through the light slip to reveal the darker clay beneath. This was an especially popular decorative technique in Europe and Britain (see 6-17). Slips and engobes can also be brushed on over a commercial medium that is used to create **wax resist** effects with glaze. To do this, apply the resist to the areas where you wish to retain the color of the clay body. Then, after the wax is dry, when you brush the slip over the piece, the slip will adhere only to the untreated areas of the pot. The resist material will burn off in the fire, revealing the contrasting body color.

To get sharp-edged color decoration, use masking tape, adhesive paper, or a paper stencil instead of painted resist; heavy-duty plastic sheeting can also be used for templates. Apply the stencil or template to the damp clay, paint over it with slip, and then carefully pull it off. Cut shapes can be held in place on a pot or sculpture with push pins. After slip is applied in or around the template, the push pins can removed and the plastic carefully lifted off the clay surface. This method—known as the *reserve method* because you are reserving the color of the pot or sculpture itself—will result in an image that remains the color of the clay body with the contrasting slip surrounding it.

Patrick Siler worked with a complex reserve stencil process, using two colors of slip to create his figurative images. He used a black slip over the greenware, then applied a light ivory slip thickly over stencils made of blotting paper. After the slip had dried for a few minutes, he peeled off the stencils, and the black slip underslip appeared in the protected areas (14-25–14-27). Siler's slip recipes are provided in *Expertise*, Chapter 1C.

Used alone, without a glaze coating or burnishing, slips and engobes fire with a dry, matt surface that can be extremely effective. On the other hand, the slip or engobe can be covered with a transparent glaze that, in addition to protecting the surface, gives it a glossy finish and enriches its color.

TERRA SIGILLATA Terra sigillata is an especially fine-grained slip made of clays that contain mica-like minerals such as illite. The glossy red and black of early Greek vases (see 2-24, 2-25) and the glowing red of Roman ware (see 2-32) were produced by using this fine coating. On the Greek pottery, the black was obtained by reduction.

FIGURE 14-28
About *Brood of Vipers,* Phyllis Kloda remarks, *I find it challenging and fascinating to create a three-dimensional vessel, then activate the surface with an account or tale from life.* After the piece is finished, dried slowly, and bisque-fired to cone 04, the surface undergoes a lengthy transformation involving glazing and china painting. A maiolica glaze is dipped or sprayed onto the piece, which is then refired at cone 018. The purpose of firing at this low temperature (1350°F/732°C) is to "set" the glaze by hardening the surface just enough to make it suitable for painting on her images. To make her maiolica paints, Kloda mixes 50% glaze stains with 50% frit 3124, and uses Stay Flow or a liquid laundry starch as the binding solution. Earthenware, cone 05, china paint 018. Ht. 23 in. (58 cm). *Courtesy the artist.*

Today, terra sigillata is used to achieve a much wider range of effects than in classical times. Like slip or engobe—which it basically is—terra sigillata appeals to ceramists striving for an intimate relationship between the surface of their work and its form; the terra sigillata becomes an integral part of the clay body rather than a coating on the surface like a glaze. Such contemporary ceramists as Pierre Bayle (see 12-1), Phyllis Kloda (14-28), and Richard Hirsch (14-29; see

FIGURE 14-29
Pedestal Bowl with Weapon Artifact #14, by Richard
Hirsch of the United States. Hirsch uses low-fire glazes,
colored terra sigillatas, and sandblasting to achieve the
appearance of antiquity on the surface of his vessels. Ht.
37½ in. (95.25 cm). *Courtesy the artist. Photo: Geoff Tesh.*

plied in thin coats to the dry, unfired clay. Once
the pot or sculpture is coated with the terra sig-
illata, it can be fired at around 1760°F/960°C. To
further refine a terra sigillata slip, use a **ball mill**
(see 14-63). Grinding the clay, or glazes, and col-
orants together for 2 to 5 hours will yield an ul-
trasmooth, homogenous blend.

Applying Terra Sigillata Terra sigillata can be
brushed or sprayed on. It can then be left unbur-
nished, since a good terra sigillata slip will dry to
an attractive sheen. It can, however, be made even
glossier by burnishing (see the discussion of bur-
nishing earlier in this chapter). Marilyn Lysohir
applies three coats to dry clay; on the fourth coat,
she starts to burnish the surface, rubbing just a
small area at a time. Richard Hirsch also applies
terra sigillata to bone-dry clay *in two or three
coats brushed on, which I burnish slightly—not a
high gloss. Then I airbrush some on to create con-
trast on the surface—i.e., glossy versus matt—and
to give some detail to the sigillata surface.*

Coloring Terra Sigillata Hirsch gave up using
the usual glaze techniques some years ago. Since
then he has experimented with a number of
other methods to develop a surface that does not
interfere with the formal aspects of his work. He
has found that using a white terra sigillata that
can be colored with stains or combined with
low-fire glazes formulated to bring out its color
emphasizes the form of his work. Recipes for
Hirsch's white and red terra sigillatas are in-
cluded in *Expertise,* Chapter 1C, along with per-
centages of other colorants that you can add to
the basic white.

 Just as the color of clay bodies can be altered
using oxides and stains, terra sigillata can also
be colored with these materials. A number of ce-
ramics artists have also found that colored terra
sigillatas lend themselves especially well to the
surfaces they wish to develop. Both Hirsch and
Lysohir find that with "sigs" they can get effects
they could obtain in no other way.

also 9-15) use terra sigillata for sculptural ves-
sels whose rich surfaces are nevertheless subor-
dinated to the strong forms of their work, while
Marilyn Lysohir (see 16-2) finds that using terra
sigillata on the bodies and clothing of her sculp-
tures gives a warm, satin-matt surface.

 Terra sigillata is made by mixing a fine clay
with water and water softener and then allowing
it to settle; Marilyn Lysohir lets hers settle for at
least two weeks. The particles—first the coarsest
ones, then the finer ones—fall to the bottom, leav-
ing a layer of water on top. This is then siphoned
off, and only the top layer of very fine slip is ap-

UNDERGLAZES

Underglazes, as the word implies, are used under other glazes. Whether they are applied as oxides or as commercial underglazes, they offer the ceramist a wide range of colors with which to achieve decorative effects (14-30–14-38).

Oxides as Underglazes

Historically, oxides have played an extremely important role in the development of ceramic colors and glazes. At first they were simply components of natural slips and clays, but once the coloring properties of oxides were better understood, the oxides themselves were isolated and used for decorative effects under glazes. Chinese potters first experimented with copper oxide to produce red underglaze decoration, but they abandoned it when the red bled into the glaze. They then turned to cobalt oxide, finding its blue a more satisfactory underglaze color that did not bleed as much as the copper red. Chinese blue and white ware, decorated with cobalt, inspired European potters to try to reproduce it (see 6-20).

One of the advantages of using oxides under a glaze is that after firing, the color seems to float, suspended in the glaze, giving the decoration a luminous quality. The Chinese cobalt-decorated porcelain was especially noted for this quality; the best of it, made in the Imperial Kilns (see 3-22), was so precious that it was kept for the emperor's sole use. Later, on the other side of the world, American colonial potters used cobalt underglaze to decorate utilitarian stoneware crocks and jugs for farmers, creating simple, direct images appropriate to the ware's use in rural homes. Oxides or slips can be applied

FIGURE 14-30
David Miller of England first sprayed slip onto his dry pots. He then bisque-fired them and colored them with underglaze colors and slip stains to which he added a small amount of frit to make them less refractory and help them adhere to the pot. *Courtesy the artist.*

(a)

(b)

FIGURE 14-31

(a) Cirque Platter, by James Aarons of the United States. Aarons uses a smooth, low-fire earthenware talc-base clay body, applies underglaze to greenware or bisque with an airbrush, and fires it to cone 03. To achieve clean design edges, he uses masking tape or a latex mask cut with a razor blade. After the underglaze dries, he removes the tape, sprays the platter with clear glaze, and fires it slowly to cone 05½. Aarons says, *A slow firing, and soaking the kiln for 1 hour at cone 05½, enhances the underglaze color.* 20 × 20 in. (50.80 × 50.80 cm). *Courtesy the artist. Photo: Cheryl Fenton.*
(b) Aarons masks off his greenware or bisque plates with tape and paper and then carefully cuts clean lines through the mask with a sharp knife. *(c)* Aarons sprays three to four layers of underglaze on a bisque-fired platter that has been marked off with masking tape and paper. He sometimes overlaps up to eight coats of underglaze on his platters to achieve strong geometric designs.

Courtesy the artist. Photo: Michael Woolsey.

(c)

with a variety of brushing techniques, with sponges, or with cords dipped in oxide or slip and trailed across the object.

Commercial Underglaze Colors

Commercial opaque underglaze colors are prepared by calcining finely ground oxides, combining them with a flux and a refractory material, and mixing them with gum or some other binder to ensure adhesion. Generally, these prepared underglaze colors are formulated for low firing; however, new red, orange, and yellow stains are stable when fired at high temperatures. It is difficult to formulate underglazes so that they fit the clay body properly and adhere well, so most ceramists use commercially prepared underglazes. It is, however, possible to mix oxides and stains with a CMC or gum tragacanth solution, and a small amount of frit if needed, and use them like watercolor paints. Commercially prepared watercolor-type paints, called *pan underglazes* (see 14-35) are good for blending and for detail work. The amount of water added to the pan will affect paint concentration and color intensity. (See *Expertise*, Chapter 1A.)

Underglaze colors can be painted on with brushes as you would use watercolors, but you can also spray on diluted underglaze with an airbrush—using a respirator and a spray booth—blending the colors as you might on a canvas. David Miller (see 14-30) decorates his vessels with a combination of techniques; first he sprays his teapots with slip and bisque-fires them; then he paints them with underglaze colors and slip stains. He adds a small amount of frit to the underglaze to make it less refractory and help it fuse to the clay body during firing. Miller outlines areas with copper or cobalt oxide, or sometimes with a mixture of both, and then gives his vessels a salt firing to coat them with a transparent glaze that will bring out the color. James Aarons (see 14-31) applies underglazes over stencils or masking tape to create hard-edged images or patterns. By using these techniques in combination with other underglaze materials such as pencils and crayons, you can extend the range even further.

Used in conjunction with commercial glazes, underglazing allows a ceramics artist such as muralist John Wehrle (see 14-33) to achieve images on tiles with almost the same freedom as a painter working on a canvas. Using underglazes,

FIGURE 14-32

Skull, by Susan Shelton of the United States. Shelton says her sculpture is an interpretation from imagery derived from traditional Mexican folk art motifs (see also 9-11). She says, *As a kid I used to go to the bakery and buy sugar skulls with people's names on them, for my friends and me to eat during the Days of the Dead.* After bisque-firing her low-fire clay sculpture, she decorates the piece with underglaze and fires it to cone 02, then applies a clear glaze and fires it to cone 05. 7 in. (17.8 cm). *Courtesy the artist. Photo: Tony Novelozo.*

John de Fazio hand painted each of the hand-modeled and slip-cast tiles that make up his MTV conference table (see 14-34). After hand-painting the tiles, he airbrushed them with additional underglaze to increase the contrast.

One advantage of using underglazes is that the applied colors appear close to the way they will look after firing, making the final results easier to visualize than when using ceramic glazes, whose colors look dusty and pale until they are fired. Moreover, underglaze pencils and crayons appeal to many artists because they can be used for detail work or shading, which makes it easier to develop an image.

Commercial underglazes come in a number of forms (see 14-35):

- Liquid—available in either opaque or translucent colors
- Pan—sold like watercolor paint sets; yield translucent colors when applied as a wash and opaque when applied thickly

(a)

FIGURE 14-33
(a) Detail, *Kern River Centennial,* by
John Wehrle of the United States. This
tile mural was installed on the portico
of the Bakersfield Convention Center in
California in celebration of the
Bakersfield Centennial. Wehrle used
commercial red terra-cotta Italian tiles,
12 × 12 in. (30.5 × 30.5 cm), and
decorated them with underglaze and
clear glaze. He then fired the work to
cone 05. 5 × 54 ft. (1.53 × 16.46 m).
(b) Wehrle painting a section of *Kern
River Centennial. Courtesy the artist.*

(b)

- Tube—applied directly from the tube for an opaque color or diluted with water for a translucent color
- Crayon or chalk—similar in effect to colored chalks
- Pencil—used for drawing detail and for shading, especially on fine-grained clay such as porcelain or low-fire white earthenware

Methods for Applying Underglaze

BRUSHING The traditional method for applying underglaze is with a brush. You may use any type of brush that will give the effect you wish (see 14-18). A sumi-style blunt-pointed brush will make a narrow to a flat, broad band. A flat ox-hair, camel-hair, or Hake brush is excellent for covering large surface areas. The longer the brush bristle, the more paint it will hold, which is good for line work. For detail work, a high-quality, fine-tip sable brush is recommended.

SPONGING Applying underglaze with a natural or synthetic sponge is another common method. It is best to dilute the underglaze with water and then sponge the color onto a bisque or greenware surface. Sponging is effective for achieving a stippled effect, for blending colors while they are still damp, or for getting color into difficult-to-reach crevices on sculpture or irregular surfaces.

AIRBRUSHING Underglaze can also be applied with an airbrush (see 14-30, 14-34, 14-36). To do this, you may need to add a little water and use a coarser tip in the airbrush to allow the diluted

(a)

FIGURE 14-34
(a) A sea of color and interwoven three-dimensional images of cars, clowns, eyeballs, hot dogs, hamburgers, guitars, brains, condoms, donuts, and popular cartoon characters flows over this dynamic work by John de Fazio of the United States. This privately commissioned work serves as the conference table for MTV of New York. Thirty-six tiles were individually constructed, using a combination of handbuilding and slip-casting techniques. To achieve the vivid colors, de Fazio hand-painted and airbrushed commercial underglazes onto each tile and then applied a clear gloss glaze to the surface. After the tiles were completed, they were set into a welded steel frame and covered with a glass top. 4 × 16 ft. (1.22 × 4.88 m). *Courtesy the artist.* *(b)* One of thirty-six tiles that comprise the MTV conference table. Earthenware, cone 05. 16 × 16 × 3 in. (41 × 41 × 8 cm). *Courtesy the artist.*

(b)

FIGURE 14-35
Underglazes are available in an assortment of forms. In addition to liquids, they may be bought as saturated pads for use with rubber stamps, or in pans to be diluted with water for achieving watercolor effects; these can also be used for detailed painting or line work. Underglazes are also available as crayons similar to chalks for use on bisqued ware or for blending with water after application. In addition, there are underglaze pencils for writing and drawing on bisque-fired ware.

underglaze to go through. Use a spray booth and wear a respirator when airbrushing.

SILK SCREENING If the ceramic object to be decorated is flat or nearly flat, you can easily use a silk-screen frame to apply underglaze colors directly onto it. If it is not flat enough to permit using a framed screen, you can sometimes screen colors onto an object by taping unframed silk-screen material to the curved form and brushing or airbrushing underglaze onto the surface. An open mesh, such as an 8XX size, is best because it will allow the paint to go through the screen easily.

UNDERGLAZE DECALS Underglaze can also be applied in the form of **decals.** Decals can be printed on transfer paper with underglaze colors. They are made with ceramic stains, a flux, and a vehicle. Such decals are generally available commercially and are custom-made to order. The image is silk-screened onto a lacquer-base decal paper. After drying, the paper is coated with another layer of lacquer. To transfer the image to the ceramic surface, the decal is soaked in water for about 15 seconds to melt the adhe-

sive holding the decal to the decal paper. It is then slid off the paper and onto the ceramic surface. The decal must then be blotted to remove excess water and ensure that the image is completely adhered to the clay. The piece is fired after it has dried completely.

TRANSPARENT GLAZE Once you have applied underglaze colors, you may wish to cover the piece with a transparent glaze before firing it to enhance and protect the rather fragile underglaze colors (see 14-36). A transparent glaze is not essential as long as durability or solubility is not a problem, and the pastel matt colors that can be achieved by omitting the glaze may suit your image better. As with every other ceramics technique, through experimentation you may discover a unique way of using underglaze that will be particularly appropriate to your own style of working. Remember that some underglaze ingredients are soluable if used in contact with certain foods. So if you mix your own underglazes and use them on any object that *could* be used as a food container, send samples to an independent laboratory for testing to ensure that they are safe.

FIGURE 14-36
Great Egret Teapot, by Annette Corcoran of the United States. Corcoran used an airbrush to spray underglaze stains onto the elegant bird, drew detail with a brush, and then sprayed a light glaze to set the underglaze. In addition, she sprayed and brushed on china paint details and gave the piece multiple firings—sometimes she does as many as twenty firings, gradually reducing the temperature for each one. Although the teapot is made of porcelain, the highest firing temperature was cone 04. Porcelain. Ht. 9½ in. (24.1 cm). 1988. *Courtesy the artist and Dorothy Weiss Gallery. Photo: Lee Hocker.*

FIGURE 14-37
James Caswell of the United States slip-cast *The Arcade* in one piece using a five-part mold. He then painted it with underglazes—aqua greens, deep pinks, yellow, and purples—and fired it at cone 05. Slip-cast earthenware. Ht. 24 in. (61 cm). *Collection, Mr. and Mrs. Alexander Grass. Courtesy the artist.*

FIGURE 14-38
Rebecca Niederlander of the United States paints fantasy figures on her platters, using a sgraffito technique. She first applies two to three coats of commercial underglaze and lets it dry. Then she paints a different color on top and carefully scratches her designs through the surface to reveal color underneath. A clear glaze is applied to the platter and fired to about cone 05. *Courtesy the artist. Photo: Andrew Guillis.*

FIGURE 14-39
A copper-red glazed bowl by Ross
Spangler of the United States. Spangler
created the glaze effects by dipping,
allowing one glaze to flow down the wall
onto another. He then fired this porcelain
bowl to cone 10 in reduction. 4¾ × 9¼ in.
(12 × 23.5 cm). *Courtesy the Toki Collection.*

FIGURE 14-40
Peter Hessemer of the United States alters his pottery so that the
shape will influence the glaze design. This faceted bowl was
dipped into a matt glaze, and then stripes of copper and gray-blue
glaze were banded diagonally on the sides. Hessemer says, *The
scale and rhythm of patterns, marks, and open spaces come from
responding to the altered forms of the pots in front of me when I
glaze.* Porcelain clay, fired in reduction to cone 10. 8 × 8 in. (20.32
× 20.32 cm). *Courtesy Native Soil, Evanston, Illinois. Photo: Peter Hessemer.*

GLAZES

A glaze is basically a glassy, impervious coating
that is fused to the surface of the clay by heat. As
the kiln heat is raised and held at a certain tem-
perature, the materials that you have mixed to-
gether begin to melt and fuse, eventually combin-
ing into a completely new material—the glaze.
Oxides of silica, alumina, and other minerals,
such as calcium, sodium, and zinc, also play im-
portant roles in the formation of glazes. Newcom-
ers to ceramics tend to think that the potter has
a palette of colors like a painter's and need only
pick one out and paint it on for the pot to take
on the color it will have once it is fired. Instead,
the glazed, unfired pot appears chalky, grayish
white, devoid of the brilliant color the firing will
reveal. It is not always easy to visualize the fired
work. Once you become accustomed to the
transformation that occurs in the kiln, when the
powdery, unfired glaze coating on your ware
turns to a rich gloss, you will understand why
glazes are so fascinating. Even the most experi-
enced ceramist gets surprised when they open
the kiln.

Glazes are not only functional, making the
fired piece impervious to liquids and giving it a
durable, watertight surface; they also add color
and visual interest to pottery or sculpture (14-39–
14-61). Remember, however, that a beautiful glaze
cannot transform your work if its forms are not
well thrown or composed in the first place.

Thinking ahead to how you want to use glazes
before applying them will help you achieve more
satisfactory results. Rather than waiting until the
bisqued form is ready to glaze, begin to think
about the glazes as you are making the piece.
Catharine Hiersoux (see 14-43) found that as she
became more experienced and adopted this way
of working, her glazes and decorations improved
considerably. Many of the principles you may
have learned in painting or design classes can be
applied to glazing your work, and if you plan a
design and color scheme with watercolors or
chalks *before* you start to throw or apply the
glaze, you can choose the glazes from your test
tiles with greater success.

Glazes can be glossy or matt, transparent or
opaque, and the color range extends from sub-
dued earth tones (see 14-50) to brilliant reds and
blues (see 14-52). A glaze can be applied very
thinly, allowing the texture of the clay to show
through, or so thickly that it develops its own

texture (see 8-13). Many decorative effects are possible with glazes, varying from those that neatly fit the shape to those that run down the sides (see 11-48), to carefully controlled applications for special effects (see 14-50, 14-51, 16-5).

Precautions When Using Glazes

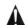

When used in extremely high concentrations, certain colors, such as copper and some other metals, fail to meet the government standards regulating safe levels of toxic substances in glazes. In some cases even a commercial glaze deemed safe to use on food containers may be unsuitable for such use if it is applied over heavy concentrations of metallic oxides and fired; the glaze, in combination with the metallic oxides, could be soluble if it comes in contact with certain foods or liquids.

FIGURE 14-41
Chian You-Ting of Taiwan, Republic of China, specializes in making teacups with unique glazes inspired in part by ancient Chinese glazes. You-Ting ball-mills his glazes and fires his pottery in a gas kiln. *Courtesy the Toki Collection. Photo: Scott McCue.*

What Makes a Glaze?

Glazes are formulated from three categories of chemical compounds, each of which performs a different function: (1) the **glass formers,** which are what the word *glaze* implies (see Table 1 in *Expertise*, Chapter 3B); (2) the **fluxes**, which help the glaze melt in the heat; and (3) the **refractories**, which increase the viscosity and stability of the glaze in the fire. These compounds are obtained from a variety of materials. The type and percentage of these materials used in a glaze will vary in accordance with the temperatures at which the ceramist intends to fire the work (usually 1500–2450°F/815.5–1343°C). Hundreds of glaze recipes with the correct chemical balance needed to form a glaze are available to the ceramist; a few are provided in *Expertise*, Chapters 1A and 1C. If after reading this chapter you want to go further into the subject of glaze calculation using chemistry, study the information on chemical analysis in *Expertise*, Chapter 3B. There you will find out more about the roles of the basic glaze ingredients.

Each of the three basic ingredients—glass former, refractory, and flux—may be introduced to the glaze by adding any of a variety of ceramics materials, and each of these materials in turn has individual properties and reacts in its own way with other materials. In order to understand what happens when you change the percentage of each, it is extremely important to become familiar with glaze materials and their interaction. For example, zinc oxide (ZnO) acts as a flux at temperatures above 2109°F/1154°C. It can also make a glaze matt and opaque if you add it in larger amounts. If used in small amounts, it can add smoothness to a glaze, but if too much is used alone as a flux, the zinc may make the glaze **crawl** on the pot or cause pinholes to develop. Zinc interacts well with copper to help produce bright turquoise, but with chrome, it sometimes produces brown rather than chrome green.

You can see from this example that in order to make successful glazes you should understand the properties and behavior of each material as well as the effect it will have on the other ingredients in the glaze. Although ceramists today can rely on chemistry more than their predecessors did, they must still test their glazes to see how they act on a particular clay or under particular firing conditions.

GLASS FORMER The main glass-forming ingredient in glazes is silica, which is highly resistant to heat. A glaze could be made of silica alone, but since silica's melting point is so high (3115°F/1713°C), that would be impractical; few clay bodies could withstand such high heat, and few ordinary kilns could fire at temperatures that

FIGURE 14-42
Lotus Vase, by Tony Yeh of Taiwan, Republic of China. He incised a calligraphy design on a wheel-thrown porcelain clay body and glazed it with a transparent amber-colored glaze that developed a beautiful crackle pattern on the surface. Yeh fired the piece to cone 7 in an electric kiln. Ht 12 in. (30.48 cm.). *Courtesy the artist. Photo: Lin Mao-Zon.*

high. A glaze melts as a result of the interaction of the oxides in the glaze materials when they are exposed to heat, and a basic fact of glaze making is that glaze materials used in such a combination (referred to as **eutectic**) melt at lower temperatures than they would if they were used alone. The proportion of silica in a high-fire glaze can be greater than in a low-fire glaze, because at low temperatures too much silica would keep the glaze from melting.

FLUX Generally, as much silica as possible is used in a glaze because silica adds durability and

helps the fired glaze resist the effects of **acids** and chemicals. Therefore, in order to lower the melting point of the silica, another ingredient must be added—a flux. The fusing temperature of a glaze may be lowered considerably, depending on the *combination* of fluxing oxides and their proportions in the glaze in relation to the silica. We are talking here about oxides as glaze compounds, not as coloring agents. However, the oxides used to color a glaze, such as iron, can also bring extra fluxing action to the glaze, lowering its melting point even further.

REFRACTORY The third ingredient of most glazes is a refractory material, alumina. A common source of alumina is china clay. Alumina increases **viscosity,** helping to keep the glaze materials suspended as well as helping the glaze adhere to the ware. Alumina, even if used in very small amounts, also adds strength and durability to the glaze and helps prevent it from running; without it, the glaze might drip down and off the sides of the object during firing. Also, without alumina, glazes tend to crystallize during the cooling process and thus may become opaque. Sometimes, however, the potter wants crystals to develop for decorative reasons; in that case the alumina content is reduced (see 14-52).

Choosing a Glaze

While studying the examples of glazes throughout the book, consider which type would be most appropriate to your own work. If the pot or sculpture to be glazed is heavily carved or modeled, a glossy opaque glaze might destroy the impact of the carving by producing distracting reflections and highlights; on such a piece, a matt surface may be the solution. On the other hand, a glossy transparent glaze may settle into the negative spaces of a piece and pool to darker shades, contrasting with the lighter shades of color on the raised surfaces and enhancing the overall effect of the form (see 14-42, 14-43, 14-46).

Deciding on what glaze to use, if any, is one of the most important aesthetic and expressive decisions every potter and sculptor has to make (see 14-47). It usually takes a good deal of experience with glazes before your choices regularly turn out as you expect, and even experts must be constantly aware of the nuances of glaze formulas and their application, temperature range,

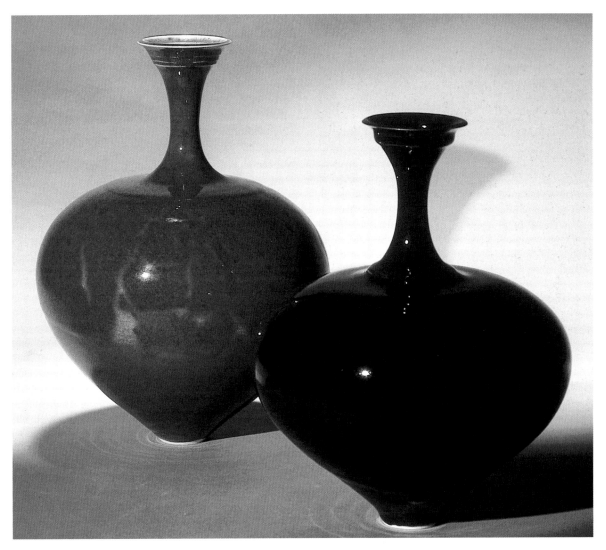

FIGURE 14-43
Two porcelain vases by Catharine Hiersoux of the United States illustrate the visual effect of different glazes on similar shapes. On the glossy black vase *(right)*, the profile becomes dominant as one's eye follows the swelling and narrowing contours, while on the copper-red-glazed vase *(left)*, the eye lingers on the more complex surface before following its profile. Porcelain; reduction; copper red and black glazes. *Courtesy the artist. Photo: Richard Sargent.*

and changes according to variations in kiln atmosphere, fuel, and kiln type and size.

The many variables a ceramist experiences in glazing and firing his or her work has an effect on the outcome of a glaze. For example, the surface texture and color of Stuart Smith's glazed sculpture shown in Figure 9-3 could have been dramatically altered by a change in the firing temperature and the reduction atmosphere. A heavier reducing atmosphere would have darkened the clay and glaze. Buldan Seka's large figures shown in Figure 14-45, on the other hand,

were modeled with a high-fire, coarse buff sculpture clay and painted with commercial low-fire glazes. If she had applied glaze to the surface thickly, it could have turned to a much darker hue; if she had applied it thinly, the clay color might have completely dominated the glaze color. This is especially true when applying a transparent or semitransparent glaze on a dark terra-cotta or brown stoneware clay; the iron content in the clay dominates the glaze, changing the color. Potter, Eric Struck fired his thrown and altered vessels shown in Figure 14-46 to

FIGURE 14-44
Clover Bee-Hive, by Elizabeth Roberts of the United States, is handbuilt with coils, clear-glazed, and fired to cone 06. After firing with a gloss glaze, Roberts paints organic, plantlike images on her sculptures with acrylic paints. Roberts prefers not to refire the work, which could cause extreme stresses on the clay and result in cracks. Stoneware clay fired to cone 06, low-fire glazes, and paint. *Photo: Scott McCue.*

cone 02 in order to counteract crazing on the surface of the commercial low-fire glazes he used to decorate his pieces. If he had bisque-fired his work at a temperature lower than cone 02, his pottery might have been susceptible to delayed crazing up to a year after it had been fired. As you can see, the variables in the glazing and firing process affect the final appearance of a glaze.

The first glazes you use may be school glazes made up in quantity from a formula that has been translated into a **batch** recipe, perhaps from the many prepared glazes that are available commercially. However, if you want to understand why glazes respond to the fire the way they do, it is worth the time and effort to learn how to formulate your own, or at least how to make changes in the formulas given in *Expertise*, Chapter 1A. This knowledge will enable

you to create new glazes or alter a color, its textures, or firing temperatures (see also 14-66).

There are a number of advantages to mixing your own glazes. One is that you will know exactly what materials are used in them; for example, you can avoid using toxic ceramic materials and toxic antispoilants. Another advantage to mixing your own glazes, as when mixing your own clay bodies, is that you will be able to make changes in the glaze composition, thereby achieving qualities that are not available commercially. Learning more about various chemicals will help you understand the unique qualities each component contributes to a glaze. For instance, Mayer Schacter achieved the red color in his high-fired porcelain-glazed teapot shown in Figure 14-53 through the addition of copper oxide in the glaze that turned red only under the reducing conditions in his gas kiln. Some materials melt easily in the heat of the kiln; others add color; and still others can change the color and texture of a glaze. Depending on the ingredients used, some glazes may be pitted and lavalike (see 8-13), while others are glossy (see 14-44).

In the past, potters knew nothing about the chemistry of glazes, so they had to learn through trial and error what chemicals to add to a glaze to achieve a desired effect. Modern chemistry, however, allows us to analyze the composition of a glaze and learn exactly what materials are needed to change its composition to achieve certain effects (see *Expertise*, Chapter 3B). This knowledge, combined with the technology of the computerized kiln, has made glaze testing more accurate, simpler, and faster. Computer programs make this process even easier. Nevertheless, it is still necessary to test. By doing so you may find that your best glaze is the result of experimentation. Indeed, there is no reason why you cannot make excellent glazes by measuring out the basic ingredients within the generally known proportions, adding and subtracting materials, and then testing the glaze. Measuring cups and spoons and a creative approach can be successful for those who wish to avoid the chemistry, and there is no need to be put off by the "mystery" of glazes.

Frits

A frit is a combination of raw glass-forming materials that has been heated to a molten state, fractured by immersion in water while still red

FIGURE 14-45
Buldan Seka's fantasy figures are imposing images in her front yard on a major thoroughfare in Berkeley, California. Motorists have stopped by her house to voice their feelings about the individuals she sculpts, furthering the mythology surrounding them. Because of their large scale, Seka prefers to sculpt the figures with a coarse stoneware clay. After bisque firing, she applies low-fire glazes and refires them to cone 05.
Courtesy the artist.

hot, and finally ground up into a powder in a ball mill. Fritting is done to make raw, soluble materials insoluble and to lower the fusion point of the individual materials by combining them. It is these qualities that make frits so useful to ceramists.

Frits are used primarily in the formulation of low-fire glazes and underglazes, and occasionally in glazes fired in the cone 5 to 6 range. They are available commercially through ceramics suppliers, who can also provide you with the exact percentages of silica, alumina, and fluxes present in each frit. Produced primarily for the ceramics industry, frits offer the ceramist a wide range of glass-forming compounds. Because their chemical composition is known, it is easier to control the uniformity of a glaze from batch to batch if you use a consistently formulated frit.

There is another reason for fritting. Many **raw glaze** materials, such as lead, barium, and cadmium, are poisonous, and some, such as borax, potash, and soda ash, are caustic alkalies that are soluble in water. Used raw, some of these materials would be toxic or injurious to the ceramist. Others, when used in their unfritted soluble state in a glaze, could be released from the

FIGURE 14-46
Eric Struck of the United States uses commercial low-fire glazes on his altered-rim vases. After decorating the pots with sharp-edge underglaze designs that echo the crisp cut edges of the rims, he bisque-fires the pots to cone 02 so that the clay will become vitrified to reduce crazing. Struck then applies a clear glaze and low-fires the pieces to cone 05. Ht. 10 in. (25 cm). *Courtesy the artist.*

glaze if the finished object were used to hold foods that contain acids such as vinegar, apple cider, wine, coffee, whiskey, and lemon juice. Used in frit form, a number of these materials are safe, or at least less dangerous, and frits therefore have become standard in the industry.

There is still concern, however, about how safe some frits are, both for the person handling the glaze in the studio and for the person eating or drinking from a glazed container. There is some controversy, for example, about the safety of handling lead even in frit form, and tests show that dangerous amounts of lead are released even from fritted lead glazes when the glazed object is exposed to acids. Increasingly, schools and institutions are banning lead-bearing frit glazes from their studios and using only leadless glazes and underglazes. For this reason, we recommend that you do not use any lead, even in frits, for glazes on the interior of any container that could be used for food or beverages. Have any glaze about which you are uncertain analyzed by a testing laboratory

to be sure that there is no danger in using it on food containers. Consider also whether you wish to expose yourself to lead in *any* form. *Expertise*, Chapter 1D, lists some leadless frits that you may use safely.

Frits also lower the temperature at which the soluble materials can be used, and because of their fluxing qualities, they are extremely useful in low-fire glazes. In addition, since the materials in a frit have already been melted once, no volatile materials are left to burn out, which can happen with raw materials. However, frit glaze fired above cone 6 may become fluid and run, as well as bubble, especially when fired in a reduction atmosphere. Because of this tendency, as well as the expense of frits, feldspars are generally used as the main flux in high-fire glazes in which more flux is needed. (In a low-fire glaze in which feldspar is used to introduce alumina, the feldspar acts as a refractory.) Feldspars are naturally formed frits, and using them is an economical way to introduce silica and alumina

FIGURE 14-47
Fantastic Shower, by Michelle Gregor of the United States, uses an ocean-life theme for a men's shower. The underwater images include twisting fish, blue-scaled patterned discs that emit steam, underwater flora, and fossilized shells, creating a wonderful showering experience. Stoneware clay, cone 5. Each tile is 24 × 24 in. (61 × 61 cm). *Courtesy the artist.*

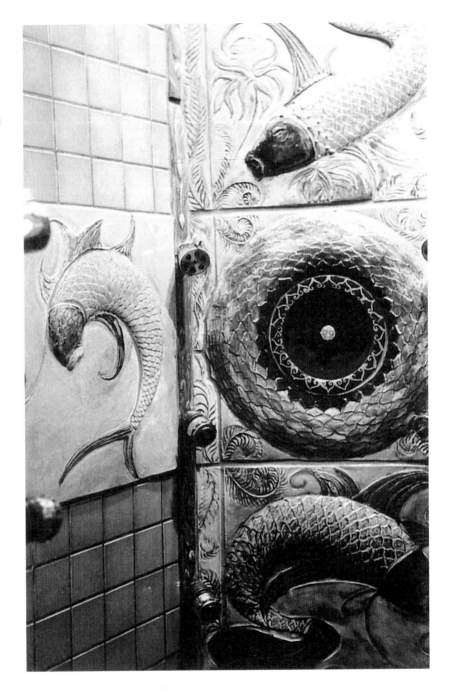

into a high-fire glaze. For example, if we compare the composition of frit 25 and Custer feldspar, we find that the alumina content of the frit is 12.1% while that of the Custer is 17.5%. When it comes to the silica, however, the difference is greater: The silica content of frit 25 is 49.7%, but the Custer feldspar contains a much larger proportion of silica—68.5%.

Another reason for using frit instead of a raw, soluble material is that in some cases a raw material could be absorbed into the porous surface of a bisque-fired ware and thus change the chemical composition of the glaze. This would affect the texture, color, or other qualities of the glaze. In addition, dry soluble materials are hard to store, since they absorb water from the atmosphere and form lumps. It is clear, then, that by using frits you can avoid some of the problems caused by soluble materials and some of the hazards of using raw glaze materials.

SURFACE COLORS

Applied stains and oxides only (oxidation)

	Cobalt	Chromium	Yellow stain	Iron
Cone 05	S1	S2	S3	S4
Cone 5	S5	S6	S7	S8
Cone 10	S9	S10	S11	S12

Stains and oxides with clear glaze (oxidation)

	Cobalt	Chromium	Yellow stain	Iron
Cone 05	ST1	ST2	ST3	ST4
Cone 5	ST5	ST6	ST7	ST8
Cone 10	ST9*	ST10*	ST11*	ST12*

GLAZES

	Clear	White	Cobalt	Iron	Chromium	Black (3 oxides)	Pink stain	Yellow stain
Cone 05	G1	G2	G3	G4	G5	G6	G7	G8
Cone 5	G9	G10	G11	G12	G13	G14	G15A G15B	G16
Matt Cone 10 Oxidation	G17	G18	G19	G20	G21	G22	G23	G24
Matt Cone 10 Reduction	G25	G26	G27	G28	G29	G30	G31	G32

*These tiles were tested with clear glaze on the left and Murphy matt glaze on the right.

FIGURE 14-48

Hands in Clay surface colors for testing. See *Expertise*, Chapter 1A, for formulas.

Fusion Testing

Fusion testing is a method of subjecting chemicals to different temperatures to determine their melting point and fusing ability. Fusion testing will help you understand the physical changes a chemical undergoes when subjected to varying temperatures. To make test tiles for this process, roll out a number of slabs $3\frac{1}{2} \times 9\frac{1}{2} \times \frac{1}{2}$ in. (9 × 24 × 1.25 cm), using a cone 10 white or light buff clay. Then press ten to fourteen $1 \times \frac{5}{16}$ in. (25 × 8 mm) depressions into the slabs with your thumb. Identify each depression with the name of the chemical to be tested in that space, or mark each space with a code number for each chemical. Mark the tile with the cone at which you are going to fire it. Then bisque-fire the tiles to about cone 05. To test, place a small amount of any chemical in the depression. For example, take the feldspar nepheline syenite and place it in a testing tile depression, then fire it to cone 05 (1915°F/1046°C). Before firing it will look like a white, chalky powder; after firing it to cone 5, it will have begun to flux and to develop a slight sheen. If fired to cone 10 (2377°F/1303°C), the nepheline syenite will develop a glossy white sheen and fuse to the clay. By using this method of testing, you will understand firsthand how you caused a physical transformation of the chemical nepheline syenite; when subjected to a low temperature, it does not mature or melt, but as the temperature is increased, the feldspar turns glassy and fuses to the clay.

During these tests, some chemicals will change color and texture in addition to melting and fusing to the clay, whereas others, such as kaolin, will not fuse at all. If you tested the kaolin using in the same formula and fired it at cones 05, 5, and 10, you would see that it does not melt at cone 10. For it to melt at a lower temperature, it would have to be blended with a flux. The atmosphere in which tests are carried out will also affect the outcomes; if kaolin is fired in a gas kiln under heavy reduction, it may take on a darker tone, depending on any minute traces of iron that may be present in the clay.

Try fusion tests of the chemical components that make up the *Hands in Clay* glaze recipes for cone 05 clear (G1), cone 5 clear (G9), and cone 10 matt (G17) (*Expertise*, Chapter 1A). Then continue testing the glaze stains that color the glazes. If you proceed by testing every clay and glaze chemical in *Expertise*, Chapter 1A, you will have a wealth of useful information about the physical

properties of chemicals and how they react to varying degrees of heat.

Types of Glazes

Like clay bodies, glazes are classified into categories according to their firing ranges: low-fire glazes, medium-fire stoneware glazes, and high-fire stoneware and porcelain glazes. Within those categories there are a variety of specific types of glazes, such as transparent or opaque, matt or glossy, ash glazes (see 14-20), slip glazes, **crystalline glazes** (see 14-52), salt glaze (see 9-16, 14-24), and raku glazes (see 9-3, 14-59).

LOW-FIRE GLAZES (CONES 015–1) Ever since potters in ancient Egypt and the Middle East developed alkaline and then lead and tin glazes, potters have used low-fire glazes to make earthenware watertight, to add color to household vessels, or to color sculpture. Today these glazes are popular with many potters and sculptors

FIGURE 14-49
This ceramic stepping stone, made for a garden path by Masina Tillo of the United States, was painted with a high-fire maiolica glaze and decorated with stains. The tiles and mosaic pieces were adhered to a concrete paver with a thin-set mortar. Tillo used stoneware clay, glaze, and mortar that was especially capable of withstanding freezing temperatures. Cone 6. *Courtesy the artist.*

FIGURE 14-50
To attain the mottled surface on this covered jar, Joe McCaffery of the United States applied a "Shino carbon-trap" glaze. A key ingredient in the glaze is soda ash, which melts early in the firing, beginning around 1623°F/884°C and introduces carbon into the glaze, causing the variegated black surface. McCaffery fires his ware to cone 10 in a 10-hour cycle, maintaining a reducing atmosphere from cone 012 to cone 10. Porcelain. Ht. 16 in. (41 cm). *Courtesy the artist.*

fluid with the higher heat, however, it may be necessary to apply less glaze to the bisqued surface. Thus, if you usually apply three coats by brushing, two coats of low-fire glaze should be adequate if the ware is to be fired higher.

Note that low-fire glaze colors tend to darken on stoneware bodies when fired to higher temperatures than those for which they were formulated. A useful technique is to low-fire glazes in consecutive firings, allowing certain colors, such as some pinks and maroons, that would burn out at stoneware temperatures, to be used on high-fire ware.

You can also fire your ware with a high-fire glaze, leave some areas blank, and then, after the first firing, apply low-fire glazes to those areas and refire the piece to create a high-fire look with low-fire accents. For his ceramic table (see 14-34), John de Fazio bisque-fired his tiles to cone 1 to increase vitrification and durability, then glaze-fired the tiles to cone 05. This method of bisquing high and glaze-firing low can be used outdoors in a temperate climate.

Many ceramists layer slips, underglazes, and glazes, firing them in successive firings. James Aarons creates geometric designs on his plates with underglazes and glaze (see 14-31); Richard Hirsch says that he sometimes uses low-fire glazes over a terra-sigillata bisque-fired surface, or he raku-fires the piece (see 9-15, 14-29). Hirsch uses many surface techniques to achieve his rich surfaces. He sandblasts some of his pieces to texture the clay surface and also uses cupric sulfate in a spray solution, as well as lacquer paints. As he says,

I have now returned to the use of glaze because I think it is appropriate to the layering effect of age I am after. Also I like the hardness versus softness, tactile versus visual play.

From these examples, and others shown throughout the book, it can be seen that low-fire glazes offer a wide range of color effects.

because they provide bright, smooth colors that enliven their work (see 14-28, 14-32, 14-45).

As the name implies, low-fire glazes melt at low temperatures (1501–2109°F/816–1154°C). Low-fire glazes have a much wider range of colors than high-fire glazes and will create surfaces that are transparent, matt, or opaque. Although most low-fire glazes begin to melt at cone 015 (1501°F/816°C) and mature at around cone 05 (1915°F/1046°C), they can often be fired as high as cone 5 (2201°F/1205°C). Most glaze colorants, now including red and orange, will fire at higher-than-expected temperatures, with interesting results. Because the glazes tend to become more

FIGURE 14-51
Three faceted stoneware pots by Tsai Jung-you of Taiwan, Republic of China. The ridges on the faceted edges of the bottles form a striking pattern that contrasts with the purples, deep browns, and white glazes. The reduction atmosphere reacted with the clay and glaze to help develop the rich iron matt glazes around the base and at the same time fuse the glazes to the stoneware clay, making the pieces extremely durable. *Left to right:* 9.92 × 8 in. (25.2 × 20.2 cm); 10.8 × 6.8 in. (27.6 × 17.2 cm); 8.9 × 5.7 in. (22.6 × 14.4 cm). *Courtesy the artist.*

LOW-FIRE FLUXES Throughout history, two types of fluxes have traditionally been used to give low-fire glazes their low-melting character-istics. Alkaline glazes depend on an alkali, such as sodium or potassium, to melt them. Today these are the primary fluxes in the leadless frits used to make low-fire leadless glazes. These al-kaline glazes, although they produce brilliant colors when coloring oxides are added to them, are rather soft and can easily be scratched, so they should be used on nonfunctional objects or objects that will have little wear. If you do use them for making dinnerware, you must accept the fact that the fired glazed surfaces are softer and must be handled carefully and cleaned using nonabrasive sponges. Alkaline-glazed tiles are appropriate for installation in a home if placed in a spot that receives relatively little wear and moisture, but for heavy-use areas such as a floor, stoneware glazes would be required.

Alkaline glazes are also difficult to fit to the clay body and tend to craze, developing small cracks over their entire surface, because they undergo a wide range of expansion and contrac-tion in the kiln. This effect may be decorative, but it weakens the glaze, which may wear off or weather with use. Moreover, glazing the inside of food containers is also not recommended because food could lodge in the cracks in the glaze. For-tunately, many commercial manufacturers have developed high-quality alkaline glazes that fit many clay bodies without crazing. Their glaze formulas have been analyzed and tested be inde-pendent laboratories or chemists, who must com-ply with national guidelines that determine whether a glaze is safe or unsafe for use on food containers. For example, some alkaline glazes, such as gunmetal colors that contain high amounts of metal oxides, are not safe for such use. If you choose to make your own glazes for

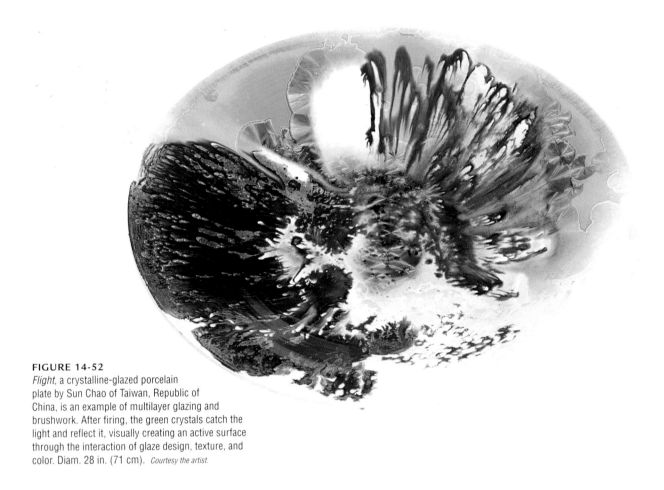

FIGURE 14-52
Flight, a crystalline-glazed porcelain
plate by Sun Chao of Taiwan, Republic of
China, is an example of multilayer glazing and
brushwork. After firing, the green crystals catch the
light and reflect it, visually creating an active surface
through the interaction of glaze design, texture, and
color. Diam. 28 in. (71 cm). *Courtesy the artist.*

food containers, it is best to have them tested by a professional laboratory.

Historically, lead was an extremely popular flux material because it was economical and glazes made with it melted at a low temperature, fit the clay with little or no crazing, and took on color well. In Tang China the lead glazes on the three-color ware melted and ran, creating a characteristic surface. Combined with tin, lead made possible the cream-colored glazes that the early Italian potters used so successfully on their maiolica ware as background for bright-colored glaze decoration (see 6-4, 6-5). Unfortunately, lead is hazardous to work with, and we know from historical documentation that many workers, including women and children who worked in the decorating rooms of pottery factories, died as a result of lead poisoning.

Using lead in fritted form is an improvement over using it raw, but even fritted lead can later be released from the glaze. Improper firing (not high or long enough), improper application (too thick), or the addition of even a small amount of

copper to a fritted glaze can increase the danger that the lead will be released when in contact with acidic food or drink. The public generally does not know about this risk, so some potters recommend putting a hole in any lead-glazed convex form that might hold liquid in order to make it impossible for anyone to drink from it.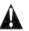

To be absolutely sure that what you make in the ceramics studio does not present a possible hazard to others, we recommend that you use only leadless low-fire glazes for anything that could *possibly* be used for the consumption of food or liquids. Also, ceramics supply companies and hardware stores sell kits that can test commercial pottery or antiques you believe could contain lead.

MEDIUM-FIRE GLAZES (CONES 2–7) A growing interest in the development and manufacturingof medium-firing glazes came about partly as a result of the energy crisis of the 1970s and partly because many electric kilns on the market do not heat above cone 6 or 8. This also led to the

development of many new medium-firing porcelain and stoneware clays that were formulated to fit these glazes. Once ceramists started to fire within the range of cone 2 (2124°F/1162°C) to 7 (2291°F/1255°C), they found that this lower firing range often added brilliance to their glazes. Certain colors, such as maroons and yellows, do not hold their color well at high temperatures and in a reduction atmosphere, but these colors, which could be lost in a cone 10 reduction firing, hold their color better in the medium firing range. For these reasons, many ceramists have had great success using medium-range glazes (see 14-15, 14-17, 14-42, 14-47, 14-49).

HIGH-FIRE GLAZES (CONES 8–13) High-fire glazes are formulated for firing from cone 8 to cone 13 (2316–2455°F/1269–1346°C) and are used on stoneware and porcelain (see 9-16, 12-86, 14-24, 14-50, 14-53). Unlike the low-fire glazes, which always remain as a surface coating on the fired object, properly fired high-fire glazes actually interact and bond with the surface of the clay body, creating a buffer layer between the glaze and the body. The advantage of this close bond is that the glaze is more resistant to the stresses that cause crazing or peeling. On the other hand, because of this interaction between the clay and the glaze, the glaze may pick up impurities from the clay body that will cause spots, such as iron spots, or splotches of color to appear in the fired glaze—an effect that some potters welcome (see 14-39).

ASH GLAZES The ashes that were blown onto the shoulders of pots from the wood fires in early Chinese and Japanese stoneware kilns often formed accidental glazes on the ware (see 3-12). Observing this, potters started to experiment, and gradually they developed deliberately applied ash glazes. It was this type of experimentation that led Steve Davis to build a cross-draft kiln in which wood ash was systematically scattered onto his pots through an innovative blower method (see 15-44–15-47).

Nowadays, ash glazes are popular worldwide (see 8-22, 14-20). You can obtain ashes from glazes by burning wood, berry canes, grasses, sawdust, corn cobs, rice hulls, and even fruit pits. If you wish to control the ingredients so that you will be able to replicate the glaze, you should isolate each type of ash and test it independently. Since the plant materials that are burned to make the ashes take up minerals from

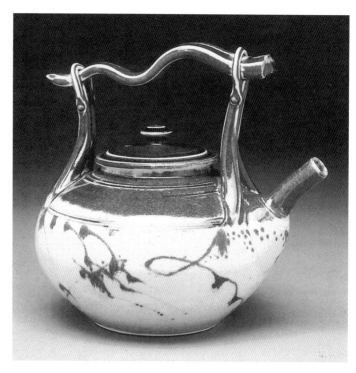

FIGURE 14-53
Mayer Shacter of the United States threw a comfortable-looking teapot, then gave it an unexpected frivolous handle, along with a spontaneous high-fire glaze decoration in reduction. Copper red glaze. *Courtesy the Toki Collection.*

the earth while they are growing, their ashes are rich in glaze-forming ingredients such as potash, lime, alumina, and silica, as well as various oxides that provide color. Each glaze will have a different chemical composition. For example, ashes from some plants, such as grass, wheat, and fast-growing weeds, contain more silica than ashes from slow-growing trees. Therefore, ashes from grasses and weeds create more stable glazes. Even the locality from where the tree or other material was taken may make a difference, because the minerals present in the soil vary from place to place.

You can try making a glaze using ashes alone, burning any organic material you can gather in sufficient quantity. Enterprising potters have even gathered ashes from state park barbecue pits; Erica Clark Shaw has developed a low-fire glaze in which she uses ashes from charcoal briquettes, while Steve Davis (15-46, 15-47) gathers mesquite wood ash from pizza parlor ovens. If you use an ash glaze on a clay body that contains a considerable amount of silica, you may find

FIGURE 14-54
Chen Songxian of the Republic of China has designed an abstract pattern on his wheel-thrown bottle so that it appears as if white string has been wrapped around the piece. High-fired black stoneware glaze. *Courtesy the artist.*

that it makes an adequate and beautiful glaze without any additions, or you may want to add feldspar, clay, and perhaps whiting as an additional flux. Generally, the proportions suggested are approximately 40% ash, 40% feldspar, and 20% clay, but the percentages can vary. *Expertise*, Chapter 1C, contains some ash glaze recipes.

To prepare ashes for making a glaze, first soak them in water to leach out the soluble materials. The water that is drained off will contain lye and can burn your skin, so wear rubber gloves when you pour it off. Even if you mix ashes dry, it is wise to wear gloves. After the ashes have soaked, put them through a sieve and mix them with the other ingredients. Although you can add small percentages of ash to low-fire glazes, the best effects with ashes come with high-firing glazes, to which larger amounts can be added.

To give the effect of an accidental ash glaze, before firing you can sprinkle dry ash directly on the ware or apply it to very damp ware so that the ash adheres to vertical surfaces, thus duplicating to a certain extent what happens when ashes fly in a wood-fired climbing kiln. Many ceramists have built Japanese-style wood kilns in order to produce ware with accidental glazes. These kilns are discussed in Chapter 15.

SLIP GLAZES Some clays or powdered rocks will make a glaze when they are used alone. For example, feldspars are natural frits that could form a glaze if fired at high enough temperatures, such as those that are possible in industrial kilns. But feldspar's melting point is so high that it would require additional flux to fuse in the average studio kiln. These are, however, natural clays that will form slip glazes in the brown range when fired at lower temperatures. Since they contain iron and manganese, the iron functions as both a flux and a colorant, but because a slip glaze contracts when it dries, it does not adhere well to bisque-fired surfaces, so it is generally applied to damp clay or greenware. This allows the two clays to shrink at similar rates. Even so, in order to fit well, a slip glaze should be carefully formulated to have the same shrinkage rate as the clay body.

An example of a natural slip glaze is the terra sigillata that the Greeks and Romans used to create the glossy surface of their pottery. It was formed of fine-grained natural clays that contained micalike substances. The dark-brown-firing Albany slip used by the early stoneware potteries in New York was also a popular slip glaze. Because Albany slip was mined out twenty to twenty-five years ago, potters have had to turn to substitute slips, such as Alberta and Sheffield slips. These new slip glazes are now more likely to be mixed rather than used in their mined form, as was Albany slip. They are formulated to provide special qualities—for example, a light hue so that the slip can be colored with stains. Sheffield slip is naturally more amber in comparison with the darkish brown hue of Albany slip. Therefore, it needs to be color-adjusted to suit the potter's preferences.

MATT GLAZES The characteristic satin surface of a high-fire matt glaze is hard and durable but lacks a strong gloss (see 14-51). The matt effect is produced by large numbers of tiny crystals—too small to be seen by the naked eye—that refract the light. These satin-matt glazes, along with "buttery" or "fat" matt glazes, are often sought for certain types of pottery.

Introducing a larger proportion of clay, such as china clay, into the glaze will increase the amount of alumina and make the glaze more refractory, so that it will tend to underfire. It is this underfired quality that gives it its matt appearance. Matt glazes can also be produced by incorporating zinc oxide into the glaze; by increasing the proportion of silica, calcium oxide, titanium dioxide, or magnesium; or by underfiring a gloss glaze, causing the surface to appear dry or have a dull sheen. Matt glazes produced by underfiring are usually highly porous, so they are used primarily for decorative purposes.

Commercial tiles made for floors are usually glazed with matt glazes. They are generally fired at cone 1 or higher and provide a surface texture that makes them less slippery than a glossy surface. The matt glaze also shows much less wear and tear because the surface is already dull.

 Barium carbonate has long been the standard material used to create high-fire matt glazes, but since it is extremely poisonous, many ceramists no longer use it. We do not recommend that you use it, but if you do, take great care in handling it, and do not use it on the inside of anything that might be used as a food container.

To produce a matt glaze, the kiln temperature must be brought down slowly to allow the crystals to form. Matt glazes that are fired too fast, such as in a test kiln, will fire out glossy because the crystals do not have enough time to grow and develop. Percentage recipes for several matt glazes are included in *Expertise*, Chapter 1C.

CRYSTALLINE GLAZES Unlike the crystals in matt glazes, which are too small to be seen, those in crystalline glazes are visible to the eye, creating unusual decorative effects on the surface of the pot and often giving a quality of depth to the glaze in which they are suspended. The crystals catch the light and reflect it, visually breaking up the glaze surface and often creating strong patterns (see 14-52). For this reason, crystalline glazes are best exhibited on simple forms. Although the crystals will form in glazes used on both stoneware and porcelain, ceramists tend to use them on porcelain because the crystals are more evident against the white clay background.

Crystalline glazes are produced by reducing the alumina content and using a variety of materials and chemicals, such as zinc oxide, borax, sodium, potassium, rutile, titanium, and iron. The snowflake-like crystals that form in this type of glaze are actually grown, through the use

of certain materials, by carefully controlling the rise and decline of the kiln temperature and by **soaking** the ware in the kiln. In order to create crystals, these glazes must contain only a small amount of alumina, so they are very runny, and the glazed ware must be placed on special stoneware clay or porcelain supports dusted with alumina to prevent it from sticking to the kiln shelves as the glaze melts. Some ceramists carve supports out of K23 or K26, a soft firebrick, making them slightly smaller than the foot of the crystalline glazed pot being fired. The support looks like a thick-stemmed, upside-down mushroom that includes a small saucer entirely painted with a high-alumina-content **kiln wash.** The saucer catches any glaze that runs down the side of the pot. After firing, the support is removed and the base is ground flat to remove any glaze drips.

Kate Malone uses English T material clay, which fires white, so that her glazes will be as bright as possible. She bisque-fires the work to 1825°F/1000°C. After bisque-firing, she glazes her large organic vessels and then gives them a careful firing and soaking in an electric kiln to produce their rich crystalline glazes. She glaze-fires it up to 2300°F/1260°C. Next she cools the ware as rapidly as possible to around 1994°F/1090°C and soaks it in stages: at 1994°F/1090°C for 3 hours; at 1963°F/1073°C for 90 minutes; at 1956°F/1069°C for 1 hour; and finally at 1904°F/1040°C for 30 minutes. She then turns off the kiln.

Varying the soak times creates differently sized and shaped crystals. An important consideration is that the glaze is very fluid at 2300°F/1260°C, so each piece must have its own tray and stilt to catch the flowing glaze. As with ware supported on soft firebrick stands, Malone must also grind the bases of her pieces after firing to remove glaze residue. One of Malone's glaze recipes is included in *Expertise*, Chapter 1C—try it and see what it does on your clay and in your kiln.

GLAZE CRYSTALS AND CHUNKS Commercially manufactured glaze crystals are available as additives to low-fire glazes. Although they are called crystals, they are actually small glass chunks that, when mixed with a glaze, melt out in the glaze. The glaze crystals are usually mixed with liquid glazes. Two coats of a base glaze are first applied; then the crystals that usually settle to the bottom of the container must be scooped out of the bottom of the jar and applied to the surface of a pot or sculpture with a brush.

You can make your own glaze chunks by pouring glaze into an open, flat plastic container about ⅛ in. (3 mm) deep. Let the glaze dry, crumble it into small chunks, and mix them into a liquid glaze; stir carefully, so as not to break up the pieces and cause them to dissolve. It is best to mix the chunks into a glaze as needed; otherwise the chunks tend to soften and not hold their shape when mixed. You can also fire the glaze chunks at around cone 022 to 019 to harden them enough so that they will hold their shape when mixed into a liquid glaze.

SALT GLAZE Potters in the Rhine Valley in Germany developed salt glazing in the Middle Ages and used it for centuries to create watertight, acid-resistant utilitarian ware; later its use spread in both Europe and colonial America (see Chapters 6 and 7). Produced when damp salt is introduced into the heated kiln (at a temperature of at least 1940°F/1060°C), the glaze is formed when the sodium is released in the presence of moisture and as the salt volatizes its vapors to fill the kiln. As the heat sends the vapors swirling around, they settle on the pots, the shelves, and the kiln walls. The sodium combines with the silica and alumina in the clay, forming a thin glaze on everything in the kiln.

A salt glaze can be thin and smooth—an especially effective surface on pieces that have carved or incised decoration, as it does not fill the lines and obscure the design—or it can have a mottled and pitted orange-peel texture caused by the glaze beading on the surface (see 9-16). Since a salt glaze does not usually penetrate and coat the interior of the pots, ceramists usually apply another high-fire glaze in the interior. Salt glaze is, however, no longer used for traditional forms alone; ceramists are now exploring its effects on sculptural creations as well. (More information about salt firing and lower-salt firing and alternatives is presented in Chapter 15.)

ALTERNATIVE GLAZE MATERIALS Any mineral material contains additives that may create interesting glaze effects. A number of contemporary ceramists have explored the use of mineral materials that they find in their locality, including volcanic materials, crushed rocks and gravel, cement, and mine tailings. Even metal shavings and remnant particles from a band saw can be mixed into glazes. Bronze, which has a high percentage of copper, and stainless steel, which contains chrome, will produce lively glaze effects.

Also, rusty chunks from a corroding piece of iron will yield brown spots when fired in a glaze. If you experiment with unusual materials, be sure to test them on small test tiles first.

OVERGLAZES

After firing your pot or sculpture with either high-fire or low-fire glazes, you can enrich the surface and color further by using overglazes, enamels, china paints, lusters, and metallic lusters on top of the glaze (see 14-54, 14-56, 14-59, 16-5).

Overglaze Decoration

Sometimes called on-glaze painting, overglazing is a traditional method of decorating a fired glazed surface and refiring the piece at a temperature well below the maturing point of the glaze. It was used in western Asia, Spain, Italy, and the rest of Europe for all low-fire, color-decorated pottery. Eventually European potters learned how to imitate the Chinese blue and white underglaze decoration on porcelain (see 6-21), but they continued to use overglazes on tin-glazed ware.

Another overglazing technique is **in-glaze painting.** Not to be confused with on-glaze, or china, paints which are fired at very low temperatures, in-glaze decoration is the application of glaze stains, oxides, or glazes on top of an unfired glazed surface. To prepare work for in-glaze decoration, apply a base coat of glaze, usually white, cream, or light gray to the surface. Once this base is dry you can paint directly on the piece. To set the colors and help avoid smearing, the work can be sprayed with a solution of gum (128 g gum to 1 gal. [3.785 l] water), which will protect it from being disturbed when the overglaze is painted on it. Use quick strokes, disturbing the base glaze as little as possible. The same method may be used with **sulfates** of different oxides, such as iron, cobalt, or copper sulfate. This coloring technique is generally used for aesthetic reasons. The sulfates tend to float in the glaze after firing which can produce subtle coloration on the surface.

China Paints and Enamels

With the present interest in complex colored surfaces on ceramic sculpture, overglazes have

FIGURE 14-55
Namorados da Lua, by Xavier Toubes
of Spain. Porcelain with gold luster. 20
× 18 × 32 in. (50 × 45 × 80 cm). 1996.
*Courtesy the artist and European Ceramics Work
Centre, the Netherlands. Photo: P. v. d. Kruis.*

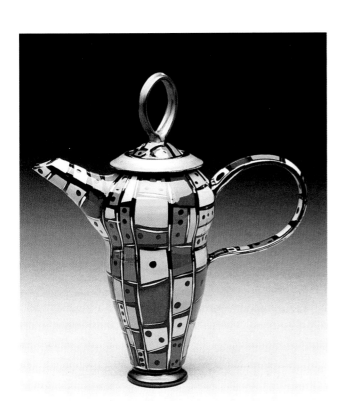

FIGURE 14-56
Alladin Tea Pot, by Julie Cline of the United
States. Cline decorated her fanciful wheel-
thrown teapot with a low-fire glaze and a third
firing of metallic lusters, accentuating the
color and line work on the piece. Fired to cone
018. 5 × 7½ in. (13 × 19 cm). *Courtesy the artist.*
Photo: Charles Frizzell.

FIGURE 14-57
Jim Melchert applied a china paint
decal of a butterfly to one of his
cups. Fired to cone 018. *Courtesy
the Toki Collection. Photo: Scott McCue.*

become popular. China painting, which used to be associated with Victorian ladies painting flowers on teacups, has become a quite different process in the hands of contemporary artists (see 14-79).

China paints and enamels are basically very low-fire glazes (1231–1350°F/666–732°C) that are applied on top of an already fired glaze. In the past they were used to decorate household china, which is why they are often grouped together and called *china paints.* However, the word *enamel* correctly refers to overglaze colors that are opaque, whereas *china paint* is the correct name for translucent overglazes.

There are a number of advantages to using china paints and enamels. Aside from the range of colors they produce, they are available in matt or gloss and translucent or opaque forms, and they are excellent for detail work. Since china paints and enamels mature at low temperatures, they are generally used for the final firing (if you apply a glaze that requires higher temperature over the china paint, the china paint is likely to change color in the higher heat). If you want to do multiple firings so that the color will hold, you should fire the highest-firing glaze first, follow it with a lower-firing glaze, and end with the china paint on top of that. On the other hand, some artists have found that they like what happens to china paints or enamels when they are fired at higher temperatures on glazed ware or on unglazed porcelain surfaces: The china paint burns into the glaze or clay surface, leaving residues, usually from oxides or minerals that will be darker in hue and somewhat mottled.

China paints and enamels are sold ready-to-use in tubes or pans (see 14-60). Some overglaze paints are like transparent watercolor paints and can be brushed on in thin washes of color. Others are opaque, oil-based overglazes that can be mixed with a special paste called *raised paste* to produce textures. Most colors can be mixed with each other to create new shades. Some, however, such as red, orange, pink, and purple, may not mix well because the various oxides and chemicals that are combined to produce them have little tolerance for contamination.

If you want to prepare your own colors, you can buy the colors in powder form, add an oil-based or water-based **china paint medium,** and mix the colors with a mortar and pestle or on the frosted side of a glass palette. Whichever type of paint you use, china paint can be brushed on, sprayed on, or applied with a silk screen or as decals. Successively sprayed coats of china paint, usually requiring firing between coats, can create subtle gradations and depth of color.

For fine-line decoration and outlining, there is a pen oil, or you can mix a blend of china paint powder and thin it to a painting consistency with turpentine and French fat oil. This oil can also be used as a thickener for oil-based china paint medium. To thin china paint medium, use balsam of copaiba or lavender oil, which also works well for painting on bisque ware, or on high-fired, unglazed porcelain surfaces. Use a mortar and pestle or a palette knife for grinding and mixing. Apply the china paints with clean, dry brushes; contaminated brushes can cause discoloration when the work is fired.

Water-based china paints can be cleaned up with water; oil-based paints, with a brush cleaner made especially for china paint or with acetone. Wear gloves when handling these chemicals, and work in a well-ventilated room. China paint is not very durable, so it generally is used on sculpture, on porcelain dolls, for decorative objects, or on the outer edges of dinner plates, where it will receive much less wear.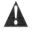

Kevin Myers decorates his raku-fired vessels with china paints (see 14-58, 14-59). After bisque-firing his raku pieces to cone 05, he applies a clear glaze and raku-fires them to cone 06. Myers uses a palette knife to mix his dry china paint powder with a china paint oil medium on a 12 × 12 in. (30 × 30 cm) piece of glass. He prefers to use Cerdec #1420 brushing oil or the more viscous Willoughby's balsam of copaiba oil to blend his colors. He begins by adding a few drops of oil to the powder and grinds the china paint to a fluid consistency. For cleaning his brushes and glass palette, he prefers to use odorless turpentine.

Before painting, Myers cleans the glazed areas by scrubbing them with a scouring pad; this removes any residue left over from the firing. After the surface is totally dry, he paints his work with china paint and fires it between cones 019 and 018 (1279–1350°F/693–732°C). He then refires the work up to ten times in a raku kiln to reintroduce smoke into the crackle glaze and the surrounding unglazed areas, thus darkening the surface with carbon from the smoke. Painting china paint onto the piece, firing it, and repainting with china paint is necessary to build up the color. If too much china paint is layered on the

FIGURE 14-58
(a) Kevin Myers of the United States blends china paint powder with painting medium and grinds the compound on a piece of glass using a palette knife. When the mixture is smooth, he is ready to paint his sculpture. (b) Myers applies china paint to the glazed portions of his sculpture and raku-fires the piece. He pulls the hot pot out of the kiln at around 1323°F/717°C) and reduces it in a can filled with newspaper. The smoke from the burning newspaper blackens the surface of the piece, and the fire affects the crackle of the glaze more or less, depending on the kiln temperature and atmospheric conditions. *Photos: Susan Myers.*

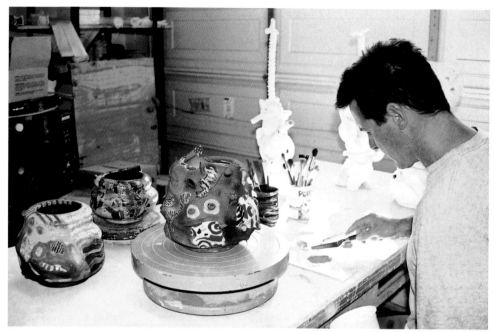

(a)

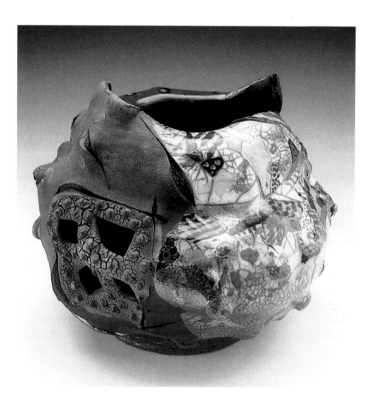

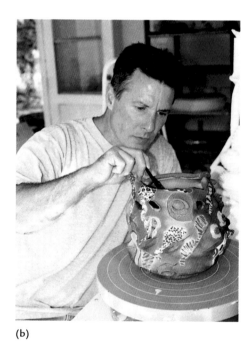

(b)

FIGURE 14-59
Slipperman Vessel, by Kevin Myers, is wheel-thrown and altered. Fragmented vessels unearthed in archeological excavations have influenced Myers's work. Areas left unglazed became black from the raku firing, while the glazed areas are crazed. Myers says that he *exploits the surface* of his pieces through the forces applied on the clay while it is wet, and later during the glazing and china painting, when the piece undergoes up to twenty firings to achieve the color and texture he is seeking. Ht. 8 in. (20 cm). *Photo: Tony Cunha.*

FIGURE 14-60
China paints are available in various forms: dry powder in small glass vials, offering a full spectrum of colors that can be mixed with oil or a special water-based medium; premixed oil-based colors in jars or tubes; and water-based pan china paints.

glazed surface at one time and fired, it could peel or flake off. As mentioned earlier, some colors, such as purple, pink, bright red, and orange, do not mix well with other china paints and are best if fired alone; then another layer of paint can be applied on or near it and the piece can be refired. More information about firing china paints and enamels is presented in Chapter 15.

Lusters and Metallics

Made from metallic salts, the earliest deliberately induced lusters were used by Persian potters on top of opaque tin glazes (see 3-37). The technique later spread to Spain with the Muslim expansion, and from there to Italy and the rest of Europe. The metallic salts in these early lusters were first painted on the fired tin glaze; then the piece was refired in the heavy reducing atmosphere necessary to develop the luster of the metal. As is still the case, the base glaze on which they were painted had to be capable of becoming soft enough during firing at a low temperature to allow the metals to adhere, but it could not become too molten, or the color would be ruined. The Persian reduction methods were used for all lusters until a new, easier luster technique was developed in France involving liquid gold. These modern lusters and metallic lusters are formulated with kiln-reducing material incorpo-

rated into them. Like china paints, they are applied on top of a fired glazed surface.

Some contemporary ceramists have replicated the ancient Persian and Spanish luster techniques. Nowadays most ceramists use commercially prepared lusters and fire them in electric kilns, a technique called **oxidation luster.** Another method of firing lusters, called **reduction luster,** makes use of a gas kiln. The kiln is fired with a combination of natural gas and nitrogen gas that is piped in through a separate gas line. If you use this method, do so under the supervision of a ceramist with experience in this process. (See the Further Reading section for books about luster firing.)

TRANSLUCENT LUSTERS These overglazes are known for their shimmering quality, with colors ranging from shades of blue, green, and orange to pink, gray, purple, maroon, and pearl. Because they are translucent, the color of the glaze on which they are applied tends to show through, creating a sumptuous effect.

METALLIC LUSTERS These opaque overglazes are available in various shades of gold, platinum, and copper; they are made with actual metal oxides (see 14-56). For example, liquid gold luster contains about 10% real gold. Because of their opacity, metallics are not greatly affected by the color of the glaze on which they are applied. When the oil burns out in firing, the metal becomes fused to the surface of the glaze (see 14-55). Gold and platinum are also available in pens for writing or fine-line decoration.

APPLYING LUSTERS AND METALLICS When applying a luster or metallic to a glazed surface, only one even coat is required. After application, let the paint dry; the work is then is ready to be fired. Apply lusters with proper ventilation to remove fumes. Since lusters are easily contaminated, your hands and the surface on which you apply them should be clean, dry, and free from dust and grease. The brushes you use for applying lusters and metallics should also be clean and dry. Clean your brush thoroughly between colors with a brush-cleaning solvent, or use a separate brush for each color and mark it with an indelible pen so that you use it for only that color. It is an especially good idea to separate brushes used for metallic colors from those used for lusters.

Gold and luster essence can be used sparingly to thin lusters and as a brush cleaner, while a small amount of luster essence and lavender oil will thin lusters that have congealed. If you make a mistake when painting luster, you can remove the spot with a cotton swab or cloth while it is still wet. If the luster is beginning to dry and has become sticky, apply a very small amount of brush cleaner to the swab or cloth to help dissolve the luster and remove it from the glazed surface. To remove a luster after it is fired, there is a liquid chemical remover for gold luster, and there are abrasive stick erasers to remove fired gold, metallic, and other lusters. There is even a liquid that creates marbleized effects when added to lusters.

A little luster goes a long way. It is possible to pour small amounts into a paint-mixing pan or onto an impervious surface such as a glazed dish or the convex bottom of a glass jar, and if any is left over when you finish working, you can cover it with plastic wrap to keep it for future use instead of pouring it back into the bottle. This will prevent possible contamination of the luster in the bottle. For special projects, it is often better to buy fresh luster paints than try to recondition old ones, because old paint may not fire well.

Nowadays lusters are used not only for decorating pottery and china to give it the luxurious, gleaming look of precious metals, but also to give a distinctive surface to sculptures. For example, Richard Notkin brushed two thick coats of silver-gray luster directly onto unglazed, vitrified stoneware to achieve a galvanized steel effect on his *Heart Teapot* (see 13-75).

Silk-Screening Overglazes

Using silk screening to add color, image, or detail to the surface of your work requires some training. When this technique is used for ceramics, the image is screened directly onto a fired and glazed surface. A silk screen usually consists of a fine mesh of real silk or a synthetic held taut in a wooden or metal frame. A stencil is applied onto the screen (see a book on silk screening for the methods), and china paint is applied through the screen with a plastic or rubber squeegee. Viscous, oil-based commercial china paints that have been refined by ball milling work well when screening directly onto flat surfaces such as tiles. Obviously, this method works best on flat surfaces;

however, it is possible to tape unframed, stencil silk-screening material directly onto curved or irregular ceramic surfaces and apply china paint through it.

Overglaze Decals

Decals for ceramics are basically images printed with china paint that is held in suspension on a special paper between two layers of decalmania lacquer. To apply a decal to a glazed surface, cut out the chosen decal, soak it in water for 15 seconds, and then slip it off the decal and transfer it to the ceramic surface. Improper adhesion or excess water may create bubbles and cause a **blistered** area when the ware is fired. Once you have applied a decal, be sure to remove any excess water from between the decal and the glazed surface. Do this by gently blotting the decal with a paper towel, cloth, or squeegee, beginning at the center and working outward.

You can also make your own decals by screening a layer of decalmania lacquer onto a sheet of decal paper. Let it dry, then screen your design with china paint onto the paper. After that has dried, screen a layer of decalmania lacquer over the printed design. Let the decal dry thoroughly before transferring it to the ceramic surface, then fire it between cone 018 and 019 (see 14-57).

Layering Glazes and Overglazes

The work of Richard Hirsch (see 9-15, 14-29) shows that it is possible to achieve extremely rich surfaces by using layering methods. The point to remember in using any overglaze technique is that the glaze that fires at the highest temperature should be applied first; then the lower-firing ones can be applied and fired in successively lower firings, one over the other. Developing the surface of a piece in a continuous process can produce a great variety of surface enhancements, as seen in the work of Kimpei Nakamura (see 16-5), Julie Cline (see 14-56), Kevin Myers (see 14-59), John de Fazio (see 14-34), Phyllis Kloda (see 14-28), and James Aarons (see 14-31). However, before using these underglaze, glaze, and overglaze methods, it is a good idea to learn more about the base glazes on which you will use them. Testing is the best way to do that.

GLAZE TESTS

In the early days of ceramics, all glaze formulation was based on trial and error. Learning through their successes and failures, Chinese potters developed their subtle celadon (see 3-17) and brilliant **flambé glazes** (see 3-19); Persian potters created their bright blue-green glazes; and the Europeans perfected colored decoration on tin-glazed earthenware (see 6-7). Modern chemistry, however, has given the potter considerable information about the components of glaze materials, and many ceramists use methods of chemical calculation to analyze their glazes (see *Expertise*, Chapter 3B).

Then why test glazes? Despite modern chemical analysis, the ultimate test of a glaze is how it fires, so the ceramist still depends on testing to find out how an individual glaze will respond to a particular clay body in a kiln firing at a certain temperature or in a given kiln atmosphere. Testing on small tiles allows you to change the proportions of a material in a glaze and quickly see what will happen to the altered glaze as a result. Since slight changes in the amount of one ingredient can change a glaze radically, by running tests you can see how these changes will alter the glaze, and you will gain an understanding of how the chemicals react under controlled conditions. Glaze tests also provide useful clues for formulating special colors and textures or producing such glaze qualities as viscous or fluid, matt or glossy.

The clues to glaze-material behavior that you pick up while doing tests on tiles in a small **test kiln** will help you when you are ready to mix a full batch of glaze. Remember, however, that the same glaze applied to a larger work and fired in a different kiln may produce different results. The length of firing time, the thickness of the clay; the position of the glazed work in the kiln, the presence of any residue oxides from a previous firing, such as copper dust loose in the kiln, on the kiln element, or absorbed into the kiln brick, and even the fumes burning off from other glazed ware in the kiln can all affect the outcome of the final glaze firing. As you gain a greater understanding of glaze components and how they react under test conditions, you will be better able to predict how a tested glaze will fire on larger objects in the same kiln in varying atmospheres. As you test, keep a notebook to record the formulas and the results of each test.

Suzanne Ashmore, one of whose teapots won a top prize in Japan, says,

> *I do many glaze tests, but I do not formulate my own glazes. I find a base formula with certain characteristics and run a series of color tests with different percentages and combinations.*

(See *Expertise*, Chapter 1C, for two examples of glazes that Ashmore has tested.)

Formulating Test Glazes and Test Tiles

The glazes for tests are generally formulated in batches ranging from 50–500 g of dry glaze materials. The chart in Figure 14-61 shows the equipment used in both testing and glaze mixing.

To conduct a series of tests, first form test tiles out of the clay body to be glazed. One way to make simple test tiles is to cut a slab into a series of square tiles or rectangles and then bend them into L-shaped tiles (see 14-64). An extruder can be used to make T-shaped tiles that are cut into 1-in. (25-mm) pieces and fired upside-down, or you can throw a low cylinder and slice it into sections to make L-shaped tiles. L-shaped tiles will allow you to see how the glaze will act on a vertical surface, such as the sides of a pot. You can also make a space-saving tile rack out of stoneware clay and stack T-shaped tiles into the rack (see 14-64). Because the tiles hang vertically, the amount of glaze that flows during the firing can easily be calculated. Also, the firing rack contains any glaze drips and protects the kiln shelf from spills. Bisque-fire the test tiles after punching a hole in the top so that you can hang the tiles in the glaze area for easy reference.

Test by changing each ingredient a small amount at a time, in increments of 5%. Fire the tiles, and record in a notebook the kiln temperature, the tiles' placement in the kiln, and the kiln atmosphere. It is also a good idea to record proportions of the glaze materials on the tile itself with an underglaze pencil or with oxide. In this way you can go back over your records and compare test results.

Expertise, Chapter 1A, contains some cone 05, cone 5, and cone 10 glazes formulated for the *Hands in Clay* white clay bodies, also listed in that chapter. These simple glazes are easy to test and use, and they contain no toxic materials. If you test and alter all the clays and glazes

Triple beam scale

For precision weighing of oxides, stains, and chemicals, and for test batches. Capacity approximately 2,600 gm (5.72 lb).

Digital scale

Fast and accurate scale for weighing small quantities of material with a total weight capacity of approximately 2,000 gm (4.40 lb). Electronic scale also operable by battery.

Spring scale

Portable scale for weighing bulk chemicals in the 1–100 lb (.45–45 kg) range.

Package scale

For weighing bulk materials in the 5–25 lb (2.27–11.35 kg) range.

Platform scale

Outfitted with wheels for easy maneuverability. Large platform for weighing bulk materials in the 50–100 lb (22.7–45.4 kg) range. Capacity 1,000 lb (454 kg).

Cup and spoon

For mixing small test batches of glaze.

Mixing bowls and containers

Bowls and containers (16 oz to 5 gal [.5 to 19 L]).

Graduated cylinder

Marked in ounces and milliliters for accurate measuring of water, sodium silicates, other electrolytes, and liquids.

Mortar and pestle

Grinds oxides, glaze stains, chemicals, and both wet and dry glaze test batches. For reducing and refining particle size of chemicals.

Ball mill

Mill has porcelain jar and high alumina pebbles or porcelain balls for grinding oxides, frits, chemicals, and both wet and dry glazes.

Kitchen blender

Efficiently mixes small glaze batches or tests in quantities from 4 to 24 oz (.12 to .7 L).

Drill mixer

Variable-speed hand-held electric drill with mixer blades of various sizes for mixing from 4 oz to 5 gal (.12 to 19 L) batches of glaze or slip.

Rapid mixer

Fits over a 5 gal (19 L) bucket. Good for mixing 2–4 gal (8–15 L) glaze batches.

Dispersion blender

Professional high-speed blender for mixing glaze in volumes from 1 – 50 gal (4 – 190 L). Mixes glazes to homogeneous solution.

Sieve

Brass or stainless steel mesh sieve for screening dry materials, glazes, and slip (30–120 mesh).

Jars

Plastic jars with lids 4–16 oz (.12–.5 L) for water-base compounds when mixing small test batches. Glass jars with solvent-resistant lids for storing oil-based compounds.

FIGURE 14-61

Here is the equipment you will use as you prepare your own glazes. Some of the equipment is basic, whereas some is for more advanced use or for preparing large quantities.

FIGURE 14-62
A mortar and pestle are excellent for grinding small amounts of oxides, glaze stains, or chemicals to refine their particle size so that they will disperse more thoroughly in a glaze. Chemicals can be ground dry or mixed with water to create a viscous solution.

FIGURE 14-63
A variable-speed ball mill is useful for grinding glazes, oxides, or chemicals to refine their particle size. To eliminate color streaking in glazes, oxides such as cobalt, copper, or iron should be ball-milled for about 3 or 4 hours. Materials such as frits, wollastonite, lithium, Cornwall stone, or zinc oxide, which could contain varied particle sizes when processed, can be refined by ball milling. This process helps disperse the chemicals more readily in a glaze, making it a homogenous solution. A glaze that is ball-milled melts more efficiently than one mixed by hand and sieve, even if the sieve is of a fine 100 mesh or finer.

given in *Expertise*, Chapter 1A, you will develop a basic understanding of the composition of clays and glazes and their relationship to each other.

Mixing a Glaze for Tests

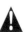

Wearing a respirator and following the precautions given at the beginning of this chapter, mix at least a 100-g batch of your selected glaze. Avoid mixing smaller batches because the possibility of measurement errors increases in small batches.

If you use oxides such as cobalt, iron, chromium, copper, or nickel for color in the final batches of glaze, you may have to grind the oxides with a mortar and pestle or put them through a ball mill to reduce the particle size (14-62, 14-63). Ball milling for 3 to 4 hours will refine the oxides to an even consistency that will eliminate color streaks, prevalent in unground oxides, that may mar the fired glaze. Of course, you may like the streaky effect or specks of color, in which case you need not grind the oxides.

To mix the batch, weigh out the dry ingredients with a gram scale (see 14-61) and add the water. For cone 05, low-fire glazes, add about 2.5 oz. (75.67 ml) of water; for cone 5 glazes, add 2.5–3.0 oz. (75.67–90.81 ml) of water; and for cone 10 glazes, add about 3.4–4.0 oz. (102.91–121.08 ml) of water (see *Expertise*, Chapter 1A, "Water Proportions for *Hands in Clay* Glazes"). A 100-g batch will yield about 3.5–4 oz. (103.50–121.08 ml) of liquid glaze. Put this mixture through a **sieve** with a number-50 to -80 mesh. For the small amount of glaze you are making for tests, mix the ingredients by shaking the glaze in a small, 4-oz. (118-ml), covered plastic container. Each time you use the glaze, shake it to keep the glaze materials in suspension. Brush some of the base glaze mixture onto a bisqued tile (or dip it), fire the test tile, and note the results. To be able to clearly identify the test glaze at a later date, it is best to label the jar with the chemical ingredients, firing cone, and kiln atmosphere, and note any fired results.

Through these small tests, you will gain clues to the behavior of the glaze components. Then, when you have narrowed the formulas down to one or two from which you might want to make a glaze, you can test 500-g batches in which you refine each glaze by changing the percentages of

certain chemicals, eliminating some chemicals, or adding others.

Color Tests

To find out exactly what effect a certain oxide has on the color of a glaze, test it by making changes in the proportions in the glaze. Remember, however, that an oxide that produces a certain color alone may yield a totally different color in combination with another oxide. A striking example is cobalt, which alone in certain glazes will yield a brilliant blue but in combination with vanadium can produce a mustard yellow. Another example of an oxide that can produce a considerable range of color is iron. It can yield creams, straw-yellows, red-browns, and the gray-greens so popular in ancient China (see 3-16), and it can produce the black-and-brown tenmoku glaze (see 3-20). Because oxides interact, we recommend that at first you test only one coloring oxide or stain at a time. In addition to causing color changes through interaction, one oxide may burn out in a kiln at a particular temperature, whereas another may hold its color intensity. The firing duration and kiln atmosphere—whether oxidizing or reducing—will have an important effect on the glaze color. The glaze color produced by each oxide will also vary depending on the color of the clay body under it, how finely the oxide was ground, and how the glaze was applied.

Clearly, there are so many factors in color formation that the only way you can be sure of how an oxide will perform is to test it in *your* glaze, on *your* clay, in *your* kiln, or even in *a specific area* of your kiln. Testing is time-consuming, but it will add to your understanding and control of your glazes. By testing one oxide at a time, changing its proportions for each test, you will get a good idea of how certain colors develop in glazes. Later, after you have tested the individual oxides listed in *Expertise*, Chapter 1A, you can test several oxides in combination. To test for black, for example, you would use cobalt (blue), iron (reddish brown), chromium (green), and manganese (dark brown) according to the percentages given in the charts.

Not only do all the components of a glaze affect the color, but the earth elements present in the oxides and clay can vary, depending on where they were mined and the industrial processing they have undergone. An anecdote will help illustrate this point: A ceramist found different color tones in batches of a glaze stain from a supplier, although they were all labeled with the same name and number. When he asked the salesperson why the color varied so much, the man replied, "Oh, the wind could have been blowing hard that day, affecting the heat of the processing furnace, and that could have affected the color." Thus, to achieve color consistency in your work over time, you need to purchase enough of a material to ensure that all components of your glaze remain the same for a reasonable period. This is especially important if you are going to construct a large mural or make a set of tableware that requires a consistent color.

Running a Series of Color Tests

Taking as an example the *Hands in Clay* cone 05 base glaze test in *Expertise*, Chapter 1A, start your color testing. Use tiles made of the cone 05 white clay body, also given in that chapter. You can make test tiles by cutting out small squares that will fit into a K-23 soft-brick rack, by making L–test tiles by making T–test tiles that fit into a rack, or by throwing a cup on the wheel and cutting it into strips (14-64, 14-65).

The recipe for the base glaze is:

Frit 3195 (3811, or F434)	88%	88 g
Kaolin	10	10 g
Bentonite	2	2 g
	100%	100 g

Dry-blend these materials, then add the powder to the proportion of water outlined in *Expertise*, Chapter 1A, "Water Proportions for *Hands in Clay* Glazes." Mix the glaze thoroughly by stirring it or shaking it in a lidded jar. A batch mixed with 100 g of glaze material and water will yield about 4 oz. (118 ml) of glaze, an adequate amount for this test. If you want to convert the percentage recipe to other amounts, such as ounces or even pounds, you can use the table in *Expertise*, Chapter 2B.

Mix the 100-g batch; then dip or brush it onto a test tile and mark it "cone 05 base glaze." Set this tile aside to be fired. For the first colorant, add cobalt. Because cobalt is such a strong colorant, add it in increments of just ½ g. When you

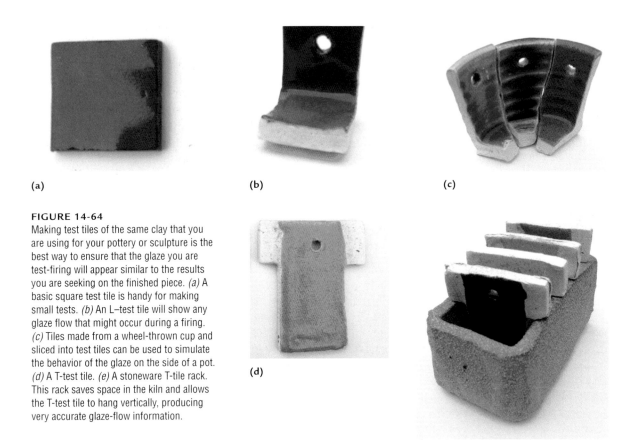

(a) (b) (c)

(d)

(e)

FIGURE 14-64
Making test tiles of the same clay that you are using for your pottery or sculpture is the best way to ensure that the glaze you are test-firing will appear similar to the results you are seeking on the finished piece. *(a)* A basic square test tile is handy for making small tests. *(b)* An L–test tile will show any glaze flow that might occur during a firing. *(c)* Tiles made from a wheel-thrown cup and sliced into test tiles can be used to simulate the behavior of the glaze on the side of a pot. *(d)* A T-test tile. *(e)* A stoneware T-tile rack. This rack saves space in the kiln and allows the T-test tile to hang vertically, producing very accurate glaze-flow information.

FIGURE 14-65
This rack is handy for firing small square test tiles. It is cut from a straight-groove kiln element brick or from a (soft) K23 firebrick with a hacksaw and file. This rack can be cut to fit into a small test kiln and can easily hold nine small test tiles.

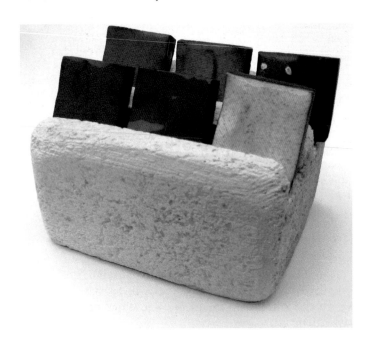

test the other colors, you can add them in larger increments.

Next, add ½ g of cobalt to the base glaze mixture. Dip or brush a tile and mark it ".5% cobalt." Repeat this step three more times, adding cobalt in ½-g increments and marking these tiles "1% cobalt," "1.5% cobalt," and "2% cobalt." Fire the tiles at cone 05 in oxidation, and see how the changes in cobalt content affect the glaze.

Continue the testing process with new tiles, adding the other coloring oxides in increments up to the percentage given in the table for the cone 05 test glaze in *Expertise*, Chapter 1A. When you finish testing the cone 05 glaze, continue testing through the cone 5 and cone 10 glazes. You may also want to fire the cone 5 and cone 10 glazes in reduction to see what effect that has on each glaze. By the time you have worked through these tests, you will have a good understanding of glaze materials and can move on to test some of the glazes from other ceramists in *Expertise*, Chapter 1C. Out of the many tests you do, you may get only one glaze that you like, but eventually you will build up a body of knowledge that

Triaxial Blend

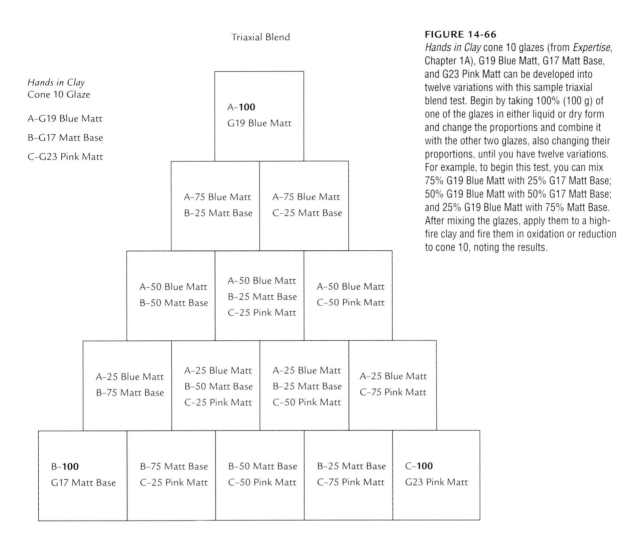

Hands in Clay
Cone 10 Glaze

A–G19 Blue Matt

B–G17 Matt Base

C–G23 Pink Matt

A-**100**
G19 Blue Matt

A–75 Blue Matt
B–25 Matt Base

A–75 Blue Matt
C–25 Matt Base

A–50 Blue Matt
B–50 Matt Base

A–50 Blue Matt
B–25 Matt Base
C–25 Pink Matt

A–50 Blue Matt
C–50 Pink Matt

A–25 Blue Matt
B–75 Matt Base

A–25 Blue Matt
B–50 Matt Base
C–25 Pink Matt

A–25 Blue Matt
B–25 Matt Base
C–50 Pink Matt

A–25 Blue Matt
C–75 Pink Matt

B-**100**
G17 Matt Base

B–75 Matt Base
C–25 Pink Matt

B–50 Matt Base
C–50 Pink Matt

B–25 Matt Base
C–75 Pink Matt

C-**100**
G23 Pink Matt

FIGURE 14-66
Hands in Clay cone 10 glazes (from _Expertise_, Chapter 1A), G19 Blue Matt, G17 Matt Base, and G23 Pink Matt can be developed into twelve variations with this sample triaxial blend test. Begin by taking 100% (100 g) of one of the glazes in either liquid or dry form and change the proportions and combine it with the other two glazes, also changing their proportions, until you have twelve variations. For example, to begin this test, you can mix 75% G19 Blue Matt with 25% G17 Matt Base; 50% G19 Blue Matt with 50% G17 Matt Base; and 25% G19 Blue Matt with 75% Matt Base. After mixing the glazes, apply them to a high-fire clay and fire them in oxidation or reduction to cone 10, noting the results.

will enable you to look at a glaze test and know why it was successful or what you can do refine the glaze.

In these tests, you have changed the colorants. In _Expertise_, Chapter 3A, you will find an example of changing and testing the flux in a high-fire glaze. After working through that, if you want to go into the subject of calculating glazes using chemical analysis, see _Expertise_, Chapter 3B.

Line Blend Testing

Line blend testing is another method for testing glazes. You can test any low- to high-fire glaze in this manner. It is especially useful for developing various shades of a color. Testing is done by methodically blending the proportions of various materials in two glazes. (For example, as one glaze is increased by 10%, the other is decreased

by 10%.) By conducting line blend testing using the _Hands in Clay_ glaze formulas in _Expertise_, Chapter 1A, you will be able to achieve a wide range of colors and glazes with various firing ranges. A sample line blend test in _Expertise_ takes you through the process.

Triaxial Blend Testing

Triaxial blend testing is a simple diagrammatic method for testing glazes. The sample triaxial blend test shown in Figure 14-66 tests three glazes. For this test, _Hands in Clay_ cone 10 matt glazes were used: G17 Matt Base, G19 Blue Matt, and G23 Pink Matt. Each corner of the triangle represents 100% of a color. The percentage of each glaze is systematically changed, producing combinations that differ in chemical composition and color intensity.

(a) (b) (c)

FIGURE 14-67
A sieve is used to produce a homogenous mixture and remove debris or contaminants such as dirt, hard glaze chunks, or coarse chemical particles. Glazes can be sieved either wet or dry and passed through the screen with a rubber spatula or rib. Sieves are usually available in mesh sizes 30, 50, 80, 100, and 120 and come in various body styles: *(a)* A light-duty plastic-frame sieve holds about 2 qt. (1.89 l); *(b)* a durable metal-frame sieve holds about 2 qt. (1.89 l); *(c)* a small cup-size sieve, handy for tests, holds about 4 oz. (118 ml).

MIXING GLAZES

Now that you have carried out some tests, have decided on a glaze, and are ready to glaze some ware, you will need to mix your glaze in a batch that is big enough to coat your work. The chart in Figure 14-61 shows the equipment required for mixing glazes in small or large batches.

Mixing is a relatively simple process, but be sure to review the precautions described at the beginning of the chapter before you begin. Use a gram scale to measure the dry ingredients, making sure that you set it on a level surface. Weigh out the dry ingredients and add them to the water. (See *Expertise*, Chapter 1A, for suggested glaze-water ratios.) The amount of water in a glaze is important because it affects glaze suspension as well as viscosity. Too much water may cause a glaze to settle; too little may make the glaze thick and affect its application.

Put the mixture through a sieve with a number-50 to -80 mesh; then, if necessary, add water until the glaze is the right consistency for dipping or brushing (14-68, 14-69). Adding gum powder (.5–1%) to a brushing glaze will thicken it. When you dip a test tile or an object in a glaze with gum and a lot of **pinholes** develop on it, the mixture may be too thick, so you will need to add more water. Using a **hydrometer** (14-70) will make it easier to keep the water content

constant so that the glaze will have the same consistency at all times.

Use a container large enough to allow you to mix comfortably. You can mix batches of less than a gallon (3.785 l) with a stick, paddle, or kitchen wire whisk; kitchen blenders have also been used for small batches with excellent results. For batches of more than 1 gal. (3.785 l), an electric paint mixer can be helpful, but since thorough blending of glaze components often takes 10 to 20 minutes, a stationary mixer is easier to use than one that you have to hold. A ball mill (see 14-64) is one of the most effective tools for mixing dry or wet glaze materials, with the added advantage that it will grind dry particles to a very small size. Glazes that are ball-milled usually melt in the kiln very efficiently; they also brush on ceramic surfaces more evenly than glazes mixed by hand using a paddle, a whisk, or an electric mixer. Oxides such as cobalt, copper, and iron are best if ground in a ball mill for 3 to 5 hours, depending on the volume; this will eliminate color speckling in glazes. Ball milling is important if a glaze is going to be sprayed, as larger particles tend to clog the tip of the **spray gun.**

A high-speed **dispersion blender** with a special blade that creates a vortex effect refines the particles even further than an ordinary mixer does and prepares the glaze quickly and thoroughly, blending it rather than mixing it. A glaze blended with this type of mixer will stay in suspension better than if mixed with a whisk, and it will also melt more smoothly in the kiln because the particles will be finer and more homogenous. Whatever method you use to mix the glaze, it is extremely important to see that the

glaze ingredients stay in suspension rather than falling to the bottom.

Occasionally, however, the heavy material *will* settle on the bottom. If you have that problem, consider doing the following with your next batch. After weighing the proper amount of water, mix the most glutinous materials—the suspending agents macaloid (hectorite), bentonite, vee gum, or CMC gum—first. (See *Expertise*, Chapter 1B, for percentages of these materials to add.) Using hot water may help, too. Once these materials are well blended, add the clay—such as kaolin or ball clay—followed by feldspars, frits, opacifiers, oxides, and other components, in that order.

Glazes that contain either CMC or gum tragacanth as a binder for brushing may decompose over time, and as they do, the gum, which also acts as a suspending agent, will lose its effectiveness and cause the glaze to smell like rotting plants. The glaze may also turn dark. This will affect only the suspension and brushing qualities. Although it is possible to slow decomposition by adding formaldehyde or Dowicide G, both of these substances pose serious health risks; we therefore recommend that you mix only the amount of glaze you will use in a reasonably short amount of time to avoid using antispoilants.

FIGURE 14-68
Jennifer Flanzer uses a hand-operated rotary sieve with three scrubber brushes that help pass the glaze through the screen quickly. She uses an 80-mesh sieve for most glazes, a 30- to 50-mesh sieve for slips, and a 100- to 120-mesh sieve for dry chemicals such as wollastonite, zinc oxide, feldspars, or frits that may contain chunky particles.

(a) (b)

FIGURE 14-69
A hydrometer measures the specific gravity of liquids. It is used to calibrate and monitor the correct amount of water in a glaze or slip, which affects its suspension and viscosity. *(a)* After mixing your glaze or slip for application, gently drop the hydrometer into the liquid, and note the number on the scale at the top of the liquid. This number is the specific gravity. Monitoring this number will allow you to calibrate and replace the correct amount of water as it evaporates from the glaze or slip. *(b)* When your glazes and slips are properly formulated for application, check them with a hydrometer. Jeff Johnson made a wooden one that is calibrated to a specific container for each liquid. Simply cut a ½-in. (13-mm) diameter dowel to 4 in. (10 cm) in length. Insert a 2-in. (51-mm) long screw, ¼ in. (6.5 mm) deep into one end of the dowel. Now gently drop the dowel, screw side down, into your glaze or slip, and draw or cut a line on the dowel at the flotation point. Label the Johnson hydrometer for each liquid, and use it for that glaze or slip only. It will tell you how much water to add when it evaporates. If the line you marked is above the top of the liquid, it means that evaporation has taken place and you need to add more water. If the line drops below the surface, you added too much water.

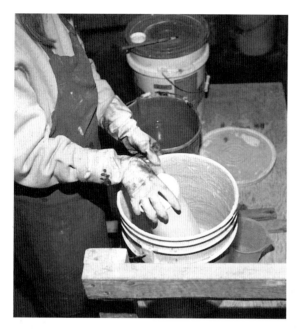

FIGURE 14-70
Isobel Deborah Cooper of the United States hand-dips a stoneware vase into a bucket of glaze. The length of time a piece is held in the glaze and the amount of time allowed between double dips are individual choices, determined by experience. Cooper wears gloves when dipping to protect her hands from glaze materials.
Courtesy the artist. Photo: John Cummings.

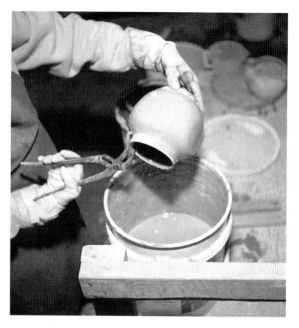

FIGURE 14-71
By using tongs for dipping, you avoid making finger marks on the pot, which means less touch-up and an even coating over the entire piece. *Courtesy the artist. Photo: John Cummings.*

APPLYING GLAZES

You probably will be applying glazes to bisque-fired ware. Although it is possible to apply a glaze to greenware and give it just one firing, in general glazes fire more satisfactorily when they have been applied to bisque-fired ware, so it is best to put your work through a first firing before applying the glaze.

The bisque ware should be free of dust and grease. Handle it with clean hands to prevent leaving oily fingerprints that will resist the glaze. Wipe the ware off with a damp sponge, or rinse it quickly under a tap to dampen it slightly and clean off the dust. This will also keep it from absorbing too much glaze. Experienced potters can mix glazes to a consistency that does not require the pot to be damp, and they can often dip or pour expertly enough to dispense with dampening, but for those who are less experienced it is usually better to dampen first.

In a kiln, the glaze can run off the sides of a pot, actually fusing it to the kiln shelf and making it impossible to remove the pot without breakage. To avoid this, either dip the bottom and

a minimum of ³⁄₁₆ in. (5 mm) of the sides of the pot in melted wax or a wax resist before glazing, or clean the glaze off this area with a sponge before firing. Alternatively, prior to glazing, Ross Spangler dips the feet of his pots into an oil-based water sealer. After it dries, he dips the ware in the glaze. Whatever method of applying glaze you choose will depend on personal preference, the object you are glazing, the type of glaze used, and the effect you wish to create on the fired piece.

Dipping

Dipping a bisque-fired piece in a bucket of glaze is one way to apply the glaze (14-70). Each person will work with a glaze consistency and method of dipping that is most comfortable or efficient. Some potters dip only once; others mix the glaze thin and double dip, a process that will cover any pinholes that may appear in the first coat. Wear rubber gloves, or use tongs (14-71) to dip the piece in the glaze—usually for only a few seconds. How long you let the piece dry between dips, if you double dip, will also affect the way the glaze will

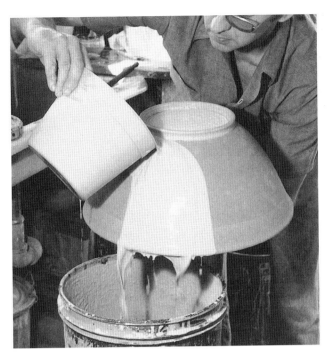

FIGURE 14-72
By pouring glazes, you can cover your work with a single glaze or achieve decorative effects by pouring one glaze over another.

FIGURE 14-73
Steven Hill of the United States glazes his pitchers in the green state. Pouring allows glaze to penetrate into the interior of the pitcher. The pitcher must be turned constantly to ensure even application as the glaze coats the interior and then is poured out.

turn out. The difference between one, two, or three dips can be dramatic. For example, a cobalt blue transparent glaze may appear as a light, washed-out blue with only one dip, but with three dips it will appear as a rich, deep blue.

Any marks remaining from holding the piece can be covered by touching up with a brush, but if you hold the piece carefully by the very bottom while dipping, this should not be necessary. After dipping, shake the piece to get rid of the excess glaze.

Pouring

You can achieve interesting effects by pouring more than one glaze on the exterior of a piece or by pouring glaze on only one part, allowing some of the clay body or another glaze to show through (14-72). Pouring is the most efficient way to coat the interior of a pitcher (14-73), and it is also a good way to glaze the interior of a bowl with a glaze different from that on the outside. It is effective on large surfaces such as plates or platters (14-74).

FIGURE 14-74
Galaxy Series #1, by Gary Holt of the United States. Holt formed this white porcelain plate over a fiberglass mold, then decorated it with soluble metal salts. He then fired it at cone 06, a low temperature for porcelain, because he wanted an absorptive body for the metallic salts. Diam. 19 in. (50 cm). *Courtesy the artist.*

Glazes for pouring are usually mixed for one- or two-coat application. If you use a glaze that has been mixed for brushing, you will need to thin it for pouring.

Brushing

You may be more comfortable using a brushing technique because it is similar to painting and allows you to vary the brushstrokes or their thickness, alter textural qualities, or paint accents on certain areas (14-76). When brushing on a glaze with a wide brush, you can control the thickness of the coat you apply, but it is sometimes difficult to get the coats even (14-75, 14-77). Usually, brushing a glaze evenly requires at least two coats, each applied after the previous coat is dry—which normally takes only a few minutes. You can also use brushing to add a

second or third glaze and to apply decoration over the glaze, or you can trail a second glaze or an oxide over a glaze with a slip syringe.

Painter Mathew Matsuoka and conceptual artist Robert Ortbal collaborated on a series of plates that developed into an installation titled *Pollinate* (14-78–14-81). They sought out thrift stores, where they purchased commercial china plates and plates produced for the tourist trade. The plates were reglazed and fired up to four times. Since the plates already had a glazed surface, the artists used a heat gun to dry the liquid glazes, thus speeding up the drying process. They applied commercial low-fire underglazes, glazes, and china paints to the plates; these altered the surfaces while interacting with the images already on the plates. In addition to the commercial glazes, they added frits, oxides, copper wire and leaf, glaze stains, and granular rutile. These materials reacted with the glazes,

FIGURE 14-75
Isobel Deborah Cooper of the United States brushes on glaze with the pot on a banding wheel. She wears gloves at all times while glazing. *Photo: John Cummings.*

FIGURE 14-76
In *Spontaneous Combustion,* Jeff Irwin used a number of materials and techniques—underglaze, vitreous engobes, wax resist, glazes, and acrylic sealer—in varying combinations to achieve the black and white woodblock-like images on his hump-molded plates. He now uses vitreous engobe instead of underglaze because it gives a smoother, satin sheen on the surfaces. Once-fired earthenware, underglaze, glaze. Diam. 22 in. (56 cm). *Courtesy the artist.*

FIGURE 14-77
Reuben Kent of the United States glazes one of his bisque-fired sculptures. Some pieces, he says, *will be glazed with up to five to seven glazes. Not all glaze combinations are compatible with each other. Some are not aesthetically pleasing so that the result is pretty uncontrollable.* Raku and sculpture clay with fine sifted grog. (See also 15-79.) *Courtesy the artist.*

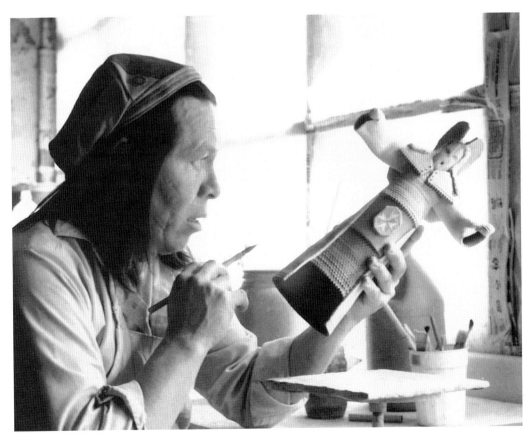

FIGURE 14-78
Pollinate, a plate installation by Matthew Matsuoka and Robert Ortbal, uses thrift store plates to the melding of individual ideas about art, life, and culture. The artists collaborated on each plate, painting freely over, under, or around the marks made by the other artist. Earthenware and porcelain, low-fire underglazes, glazes, china paints, oxides; cone 05. 3 × 5 ft. (.91 × 1.52 m). *Courtesy the artists.*

FIGURE 14-79
This plate, retrieved by Matthew Matsuoka and Robert Ortbal from a thrift store, has a floral design with a built-in sense of history that one could only speculate on. Perhaps it served as a luncheon plate for a family during a festive occasion or at a memorial dinner following a funeral. The artists felt it was important that portions of the original design showed through their fired glazes. Porcelain, underglaze, glaze, china paint. 7½ in. (19 cm). *Courtesy the artists.*

creating variegated surfaces. In commenting on their collaboration, Matsuoka and Ortbal said,

> The artists cross-pollinated their ideas about art and life with a variety of materials and application techniques, resulting in a hybrid of painting and ceramics. The resulting dinnerware conjures up images of disease research, more often than the desserts these vessels might have served during their past life in the home as dishes or plates.

Their spontaneity and openmindedness to experimentation enabled unlimited possibilities in the glazing process.

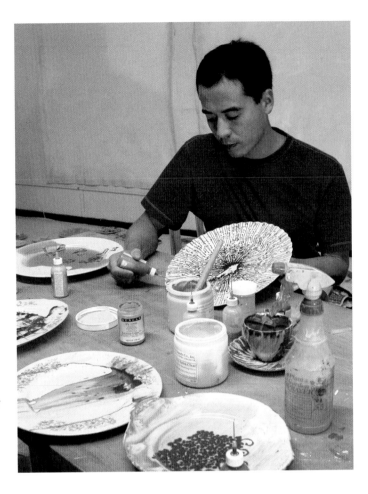

FIGURE 14-80
Matthew Matsuoka uses a squeeze bottle to apply underglaze to one of the thrift store plates. He says, *Most of the glazes used were store-bought low-fire glazes adjusted with frits and other glazes to help with the fit problems.* **Shivering** *was always a major technical issue, and of the hundreds of plates we made, only about half were successful artistically and technically.* Courtesy the artists.

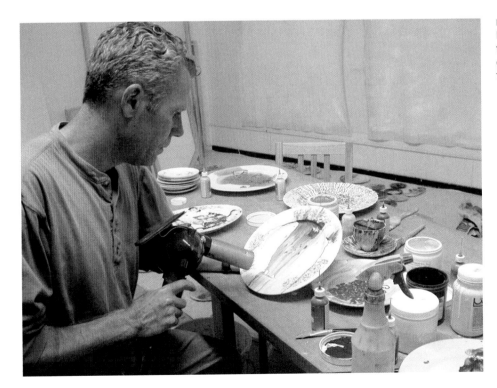

FIGURE 14-81
Robert Ortbal uses a heat gun to accelerate the drying of a glaze on a fired dinner plate for the *Pollinate* installation.

Resist Methods

Many decorative effects can be achieved by covering sections of a piece with commercial wax-resist compounds, latex, or other resistant materials. The covered areas will repel the glaze when the piece is dipped or poured. White wax can be tinted with a small amount of blue or green food coloring to provide contrast when it is applied to glazes. The dye burns out in the firing. If you are spraying or painting on a glaze, you can mask off areas with paper or tape so that parts of the clay body will remain unglazed, or use stencils through which to apply a contrasting image or pattern onto an already glazed area (see 14-31). If you use an electric skillet to heat wax-resist material, setting the burner to the lowest possible temperature will keep the wax melted, avoiding possible combustion. Resist 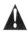 materials are available that do not require heating and therefore are safer to use.

Spraying

Before **air compressors** and spray guns were developed, potters sprayed glazes or areas of glaze onto their pottery by blowing them through a straw or metal tube—thus exposing themselves to hazardous materials. Now that we have spray guns, airbrushes, and ventilated spray booths and respirators, we can protect ourselves more fully from glaze materials. Preferably, do all 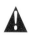 spraying in a booth (14-82, 14-83), and wear a mist-rated respirator and gloves.

When spraying your pottery, it helps to place your work on a banding wheel or turntable inside the spray booth so that you can turn it by hand as you spray. This will help you achieve an even glaze over the entire work. Some production potters set up an electric potter's wheel inside their spray booth and use an electronic foot pedal to activate the wheelhead, thus freeing themselves from having to spin the top and spray at the same time; moreover, their hands do not get covered with glaze. If your piece is too large to fit in a booth, glaze it outdoors with the wind blowing the spray *away* from you. Wear a respirator and goggles so that if there is any back spray it doesn't get into your eyes; this is especially important for contact lens wearers. Before spraying, reread the precautions about using glaze materials presented earlier in the chapter.

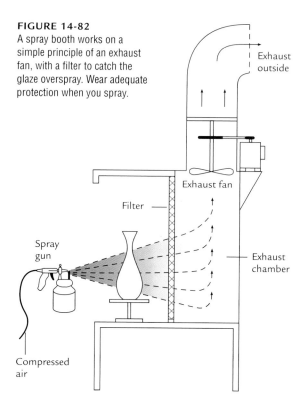

FIGURE 14-82
A spray booth works on a simple principle of an exhaust fan, with a filter to catch the glaze overspray. Wear adequate protection when you spray.

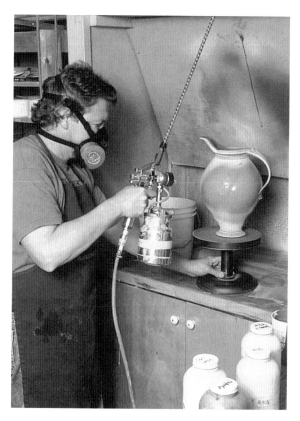

FIGURE 14-83
Steven Hill of the United States sprays a high-fire glaze.

Spray guns are useful for spraying glazes, engobes, and slips when a wide fanning spray is required to cover the piece and for fast coverage of a large area. Spraying allows you to develop gradations in color, but it takes practice to learn to spray the glaze on evenly, building up the coats gradually. Usually, 10–40 lb. (40–160 bar) of air pressure will pull the glaze through the spray gun. Spraying is most efficient when the compressor is set at around 30 lb. (120 bar) of pressure.

Spray guns are available with different **orifice** sizes; the larger the particle size of your glaze, the larger the orifice you'll need. For most ceramic spraying, a medium-coarse tip is recommended. If your glaze, underglaze, or stain is finely ground, a smaller tip will deliver a finer-misting spray.

It is important to sieve your glaze through a 50- to 80-mesh screen before spraying, but if the gun clogs up, you may need to screen your glaze through a sieve with a finer mesh. The air intake hole, usually located in the lid of a spray gun, must also be clear of debris or dried glaze to let air into the glaze chamber, allowing the siphoning action to work properly.

Use airbrushes for spraying oxides, ceramic stains, underglazes, lusters, and china paints, and for detail work over small areas (see 14-30, 14-33). And as with spray guns, the material must be sieved and ground fine with a mortar and pestle or in a ball mill. When using oxides or stains in an airbrush, you can add a small amount of gum solution to help them stay in suspension and adhere to the object's surface. The gum-solution recipe is presented in *Expertise*, Chapter 1A. As mentioned for spray guns, when using airbrushes with coarser and more viscous material, you will require a larger orifice. The type of glaze material and the size of the tip will also affect the amount of air pressure needed to pull it through the airbrush; 10–20 lb. (40–80 bar) will usually suffice.

Ready to Fire

Once you have glazed your ware, you are ready to fire. The next chapter discusses loading the kiln, firing temperatures and duration, and kiln atmospheres, all of which affect the glaze.

When you finally take your fired piece out of the kiln, you may be satisfied or even delighted with the glaze, or you may be disappointed and wish to improve it. After firing is the time to refer to and update your glaze records and test results. It is only by building up an understanding of what happened in the kiln that you can improve your knowledge of glazes. Keeping accurate records on fired glaze tests, along with the fired test tiles, will help you develop your knowledge.

COMMON GLAZE PROBLEMS

If you have problems with a glaze, it is important to study and analyze your formula, and later your fired glazed pieces, to try to determine why a particular defect appeared when the ware was fired. How the glaze was formulated, how it was applied, and how it was fired may *all* contribute to the problem, so it is often difficult to know just what went wrong. Here are some questions to consider:

- *Was the glaze correctly weighed and mixed to formula specifications?*
- *Was the chemical dry before it was weighed?* Damp chemicals can contain up to 20% water, causing substantial errors in weighing.
- *Were there any chemical substitutions?* This is often the key to defects and may be overlooked.
- *Was the clay body changed since the previous test?* This could affect the color or the fluxing of the glaze.
- *Was the test glaze applied to a different clay body than the fired ware?* Even a slightly different clay than the one you used for your tests can affect a glaze texture or fluxing ability.
- *To which cone or temperature was the ware bisque-fired?* Bisque-firing at too low a temperature (015–010) could cause pinholes to form in the glaze. Refire at a higher bisque temperature.
- *Were there changes in the glaze firing pattern?* Did you give it a longer or shorter firing?
- *How was the ware placed in the kiln?* Was it placed in a hotter or cooler area?
- *What was the kiln shelf pattern?* Tightly packed or loosely stacked shelves, as well

as the total mass, will affect the heating and cooling of the kiln. This, in turn, will affect the glaze.

- *What type of fuel was used?* Was it changed?
- *What was fired in the kiln previously?* Clays or glazes containing oxides such as copper can affect a glaze in the next firing because traces remain in the kiln.
- *Why does the glaze look thin or washed out?* The glaze mixture may have been thinned with water or the glaze materials may have settled before applying.

With all these factors in mind, study the defects that appear on your pieces for clues to what happened in or before the firing.

Defects in Fired Glazes

CRAZING Several factors can cause fine cracks to develop in a fired glaze. For example, crazing may be caused by an incompatibility between the glaze's and the clay body's rates of expansion and contraction. Crazing can also occur if a glaze is too thick or if a low-fire glaze is applied to a high-fire clay. Altering the clay body, reducing the thickness of the glaze, or using clays and glazes that mature at or around the same temperature may solve the problem.

On the other hand, one person's defect may be another's decorative effect; then the crazing is called *crackle.* Chinese potters appreciated the surface cracks and deliberately increased the amounts of certain ingredients in order to produce them, learning to control the spacing of the cracks. They often rubbed color into the cracks after firing for emphasis. Contemporary ceramists soak their ware in tea or rub various colors of India ink or shoe polish into a glazed surface to enhance the cracks. Crazing is also characteristic of low-fire alkaline glazes. Delayed crazing may occur days, weeks, or even months after firing as a piece absorbs moisture. The moisture creates glaze tension through expansion, causing the glaze to craze.

CRAWLING This defect can occur when there are fingerprints, dust, oil, or grease on the bisque-fired ware or when the unfired glaze shrinks unduly as it dries. Crawling, in which glazed areas alternate with areas of bare clay, can also be

caused by firing a piece when the glaze is not completely dry or by adding too much of certain materials with high shrinkage rates, such as zinc oxide or an opacifier such as zircopax, to the glaze. In slip-cast ware, hard spots in the clay body caused during casting can also induce glaze crawling or cause the glaze to pull away in spots. Pinholes caused by the presence of certain ingredients, such as colemanite, that give off gases when they reach high temperatures in the kiln can also cause glazes to crawl.

Opaque glazes, especially those that have a high percentage of opacifiers such as zircopax, tin oxide, or superpax, and are more viscous than transparent ones, are more prone to crawling; crawling can also occur when a glaze is applied over underglaze. This is especially likely if the underglaze has been applied thickly. A low-fire glaze applied to a high-fire porcelain bisque may also peel after it is applied or crawl when it is fired, owing to differing shrinkage rates; this can sometimes be remedied by adding a few drops of **electrolyte** (such as Darvan #7) to the glaze.

PINHOLES AND PITS Sometimes pinholes and pits are caused by applying glaze to bisque ware that is too porous so that during firing, air or moisture escaping from the pores of the clay body may cause pinholes to develop in the glaze as the vapors burst through it. Also during firing, tiny gas bubbles form while the clay body and glaze components break down in the heat, sometimes causing pinholes and pits to burst through the surface. Ball-milling a glaze can often alleviate pinholes by improving the "melt" of the glaze which may have been improperly mixed or unsieved. Variations in the particle size of glaze chemicals, such as Cornwall stone, wollastonite, or lithium carbonate can affect the glaze melt as well; such chemical combinations should be ball-milled.

Tiny pinholes sometimes also appear in glaze that has been intentionally underfired to achieve a matt effect. Too much zinc or rutile in a glaze can also cause pits. Bisque-firing to a higher temperature, adding more flux, applying the glaze less thickly, increasing the heat, soaking the kiln, or lengthening the firing time may all help prevent pinholes.

BLISTERING With blistering, the surface looks like a magnified photo of the moon's surface,

with many little craters. This is usually caused by gases escaping from a glaze that was fired too rapidly; by applying the glaze too thickly; by applying a glaze that was thinned too much; or, in some low-fire glazes containing frit, by firing them above cone 6.

Refiring Additional Glazes

An already glazed piece that is to be coated with a second or third coat of glaze can be warmed in the kiln first to ensure that the first glaze is dry. Adding a small amount of gum to the second glaze will also help the additional glaze adhere. When reglazing and refiring high-fire pottery, it is often necessary to reglaze the inside of a pot as well as the outside with a thin coat. This helps equalize the tension created on the piece by the second glaze and thus prevents cracking on refiring.

By continuing to study and analyze your glazes as you remove ware from the kiln, your control over this important aspect of ceramics will increase. You will then be able to concentrate on your work's form and image.

POSTFIRING COLOR

If, after trying a range of glazes, you decide that finishing nonfunctional objects or sculpture with glaze is not for you, you can do what many artists do: Use paint. There is nothing new about using paint on fired clay. In fifteenth-century Italy, religious figures sculpted by Nicollò Dell'Arca (see 6-9) and other artists were coated with a thin coat of **gesso** and then painted very realistically, as were many terra-cotta portrait busts made in the sixteenth century by sculptors such as Verrocchio. Acrylic paints, stains, oil paint, enamels—any coloring material you would use on wood or canvas—may be appropriate surface mediums for your sculpture or nonfunctional vessels. Moreover, a clear or matt acrylic medium, terrazzo **sealer,** varnish, shoe polish, or beeswax creates a protective surface that will enhance the color. These types of coatings, however, should not be used on food containers or fountains.

Louise McGinley (see 8-16) never glazes her work but uses acrylic paint, either watered down to a transparent stain or left thick for opaque areas. Beverly Mayeri (see 8-19) and Karla Scholer (14-84) paint their fired work with

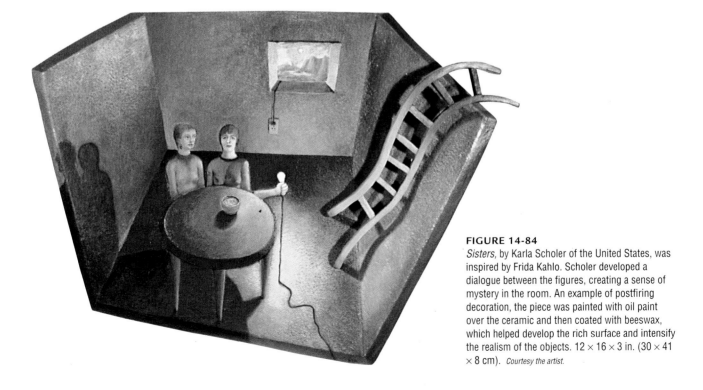

FIGURE 14-84

Sisters, by Karla Scholer of the United States, was inspired by Frida Kahlo. Scholer developed a dialogue between the figures, creating a sense of mystery in the room. An example of postfiring decoration, the piece was painted with oil paint over the ceramic and then coated with beeswax, which helped develop the rich surface and intensify the realism of the objects. 12 × 16 × 3 in. (30 × 41 × 8 cm). *Courtesy the artist.*

nonceramic colors, while Ron Nagle (see 8-13) uses a combination of fired china paints and sometimes applies nonfiring paints to his cups. Paul di Pasqua (14-85) searches for found ceramic objects, which he assembles into imaginative figures, and Toby Buonagurio (14-86) adds glitter, flock, and glass gems to her work.

FIGURE 14-85
Potter/mold maker Paul di Pasqua of the United States no longer does his own glazing. More interested in sculpture, he creates his colorful figures entirely from already-glazed found objects. The pieces are held together with silicone glue. *Courtesy the artist.*

FIGURE 14-86
Poodle Puff Gun Shoes, by Toby Buonagurio of the United States. After glaze-firing, Buonagurio painted lusters on the shoes, adding metallic accents to the surface. She then highlighted the piece with acrylic paint, flock, glitter, and glass gems to complete this metaphor for high style. 17½ × 11½ × 7½ in. (44 × 29 × 19 cm). 1993. *Courtesy the artist. Photo: Edgar Buonagurio.*

15

Firing

Considering the destructive aspects of fire and its ability to transform clay and metal, it is not surprising that early humans believed that fire was a gift from the gods, or that in many early cultures metal workers and potters were considered to be magical or supernatural beings. From the ancient Greeks to indigenous Americans, many peoples have created myths in which gods or goddesses teach humans how to shape metal and harden clay with fire. Even today in ceramics studios you will often see a handformed kiln god or goddess seated atop the kiln—a symbol of fire's power, a protective spirit for the ware being fired.

Is it really true that the fire controls the outcome of your hours of forming and glazing your pottery or sculpture? Yes and no. It depends a great deal on the type of clay, glaze, and kiln you use, as well as on your approach to firing. There are those who believe in giving a considerable amount of control to the fire, enjoying the unexpected effects it can have on the contents of the kiln and responding to the sense of adventure that type of firing gives them. Others are more concerned with retaining their original conceptions, so they try to regulate the firing as much as possible (15-1).

HEALTH AND SAFETY PRECAUTIONS

Before firing a kiln, it is important to address some basic safety issues that will ensure a healthy working environment in the studio.

FIGURE 15-1
Edward C. Persike of the United States unloading a slab-built vessel from a modern computerized electric kiln that also includes a special downdraft venting system that draws moisture and fumes from the kiln chamber and expels them outside. When he glaze-fires, Persike uses the factory-set automatic firing program and fires his work to cone 6 over a period of 12 hours. He bisque-fires thick slab vessels using the computer program customized to fit his firing schedule. *Courtesy the artist. Photo: Diane Persike.*

Storm Collar
Curb
Roof
Rafter
2x Blocking
1 " mineral wool block covered with sheet metal
Hood
3'0" Clear all around

FIGURE 15-2
To vent a gas kiln, the hood must cover the entire top of the kiln, including the flue. The exhaust pipe draws off moisture, heat, and fumes to the outside. If you expect to fire clay or glazes that give off excessive amounts of toxic or noxious fumes, it is best to extend the hood 1 ft. (30.48 cm.) or more around the entire perimeter of the kiln, including the door. A double-wall stainless steel exhuast pipe separated from the ceiling at the penetration point by an insulated mineral-wool collar or box keeps the ceiling and rafter area cool. The top of the exhaust pipe cap generally rises above the roof peak. The specific pipe dimensions and installation design should be calculated by the kiln manufacturer and installed by a licensed sheet metal contractor, who will install the hood and flue in accordance with local and national safety codes. It is always best to hire a licensed sheet metal contractor when installing a hood and flue.

Kiln Ventilation

It is essential that any indoor kiln—whether gas or electric—be well vented in order to draw away the gases and moisture that are released during firing from organic materials in clay, the carbon monoxide produced during incomplete combustion (as in reduction firing), and the heavy-metal fumes that escape from the kiln during glaze firings. Venting can be done on a gas kiln by building a **kiln hood** to exhaust the fumes to the outside (15-2). If needed, an additional room exhaust fan set high in the ceiling or wall will vent residual heat that may accumulate in the room.

For electric kilns, there are ready-made venting systems (15-3). The downdraft vent system operates by pulling a small amount of fresh air through small holes in the kiln lid; fumes are expelled through a pipe extending from the kiln floor or side wall to the outside (see 15-3a, 15-3b). This system, which operates with all the peepholes plugged, removes moisture and contaminants in the kiln chamber for cleaner firings, especially when firing glazes sensitive to contamination. Glaze colors tend to fire cleaner and with less trapped-fume contamination with this

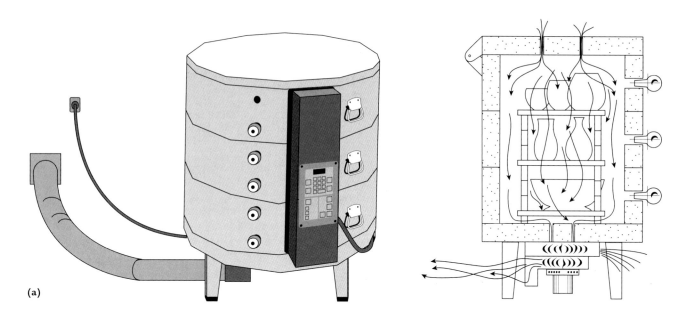

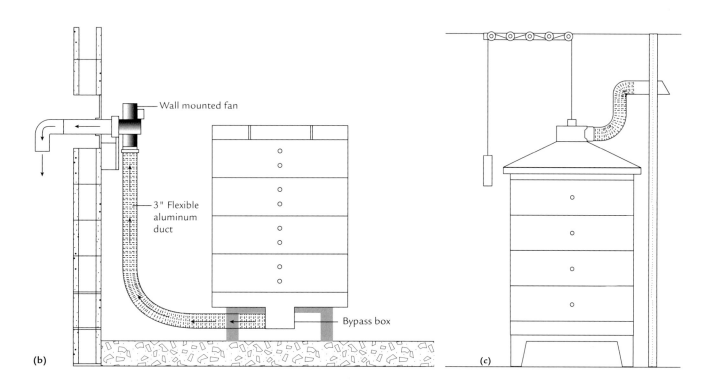

FIGURE 15-3

(a) A top-loading electric kiln with a motorized fan downdraft vent system is fired with the lid and peepholes closed throughout the entire firing. Fresh air is drawn into the kiln chamber through specifically calculated holes drilled into the lid. Moisture and fumes expelled from the clay and glazes during a firing are drawn down, around the ware, and out small holes in the kiln floor to the outside. In addition to this system, some individuals install an overhead hood (see 15-3c) to draw off residual heat or smoke from their kiln. *(b)* A wall-mounted vent system for an electric kiln efficiently draws fumes and moisture out of the kiln. Small holes drilled into the lid let air into the kiln chamber, the air is then pulled down through the chamber, around the ware, and out through the kiln floor. The heat vented out of the pipe extending from the bypass box is about 160°F/71°C, well below a dangerous temperature. *(c)* An aluminum hood with a fan motor made for electric kilns expels fumes, moisture, and heat through a 5-in. (12.7-cm) diameter metal flex hose. A counterweight system in which the entire hood lifts up and out of the way when the kiln is being loaded, then lowers down over the kiln lid during firing.

venting system. A fan motor mounted on a wall is useful when exhausting more than one kiln. A hood with a fan motor mounted on the top (see 15-3c) and attached to a pulley system is excellent for expelling moisture and fumes from top-loading kilns. After a kiln is loaded, the hood is pulled down over the lid and the fan motor turned on during the entire firing. The hood should extend at least 2 in. (51 mm) beyond the lid diameter. (See Chapter 17 for more information about selecting and safely installing a kiln.)

Protection against Open Flames and Infrared Radiation

Remember that while working around a kiln, you are dealing with high heat and, in the case of a gas kiln, an open flame. Especially around a gas kiln, take the same precautions you would take around any gas appliance or open flame:

- Tie back long hair and loose clothing, and keep them under control.
- Protect your eyes from flames and infrared radiation. When looking into a kiln, wear either shaded goggles or a face shield with number-3 to number-5 lenses to protect your entire face from infrared radiation and the flames that often escape through the spyholes during reduction.
- Use aramid fiber (nonasbestos), kevlar, or heat-resistant gloves (or leather welding gloves) whenever you have to touch the hot parts of a kiln.
- When the time comes to unload the kiln, remember that even if the exterior seems cool, the pots inside will be hot. Curb your desire to grab your glazed pot with your bare hands; it may be hotter than you think. If your gloves start to smoke, it's too hot!

STARTING TO FIRE

If you have carried out the clay-body and glaze tests recommended in *Expertise*, Chapter 1A, you have already had some experience with a kiln. Firing clay and glaze tests, however, though interesting, hardly gives one the same satisfaction as firing one's own pot or sculpture.

It is important for you to know what happens in the kiln, because in ceramics everything works together—clay, glaze, and heat interact so that any change in one area of the kiln affects the others. It is important to recognize this, for it means that the aesthetics of ceramics continues through the firing process.

Firing Ranges of Clays

The type of clay used dictates to a considerable extent the temperature at which finished work is fired. Early earthenware pottery, for example, was usually fired only once to a low temperature, generally in an open fire or a rudimentary kiln (15-4). Depending on the heat and duration of the firing, either the ware—pots or sculpture—was heated barely beyond the sun-dried state, or its low-fire clay was brought to maturity; for most earthenwares this would have been about 920°F/510°C. Later, however, when it was discovered that certain clays became denser and more vitreous at higher temperatures, and when high-firing glazes were developed, kilns and their firing became more complex (15-5–15-8; see also 15-22). Today a bewildering number of firing choices are available to a ceramist. These range from single firing, in which dry greenware is placed in a kiln that is slowly brought up to the desired temperature, to multiple firings, in which a piece may be given a bisque firing, then a high firing, and possibly additional successive low firings in order to mature different layers of overglaze.

Some examples of the temperature ranges of modern commercial clay bodies include low-fire clays that begin to get hard but not mature at cone 015 (1501°F/816°C) and mature from cone 06 (1852°F/1011°C) to cone 1 (2109°F/1154°C); medium-range clays that fire between cone 2 (2124°F/1162°C) and cone 7 (2291°F/1255°C); high-fire stonewares that mature between cone 8 (2316°F/1269°C) and cone 12 (2415°F/1324°C); and porcelains, whose range is from cone 10 (2381°F/1303°C) to cone 13 (2455°F/1346°C). The potential range of most clays, however, is considerably wider than labels or recipes may suggest, and you might well find that a particular clay can go to a higher temperature than you would expect. Be sure, however, to test before you try to fire your favorite pot beyond the recommended range.

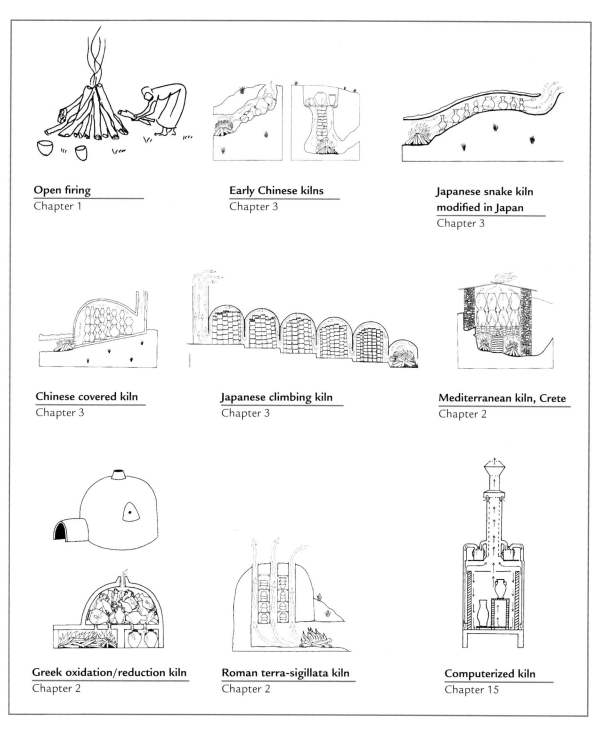

Open firing
Chapter 1

Early Chinese kilns
Chapter 3

Japanese snake kiln modified in Japan
Chapter 3

Chinese covered kiln
Chapter 3

Japanese climbing kiln
Chapter 3

Mediterranean kiln, Crete
Chapter 2

Greek oxidation/reduction kiln
Chapter 2

Roman terra-sigillata kiln
Chapter 2

Computerized kiln
Chapter 15

FIGURE 15-4
This chart shows some of the developments in firing technology throughout history, from open firing through various forms of up-, down-, and multidraft kilns, to today's electric and gas computerized kilns. More information is available in the chapters listed.

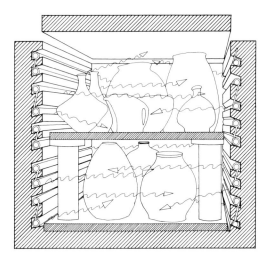

FIGURE 15-5
The heat in an electric kiln is radiated outward from the elements set in the walls. In the United States, electric kilns are generally used for bisque firings and oxidation firings. In other parts of the world, electric kilns are frequently the only type available to ceramists, so if a reduction atmosphere is needed, it must be produced through the introduction of reduction materials either in the kiln or in individual saggars. *Drawing: Danute Bruzas.*

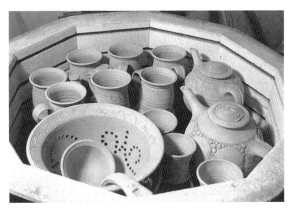

FIGURE 15-6
Bisque firing is often done in an electric kiln even if the glaze firing will be done in a gas or wood kiln. For a bisque firing, a kiln can be loaded tightly, with pieces touching each other or even nested.

FIGURE 15-7
In an updraft gas kiln, the heat from the **burners** goes up through the ware on the shelves and is vented out through the top of the kiln. The modern updraft uses the same principle of rising heat that led to the development of early kilns in Asia and the Mediterranean (see Chapters 2 and 3). *Drawing: Danute Bruzas.*

FIGURE 15-8
A downdraft kiln is designed to send the heat from the burners first upward and then down through the ware to the flue at the bottom. Finally, the heat is vented out the stack at the back of the kiln. A **bag wall** may be built inside the outer walls to direct the flames and heat upward. *Drawing: Danute Bruzas.*

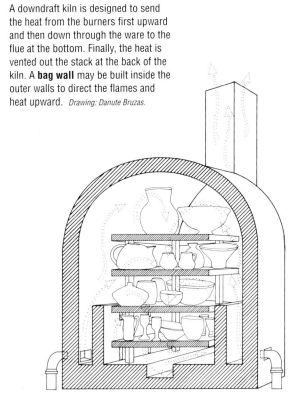

Drying before Firing

We cannot emphasize strongly enough the importance of drying greenware, especially thick-walled pieces. Take extra measures to dry a thick-walled object completely: give it additional drying time next to a space heater or near a kiln that is firing, or use the tent method described in Chapter 11.

You can also place the ware in the kiln with the door left open about 1–10 in. (2.54–26 cm) while the heat starts to rise. Once the piece is thoroughly heated and dry, then close the door and proceed with the firing.

Firing Temperature and Duration

It is important to recognize that to become fully mature, clay and glaze need *time* in addition to heat. An experienced ceramist can judge the temperature of a kiln by looking through a peephole and observing the kiln interior's color as the temperature rises—from dull-red orange, to light orange, to white. (See *Expertise,* Chapter 2A, for a table that shows temperatures and kiln colors.)

A dull-red kiln interior is associated with temperatures of around 1200°F/648.8°C, appropriate for firing luster and china paint; an orange color is seen during bisque or low firings; yellow appears at the usual temperatures for firing earthenware and medium-fired stoneware; and an intense white glow occurs when firing high-fire glazes.

Whenever you peer into the kiln, always wear goggles to protect your eyes from the infrared radiation, which has a cumulative effect on the eyes, possibly causing cataracts. The potential for damage increases with the frequency of exposure. The goggle shades that will protect your eyes from damage range from number-3 lenses for low temperatures to number-5 lenses for high firing. Number 5 will protect you through the entire range.

The experienced ceramist also knows how long to leave the kiln at the correct heat and how long it takes to bring it down to a temperature low enough for unloading. To ensure successful firing, however, it is best at first to use cones and/or a pyrometer or to set a computerized kiln to the appropriate firing program that will control the heat rise and decline over a specified period.

KILN MONITORING EQUIPMENT

Pyrometers

A **pyrometer** is a gauge that measures the temperature inside a gas or electric kiln. It shows the temperature readings as you raise or lower the heat in the kiln and is usually calibrated to show increments of 20°F/–6.6°C. Since the pyrometer is usually installed on the inside wall of a kiln rather than in the middle of the chamber, the readings you get from it will not indicate the temperature throughout the entire kiln; but because the pyrometer shows any temperature change almost immediately, it will indicate whether the kiln is heating or cooling too fast. In that case you can slow the rise or fall of the heat. A pyrometer is a useful aid, but since it can measure only the temperature in the kiln, not the effect of time plus temperature, ceramists usually use pyrometric cones as well.

A pyrometer installed permanently in a gas kiln should have a protective porcelain tube over the thermocouple. This shield protects the thermocouple from the reducing atmosphere and other corrosive elements inside the kiln that slowly deteriorate its special bimetal tip, causing it to wear out sooner than an unprotected one. When a tube is installed over a thermocouple, the temperature read out on the pyrometer gauge can be off by 70°F/21°C or more, causing inaccuracies in the actual temperature. For occasional temperature monitoring of a gas kiln, many ceramists insert a pyrometer without a protective tube over the thermocouple. Doing so allows the pyrometer to register the heat relatively quickly since there is no protective tube over the thermocouple to heat up. Occasional use to measure gas-kiln temperatures causes minimal wear on a temporary thermocouple as compared to the constant wear on a permanently installed pyrometer.

Pyrometric Cones

A pyrometric cone will show you when both the time and the temperature have reached the point at which the clay or glaze has matured. These cones are made of ceramic materials that are formulated to fuse and bend when they have been exposed to a certain amount of saturation. In effect, cones are carefully calculated miniature tests (15-9, 15-10).

(a)

(b)

FIGURE 15-9
Before and after illustrations of large pyrometric cones inserted into a clay pad, called a *cone pad*. *(a)* The cones are set at an 8-degree angle, with the cones placed in a row from left (lowest bending cone) to right (highest bending cone) in the order in which they will slump. *(b)* The fired cone pad shows the slumped cones after a firing. The depression on the pad marks the firing cone; when this cone melts, the correct temperature has been reached. The kiln is turned off when the firing cone bends.

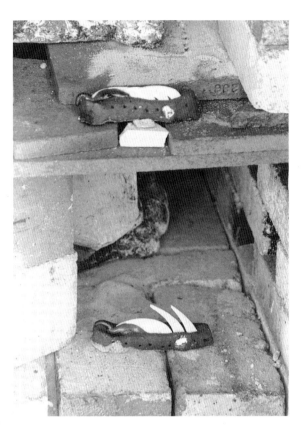

FIGURE 15-10
These two sets of cones show the results from a cone 10 reduction firing. Five cones were set into each clay pad, which was perforated with holes so that it would dry out and not blow up during the initial stage of the firing. Each pad contained (from left to right) cones 05, 8, 9, 10, and 11; cone 05 was set to show when to start the reduction. To make it easier to identify the firing cone (cone 10), a small depression was dabbed with kaolin. The photograph shows evidence of a temperature difference between the upper and lower levels of the kiln: Cone 10 was beginning to bend on the bottom shelf, while on the upper shelf cones 10 and 11 had totally bent over.

American Orton cones and European Seger cones are formulated to bend according to the work done by the heat during a certain temperature rise per hour. The large Orton cones used in the United States cover temperatures from cone 022 (1166°F/630°C) to cone 13 (2455°F/1346°C), with their numbers representing a series of points at which they bend over. The cone numbers and temperatures used in this text are those for the large Orton cones with a temperature rise of 270°F/150°C per hour. Refer to the table in *Expertise,* Chapter 2A. The same table shows equivalent Seger cones and temperatures. The most commonly used Orton cones run from the lowest number of cone 022 (1166°F/630°C) through cone 020 to 018, used for firing lusters and china paints, up to cone 13 (2455°F/1346°C), used for stonewares and porcelains. The cones below cone 1 begin with a zero; they are numbered so that the lower the cone temperature, the larger the number—that is, 022 is lower than 019—a fact that sometimes confuses beginners. There are cones as high as 42, but they are normally used for industrial firings.

To use cones in a gas kiln, insert three consecutively numbered cones in a series. Place them at an 8-degree angle in a wad of clay or in a specially designed reusable, heat-resistant metal cone holder or in soft firebricks cut to support the cones at the correct angle. For a reduction firing, you may insert up to five cones—one to signify when to begin the reduction, three firing cones, and a guard cone (see 15-9).

Usually you would use three cones, known as the *guide cone,* the *firing cone,* and the *guard cone.* For example, you might use cones 06 (1852°F/1011°C), 05 (1915°F/1046°C), and 04 (1958°F/1070°C), placed in a series. To use cones as guides, you must check on them periodically (wearing shaded goggles) through the kiln peepholes. Once the first cone has bent, begin to check on the middle one every 15 to 45 minutes, because at this point the kiln is approaching the

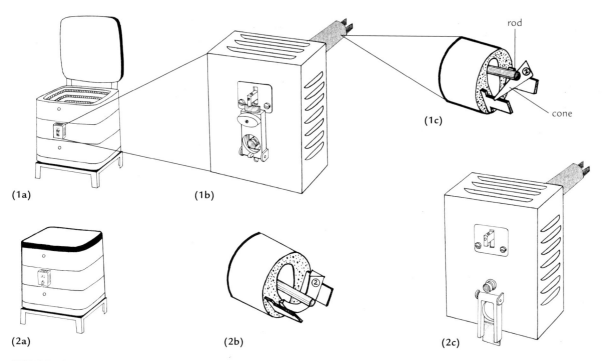

FIGURE 15-11
A kiln sitter (1*a,b*) is a mechanical device attached to a kiln that automatically shuts off the electricity.
A thin metal rod (sensing rod, 1*c*) is held up by a small pyrometric cone that sits on two flat metal bars
(Kanthal tips). To use, place the small cone in the kiln sitter, load the kiln, and close the lid (2*a*). Turn
on the kiln; when it reaches the correct temperature, the cone slumps (2*b*) into a half-moon shape,
lowering the sensing rod. This releases a weight that trips an electric switch, shutting off the kiln (2*c*).

desired temperature. As soon as the middle cone bends, stop the heat rise. If the third cone starts to bend, you have **overfired.** Since there can be a wide difference in heat saturation in a large kiln—as much as several cones' difference—it is best to place several sets of identically graduated cones at different shelf levels (see 15-10).

Draw Rings

A **draw ring** is a small ceramic ring made of the same clay and glaze of the ware inside the kiln. It is a small test to periodically check on the condition of the glaze color, clay color, vitrification, or shrinkage during a firing. The ring, usually 1–2 in. (25–20 mm) in diameter, is made small enough to fit through a spyhole. It has a hole in the center large enough to accommodate a metal rod with a hook on the end that is inserted through the spyhole to extract the ring during a firing (see 15-61b). Draw rings are used in salt or wood firings to accurately check on the firing conditions in different parts of the kiln,

especially when there can be variations in the temperature and atmospheric conditions that may affect the color and surface texture of the glaze or clay. They are especially useful in salt firings for checking on the glaze buildup just after salting. Draw rings are usually used in non-electric firing kilns. If, however, you attempt to use a draw ring in an electric kiln, you must turn off the power before inserting a metal rod into the kiln chamber to avoid electric shock.

Kiln Sitters and Electronic Controls

Since the heat of a kiln must be raised slowly to the correct point, firing requires careful attention. For electric kilns, however, kiln sitters eliminate the need to watch the kiln constantly (15-11). Kiln sitters allow you to place a small cone of the appropriate number in the sitter, set the mechanism, and leave it to the sitter to switch off the kiln mechanically. At the point when the clay cone bends, it trips a switch that breaks the electric circuit. The cones used in sitters are

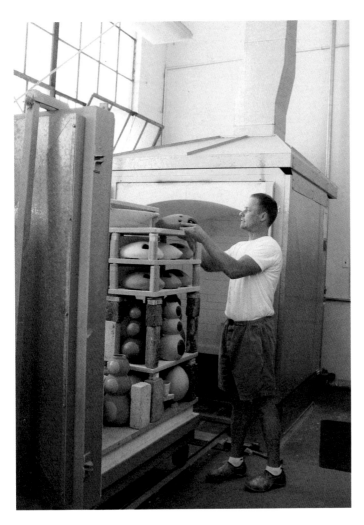

FIGURE 15-12
Bruno Kark of the United States uses state-of-the-art kiln techno-logy with a computerized gas-burner system that automatically increases the temperature based on his firing program. A thermo-couple inside the kiln senses the heat and relays the information electrically to the computer, which operates the main gas valve, increasing, stabilizing, or decreasing the temperature. After the kiln floor is loaded with ware, it is rolled to within a few inches (51 mm) of the chamber and the burners turned on. It is left in this position for a few hours or overnight to dry out the ware. Once the dry ware has been rolled into the kiln chamber and the firing has begun, the door is kept open and some of the burners are turned off to prevent the kiln temperature from rising too quickly during the initial stages, when the ware could blow up.

"junior-sized," and their response is different from that of the large cones placed in gas kilns.

One of the advantages of kiln sitters is that they help prevent overfiring. Nevertheless, it is recommended that a person firing with a kiln sitter, timer, or other automatic control check the kiln within an hour or two of the expected firing time, since equipment is not foolproof. If there is any question in your mind about what is happening inside the kiln, or if the equipment seems to be malfunctioning, turn off the kiln manually, let it cool, and check it thoroughly, or call a repair person.

Computer Controls

Computers that can be programmed to fire either an electric or a gas kiln are now available, re-lieving the ceramist of a great deal of kiln watch-ing (15-12). For electric kilns, the computer can be programmed to do everything you would nor-mally do in a firing except lowering the lid and plugging spyholes. These kilns also give a digi-tal readout on a computer screen that shows the interior temperature (in Fahrenheit and Centi-grade) at all times.

Advances in electronic kiln controllers now provide the ceramist with kilns that fire more evenly from top to bottom than kilns of the past. And since some kilns no longer come with peep-holes for viewing cones or the kiln color, it is im-perative that sophisticated electronics accurately control the kiln temperature. *Zone control* is a kiln feature that monitors and adjusts the tem-perature from top to bottom as the kiln is firing. A series of thermocouples—usually set at the top, middle, and bottom of the kiln—measures the heat, relaying the information to the kiln con-troller. If a section is firing too hot, it will cycle off, and a section that is too cool will cycle on as a means of evening out the temperature of the kiln. A digital temperature readout is expressed in Fahrenheit or Celsius. Some kilns have a switch for each thermocouple that separately registers the heat and provides a detailed tem-perature readout for its particular kiln zone.

There are a number of advantages to firing with a computerized kiln. Fuel is economized because the kiln operates automatically; it ad-justs in power/heat in the manner you have pro-grammed it to climb, hold, or turn off. This elim-inates the need for constant monitoring. You can program a kiln to start at midnight or early in the morning so that when you arrive at your studio it is already up to the specified temperature. The kiln can thus be programmed to turn off when you are present. Although computerized kilns now provide exceptional control over a firing, thus relieving the ceramist of much active mon-

itoring time, the kiln is still made with electrical parts that wear out. For example, if a controller relay wears out, a thermocouple tip burns out, or a kiln element stops working during a firing, the controller will register an error, and the kiln may stop altogether. Therefore, kiln manufacturers recommend that the operator be present when the kiln is timed to turn off—no mechanical device is foolproof.

Many computerized controllers have preprogrammed settings for slow, medium, or fast firing. These programs have been established for firing most pottery and sculpture. On the other hand, although these preprogrammed firing schedules are simple to operate, when firing thick-walled work you may want to establish your own program for slower firing over three or four days or longer. An advantage of computer-controlled kilns is that the entire firing can be preset for the critical stages in the firing cycle. For example, you can program the kiln temperature to rise at a slow rate up to 212°F/100°C, then continue at a slightly faster rate through **quartz inversion** (1070°F/576°C), then continue again at a slightly faster rate up to your desired cone (see *Expertise*, Chapter 2A). Many controllers will retain your last firing in memory, so if you want to use the same schedule for your next firing you will have it already programmed.

Bruno Kark fires his pottery in a gas-fired 54-cu.-ft. (1.53-cu.-m) computerized **car kiln** (or shuttle kiln; see 15-12). Once the kiln is programmed, the computer automatically takes it through a firing. For Kark, a production potter, this relieves him of having to constantly monitor the kiln. When the kiln is up to red heat, he chooses to switch the kiln controller back to the manual mode of firing; he then manually adjusts the gas pressure valve and sets the damper.

Computer-programmed controllers are also ideal for firing glazes that are sensitive to rises and falls in temperatures; crystalline glazes, for example, usually require carefully monitored firings to allow the crystals to grow.

Gas kilns at the European Ceramics Work Centre in Holland are outfitted with totally computerized controllers with software that programs the air-gas mix as well as the amount of reduction atmosphere (see 15-22). An **oxygen probe** inside each kiln measures the atmospheric conditions during a high-fire reduction and is linked to the controller. Powered by an electric motor, the damper plate moves in and

out of the damper slot during the firing. A central computer monitors all the kilns during firings and can adjust or alter the drying periods, firing temperatures, and reduction atmospheres. Because the computer operates all phases of the firings, the results are relatively consistent, and the fuel savings are enormous. Through the elimination of spyholes, unwanted cool air cannot enter the chamber and cause variations in the kiln temperature; this also relieves the ceramist from having to peer into the kiln to view cones or monitor the chamber color to determine the temperature.

Alternative Fuels and Energy Saving

A discussion of kiln design is beyond the scope of this book, but be aware that potters have experimented with fuels other than natural gas, propane, or electricity. Some potters have fired successfully with used crankcase oil, recycling it but perhaps polluting the air. Others have fired with methane gas from the sludge of a paper mill, and at least one ceramist has managed to fire very small pots in a solar-heated kiln. After getting his 36-cu.-ft. (1-cu.-m) kiln up to red heat using natural gas, Gary Holt completes his sawdust-kiln firing using twenty-five large garbage cans of fluffy sawdust generated by a cabinet shop (see 15-51). The shop gladly gives Holt the sawdust so that it does not have to pay the local waste management company to get rid of the material.

Some ceramists have saved energy by using extra insulation—from a mixture of vermiculite and clay applied to the outside walls of a kiln to a **ceramic fiber** wrap around the kiln. Such ceramic fiber insulation is most efficient when applied to the *inside* walls of a kiln, where it reflects the heat best, but it still helps hold in some heat if it is used on the outside.

THE FIRING PROCESS

Assuming that your greenware has completely dried and is ready for placing in the kiln, you have a choice between glazing and firing it in a single firing or firing it unglazed in a bisque firing and then in a **glaze firing.** Since in single firing the ware is handled only once, this can save

TABLE 15-1 Sample Cone 05 Bisque-Firing Program for a Piece ¼–⅜ in. (7–10 mm) Thick

Segment	Total firing time 22 hrs. Rate/hour	Temp.	Hold	Hours	Notes
1	60°F/16°C	240°F/116°C	0	4	lid up 3 in. (76mm), all 6 peepholes open
2	100°F/38°C	1040°F/561°C	0	8	lower lid to 1 in. (25mm) at 400°F/204°C
3	65°F/18°C	1300°F/704°C	0	4	close lid at 600°F/316°C plug 50% of peepholes on the lower kiln sections
4	133°F/56°C	1700°F/927°C	0	3	plug the remaining peepholes except the top one
5	72°F/22°C	1915°F/1046°C	0	3	
Total Firing Time				**22 Hours**	

fuel and labor. Indeed, when the pot or sculpture to be fired is heavy, or when thick walls require a very slow firing, a single firing is preferable in order to eliminate the effort of a second loading. However, since greenware is fragile, many potters prefer to bisque-fire first. In a school studio or a production pottery where a large number of objects must be fired, at least two kilns are necessary—one for bisque firing and one for glaze or sculpture firing.

Bisque Firing

Greenware can easily break while you are handling it or applying a glaze. Also, if the ware has not been bisqued, there is a greater chance that it might blow up in the kiln, causing its glazed fragments to stick to the kiln interior or to other ware. In addition, some glazes are affected by the release of gases from organic materials in the clay bodies that would have been eliminated during a bisque firing. As a result, glazes that have been applied to bisqued ware are generally less likely to be subjected to the bubbling that the escaping gases from these organic materials can cause. Ware that is bisque-fired before glazing also tends to have brighter, clearer colors after it is fired. For all these reasons, you probably will choose to bisque-fire your work to somewhere between 1675°F/913°C and 1915°F/1046°C before glazing it. Bisque firing can be done in any type of kiln, but many prefer to use an electric kiln for bisque firing, even if they use gas for glaze firing.

A bisque firing at cone 010 (1675°F/913°C) not only saves fuel but also leaves the fired ware more porous than a higher firing. This can be a help in applying certain glazes that require an especially absorbent surface in order to build up the correct thickness. On the other hand, some glazes may develop defects such as excessive pinholes or craters when the clay body has been bisque-fired at too low a temperature. If that happens, try a cone 05 (1915°F/1046°C) bisque.

The length of time required to bisque-fire a load of greenware depends on many variables: the type of clay used to build the ware, the thickness of the ware's walls, the level of moisture in the clay, and the amount of ware being fired. A bisque firing should be done slowly so that the moisture in the clay has enough time to disperse. A piece of ceramic can appear dry, yet moisture in the clay can easily account for 15% of its weight. If a piece is fired too fast, steam and pressure built up inside the clay wall can cause an explosion, turning the piece into rubble.

A sample firing program for a cone 05 bisque firing in a 7-cu.-ft. (.19-cu.-m) top-loading electric kiln are included here for you to follow so that you can see how long a typical firing will take when loaded with pottery or sculpture ¼–⅜ in. (7–10 mm) thick (15-13). This firing program can be used with an electric computerized kiln or with a standard kiln with heat-advancing dials, and followed along by using a pyrometer to monitor the temperature rise and help you determine when to turn up the kiln. One difference between a bisque and a glaze firing is the length of time

FIGURE 15-13

This sample cone 05 bisque-firing program for firing pottery or sculpture ⅕–⅜ in. (7–10 mm) thick shows that the entire firing required 22 hours. In theory, the firing begins at zero degrees. *Segment 1:* Preheating the ware took 4 hours with the kiln lid propped up 3 in. (76 mm) and all the peepholes open. The kiln temperature was programmed to rise at a rate of 60°F/16°C per hour until 240°F/116°C was reached. *Segment 2:* The temperature rose at a rate of 100°F/38°C per hour. The kiln lid was lowered to 1 in. (25 mm) when the temperature reached 400°F/204°C. The entire segment occurred over an 8-hour period in which the kiln temperature rose to 1040°F/561°C. *Segment 3:* The kiln lid was closed at 600°F/316°C, and the lower half of the peepholes were closed. The temperature rose at a rate of 65°F/18°C per hour over a period of 4 hours until it reached 1300°F/704°C. *Segment 4:* The remaining peepholes were plugged, except the top hole, which was for venting fumes. The temperature rose 133°F/56°C per hour over a period of 3 hours until it reached 1700°F/927°C. *Segment 5:* During the final segment, the temperature rise per hour was 72°F/22°C for a total of 3 hours until 1915°F/1046°C was reached, at which point the kiln was turned off and left to cool.

Segment	Rate	Temperature	Hold	Hours	Notes
1	60°F/16°C	240°F/116°C	0	4	lid up 3" (76mm), all 6 peepholes open
2	100°F/38°C	1040°F/561°C	0	8	lower lid to 1" (25mm) at 400°F/204°C
3	65°F/18°C	1300°F/704°C	0	4	close lid at 600°F/316°C, plug 50% of peepholes on the lower kiln sections
4	133°F/56°C	1700°F/927°C	0	3	plug the remaining peepholes except the top one
5	72°F/22°C	1915°F/1046°C	0	3	

Firing Notes: Cone 05 Bisque Firing

Total Firing Hours: 22
Clay thickness: 1/4–3/8" (7–10mm)
Clay type: Low fire white clay
Ware type: Wheel-thrown pottery, small handbuilt sculpture
Kiln style: Top-loading electric 7 cu. ft. (.19 cu. m.)
Firing atmosphere: Oxidation
Firing speed: Medium slow bisque
Firing temperature: 1915°F/1046°C

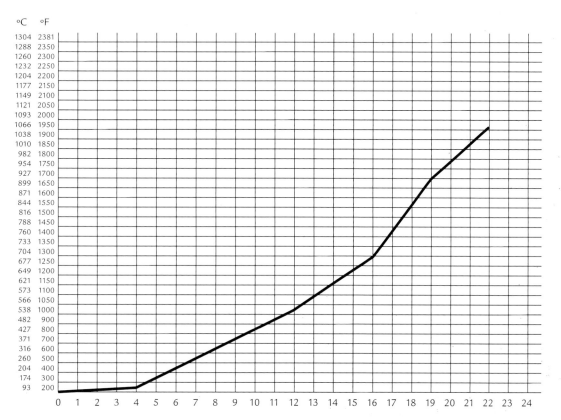

required; a bisque firing can easily take twice as long as a glaze firing. Additional firing programs and graphs are included in *Expertise*, Chapter 2B.

Loading a Bisque Kiln

To stack an electric kiln with greenware, first set the kiln sitter or electronic control, then load the ware and turn on the kiln. In a gas kiln, you would first place the ware on the shelves and then insert the cones and set the controls.

Without any melting glaze to cause the ware to stick together, the pots or sculpture in a bisque kiln can be tightly stacked, even touching or nested inside each other (see 15-5, 15-6). A closely stacked bisque load, however, necessitates a slower firing than one that is stacked more loosely. It is wise to turn thick-bottomed pots or sculpture upside-down so that the moisture can escape more efficiently.

In a bisque firing, the clay should not reach full maturity because the objects to be glazed should remain absorbent enough for the glaze to adhere to them. Once the kiln has reached the desired temperature for the bisque, it must be cooled very slowly, probably overnight. If you open the door too soon, the ware may crack. The raw clay has now been changed by the action of the fire to a new material—one that can never revert to its original chemical or physical state.

Raising the Temperature

With the ware in the kiln, the computer set or the cones in place (see 15-10), the controls set, and the door closed or bricked in, the temperature can be raised. As the temperature rises, the ware will go through many phases before you open the kiln door again.

Water Release

Remember that by the time the heat in the kiln has reached about 660°F/348°C, most of the water that was still left in the clay has been driven out in the form of vapor. This is a critical time in firing, because if the heat is raised too rapidly during this period, the object can explode as the steam escapes. The more temper there is in the clay, the more porous the clay will be, and the spaces be-

tween the particles will allow the steam and gases to escape. For this reason, thick-walled pots or sculpture should be made with a high percentage of grog or other temper—20 to 40%.

As the temperature continues to rise to between 1650°F/900°C and 2010°F/1100°C, the chemical water (H_2O) that has combined with the molecular structure of the clay particles is also driven out, along with the gases formed by the decomposition of any organic materials remaining in the clay. These gases can cause problems as they escape, especially in a glaze firing, when they can cause pinholes, bubbles, or craters as the glaze melts. So by raising the temperature slowly and high enough to cleanly burn off organic materials, the later glaze firing will be more successful. It is essential that the fumes and smoke emitted from the kiln as these organic materials decompose be removed by a well-functioning ventilation system.

Quartz Inversion

As it is fired, clay undergoes various changes, some visible, some invisible. One invisible change that takes place as the kiln is heated and the silica crystals in the clay change in volume and form is a phenomenon called *quartz inversion*. As it is heated, the silica contained in the flint, quartz, or sand in the clay first expands gradually; then, at the quartz inversion point—between about 440°F/227°C and 1070°F/577°C—a series of rapid changes and expansions in the silica takes place. After the clay has been fired to maturity, if the temperature changes during these expansion and contraction periods have been too rapid, they can cause fracturing of the clay body. The same applies to glaze firings, during which these stresses can affect the fit of the glaze to the clay.

Vitrification

The term *maturity* refers to the point at which the clay has been fired as high as possible, before it starts to slump and melt. At maturity, certain clays, such as stoneware and porcelain, become vitrified: rocklike and dense. Potters like to fire their high-fire ware to vitrification so that it becomes impermeable to moisture and will not allow liquids to seep through it. Although low-fire clays are said to be vitreous when they

are fired to maturity, they generally are not impervious to water. For this reason, to make low-fire ware watertight, the potter will often glaze it on the bottom as well as the inside.

GLAZE FIRING

Before you start to fire a glaze kiln, you need to know something about kilns and the atmosphere in the kiln. The school studio will frequently have a gas kiln as well as an electric one, and chances are you will be taught to use the gas kiln to fire your glazed ware.

There are many types of gas kilns—updraft, downdraft, cross-draft, with natural or forced-air-type burners, and with multiple burners at angles that can create a swirling effect—but the most common types are variations within the two categories of updraft and downdraft kilns. These terms describe the flow of the heat as it enters from the burners or other fuel source and exits through a vent or chimney (see 15-7, 15-8). The kiln may also have a **muffle** or a bag wall in the chamber to protect the ware from the direct flame. Variations in these factors will affect the final surface and appearance of the glaze.

Kiln Atmospheres

There are three atmospheres that may develop in the kiln as it fires: *Oxidation* and *reduction* atmospheres produce very different effects on clays and glazes, as we discuss in the following sections; a **neutral atmosphere** is the point at which the kiln atmosphere is balanced between oxidation and reduction. Craig Petey, who fires his pottery in a wood kiln says, *A neutral atmosphere in my kiln is the point just after the stoked wood has completely burned out and the reduction atmosphere is transitioning into an oxidation atmosphere.*

OXIDATION This is a clean-burning atmosphere. Any burning requires some oxygen if it is to continue, and if plenty of air is entering a fire, it will produce an oxidizing atmosphere, in which the fire can burn bright and clear, with full combustion taking place. Oxidation gives glazed work a certain appearance (see "Firing Low-Fire Glazes," p. 449).

REDUCTION Reduction is the result of incomplete combustion, which produces smoke and carbon. When such an atmosphere is produced in a kiln, the carbon and carbon monoxide formed in the oxygen-starved fire draw oxygen from the clay body or from the oxides in a glaze. When this happens, some of the oxides in the clay or glaze lose oxygen; they are then said to be reduced. Depending on how much oxygen is removed from the oxides, the color of clay or glaze can change radically. A dramatic example of what reduction can do to the color of a glaze ingredient is the color change that takes place in copper oxide: When fired in an oxidizing atmosphere, copper oxide becomes green, but in a successful reduction atmosphere it becomes red. Thus, it is obvious that the atmosphere of the kiln plays a vital role in creating glaze effects.

During a reduction firing, there is visible evidence of the reduction process: In an updraft kiln, the flames may have a greenish tinge, and in an up- and downdraft kiln, black carbon forms around the spyholes or door jambs. As the reduction firing is nearing completion with all burners on, the gas pressure up, the air valves open, and the damper adjusted, a sense of excitement builds. At this point, when the heat is high, a soft roar comes from the kiln, and the flames dance as they leave the chamber. The kiln deity is working its magic while the fire gives the clay a new life.

Depending on the kiln, or on the methods used, you can change the kiln atmosphere from oxidizing to reducing either by controlling the flow of air into the kiln or by cutting down on the draft. Closing the damper of a gas kiln about 85 percent, for example, forces the air to back up and prevents new air from entering the kiln; thus, as the oxygen in the kiln is consumed, the fire is forced to draw oxygen from the oxides. Many stoneware and porcelain glazes require reduction to reach their best appearance, but the reduction must be controlled and not become too heavy; otherwise the clay body can become brittle. One way to monitor the amount of reduction in a kiln is to use an oxygen probe, which will help in achieving a consistent reduction atmosphere.

Each ceramist develops an individual reduction firing pattern. For example, some begin reducing at cone 05 and maintain that atmosphere all the way to the end of the firing, whereas others reduce twice—once around 1900°F/1038°C for 1 hour and again during the last hour of firing.

Reduction in Electric Kilns

An electric kiln will always fire with an oxidizing atmosphere unless you take special steps to change the atmosphere. Where stringent fire regulations prohibit gas kilns in built-up areas, ceramists who want to achieve glazes that require reduction have to reduce in their electric kilns by adding smoke-producing materials. This material may range from excelsior or straw to mustard seeds, seaweed, sawdust, pine needles, or paper—anything that will burn and create a local reducing atmosphere. Alternatively, you can place the materials directly in the kiln or place your ware in a saggar (a protective container) along with the reducing material. This method of using saggars is the opposite of their original use, which was to protect the delicate ware in the kiln from the effects of flame and carbon (see 3-22).

The addition of approximately 1% of the chemical **silicon carbide** 3F (carborundum) powder to some glazes also creates a reducing effect. For example, silicon carbide powder mixed with some copper-containing glaze creates a localized reduction when fired in an electric kiln at cone 6, resulting in an ox-blood-colored glaze. Another method of creating a reduction atmosphere in an electric kiln is to introduce an inert gas or a small amount of propane into the kiln chamber after it has reached red heat.

These methods make it possible to reduce in an electric kiln, but constant reduction firings can wear out the electric elements and wiring connectors, and any reduction material that remains in the kiln after such a firing can spoil certain glazes that you might want to fire in it later. To reduce wear on the elements and to clean the kiln, heat the empty electric kiln to high heat, or fire it under oxidizing conditions, after each reduction firing. Even heavy-duty electric elements, however, will eventually have to be replaced if they are subjected to frequent reduction atmospheres.

THE GLAZE KILN

When the glaze has dried after applying it to the ware, you are ready to proceed with the glaze firing. Before loading the kiln, be sure that its interior is clean and there are no loose fragments in the brick lining that can fall on the ware. The next step is to load the kiln, using **kiln furniture.**

Kiln Furniture

Kiln furniture consists of heat-resistant slabs, shelves, and posts that support the ware in the kiln during firing (see 15-15). Kiln shelves are commonly made of three materials: silicon carbide, high alumina, and cordierite. Cordierite shelves ½–⅝ in. (13–16 mm) thick are commonly used in electric kilns up to cone 6, and shelves 1–1½ in. (25–38 mm) thick are used to cone 10. These can withstand rapid heat fluctuations without cracking. Silicon carbide and high-alumina shelves are used in gas kilns since they can withstand the high temperatures needed to fire stoneware and porcelain without excessive warping. Silicon carbide shelves range in thickness from ⅝–1¼ in. (16–32 mm); the higher the temperature and the heavier the load on each shelf, the thicker the shelf you should use.

Lightweight, thin (approximately ⁵⁄₁₆ in. [14 mm] thick) silicon carbide kiln shelves are now available as well. These are popular with potters because they cause less back strain when loading and take up less space inside the kiln than the older, thicker shelves.

Kiln Furniture Accessories

In addition to kiln shelves and posts used for supporting pottery and sculpture in a kiln during firing, there are also various types of refractory supports and wire racks used for firing beads, tiles, and plates (15-14). In many cases more ware can be fired in a kiln when using tile racks or bead trees. They save space because they reduce the number of kiln shelves needed for a load. Also, using a rack or stackable plate holders is a more efficient way to fire glazed plates or tiles, since heat from the kiln can easily radiate around the entire ware, helping the glaze melt more evenly.

Most tile racks and tile holders can be fired up to cone 5. Wire bead trees and racks can be fired to around cone 1 safely. In most cases the refractory supports and racks have a high-fire rating, but the ware being supported often slumps or warps on a rack if fired too high. It is best to consult with your supplier to find

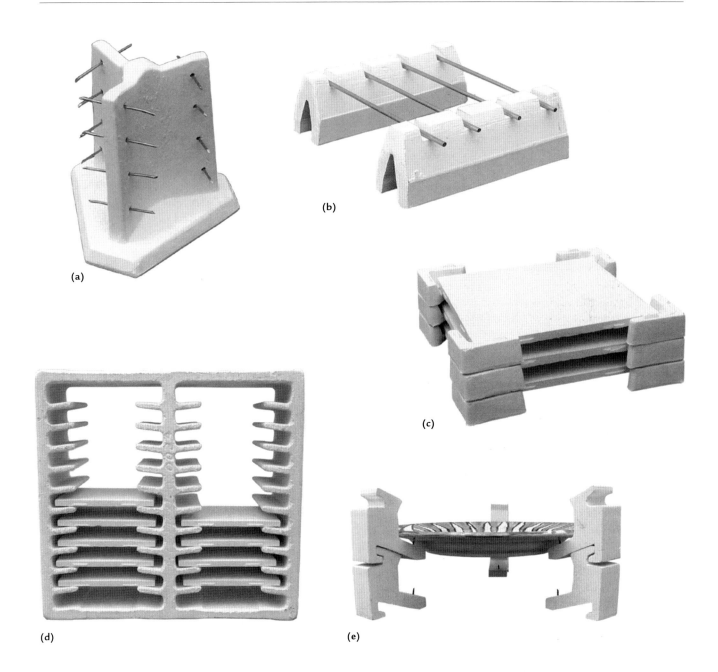

FIGURE 15-14

Bead, jewelry, tile, and plate firing racks and supports make loading kilns easier and also reduce the number of kiln shelves needed. Most wire racks work best when fired between cone 05 and cone 1. Firing higher than cone 1 can be risky in that the wire may fatigue and bend under too much heat or the weight of the object being fired. Tests should be conducted when firing racks above cone 1. *(a)* A bead and jewelry tree supports small glazed pieces on high-temperature wire. *(b)* A rack with high-temperature wire placed horizontally is convenient for loading and firing beads. *(c)* Stacking corner tile posts for loading and firing commercial tiles is an economical way to fire tiles. *(d)* The easiest way to load and fire tiles under ½ in. (13 mm) thick is with a tile rack. Tiles can be loaded into a rack outside the kiln and then the entire rack can be lifted into the kiln. Tile racks can be stacked one on top of another. The maximum temperature for a tile rack is around cone 5. *(e)* Stacking-style ceramic and metal-point plate stilts work well when firing plates that are the same size. The metal points may leave a glaze firing mark on the backside of a plate that must be sanded with a grinding stone.

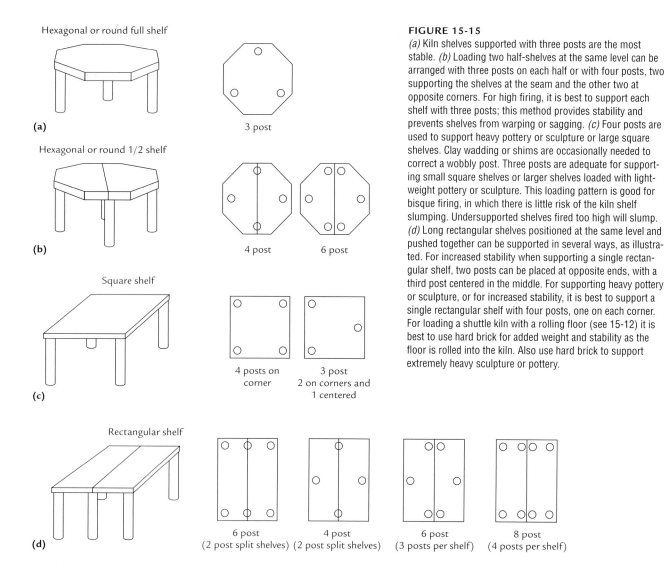

Hexagonal or round full shelf

(a)

3 post

Hexagonal or round 1/2 shelf

(b)

4 post 6 post

Square shelf

(c)

4 posts on corner

3 post 2 on corners and 1 centered

Rectangular shelf

(d)

6 post (2 post split shelves)

4 post (2 post split shelves)

6 post (3 posts per shelf)

8 post (4 posts per shelf)

FIGURE 15-15

(a) Kiln shelves supported with three posts are the most stable. *(b)* Loading two half-shelves at the same level can be arranged with three posts on each half or with four posts, two supporting the shelves at the seam and the other two at opposite corners. For high firing, it is best to support each shelf with three posts; this method provides stability and prevents shelves from warping or sagging. *(c)* Four posts are used to support heavy pottery or sculpture or large square shelves. Clay wadding or shims are occasionally needed to correct a wobbly post. Three posts are adequate for supporting small square shelves or larger shelves loaded with lightweight pottery or sculpture. This loading pattern is good for bisque firing, in which there is little risk of the kiln shelf slumping. Undersupported shelves fired too high will slump. *(d)* Long rectangular shelves positioned at the same level and pushed together can be supported in several ways, as illustrated. For increased stability when supporting a single rectangular shelf, two posts can be placed at opposite ends, with a third post centered in the middle. For supporting heavy pottery or sculpture, or for increased stability, it is best to support a single rectangular shelf with four posts, one on each corner. For loading a shuttle kiln with a rolling floor (see 15-12) it is best to use hard brick for added weight and stability as the floor is rolled into the kiln. Also use hard brick to support extremely heavy sculpture or pottery.

out your refractory supports' maximum firing temperature.

Kiln Wash

Most potters and sculptors brush or roll the top surfaces of new kiln shelves with two or three coats of kiln wash. Kiln wash acts as a separator, so that if the glaze drips onto the shelves from the ware, the shelves can be easily cleaned. The wash is a mixture of one-half china clay (kaolin) and one-half flint, plus two to five percent bentonite diluted with only enough water to make it possible to paint it on. Usually, after a dozen or

more firings, glaze drippings will need to be scraped off and a new coating of kiln wash applied. Shelves that are heavily coated with glaze and kiln wash may need to be brushed and scraped or sandblasted to clean them thoroughly and then recoated with kiln wash.

Arranging Kiln Shelves

It takes a good deal of ingenuity to arrange kiln shelves on posts so that they provide the most space and support for the various shapes of work you may want to fire (15-15). When you start to build up the shelves, use three rather

than four posts for each shelf; three points make for a firmer support. However, it is best to support kiln shelves with four posts when loading heavy sculpture or when loading a car kiln that may vibrate while being rolled into the kiln chamber and possibly cause the shelves and ware to tumble.

If a shelf does not sit evenly on its posts, take a small wad of clay, shape it into a wafer (called a *shim*), and dip it into alumina oxide or high-fire kiln wash powder. It is best to use high-fire clay—preferably a white stoneware type—for such shims. Place the soft wafer on the uneven post; then position the kiln shelf on the posts and lightly pound it with the palm of your hand until it seats itself. To shim a large kiln with many shelves, use a heavy rubber mallet to tap the shelves down onto the clay shims. When there are large gaps between shelves and posts, use a low-shrinkage mixture of coarse grog mixed with the smallest amount of fire clay necessary to bind it; blend it with water into a stiff, puttylike consistency; and use it to shim the posts.

Stilts

Since low-fire ware needs to be glazed on the bottom to be watertight, you will need to use stilts to keep it from sticking to the kiln shelves (15-16). Stilts are triangular supports on which the ware is balanced on the kiln shelf; they leave only small marks in the glaze when they are removed.

Three types of stilts are available commercially. For low-fire ceramics, the stilts may be made of clay and are generally rated to withstand temperatures from cone 05 (1915°F/1046°C) or lower up to cone 1 (2109°F/1154°C). Clay stilts with metal points are also good for low firing; the points leave only small marks on the foot when they are removed after firing. The sharp edges left after removal can be filed or ground down (wear goggles and a respirator), and the spots can then be touched up with paint, colored epoxy, or marking pens. The third type of stilt is all metal—a special heat-resistant metal that can be fired to cone 1, although some potters fire them successfully to cone 5 or higher. These are reusable, so they may be well worth the extra cost.

It is possible to make your own supports from nichrome wire for low firing and from Kanthal A1 or kiln-element wire for high firing, but don't

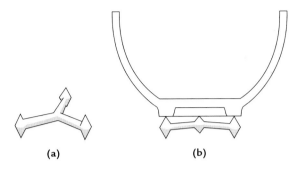

FIGURE 15-16
Triangular ceramic stilts support ware and keep glazed bases and feet from sticking to the kiln shelves during firing. They are used primarily for low-fire applications up to cone 1 (2109°F/1154°C). *(a)* A stilt showing three points of contact. *(b)* A cross-section of a low-fire bowl that has been entirely glazed, including base and foot, resting on a reusable stilt that will keep it from sticking to the kiln shelf.

use coat hanger metal—it will fatigue or disintegrate in high firings. There are other ways to keep ware from sticking. For example, Ewen Henderson of England stilted his sculptures by placing them on oyster shells and firing them to stoneware temperatures.

Because clays that fire above cone 10 (2377°F/1303°C)—porcelain and even some high-fire stonewares—soften as they reach the high temperatures at which they mature, anything made from those clays will slump and warp if it is placed on stilts. Therefore, objects made of these clays must be placed flat on the shelf; for that reason, their feet must be unglazed. Early Chinese potters frequently fired their porcelain bowls upside-down to keep them from warping, leaving a band of unglazed clay around the rim to keep the piece from sticking to the shelf. They frequently turned this glaze-free rim into a decorative feature by covering it with a band of metal.

Loading a Glaze Kiln

One of the challenges of loading a glaze kiln is to find just the right spot for each piece, where it will not touch any other (15-17). It is best to leave at least ¼ in. (6 mm) between pieces when glaze-firing. When the glaze goes through its maturing process, it bubbles up, and the bubbling glaze on pieces set too close to each other may touch and cause the pieces to stick together as the kiln cools.

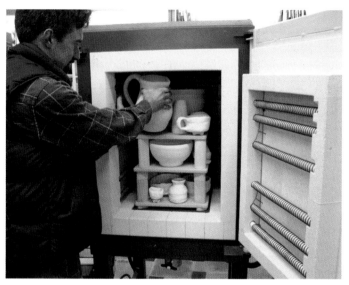

(a)

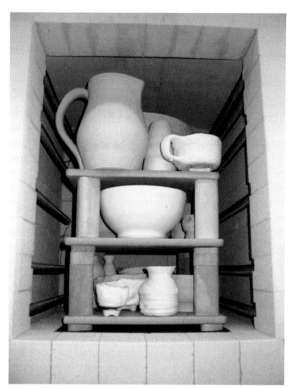

FIGURE 15-17
(a) Bryan Higgins of the United States loads an electric kiln with low-fire glazed ware, leaving about ¼ in. (6 mm) between pieces so that they will not stick to each other during the firing. *(b)* Pottery that has been completely glazed, including the bottom, is stilted so that the glaze will not stick to the kiln shelf. Higgins stacks the tallest or widest work on the top shelf, where there are no posts to impede the loading. *Photo: Nabertherm Kilns, Germany.*

(b)

FIGURE 15-18
Kathleen Weideman of the United States unloads her pottery from a front-loading Paragon Industries computerized electric kiln that was fired to cone 6. For kiln shelf stability, Weideman loads smaller pieces in the bottom half of the kiln and taller pieces in the middle, where the heat is the most even. *Courtesy the artist.*

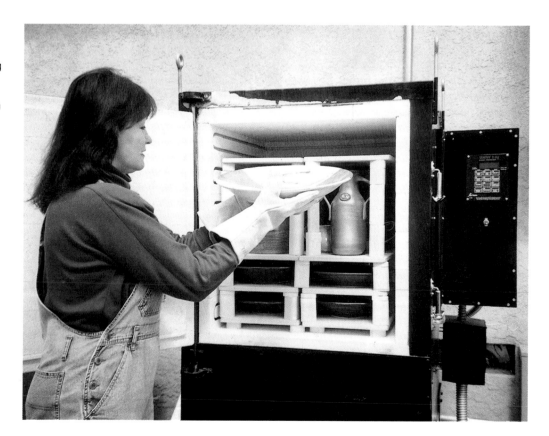

To help stabilize kiln shelves and posts, it is best to arrange small sculptures or flat ware such as plates and saucers in the lower half of a kiln, and then set taller works in the middle, where the heat tends to be most even (15–18). Also, increasing the space between shelves will provide more efficient heat radiation to the ware. For example, if a plate is loaded on a shelf with ¼-in. (6-mm) clearance from the shelf above, as compared to 1 in. (25 mm), it is possible that the glazed ware may not fire adequately under the most ideal conditions. Efficient glaze melt on ware may be reduced by placing kiln shelves too close together. Professional potter Bruno Kark found that increasing the distance between his shelves by 1 in. (25 mm) or more when he loaded his car kiln dramatically affected the glaze melt and color on some of his flat ware.

In a gas kiln, the quality of a reduction-firing atmosphere can also be affected if the heat is restricted by kiln bricks, posts, and shelves too densely packed in the kiln, which could also cause uneven fired results. **Flashing,** a term used to describe a fired piece that comes out of the kiln with distinctly different colors on different sides even though the glaze was applied uniformly, is often caused by the flame being directed onto a pot by a shelf, post, or other ware. This tends not to be a problem in electric kilns because the heat radiates from the side wall elements to the center of the kiln, providing more even heat throughout the chamber.

Each kiln, regardless of its type, has its idiosyncrasies. For example, many kilns have hot spots where certain glazes would be overfired. Once you have become acquainted with a particular kiln, you will know which areas go to a higher heat and which areas get more reduction than others, so you will be able to load the kiln according to the heat and atmosphere each piece requires. Finally, when the kiln is loaded, place sets of cones in appropriate places, usually in the middle of the kiln and possibly also at the top and bottom; the number of sets you use will depend on the size of the kiln and its individual variations.

Glaze in the Kiln

The chemical composition of clay or glaze is affected by the heat of the kiln and the type of fuel used to fire it. It is also important to remember that glazes fired quickly in a small test kiln (for example, 6 × 6 × 6 in., or 15 × 15 × 15 cm) will yield different results than they will when fired in a large kiln with a similar atmosphere. In general, glazes are brighter and richer in depth when fired in a full-size kiln.

If you look through the kiln peepholes at the right moment (wearing the correct goggles), you will see the glaze actually melting. In this stage the glaze bubbles and boils, and you may well wonder if it will ever become the smooth, glossy surface you pictured on your pot. It usually does, and the bubbles generally smooth out as the melting process continues—assuming that there are no problems with formulation, fit, application, or firing.

Rate of Temperature Rise

The slower the temperature rises in the kiln, the better. No ware was ever damaged by raising the temperature too slowly, and the speed at which you raise the kiln temperature is especially critical in the initial stages of glaze firing. Even if the glazed bisque ware appeared to be thoroughly dry, there may have been some moisture in the clay, and if this is driven off too quickly as vapor through the glaze, it can damage the adhesion of the glaze to the clay surface, causing defects. Kiln temperature is usually raised at a rate of around 150°F/65.5°C to 210°F/100°C an hour as an average for the firing.

How long it will take to bring a kiln to the point at which a particular clay or glaze will mature will vary from one kiln, clay, or glaze to another and will depend on the amount of ware in the kiln: Temperature rise will take longer in a tightly packed kiln, and the type of objects being fired in the kiln will also influence how quickly the temperature should be raised. For example, some potters will bring a kiln of thrown ware up to cone 10 reduction in 10 hours. Sculptors, on the other hand, may preheat the kiln with sculpture in it for two days before starting to fire it. Other factors may also influence the amount of time needed: A kiln located outdoors may retain moisture in the porous brick of the firing chamber and require a much slower start to dry it out, and obviously weather conditions can affect the firing speed. A good rule of thumb is to go slowly until the pyrometer gauge is at 1200°F/648.8°C or the entire kiln becomes red-orange; then you can go faster.

TABLE 15-2	Cone 06 Bisque-Firing Program by Gary Holt			
Time	*Temperature*	*Gas Pressure*	*Burner*	*Notes*
8:00 PM–7:30 AM	375°F/196°C	¼ in. (1 millibar)	#1	preheat overnight with door closed, very low flame
7:30 AM	375°F/196°C	¼ in. (1 mb)	#2	light second burner; keep pressure at ¼ in. (1 mb)
12:00 PM	800°F/427°C	¼ in. (1 mb)	#3	light third burner; keep pressure at ¼ in. (1 mb)
4:00 PM	1250°F/677°C	½ in. (2 mb)	#4	light last burner; increase gas pressure to ½ in. (2 mb)
6:00 PM	1500°F/816°C	¾ in. (3 mb)		increase gas pressure to ¾ in. (3 mb)
7:30 PM	1650°F/893°C	1 in. (4 mb)		increase gas pressure to 1 in. (4 mb)
8:00 PM	1750°F/954°C	1 in. (4 mb)		cone 08 bent over
8:15 PM	1800°F/982°C	1 in. (4 mb)		cone 06 beginning to bend
8:40 PM	1830°F/999°C	1 in. (4 mb)		cone 06 bent over; turn off kiln and close damper

Total Preheating (11.5 hours) and Firing (13.1 hours) Time = 24.6 Hours

FIGURE 15-19

Gary Holt of the United States bisque-fires a kiln load of wheel-thrown pottery ⅕–⅜ in. (6–9 mm) thick in a four-burner natural-draft downdraft gas kiln to cone 06. The firing takes a total of 24.6 hours. After preheating the ware on a low flame with the first burner for 11.5 hours, the temperature reaches 375°F/196°C. Holt then lights the second burner and maintains a gas pressure of ¼ in. (1 mb). After 4.5 hours the kiln temperature is 800°F/427°C, at which time Holt turns on the third burner and keeps the gas pressure at ¼ in. (1 mb). After 20 hours the kiln temperature is 1250°F/677°C; Holt then lights the fourth burner and increases the gas pressure to ½ in. (2 mb). Because the temperature is beyond quartz inversion, Holt can safely increase the temperature without blowing up the ware. After 22 hours the kiln temperature reaches 1500°F/816°C, and Holt turns the gas pressure up to ¾ in. (3 mb). After 23.5 hours the kiln temperature rises to 1650°F/893°C, and Holt turns the gas pressure up to 1 in. (4 mb). At 24 hours into the firing, cone 08 bends over. At 24 hours and 15 minutes, cone 06 is beginning to bend, and at 24 hours and 40 minutes, cone 06 bends over and the kiln is shut off and the damper closed. The kiln is left to cool for about a day and a half before being unloaded.

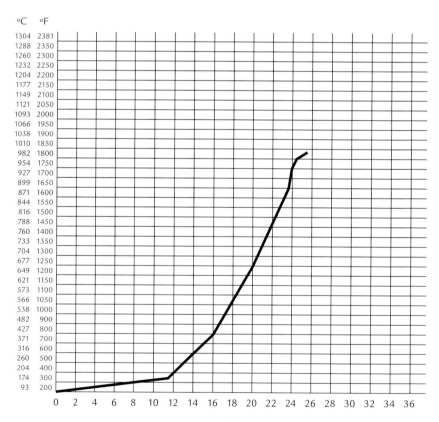

TABLE 15-3	Cone 10 Reduction Glaze-Firing Program by Gary Holt		
Time	*Rate/hour*	*Temperature*	*Notes*
8:00–11:45 AM	467°F/242°C	1750°F/954°C	Begins body reduction at cone 08 for 1 hour
11:45–5:00 PM	95°F/35°C	2250°F/1232°C	Increase reduction atmosphere at cone 6
5:00–6:15 PM	40°F/4.4°C	2300°F/1260°C	
6:15–7:00 PM	66°F/19°C	2350°F/1288°C	
7:00–8:00 PM	31°F/−.55°C	2377°F/1303°C	
8:00–9:00 PM			Soak kiln for 1 hour. Turn off two (two of four) back burners, and reduce gas pressure to 1 in. (4 mb). This lets the glazes smooth out, eliminating glaze bubbles. The kiln temperature will drop slightly.
Total Firing (12 hrs.) and Soak (1 hr.) Time = 13 Hours			

Using Cones

Cones are very helpful for determining when to raise the kiln temperature. Place the cones where they can be seen easily but as far as possible out of the direct flame or draft so that they will give accurate readings. Then check them often for signs of bending. As the first one bends, monitor the kiln more carefully (every 25 to 45 minutes for an electric kiln, every 15 to 60 minutes for a gas kiln) to be sure that you leave enough time between the bending of all the cones. Using such conservative timing, thirty students (who used and fired about nine to ten tons of clay in a semester) had 100% firing success.

Gary Holt, who has been a professional potter for over thirty-three years bisque-fires his ware to cone 06 in a 16-cu.-ft. (.45-cu.-m) downdraft kiln. By following his firing plan, you can see that he preheats his ware for 11½ hours and fires for an additional 13 hours (15-19). Note that in the beginning stages of the firing, when he lights the second burner, he does not increase the gas pressure but lets the heat build up inside the kiln. When the temperature is at 1250°F/677°C and past quartz inversion (1070°F/577°C), Holt increases the gas pressure steadily to ½ in. (2 millibar), then ¾ in. (3 mb), and finally fires off the kiln at 1 in. (4 mb) pressure.

Holt fires his pottery in a reduction atmosphere to cone 10 (15-20). The entire process takes 12 hours, including a 1-hour soak (15-21). During the first 3½ hours of the glaze firing, Holt

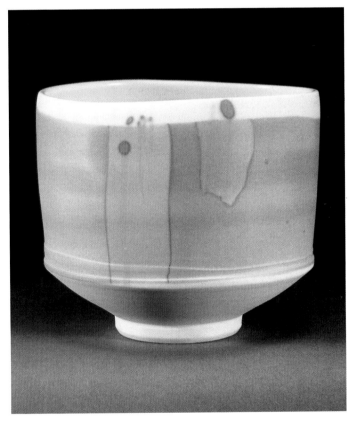

FIGURE 15-20
A delicately thrown and trimmed porcelain bowl by Gary Holt is clear glazed on the inside and decorated with soluble metal salts (gold, cobalt, and tin chloride) on the outside, producing bold lavender-colored brushstrokes. Fired in a reduction atmosphere to cone 10. Ht. 4½ in. (114 mm). *Courtesy the artist. Photo: Richard Sargent.*

FIGURE 15-21

This firing program demonstrates how Gary Holt glaze-fires his pottery. He fires to cone 10 in a soft-brick-lined, 16-cu.-ft (.45-cu.-m) downdraft kiln. He modifies the total firing time, temperature increases, length of reduction, and soaking period according to the type of ware being fired, as well as his glaze, clay color, and texture expectations. The entire firing takes 12 hours, with a 1-hour soak period once the kiln temperature reaches cone 10. Since the ware is already bisque-fired, there is no chance any pieces will blow up. Therefore, Holt fires his glazed ware in half the time required for a bisque-firing. In 3½ hours, and with all four burners on, the kiln temperature reaches 1750°F/954°C. He begins a clay body reduction at cone 08 (1749°F/954°C) and maintains it for 1 hour. He gradually increases the reduction atmosphere during the course of the firing, adjusting it based on the clay and glaze results he wants to achieve. After 9 hours, the kiln temperature reaches 2250°F/1232°C, at which time Holt increases the reduction atmosphere. After 12 hours, the kiln temperature reaches cone 10 (2377°F/1303°C). Holt heat-soaks the pottery for 1 hour by turning off two of the four back burners and decreasing the gas flow to the other two burners, thereby maintaining a temperature between cone 7 and cone 9 (2291°F/1255°C and 2232°F/1278°C). This helps smooth out the glazes and ensure a proper melt. After soaking for 1 hour, the kiln is shut off and the damper, burner ports, and peepholes closed.

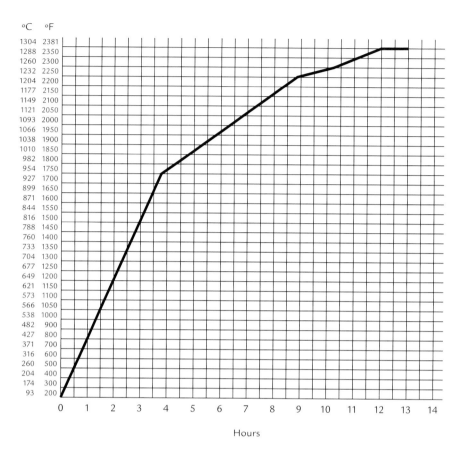

Hours

increases the kiln temperature an average of 467°F/242°C per hour, as compared to an average per-hour increase of 57°F/14°C during the first 20 hours of his bisque firing (see 15-19). Holt fires the glaze kiln relatively fast; since the ware is already bisque-fired, there is no chance it will blow up. The entire firing takes 13 hours, as compared to the lengthy bisque firing, which takes almost 25 hours.

The chemical and structural changes that take place in different types of glazes as they are fired are beyond the scope of this book, but it is important to be aware that the speed at which the kiln is heated or cooled at certain points in the firing cycle affects the relationship between the glaze and the clay body and the ultimate fit of the glaze. Changes that occur in the clay and glaze materials under heat and on cooling can cause either desired glaze effects, such as those achieved when successfully using crystalline glazes, or defects such as dunting (cracking that goes through both the glaze and the clay body).

Soaking

Soaking simply means keeping the kiln at a specific heat, often for about 30 minutes to 1 hour, while the glaze sits and smooths out. To soak in a gas kiln, once the appropriate firing cone has bent, turn half the burners down to low heat (or to about ⅛–½ in. [½–1 mb] in gas pressure) for about 1 hour, with the damper open. After the soaking time, shut off the kiln, close the damper, and plug all spyholes while the kiln cools.

To soak in an electric kiln, when the cone has bent and the kiln has been shut off by the kiln sitter or electronic controls, turn the kiln back on and set one or all switches to low for about 30 minutes. At the end of the soaking period, shut the kiln off, plug all spyholes, and allow the kiln to cool. Some people never soak, or they use an alternative method, firing either an electric or a gas kiln to one or two cones higher than usual. You can also program a computer-controlled kiln for a hold/soak pattern.

Cooling the Kiln

Careful control of the kiln during cooling is essential to prevent defects or to produce certain desired effects, such as those achieved with matt and crystalline glazes. In general, the most critical time for glazes is during the first period of cooling, when slow, careful lowering of the temperature is essential. The number of hours it takes depends on the mass of ware in the kiln, how closely it is packed, and the mass of the kiln itself. The time involved depends on so many factors that you should treat each firing individually. For example, to give an electric kiln plenty of cooling time, after the kiln shuts off, wait between 9 and 12 hours and then open the peephole. When you feel that the heat coming from the kiln is well below searing hot, open the lid 1 in. (2.5 cm) every 2 to 6 hours. On the other hand, with a large gas kiln, be sure to give it adequate cooling time; with it still loaded, leave it shut for a minimum of 12 hours and then open the damper 1 in. (2.5 cm) every 3 to 6 hours. These are conservative cooling times, but by cooling this slowly it is possible to achieve a high success rate in firing. Once the kiln has cooled to about 150°F/65.5°C, the door can be opened to reveal the kiln of glazed ware ready to be unloaded (see 15-18).

Glazed ware that comes out of the kiln with bubbles hardened into it is often the result of too-rapid cooling, although it might also occur because the bisque firing was at too low a temperature and therefore failed to burn all the volatile materials out of the clay body. These materials would then have escaped during the glaze firing through the clay pores as gases, bubbling up through the glaze.

Firing Low-Fire Glazes

Low-fire glazes are generally fired in an electric kiln, because in order to achieve the clear, bright glaze colors associated with them, they require the clean oxidizing atmosphere characteristic of that type of kiln. Low-fire ware is made of clays that mature at low temperatures, and is decorated with glazes that mature between cone 015 (1501°F/816°C) and cone 1 (2109°F/1154°C). The most common low-fire firings are to cone 07, 06, 05, and 04 (1805–1958°F/985–1070°C).

If overfired, the red and orange glazes may emerge splotchy black or clear. In electric kilns, you generally would fire these glazes in the coolest areas of the kiln—usually the very bottom or the very top. These colors need a well-ventilated kiln atmosphere, so you may even consider firing them with most of the spyholes open. If you are firing reds and oranges, avoid firing any ware glazed with copper or other metallic oxides in the same kiln; this could affect the red or orange colors.

Firing Overglazes (China Paint)

Overglazes are either water- or oil-based enamels that melt between cone 022 and cone 018 (1166–1350°F/630–732°C). Firing overglazes is a much faster process than bisque firing or glaze firing, because overglaze paint melts in a relatively short time at temperatures that need to be only high enough to soften the base glaze somewhat so that the china paint or enamel will fuse with it. Because overglazes melt at such low temperatures, the firing process usually takes only about 2½ or 3 hours from beginning to end (not counting the cooling time).

The firing temperature for overglazes depends on the color used as well as the glazed surface on which it is painted. The cone to which the ware is fired is determined not only by the melting point of the overglaze but also by the relation of the clay and the base glaze to the overglaze. For example, china paint over low-fire glazes can be fired at a lower temperature than china paint over high-fire glazes, because it takes less heat to make the base glaze tacky. Thus, china paint on a low-fire glaze can be fired at cone 020 to cone 017, whereas the same color may need a hotter firing (cone 016) on glazed porcelain ware. China paint is often fired in multiple firings, one color at a time, because many of these colors will be contaminated by touching another color. Too many layers could also cause peeling, so a number of coats of paint and multiple firings may be required to build up a particular color effect. These successive coats of china paint can create subtle gradations and depth of color (see 8-13).

A clean oxidation atmosphere is crucial to the brilliance of some overglaze colors. To achieve this in an electric kiln, keep all spyholes open through the *entire* firing. Then follow this procedure: Turn all switches to low and keep the lid propped open about 2 in. (5 cm) for 30 to 40 minutes. Then turn all switches to medium with the lid still propped open about 1 in. (2.5 cm) for

another 30 to 45 minutes. Next, close the lid, turn all switches to high, and fire until the kiln sitter shuts off, the cone bends, or the fast-fire computer program is completed. This usually takes another 1½ hours. Cool for approximately 15 to 20 hours, or until the ware can be handled safely.

Firing Lusters

Some ceramists have researched and duplicated the ancient lusters as they were fired in strong reduction in Persia, but most of the lusters used today are commercial oil-based colors that contain their own reduction materials in the glaze medium. These are usually fired in an electric kiln. During firing, lusters emit toxic fumes that must be carefully vented to prevent anyone nearby from inhaling them. All spyhole plugs should be left open during the entire luster firing. Often the kiln lid is also left cracked open about ⅛–¼ in. (3–6 mm) so that the kiln is not trapping the fumes and creating too heavy a reduction atmosphere. This could cause discolorations or leave a murky film or residue on the surface.

SUPPORTING AND FIRING TILES

To ensure that tiles stay flat when fired, it is necessary to support them in the kiln on shelves, racks, or props. The higher the firing temperature, the more support a tile needs in the center to avoid sagging and warping.

Bisque-Firing Tiles

When bisque-firing (approximately 1915°F/1046°C), thin tiles can be lined up on end. Tiles stacked in this way can be fired slightly faster than thick ware because there is more air circulation around the pieces. Tiles ⅜–1 in. (10–26 mm) thick are best loaded flat on kiln shelves and should be fired slowly.

Glaze-Firing Tiles

As in bisque firing, when firing low-firing glazes on tiles, thin tiles up to ¼ in. (6.35 mm) thick can be fired in tile racks. Tiles over 12 × 12 in.

(30 × 30 cm) are best fired flat on a kiln shelf so that their centers are fully supported to prevent sagging in the middle or stress on the edges, which could cause cracking. Also, a slow firing places less stress on tiles with large surface areas. Be sure that the glaze will not run off the edges and cause the tiles to stick to the shelf.

Firing Tiles with China Paint, Lusters, and Metallics

Tiles painted and fired with china paint, lusters, and metallics can be fired on tile racks with slots that can accommodate 4 × 4 in. (102 × 102 mm) or 6 × 6 in. (152 × 152 mm) tiles. There are also U-shaped corner firing posts, and racks with posts set at an angle that hold about five small tiles (see 15-14c, d). Because the firing temperature of china paint, lusters, and metallics is so low (approximately 1350°F/732°C), there is no fear of them warping or sticking.

SCULPTURE IN THE KILN

Although much of the firing information given so far can also be applied to sculpture, some special factors must be taken into consideration when firing sculpture (15-22–15-24).

Firing Small Sculpture

The process of firing a small piece of sculpture (15-25, 15-26) is basically the same as that used when firing pottery, provided that it was built

FIGURE 15-22 ▶

(a) The kiln room with computerized gas kilns in the European Ceramics Work Centre in Holland. The highly automatic kilns can be programmed to inject only cool air into the kiln chamber for drying out damp ware and also to induce reduction at an exact temperature for consistent firing results. For the convenience of making or loading large-scale work, kiln cars can be rolled directly into an artist's studio, where they can be used for building sculpture directly on a car floor for easier loading. After loading, the cars are pulled by forklift or pallet jack into the kiln. Then motors automatically lift the kiln floor into position, the door is closed, and the firing begins. *(b)* Workshop supervisor Peter Oltheten loads a rolling car kiln with sculpture by one of the visiting artists, as studio supervisor Anton Reijnders observes.
Courtesy European Ceramics Work Centre, Holland. Photo: Els van den Boorn.

(a)

(b)

FIGURE 15-23
Figuring out the best way to load sculptures with unusual shapes can present a challenge. Marilyn Lysohir of the United States contemplates parts of her *Bad Manners* figures (see 16-2). While they await loading, the sections rest on foam pads, which protect their unfired finish. Lysohir fires her terra sigillata-coated pieces to cone 06 in a single firing in a downdraft gas kiln. *Courtesy the artist. Photo: Arthur Okazaki.*

FIGURE 15-24 ▶
Stephen De Staebler of the United States unloads a section of one of his large sculptures from his car kiln. Although the kiln carriage (right) rolls easily in and out of the kiln on a track, it still takes careful maneuvering to load or unload the work, using a hoist and considerable pushing on grog-coated pallets. 1993. *Courtesy the artist.*

FIGURE 15-25
Fired once to cone 6 in an electric kiln, the delicately constructed porcelain slabs that comprise Bambi Waterman's hollow, leafy, cocoon-shaped sculpture attain a lustrous sheen when fired to vitrification. *Courtesy the artist.*

FIGURE 15-26
Floating and Dreaming, by Tony Marsh of the United States, evokes a sense of mystery conveyed through the white, abstract, sculpted elements set into the softly glazed blue keyhole-shaped container. Earthenware clay, terra sigilatta. 18 × 8 × 6 in. (48 × 20 × 15 cm). *Courtesy the artist.*

hollow or was hollowed out adequately and that it was well dried (see Chapter 11). Because the walls of handbuilt sculpture may be of uneven thickness, it is especially important that it be dried slowly and, to keep it from exploding, that the heat in the kiln be brought up extremely slowly.

Before starting to fire a kiln load of sculpture, be sure to preheat the piece or pieces with the kiln door open. This is critical. Follow the preheating by gradually increasing the temperature: In an electric kiln, turn the first switch one notch every 1 or 2 hours; repeat with the second switch, third switch, and so on until all the switches are at their highest position; in a gas kiln, adjust the gas pressure by ⅛ in. (½ mb) every 6 to 12 hours until the kiln reaches 1200°F/537.7°C or is dull orange in color. After that temperature has been reached throughout the entire kiln from top to bottom, raise the gas pressure by ¼ in. (1 mb) every 3 to 6 hours. The length of the complete firing will vary, depending on the size and thickness of the sculpture and how tightly it is loaded. In an electric kiln, the glaze firing of a sculpture may take between 8 and 12 hours to bring it up to the desired cone, and in a gas kiln it may require 8 to 16 hours, depending on the amount of ware and the size of the kiln.

Slip-cast sculpture generally takes less time to fire, because the slip used in the casting process is homogenous. If a small sculpture has been bisque-fired first, there is no chance that it will blow up during a glaze firing. Now, with a computerized kiln, you can set the entire process to fire automatically to match the type of clay and glaze being fired.

Loading Large Sculpture

Loading a large sculpture into a kiln can be a challenge. First you have to get it into the kiln, then place it in the best spot for firing. Large sculptures are not normally bisque-fired first, because this would just double the effort and time needed for the process. Since sculpture is therefore often loaded in the green state, and because a heavy sculpture must often be pushed or forklifted into a kiln or loaded with a hoist using nylon slings, it should be constructed carefully so that it can accept the stresses that will be applied to it at that time. Generally, a large sculpture is constructed in relatively small sections or cut into sections for firing. This is partly for convenience during forming and partly so that the sections can be fitted into the kiln more easily.

There may be instances, however, when a large sculpture cannot be made in sections or cut; in such cases the work must be loaded into

the kiln in one piece. The key to loading large sculpture is careful planning, so before tackling the job, organize your loading equipment to give you as much help as possible, and work out the placement of each piece (see 15-22b, 15-23). First, bring all the items planned for loading into the kiln to a surface near the mouth of the kiln and study and measure them. Make charts, measuring each piece and deciding where it should go in the kiln. Remember that position in the kiln is related to heat, which in turn affects color. Also measure and mark the bricks inside the kiln where shelves will be positioned, to show where each piece will go. Chart which piece will go in first, second, third, and so on, and calculate how many shelves and posts will be needed for each piece. Only when you have all this worked out should you actually begin to load the kiln. If you are working alone, it can take as long as 40 hours to load a 100-cu.-ft. (2.83-cu.-m) kiln.

A level floor and level shelves are important when sliding large work into the kiln. This is where the newspapers you planned to take to the recycling center come in handy—heavy works slide easily on three to six layers of paper (the heavier the work, the more layers are needed), especially on the glossy sections. To help you push large sculpture into a kiln, you can also attach braces to the floor, positioning them so that you can get leverage against them while you push. For extremely heavy pieces, however, no amount of manual work may be enough, and you may have to use a hydraulic hand cylinder with a hose and ram, a scissor-style automobile jack, or a forklift. If you use hydraulic aids to push the sculpture, it is extremely important to pad the surfaces on the sculpture against which the ram will push.

But even the hydraulic alternatives to muscle power and leverage frequently require a good deal of physical labor and ingenuity, and one of the most important qualities you need at this point is patience. Allow yourself plenty of time. To load one large section, allow anywhere from 2 to 5 hours. Remember, too, that unloading the sculpture from a large kiln after firing can take a good 12 hours of effort as well.

One way to avoid the pushing and pulling required to load a large sculpture is to build the kiln up around the sculpture instead. Maria Kuczynska did this when she constructed one of her draped slab pieces on a larger scale than usual

FIGURE 15-27
To fire *Icarus,* a larger-than-usual example of her slab sculpture, Maria Kuczynska used a kiln that was specially built up around the sculpture. Kuczynska's sculptures are built of slabs draped while still damp over an interior hollow clay support that has been allowed to stiffen enough to support the slabs. *Courtesy the artist.*

(15-27). Building a temporary kiln around a sculpture requires knowledge of kiln construction and burner installation, however, and should not be attempted by those who are inexperienced.

Firing Large Sculpture

Firing large sculpture that has not already been bisque-fired can be a lengthy process. Patience and time are required to raise the heat of a kiln to the required temperature and then to cool it down slowly after firing. Because the clay walls of a large sculpture often vary in thickness, it is

crucial to raise the temperature of the kiln gradually and to gauge the firing time correctly in relation to the sculpture's thickest section. It is also important to preheat a thick piece of sculpture. Preheating an extremely thick sculpture (1–3 in. [25–76 mm] thick) can take anywhere from 24 to 48 hours, with an additional 120 to 160 hours or more to complete the firing with a rate of temperature increase of 15–20°F (–9°C to –7°C) per hour for the first 100 hours, increasing to 28–40°F (–1.6°C to 4.4°C) during the later part of the firing. For good results, it is generally best to use a temperature rise of between 20°F and 60°F (–6.6°C and 15.5°C) per hour.

When firing work approximately 1 in. (25 mm) thick, the process can easily take 49 hours or more. By following the firing program outlined in Figure 15-28 for a 1-in. (25.4-mm) thick sculpture or pot, you can see how long the preheat was maintained and the overall length of firing.

In this sample bisque-firing program, segment 1 is the preheating and drying period. Assuming that the room temperature is 75°F/24°C, the temperature in the kiln is programmed to rise at a rate of 33°F/.74°C per hour, with a target temperature of 175°F/79°C. This means that in 3 hours, at a temperature rise per hour of 33.33°F/.74°C, the kiln temperature will rise 100°F/38°C. At 175°F/79°C, the kiln will be placed in the "hold" mode for 16 hours, during which time the ware will dry out thoroughly.

In segment 2, the kiln climbs at 60°F/15.6°C per hour over a period of 13.75 hours until reaching 1000°F/538°C, where it is held for 1 hour. Then, in segment 3 through quartz inversion, the rate of increase is lowered to 30°F/–1.1°C per hour over a period of 8.33 hours. Once past this point, the rate is safely raised to 80°F/27°C per hour over a period of 8.31 hours.

When firing a preprogrammed computerized electric kiln with work that is about ⅜ in. (7 mm) thick, use the slow-fire setting, which is generally set by kiln manufacturers at about 12 hours. To dry out ware thoroughly, it is common to use the "ramp hold" mode and program in one segment. With the kiln lid propped up or the door of a front-loading kiln open approximately 1½–3 in. (38–76 mm), set the temperature to 200–300°F/ 93–149°C and hold it there for approximately 12 hours. Then go back to the preprogrammed mode and enter a slow setting in which the computer automatically increases the temperature.

In a manually operated electric kiln, you can fire any sculpture that will fit in the kiln by turning up each switch—one switch at a time—one notch every 1 to 4 hours until all the switches are in the high position.

In gas kilns, the heat rises to the ceiling, so as the temperature is increased during the initial drying period and through quartz inversion, most of the heat collects in the upper portion of the kiln. As the temperature rises further, the heat moves downward. Therefore, if a large or thick sculpture is being fired, it is best to heat the kiln very slowly until the temperature in the kiln is equal from top to bottom. You can adjust the burner by changing the gas pressure by ⅛ in. (½ mb) every 6 to 12 hours until about 1200°F/ 537.7°C is reached or the interior of the kiln is red-orange. The temperature could be raised faster with thinner-walled sculpture.

Although a slow rise in temperature is recommended throughout the entire firing, when using such a long firing period some ceramists successfully increase the temperature rise per hour once the kiln has passed through the critical quartz inversion point, or after the entire kiln chamber has risen beyond 1200°F/648.8°C. (See the "Temperature Rise per Hour" chart in *Expertise*, Chapter 2A.)

Since sculptures vary so much, each firing has to be planned individually, depending on the number of pieces that will be placed in the kiln and their thickness. In general, a larger kiln is preferable for firing large work because it provides more air space around a piece, allowing it to heat up more evenly; this is especially critical during the drying, preheating, and through quartz inversion. The interior size of a kiln can also have an effect on the rate of temperature rise per hour during the firing. For example, if you place two sculptural sections of the same size in two different-sized kilns, you should fire the smaller kiln more slowly.

The placement of the work in the kiln is also important, as the heat in different areas of the kiln may vary by several cones (see 15-10). Electric kilns heat from the sides and sometimes from the sides and bottom; therefore, because heat radiates toward the center mass of a sculpture, it is important to fire very slowly. Electric kilns with zone control—that is, two or three thermocouples set at the bottom and top, or on the bottom, middle, and top—sense the heat at each level and relay that information to the computer, which cycles the kiln elements at the section that requires more heat. For example, if the bottom section is cool, the bottom element will cycle on

TABLE 15-4	Sample Cone 05 Bisque-Firing Program for a Piece 1 in. (25.4 mm) Thick			
Segment	Rate/hour	Temperature	Hold hours	Total time
1	33.33°F/.74°C	175°F/79°C	16	3 + 16 = 19
2	60°F/15.6°C	1000°F/538°C	1	1 + 13.75 = 14.75
3	30°F/−1.1°C	1250°F/677°C	0	8.33
4	80°F/27°C	1915°F/1046°C	0	8.31
Total Firing Time				50.39 Hours

FIGURE 15-28

This is a sample cone 05 bisque-firing program for firing thick pottery, tiles, or sculpture approximately 1 in. (25 mm) thick in a top-loading 10-cu. ft. (.28-cu.-m) electric kiln. The firing takes 50.39 hours and works well when firing slightly damp ware, in which case the lid should be left open about 5–8 in. (12–20 cm) for 8 to 12 hours. All the peephole should be left open during the initial drying-out period. *Segment 1:* Once the kiln temperature reaches 175°F/79°C, it is held for 16 hours to dry out the ware. At the end of this segment, the lid is closed and all the peepholes left open. *Segment 2:* The rate of temperature climb per hour is 60°F/15.6°C over a period of 13.75 hours until the kiln temperature reaches 1000°F/538°C. It is held there for 1 hour to soak. *Segment 3:* With half the peepholes closed, over the next 8.33 hours and through quartz inversion (1070°F/577°C), a point when ware can still blow up, the rate of temperature climb is reduced from 60°F/15.6°C per hour to 30°F/−1.1°C per hour until 1250°F/677°C is reached. *Segment 4:* Leaving one or two top peepholes open throughout the remainder of the firing, once safely past quartz inversion, the rate of temperature climb per hour can be speeded up to 80°F/27°C over a period of 8.31 hours until the target temperature of 1915°F/1046°C is attained. A long, slow firing gives thick pottery or sculpture enough time to thoroughly dry out; it also heat-saturates the thickest portions of the piece, keeping the ware from blowing up. Slow cooling is also important in order to eliminate cracks that may develop in thick ware, especially when going through quartz inversion.

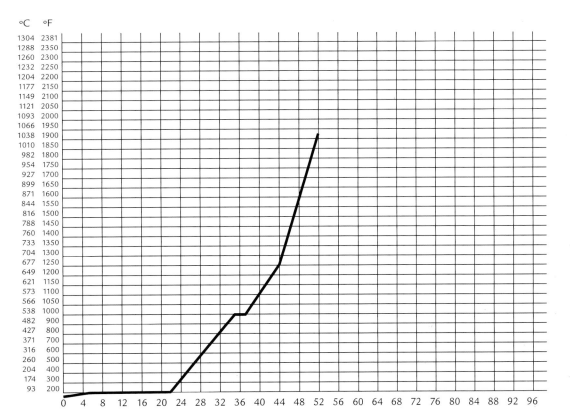

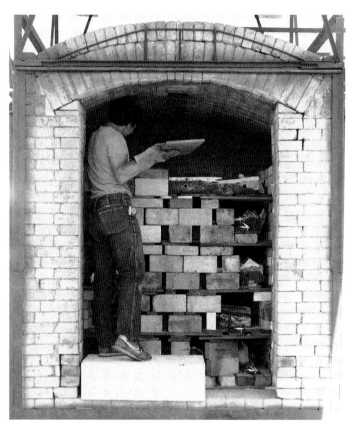

FIGURE 15-29
Removing shelves and bricks before unloading sculpture.
Note how the shelves have been doubled and built up with
firebricks to provide adequate support for heavy sections.

while the middle and top elements are off until the heat evens out.

The final temperature to which you fire the sculpture will, of course, depend on the clay from which it is built and the type of glaze, if any, or other colorants you have applied. And just as it was essential to raise the heat slowly, it is equally important to give a kiln loaded with large sculpture a long, slow cooling period, which can extend form one to six days.

Unloading Large Sculpture

Unloading large fired sculpture is not as difficult as loading it into the kiln in the fragile green state, but unloading can still be a challenging process. For example, it is often impossible to get hydraulic equipment into the kiln. If that is the case, tap wooden wedges under a large piece

to lift it enough so that you can slide layers of newspaper or a series of three or four steel pipes or wood dowel rollers under it. Then you can slide or roll it out of the kiln chamber more easily. You can usually tilt sculpture that does not have a flat bottom enough to insert a thick plywood board under it and then lift the board on which the sculpture rests with a pry bar in order to insert rollers under it.

A hydraulic-lift hand truck is a valuable piece of equipment to have if you have to slide large sculpture off a kiln shelf. The lift platform can be raised or lowered to the exact level of the shelf, to facilitate the safe removal of the sculpture. Some sculptors use a chain hoist equipped with ropes or polyester lifting straps tied around their large works to help lift them off the kiln floor (see 15-24). Engine hoists, forklifts, or cranes are also useful in unloading large sculpture and are invaluable for people with limited strength or back problems.

If a large sculpture was well constructed in the first place, if it is handled with care, and if it is carefully dried and fired slowly, it will stay together and you can remove it without breakage (15-29). On the other hand, if the sculpture has developed cracks during the firing and could be further damaged by moving it out of the kiln, leave it in its firing position and glue any broken parts with an appropriate adhesive before moving it. Let the glue dry, and then unload the work. For further information about what adhesives to use, see Chapter 11 and *Expertise*, Chapter 4C.

Choosing a Kiln

Your choice of kiln can ease the loading of large, fragile, or heavy sculpture. There are commercially available hexagonally shaped top-loading kilns that can be dismantled and stacked around a piece (15-30). After the unit has been unplugged, the kiln sections are dismantled. The sculpture is then placed on the kiln floor and the sections reinstalled over the piece. An **envelope kiln** with a stationary floor (15-31) or an envelope shuttle kiln with a rolling floor makes loading heavy work easier than a top- or front-loading kiln. Access on two or three sides makes stacking kiln shelves and posts easier, and if forklifts, hoists, hydraulic carts, or lifts are used, they can be positioned more efficiently to help in the loading process.

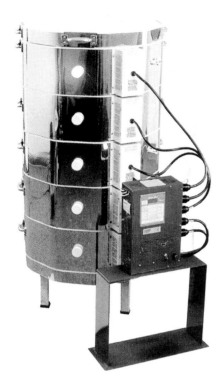

FIGURE 15-30
For loading and firing tall or heavy sculptural pieces or pots, a computerized stacking electric kiln is an economical and convenient solution. Each kiln section has a separate control box and plug, making dismantling and reassembly easy. To load a piece, first unplug the kiln from the main power supply. Then unstack the kiln rings until the kiln floor and stand remain. Next, load the ware on the kiln floor and restack the kiln sections one at a time over the piece. Place the lid on top of the last ring, plug all the wires back into the main computerized control box, and begin the firing. *Photo courtesy L & L Kilns.*

FIGURE 15-31
An electric envelope kiln with guillotine-style doors is an efficient production kiln. The kiln body rolls on a track over a stationary floor. The kiln can be outfitted with two floors: While one load of pottery or sculpture is being fired, the other floor is being loaded or unloaded. The computerized kiln has heating elements in the floor, sides, and door, providing an evenly heated firing chamber.
Photo courtesy Nabertherm.

Generally, a larger kiln is preferable when loading and firing large work because it provides room for the kiln loader to maneuver around or in the kiln and makes lifting or pushing a piece into place in a kiln much easier.

Firing Clay and Steel

A number of ceramists have experimented with firing clay and metal together. This requires low temperature firing. When you combine clay with steel, some shrinkage usually occurs. The clay shrinks around the steel during drying and firing, and cracks. Clay stilts, made with nichrome or Kanthal wire and used to support low-fire glazed ware, do not crack because the mass of the clay is far greater than the mass of the wire. Using a heavily grogged clay will reduce the shrinkage around steel and thus cause less cracking. A number of artists use steel or metal alloys in their sculptures. Cecille McCann's abstract melon-shaped oval sculpture (15-32) is made with steel trimming shaped from a cutting torch and inserted into the wet clay before firing. Erin Poe's ornamental headdress (15-33) uses steel tie-wire, normally used for tying reinforcement bar together, to hold her ceramic balls, while Benjamin Belknap used old Kanthal kiln elements to make his robot-machinery-inspired sculpture (15-34). Belknap supported his sculpture with stilts and posts to keep the kiln element wire

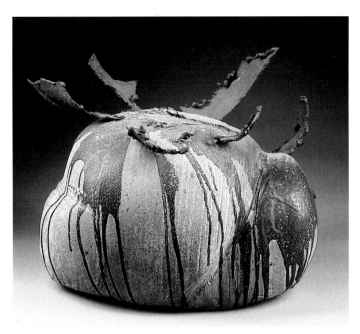

FIGURE 15-32
An abstract clay and steel orb by Cecille McCann of the United States. The jagged steel fragments were formed from a cutting torch, embedded in the clay, and high-fired. Stoneware clay with cobalt blue matt glaze. Diam. 15 in. (38 cm).
Courtesy the Toki Collection.

FIGURE 15-33
Daydream, a headdress by Erin Poe of the United States, was designed after an actual daydream. Poe says, *The piece is about the fashion world and the love and hate that swirls around in my head.* After the ceramic balls were attached to steel wire, they were fired to cone 08 (1749°F/954°C). Clay, steel, feathers. *Courtesy the artist.*

FIGURE 15-34
Pedestal, by Benjamin Belknap of the United States, was inspired by robots, machinery, old radios, and American-made objects from the 1950s and 1960s. Constructed with kiln element coils and clay, it was decorated with underglazes and overglazes. To keep the coils from slumping during the firing, Belknap supported the structure with kiln bricks and refractory supports. Fired to cone 08. 14 × 5 × 5 in. (36 × 13 × 13 cm). *Courtesy the artist.*

from bending during the firing. Sculptures that contain steel should be supported with kiln bricks, posts, and stilts, since the metal will tend to slump during firing.

If steel is fired to low temperatures, it will remain relatively intact, but when iron is heated in a kiln at temperatures above cone 08 (1749°F/954°C), it begins to soften and can bend or slump. A metal rod, flat bar, angle iron, t-beam, pipe, or tube over ⅛–¼ in. (3–6 mm) thick is fairly stable when fired. The more times a piece is fired, the more likely it is to become weakened by the heat. Nonferrous metals such as brass, bronze, and aluminum do not hold up well in a kiln firing even as low as cone 08. Stainless steel, Kanthal, and Nichrome wire, on the other hand, can withstand more heat than plain iron without flaking; these alloys will not rust or corrode. At the California College of the Arts, students found that coarse steel wool embedded in clay is an excellent reinforcement material for clay. It is especially useful when making ankles on figures or animal legs, or when wrapping clay around a steel rod. Galvanized (zinc) or chrome-plated metals are not recommended for use with clay fired in electric kilns. Fumes emitted from metals made with unknown compounds during firing could damage the kiln elements or the metal thermocouple sensing probe.

Some artists prefer not to fire steel in clay because of the deformation that occurs with that metal. Thinner-gauge metals are more susceptible to metal deformation. Sculptor Alex Nolan, however, chose to combine steel with his ceramic because he needed the strength of the steel to hold his work up. He built a 23-ft. (7-m) tall kinetic, ceramic, and steel sculpture using a durable coarse raku clay, which he sculpted into vessels that rotated on bearings turned by a sprocket and chain. Each sculptural section was set with gears that rotated the vessels at different speeds, powered by an electric motor (15-35).

FIGURE 15-35

A kinetic clay and steel sculpture at the California College of the Arts by Alex Nolan of the United States. Nolan says, *Each hole in the ceramic tubes represents an individual who lost their life in the September 11, 2001, Twin Towers disaster, in New York.* After firing, the pieces were reinforced with fiberglass and stacked over a heavy-wall steel pipe. Each ceramic section, connected to a series of gears turned by heavy-duty chains, spun at a different speed. A 1-hp DC motor mounted at the top of the sculpture provided the power to turn the ceramic. Ht. 23 ft. (7 m). *Photo: Steven J. Gelberg.*

FIGURE 15-36
Catharine Hiersoux of the United States, with ten helpers, built her modified *anagama* kiln of brick with cast refractory arches. For insulation, the kiln was coated with a 4-in. (10-cm) thick mix of cement, adobe, and straw. Access from the side of the kiln provides easier loading of the 90-cu.-ft. (2.5-cu.-m) kiln. A second chamber is sometimes used for salt firing. During firing, the kiln reaches cone 11–12. 1993. *Courtesy the artist.*

FIGURE 15-37
Jesse Bay of the United States loading ware into an anagama-style cross-draft wood kiln. When fired to cone 10, the rectangular kiln shape causes the flame to travel across the ware, depositing ash along the way as it reacts with the clay and glaze. After the kiln has been heated with propane fuel to approximately cone 08, Bay begins wood-stoking the kiln and continues for one to two days, until the kiln reaches cone 10. Heavy ash buildup in the firebox (located where Bay is kneeling) causes accumulated ash to react with the ware closest to the wood-stoking hole.
Courtesy Idyllwild Arts. Photo: John Toki.

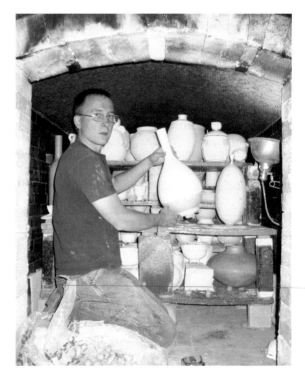

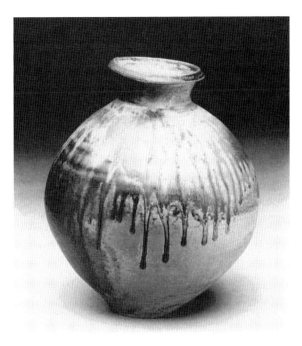

FIGURE 15-38

This wood-fired bottle by Jack Troy of the United States received a natural glaze from the wood ash that fell on its shoulders, recalling a jar made by a Chinese potter in about 200 B.C. (see 3-12). Because the heaviest ash particles settle near the port through which the wood is introduced and the kiln temperature may vary by as much as eight cones, Troy's placement of his ware in the kiln is crucial to how the glaze develops. Porcelain. Ht. 14 in. (35 cm).

Courtesy the artist and Helen Drutt Gallery. Photo: Schecter Lee.

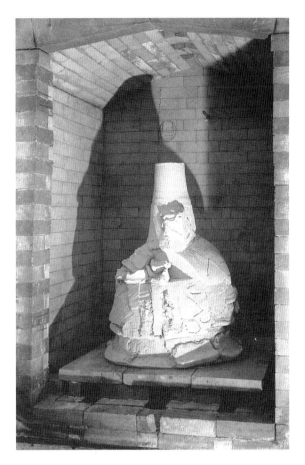

FIGURE 15-39

This greenware sculptural vessel by the late Peter Voulkos of the United States awaits bisque firing. Many of Voulkos's vessels have been shipped across the country to New Jersey for firing in Peter Callas's wood kiln (see 15-40). *Courtesy Braunstein/Quay Gallery. Photo: Schopplein Studio, San Francisco.*

WOOD FIRING

In recent years the ancient process of wood firing has regained popularity with Western ceramists (15-36, 15-37). There is, of course, nothing new about using wood to fire a kiln full of pots. Through the centuries, especially in China and Japan, designs of wood-burning kilns showed a progression from the simple pit fire to highly sophisticated structures that maximized efficiency of combustion and heat retention (see 3-7, 3-30 and 15-4). Today, wood-fired kilns are built to many differing designs, some of which still carry Japanese names. Although in the West the trend toward wood firing started with concerns about the use of fossil fuel, it was also the result of an interest in Japanese ceramics that led numerous British and American potters to study in Japan. As these ceramists discovered that with wood firing they could achieve surface effects that were impossible to get in any other way, they came to value the process for itself (15-38). Impressed with what they saw in Japan, some of them returned to build their own Japanese-style kilns (see 15-36, 15-37). Peter Voulkos, (15-39) who liked the effects of wood firing, used to ship his bisque-fired pots across the country to be fired in Peter Callas's wood-firing kiln (15-40).

In wood firing, in addition to producing the surface effect called *flashing*, the minerals in the ash deposited on a pot's surface may interact with the minerals in the clay, fuse, and form a glaze (15-41–15-43; see also 15-38). These ashes will also affect any slip or glaze applied to the pot, as will the type of wood used for fuel, its degree of seasoning, and even the soil in which it grew and from which it drew minerals.

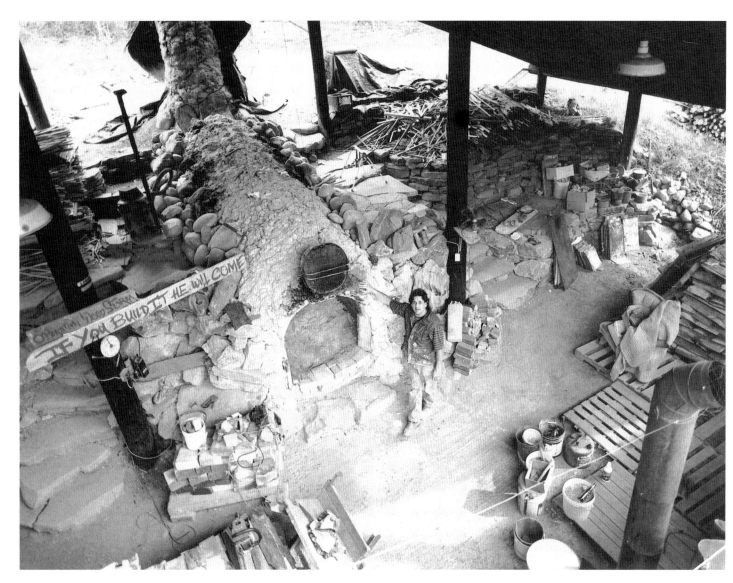

FIGURE 15-40
Peter Callas of the United States, built his 300-cu.-ft. (8½-cu.-m)
stacking-space anagama kiln in 1987, using natural materials. The
rocks along the side support the arch. He fires to approximately
cone 12 using pine wood, and each firing lasts seven days. The
round counterweight balances the door when firing is taking place.
Callas uses iron-bearing and iron-free clay bodies in saggars and on
open shelves, and he experiments with glazes such as black shino.
Courtesy the artist. Photo: Bruce Riggs.

FIGURE 15-41
This wood-fired stoneware vessel by Eric Struck of the United States achieved its color in part from its location in the kiln, the glaze, and the ash that interacted with the glazed surface during the firing. Cone 10. Ht. 18 in. (46 cm). *Courtesy the Toki Collection. Photo: Scott McCue.*

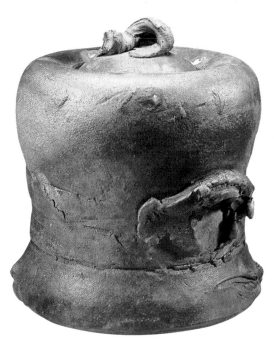

FIGURE 15-42
The ash that settled on the shoulder of this organic lidded jar by Don Reitz of the United States reacted with the clay to form a variegated straw-colored glaze. Cone 10. 24 × 18 in. (61 × 46 cm). *Courtesy the artist.*

FIGURE 15-43
This wood-fired vase by Masakazu Kusakabe of Japan relied heavily on ash buildup reacting with the clay during the firing to roughly texture the surface. Cone 10. 12½ × 6 × 4 in. (32 × 15 × 10 cm). *Courtesy the artist. Photo: Heidi Desuyo.*

FIGURE 15-44
Steve Davis admiring the finished ware from his Kazegama kiln, which is ready for unloading. The heavy kiln lid is lifted straight up, using a hoist, and then sideways with the aid of a trolley.
Courtesy the artist. Photo: John Toki.

Western Adaptations of Eastern Kilns

After spending a year in Japan, where he studied the history and methods of wood-burning kilns, Paul Chaleff built a large wood-burning kiln designed for firing his own work. Speaking of the increasing popularity of wood firing, Chaleff says,

> One of the reasons I believe that this technique has such allure for potters, beside the obvious excitement of the firing process, is that the finished work imparts a sense of history, a continuum of human emotion.

Chaleff prefers the terms *fire-glazed* or *kiln-glazed* for his pottery, because he, like other Western artists, has adapted the process so that his work reflects his own creativity and the society in which he lives rather than an ancient Oriental style.

Since wood-firing of kilns is prohibited in some cities or areas because of the air pollution caused by the smoke, be sure to check your local ordinances before you build a wood-fired kiln.

GAS-FIRED WOOD-ASH KILN After participating in several wood firings, Steve Davis decided that he wanted to pursue this firing process. But because he lives in an urban setting where it is impossible to build a traditional wood kiln, he

sought an alternative method for achieving the results of a traditional wood firing without having to spend a week firing and without consuming several cords of wood. He researched and developed a kiln that he calls a *Kazegama,* which means "wind kiln" in Japanese (15-44). This kiln achieves anagama-fired results though a system using blowers that disperse ash throughout the chamber. The cross-draft design has a set of forced-air burners positioned horizontally at one end of the kiln. The force of the blowers scatters ash across the ware inside the kiln, simulating the heat flow and ash movement of a traditional anagama kiln. Davis uses the same clay bodies, slips, and glazes when he makes ware for the kiln and loads his kiln with the same shelf-stacking configurations that he uses in a traditional wood kiln.

A unique feature of Davis's kiln is that it is built on a trailer so that it can be easily transported to Kazegama workshop sites (see 15-44). A welded steel frame is lined with a backup **Kaowool** fiber blanket and a 2-in. (51-mm) "M board" hot face that is pinned to the expanded metal mesh walls with ceramic buttons and nichrome wire, which is twisted through the expanded-metal-mesh and angle-iron frame. A coating of kiln wash made with 70 parts alumina oxide, 30 parts kaolin, 70 parts water, and 2% CMC gum helps protect the kiln wall, firebox,

FIGURE 15-45
When the temperature of the wood-ash Kazegama kiln reaches cone 9 (2332°F/1278°C), Davis opens the air flaps on the blower-burner attachments and begins to feed finely sieved mesquite ash into the blower-burner cage, which sucks in the ash and blows it throughout the kiln chamber. *Courtesy the artist. Photo: John Toki.*

and shelves from the caustic effects of the wood ash. The added CMC gum helps make the kiln wash easier to brush onto the kiln wall.

After the kiln has been loaded with pottery, the forced-air burners are lit. In approximately 3 hours the kiln temperature reaches cone 9 (2332°F/1278°C). At this point in the firing, Davis begins feeding handfuls of mesquite wood ash into the air-intake blower cage, which carries it through the burner tube and blows it out the end and into the kiln chamber, where it covers the pottery (15-45, 15-46). Over a period of 40 minutes, Davis adds about 15 lbs. (7 kg) of ash to the 35-cu.-ft. (1-cu.-m) kiln. To get full coverage of ash throughout the kiln chamber, Davis turns off the burner unit partway through the firing. He removes the burner unit from the kiln frame support but leaves the blowers on, and empties ash

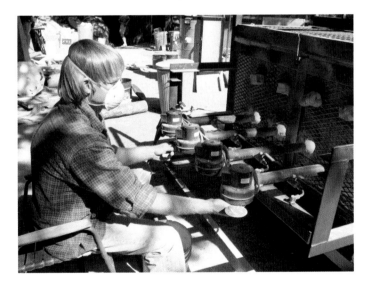

FIGURE 15-46
Davis feeding mesquite ash into the blower-burner cage. After the ash has covered the ware in the lower half of the kiln, Davis removes the burner system from the frame and shakes out any accumulated ash trapped in the burner tubes. He then moves the entire burner system up to a secondary level and reattaches it to the kiln frame. The burners are reignited, and ash is blown into the upper section of the kiln, covering the ware. Approximately 15 lb. (7 kg) of ash is dispersed throughout the 35-cu.-ft. (1-cu.-m) kiln during a cone 10 firing. *Courtesy the artist. Photo: John Toki.*

FIGURE 15-47
Boat, a wheel-thrown and altered container by Steve Davis, was fired to cone 10 in 5 hours in his Kazegama wood ash kiln. 18 × 9 × 7 in. (46 × 23 × 18 cm). *Courtesy the artist. Photo: Steve Davis.*

that has accumulated in the burner pipes. He shakes the ash out, thus clearing the tubes and burner orifices of any debris and he then moves the entire burner system up to a secondary level, which is also equipped with burner ports, and attaches it to a supporting frame, relights the burners, and begins to add ash. After all the ash has been fed into the kiln, it is heat-soaked for 20 to 60 minutes to let the ash melt. Davis says,

My approach to firing, whether it is a wood or Kazegama firing, is that it should support the aesthetic achievement by complementing the form, gesture, and surface qualities through the natural coloring and layering of the ash, from very subtle blushes to heavy ash flows (15-47). Ware from the Kazegama kiln is remarkably similar to those fired in a 5-day wood firing.

GAS-FIRED SAWDUST KILN Gary Holt, who lives and works in a residential neighborhood in an area with strict air-quality regulations, knew that

building a typical wood-fired kiln was out of the question. For years he fired his ware in a traditional wood-fired kiln. Then he researched other methods for achieving a wood-fired surface on his pottery. He settled on building a 36-cu.-ft. (1-cu.-m) gas- and sawdust-fired kiln designed by Lowell Baker (15-48, 15-49). Baker estimates that the kiln can produce one million BTUs per hour.

Combustion in Holt's sawdust kiln is carried out through an efficient blower-burner system that provides excellent control over the air-to-fuel mix, resulting in nearly complete combustion and producing only a small amount of smoke. The kiln is fired up to bisque temperature, about 1805°F/985°C, on natural gas, at which point the gas is shut off and the remainder of the firing is done using sawdust (15-50). Beginning at about cone 06, 15–20 lbs. (6.81–9.0 kg) of softwood and hardwood ash is blown into the kiln via the kiln blower-burner. Sawdust dumped into a custom-made hopper is blown into the kiln chamber

FIGURE 15-48
Gary Holt unloads pottery from his sawdust injection kiln. Holt glazed some of the pottery and let other pieces simply react with the ash to develop a glazed surface. Holt says, *The ash effects are the same as from any wood-fired kiln and can vary from light to heavy according to treatment.* Photo: Jim Hair.

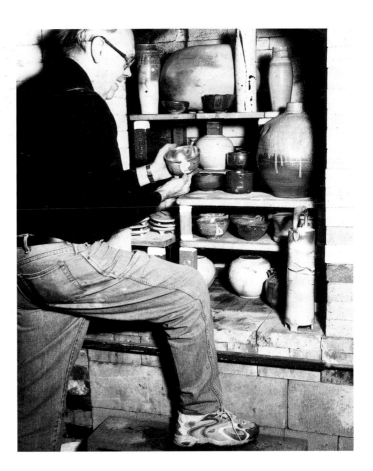

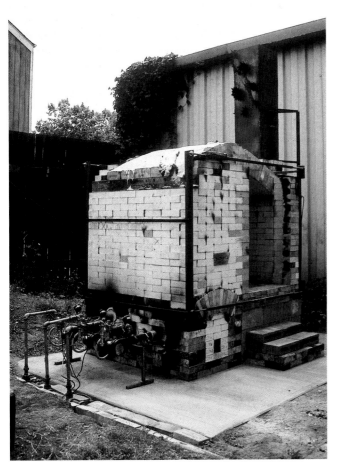

FIGURE 15-49
Holt's 36-cu.-ft. (1-cu.-m) sawdust-injection kiln was built at his Berkeley, California, studio during a kiln-building workshop led by Lowell Baker. After the kiln is heated to about 1800–1900°F/982–1038°C on natural gas, the burners are shut off and the system switches over to the sawdust-injection burners. Fine sawdust particles blown through a pipe into the side of the kiln produce a tremendous amount of heat, yielding an estimated 1 million BTUs per hour. At about 1800°F/982°C, ash is blended with the sawdust and inserted through a side plate in the pipe; the materials are sucked into a squirrel cage blower and blown through the pipe and into the kiln firebox.

FIGURE 15-50
The sawdust kiln is first heated to about 1805°F/985°C using three natural-gas forced-air burners positioned at the end of the kiln. Each burner is equipped with a blower speed control, gas pressure gauge, safety shutoff valve, and gas valve. After the burners are turned off, kiln shelf plates are slid over the burner ports, closing off the holes. Photo: Jim Hair.

FIGURE 15-51
Holt's sawdust kiln requires about twenty-five large garbage cans of sawdust fuel to reach cone 10. He pours sawdust into the metal hopper, one can at a time. The bottom of the hopper feeds into a 5-gal. (19-l) plastic bucket via a 1-ft. (30-cm) box that he calls a *drop-out box;* this traps any large chunks of wood or debris before it can be sucked into the squirrel cage blower unit and cause any damage. A 12-ft. (3.6-m) plastic pipe connected to a 12-ft. (3.6-m) metal pipe transfers the sawdust to the firebox located on the side of the kiln. For safety reasons, Holt stresses the need to ground the sawdust transfer pipe to prevent static buildup caused by sawdust traveling through the pipe. A perforated (plumber's tape) metal strip runs along the pipe, attached with screws that penetrate the pipe wall so that the screw tips can touch sawdust as it travels through the pipe without causing any resistance. At the end of the pipe, a grounding rod connected by a wire is inserted into the ground. *Photo: Jim Hair.*

FIGURE 15-52
(a) This door-side elevation drawing of Holt's sawdust kiln shows the door opening and firebox that receives the sawdust. *(b)* This chimney elevation drawing shows the location of the damper. The position of the damper inside the chimney affects the temperature and the reducing atmosphere. *Courtesy the artist. Drawings by Charles Stewart, architect.*

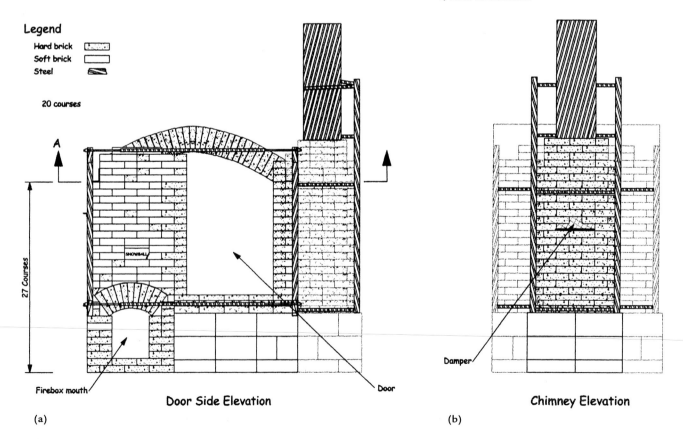

Legend
Hard brick
Soft brick
Steel

20 courses

A

27 Courses

SNOWBALL

Firebox mouth

Door

Door Side Elevation

(a)

Damper

Chimney Elevation

(b)

(15-51, 15-52). About twenty-five large garbage cans of sawdust are required for the kiln to reach cone 10. Holt says, *The results from my sawdust-fired kiln are perfectly suited to an urban setting.*

SALT-VAPOR FIRING

Salt glazing has a long tradition in Europe, England, and the United States, where it proved to be ideally suited for use on jugs and crocks for domestic use (see 6-16, 7-5). The glaze that develops when the sodium in the salt combines with the silica in the clay is impermeable to both water and acids. In the days before refrigerators, when many foodstuffs were preserved in brine and vinegar, this was an important feature of salt-glazed ware. It is no wonder that when European and British potters came to the American colonies, they searched for a stoneware clay on which they could use their traditional salt glaze.

In order for a salt glaze to develop, the clay body must contain the right amount of silica, the silica must be softened enough by the heat of the kiln to fuse with the sodium, and the salt must be damp in order to form a vapor in the heat of the kiln. When the damp salt is introduced into the kiln at about cone 7 (2291°F/1255°C), the sodium combines with the silica of the clay to produce a transparent glaze on the surface of the ware.

Since salt releases chloric and hydrochloric acid fumes when it vaporizes—fumes that are capable of seriously damaging the lungs, as well as causing metal corrosion—you must take special precautions in placing the kiln and stack so that the gases will not be released too close to people or inhabited buildings. In addition, insert the salt when there is no wind, and avoid any fumes as you insert it. For added protection, wear a respirator rated for vapors, acid mists, and fumes.

Salt Kilns

Although it is possible to build a special kiln with a calcium alumina lining that can be used for both bisque and glaze firing as well as infrequent or lightly salted firings, usually a salt kiln is used only for salt firing. This is because the bricks lining the kiln become glazed at the same time that the objects receive their glaze. If a salt

FIGURE 15-53
Mary Law of the United States opens the low-salt-vapor kiln at Walnut Creek Civic Arts Center, in which her work was fired to cone 11. She left the exteriors of some pots unglazed—their surface differences are due to their placement in the kiln.

kiln were to be used for bisque firing or ordinary glaze firing after salt-glaze firing, the salt glaze remaining on the bricks would melt again and cause problems with the newly introduced ware. Electric kilns cannot be used for salt glazing, as the elements would be harmed by the buildup of glaze.

Many potters, including Mary Law and Kris Nelson, respond positively to the surface that salt glazing creates (15-53–15-55). In order to get a combination of smooth areas and the characteristic mottled and textured "orange-peel" glaze that salt can produce, Walter Keeler (15-56) often first coats part of a jug or pot with a colored engobe (see *Expertise*, Chapter 1C). Where

FIGURE 15-54
Partially unloaded, Law's salt-vapor firing displays her work's varied forms and the surfaces she achieved with several clays, slips, and glazes. She used an environmentally friendly vapor-producing mix of about 95% sodium bicarbonate, 4% salt, and 1% borax packed in paper cups and dampened with a weak saltwater solution. Every 15 minutes she placed two cups in the burner ports over a period of 2 to 3 hours.

FIGURE 15-55
(a) Law fired a number of mugs in the low-salt-vapor firing kiln illustrated in Figure 15-54. The differences in surfaces are due to the kiln placement and various clays. 1993. Stoneware. *Courtesy the artist. Photo: Richard Sargent.*
(b) Kris Nelson of the United States glaze-fires his cups to cone 11 (2394°F/1312°C) for 30 hours in a Norborigama-style kiln. At approximately cone 8 (2316°F/1269°C) he introduces a small amount of a salt and copper mixture into the kiln chamber, which influences the color of the clay body, as well as glazes that can develop various combinations of blues, pinks, purples, and green hues. *Courtesy of Native Soil, Evanston, Illinois. Photo: Lynn Rosenthal.*

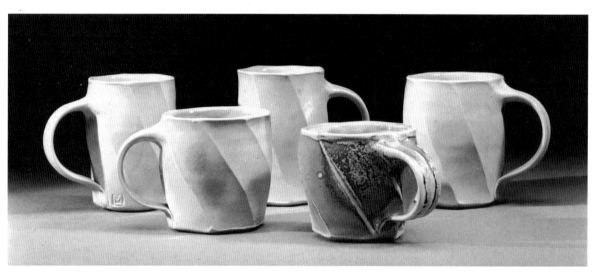

(a)

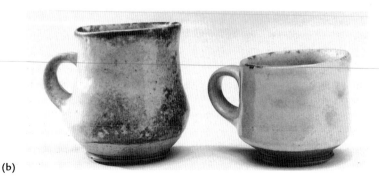

(b)

he sprays the engobe onto the clay, the surface will fire smooth, but when he leaves the clay uncoated, the orange-peel effect appears.

Eileen Murphy, on the other hand, does not want the details of her delicately incised and painted vessels to be obliterated by the orange-peel texture, so she fires her work very carefully, avoiding the "blast" that could destroy the delicacy of the image drawn on the pot (15-57).

Traditionally, salt ware was fired without added color, and the pots emerged predominantly

FIGURE 15-56
Walter Keeler of the United Kingdom created a variation of a traditional metal jug form in salt-glazed clay. Keeler fires his stoneware to cone 10 (Orton), reduces from 1832°F/1000°C, and salts the kiln at cone 9 for 1 hour, finishing with a ½-hour soak. He achieves the variation in texture by coating part of the ware with an engobe, which fires smooth, while the remaining part fires with an "orange-peel" salt texture. Stoneware, gray/gray-blue. Ht. 17 in. (43 cm).
Courtesy the artist.

FIGURE 15-57
Blue Heron Rookery. Eileen Murphy of the United States creates vessels celebrating the animals and birds that live on her country acreage. She brushes on slips and stains, and incises detailed line work into the dry clay. Murphy depends on salt firing to coat, but not obliterate, the complex surface detail and color.
Courtesy the Smith Gallery, New York. Photo: Richard Walker.

FIGURE 15-58
Peter Coussoulis of the United States introduces sodium into his salt kiln by spraying a solution of soda ash and salt into the kiln chamber. *Courtesy the artist and the City of Walnut Creek, California, Civic Arts Education Program, Walnut Creek Civic Arts Center. Photo: David Hanney.*

FIGURE 15-59
Old Odobenus #2, by Peter Coussoulis, is a salt-and-soda-ash-fired sculpture. The sculpture is modeled in stoneware clay, with pyrometric cones for the walrus tusks. Coussoulis applies a bronze-colored slip glaze and then overlays a white slip over the glaze, which crawls and provides a sunburned peeled surface effect. Fired to cone 11. *Courtesy the artist.*

the color of the fired clay body—sometimes brownish if there was iron in the clay and sometimes gray if the fire was heavily reducing and the iron content low. The only added color was in the cobalt blue decoration (see 7-5). Contemporary ceramists, however, use oxides, slips, stains, and glazes to impart color to their salt-glazed objects. Peter Coussoulis, for example, uses bronze-colored slip glaze on his sculpture and overlaps it with a white slip that crawls when salt fired (15-58, 15-59).

Low Salt Firing

Aware of the environmental impact of salt-vapor firing, potters have looked for ways to reduce the amount of chlorine gases emitted by their kilns. For example, Mick Casson in England (12-2) first cut down on the amount of salt and found that a smaller total amount put into the kiln more frequently in smaller batches worked well. He then switched to using sodium bicar-bonate, spraying a heated, saturated solution of sodium bicarbonate and water through several ports in about five-second bursts.

For salt-vapor firing in his cantenary arch gas kiln (15-58), Peter Coussoulis uses a low-salt mixture combining 90% sodium bicarbonate and 10% fine-grain salt and adds a small amount of water to make a paste. He prepares 20 paper cups full of this blend, and beginning at cone 8 (2316°F/1269°C) he adjusts the dampers of the kiln to create a turbulant reducing atmosphere. When the kiln reaches about cone 10 (2377°F/

1303°C), he begins to add the salt mixture, one cup in each kiln port every ten minutes.

After Coussoulis completes the firing, he turns the kiln off and closes all the burner ports and the damper. When the kiln has dropped to 1750°F/954°C, he fumes the pottery by introducing a mixture of 2.5 ounces (70 grams) of tin chloride and 1.06 ounces (30 grams) of bismuth subnitrate.

Janet Mansfield of Australia (12-6) fires her work in a 10-cubic-foot (.28-cubic-meter) low-polluting salt kiln, designed by Max Murray. The kiln has a stainless-steel "scrubber" chamber attached to the kiln flue. Inside the chamber is a pressurized water spray system that dissolves the hydrochloric acid fumes into a solution, which in turn is collected in a tank and drained into a neutralizing tower filled with limestone chips. This process neutralizes the acidic water, resulting in water safe enough to be discharged into a sewer.

If you choose not to use salt for vapor firing, you can use a more environmentally friendly mixture of dampened borax, pearl ash, soda ash, whiting, lithium carbonate, and bentonite. (See *Expertise*, Chapter 1C, for the formula and some slips to use with salt firing.)

Firing in a Salt Kiln

Greg Kennedy, director of the Ceramic Department Program at the Idyllwild Arts School in California, built his 24-cu.-ft. (.68-cu.-m) catenary-arch salt kiln, which he fires to cone 10–11. The kiln's shape makes it self-supporting, requiring no mortar. Kennedy laid a course of hard brick around the firebox, which rises 23 in. (58 cm); above that level, he stacked K23 soft insulation bricks. He outfitted the kiln with six venturi burners, three on each side, and fires it with propane fuel.

Before the initial firing, he coated the interior walls with a kiln wash mixture made with 60 parts alumina hydrate, 40 parts EPK kaolin, and enough water to make a creamy solution. The coating protects the walls from the corrosive salt introduced into the kiln during the firing. Before firing, all the ware is stilted with wadding made from the same kiln wash mixture, which prevents the ware from sticking to the kiln shelves (15-60). Kennedy sets cones 010, 8, 9, 10, and 11 inside the kiln, as well as a half-dozen ceramic draw rings (15-61), which he pulls out during the course of the firing. The clay rings, which are made of the same clay that is used to make the pottery, serve as small tests that monitor the salting action on the pottery. When cone 010 (1675°F/913°C) is reached, the kiln is set into a clay body and glaze reduction for 45 minutes. Pieces of pine wood are sometimes inserted into the salting ports throughout the firing to introduce ash into the chamber, which affects the clay color.

At cone 8 (2316°F/1269°C), Kennedy inserts dried rock salt into the burner ports, using a scoop. After each salting, he extracts a draw ring from the kiln and analyzes it for glaze thickness and texture (see 15-61b). When the desired surface is achieved, usually around cone 10, Kennedy shuts off the gas and closes the damper,

FIGURE 15-60
Greg Kennedy of the United States stilting ware with a putty-like wadding compound made with kaolin and alumina hydrate that keeps the pottery from sticking to the kiln shelves during a salt firing.

(a)

(b)

FIGURE 15-62
After cooling his catenary-arch salt
kiln for 2 days, Kennedy opens the
kiln and removes the ware. *Courtesy
Idyllwild Arts. Photo: John Toki.*

FIGURE 15-61
(a) Kennedy peers into the peephole of his 24-cu.-ft (.68-cu.-m) catenary-arch
salt kiln, preparing to pull out a ceramic draw ring with a long steel rod probe.
The ring is set directly in line with the peephole brick on a shelf inside the kiln for
easy retrieval. *(b)* To check the amount of salt surface that is attained after each
salting, Kennedy pulls out a ceramic draw ring, which serves as a miniature test.
He places a number of draw rings into the kiln that he periodically pulls from the
chamber.

burner ports, and spy holes. After cooling the
kiln for 2 days, Kennedy unbricks the kiln door
to reveal a load of successfully salt-glazed ware
(15-62).

Traditionally, salt firing is performed at high
temperatures between cone 10 and cone 11
(2377°F/1303°C to 2394°F/1312°C). Elizabeth
Loo, who studied at the Nova Scotia College of
Art and Design, fires her porcelain cups to cone
6 (2266°F/1241°C), which is about 150°F/66°C
lower than a typical salt firing (15-63). Loo ap-
plies low-fire glazes to her cups and fires them
in a gas kiln. At cone 010 she adjusts the burners
and damper to cause the clay body of the ware
to reduce. She uses two different solutions of
soda ash diluted with water, which she sprays
into the kiln burner ports. To achieve a light salt

FIGURE 15-63
Two for Me, a set of soda-fired porcelain cups by Elizabeth A. Loo of the United States, fired to cone 6. Loo decorated her cups with low-fire glazes and sprayed a soda-ash-and-water solution into the kiln to achieve this salt-textured surface.

texture on the ware, she sprays a mixture of 1 lb. (454 g) of soda ash with 1 gal. (3.785 l) of water. For a heavier, less runny salt glaze surface, she sprays a solution of 4 lbs. (1816 g) of soda ash mixed with 1 gal. (3.785 l) of water.

During each soda spraying, Loo turns off the kiln briefly and closes the damper rather than wasting the soda ash by letting it vent out the flue; closing the damper also acts to contain the soda-ash solution inside the chamber so that it can react more readily with the pottery. After each spraying, Loo opens the damper and turns the kiln back on. Because the kiln temperature is lower than that of a traditional high-fire salt kiln, a higher quantity of soda ash has to be introduced into the kiln chamber so that the clay and glaze can react with the soda ash over a longer period to attain a salt glaze appearance. At cone 5 to 5½, Loo begins spraying the soda solution into the kiln; she continues this process over a period of 45 minutes.

The work of the preceding artists are examples of how contemporary ceramists have taken a historical process, experimented with it, expanded its traditional limits, and found ways to adapt it to their needs.

RAKU FIRING

Another process that has spread from one culture to another is raku, developed in sixteenth-century Japan, where raku-fired pots were used in the traditional tea ceremony (see 3-31). Its popularity in the West began in the 1950s and 1960s, when an interest in Zen philosophy developed in the United States and Europe. Linked with a keen appreciation of nature and recognition of beauty in nonperfection, raku also appealed to ceramists because of its participatory aspects and the spontaneous and dramatic results it produced. Now, like many of the traditional processes that are now used around the world, raku has been absorbed, changed, and adapted to other cultures (15-64–15-71). More significant than the use of new methods and equipment are the aesthetic changes that have

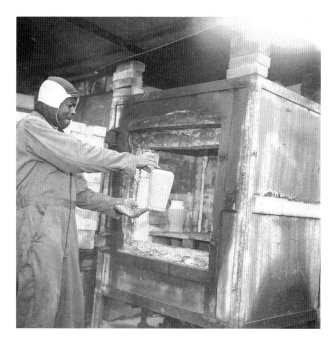

FIGURE 15-64
Alvin Bernard Cooper of the United States stacks ware in his front-loading gas-fired raku kiln. Cooper prefers a front-door style kiln because it makes the removal of hot pots easier than does a top-loading kiln. Since the kiln is cold, there is no need for him to wear heat-resistant gloves when loading. *Courtesy the artist.*

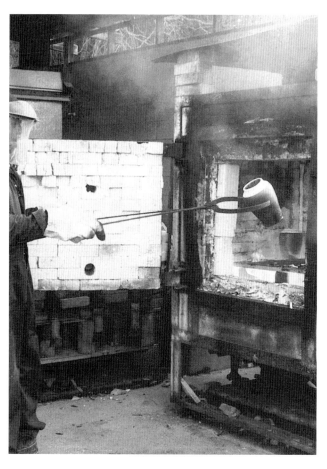

FIGURE 15-65
When his pieces become red hot, Cooper removes them with long raku tongs. Cooper wears protective safety gear, including a welder's face shield and gloves. His entire body and head are protected with a jumpsuit and headgear, which shield him from the intense heat of the kiln and the pots. *Courtesy the artist.*

FIGURE 15-66
After placing his pots in a metal drum containing straw, Cooper closes the lid and lets the pots cool slowly. Sometimes he adds extra sawdust, hay, and paper to the smoking cans, which increases the reducing atmosphere and produces the lustrous copper colors on his pots.
Courtesy the artist. Photo: John Cummings.

FIGURE 15-67
Cooper demonstrates another method that he uses to reduce his raku pots. After placing a pot on a kiln shelf with combustible materials, he covers the piece with a metal garbage can. *Courtesy the artist. Photo: John Cummings.*

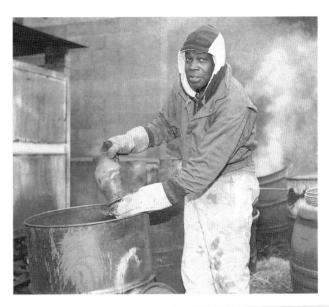

FIGURE 15-68
Cooper holding a fired raku pot. *Courtesy the artist. Photo: John Cummings.*

FIGURE 15-69
Cooper reduces his work in a can with sawdust, hay, or newspaper. Combustible material smoking in a metal can, and the length of time a piece is left in the metal, can help develop more or less lustrous glaze colors. *Courtesy the artist. Photo: Scott McCue.*

FIGURE 15-70
Enviroman, by Stephen Braun of the United States, was raku-fired in sections. Braun created the surface with matt raku glazes and a semiglossy white glaze with various oxides under it. White raku clay with 30% grog. Ht. 94 in. (2.39 m), not counting the airplanes. *Courtesy the artist. Photo: Tony Novelozo.*

taken place as contemporary ceramists have adapted the raku tradition to their work, using what is applicable and discarding what is inappropriate to their own ceramic traditions.

Before a pot or sculpture can be fired using the raku process, it should be built of a clay that can withstand the thermal shocks to which it will be subjected (see *Expertise,* Chapter 1C). The pot should then be bisque-fired in any type of kiln and glazed with a low-fire glaze adapted for raku firing (see *Expertise,* Chapter 1C). Although the traditional raku kiln was a small wood-burning kiln with an inner saggar in which the ware was fired, you can use any kiln that can be heated quickly to red-hot heat—

between cone 015 (1501°F/816°C) and cone 05 (1915°F/1046°C)—and provides easy access to its firing chamber. It can be an electric kiln or a gas kiln fired with propane or natural gas. Since the process involves placing the preheated pot directly in the hot firing chamber and then withdrawing it, the interior should be accessible so that you can easily insert and withdraw the pots. Be sure to use tongs and protective gloves when you do this (15-72, 15-73; see also 15-65), and wear a face shield or safety goggles when you look into the fire. Depending on the design of the kiln, as the firing progresses, you may be able to look in and see the glaze actually maturing on the ware.

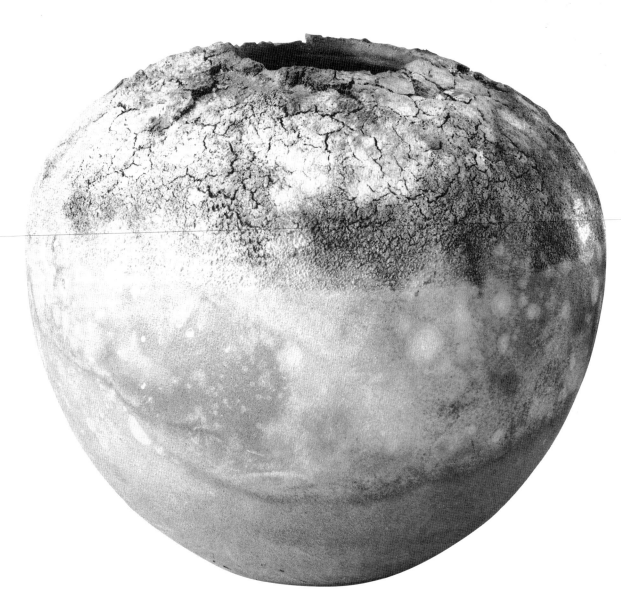

FIGURE 15-71
Skip Esquierdo of the United States fires his pots to 1900°F/1038°C in a propane-fueled raku kiln. He then places pine needles over the hot pots and covers them with a metal can so that they can reduce in the smoldering atmosphere, which helps bring out a variegated surface. *Courtesy the artist. Photo: Lee Fatheree.*

FIGURE 15-72
Reuben Kent of the United States places a piece of his sculpture in the reduction chamber. Although he usually uses wood shavings, for a nice flash he uses paper printed with color—*advertisement circulars are good,* he says. However, since this particular paper stock usually has lead in the ink, it is advisable to use any and all safety precautions: *A healthy artist is a happy artist.* *Courtesy the artist.*

FIGURE 15-73
Robert Abrams uses appropriate safety equipment when raku-firing. He wears a leather welding jacket, Kevlar gloves, shaded goggles to protect him from the bright light emitted from the kiln when it is opened, a face shield, high-top leather boots, and jeans. *Photo: John Murphy.*

FIGURE 15-74
To produce a crackle texture, this pot was removed from the kiln and placed on a shelf, where it was immediately fanned to increase the crackle; then it was quickly placed in the trash-can reduction chamber shown here while still hot but not glowing. After the newspaper flamed up, the can was covered for 20 minutes. *Courtesy Richmond Art Center Ceramic Studio, Richmond, CA. Photo: Carl Duncan.*

As soon as the glaze matures, remove the pot and leave it to cool rapidly, or place it immediately in a heat-resistant container of sawdust, charcoal, newspapers, (15-74), seaweed—anything that will burn and create a reducing atmosphere when the container is covered. Reduction will cause iridescent luster areas to appear, and the fire marks that enrich the surface will often develop (see 15-69, 15-70). Most raku develops crackles in the glaze (see 15-71), but if you want more crackle, you can plunge the piece into water while it is still hot.

Robert Abrams fires his raku pots in a 7-cu.-ft. (.20-cu.-m) natural-gas-fueled top-hat kiln (see 15-73). The interior is lined with K23 bricks, which reduce heat loss when the kiln body is lifted. It has a crank-style winch with a wire rope cable that safely lifts the entire kiln body and lid up and out of the way for conveniently loading ware and removing hot pots. Abrams fires his raku ware to cone 05, then removes the

FIGURE 15-75
A student unloads a piece from a top-hat raku kiln at Idyllwild Arts School. After the temperature reaches about cone 05, the kiln shell is lifted up and the pottery and sculpture is removed and placed in metal cans with newspaper as a reducing material. For safety measures, long pants and a face mask are recommended in addition to the safety gloves. *Courtesy Idyllwild Arts. Photo: John Toki.*

hot pots from the kiln and places them in a shallow metal pan that is partially filled with wood chips. Once the pots have set the wood chips on fire, he covers the pots with metal garbage cans. He prefers the kinds of wood chips that are used in hamster cages; he purchases the chips at pet stores.

At Idyllwild Arts School, raku pottery is fired in a propane-fueled **top-hat kiln** (15-75). For loading and unloading, the kiln body is safely lifted with the aid of a cable attached to a heavy-duty spring. The kiln interior is lined with Kao-wool pinned with refractory buttons attached to the metal shell. Unlike a brick-lined kiln, one lined with Kaowool reflects rather than absorbs heat and heats the ware quickly. This kiln style is fuel efficient and is excellent for firing pottery at raku temperatures, which usually range between cone 05 and cone 08 (1915°F/1046°C to 1749°F/954°C). (This type of kiln is generally not used for high firing—above cone 5—because of its minimal Kaowool insulation and wall thickness.) By leaving plenty of space between the kiln shelves, the kiln operator provides enough room

FIGURE 15-76
After a hot pot is placed into a metal reducing can, a student quickly tosses a small amount of newspaper on top of the ware, causing the paper to combust. A metal lid quelches the fire and creates the smoke that reduces the red-hot pot. When the pot is cool, after 20 to 30 minutes, it is removed from the can. *Courtesy Idyllwild Arts. Photo: John Toki.*

for the heat to flow through the kiln chamber efficiently, and this also helps heat the ware evenly. Also, by leaving extra space between the shelves, the operator gains easy and safe access to the hot pots with long metal tongs, and enough room for the tong claws to reach into the mouth or around the collar of a pot when removing ware from the kiln. Once the kiln temperature reaches cone 05, the glowing-orange pots are removed, set on a bed of newspaper in a metal can, and immediately covered with a newspaper and a lid; this creates the reducing atmosphere (15-76).

In the past, the glazes used for raku firing were lead glazes, because lead was a readily available flux that enabled the glaze to melt at the low temperatures the kilns achieved. However, for health reasons lead is to be avoided; in addition, raku-fired pots, with their pitted, crackled glazes, are not considered safe for use as food containers.

The experience of pulling a pot from the kiln and plunging it into sawdust or seaweed and water can be exhilarating for those who are new to clay. But raku-firing techniques can also be an expressive tool, not only for the excitement of the process but, more important, for the aesthetic results that can be obtained with it. One artist who uses raku in a highly expressive manner is Richard Hirsch. Hirsch uses a combination of terra sigilatta and low-fire glazes to surface his vessel forms (see 9-15, 14-29; see also

Expertise, Chapter 1C, for one of Hirsch's glaze recipes). Of his raku-firing method, Hirsch says,

The piece is removed while very hot (approximately 1400°F/760°C) and sprayed with several metallic salts (i.e., copper, iron). I use a mask when spraying outdoors and never do this indoors because the fumes are toxic.

(Note: The respirator you use should be rated for toxic fumes.) Hirsch continues this process for several removals and sprayings to build up the surface. His final step is to remove the piece from the hot kiln and place it in straw for the postfiring reduction. Hirsch says that this

further enhances the visual depth of the surface and changes the coloration of the salts and sigs. The results are a colored patination that expresses age and history, which is an integral aspect of my work.

Raku firing, with its unexpected results, appeals to many people because of its spontaneity. Nevertheless, there are health and safety precautions that you should follow when working with flaming materials and red-hot objects. Keep a hose or bucket handy; don't go barefoot, and wear safety shoes as protection against stray burning straw or a dropped pot. Keep the area around the kiln free of combustibles, and if you reduce in a container, also keep the area around it clear of loose straw or paper. Lift the lid of the reducing container carefully so that any flames will be directed away from you or other people. And, as Reuben Kent (see 15-72) demonstrates, use all safety precautions.

POSTFIRING SMOKING

A number of artists use postfiring smoking and fuming techniques to give a rich, smoky quality to their pots or sculptures without subjecting them to the stresses of the raku method. By using this process, they can also achieve interesting reduction effects without damaging the elements of their electric kilns. There are various ways to do this, but basically it is a matter of exposing the already-fired piece to the effects of a reduction atmosphere. Paul Soldner used salt-fuming and reduction to give his wall piece its misty night-time quality (see 8-23). Stuart Smith captured the atmosphere of Indian cities by using raku.

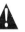

A word of caution: Do not fume or smoke your pieces by burning straw soaked in salts without wearing a respirator rated for protection against toxic fumes.

PIT FIRING

The earliest potters fired in open firings on the top of the ground or in shallow pits. This type of firing produces a low-fire, porous type of earthenware that is not watertight. The tradition of open firing has continued throughout history and is still used in nonindustrial areas around the world—Africa (see 4-14), Mexico and the American Southwest (see 5-21), and Fiji (see 1-21). Contemporary potters, captivated by the fire marks and other effects that can be achieved with pit firing, have experimented with firings ranging from sawdust and peat in an open-top brick kiln to pit-firing on a beach. Each person has a favorite way of conducting this type of firing.

A backhoe was used to dig Cara Moczygemba's temporary pit—10 ft. long × 5 ft. wide × 4 ft. deep (305 × 127 × 122 cm)—during a workshop at the Idyllwild Arts School (15-77–15-79). The deep pit provided an ideal chamber for efficiently retaining the heat of the fire during the firing. The type of clay used to make pit-fired ware can have a dramatic effect on the final outcome. Moczygemba says,

Any clay can be used for pit firing, but coarser clays should have a terra sigillata applied before bisquing for a smoother surface that will take the colors better. All the clays are improved by being burnished.

After the pieces had been bisque-fired to around cone 06, they were wrapped with a variety of coloring materials before being placed in the pit. Moczygemba and her students used the following materials to cover the ware: copper wire, copper pot scrubbers, copper tape, cotton string dipped in a salt-and-copper-carbonate solution or a salt-and-iron-oxide solution, steel wool, banana peels, eggshells, seashell shards, and seaweed. In addition, some forms were sprayed with copper paint. After the pieces were wrapped and sprayed, they were covered with newspaper. The bundles were held together with steel baling wire. This technique kept the coloring materials from moving as they pressed against the clay surface, which provided a positive bond and interaction

FIGURE 15-77
Cara Moczygemba loads pottery and sculpture into a large pit at the Idyllwild
Arts School. The ware was covered with many different coloring materials,
such as copper wire, copper pot scrubbers, copper spray paint and tape,
banana peels, shell shards, steel wool, and string soaked in a salt-and-iron or
salt-and-copper solution. After the ware was decorated, it was wrapped in
newspaper and tied with wire to keep everything together during the pit firing.
Courtesy Idyllwild Arts. Photo: John Toki.

FIGURE 15-78
After placing the ware in the bottom of the pit, wood is stacked carefully around and on top of the pieces. The wood is then lit and left to burn until there is a strong flame. The pit is then covered with corrugated sheet metal, leaving openings at both ends for oxygen. Moczygemba or one of her students stands by during the entire firing with a hose to contain the fire should it spread beyond the pit. *Courtesy Idyllwild Arts. Photo: John Toki.*

FIGURE 15-79
Eric Chow watches as Moczygemba's pit fire actively burns the
wood covering the pottery. *Courtesy Idyllwild Arts. Photo: John Toki.*

(a)

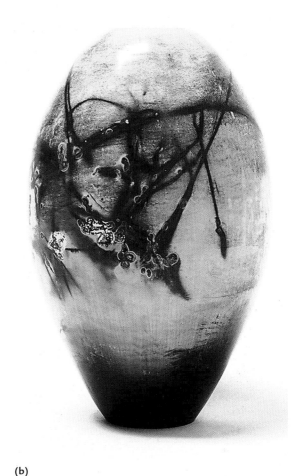

(b)

FIGURE 15-80

(a) Virginia Mitford-Taylor of the United States protects her delicate pit-fired ware in a lidded metal can perforated with holes. By containing her ware in the saggar, she is able to contain the reducing materials and chemicals that help produce the surface color. *Courtesy the artist. Photo: John Toki. (b)* A pit-fired vase by Mitford-Taylor. After placing her vase in a custom-made reusable metal saggar, Mitford-Taylor packs oak and walnut hardwood chips around the piece; the chips burn slowly during the pit firing. To attain pink colors, she adds seaweed to the saggar, and for black lines, she unravels copper battery cable wire and wraps her pottery. Mitford Taylor says, *I sometimes add rose petals or any flowering plants from my garden that have color to the saggar for additional color.* *Courtesy the artist.*

with the fire. To contain the reducing materials and protect small, delicate ware, some pieces were placed inside metal-can saggars with holes punched into the sides and lids to let the heat reach the pottery (15-80).

After the ware was loaded into the pit, wood was carefully stacked on top of the pottery, the fire was started, and the pit was covered with long sheets of corrugated metal with openings at both ends to let in oxygen. The fire was left to burn until all the wood had been consumed,

resulting in a chamber of glowing orange-red embers. For safety reasons, a person stood by the fire with a hose throughout this process to ensure that the fire did not spread beyond the pit. After the flames subsided, the metal sheets were moved so that they completely covered the pit, and the ware was left to cool until the next morning. The wrappers and coloring materials were removed to reveal beautiful rich reds, soft yellows, and orange colors that were achieved from the copper, salt compounds, and organic materials. To seal

the ceramic surfaces and enrich the colors, a satin, gloss or matt polyurethane sealer was sprayed onto the pottery.

Cara Moczygemba says,

> I find pit-firing seductive—the process, the art of the firing itself, the results. Pit-fired ceramics seem to speak of something more primitive, closer to the rhythms of nature and the earth than a glazed surface. At heart, ceramics is a process-oriented art form, and unlike some other mediums it is necessary to understand, even master, the process before art can be achieved.

Marc Lancet, who conducts large-group pit firings with his students from Solono College in California, embeds steel nails into some of his sculptures (15-81). The reddish pink blushes of color achieved from the pit firing contrast with the multitude of nails stuck into the effigy-like figure, creating a visual tension. Since the pit firing occurs at such a low temperature, the steel nails remain intact, with minimal scaling.

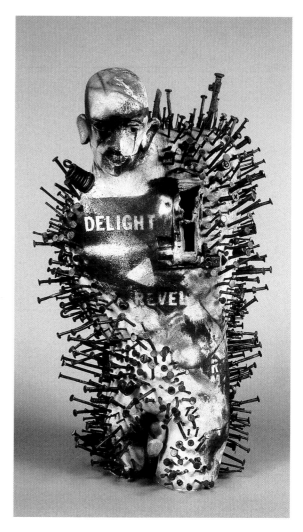

FIGURE 15-81
Compliance, a collaborative pit-fired steel sculpture by Marc Lancet and Tracey Grubbs of the United States, combines the ancient look of an effigy figure with English text, creating a sense of mystery about its origin. 25 × 13 × 10 in. (64 × 33 × 25 cm).
Courtesy the artist. Photo: Hedi Desuyo.

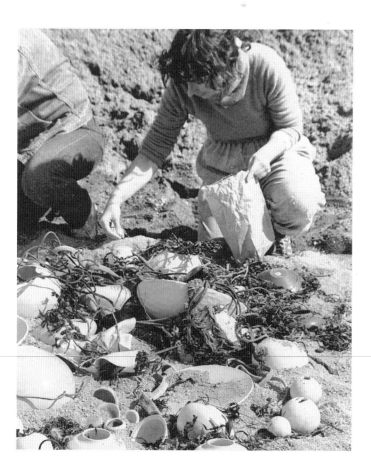

FIGURE 15-82
A group pit firing on a beach can be a rewarding experience, especially if the fire is good to your ware and creates the colored surface you desire. Here, Carol Molly Prier of the United States sprinkles copper carbonate on some of the pots that have been buried in sawdust at the bottom of the pit and then covered with seaweed.

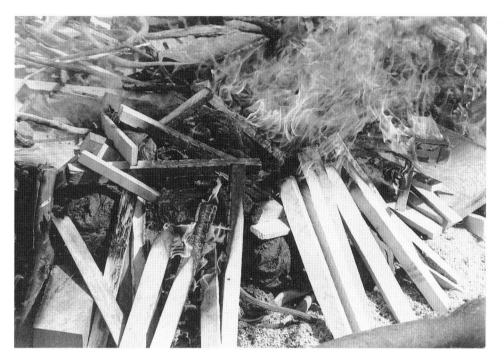

(a)

FIGURE 15-83
(a) After the pots have been covered with cow dung and wood, and after a ritual scattering of cornmeal over them, the fire begins to play its part. *(b)* The fire has burned down and the pots emerge surrounded by the ashes, which hold the shape of the dung until they are disturbed. The hardest part of pit firing is not digging the pit or lugging the wood and dung, but waiting until the ashes are cool enough so that you can remove and study your pots.

(b)

Some people use only earthenware clay for their pit-fired ware, feeling that it will survive the stress of the firing better than high-fire clays. Carol Molly Prier, however, has fired every type of clay in pit fires—from low-fire to porcelain—and finds that no one clay seems to crack more or less than another. Since her vessels are usually burnished, she chooses clay with no grog. At one group pit firing, held on a beach, the ware was partially buried in a layer of sawdust with seaweed and driftwood placed over it to provide salt and other minerals (15-82–15-84).

The surface was then sprinkled with copper carbonate, covered with cow dung, and prepared for firing by piling wood on top of the cushioning provided by the dung. With everyone pitching in to dig the pit, gather driftwood and seaweed, and place their pots in a layer of sawdust, the sense of community effort gave this group of contemporary clay crafters a vivid sense of identification with early potters, bringing the human experience with clay and fire full circle.

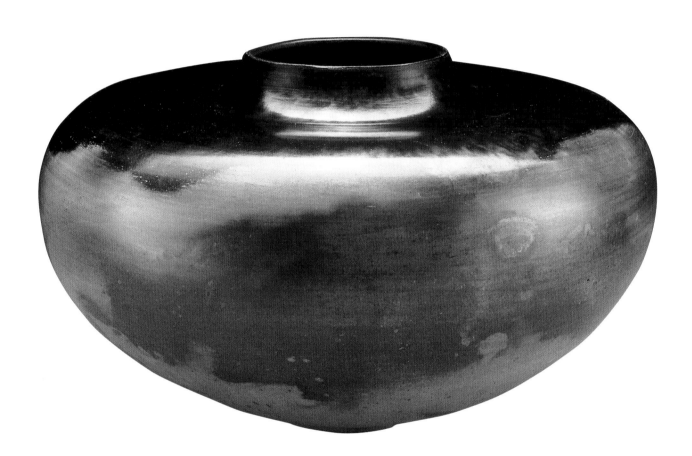

FIGURE 15-84
On a windy beach within sound of the surf as background music, fire, clay, and human artistry unite to create an elegant vessel, using a firing method as old as the art of ceramics. Pit-fired, burnished vessel by Carol Molly Prier of the United States. *Courtesy the artist. Photo: Charles Frizzell.*

16

Installations and Architectural Works

Installations are generally considered to be a recent development in clay sculptures, but it could be said that unfired clay was used in an "installation" and in "performance art" as early as the Ice Age. In a cave in France, a talented sculptor modeled a relief of mating bison that, though unfired, has remained intact until the present day (see 1-2). Nearby, a circling pattern of small footprints suggests that some form of adolescent initiation ritual was enacted there in conjunction with the vigorous bison relief.

INSTALLATIONS AND PERFORMANCE ART

Modern installations and performance art grew out of the art scene of the 1960s and 1970s, a period when artists began using old media in new ways. Judy Chicago's *Dinner Party,* for instance, displayed china-painted place settings to honor famous women, commenting on traditional "women's crafts." The installation contained sexual images that delighted the work's mostly female viewers while sometimes confounding the few male artists or potters who came to see it. Some artists even incorporated their own bodies as part of the medium. For example, in one performance piece dancers slithered in slip (16-1); in another, James Melchert and other ceramists poured slip over themselves and sat waiting for it to dry.

Since the 1960s, ceramic installations have regularly been displayed in venues ranging from outdoor settings to art galleries. George Guyer and Tom McMillin exposed panels of unfired stabilized clay to California surf, monitoring their work as it eroded. Charles Simonds used the impact of the unexpected site as an integral component of his

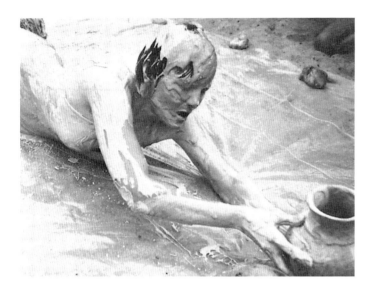

FIGURE 16-1
In the early days of performance art, dancer Jere Graham of the United States explored the potter's medium, slithering in creamy colored slips until she became a moving clay sculpture.
Courtesy Crossweaves Dance Company. Photo: ISHA.

FIGURE 16-2
(a) About her installation *Bad Manners,* Marilyn Lysohir of the United States wrote, Bad Manners *is about confusing luxuries with necessities.* Bad Marnners *is about conspicuous consumption.* Bad Manners *is also about greed.* The luscious ceramic surfaces of the food were obtained with low-fire clay colored with underglaze and then finished with a transparent overglaze. *(b)* Lysohir in her studio working on the figures, which, when colorfully glazed and fired, sat around the laden table of her installation. 1984. *Courtesy the artist. Photo: Rick Semple.*

(a)

(b)

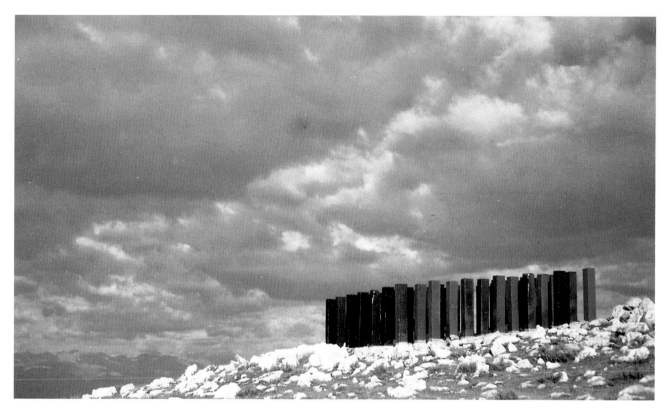

FIGURE 16-3
In a temporary mountaintop installation by Bernard De Jonghe of France, ceramic holds its own against the sky and clouds. De Jonghe built a series of slab-constructed columns, gave them a brilliant cobalt glaze, and wood-fired them. Then he and some friends carried them up to the top of a mountain in Provence while a cameraman made a video of the process. *Courtesy the artist. Photo: François Galec.*

work (see 8-15). Using installations to create settings for her figurative sculpture, Marilyn Lysohir expressed social criticism while creating luscious ceramic surfaces (16-2). In France, Bernard De Jonghe carried glazed, fired columns to a mountaintop and made a video of the process (16-3). British sculptor Paul Astbury assembled unfired cups and teapots in airtight display cases, where the objects could be seen through plastic windows (see 9-17). Unable to escape, the moisture in the clay evaporated, misting the windows, and then returned to remoisten some of the clay objects to the point of collapse. And in a convivial setting in Holland, Frans Duckers played bartender to one of his large sculptures (see 9-9) and waited to see if customers would chat with it. They did.

All the clay-forming methods illustrated in this book have been adapted to creating installations: handbuilding, modeling, rolling out slabs, extruding tubes, pressing clay into molds, working on the wheel, or using a combination of these meth-ods. Many artists have also taken advantage of the adaptability of modules to create a variety of installations. Since large individual sculptures often require a great deal of space to construct and are often difficult to transport, one solution to exhibiting such works is to build large sculptural pieces or installations composed of modules. The term *modules* normally refers to identical sections, such as tiles, but it can also refer to individual parts of varying shapes and sizes. French sculptor Jacques Kaufmann, for example, has placed temporary exhibits consisting of modules in various surroundings, using ready-made damp bricks juxtaposed with other materials (16-4).

Much of Kimpei Nakamura's ceramic work in Japan has been architectural and site specific, but he also created an outdoor installation that included small hand-sculpted modular elements and a massive steel cylinder covered with high-fired tiles, along with casts of plumbing fixtures, machine parts, and rough-textured rocks—all formed in molds (16-5).

FIGURE 16-4
Installation by Jacques Kaufmann of France. Kaufmann used two materials from the natural world, combining damp clay in the form of unfired bricks and marble in a mixed-media sculpture. *Courtesy the artist.*

FIGURE 16-5
For this outdoor installation, Kimpei Nakamura of Japan covered a steel cylinder with high-fired tiles, photo decal decoration, overglaze, and luster brushwork. He also attached mold-made sculptural forms. The individual tiles are about $22 \times 22 \times .3$ in. ($57 \times 57 \times .8$ cm).

FIGURE 16-6 ▶
Eerste druk ("first impression"), by Rosa Verhoeve of Holland. This installation in Verhoeve's study incorporates both the cerebral and spiritual aspects of the human mind, symbolized by clay impressions of the artist's forehead. Verhoeve says, *It was not my intention to work from a concept while making the forms of clay. I just wanted to mold the clay with specific parts of my body from which a sculpture might evolve.* Terra-cotta, wood, copper. 94×39 in. (2.40×1 m). 1991. *Courtesy the artist.*

FIGURE 16-7
A gallery installation by Lourdan Kimbrell of the United States combines ceramic, feathers, rocks, and sand to remind us of the devastating impact of oil spills on wildlife.
Courtesy the artist.

(a)

(b)

FIGURE 16-8
(a) First Harvest, an installation by Juan Granados of the United States, comments on the environmental issue of clear-cutting forests. *(b)* Granados used a semimodular approach that emphasizes his message. To form his pieces, he drapes slabs over wadded, shaped newspaper. Colored with stains and oxides, then fired in oxidation. 12 in. × 8 ft. × 14 ft. (30.48 cm × 2.44 m × 4.26 m). *Courtesy the artist. Photos: Jan Q. Thompson.*

FIGURE 16-9
Tulip vases, by Jan van der Vaart of the Netherlands, installed in the Frans Hals Museum in Harlem, the Netherlands. These giant vessels recall the decorated table-top tulip vases popular in Holland at the time tulips were first introduced to Europe in the seventeenth century. Vases built at Strukturr '68.
Courtesy Frans Hallsmuseum de Hallen, the Netherlands. Photo: Thijs Quispel.

In a more personal work, Dutch artist Rosa Verhoeve fired casts of her own forehead and installed them in a bookcase in her study (16-6). Lourdan Kimbrell and Juan Granados have both assembled modular forms in installations to comment on the depletion of earth's natural resources and wildlife (16-7, 16-8).

An installation can sometimes be functional while making a statement: Jan van der Vaart placed a group of giant vases in a museum in Holland (16-9), where Dutch viewers would recognize the historical reference to the ceramic table vases made to hold tulips during the craze for imported tulips that swept their country in

FIGURE 16-10
The richly textured and glazed surface of Lidia Zavadsky's towering ceramic jar, installed in the lobby of the Hyatt Hotel at the Dead Sea, Israel, creates a dramatic contrast with the surrounding architecture. Low-fired red glaze fired at 1688°F/920°C. Ht. 53 in. (134 cm).
Courtesy the artist's estate.

the seventeenth century. These vases, as well as Lidia Zavadsky's red vessel in a hotel lobby in Israel (16-10), are close to being site-specific or architectural works.

CERAMICS AND ARCHITECTURE

Throughout the long history of its use by humans, clay has been employed as a material for architectural works of all types—from utilitarian to symbolic. Wherever appropriate clay sources existed, humans soon discovered its usefulness for building—from daubing mud on the walls of huts to molding clay into bricks to dry in the sun. After the discovery that clay could be hardened in fire, this new building material was used to construct more substantial shelters. Eventually, glazes were discovered, bringing color and decoration to tiles covering the walls of buildings (see 2-10, 2-29) and making bricks and tiles more moisture resistant. It was now possible to construct large, durable buildings, and architectural projects often became symbols of power, proclaiming the importance of cities, kings, and emperors.

Fired clay was also used as an expressive sculptural material, with artists creating images of rulers, gods, and goddesses to adorn facades or roofs (see 2-31, 3-42, 3-43). It was also used to mark the burial places of important personages (see 3-28) or to fabricate containers to hold their remains.

In these ways, ceramics has been closely linked with the development of architecture in many parts of the world. Today modern materials may take the place of clay in some situations, but brick is still widely used as a building material, and ceramic decoration is applied in various ways to humanize public and private spaces. These various applications provide opportunities for contemporary ceramics artists to create site-specific works that range from large government commissions to more intimate works for private individuals.

SITE-SPECIFIC WORKS

Each commission for a specific site—whether a wall piece for a public building (see 16-15), a colorful fountain for an outdoor site (see 16-20),

(a)

FIGURE 16-11
(a) When Michelle Gregor of the United States received a private commission, she built a sculptured double fountain for her clients' garden. (b) With its romantic sculptured figure, decorative painted tiles, and the sound of flowing water, her creation provides a restful corner in a California garden.
Courtesy the artist.

(b)

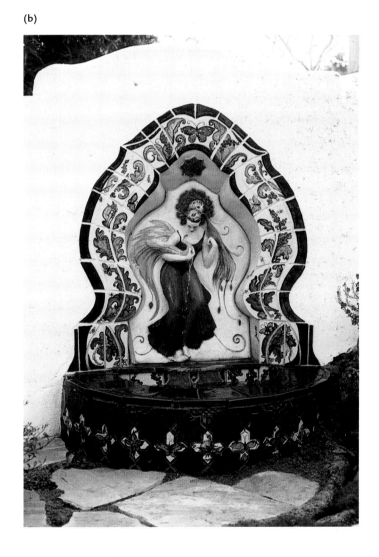

tall sculptures in public spaces (see 16-16, 16-18), or vessel forms in a courtyard (see 16-19)—involves a particular set of opportunities, limitations, and specifications with which the designer and maker must become familiar. Each of the varied sites offered to the artists mentioned in this chapter represented a unique situation. Not only did the ambiance of the sites vary, but each called for careful planning in order to execute work that was appropriate to the situation. All required an adaptable artist who was able to satisfy the commissioning entity—whether an individual client (16-11), a government committee (see 16-37, 16-38), or a corporate client (see 16-20).

A commissioned artist must also be able to participate successfully in setting up a practical installation scheme, so the ability to work with engineers, architects, and clients is equally important. At the same time, the artist must achieve his or her own aesthetic goals in relation to the work while also considering the needs and safety of the people who will use or pass by the site. For example, if you were installing a work in a government facility or in a public setting, structural drawings and engineering consultations would be required for the installation process. Clearly, the type of thinking needed to carry out a commissioned work is different from that used to create a personal, expressive piece that is not planned for a designated site.

FIGURE 16-12
Paula Winokur of the United States first built a ⅙-scale model of her work, *Earthshift,* for the Pennsylvania Convention Center in Philadelphia. With the scale model and the dimensions of the site in mind, she constructed the final piece, using stiff porcelain slabs built over a clay framework. *Courtesy the artist. Photos: Michael Winokur.*

FIGURE 16-13
(a) A template of *Earthshift* is used to mark the placement of the hanging brackets. Steel hanging brackets were then screwed into ¼-in. (6.35 mm) multiple-density plyboard backing, and the fired clay sections were glued to the wood with silicone caulk. *(b)* After placement of the brackets, the sections will be hung in place on the purple wall.

(a)

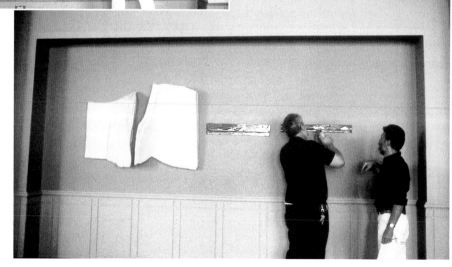

(b)

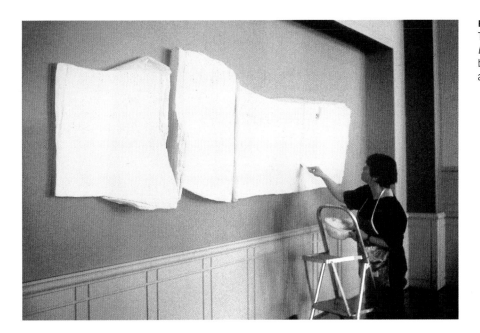

FIGURE 16-14
The eleven sections of *Earthshift* are hung on the brackets, and Winokur grouts areas of the installed piece.

FIGURE 16-15
Winokur's porcelain mural, *Earthshift,* in place on the wall at the Pennsylvania Convention Center. The sculpture measures 36 × 108 × 12 in. (91.44 × 274.32 × 30.48 cm) at its thickest part. *Courtesy the Helen Drutt Gallery and the Pennsylvania Convention Center, Philadelphia.*

The Selection Process

Having decided to apply for a commission, the artist must present the proposed work as attractively and as graphically as possible in order to convince the competition jury, architect, or client that her or his particular design is the most appropriate one for the chosen site. The artist's presentation generally covers concept, design, material, budget, site-specification, scheduling, and installation details. This presentation also often includes a written description, installation plans, and elevation drawings showing the suggested placement, plus a three-dimensional model (see 16-37c). Occasionally, as was the case for Paula Winokur (16-12–16-15), an artist may receive a commission based on only one drawing of the proposed work. Regardless of the preliminary selection process, a commissioned work is governed by a contract signed by the artist and the client.

Planning for Specific Sites

If called on to design a work for a specified space, the artist must consider many factors. Among the most important of these is the scale of work that would be most appropriate for the particular building or outdoor environment. For example, an extremely large or heavy mural might dominate and overwhelm a small room, while the same mural might be especially appropriate on an extensive outdoor wall.

Other factors that the designer should consider are the following:

- In what size or type of space will the work be placed?
- How will the area around the work be used?
- From what distance or at what angle will the viewer see the work?
- Under what type of lighting will the work be viewed?
- What scale and color of work would be most appropriate to the furnishing or color of the surroundings? For example, the brilliantly colored glazes that are appropriate for a school mural (see 16-41) or a freestanding sculpture in a schoolyard (see 16-35) would probably be out of place in a bank office.
- What scale of surface texture or type of glaze treatment would blend or contrast successfully with the surroundings? An extremely detailed surface or glaze treatment would be lost on a tall column (see 16-30), where people do not linger, but could create calm in an intimate setting (see 16-38).
- If the work is to contain images, are they appropriate to the activity for which the space is used?
- Will the work be installed in a climate where alternating freezing and thawing might cause the work to deteriorate?

Other factors may apply to three-dimensional sculpture:

- Will people merely look at the work, or will they be able to walk around or through it or climb on it?
- Might there be a danger of personal injury from structural failure?

FIGURE 16-16
John Toki of the United States built *'s-Hertogenbosch* while working as a technical assistant at the European Ceramics Work Centre in the Dutch town for which the sculpture is named. Shipped back to the United States in sections, the work was bought for public installation by the City of Berkeley, California. Built of stoneware with porcelain inserts, it measures 168 × 29 × 46 in. (4.26 × .73 × 1.17 m). *Courtesy the artist.*

- Will children be deterred from climbing on the work?
- If children have access to the work, will it withstand their activity?
- Is protection needed from injury due to sharp forms or edges?
- Does the space around the sculpture require soft material to protect children from injury if they fall? A playground specialist should be consulted in such cases.

(a)

FIGURE 16-17
When entering *'s-Hertogenbosch* for a City of Berkeley commission, John Toki
submitted his drawings for its installation, following the recommendations of a
structural engineer. *(a)* The central armature for attaching the sculpture to a
concrete base. Shown here are the steel tie rods that secure the sculpture to the
armature. *(b)* A drawing of the rebar cage to be sunk in the earth and connected
to the concrete sculpture base. *(c)* A cross-section drawing of the cage and base
in place. *Drawings by the artist. Structural engineer: Joe Bauer.*

(b)

- Might the work be exposed to vandalism?
- Does the landscaping plan allow for good
 viewing of the work? The artist should
 consult with the landscape designer be-
 fore finalizing any design.

These are only a few of the questions that must
be considered in relation to the site.

Construction Concerns

A designer of large works for public spaces must
become familiar with the use of bolts, rods, or
brackets to attach heavy sections to a wall (see
16-13). If the work is a freestanding sculpture,
the artist must become familiar with built-in en-
gineered steel supports and how to bolt the work
to foundations that will keep columns from
falling and injuring passersby (16-16, 16-17).

Other types of work may require a knowledge
of construction-grade adhesives, which are used
to attach sections to a backing. (See *Expertise,*
Chapter 4B and 4C, for further information about
adhesives and installations.)

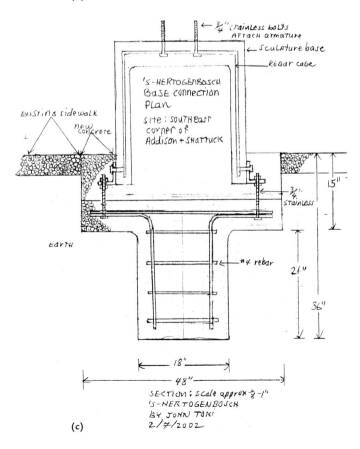

(c)

Lighting and Landscaping

The lighting arrangement will greatly affect how the viewer will see a work once it is installed; poor lighting has more than once obscured artworks that have taken months to create. The type of lighting—incandescent, fluorescent, low-voltage spotlighting, or natural light—and its placement should be agreed on with the architect or the client, and the amount of electrical current needed to supply the fixtures should be analyzed and included in the plan.

If the work is for an outdoor site, it is important to study the landscaping plans to ensure that plantings will not conflict with the placement of the sculpture or, when full grown, obscure it.

Budgets

The artist must also understand the budgeting requirements for the work and find out who is responsible for the cost of any changes desired by the client or imposed by engineering requirements. It is important that the budget and installation be planned and fully understood from the start.

"PERCENT FOR ART" COMMISSIONS

The commissioning of a work for a public or corporate building may be part of a program that sets aside a certain amount of the building budget for art—known as a "percent for art" program. How an artwork, or the artist creating it, is selected for this program varies from one place to another. The applying artist must be aware that officials who commission a work for a public building may not necessarily understand the conditions an artist faces when proposing a work for a specific site. Thus, an applicant for a commission should be prepared to explain how he or she will work on the project. As a result, each artist may have a different experience with the same commissioning body, sometimes involving many meetings and much discussion. For this reason, some artists prefer to obtain commissions through a gallery or an artists' representative who has experience with the commissioning process.

Submitting a Proposal

In the case of art commissioned for the Pennsylvania Convention Center in Philadelphia, the question of who was to choose the art was itself the subject of a long debate. It was finally agreed that a committee of curators, designers, and others from the art community would look at submitted works and decide which should be chosen. Since the building is large, with a great deal of space for art, the committee agreed to include as much work by area artists as possible.

Paula Winokur's *Earthshift* (see 16-15) was one of the works chosen. The site assigned for her work was a long corridor with niches, each of which is 13 ft. long by 5 ft. high (3.9 × 1.5 m.). Because the windows opposite the niches allow full sunlight to enter, any work to be hung in the niches needed to be impervious to strong light. Obviously, ceramic was an excellent choice for such a spot. (The corridor on the other side of the building, which received much less light, was set aside for light-sensitive paintings, prints, and fiber art.) The only other restrictions were that the work had to be appropriate for the size of the niche and that it had to reside happily against the back wall, which was specified to be purple.

Winokur's work was presented to the committee by Helen Drutt, her representing gallery. Her proposed sculpture was shown to the selection committee in the form of a drawing. Not only was her mural sculpture chosen for one of the niches, but Winokur's drawing, made with porcelain clay on brown paper, was also purchased, framed, and hung in the building.

After building a scale model ⅙ the size of the planned work, Winokur was ready to create the full-sized *Earthshift*. Of her wall piece, Winokur says, *It reflects my continued interest in the landscape, in geological rifts, splits, faults and other geological occurrences* (see also 9-7).

In a quite different situation, John Toki was chosen to provide a work for an outdoor space in California. Since Toki had experience in obtaining commissions in California, when he entered

FIGURE 16-18
Totem Telúrico, by Jaime Suárez of Puerto Rico. This commemorative column was erected in the Plaza del V Centenario in San Juan. The column is concrete, faced with Suárez's ceramic reliefs, which display images and symbols honoring Puerto Rico's Hispanic and indigenous heritage. Ht. 50 ft. (15 m), diam. 5 ft. (1.5 m). 1991. *Courtesy the artist.* Photo: Johnny Betancourt.

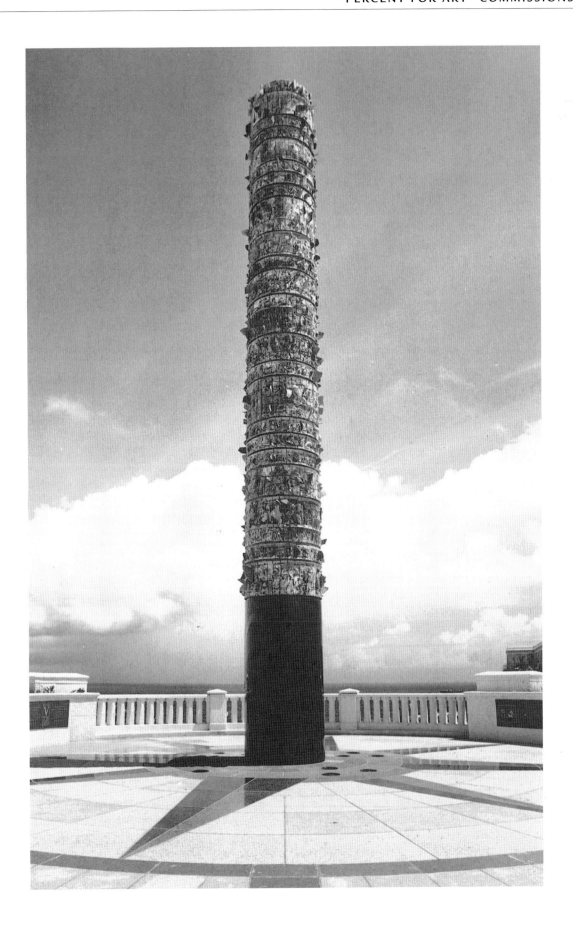

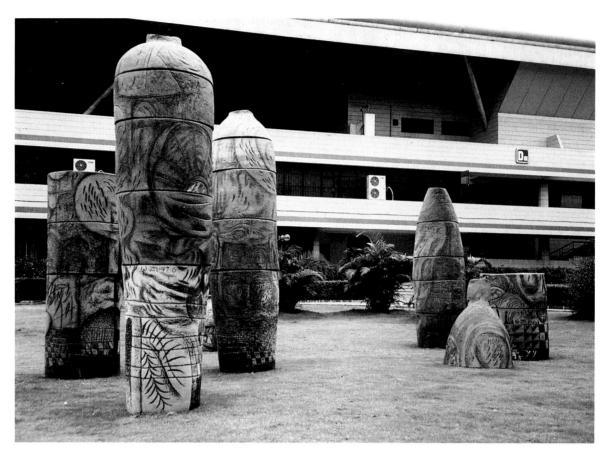

FIGURE 16-19
Tall vessel forms by Zang Wen Zhi of the People's Republic of China evoke the ceramics traditions of the area's ancient culture. Once the coiled pieces were complete, Zang painted the imagery onto the stoneware clay using iron oxide. Fired in sections at 2282°F/1250°C. Ht. 62 in. (157.5 cm). *Courtesy the artist.*

the competition for an outdoor sculpture for the City of Berkeley, he was familiar with the safety requirements for public installations in areas subject to earthquakes. Nevertheless, Toki worked closely with a structural engineer to ensure that his entry (see 16-16) complied with these standards. In this case, Toki submitted a completed work that he had created at the European Ceramics Work Centre in 's-Hertogenbosch (the Dutch town for which his sculpture is named) and had shipped back to the United States in sections. In his presentation, Toki included a carefully calculated plan for the work (see 16-17).

If an artist is called upon to propose a sculpture or ceramic mural for a specific site *after* a building has been completed, it is important to study the architectural drawings and the construction details of the building if they are available. For an interior site, these drawings should include wall construction details and electrical plans that show the location of wiring and available outlets. This is important if the artist's work requires electrical power for lighting or a pump. It is also essential to study ground plans when digging to place the foundations for an outdoor sculpture (see 16-17), especially when the site is in the vicinity of electrical cables or gas or water lines.

On occasion an artist may be brought into the process of selecting the best site for his or her work, but at other times the commissioned artist may have nothing to say about where the work will be installed. Jaime Suarez, for example, was chosen to create a monument about a historical subject for an imposing specified site (16-18). Other artists may be given more freedom, and the spot chosen for a work may allow enough open space to incorporate several pieces of sculpture into the design (16-19). On the other hand, sometimes the availability of supporting utilities, such

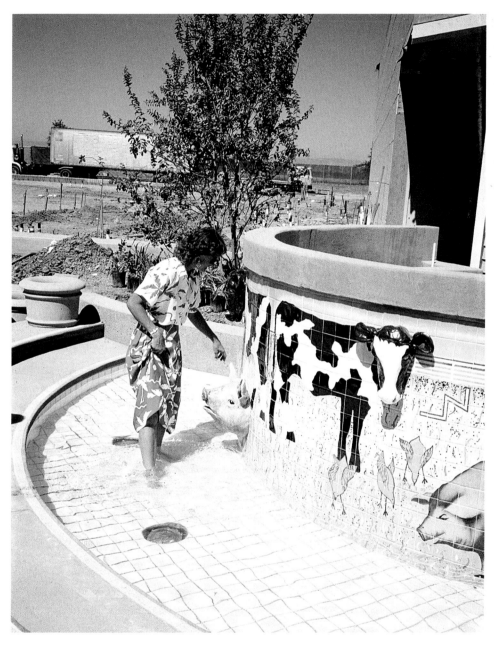

as water or electricity, might affect the choice of
the site (16-20).

OTHER SOURCES
OF COMMISSIONS

Private clients are another source of commis-
sions for ceramic works. There are a variety
of ways to obtain private commissions: Juliet
Thorne, for example, exhibited her sculpture in
a gallery in Ghent, Belgium, where she is cur-
rently living. From a client who visited that ex-
hibit, she received a commission for a similar
piece to be placed in a pool in a private garden.
The client chose a figurative work, and Thorne
built it as one of a series entitled *Fertility God-
dess I, II, III.* The method she used to build these
three pieces was basically the same, with only
some variation in the size or number of slabs
(16-21–16-27).

(a)

(b)

FIGURE 16-21

(a) When preparing to build her sculpture *Fertility Goddess II*, Juliet Thorne of England, who currently lives in Belgium, rolled out her slabs and arranged them on top of newspaper. *(b)* The first layer of slabs are in place on newspaper laid over foam padding. *(c)* A tapering rod is covered with newspaper and then positioned on the slabs. The weight of the rod and top slabs will indent the lower slabs as they sink into the underlying foam. *(d)* The version of *Fertility Goddess* shown in this photo was made from one long slab that was cut into sections after placement over the rod. To cut the slab, Thorne used a large palette knife. *Courtesy the artist.*

(c)

(d)

FIGURE 16-22
Cut sections of *Fertility Goddess II* waiting for bases and tops to be attached before firing. Thorne used her carved, fired clay stamps to impress personal symbols on the edges of the sections.

(a)

FIGURE 16-23
(a) To make the tops and bases for the sections, each part was placed on a rolled-out slab, which was then cut around the contour of each section to fit. *(b)* A section of *Fertility Goddess II* with its slip-painted and scored top attached. *(c)* Next, Thorne assembled the piece to be sure the central support pipe would fit properly through the holes in the tops and bases of the sections.

(b)

(c)

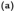

(a)

(b)

FIGURE 16-24

(a) Final assembly shows a clean join of the torso sections and the successful installation of the support pipe. *(b)* Thorne's personal stamped symbols can be seen along the sides of the torso. For this detailing she makes fired clay stamps, then presses them into the damp clay (see also 9-6).

FIGURE 16-25

To prepare the base for installation, Thorne hired a stonemason and a technical assistant. Here, her assistant drills holes for the 12-mm (0.47 in.) steel pins to be inserted in the concrete base. Copper tubes were then glued into the holes in the concrete plinth so that when the steel pins were inserted, any movement of the sculpture in the wind would not damage the friable concrete. The entire assembly is demountable so that the sculpture can be moved to another location if desired.

FIGURE 16-26
Juliet Thorne places the first section of her glazed *Fertility Goddess II* on the 12-mm (0.47 in.) diameter steel rod that was cemented into the stone base. She cut clear plastic "washers" to fit between the sections of the sculpture to keep the edges from grinding against each other when they move in the wind.

This particular commission required Thorne to figure out how to make a piece that could be demounted in case the owner moved, how to install it in water, and how to ensure that it would withstand wind and freezing temperatures. At the same time, Thorne wished to provide a graceful complement to the pool setting and to express her own response to nature. The commission also involved working with technicians and a specialist; the base for the sculpture was made by a local stonemason, and she hired a technical assistant to help with the installation.

FIGURE 16-27
Fertility Goddess II is now in place in the garden pool for which it was designed. The sculpture is built of stoneware clay—high-fire clay is essential for outdoor installation where frost and thawing could damage low-fired work. Glazed with a cobalt glaze and fired at 2300°F/1260°C). *Courtesy the artist.*

(a)

Danae Mattes had worked for several years on sculptures that dealt with water, suggesting the action and appearance of water in pools and in sluices, its effects on clay, and its spiritual symbolism. While living in Germany, she was commissioned to create a mural for the facade of an apartment house as a memorial for several residents who had been killed there in a hate crime. For this work, Mattes chose fire and flames as symbols of destruction (16-28), but as her ceramic mural ascends the facade of the building, the forms of the flames change from the red and black colors of fire to the blue of water, symbolizing hope and tolerance.

FIGURE 16-28
(a) The facade relief in place in Möhl, Germany. Mattes fired the piece in sections, using colored clays and additional colored engobes. *(b)* The blue tones of the upper section symbolize hope and tolerance *(c)* Detail. The flame forms, in red and black, suggest fire, destruction, and hate. *Courtesy the artist.*

(b)

(c)

The works shown on these pages make it clear that private and public commissions offer a wide range of possibilities to those who wish to extend their work to architectural applications— from a fish sculpture in a nature reserve (16-29) to chimney pots for private houses (16-30), to a symbolic sculpture for a health center inspired by African granaries (16-31). Commissions may range in size from a garden pool sculpture (see 16-27) to the tall *Portal* constructed of porcelain modules that rises above the entrance to the European Ceramics Work Centre (16-32).

FIGURE 16-29
Rise and Shine, Magical Fish by Kate Malone of England. This installation is located in the disused filter beds that once purified water for East London. The brightly glazed heads and tails of the surfacing fish, contrasting with the power line, underline Malone's environmental message. Leq Valley Park Nature Reserve. *Courtesy the artist.*

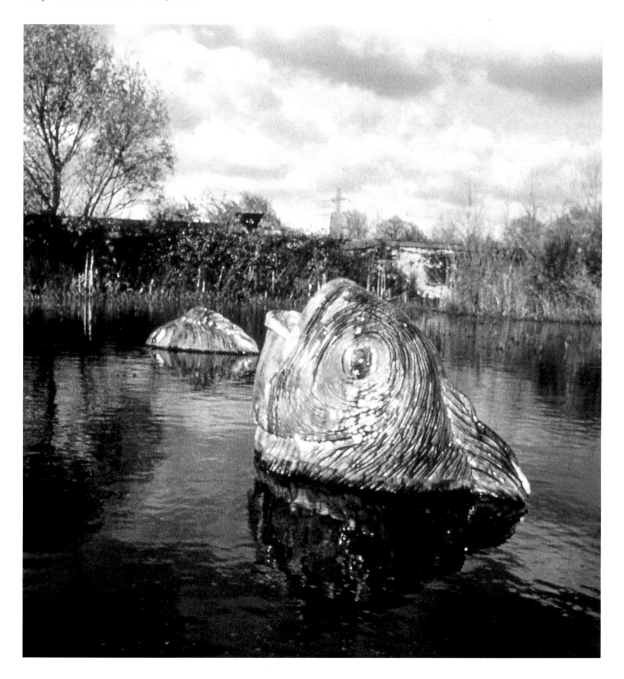

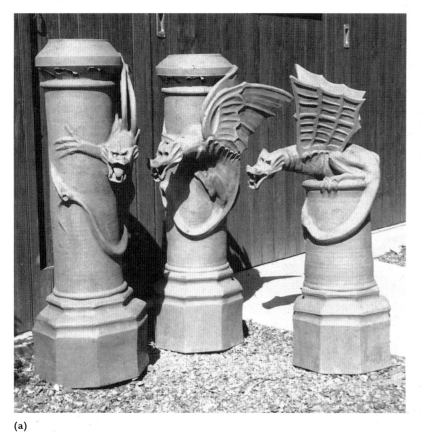

(a)

FIGURE 16-30
(a) Chimney pots by Mark Donaldson of England. Donaldson makes all manner of "roof furniture" for clients around the world—decorative tiles, special bricks, regular clay chimney pots, and these dragon pots. *(b)* Some of the dragons emit smoke from their mouths when the fire is lit. The architectural components are glazed or unglazed, according to clients' choice.

FIGURE 16-31 ▶
Left-Overs of the Spirit by Ernest Aryee of the United States, in place at the Orion Health Center in Eindhoven, Netherlands. While living there, Aryee ordered 2 tons (2,000 kg) of brickmaking clay from a brick factory and used most of it to build the sculpture. Aryee says, *The piece was made at the end of my stay in the Netherlands, as an expression or summary of my experiences, mostly cultural and social.*" Since Aryee had already left by the time the work was chosen to be placed at the health center, Aryee says he left detailed instructions for its installation with his professor, Dutch artist Michael Kuipers, who did the installation (see Chapter 11). *Courtesy the artist.*

(b)

517

FIGURE 16-32
Portal, created by architects Alexander Brodsky and Ilya Utkin of Russia for the entranceway of the European Ceramics Work Centre, consists of a stainless steel portico that rises to the roofs of the surrounding buildings, surmounted by a steel pyramid-shaped "roof" to which three hundred ceramic elements are attached. Stoneware and stainless steel. 46 × 23 × 23 ft. (14 × 7 × 7 m). 1992. *Courtesy European Ceramics Work Centre, Holland. Photo: Peer van Kruis.*

In 1968 two young men in Holland pooled their knowledge of constructing, glazing, and firing ceramic sculpture and opened a facility in The Hague whose mission was to aid artists working on architectural commissions or large sculpture. They named the studio Strukturr '68, and since that date the knowledgeable staff has provided advice, working space, and expertise, to artists carrying out a variety of sculptural and architectural projects (16-33, 16-34).

FIGURE 16-33 ▶
Hans van Bentem of the Netherlands created this sculpture for a schoolyard in Zwolle at the Strukturr '68 studio in The Hague, where the shaping, firing, and glazing of large ceramic works is facilitated by a knowledgeable staff. Van Bentem has created site-specific ceramic works for spaces ranging from parks to lobbies of government buildings. *Courtesy the artist and Strukurr '68.*

FIGURE 16-34
Gÿs Assmann of the Netherlands built a lighthearted mural at Strukturr '68 for a senior housing complex in Amsterdam. Strukturr's colorful glazes are formulated to withstand harsh winters, and they also bring cheer to an otherwise stark entrance. *Courtesy the artist and Strukturr '68.*

The artist designing site-specific or architectural works may face a wide variety of situations. For example, a frieze for the entrance lobby of a state court building called for quiet dignity (16-35). By contrast, it was appropriate for the design of an Islamic prayer niche (16-36) to be colorful and contemporary, but the artist wisely used traditional glaze tones and the suggestion of historical tiling. When groups of local citizens collaborated on a mural, the decorative outcome reflected the community's diversity (16-37), while in a zoological mural on a school building (16-38) the images needed to *appear* real, even if they came from the artist's fantasies.

(a)

FIGURE 16-35

(a) Marylyn Dintenfass of the United States created *Diagonal Frieze* with porcelain modules. *(b)* To enter a competition for a commission for the lobby of the Superior Court Complex in Enfield, Connecticut, she studied the site and the architect's drawings. The photo shows the entrance and lobby beyond where the work was placed. *(c)* She built a scale model to show the jury the mural's projected scale and placement— safe above the reach of possible vandals. *(d)* Dintenfass also took into account how the finished sculpture would appear as seen through the building's entrance. *Courtesy the artist.*

(b)

(c)

(d)

FIGURE 16-36
A tiled mirhab (an Islamic prayer niche), by Bingül Basarir of Turkey. Basarir has
created numerous ceramic architectural works and is also known for her smaller
sculptures. In early Islamic architecture, walls of mosques and mirhabs were
frequently surfaced with tiles, often in monochromatic shades of blues and
turquoise. Here, Basarir has created a contemporary work that refers to tradition in
its form and surface. *Courtesy the artist.*

FIGURE 16-37
Making this mixed-media, ceramic-tile, and painted mural on a parking garage in Soho, London, was a community project. Schools, senior centers, libraries, and others took part in planning and executing this map of the Soho district, which celebrates its history and the diversity of its residents. *Sponsors: Free Form Arts Trust Ltd., London, England. Photo: Tom Cook.*

ADDITIONAL OPPORTUNITIES

Opportunities for applying ceramic skills to architecture also include historic restoration. Many of the ceramic-faced buildings erected in the United States and other countries where ceramics was used extensively in architecture in the nineteenth and early twentieth centuries are now protected as historic artworks (see 7-10). Many of these ceramic facades have suffered the ravages of time, since their construction has allowed water to seep in and alternately freeze and thaw, damaging the ceramic cladding. The deteriorating ceramic decoration requires individuals with sculptural skills to reconstruct the originals and make molds to cast replacements. There is also a need for well-designed contemporary ceramic components for new buildings and their surroundings. Park furniture with ceramic tiles, exterior columns, light fixtures, and many more building components offer additional opportunities for creative ceramic work.

FIGURE 16-38
Pond Life. A relief mural by Jola Spytkowska of England. Commissioned by Lancashire County Council for a primary school in Blackpool. Earthstone clay, fired to 2300°F (1260°C). Glazes fired to 1832°F/1000°C. 31 × 31 in. (80 × 80 cm). *Courtesy the artist.*
Photo: Dave Clark, Folly Pictures Ltd.

17

Setting Up
Your Studio

It can take years to organize your own ceramics studio properly so it is worthwhile to prioritize your list of needed equipment. Think in terms of your needs today and what it will take to achieve them; then project your needs for the near future, and ask yourself if the equipment purchased today and your studio space will be adequate one year from now. Put a timeline next to the list, using realistic target dates as to when you will purchase each item. Include the prices of the equipment so that you can develop a budget.

Obviously, your studio requirements are based on the type of work you do. This reflects the scale of your work and the processes used, which in turn influence the equipment you will need. Geographic location and weather conditions can also have an effect on your studio location and work schedule. Consider some artists around the world who have adapted their work space to fit their special needs. For example, Kate Malone (see 16-29) got a bank loan to build a new studio in London to house her large electric kiln. She recouped some of the expense by renting space and the use of her car kiln (also called a *shuttle kiln*) to other artists. Marylyn Dintenfass set up a studio in an old building that she and a friend remodeled into artists' studios. Bruno Kark (15-12) got a bank loan to buy his shuttle kiln. Kimpei Nakamura (see 16-5) creates his ceramics in a basement studio in downtown Tokyo, calling the work produced there "urban ceramics." For large-scale commissions, he builds his sculptures at ceramics factories. The Potter's Shop in Massachusetts, where Steve Branfman (see 12-3) and Carol Temkin (see 12-86) work, is adapted to serve as both a teaching studio and a work space for pottery production.

Julie Hunter Bagish (17-1) studied with Kimpei Nakamura in Kanazawa, Japan, in 1968 and now lives and works in southern California. She has a home with an adjoining studio in a residential neighborhood

(a)

FIGURE 17-1

(a) Julie Hunter Bagish throwing a pot on an electric kick wheel at her studio in Los Angeles, California. Bagish designed and set up her live-work studio, which includes gas and electric kilns, wheels, a slab roller, a showroom, and an office. She and her husband eat the grapes they grow along a trellis, and Bagish uses the grape leaves to impress patterns into her ceramic ware. *(b)* Bagish with her apprentice in the studio.

(b)

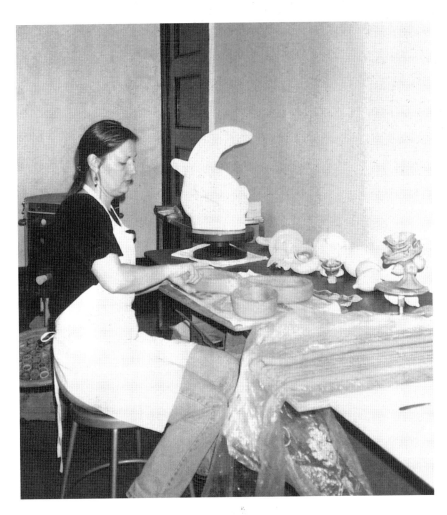

FIGURE 17-2
Vanessa L. Smith of the United States working on a sculpture in her private studio located in the Fine Arts Building in Chicago, Illinois. Smith acquired her studio equipment over a period of years. She still uses a second-hand electric kiln she purchased in the early 1980s. Smith now has a fully equipped studio with two kilns, a potter's wheel, wedging table, ware carts, banding wheels, and tools. Describing her studio, Smith says, *It is a wonderful, yet modest space that gives me a "room of my own" to explore my ceramic art. Courtesy the artist. Photo: Florette Schneider, Chicago, Illinois.*

where she produces handmade pottery and sculpture with the help of two apprentices. Her studio is set up with a slab roller, a kick wheel, an electric wheel, a 22-cu.-ft. (.62-cu.-m) gas kiln, and three wedging tables, one each for different-colored clays. Bagish set up a business office in her home and sells work directly to the public at her gallery, which is also on the premises. By consolidating all facets of her studio—office, production, and sales—she maximizes her convenience, efficiency, comfort, and safety.

Tim Frederich (see 17-5, 17-6, 17-9) of Columbus, Ohio, has been a professional potter for over twenty-five years. He produces and sells his ware at his studio, where he also teaches classes. Frederich purchased or built equipment to outfit his studio as needed over a period of years. Today he has a well-equipped studio with pottery wheels, electric and gas kilns, extruders, a slab roller, ware carts, pug mills, and clay-mixing machinery. He also repairs almost all of his own equipment, thus reducing his maintenance costs. The self-sufficient studio that Frederich built makes his production capability efficient while keeping his overhead costs low.

As these examples show, by being resourceful in terms of collecting tools and equipment and utilizing your available work space (17-2), you can keep your expenses down. Your work space can be an extra room in your house, a vacant garage, or a back porch. On the other hand, you may be in a position to set up a professional studio (17-3) with adequate electrical service to accommodate electric kilns; clay mixers or other equipment; a gas meter and plumbing capable of handling a gas kiln; proper ventilation for kilns; a sink with a sediment trap to catch clay, glaze, and plaster sludge; slop buckets for clay trimmings; a wedging table; and shelves or bins for storing raw materials, work in process, and completed work. In addition, your studio may

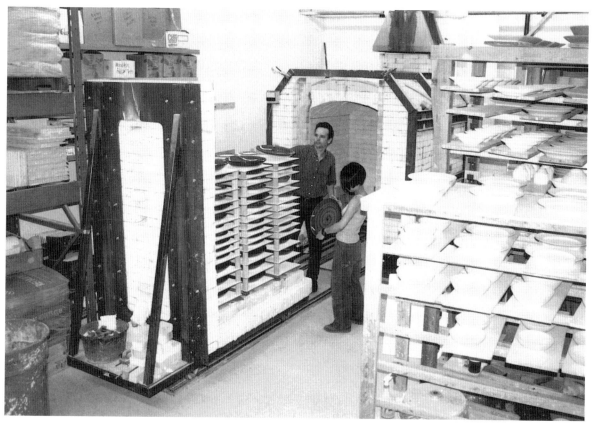

FIGURE 17-3
Charles Jahn of the United States in his production studio with assistant Mie Kongo unloading a 100-cu.-ft. (2.83-cu.m) gas-fired car kiln. With the help of three employees the Jahn studio produces a line of twelve porcelain pieces that are sold in over eighty-five craft galleries. The functional pottery line is made from throwing, jiggering, and RAM pressing. *Courtesy the artist. Photo: Yakao Kyota.*

contain heavy-duty tables; a spray booth and air compressor to operate spray equipment; proper lighting; turntables for sculpture; and banding wheels for decorating. The list can go on and on.

Other major investments are potter's wheels, slab rollers, clay extruders, pug mills, slip mixers, glaze mixers, and a high-quality microfilter vacuum cleaner. Refer to Chapter 10 for additional information about equipment.

WHEELS

If you intend to throw, you will need to buy a potter's wheel. Electric wheels are popular because their speed is variable and they are powerful enough to handle 50 lb. (22.70 kg) of clay or more. If your aim is production, an electric

wheel will greatly increase your output and is worth the cost.

Commercial pottery wheels are available with motors that range from $\frac{1}{16}$–$1\frac{1}{2}$ horsepower (hp), with the most popular being $\frac{1}{2}$ hp for most general use and 1 hp for individuals who throw large works or use stiff clay, which requires additional torque at low speeds when centering the clay. There are portable wheels that are relatively lightweight and easy to move around a studio; these are good for making small to medium-sized pottery. For making medium-sized to large works, it is preferable to purchase a heavier wheel with a wide-stance body that will not move or slide on the floor when one is throwing large amounts of clay.

For those who like to throw standing up, pottery wheel leg extensions are available. Wheel-heads on such wheels are usually set about 30 in.

(76 cm) from the floor or higher, depending on the height of the individual. This type of wheel is especially popular for potters who have lower-back problems and prefer to throw standing up.

For left-handed potters or those who like to trim in reverse, wheels are available with a reversing switch that changes the direction of the wheelhead's rotation. Some wheels come with reversing switches on the motor, or reversing plugs that change the direction of rotation of the wheelhead.

There are also electric pottery wheels with wide bodies designed to accommodate individuals in wheelchairs; these feature a crank-style lift system that adjusts the frame height and wheelhead to fit the user (see 12-9b). Wheel speed is usually controlled with a hand lever.

Most wheels come with bat pins centered 10 in. (254 mm) apart, which facilitates the attachment or removal of a bat supporting a pot. They accommodate masonite, plywood, or plastic bats. Some wheelheads can be removed from a tapered shaft, making it easy to clean the splash pan or trough area. Other wheels include shaft extension collars for raising the wheelhead above the splash pan or tray area when throwing large or wide work.

Free-momentum spinning kick wheels are popular with potters who prefer the smooth torque of a wheel driven by foot power (see 12-7). Kick wheels gain speed by kicking a heavy concrete or cast-iron flywheel attached to a wheelhead and shaft that rotate on bearings. Kick wheels usually have large metal frames that are very stable and free of vibration. Some potters prefer trimming on a kick wheel because they have a smooth torque range. Kick wheels can be motorized and are also available with a reversing switch and a brake that makes it safer to slow down the wheel or stop it in an emergency.

When you decide to purchase a wheel, you need to ask yourself the following questions: How much power do I need for throwing? Do I need a wheel with a tabletop for tools, a water-bucket, and clay? What size wheelhead do I need: 10, 12, or 14 in. (254, 304.8, or 355.6 mm)? Is the motor noisy? Will I need a reversing switch to change the direction of wheelhead rotation? Is the pedal sensitive to my speed-control needs, especially at low speeds? Are the foot pedal and wheel ergonomically designed for my comfort? Is the wheel's weight or size an issue, and is portability a concern?

KILNS

Unless you avoid the major expense of purchasing a kiln by renting space from an established pottery, a kiln is one of the most essential pieces of equipment you will need to get started. Many potteries either allow artists to fire their own work there or fire it for them, charging by the weight or volume of the work. The advantages of having your own kiln, however, are that you control the outcome of the work, save time in transportation, and move your work fewer times, minimizing the possibility of damage.

Kilns come in many different styles, shapes, and sizes (see Chapter 15). They are usually fueled by electricity or gas, although wood-burning kilns are now popular with many artists. Gas and electric kilns can be accessed from the top or through a door in the front. Another type, in which the entire kiln shell is lifted off the kiln floor and straight up, is called a top-hat kiln. There is also the car kiln (see 17-3), which has a stationary shell and a floor with wheels that rolls into the kiln on a track. In addition, there is an envelope kiln, which has a stationary floor with burners and a shell that rolls on a track over the floor. These kilns make loading and unloading faster and easier than toploading kilns.

Your decision on the best size of kiln to buy often comes down to output. Remember that the total volume of the kiln will be reduced by approximately 10–20% once you have stacked the kiln posts and shelves inside. If you purchase a smaller kiln, you can load it to capacity and fire more often, but a larger kiln will hold more work. Thus, the question you must ask yourself is: How long will it take to fill the kiln? A larger kiln is easier to load, and the firings are likely to be more even if there is additional space around each piece.

Some kilns, such as car kilns, are best for individuals with special needs because reaching deep into kilns to place heavy kiln shelves and ware can put a strain on the body. Therefore, if you have a physical disability such as back problems and expect to fire frequently, a car kiln would be a good investment. With this type of kiln, the floor rolls out from the kiln shell on a track and is accessible from three or four sides. Remember that you must load unfired work carefully so that the work will not fall over when the floor is rolled into the kiln. Some production potters have two rolling floors so that

FIGURE 17-4
A computerized electric kiln with zone control provides ceramist Vince Miller with even heat from the top to the bottom when he fires his tiles or sculpture. He fires his tiles to cone 05 and uses one of the preset computerized programs that came standard with the kiln. When he fires large sculpture, he dismantles the kiln ring by ring and loads his work on the floor. He then stacks the kiln rings around the sculpture. For large or thick sculpture he uses the ramp-hold firing mode and programs in his own firing schedule.

while one load is firing, the other floor is being loaded.

If wheelchair access is necessary, some manufacturers can modify the kiln by making it lower to the ground, widening the space between the legs of the stand, and lowering the control panel. Computer-controlled kilns make programming

and firing easier for the person in a wheelchair because they eliminate the need to turn numerous dials or set cones into automatic kiln sitters.

Computerized Kilns

Computerized software that controls the firing of either an electric or a gas kiln relieves the ceramist of a great deal of kiln watching (17-4). It eliminates the need to set pyrometric cones and kiln sitters, as well as turn dials to adjust the heat and turn off the kiln. Computerized kilns are cost effective because they automatically increase the temperature at a specific rate.

Computerized electric kilns can be outfitted with an electric-fan-driven downdraft venting system that draws fresh air in through the kiln lid, through the kiln chamber and around the ware. The air is then piped outside through the kiln floor or side wall. This system removes moisture, heat, and fumes from the kiln chamber. Some kiln fans are operated manually with an on-off switch, while others are connected to the kiln computer, which automatically turns the fan on when the kiln starts to fire, then off when the kiln reaches the desired temperature, then on again around 1000°F/538°C to assist in cooling, and then finally completely off at about 200°F/93°C.

Modern computerized gas kilns can also monitor the progress of the firing. After a program is written and entered into the computer, the monitor displays the temperature, atmospheric conditions, rate of temperature increase, and cooling rate. An automatic electric damper connected to an oxygen probe monitors the oxygen-reducing atmosphere and is especially popular with production potters, who require consistent results from every firing.

Electric Kilns

Many ceramists favor electric kilns because they fire relatively evenly from top to bottom and now are available with computerized controls, making operation simpler (17-5). Most are easily transported, and setup time is minimal. In a home studio, the simplest electric kiln to install is one that can be plugged into standard house current (120 volts). The sizes available for this type of kiln are generally limited to under 1 cu. ft. (.028 cu. m), with a maximum firing tempera-

FIGURE 17-5
Production potter Tim Frederich formulates and mixes his own glazes and fires his ware to cone 6 using a 7 cu. ft. (.20 cu. m) computerized electric kiln.

ture of cone 6 (2232°F/1222°C). This type of kiln is excellent for firing small pots and sculptures. Smaller kilns, approximately .30 cu. ft. (.01 cu. m) in size, will fire to cone 10 (2377°F/1303°C) and are good for firing tests quickly or for firing small cups and bowls. Electric kilns larger than 1 cu. ft. (.028 cu. m) normally operate on 220/240 or 208 volts and require special wiring; a licensed electrical contractor should be called in to run new wiring to match the electrical specifications for kilns operating on special voltage. There are also special electric kilns that operate on two 120-volt circuits. They are usually under 2 cu. ft. (.057 cu. m) in size, have two plugs, and generally are limited to low temperatures.

BUYING A NEW ELECTRIC KILN When preparing to buy a new electric kiln, you will first need to determine the kiln size and maximum firing temperature you want for firing your work. Remember that the kiln shelves and posts take up space and will reduce the amount of kiln space available for your work. After you have selected a kiln, you will need to check to see if you have the correct wire size and the electric power capable of heating the kiln to its maximum firing temperature. It is recommended that a licensed electrician be called in to perform all kiln wiring. Kiln manufacturers and ceramics supply stores that sell kilns can advise you on the wiring requirements for different kilns.

Improperly wired kilns often never reach the desired temperature and can be extremely unsafe if the wrong wire size (usually too small) or an undersized circuit breaker is installed, posing a risk for electrical fire. One of the biggest mistakes is purchasing a kiln with the wrong voltage and phase power.

Another problem is buying a kiln that is underpowered. Underpowered kilns have difficulty reaching sufficiently high temperatures and can take many hours to do so. Kilns rated to fire to high temperatures require plenty of kilowatt energy. Additional insulation in the kiln wall, in the form of thicker brick or fiber insulation or board, helps a kiln reach higher temperatures more efficiently, as it reduces heat loss. A thick kiln wall also slows the cooling process,

thus helping to reduce cracks in the clay while also improving some glazes, such as matt or crystalline glazes. Some kilns are built with an air space between the kiln wall and the outer shell and top; this helps keep the kiln cool to the touch and is especially desirable in school situations. On the other hand, some production facilities, potteries, schools, and institutions prefer kilns with thinner walls because they cool quickly, making the turnaround time for loading, firing, and unloading much faster. Kilns are available with optional vents that remove noxious fumes, heat, and moisture; these are recommended especially if the ceramist is working near a kiln that is in operation.

Electric kilns manufactured outside the United States usually require a safety shutoff switch that cuts off the electricity in the event that the lid or kiln door is opened.

Whichever kiln you choose, be sure that it fits your firing needs related to volume, clay and glaze maximum firing temperature, and computer-controlled program capacity or semiautomatic control ability. In addition, consider the overall ease of loading and unloading the kiln.

BUYING A USED ELECTRIC KILN Used kilns can be purchased at reasonable prices, often less than half the current retail price for a new kiln. Find out if the used kiln is a name brand and if the manufacturer is still in business; if so, this will assure you that replacement parts are available. Ask the seller at what temperature the kiln has been fired: If it was used for low firing, approximately cone 05 (1915°F/1046°C), it is probably worth pursuing. On the other hand, if the kiln was used for high firing, approximately cone 5 to 10 (2201–2377°F/1205–1303°C), the kiln elements might be worn, in which case the kiln may have difficulty reaching maximum temperature. In addition, if the kiln was used strictly for high firing over a number of years, the kiln elements probably have been rewired at some point. Ask the seller if that is the case and how many firings have taken place since that time. This can help you determine how much longer the kiln can be used before needing new elements.

The number of expected firings for a 120-volt kiln when fired to its maximum temperature is about 30. If it is used only for low firing, the total is approximately 50. For a 220-volt kiln, when fired to its maximum, the number of expected firings is nearer 50. If the kiln is used only for low

firing or for china paint firings (1279°F/693°C), the total can reach as high as 250 firings. Since individuals' firing schedules vary, these totals should be viewed only as a rough guide.

If the kiln elements are broken, you will need to evaluate the time required to make the repair, not to mention the cost of parts. In addition, check to make sure that the elements are not hanging out of their grooves, that the kiln brick under the elements is not heavily chipped, and that chunks are not broken off, leaving the elements vulnerable to excessive sagging. Elements in this condition can get worse over time and are difficult to push back into place without risk of permanent damage.

Kilns that have been installed outdoors with limited cover are susceptible to excessive corrosion on electrical parts, which can lead to insufficiently heating elements or to other problems. If you buy such a kiln, check the electrical wiring. First unplug the kiln, then open the electrical box and check all wiring connections for excessive rust or corrosion. If connections are rusted, carefully loosen them and clean all contact points with sandpaper or emery cloth. Kilns that have been stored outside are also susceptible to bugs and spiders building webs or nests inside the control box, which, along with dust and dirt, can lead to poor electrical connections. In addition to cleaning all electrical contacts, it is important to vacuum out the control box and check the seal between the doorjamb or top rim of the kiln and the lid. Gaps of over ⅛ in. (3 mm) could make it harder to reach desired firing temperatures. You can fill larger gaps with kiln cement, a castable refractory, or a ceramic fiber gasket.

INSTALLING AN ELECTRIC KILN If you plan to install an electric kiln in a rented studio, find out what type of electrical service comes to the studio so that the kiln is matched to your power supply, or at least understand the steps necessary to bring in the correct power for its needs. For maximum efficiency in powering electric kilns ranging in size from 1–20 cu. ft. (.028 to .57 cu. m), it is best to operate them on 240 volts (single-phase power). Homes usually have 220/240-volt service. Many schools and industrial buildings operate on 208 volts (single- or three-phase power), and some factories operate on 440 volts. In Europe, wiring for electric kilns is usually 230 volts. Kilns with special wiring are needed to match these types of electrical ser-

vice, so it is best to contact the kiln manufacturer or your local dealer for specific information about the electrical requirements for each kiln. Call in a licensed electrician to perform any wiring related to the installation of a kiln.

Gas Kilns

If you want to do reduction firings or fire between cone 5 and 10 (2201–2377°F/1205–1303°C) or above, or if you have limited electrical power, you will probably decide to buy a gas kiln. Among the many variables to consider when purchasing and installing a gas kiln is whether it will be an updraft or a downdraft kiln. Also, will it be front- or top-loading? Front-loading gas kilns are available in updraft and downdraft styles; the downdraft type tends to fire more evenly. Front-loading kilns also make loading easier for large sculpture or odd-shaped work that is often difficult to load into top-loading kilns, and for individuals in wheelchairs, small front-loading kilns are the easiest to load. Another variable to consider is whether the kiln will operate on natural gas or propane? If it is operated on natural gas, be sure the gas meter is large enough to handle the BTU requirements for the kiln. You must also remember that in order to allow for the fire box, the actual stacking space of gas kilns can be up to 30% less than the total volume.

One of the most important factors to remember when installing a gas kiln is that there must be adequate gas pressure and volume at the kiln— usually 7 to 8 lb. (1,010 mb) of pressure. The size of pipe necessary to carry the needed volume of gas to the kiln is also critical to its operation, because kilns that have been plumbed with undersized piping, or operated on an undersized gas meter, may never reach stoneware temperatures (cone 10, 2377°F/1303°C). The closer the kiln is to the gas meter, the more likely there will be adequate gas pressure and volume, but as the distance between the kiln and gas meter increases, the size of the piping must be increased. In addition, every bend in the pipeline also affects gas flow and efficiency. You can find calculations for proper pipe sizes in books about kiln building. Gas kilns up to 20 cu. ft. (.57 cu. m) in size can be operated on a standard house gas meter, but if you are looking for a kiln with a capacity over 10 cu. ft. (.28 cu. m), the total BTU load should be carefully calculated to determine whether a larger gas

meter is needed. Remember that before a utility company will install a larger gas meter on your site, the kiln must be physically in place. Your gas kiln dealer has the BTU requirements on all the kilns it sells and can advise you on the necessary steps in a proper installation.

If the kiln is installed inside a room, there must be a way to draw off excess heat and fumes. An updraft kiln will need a kiln hood, and a downdraft kiln will need a stack. Custom hoods can be fabricated by licensed sheet-metal contractors. Usually each city has building codes for the installation of equipment operating on gas and will require permits from your local building department. It is also a good idea to contact your kiln manufacturer or dealer for information about the latest safety devices and controls for operating the kiln, and also for the type of ventilation system necessary to draw off excess heat and fumes.

PORTABLE GAS KILNS There are a number of reasonably priced light-duty, portable top-loading gas kilns on the market that range in size from about 3–20 cu. ft. (.08–.57 cu. m). Most come in sections that two people can move. These are usually updraft kilns that can work off a standard house gas meter. To monitor the evenness of a firing, some computers have thermocouples mounted at the bottom, middle, and top of the kiln so that a median temperature is achieved during a firing. With these, the operator must still adjust the damper for reduction and plug the spyholes manually.

GAS KILN FUELS Natural gas is commonly used for firing kilns if it is available. It is economical, readily available, and clean burning. For natural gas, you must have a gas meter carefully calculated to match the BTU capacity of your kiln, and the plumbing must be accurately calculated. In addition, the pipes must be properly installed so that you have the required volume of gas as well as pressure at the kiln.

Propane is a hotter-burning fuel than natural gas and is often used in rural locations where there is no natural-gas service. Propane is stored in tanks ranging in size from 5–500 gal. (19–1,900 l) or larger. Portable tanks come in sizes from 5–100 gal. (19–379 l). The 5 and 10 gal. (19 and 38 l) sizes are easily handled by one person. Although a 20 gal. (76 l) tank is considered portable, keep in mind that it weighs about 150 lb. (68 kg),

including the tank, so you might need help installing it. Kilns under 7 cu. ft. (.20 cu. m) can be operated on portable 20–30 gal. (76–114 l) tanks. It is a good idea to have two tanks, one as a main gas tank and the other as a backup in the event the first tank runs out of gas partway through the firing. On the other hand, if you are considering a kiln larger than 7 cu. ft. (.20 cu. m) and plan to fire often, it is worthwhile to investigate the cost of installing a 250–500 gal. (946–1,893 l) permanent tank. These tanks can be purchased or rented and are always installed outdoors. Large tanks are more convenient because they contain enough gas to fire a number of loads; and since the tanks are never totally filled for functional purposes, it is best to have a larger tank than you think you will need. Portable tanks are filled at propane-filling stations; larger tanks can be filled on-site.

Each propane tank has a manufacturing date stamped into the cylinder, and for safety reasons all tanks must be requalified within twelve years of that date. Any tank over twelve years old will likely have another stamp showing that it was checked against damage, heavy rusting, or deficient valves or seals. Tanks can be requalified for continuous use or disqualified if deemed unsafe. This check is done by authorized personnel from propane-fuel companies.

INSTALLING A GAS KILN Before selecting a gas kiln, draw up a plan showing the future kiln location, indicating the position of the existing gas meter or where a new meter will be located, along with all the measurements to the kiln from the gas meter, property line, and relevant structures. Include notes about the type of building the kiln will be positioned next to—for example, a cinderblock-walled building or a wood structure—as this will affect the building code requirements. It is also important that the kiln be easily accessible for loading and unloading work and that there be enough room for easy access to kiln shelves, posts, and equipment, as well as elbow room for maneuvering as you load. If you will be rolling ware carts to the kiln, you will need a hard and relatively flat surface to move your work smoothly. Remember also that a kiln puts off a tremendous amount of radiant heat, especially a thin-walled (approximately 2.5 in./6.35 cm) type. This must be kept in mind when positioning a kiln in a confined space or near combustible materials, and a de-

tailed plan will assist your city building department in helping you position the kiln in accordance with safety codes. You must submit this plan, along with drawings of the site and all kiln specifications and installation requirements, to the building department when applying for a permit. This information will also help the kiln dealer, contractor, plumber, and transport companies provide you with accurate cost estimates. Moreover, it will help you immeasurably at the time of installation; collecting accurate information prior to a gas-kiln installation can save you thousands of dollars.

When the time comes to move a bulky and heavy gas kiln to your location, the moving company will want to know the dimensions of the kiln, the type of materials the kiln is constructed of, its weight, and the type of paving and width of access to the site before giving you an estimate. In some cases it is important to have the moving company come to your site to provide an estimate.

When it comes time to install a (nonportable) gas kiln, be sure to get professional help. Usually gas kilns require special equipment and handling by transport companies. Sometimes this is a two-step operation: An independent trucking firm drives the kiln to your site. Then a transport or crane service company unloads the kiln. In some instances this company will arrange for a forklift to pick up and move the heavy kiln into your studio. To find a company to move your equipment, look in the phone book under "crane," "rigging," "drayage," or "forklift." Most companies have a three-hour minimum and an hourly fee thereafter. In the end, it is well worth the investment in hiring professionals to transport your kiln from the manufacturer or dealer to your location and then to move it into your studio.

Alternative-Fuel Kilns

Kilns fueled by wood, oil, coal, sawdust (see 15-49 to 15-54), and charcoal are generally used when unique reducing atmospheres are desired, as in high-fire wood firings, pit firings, and raku firings. Alternative-fuel kilns are usually more appropriate for rural areas, but there are local, state, and national air-quality rules or restrictions that may affect the use of these types of fuels. For example, some areas require special permits to fire with wood, and others prohibit it

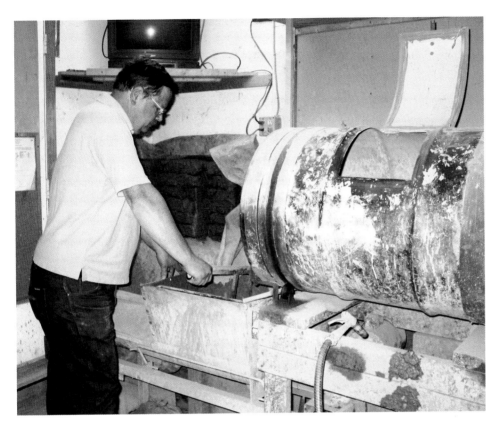

FIGURE 17-6
A clay-mixing system set up by Tim Frederich includes a dry mixing tumbler that first blends the raw clay components. After the material is blended it is dumped into the pug mill for mixing with water. After the clay is mixed to Frederich's specifications it is extruded out of the machine. Having his own clay-mixing equipment allows Frederich to make custom clay bodies, and it also provides him with greater control over the moisture content of his clay when he needs to make it wetter for extrusions or drier for use in his slab roller.

entirely. To get some of the effects of wood firing, some ceramists begin by firing with gas and get the temperature up to approximately cone 08 (1749°F/954°C) or above and then introduce wood or sawdust through a special fire box or add charcoal briquettes through the spyholes in strategic places.

CLAY-PROCESSING EQUIPMENT

Most ceramists begin by purchasing premixed clay because there are so many clays available on the market. When using small quantities, it can be more economical in terms of both time and money to buy ready-mixed clays. You can recycle dry clay in small quantities by soaking down scraps in a garbage can until the material is totally saturated and becomes a thick slurry. You can then scoop out this slop and place it on a plaster bat, wooden board, or concrete slab to dry. Once the slurry has dried out enough to be workable, you can wedge it into reusable clay. However, if you are going into production or

using large quantities of clay, you may want to consider mechanical mixing equipment.

Clay Mixers and Pug Mills

Clay mixers are valuable for blending custom clay bodies or for processing large quantities of clay. They can also be used to recycle scraps. For best results, scraps should be premoistened. Most small mixers require blending a minimum of 150 lb. (68 kg) of clay.

Production potter Tim Frederich dry-blends his clays in a tumbler (17-6). After mixing, the powder is released from the barrel and into the pug mill hopper. He turns on the machine and adds water to the clay. When the clay becomes homogenous and reaches a throwing or hand-building consistency, he pushes the clay down into the hopper with a tamper, forcing the clay through the pug mill auger and out the end of the nozzle.

For those who buy premixed clay and prefer a machine to reprocess scraps, a pug mill is a valuable piece of equipment. If you intend to

Slab Rollers

If you plan to work on a large scale, want to make slabs quickly, or anticipate producing a large number of slab-built shapes, then you probably should buy a slab roller (17-8). Slab rollers can efficiently roll out clay slabs of uniform thickness and consistency and are especially useful for ceramists making slab-built pottery, sculpture, jewelry, or tiles. The machines are available in sizes that produce slabs from 12–40 in. (30–102 cm) wide by up to 48 in. (122 cm) long, by 1/8–1 3/4 in. (3–44 mm) thick. They are either powered by hand or motorized for the high-production artist.

Extruders

Clay extruders efficiently produce solid or hollow extrusions or narrow slabs. Ceramists find them useful for producing handles for pottery, tubes that can become containers, or coils for handbuilt vessels (17-9). If you plan to work in white or porcelain clays, buy an extruder with a stainless steel or aluminum chamber and dies to avoid contaminating the clay with iron residue or rust that could be released from extruders with steel chambers. Extruders are available in sizes from hand-held, to caulking-gun size, to larger table or wall-mounted types. The small units can produce coils as fine as 1/16 in. (1.6 mm) and coils or tubes up to 8 in. (20 cm) in diameter. For large extrusions, expansion boxes can be attached to the smaller units to widen the opening so that it can accept larger dies. You can buy extruders that are operated either manually or mechanically with a hydraulic plunger driven by compressed air.

Slip-Casting Equipment

Slip casting generally requires a mixer for the slip and a special table for pouring and then draining the excess clay from the plaster molds. Fiberglass casting and draining tables are commercially available, and the ultimate setup comes with a mixer and tank, a casting and drain table, and an electric pump for pouring slip into the molds, all in one unit. However, a casting setup can simply be a bucket or a bowl with two wooden slats for mold draining (see 13-38). If you are going into production or are planning to do large-scale

FIGURE 17-7
A pug mill with the capability of mixing new clay and recycling clay is popular with individuals and schools who need one machine to perform both tasks. Noelle Nakama recycles her scrap clay in a de-airing pug mill. She first soaks down all of her dry clay trimmings and chunks and then dumps them into the pug mill hopper and turns on the machine to mix the clay for about 15 minutes. She then switches the machine to the pug mode and extrudes the clay. Sometimes she extrudes the clay from the machine very damp and lets it air dry on bats, a wedging table, or ware boards until the clay stiffens up. Occasionally she adds dry clay powder to the clay slop during the mixing process to make the consistency usable right away.

process clay for the wheel, a de-airing type of pug mill will homogenize the clay and eliminate or minimize wedging. If you plan to use white or porcelain clays, it is important to purchase a pug mill with stainless-steel blades and a non-rusting chamber to avoid clay contamination.

Sculptor Noelle Nakama uses a combination clay mixer–pug mill that mixes damp clay trimmings, de-airs the clay, and then extrudes the clay into a 3 in. (76-mm) diameter coil (17-7).

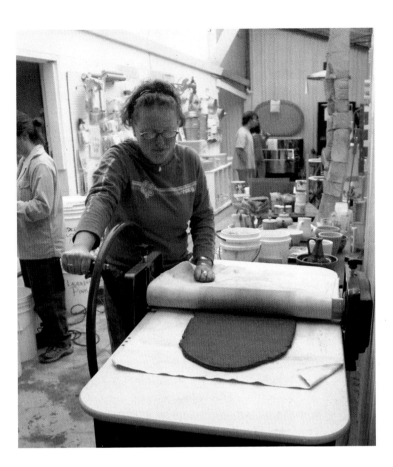

FIGURE 17-8
A slab roller is an efficient machine for rolling out uniformly thick clay slabs. Carla Higi uses a slab roller with adjustable rollers to make various-sized slabs for her sculptures.

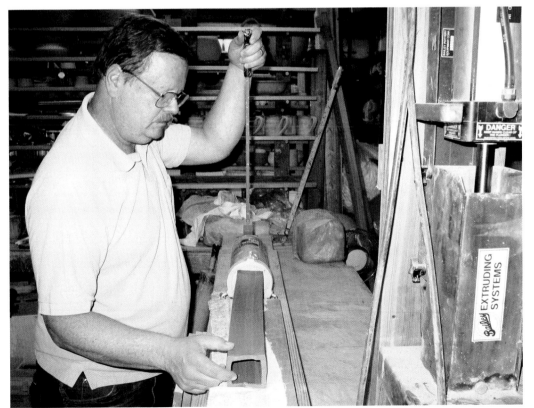

FIGURE 17-9
A hand extruder mounted on a hinged board turns a wall mount extruder into a vertical-horizontal extruder. Tim Frederich designed this extrusion system, which he finds to be an efficient method for extruding custom handles and shapes for his pottery.

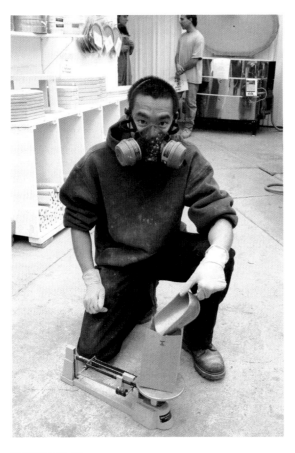

FIGURE 17-10
A triple-beam gram scale is an essential piece of equipment for weighing out clay and glaze chemicals. Mitsu Kimura uses both a triple-beam balance scale with a capacity of 2,610 g and a digital scale for weighing out larger quantities of materials. A digital scale is best when the speed of weighing chemicals in quantity is a factor.

casting, then it is worthwhile to consider purchasing commercially available equipment for mixing the slip. Popular slip-mixer sizes for individuals are the 15–50 gal. (19–190 l) types that come with mixer/motor, container, spigot, and stand. Mixing slip from dry powder requires wearing a protective mask (see Chapter 10), a gram scale to measure chemicals and 30 to 45 minutes of mixing to blend all the components thoroughly (see *Expertise*, Chapter 1C). For mixing small test batches of slip under 1 gal. (3.785 l), you can set up a mixer blade on the end of a drill press and run it at the lowest speed to mix for 30 to 45 minutes. If, however, your production is limited to occasionally casting a few gallons (about 8 l) of slip, then it usually is time saving to purchase premixed slip.

GLAZES IN YOUR STUDIO

Some ceramists prefer to purchase glazes, slips, and other glaze compounds premixed. In fact, some companies will take your own glaze formula and custom-mix it into a liquid or dry form. This will save you from purchasing numerous chemicals and mixing equipment, not to mention installing adequate ventilation to eliminate the dust created by mixing glazes and the problems associated with storing bags of chemicals. On the other hand, mixing and then firing your own glazes can be satisfying.

If you decide to set up a glaze mixing and glazing area in your studio, there is some equipment you will need to acquire. You will need a gram scale for accurately weighing out test glaze batches (17-10) and a package or platform scale for weighing bulk items such as bags of clays, frits, and feldspars. You will also need a mixer blade attached to a drill for mixing glazes, as well as an assortment of sieves to screen liquids and dry materials. For grinding small quantities of glaze materials, a mortar and pestle is adequate, but for grinding large quantities of stains and oxides, such as cobalt and copper-based colorants, you may want to invest in a ball mill. If you expand your production of glazes, you may decide to buy a professional-style dispersion blender. Be sure to provide and use the protective equipment discussed in Chapter 10.

Some ceramists prefer to buy a small electric test kiln that allows them to glaze-fire a test immediately, rather than wait to fire their tests in a large kiln that may take weeks to fill and fire. A small test kiln can be fired in one day, and some very small test kilns can even be fired two or three times in one day. For convenience it is ideal to place your test kiln in the glaze room, and it is important to have venting over the kiln to draw off fumes. Most test kilns operate on 120 volts (European, 230 volts) and can be plugged into standard electrical outlets.

SPRAY BOOTHS

If you want to spray your glaze on pottery or sculpture, you should consider installing a spray booth in your studio. To help you know when to change the filter, invest in a **draft gauge,** which measures the air draft through the filter and lets

 you know if there is adequate draft to properly collect and filter the overspray. When using spray equipment, always wear a respirator.

Purchasing a Spray Booth

Spray booths are available in a variety of sizes and styles. They have fiberglass, painted steel, or galvanized steel interiors, and they come in free-standing or table-mounted models. Most standard spray booths for ceramics are meant for spraying water-based liquids. However, if you are also planning to spray flammable liquids such as lusters, metallics, or oil-based paints, you should purchase a spray booth installed with a totally enclosed explosion-proof motor.

Spray-Booth Wiring

Most spray-booth motors operate on 120, 208, or 230 volts. For advice on wiring a spray booth, contact the spray-booth manufacturer or your local dealer. Most studio spray-booth fan motors operate on 120 volts (European, 230 volts) for a ¼–½ hp (.19–.37 kW) motor.

SPRAYING EQUIPMENT

Spray Guns

If you are going to spray underglazes, glazes, or stains over large broad surfaces, then you will need a spray gun. Two types of spray guns are popular among ceramists, and each usually holds about ½–1 qt. (.473–.946 l) of glaze. One style is the siphon-feed type that is activated by air being blown through a horizontal tube intersecting a vertical siphon tube inside the glaze canister. You may, however, prefer using a gravity-feed spray gun, which usually holds about 8 oz. (.24 l), because you can change spray material more quickly and frequently than with the siphon-feed gun.

Air Brushes

If you will be doing detail work over small surfaces using stains, underglazes, china paints, lus- ters, or metallics, then consider purchasing an air brush. These usually have a 1–3 oz. (30–90 ml) jar attached to the brush for spraying.

Air Compressors

Spray guns and air brushes need compressed air to function. Two common types of air compressors are the oil-less and the air tank-mounted styles. If you need clean (oil-free) air, then you should consider an oil-less compressor installed with a tank, but if portability and size are important, consider purchasing an oil-less compressor without air tank, which operates on standard house current at 120 volts (European wire, 230 volts). Because the pump is not lubricated with oil, it puts out the clean air that is especially critical when spraying materials such as lusters, metallics, and china paint, which are sensitive to contamination. A ⅓-hp (.25 kW) oil-less compressor that delivers 50 lb. (170 bar) of pressure will operate both a spray gun and an air brush. A ⅒ hp (.075 kW) oil-less compressor delivering 30 lb. (120 bar) of pressure will spray thinned-down glazes, underglazes, and stains.

A ¾–1 hp (.56–.76 kW) compressor with an oil-lubricated pump and an 11 gal. (42 l) tank will be powerful enough to spray all of your water-based glazes and paints. Compressors with motors up to 1 hp (.76 kW) operate on 120 volts (European wire, 230 volts). If you are in production, operating more than one piece of spray equipment at the same time, or setting up a shop to accommodate other air tools, then you will want a heavy-duty compressor with a tank. A 5-hp (3.7 kW), 80 gal. (303 l) compressor will handle almost all the requirements of a large studio setup; it will also have the power to sandblast.

Air Lines

Most compressors have a flexible hose attachment to the spray gun or air brush. If you plan to operate more than one spray unit, you will want to consider installing a union tee, which will accommodate two air hoses. In addition, if you are going to operate more than two spray units or are planning on using other air tools from one compressor, consider installing **quick couplers** on all of your air tools. These devices allow you to remove air equipment from the air

line without having to use a wrench. If you are using oil-based paints sensitive to contamination from water moisture, you will want to install a **moisture trap** in your air line.

PLASTER IN YOUR STUDIO

If you are going to make plaster molds for slip casting or for press molding, or if you plan to turn plaster on a lathe or carve plaster in your studio, then you should set up an area specifically for use of this material. This is because plaster chips can become a contaminant if they are inadvertently wedged into the clay and a piece made of that clay is bisqued and then glaze-fired; the moisture absorbed by the plaster that has been embedded in the fired clay may expand over a period of months or even years and pop pieces of clay or glaze off the surface. Keep plaster away from your clay! For example, always use separate mixing and cleaning buckets for the plaster; they should never be used for clay storage.

If you intend to integrate plaster into your studio, install a sink trap below your sink. This is a stainless steel, ceramic, or plastic container that receives water and material from the sink and traps the particles before the water enters the sewer line. Its primary function is to keep your drain pipes free of large particles of clay, plaster, or chemical contaminants. It usually has three evenly spaced traps; the first trap collects the largest particles of debris, and the third trap collects the finest.

HEALTH AND SAFETY

A clean, well-lighted, and organized studio makes for a pleasant, safe, and productive work space (see 17-2, 7-5). Planning your studio to include proper personal safety equipment is your best insurance against illness or accidents. It is also important to stay informed on the proper methods of handling ceramic chemicals and materials and operating machinery.

The very basic equipment needed to keep your studio clean is a large synthetic sponge and a bucket of water—to sponge off dusty or dirty tables—and a wet mop for damp-cleaning your floors. For greater cleanliness, install a ceiling-mounted electric air purifier that filters out very fine clay and chemical particles; this is recommended for health protection.

One of the most effective pieces of cleaning equipment is a vacuum with a HEPA filter—one that collects the finest clay and chemical powders and dusts from the floor, shelves, and tabletops. You can also use it when sanding greenware or drilling dry clay by placing the vacuum nozzle in front of the area where you are sanding or drilling. Be sure to wear personal protection when sanding (see Chapter 10).

The European Ceramics Work Centre in Holland (see 16-32) is an example of a large studio that was built from the ground up with the health and safety of its staff and artists-in-residence in mind. In addition to a complete venting system for clean air, floor drains and sinks lead to special underground tanks that collect all clay or glaze sludge, and when they become full the contents are tested for heavy metals and the materials are properly disposed of or recycled. Excess amounts of heavy metals or toxic materials are processed through a special sifter, and the residue may later be fritted in order to be reprocessed into other products. The kiln room also has gas-detection devices set in the ceiling to monitor any leaks from gas lines. Over each measuring scale in the glaze room an overhead flexible vacuum tube with hood and light removes the dust generated from measuring and weighing chemicals, which then is drawn into a dust collector. When chemicals are being weighed, the vacuum is turned on and the hood lowered to just above the chemicals. Although such systems may be beyond your budget, they will provide the ultimate in safe, clean ceramics environments.

Every studio needs fire extinguishers positioned near combustible materials. Your local fire department can tell you how many and what size fire extinguishers you will need for your studio, as well as their correct location. They can also advise you on fire alarms and other fire safety equipment.

Personal Safety Equipment

You will also want to invest in adequate personal safety equipment. For example, a form-fitting dual-cartridge respirator rated for dusts is essential when handling clay powders and chemicals.

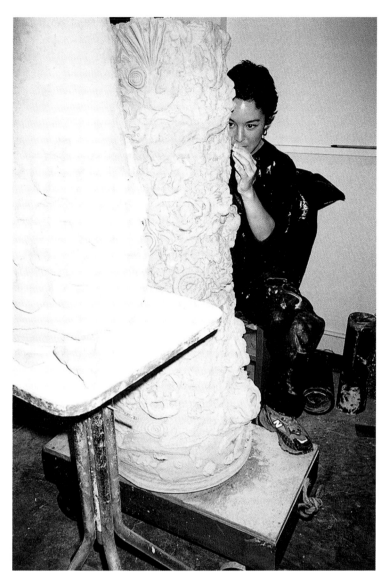

FIGURE 17-11
Maika Kusama sculpts in her studio at home and also utilizes the ceramics facilities at Chabot Junior College, where she fires her work. Kusama has a wheel, extruder, and tables in her studio. She makes her own extruder dies and says that one of the most important pieces of equipment in her studio are carts for moving her sculptures.

 When handling toxic materials you should wear a pair of neoprene gloves or light-duty vinyl gloves (disposable after using); safety goggles or a face shield; and a respirator with filters rated for protection against the toxic materials you will be handling. Pants, a long-sleeve shirt, and shoes are necessary to protect you against excessive exposure to toxic chemicals. For handling hot kiln shelves, pots, or sculpture, you will need a pair of heat-resistant gloves, or leather welding gloves. When looking through kiln spyholes to check pyrometric cones, you will need to wear shaded goggles or a welder's hand-held face shield with a number-3 lens to protect you against harmful ultraviolet rays and heat. It is a good idea to post safety rules (see Chapter 10) in the studio as reminders.

Recycling Ceramic Materials

Along with an increased awareness of environmental issues related to human health and a concern for how we interact with our earth, there is a heightened awareness of the need to recycle ceramic materials and toxic wastes. Some ceramists have devised ingenious methods for dealing with these wastes.

For example, Bill Roan of the California State University at Hayward and Clayton Bailey

developed a no-waste system for reprocessing clay and clay sediment from the school studio. They begin by washing buckets of clay and glaze scraps in an industrial parts washer with a recirculating water spray. The water from the parts washer can also be collected and used for mixing the clay, thus utilizing all materials in a recycling process. The damp residue is screened through a 30-mesh sieve and mixed with a flux, a refractory, and a colorant, and then used as a glaze. They also make up a clay body they call "reprocessed glaze sediment," by taking the same residue and mixing it at a one-to-one ratio with scrap clay and floor sweepings screened through a 16-mesh sieve, or with sand or fire clay (see *Expertise*, Chapter 1C). They then press out tiles, fire them to cone 10, and sell them for income for their school studio. This simple recycling method can be adapted for use by any small or large studio.

Although the setting-up process described in this chapter may take much of your energy at first, an organized work space and good equipment will free you to use your skills creatively and to work with joy (17-11). Good luck!

Glossary

For a complete list of chemicals and materials, see *Expertise,* Chapter 1E.

acids In glaze calculation, the term refers to glaze chemicals that combine and interact with **bases** and **neutrals** under heat as glazes are formed in the kiln. Silica is the most important acid. Acids are represented by the symbol RO_2. (See *Expertise,* Chapter 3B.)

airbrush An atomizer that uses compressed air to spray a liquid. In ceramics, used for spraying oxides, underglazes, glaze stains, china paint, and lusters.

air compressor A device that compresses air to below atmospheric pressure. In the studio, used to activate spray guns and air brushes.

Albany slip A natural slip glaze made of clay that was mined near Albany, New York. It was used for glazing stoneware in the United States until it was mined out.

alkalies Mainly sodium and potassium, but also lime, lithium, and magnesium. They act as fluxes in certain glazes.

alkaline glazes Glazes in which the fluxes are alkalies (mainly sodium and potassium). The earliest glazes developed in the Near East were alkaline.

alumina One of the refractory (high-melting) materials in glazes. (See *Expertise,* Chapters 1E and 3B and Chapter 14.)

amphora An ancient Greek vase form used for transporting liquids and for prize presentations to Olympic games winners.

antefix An ornament covering the ends of tiles on the roofs of Greek and Etruscan temples. (See Chapter 2 in *Hands in Clay.*)

armature A framework of any rigid material used as a support while building clay sculpture. Most armatures must be removed before firing.

ashes Ashes from trees, plants, or animal bones may provide fluxes for use in glazes. Ashes contain varying amounts of silica and alumina, as well as potash, iron, magnesium, phosphorus, and lime. Oriental glazes such as tenmoku frequently used rice straw ash, naturally high in silica. Tree and plant ashes are still popular glaze ingredients, while bone ash is used in making china.

aventurine glaze A glaze that, when cooled slowly, crystallizes and produces small spangles that catch the light. Generally high in iron.

bag wall A wall built inside a **downdraft kiln** to separate the firing chamber from the fire. It directs the flames upward, producing even circulation, and also protects the ware from direct contact with the flame.

ball clay A plastic fine-grained, secondary clay. Often containing some organic material, it is used in clay bodies to increase plasticity and in glazes to add alumina. Ball clay fires to a grayish or buff color.

ball mill A rotating porcelain jar filled approximately half-full with flint pebbles or porcelain balls that revolve and grind dry or wet glaze materials or pigments into powder or a refined liquid state.

banding wheel A turntable that can be revolved with one hand to turn a piece of pottery or sculpture while the other hand decorates or models it.

Basalt ware A black, unglazed stoneware first developed by Josiah Wedgewood in eighteenth-century England. (See Chapter 6.)

bases Glaze oxides that combine under heat with **acids,** acting as fluxes. Represented in glaze calculation by the symbol RO/R_2O. (See *Expertise,* Chapter 3B.)

bas-relief Three-dimensional modeling that is raised only slightly above a flat background.

bat A plaster disk or square slab usually ¾–1½ in. (6.35–38.1 mm) thick on which a pot is thrown or is placed to dry when removed from the wheel. Also used when handbuilding.

batch A mixture of glaze materials or ingredients that have been weighed in certain proportions to obtain a particular glaze or clay body.

bisque (bisquit) Unglazed ceramic ware that has been fired at a low temperature to remove all moisture from the clay body and to make handling easier during glazing.

bisque firing The process of firing ware at a low temperature, usually from cone 010 to cone 05, to produce bisque ware.

bizen ware Produced in Japan in wood-fired kilns in which the pots are stacked along with straw

that is high in silica content. The straw's combustion causes fire markings, and ashes from the fire may also create glazed areas. Bizen ware was originally intended for use in traditional Japanese tea ceremonies. Modifications of the technique are now popular with potters elsewhere.

black figure Early Greek pottery on which the decoration was black. To achieve this effect, the vessel was painted with a specially formulated slip, then fired in a sequence of reducing and oxidizing firings that turned the decoration black but left the background the natural reddish color of the clay. (See Chapter 2.)

blistering A pitted, craterlike surface on a glaze caused by gases bursting through the glaze as it is fired, often caused by too-rapid firing or overfiring.

blunger A machine with revolving paddles used to mix slips or glazes.

body (clay body) Any blend of clays and nonplastic ceramic materials that is workable and has certain firing properties. Clay bodies are formulated to serve particular purposes and to achieve maturity at various firing temperatures. See **earthenware, stoneware,** and **porcelain.**

bone ash Calcium phosphate ash made from animal bones. Used in a clay body for making **bone china.**

bone china Ware made of clay to which bone ash has been added to lower its maturing point. Produced mainly in England, it matures at lower temperatures—usually around 2270°F/1240°C—than true porcelain.

bottle kiln A kiln shaped like a bottle. Developed in the eighteenth century in Stoke-on-Trent, England, it was widely used in English pottery factories. It was an updraft kiln usually containing two chambers, one for bisque-firing and the other for glaze-firing. With multiple flues extending to the stoke holes, the kiln generally had a baffle wall inside to protect the ware. Ware was stacked into the kiln in **saggars.** Often, a shelter was built around the kiln where the ware could be dried.

burner (gas, propane, or oil) The system through which fuel, combined with air (usually controlled by a butterfly valve or air shutter), is fed into the kiln, creating the necessary mixture for combustion.

burnishing Rubbing leather-hard or dry clay with any smooth tool to polish it, tighten the clay surface, and compress the clay particles.

calcine (calcining) To heat a substance to a high temperature, but below its melting point, causing loss of moisture.

caliper An instrument used to measure the inside and outside diameter of an object. (See Chapter 12.)

car kiln (shuttle kiln) A kiln that is loaded by moving a stacked car on rails into the kiln. Used widely for production pottery and also for firing large sculpture. (See Chapter 15.)

casting The process of forming pottery or sculpture by pouring liquid clay (slip) into absorbent plaster molds or, historically, terra-cotta molds.

celadon The Western name for a type of glaze first used in China on stoneware and porcelain in an attempt to imitate the color and texture of jade. Its colors, ranging from shades of green to gray-green tones, depend on the percentage of iron it contains. Historically, celadon has been fired in a reducing atmosphere, but celadon colors may now be attained in an electric kiln. (See 3-17.)

centering The act of forcing a lump of clay by hand into a symmetrical form at the center of a spinning potter's wheel in preparation for throwing.

centrifugal force The force that tends to impel an object or material outward from the center of rotation. It acts on the clay while it rotates on a potter's wheel, and the action of the potter's hands in conjunction with this force causes the pot's wall to rise.

ceramic-fiber materials Lightweight refractory materials developed for the space exploration program. When exposed to the heat range for which each one is designed, they reflect heat and are resistant to thermal shock. They are also excellent insulating materials used for kiln insulation.

ceramic-fiber rigidizer A liquid that can be applied to ceramic fiber to harden the surface, make it more rigid, and help eliminate the dust it releases when handled.

ceramics Objects made from earthy materials with the aid of heat; the process of making these objects.

chambered kiln A type of kiln developed in China, built on a hillside with several separate firing chambers opening into each other. Sometimes called a *climbing kiln.*

chamotte A term generally used in Europe for **grog.** (See Chapter 10.)

china A term usually applied to any white ware fired at a low porcelain temperature. It was developed in Europe to compete with the expensive imported Chinese porcelain.

china clay See **kaolin.**

china paint An opaque overglaze paint that is fired onto already-fired glazed ware at various low-range temperatures, usually 1175–1325°F/635–717°C. Because of the low firing temperatures, colors such as red and orange remain stable and do not burn out. Sometimes called *overglaze enamel* or **enamel.**

china paint medium A substance in which china paint pigment is ground so that it can be applied

like paint. China paint may have either an oil or water base.

chinoiserie Decoration used in eighteenth-century Europe inspired by the newly imported Chinese crafts. The motifs were used on furniture, china, and other objects.

chuck An open container that holds work in place while trimming on the wheel. (See Chapter 12.)

clay A variety of earthy materials formed by the decomposition of granite. In the process, these may have been combined with a variety of other materials, forming clay bodies with differing maturing points. See also **primary clay** and **secondary clay.**

clay body See **body.**

CMC A synthetic **gum** used as a binder for pigments and glazes.

coiling A method of forming pottery or sculpture from rolls of clay melded together to create the wall. (See Chapter 11.)

colloidal clays Clays, such as Hectorite, macaloid, or Bentonite, that are commonly used as suspending agents in glazes or plasticizers in clay bodies.

compressed air See **air compressor.**

cone See **pyrometric cone.**

Cornish stone (Cornwall stone) A feldspathic material found in England, containing silica and various fluxes. Similar to the Chinese **petuntze** used in the first porcelains.

crackle glaze A glaze with deliberate crazing that forms a decorative surface. Color may be rubbed into the cracks to emphasize them, or the ware may be soaked in tea or coffee.

crawling Crawling is characterized by bare, unglazed areas on fired ceramic ware alternating with thickened glazed areas. Usually caused by surface tension in the molten glaze, pulling it away from areas of grease or dust on the surface of the bisque ware. Also may occur when glaze is applied over underglazed areas, when low-fire glaze containing gum is applied to high-fire porcelain bisque, or when a glaze solution contains too much gum.

crazing Unintentional cracks that occur over the entire glaze surface because the glaze expands and contracts more than the clay body to which it is applied. Caused by an improper **fit** of the glaze to the clay.

crystalline glazes Glazes in which light-reflecting crystals are formed. Large crystals may be caused to grow, creating a desired decorative effect. Slow cooling helps to produce crystals in glazes that are low in alumina.

cuenca A Hispano-Moresque technique in which designs for tiles or pottery were impressed into damp clay, forming ridges that acted as barriers between glaze colors to keep them from running into each other. (See Chapter 6.)

cuerda seca A technique used by Hispano-Moresque potters in which they drew lines around the designs on tiles or pottery, using a mixture of manganese and grease. This barrier created a dark outline and prevented the multicolored glazes from melding together and (See Chapter 6.)

de-airing Any method of removing air from clay to avoid bloating in fine-grain clay during firing. **Wedging** de-airs clay to a certain degree, but a **pug mill** equipped with a de-airing vacuum chamber does a more complete job.

decal An image or a design printed with ceramic material on a special paper so that it can be transferred to bisque ware or a glazed surface and fired to permanency. (See Chapter 14.)

deflocculant Material, such as sodium carbonate or sodium silicate, added to slip for casting to maintain its fluidity. Less water is needed in a slip containing deflocculant; thus less shrinkage will occur in drying the cast object. (See *Expertise,* Chapters 1A and 1B.) When spraying a glaze that is too viscous, add Darvan #7 to it to thin the solution.

die A pattern made of steel, acrylic, or wood for cutting or stamping clay; an attachment for an **extruder** that produces a desired form.

dipping Applying glaze or slip to a pot by immersing it and shaking off the excess glaze.

dispersion blender A type of high-speed (vortex) blender useful in mixing glazes. Reduces glaze particle size and blends glaze more thoroughly and efficiently than traditional propeller blades.

downdraft kiln A kiln in which the heat moves up through the firing chamber, down through the ware, and then is vented into a stack (chimney) opening at the bottom of the kiln. (See Chapter 15.)

draft In mold-making, the angle on an original model or prototype part or section. The tapered angle must be a minimum of 1 degree or greater to ensure that a cast section will release or slide out from another part. **Mold soap** is used as a separator between sections during casting.

draft gauge A gauge in a glaze spray booth that measures the strength of the air current passing through the filter. This lets the person spraying know if there is adequate air circulation to collect and filter the glaze overspray properly. (See Chapter 14.)

drape mold A support (such as a stretched cloth, a wooden frame, or rope network) in or over which a clay slab is draped to shaped as it stiffens. The term is also sometimes used for a **hump mold,** another type of support over which slabs of clay are stiffened. (See Chapter 13.)

draw ring A small ceramic ring made of the same clay and glaze of the ware being fired, used to

check periodically on the condition of the glaze color, clay color, vitrification, or shrinkage during a firing. (See 15-63.)

drill For drilling holes in ceramics, a carbide-tip drill bit will penetrate soft bisque. For high-fired ceramics, use a diamond-core drill bit lubricated and cooled with water.

dunting The cracking of pots during cooling, caused by too-rapid cooling of the kiln, by drafts reaching the ware as it cools in the kiln, or by removing the ware from the kiln before it is cool enough.

earthenware Pottery that has been fired at a low temperature (below cone 2) and is porous and relatively soft. Usually red or brown in color. Used worldwide for domestic ware, glazed or unglazed.

Egyptian paste A self-glazing low-fire clay body that contains glass-forming materials. Used by the Egyptians for small sculpture and ceremonial vessels. Now available commercially in a number of colors. (See 10-10; see also Chapter 2 and *Expertise,* Chapter 1A.)

electrolyte A substance, usually alkaline, that changes the electrical charges in clay particles so that they repel rather than attract each other, thus maintaining them in suspension in water. See **deflocculant** and Chapter 1B.

enamels Low-temperature opaque or translucent glazes that are usually painted over higher-fired glazed surfaces. More commonly called **china paints.**

engobe Originally, the term referred to slip that is applied over the entire surface of a piece of pottery or sculpture to change the color and/or texture of the clay body. The term now often refers to slip used for decoration.

envelope kiln A rectangular-shaped kiln with doors on one or both ends. After loading, the mobile kiln is rolled over a fixed floor and the door or doors are shut. Because the kiln floor does not move, there is no risk of disturbing the ware, kiln shelves, or posts, which is a drawback with a **car kiln** (shuttle kiln). Some potteries prefer to use envelope kilns because the shelves can be left in the same position after every firing for loading and unloading the ware.

epoxy An adhesive made from a thermosetting resin. Often used in ceramic repair. May be colored with a variety of coloring additives. Ultraviolet light may affect the color over an extended period of time. (See *Expertise,* Chapter 4D.)

eutectic A combination of two or more ceramic materials whose melting point is always lower than that of any one of the materials used alone.

extruder A mechanical aid for forming moist clay by pressing it through a **die.** Extruders can form clay quickly into many forms, from tubes to tiles to sewer pipes. (See Chapter 11.)

faience From the French name for the Italian town Faenza, where much tin-glazed earthenware (maiolica ware) was made. Frequently, a general term for any pottery made with a colored, low-fire clay body covered with opaque base glaze and decorated with colored glazes. (See **maiolica** and Chapter 6.)

feathering A method of making a decorative feather pattern with slip or glaze.

feldspar Any of a group of common rock-forming minerals containing silicates of aluminum, along with potassium, sodium, calcium, and occasionally barium. Used extensively in stoneware and porcelain bodies and in glazes as a flux. Feldspars melt at a range of temperatures between 2192°F/1200*C and 2372°F/1300°C depending on their composition. (See *Expertise,* Chapter 1D.)

ferric oxide and **ferrous oxide** The red and black iron oxides that produce reddish and brown colors in clay bodies and glazes, as well as acting as fluxes. They also produce the greens of celadon glazes when fired in a reducing atmosphere. (See *Expertise,* Chapter 1E.)

fettle The thin extrusion of clay left on a slip-cast form at the line where the mold sections were joined.

fettling knife A long, tapered knife used for trimming clay, and removing the **fettle** from a cast.

fiberglass A material consisting of glass fibers in resin. Sometimes called *spun glass,* it is used as an additive to clay bodies to strengthen them or as a reinforcing material in a matrix of epoxy or resin applied to sculpture after firing.

firebox The part of the kiln into which fuel is introduced and where combustion takes place.

fire clays (refractory clays) Clays that withstand high temperatures. Used in kiln bricks and also as ingredients in stoneware bodies or in clay bodies for handbuilding or sculpture.

firing Heating pottery or sculpture in a kiln or open fire to bring the clay or glaze to **maturity.** The temperature needed to mature a specific clay or glaze varies.

fit The adjustment of the glaze composition to the composition of a clay body so that it will adhere to the surface of the ware.

flambé glaze A high-fire red and purple-red glaze produced by firing copper in a reducing atmosphere. (See 3-19.)

flashing Refers to a glazed or unglazed fired ceramic piece that comes out of the kiln with a distinctly different color or glaze texture, usually on one side. It often occurs in a gas kiln when the flame is inadvertently or purposefully directed onto one side of the ware, causing uneven heat or a reducing atmosphere. Flashing can cause the same glaze to fire totally glossy on one side and matt on the other, or a wood-fired

bowl can appear light beige on one side and a warm golden orange on the other.

flocculant A material, such as calcium chloride or hydrated magnesium sulfate (Epsom salts), that helps keep clay particles together. Used to aid the suspension of glazes or for thinning slip. (See *Expertise,* Chapter 1B.)

flues The passageways in a kiln designed to carry the heat from the chamber to the chimney or vent.

flux A substance that lowers the melting point of another substance. Oxides such as those of iron, sodium, potassium, calcium, zinc, lead, boron, and others that combine with the silica and other heat-resistant materials in a glaze, helping them to fuse.

foot The base of a piece of pottery. Usually left unglazed in high-fired ware; occasionally glazed in low-fire, in which case the ware must be put on stilts to keep it from sticking to the shelf.

frit (fritt) A glaze material that is formed when any of several soluble materials are melted together with insoluble materials, cooled rapidly, splintered in cold water, and then ground into a powder. This renders them less soluble and less likely to release toxic materials. Feldspar is a natural frit.

fusion testing A method of subjecting ceramic chemicals to various temperatures in order to determine their melting points and fusability.

galena Lead sulfide, formerly used in Europe to glaze earthenware. No longer used because of its toxicity.

gesso A mixture of plaster and gum used as a base for painting.

glass former An essential component of any glaze. The main glass former is silica. (See *Expertise,* Chapters 1E and 3B and Chapter 14.)

glaze Any vitreous coating that has been melted onto a clay surface by the use of heat. Made of fine-ground minerals that, when fired to a certain temperature, fuse into a glassy coating. Glazes may be matt or glossy, depending on their components.

glaze firing (also called **glost firing**) The firing during which glaze materials melt and form a vitreous coating on the clay body surface.

glaze stain Commercial blends formulated with various coloring oxides that produce a wide range of colors when used in glazes or clay bodies.

glost Ware that has been glazed.

greenware Unfired pottery or sculpture.

grog (chamotte) Crushed or ground particles of fired clay graded in various sizes of particles. Added to a clay body to help in drying, to add texture, and to reduce shrinkage and warpage.

gum A viscous material, such as gum tragacanth, that is exuded from certain trees, or a chemically formulated substance; used as a binder for pigments. (See *Expertise,* Chapter 1B.)

hard paste True porcelain made of a clay body containing kaolin, traditionally fired between 2370°F/1300°C and 2640°F/1450°C. It is white, vitrified, and translucent. See **porcelain.**

hematite Iron oxide (Fe_2O_3) used as coloring on much early pottery.

high-fire Describes clays or glazes that are fired from cone 2 up to cones 10 to 13. Ware fired at cone 2 and higher is usually considered to be **stoneware.**

Hispano-Moresque Describes tin-lead-glazed earthenware produced in Spain in the Middle Ages. Frequently decorated with luster, its style exhibited influences from both Islam and Christian Europe. (See Chapter 6.)

hump mold A mold of plaster or terra-cotta or a found object such as a rounded rock, an upended bowl, a bag of sand, foam padding, or crumpled newspaper over which a slab of clay can be laid to shape as it stiffens. (See Chapter 13.)

hydrometer An instrument that determines specific gravity. In ceramics, used to monitor the proportion of water in a slip or a glaze. (See Chapter 14.)

in-glaze painting A decorating technique in which stains, oxides, or glazes are applied on top of an unfired glazed surface. Sometimes referred to as *overglazing,* but should not to be confused with *overglaze china painting.*

ione grain Hard, fired kaolin clay that has been crushed to various mesh sizes. White to grayish, its sharp particle shape adds tooth to clay bodies. Used for handbuilding and wheel clay bodies. Increases workability and strength, and reduces shrinkage in proportion to the amount added.

iron oxide See **ferric oxide.**

jig A frame or template, usually made of wood, to support damp clay slabs or constructions as they dry. A jig can also be called a *mold.* (See Chapter 11.)

jiggering A method of forming multiples rapidly. Soft clay is placed in a mold, pressed into or onto the mold walls either mechanically or by hand, then trimmed to size by hand or with a **jolley.** The Greeks and Romans used hand-jiggering methods to make utilitarian ware, and potters today use modifications of this method. Mechanical jiggering is used in ceramics factories. In industry, kerosene is used as a lubricant instead of water while jiggering.

jolley The mechanical arm and template used to shape clay as it turns on a jigger machine or on a potter's wheel.

kaolin (also called **china clay**) A white-firing primary clay that withstands high temperatures but is not very plastic. An essential ingredient

in porcelain, its presence in large quantities in China allowed the potters there to develop their fine white porcelain.

Kaowool Trademark of an insulating material for kilns. See **ceramic-fiber materials.**

keramos A Greek word meaning "earthenware," from which our term *ceramics* is derived.

key In ceramics, a low-relief round or tapered convex dome, usually about 1 in. (25 mm) in diameter and ½ in. (12 mm) high, on a mold that precisely fits a concave depression on a matching mold part. A mold key is a matching male and female registration guide to line up plaster mold sections.

kick wheel The traditional potter's wheel, powered by kicking a lower wheel or by pushing a treadle back and forth with the feet. (See Chapter 12.)

kiln A furnace or an oven built of heat-resistant materials for firing pottery or sculpture, sometimes referred to as a *kil.*

kiln flue A shaft, pipe, or tube for the passage of hot air and fumes from the kiln chamber. Flues are usually constructed from brick, insulated steel pipe, or triple-wall stainless steel pipe. (See Chapter 15.)

kiln furniture Heat-resistant shelves, posts, and slabs that support the ware in the kiln during firing. Kiln shelves may warp in firing if they are not well supported. (See Chapter 15.)

kiln hood The metal hood containing a venting system permanently built over a kiln or lowered over a kiln during firing to exhaust the heat and gases that are released from clays and glazes during firing. It is extremely important that all kilns be vented properly and to building codes. (See Chapters 15 and 17.)

kiln sitter A control that uses small pyrometric cones that slump when the desired temperature is reached and turn off the power to an electric kiln by tripping a switch or to a gas kiln by shutting off the gas solenoid valve. (See Chapter 15.)

kiln wash A coating of refractory materials (half flint and half kaolin) painted onto the kiln floor and the top side of shelves to keep the melting glaze from fusing the ware onto the shelves.

latex An emulsion of rubber or plastic material with water. Used in ceramics as a resist material in applying glazes; also a material for making flexible molds for plaster, wax, or concrete casting.

lead Until recently lead was used extensively in a variety of forms as a flux for low- or medium-temperature glazes. Although the dangers of handling toxic lead were known quite early, its solubility in acidic foods and liquids was not understood until comparatively recently. Lead glazes should not be used on food containers. (See *Expertise,* Chapter 1E.)

leather hard The condition of a clay body when much of the moisture has evaporated and shrinkage has just ended, but the clay is not totally dry. Carving, burnishing, or joining slabs are often done at this stage.

line blend testing A system of testing glazes through changing the proportions of two or more different glazes to develop a range of color shades. (See *Expertise,* Chapter 1A.)

low-fire The range of firing of clays and glazes in which the kiln temperature reached is usually in the cone 015 to cone 1 range.

low relief See **bas-relief.**

luster (lustre) A thin film of metallic salts usually, though not always, applied to a glazed surface and then refired at a low temperature in reduction. Modern luster mediums include a reducing material, so no further reduction is necessary, but the early lusters developed in Persia and brought to Europe by the Moors required a reducing atmosphere in the kiln to develop their characteristic sheen. (See Chapters 3 and 14.)

luster resist A special water-based resist material used like **wax resist** for luster-resist decoration.

luting The method of joining two parts of a still-damp clay object. Used for constructing both pottery and sculpture, especially large objects that cannot be made in one piece.

maiolica The Italian name for tin-glaze ware that was sent from Spain to Italy via the island of Majorca. Later, local styles of decoration were developed in Italian pottery towns such as Faenza and Deruta. Now a general term for any earthenware covered with a tin-lead glaze. (See Chapter 6.)

majolica Trade name for decorated earthenware made by British pottery, Minton. Inspired by Italian maiolica.

maquette A French term for a sketch or model from which a larger work is developed.

matt glaze A glaze that has a dull, nonglossy finish due to its deliberate composition. Barium carbonate (toxic) or alumina added to the glaze, along with a slow cooling, assists the formation of matt glazes.

maturing point (maturity) Refers to the temperature and time in firing at which a clay or glaze reaches the desired condition of hardness and density. Both clays and glazes have differing maturing points, depending on their composition.

model The original form in clay, plaster, wood, plastic, metal, or other material from which a mold is made.

moisture trap Used in the air lines of spray guns and air brushes intended for spraying oil-based paint such as luster and china paint. It traps any water vapor or moisture that might contaminate the oil-based paint. (See Chapter 17.)

mold Any form that can be used to shape fluid or plastic substances. In ceramics, usually the negative form from which pottery or sculpture can be cast by pouring or pressing methods using either liquid slip or damp clay. Molds can be made in one piece or in multiple sections. See also **drape mold** and **hump mold** (See Chapter 13.)

mold soap Water soluble soap used as a plaster separator. See **draft.**

molochite Crushed, fired white porcelain. Added to clay bodies, it assists in reducing shrinkage, cracking, and warping.

muffle A kiln, or section of a kiln, in which ceramics can be fired without direct contact with the flame.

mullite An additive material available in raw or **calcined** form. Acting as a heavy-duty refractory, it aids in producing strong clay bodies with high resistance to thermal shock, cracking, warping, or other deformations.

mullite crystals Crystals of aluminum silicate that start to form in clay as it is fired between 1850°F/1010°C and 2200°F/1204°C. These crystals strengthen stoneware and porcelain when fully developed at high temperatures and also help in the interaction that unites high-fire glazes and high-fire clay bodies.

multipart mold A mold for casting that is made in sections so that it can be removed easily from the cast object without distortion. Generally used to cast an object that has **undercuts** and that therefore cannot be removed from a one-piece mold. (See Chapter 13.)

neutral atmosphere The point at which the atmosphere in a kiln is balanced between oxidation and reduction.

neutrals Materials that are neutral and can react as either an acid or a base. Also called *amphoteric,* they are represented in glaze calculation by the symbol R_2O_3. (See *Expertise,* Chapter 3B.)

nylon fiber Synthetic fiber added to a clay body for strength.

opacifier A material that causes a glaze to become opaque by producing minute crystals. Tin, zirconium, and titanium oxides are used as opacifiers in combination with various oxides. (See *Expertise,* Chapter 1F.)

open firing Firing that is not done in an enclosed kiln. (See Chapter 15.)

orifice In a gas burner, the opening through which the fuel comes from the gas line and is mixed with air as it enters the burner. (See Chapter 15.) Also, the small channel or opening in the end of a spray gun or air brush that comes in varying diameter sizes through which ceramic glazes, underglazes, stains, or china paints are sprayed. (See Chapter 14.)

overfire To fire a clay body or glaze above its maturing point.

overglaze A low-temperature ceramic enamel painted on a previously glazed and fired surface and then fired for a second time at a lower temperature, usually as the final firing process. Bright colors such as red and orange that would burn out at high temperatures will be maintained in the lower firing (around 1300°F/705°C). Often called **enamel** or **china paint.** (See Chapter 14.)

oxidation (oxidizing firing, reduction atmosphere) The firing of a kiln or open fire with complete combustion so that the firing atmosphere contains enough oxygen to allow the metals in clays and glazes to produce their oxide colors. Electric kilns always produce oxidizing firings unless reducing materials are added. Bright and clear low-fire colors are often associated with glazes and clays fired in an oxidation atmosphere.

oxide A combination of an element with oxygen. In ceramics, oxides are used in formulating glazes and for coloring glazes and clays. They are also used for decorating ware.

oxygen probe (CO_2 analyzer) A probe inserted into a kiln while firing to monitor the **reduction** atmosphere and to keep the firings consistent time after time. Especially useful for a production potter.

parallel-flue kiln A rectangular kiln used by Roman and later potters in which parallel flues were placed under the perforated floor.

parting line In mold-making, a demarcation or guide on a model or prototype that determines the point or level to which clay is blocked up. It establishes the level where plaster or another material is poured or applied and also denotes the section line between plaster parts when casting a new mold. An indelible-ink marker is used so that the line will not blur or smudge when water-based clay touches the line. (See Chapter 13.)

peephole A hole in the door or wall of a kiln through which the ceramist can watch the pyrometric cones, the color of heat in the kiln, and the process of the firing. (Always wear goggles of the proper shade [number-3 to number-5] when peering into a kiln through a peephole.)

petuntze A type of feldspar rock found in China from which, with kaolin, the Chinese formed their porcelains. In Europe and the United States it is called **Cornish stone,** *Cornwall stone,* or *china stone.*

pinholes Small holes in a glaze caused by the bursting of blisters formed by gases as they escape through the glaze during firing.

pithos (plural, pithoi) A Greek term for a large storage jar made of earthenware. (See Chapter 2.)

plasteline A nonhardening clay made from motor oil, kaolin, and beeswax. It comes in different

colors and hardnesses. It is generally used for models, prototypes, or sculptural studies. It will not shrink and can be used over and over.

plastic clay (plasticity) The ability of a damp clay body to yield under pressure without cracking and to retain the formed shape after the pressure is released.

platelets (clay) The basic particles of clay.

porcelain A translucent, nonabsorbent body fired at a high temperature. White and hard, it was first developed in China. Traditionally fired in the 2370–2640°F/1300–1450°C range, some porcelain bodies have been developed that mature in the 2230–2340°F/1220–1280°C range.

potshard (potsherd) See **shard.**

potter's wheel A machine that spins a metal, plaster, wood, or stone disc on which a clay mound is shaped into pottery, tubes, or round forms. It is either driven manually by foot or hand or electrically powered by a motor.

pottery Originally a term for earthenware, now loosely used to refer to any type of ceramic ware, as well as to the workshop where it is made.

press mold Any mold made from plaster, fired clay, wood, or a found object into which damp clay can be pressed to reproduce the shape of the mold. (See Chapter 13.)

primary clay Clay found in nature that was formed in place rather than transported by the action of water. Also called residual clay. **Kaolin** is a primary clay.

proto-porcelain (proto-porcelaneous) Refers to an early high-fire ware developed in China as kilns became more efficient and capable of reaching higher temperatures. It preceded true porcelain.

pug mill A machine used to blend clay into a moist, workable consistency. Also used to recycle clay scraps and, when equipped with a vacuum pump system, to **de-air** clay. (See Chapters 10 and 17.)

pyrometer A device for measuring and recording the exact interior temperature of a kiln through out the firing and cooling process. (See Chapter 15.)

pyrometric cones Small pyramids of ceramic materials formulated to bend over and melt at designated temperatures. Orton cones in the United States and Seger cones in England and Europe have different ranges. In addition to the brown and white Orton cones that range from cone 022 to cone 42 (for industrial use), there are now cones that contain color coding to avoid confusion. (See *Expertise,* Chapter 2A and Chapter 15.)

quartz inversion point The point at which the silica crystals in clay change in structure and volume during the rise and fall of the temperature in the kiln. This development influences the fit of a glaze to the clay body.

quick coupler A coupling device that joins an air tool to an air line, allowing quick release without a wrench. This makes it easy to use the air line for several different air tools. (See Chapter 17.)

raku Originally a name used by a Japanese family that has made tea ceremony ware since the seventeenth century. Now refers to both the process of raku firing and to ware glazed in such a firing. Soft and porous, traditional raku ware was lead-glazed, placed in a red-hot kiln, and quickly withdrawn when the glaze melted. In the West, lead is now rarely used in raku glazes. Leadless frits and gerstley borate are now commonly used fluxes in place of lead. Raku ware is often reduced after firing by burying it in straw, sawdust, paper, or other combustible material, then covering it with an airtight lid to create a reducing atmosphere that aids in producing luster or opalescent colors.

raw glaze Glaze that does not contain fritted material.

reduction (reducing firing, reduction atmosphere) A firing in which insufficient air is supplied to the kiln for complete combustion. Under these conditions, the carbon monoxide in the kiln combines with the oxygen in the oxides of the clay body and glaze, causing the oxides to change color. Commonly associated with high-fire stoneware, porcelain, raku, and lusters.

refractory Resistant to heat and melting. Refractory materials are used in porcelain and stoneware and for building kilns and kiln furniture. In combination with other materials, they are also used as kiln insulation.

reserve A technique of painting *around* an area, reserving the area so that it remains the color of the clay body or glaze while the painted area around it fires a different color. Used on Greek red-figure ware, and still in use today, as when using some resist method to mask areas. (See Chapter 2.)

resist A method of applying a covering material such as wax, latex, or special luster resist to bisque or glazed ware and then coating the piece with a glaze or a second glaze. The resist material will not accept the glaze so that on firing the color of the covered area will remain intact.

retardant A chemical, such as sodate retarder or sodium citrate, added to plaster to slow its setting time.

rib A curved tool made of wood, metal, or plastic, used for shaping, scraping, or smoothing clay objects. (See Chapter 10.)

rondelle A round relief panel. (See 6-11.)

roulette A carved or textured wheel that imprints repeated motifs or texture when run over a damp clay surface.

saggar A refractory container in which glazed ware is placed during firing to protect it from the kiln fire. Saggars are also used to introduce local reducing material by placing leaves, seaweed, cow dung, or other organic material in the saggar with the ware.

salt glaze A glaze formed by introducing salt into a hot kiln. The vaporized salt combines with the silica in the clay body, forming a sodium silicate glaze on the surface. It also combines with the silica in the kiln bricks, coating them with a glaze that will be transferred to any ware fired in the kiln later. Salt glazing releases noxious and toxic fumes, so many potters now use alternatives for **vapor firing.** (See 9-16 and Chapter 15.)

sandblasting A method of etching the surface of a fired object or kiln shelves by directing a blast of air carrying fine sand onto the surface at high velocity. Since sand is largely silica and is extremely harmful to the lungs, use a sandblasting booth or wear a supplied-air respirator that covers your head.

sang de boeuf The French name for the ox-blood red glazes of China.

screed A flat scraper usually made of wood, metal, or plastic, used for smoothing trimming, or leveling uneven clay forms. Also the back of clay that has been pressed into a tile mold. (See Chapter 13.)

sealers Used to protect unglazed fired work from dust, fingerprints, and moisture as well as to heighten color use. Shellac, varnish, water-based acrylic paints, concrete sealers, linseed oil, or oil-based marble floor sealers can be used to seal ceramic. They are recommended for sealing objects for decorative purposes only but *not* for food containers.

secondary clay Natural clay that has been moved by water or wind from its source and settled elsewhere in deposits.

setting Placing the ware in the kiln in preparation for firing.

sgraffito Decoration of pottery made by scratching through a layer of colored slip to the differently colored clay body underneath.

shard (sherd) A broken piece of pottery. From these fragments, archaeologists can learn much about ancient cultures.

shim A small wooden wedge, metal spatula, thin metal rib, or scraper, that is inserted between plaster mold sections that are stuck together. Tapped into the mold seam or crevice, the shim exerts force to help separate the mold parts.

shivering The flaking off of slivers of glaze due to poor glaze fit, frequently due to greater shrinkage of the clay body than the glaze.

short Clay that is not plastic and that cracks after brief manipulation.

shrink ruler A scale ruler used to calculate the percent of shrinkage of clay during firing (See *Expertise,* Chapter 1A.)

shuttle kiln See **car kiln.**

siéve A utensil of wire mesh (usually brass to resist rust) used to strain liquids or powdered materials.

silica An oxide of silicon (SiO_2). Found in nature as quartz or flint sand, it is the most common of all ceramic materials. (See *Expertise,* Chapter 1E.)

silicon carbide Used in a glaze (as 3-F powder) to produce local reduction in an electric kiln. Also used in making kiln furniture for high-fire ware.

silk screening The process of transferring an image to a surface by forcing paint through a fine screening material, such as silk or polyester, on which a stencil of the image has been applied. In ceramics, it is generally used for applying china paint. (See Chapter 14.)

sintering The stage in glaze firing during which the heat converts a powder into a cohesive mass before melting it into a glassy material.

slab roller A mechanical device for rolling out slabs to a set, consistent thickness.

slaking The process of chemically combining a material, such as plaster, with water.

slip A suspension of clay in water used for casting pottery or sculpture in molds. Slip (sometimes called **engobe**) can also be used for painted decoration or for the **sgraffito** technique. Often contains sodium silicate N and soda ash, or Darvan #7, to help keep the particles in suspension and for fluidity.

slip casting The process of forming objects by pouring slip into a plaster mold. The mold absorbs the water in the slip so that solid clay walls are formed to create a positive of the original. (See Chapter 13.)

slip glaze A glaze that contains a large proportion of clay, generally one that contains enough flux to form a glaze with few or no additives. Albany slip was widely used as slip glaze in traditional American potteries before its supplies were mined out. Substitutes for it are Sheffield (Massachusetts) and Seattle slip clays.

slip reservoir In slip casting, a space left in a mold to be filled with additional slip. (See Chapter 13.)

slip trailer A rubber syringe used to apply decorations of slip on ware.

slurry A semiliquid mixture of clay and water such as the result of soaking scraps for recycling or reconstituting natural clays. (See 1-6.)

soaking Maintaining a certain temperature in the kiln for a period of time to achieve heat saturation.

sodate retarder A material that can be added to plaster (in proportions of ¼ to 2 tsp. to 100 lb.

[45.4 kg] of plaster) to slow its setting time by 10 minutes to 1 hour.

soft paste A porcelain body that fires at a lower temperature than true porcelain.

soluble Capable of being dissolved in a fluid.

soluble salts Mineral salts such as silver nitrate, bismuth subnitrate, and copper and iron sulfate. When used in ceramics, they are applied to bisque ware or to glazes and then fired to create interesting color effects. (See Chapter 14.)

splash coat In mold-making, the first coat of plaster applied on an original model, prototype, or mold section. The plaster is usually very fluid and is applied by splattering it onto a form, which ensures that it gets into the crevices of a model. It is commonly used for applying plaster to vertical surfaces.

spray booth A ventilated booth that removes chemicals and fumes from the air so that the worker does not inhale them while spraying glazes, underglazes, or overglazes. (See Chapter 14.)

spray gun A gun-like device through which compressed air passes, forcing the glaze into a fine mist for application.

sprigging The process of attaching low-relief decorations of damp clay onto already formed **greenware.**

sprue In ceramics, a narrow plastic tube, usually ½ in. (12 mm) in diameter, inserted into a plaster mold for draining the casting slip.

stains Commercially processed and refined raw chemicals offered in a wide range of shades for coloring clays and glazes. They are generally more color stable than oxides. (See Chapter 14.)

stilts In glaze firing, triangular supports with either clay (for low-fire glazes) or heat-resistant metal points (for low- or high-fire glazes), used to keep glazed pottery from sticking to the shelf. Small stilt marks can be filed, sanded, or ground smooth. (See Chapter 15.)

stoneware A type of clay body fired to a temperature at which the body becomes vitrified, dense, and nonabsorptive, but not translucent. Natural stoneware clay is usually brownish in color because of the presence of iron, but there are formulated white stoneware bodies. Usually matures at temperatures above 2192°F/1200°C.

sulfates Sulfates—chemicals that contain SO_4— are present in water and in materials you might use in a glaze such as soda, borax, or boric acid. In ceramics, copper, iron, and cobalt sulfate are commonly used as stains or colorants in glazes or are applied on top of glazes. Fuming with a sulfate diluted in a water-based solution can be achieved by painting a ceramic container with a sulfate and then by placing a smaller piece (generally a white ware, clay body) on the inside. Sulfate fumes/color are absorbed by the smaller piece during the firing process.

tamper Either a hand held tool or a machine which packs a material into a space or forces it through a machine such as an extruder or pug mill.

temper Any material, such as sand, mica, or crushed fired pottery fragments (**grog**), added to a clay body to make it more porous and less likely to shrink and warp.

template A wooden, metal, or plastic pattern used as a guide for shaping clay. A template can be used on the inside or outside of a pot as it turns on the wheel, in a process called **jiggering.**

tenmoku (temmoku) High-fired, saturated iron glaze; black, brown, and yellowish. Used by the Chinese and Japanese, especially on tea ware. Still a popular glaze. (See Chapter 3.)

terra-cotta A low-fire, porous, reddish clay body, frequently containing grog or other temper. Used throughout history for common, utilitarian ware; also used for sculpture.

terra sigillata A fine slip glaze used by the Greeks, Etruscans, and Romans to coat their pottery. It fired black or red according to the kiln atmosphere. Now used in a wide variety of colors by many potters and sculptors to surface their ware or sculpture. (See Chapters 2 and 14.)

test kiln A small kiln, usually under 1 cu. ft. (.0283 cu. m), with a firing range up to cone 10 or higher that is used for firing small clay and glaze test tiles, sculptures, or pottery. Such kilns fire quickly because of their small size. They can be computer-programmed to follow a firing pattern that simulates a large kiln with accurate results.

test tiles Small tiles made of clay used to test clay bodies in the kiln or to test glazes on a specific clay body. (See 10-10 and Chapter 14.)

thermal shock The stress to which ceramic material is subjected when sudden changes occur in the heat during firing or cooling.

throwing Forming objects on a **potter's wheel** using a clay body with plastic qualities (see **plastic clay.**)

throwing off the hump A method of working on the wheel in which a potter forms a number of pots or components of pots from one chunk of centered clay (See 12-76–12-78.)

tin enamel A low-fire overglaze containing tin.

tin glaze (tin-lead glaze) A low-fire, opaque glaze containing tin oxide.

top-hat kiln A kiln shaped like a cube, a tall rectangular box, or a tubular can that is open on the bottom. The kiln shell sits on a fixed floor during firing. To load or unload ware from the kiln, the shell is lifted straight up over the ware, kiln shelves, and posts with a hoist or winch. Some

top-hat kilns have two movable floors. While one floor is loaded and firing, the other one is being loaded. The floors roll on a track and exchange places after each firing.

trailing A method of decorating in which a slip or glaze is squeezed out of a syringe. Historically, decoration trailed from a quill inserted in a narrow-necked clay cup.

undercut A negative space in a solid form, creating an overhang. Casting a form with undercutting requires a **multipart mold** in order to release the mold from the cast. (See Chapter 13.)

underfire To fire clay or glaze—accidentally or deliberately—to a point below its maturing point. Underfiring can turn a normally glossy glaze into a matt surface.

underglaze Any coloring material used under a glaze. The color can be provided by oxides or by commercially prepared glaze and clay body **stains.** (See Chapter 14.)

updraft kiln A kiln in which the heat goes up through the chamber and is vented through the top of the kiln. (See Chapter 15.)

vapor firing (low-sodium firing) An environmentally friendly alternative to traditional salt-firing methods, which use heavy doses of air-polluting sodium. (See *Expertise,* Chapter 1C for an alternative recipe.)

viscosity The ability to resist running. A glaze must have enough viscosity to avoid flowing off the ware when it is melted under heat. China clay is often used to stabilize a glaze.

vitreous (vitrified) Pertaining to or having the nature of glass. In ceramics, a vitreous glaze or clay body has been fired to a dense, hard, and nonabsorbent condition. High-fire glazes vitrify and combine with the glassy particles that form in the high-fire clay body as it approaches vitrification. This results in a glaze that is united with the clay body, as compared to a low-fire glaze that merely coats the surface of the fired clay.

ware A general term applied to any ceramic—earthenware, stoneware, or porcelain—in the green, bisqued, or fired state.

warping A change in the form of a clay body that can occur during drying or firing if the wall of a piece is built unevenly, if drying or firing is uneven, or if the ware is improperly supported during firing.

waster (kiln waster) A piece of pottery discarded due to slumping, warping, or breaking in the kiln. Many wasters have been found in excavations at ceramic sites such as Faenza, Italy, and early New England potteries, helping archaeologists date styles and types of ware.

wax-burnout kiln An electric or gas kiln designed to burn out wax (called *lost wax*) at around 1000°F/538°C from plaster and sand molds (called *investment molds*) or ceramic shell molds. This type of kiln is generally used for making bronze and silver jewelry and for casting sculpture.

wax resist A method of decoration in which melted wax or oil emulsion is painted onto a clay body or a glazed piece. See **resist.** (See Chapter 14.)

wedging Any one of various methods of kneading a mass of clay to **de-air** it, get rid of lumps, and prepare a homogeneous material. (See Chapter 10.)

wedging table A table of plaster, wood, or concrete, often covered with canvas, on which clay can be wedged. A stretched wire attached to the table allows one to cut the clay to check for air bubbles, lumps, or lack of homogeneity. (See Chapter 10.)

Further Reading, Videos, and Websites

PERIODICALS

General

American Ceramics. 15 West 44th St., New York, NY 10036.

American Craft (Craft Horizons). American Craft Council, 72 Spring St., New York, NY

Ceramic Review. 21 Carnaby St., London, W1V 1PH, England.

Ceramica. Apartado 70008, Acacias 9, Madrid, Spain.

Ceramics: Art and Perception. 35 Williams St., Paddington, Sydney, NSW, 2021, Australia.

Ceramics Monthly. The American Ceramic Society, 735 Ceramic Place, Westerville, OH 43081.

Ceramics Technical. 35 Williams St., Paddington, Sydney, NSW 2021, Australia.

Clay Times. P.O. Box 365, Waterford, VA 20197-0365.

Fine Art Ceramics P.O. Box 448, Welches, OR 97067

La Revue de la Céramique. 61 Rue Marconi, 62880 Vendin-le-Vieil, France.

L'Atelier des Métiers d'Art. 18 Rue Wurtz, 75013 Paris, France.

New Zealand Potter. 15 Widestown Road, Wellington 1, New Zealand

Pottery in Australia. 48 Burton St., Darlinghurst, NSW, 2010, Australia.

Studio Potter. Box 70, Goffstown, NH 03045.

Studio Pottery. 5 Magdalen Road, Exeter EX2 4TA, UK.

Works and Conversations. P.O. Box 5008, Berkeley, CA 94705

YANN/Ceramics. P.O. Box 73-77, Taipei, Taiwan, Republic of China. (Chinese text.)

Health and Safety

ACTS FACTS. Arts, Crafts and Theater Safety, 181 Thompson Street, #23, New York, NY 10012-2586 (212) 777-0062 or 75054.2542@compuserve.com.

Art Hazard News. Center for Occupational Hazards, 5 Beekman St., New York, NY 10038.

Best's Safety Directory (two volumes). A. M. Best Company, Ambest Road, Oldwick NJ 08858 (908) 439-2200.

Additional listings in are provided in *Expertise.*

BOOKS: SHAPING THE PAST

General

Barnett, William K., and J. W. Hoopes, eds. *The Emergence of Pottery: Technology and Innovation in Ancient Societies.* Washington and London: Smithsonian Institution, 1995.

Charleston, Robert J. *World Ceramics.* New York: McGraw-Hill, 1968.

Cooper, Emanuel. *A History of World Pottery.* 2d ed. New York: Larousse, 1981/England: Batsford.

Ehrenberg, Margaret. *Women in Prehistory.* London: British Museum, 1989.

Freestone, Ian, and Daniel Gainster, eds. *Pottery in the Making.* London: British Museum, 1997.

Kingery, David W., and Pamela Vandiver. *Ceramic Masterpieces: Art, Structure and Technology.* New York: Free Press, 1986.

Munsterberg, Hugo, and Marjorie Munsterberg. *World Ceramics from Prehistoric to Modern Times.* New York: Penguin Studio Books, 1998.

The Mediterranean World

NEAR EAST

Hodges, Henry. *Technology in the Ancient World.* New York: Knopf, 1970.

Kingery, W. D., ed. *Ceramics and Civilization: Technology and Style.* Columbus, OH: American Ceramic Society, 1985.

GREECE, ROME, ETRURIA

Bendel, Otto J. *Etruscan Art.* Harmondsworth, England, and New York: Penguin, 1978.

Bibke, Joseph V. *The Techniques of Painted Attic Pottery.* New York: Watson-Guptill, 1965.

Boardman, John. *Athenian Black-Figure Vases.* London, New York, Toronto: Oxford University Press, 1975.

Gisela M. A. Richter. *A Handbook of Greek Art.* London: Phaidon, 1998.

Herbert, S. *The Red Figure Pottery.* Athens: American School of Classical Studies, 1977.

Noble, Joseph V. *The Techniques of Painted Attic Pottery.* New York: Thames and Hudson, 1988.

Peacock, D. P. S. *Pottery in the Roman World.* New York: Longman, 1982.

Europe and Great Britain

Bagdade, Susan, and Al Bagdade. *Warman's English and Continental Pottery and Porcelain.* 3d ed. Iola, WI: Krause, 1998, Iola, WI: 54990 0001

Bartlett, John. *English Decorative Ceramics.* Kevin Francis, 1989.

Barton, K. J. *Pottery in England from 3500 B.C.–A.D. 1730.* South Brunswick/New York: Barnes, 1975.

Brears, Peter C.D. *The English Country Pottery. Its History and Techniques.* Rutland, VT: Tuttle.

Carnegy, Daphne. *Tin-glazed Earthenware: From Maiolica, Faience and Delftware to the Contemporary.* London: A & C Black, 1993; Radnor, PA: Chilton, 1993.

Clark, Garth. *The Potter's Art: A Complete History of Pottery in Britain.* London: Phaidon; San Francisco: Chronicle, 1995.

Hildyard, Robin. *European Ceramics.* Philadelphia: University of Pennsylvania Press, 1999.

Lewis, Griselda. *A Collector's History of English Pottery.* New York: Viking, 1970.

Neuwirth, Waltraud. *Wiener Werkstatte Keramik: Original Ceramics, 1920–31.* Cincinnati, OH: Seven Hills, 1981.

Ramié, Georges. *Ceramics of Picasso.* Poughkeepsie, NY: Apollo.

China

Blumenfield, Robert H. *Blanc de Chine: The Great Porcelain of Dehua.* Berkeley, CA: Ten Speed Press, 2002.

Hetherington, A., and R. L. Hobson. *The Art of the Chinese Potter.* Magnolia, MA: Peter Smith, 1983.

Medley, Margaret. *The Chinese Potter.* Ithaca, NY: Cornell University Press, 1982.

Medley Margaret. *The Chinese Potter: A Practical History of Chinese Ceramics.* London: Phaidon, 1999.

———. *Yuan Porcelain and Stoneware.* London: Faber & Faber, 1974.

Korea

Adams, Edward B. *Korea's Pottery.* Rutland, VT: Tuttle, 1986.

Asia Society. *The Art of the Korean Potter: Silla, Koryo, Yi.* New York: Asia Society, 1968.

d'Argencé, Réne-Yvon Lefebvre, ed. *5,000 Years of Korean Art.* Asian Art Museum of San Francisco, 1979.

Japan

Cardozo, Sidney B., and Masaaki Hitano. *The Art of Rosanjin.* Tokyo: Kodansha, 1987.

Cort, Louise. *Shigaraki Potter's Valley.* New York: Kodansha, 1980.

Jenyns, Soame. *Japanese Pottery.* London: Faber & Faber, 1960; New York: Praeger, 1971.

Leach, Bernard. *Hamada, Potter.* New York: Kodansha, 1975.

———. *A Potter in Japan.* London: Faber & Faber, 1960.

Munsterberg, Hugo. *The Ceramic Art of Japan.* Rutland, VT: Tuttle, 1964.

Peterson, Susan. *Shoji Hamada: A Potter's Way and Work.* New York: Kodansha, 1984.

Rhodes, Daniel. *Tamba Potter: The Timeless Art of a Japanese Village.* New York: Kodansha, 1982.

Saint-Giles, Amaury. *Earth 'n' Fire: A Survey Guide to Contemporary Japanese Ceramics.* Tokyo: Shufunotomo, 1981.

Sanders, Herbert H., and Tomimoto, Kenkichi. *The World of Japanese Ceramics.* Tokyo: Kodansha, 1983.

Wilson, Richard. *The Art of Ogata Kensan: Persona and Production in Japanese Ceramics.* New York: Weatherhill, 1991.

———. *Kenzan: Meeting of Ceramics and Design.* New York: Weatherhill, 1991.

Yanagi, Soetsu. *The Unknown Craftsman: A Japanese Insight into Beauty.* New York: Kodansha, 1990.

Thailand

Uno, Kaworu, and Carolyn Nakamura, trans. *Thai Ceramics from the Sōsai Collection.* New York: Oxford University Press, 1989.

Islam

Atasoy, Nurhan, and Julian Raby. *Iznik: The Pottery of Ottoman Turkey.* London: Alexandria, 1994.

Atil, Esin. *Ceramics from the World of Islam.* Washington, D.C.: Freer Gallery of Art, 1973.

Bloom, Jonathan, and Sheila Blair. *Islamic Arts.* London: Phaidon, 1997.

Damby, Miles. *Moorish Style.* London: Phaidon, 1995.

Mitsukuni, Yoshida. *In Search of Persian Pottery.* New York: Weatherhill, 1972.

Öney, Gönül. *Ceramic Tiles in Islamic Architecture.* Istanbul: Ada Press, 1988.

Wilkinson, Charles K. *Iranian Ceramics.* New York: Asia House, 1963.

———, ed. *Nishapur, Pottery of the Early Islamic Period.* New York: Metropolitan Museum of Art, 1974.

India

Philadelphia Museum of Art. *Unknown India. Ritual Art in Tribe and Village.* Philadelphia, PA: Philadelphia Museum of Art, 1968.

Singh, Gurcharan. *Pottery in India.* New York: Advent, 1979.

Africa

Barley, Nigel. *Smashing Pots: Feats of Clay from Africa.* London: British Museum, 1994.

Cardew, Michael. *Pioneer Pottery.* New York: St. Martin's, 1976.

Clark, C., and L. Wagner. *Potters of Southern Africa.* New York: Hacker, 1974.

d'Azevedo, Warren L., ed. *The Traditional Artist in African Societies.* Bloomington: University of Indiana Press, 1973.

Fagg, William, and John Picton. *The Potter's Art in Africa.* London: British Museum, 1970.

Gardi, Rene. *African Crafts and Craftsmen.* New York: Van Nostrand Reinhold, 1969.

Gebauer, Paul. *Art of Cameroon.* Portland, OR, and New York: Portland Art Museum and Metropolitan Museum of Art, 1979.

Wahlman, Maude. *Contemporary African Arts.* Chicago: Field Museum of Natural History, 1974.

Indigenous America

MEXICO, MESOAMERICA, AND SOUTH AMERICA

Banks, George. *Peruvian Pottery.* Aylesbury, England: Shire Publications, 1989.

Coe, Michael D. *The Maya.* New York, London: Thames and Hudson, 1987.

Lackey, Luana M. *The Pottery of Acatlan: A Changing Mexican Tradition.* Tucson: University of Arizona Press, 1982.

Schele, Linda and Mary Ellen Miller. *The Blood of Kings: Dynasty and Ritual in Maya Art.* New York: George Braziller, 1986.

North America

Brody, J., Catherine J. Scott, and Steven A. Le Blanc. *Mimbres Pottery: Ancient Art of the American Southwest.* New York: Hudson Hills, 1983.

Dillingham, Rick. *Fourteen Families in Pueblo Pottery.* Philadelphia: University of Pennsylvania, 1994.

Dillingham, Rick, with Melinda Elliot. *Acoma and Laguna Pottery.* Santa Fe, NM: School of American Research Press, 1992

Harlow, Francis H., and Larry Frank. *Historic Pueblo Indian Pottery.* Santa Fe: Museum of New Mexico, 1967.

Kramer, Barbara. *Nampeyo and Her Pottery.* Philadelphia: University of Pennsylvania Press, 1996.

Lister, Robert H., and Florence C. Lister. *Anasazi Pottery.* Albuquerque: University of New Mexico, 1978.

———. *Anasazi Pottery: Ten Centuries of Prehistoric Ceramic Art in the Four Corners of the Southwestern United States.* Albuquerque, NM: University of New Mexico Press. 1998.

Milford, Nahohai, and Elisa Phelps. *Dialogues with Zuni Potters.* Zuni, NM: Zuni Ashiwi, 1995.

Peterson, Susan. *The Living Tradition of Maria Martinez.* New York: Kodansha, 1981.

———. *Lucy M. Lewis: American Indian Potter.* New York: Kodansha, 1984.

———. *Pottery by American Indian Women: The Legacy of Generations.* New York: Abbeville Press, 1997.

Trimble, Stephen. *Talking with the Clay: The Art of Pueblo Pottery.* Santa Fe, NM: School of American Research Press, 1987.

The United States

Baizerman, Suzanne, Lynn Downey, and John Toki. *Fired by Ideals: Arequipa Pottery and the Arts and Crafts Movement.* Rohnert Park, CA: Pomegranate Communications, 2000.

Barber, Edwin Atlee. *Tulip Ware of the Pennsylvania German Potters.* New York: Dover, 1970.

Barret, Richard Carter. *Bennington Pottery and Porcelain.* New York: Crown, 1958.

Blasberg, Robert W., and J. W. Carpenter. *George Ohr and His Biloxi Art Pottery.* Port Jarvis, NY: J. W. Carpenter, 1973.

Burrison, John. *Brothers in Clay: The Story of Georgia Folk Pottery.* Athens: University of Georgia Press, 1983.

Clark, Garth. *American Potters: The Work of Twenty Modern Masters.* New York: Watson-Guptill, 1981.

———. *The Mad Potter of Biloxi: The Art and Life of George E. Ohr.* New York: Abbeville, 1989.

Clark, Garth, and Margie Hughto. *A Century of Ceramics in the United States 1878–1978.* New York: Dutton and Everson Museum of Art, 1981.

Ferriday, Virginia Guest. *Last of the Handmade Buildings: Glazed Terra Cotta in Downtown Portland.* Portland, OR: Mark, 1984.

Ferris, William. *Afro-American Folk Arts and Crafts.* Boston: Hall, 1983.

Greer, Georgeanna H. *American Stoneware: The Art and Craft of Utilitarian Potters.* West Chester, PA: Schiffer, 1981.

Griffin, Leonard. *Clarice Cliff: The Art of Bizarre* Rohnert Park, CA: Pavilion, 2001. London SW11 4NQ

Henzke, Lucile. *Art Pottery of America.* West Chester, PA: Schiffer, 1982.

Kurutz, Gary. *The Architectural Terra Cotta of Gladding McBean.* Sausalito, CA: Windgate, 1989.

Levin, Elaine. *The History of American Ceramics.* New York: Abrams, 1988.

Perry, Barbara. *American Art Pottery from the Collection of Everson Museum of Art.* New York: Harry N. Abrams, 1997.

Poor, Henry Varnum. *A Book of Pottery: From Mud into Immortality.* Englewood Cliffs, NJ: Prentice-Hall, 1958.

Rago, David, and Suzanne Perrault. *Treasure or Not? How to Compare and Value American Art Pottery.* London: Octopus, 2001.

Rindge, Ronald L. *Ceramic Art of the Malibu Potteries.* Malibu, CA: Malibu Lagoon Museum, 1988.

Rosenthal, Lee. *Catalina Tile of the Magic Isle.* Sausalito, CA: Windgate, 1992.

Schlanger, Jeff, Toshiko Takaezu, and Gerry Williams, eds. *Maija Grotell: Works Which Grow from Belief.* Goffstown, NH: Studio Potter, 1996.

Sweesy, Nancy. *Raised in Clay.* Washington, D.C.: Smithsonian Institution, 1984.

Tuchman, Mitch. *Bauer: Classic American Pottery.* San Francisco: Chronicle, 1995.

Vlach, John. *The Afro-American Tradition in Decorative Arts.* Cleveland, OH: Cleveland Museum of Art, 1978.

Watkins, Lura Woodsie. *New England Potters and Their Wares.* Cambridge, MA: Harvard University Press, 1968.

Webster, Donald Blake. *Decorated Stoneware Pottery of North America.* Rutland, VT: Tuttle, 1970.

Zug, Charles G., III. *Turners and Burners: The Folk Potters of North Carolina.* Chapel Hill: University of North Carolina Press, 1986.

BOOKS: SHAPING THE PRESENT

General and Aesthetics

Anderson, Bruce, and John Hoare. *Clay Statements: Contemporary Australian Pottery.* Darling Downs Institute, Australia, 1985.

Axel, Jan, and Karen McCreary. *Porcelain: Traditions and New Visions.* New York: Watson-Guptill, 1981.

Bender, Sue. *Everyday Sacred: A Woman's Journey Home.* San Francisco: Harper, 1995.

Berensohn, Paulus. *Finding One's Way With Clay.* Dallas: Trinity Ceramic Supply, 1997.

Birks-Hay, Tony. *Art of the Modern Potter.* New York: Van Nostrand Reinhold, 1977; London: Hamlyn, 1976.

———. *Hans Coper.* New York and Sherborne, England: Harper & Row/Alphabooks, 1983.

———. *Lucie Rie.* Sherborne, England: Alphabooks, 1988.

Blandino, Betty. *Coiled Pottery: Traditional and Contemporary Ways.* Radnor, PA: Chilton, 1997.

Carney, Margaret. *Charles Fergus Binns.* New York: Hudson Hills, 1998.

Casson, Michael. *The Craft of the Potter.* England: Barron, 1979.

DePaoli, G. Joan and Dr. Gladstone. *Clayton Bailey: Happenings in the Circus of Life.* John Natsoulas, 2000.

Dormer, Peter. *Functional Pottery: Form and Aesthetic in Pots of Purpose.* Radnor, PA: Chilton, 1986.

———. *The New Ceramics: Trends and Traditions.* New York: Thames & Hudson, 1986.

Khalili, Nader. *Racing Alone.* New York: Harper & Row, 1983.

Hopper, Robin. *Functional Pottery: Form and Aesthetic in Pots of Purpose.* 2d ed. Iola, WI: Krause, 2000.

Lackey, Louana M. *Rudy Autio.* Westerville, OH: American Ceramic Society, 2002.

Lane, Peter. *Ceramic Form.* New York: Rizzoli, 1987.

Monroe, Michael W. *The White House Collection of American Crafts.* New York: Abrams, 1995.

Nachmanovitch, Stephen. *Free Play: The Power of Improvisation in Life and the Arts.* New York: G. P. Putnam's Sons, 1990.

Needleman, Carla. *The Work of Craft.* New York: Avon, 1979.

Nierman, Kevin. *The Kids 'N' Clay Ceramics Book.* Berkeley, CA: Tricycle, 2000.

Nigrosh, Leon. *Claywork: Form and Idea in Ceramic Design.* 2d ed. Worcester, MA: Davis, 1986.

Nordness, Lee. *The Genesis and Triumphant Survival of an Ohio Artist.* Racine, WI: Perimeter, 1985.

Peterson, Susan. *Jun Kaneko.* London: Laurence King, 2001.

Peterson, Susan and Jan Peterson. *Working with Clay: An Introduction.* 2d ed. Woodstock, NY: Overlook, 1998.

Preble, Duane, and Sarah Preble. *Artforms.* New York: Harper Collins College, 1994.

Rawson, Philip. *Ceramics.* Philadelphia: University of Pennsylvania Press, 1984.

Richards, M. C. *Centering in Pottery, Poetry and the Person.* Middletown, CT: Wesleyan University Press, 1989.

Rubino, Peter. *The Portrait in Clay.* New York: Watson-Guptill, 1997.

Simpson, Penny, Lucy Kitto, and Kanji Sodeoka. *The Japanese Pottery Handbook.* New York: Kodansha International, 1979.

Slivka, Rose, and Karen Tsujimoto. *The Art of Peter Voulkos.* New York: Kodansha America, 1995.

Smith, Lindsay. *I Shock Myself: The Autobiography of Beatrice Wood.* San Francisco: Chronicle, 1992.

Snyder, Jill. *Caring for Your Art: A Guide for Artists, Collectors, Galleries, and Art Institutions.* New York: Allworth, 1996.

Speight, Charlotte F. *Images in Clay Sculpture. Historical and Contemporary Techniques.* New York: Harper & Row, 1983.

Topal, Cathy Weisman. *Children, Clay, and Sculpture.* Worcester, MA: Davis, 1983.

Whyman, Caroline. *Porcelain: The Complete Potter.* Philadelphia: University of Pennsylvania Press, 1994.

Wissinger, Johanna. *Arts and Crafts.* San Francisco: Chronicle, 1994.

Wondrausch, Mary. *Mary Wondrausch on Slipware.* Westerville, OH: American Ceramic Society, 2001.

Zakin, Richard. *Ceramics: Ways of Creation.* Iola, WI: Krause, 1999.

TECHNICAL

General

Bastarache, Edouard. *Substitutions for Raw Ceramic Materials.* Quebec: Edouard Bastarache, 1997.

Beard, Peter. *Resist and Masking Techniques.* London: A & C Black; Philadelphia: University of Pennsylvania Press, 1996.

Birks, Tony. *The Complete Potter's Companion.* Boston, Toronto, London: Little, Brown, Bulfinch Books, 1996.

Chappelhow, Mary. *Thrown Pottery Techniques Revealed.* Iola, WI: Krause, 2001.

Chavarria, Joaquim. *The Big Book of Ceramics.* New York: Watson-Guptill, 1994.

Cuff, Yvonne Hutchinson. *Ceramic Technology for Potters and Sculptors.* Philadelphia: University of Pennsylvania Press, 1996.

Davis, Don. *Wheel-thrown Ceramics.* New York: Lark/Sterling, 1998.

Fournier, Robert, ed. *Illustrated Dictionary of Practical Pottery.* New York: Van Nostrand Reinhold, 1976.

Hall, Morgen. *The Potter's Primer.* Iola, WI: Krause, 2000.

Hamer, Frank, and Janet Hamer. *The Potter's Dictionary of Materials and Techniques.* Philadelphia: University of Pennsylvania Press, 1991.

Hamilton, David. *Thames & Hudson Manual of Architectural Ceramics.* New York: Thames & Hudson, 1978.

———. *Thames & Hudson Manual of Pottery and Ceramics.* New York: Thames & Hudson, 1982.

———. *Thames & Hudson Manual of Stoneware and Porcelain.* New York: Thames & Hudson, 1982.

Holden, A. *The Self-Reliant Potter.* London: A & C Black, 1986.

Kenny, John B. *The Complete Book of Pottery Making.* 2d ed. Radnor, PA: Chilton, 1976.

Peterson, Susan. *The Craft and Art of Clay.* Englewood Cliffs, NJ: Prentice-Hall, 1996.

Piepenburg, Robert. *A Classic Guide to Ceramics.* Richmond, CA: Pebble, 1996.

Speight, Charlotte F., and John Toki. *Make It in Clay: A Beginner's Guide to Ceramics.* Mountain View, CA: Mayfield, 1997.

Triplett, Kathy. *Handbuilt Ceramics.* New York: Lark/Sterling, 1997.

Wilson, Lana. *Ceramics: Shape and Surface.* Del Mar, CA: Lana Wilson, 1996.

Zakin, Richard. *Ceramics: Mastering the Craft.* Radnor, PA: Chilton, 1990.

Sculpture and Handbuilding

Cuff, Yvonne Hutchinson. *Ceramic Technology for Potters and Sculptors.* Philadelphia: University of Pennsylvania Press, 1996.

Gregory, Ian. *Sculptural Ceramics.* London: A & C Black; Oviedo, FL: Gentle Breeze, 1992.

Grubbs, Daisy. *Modeling a Likeness in Clay: Step-by-Step Techniques for Capturing Character.* New York: Watson-Guptill, 1982.

Lucchesi, Bruno and Margit Malstrom. *Modeling the Figure in Clay: A Sculptor's Guide to Anatomy.* New York: Watson-Guptill, 1996.

———. *Modeling the Head in Clay: Creative Techniques for the Sculptor.* New York: Watson-Guptill, 1996.

————. *Terracotta: A Technique of Fired Clay Sculpture.* New York: Watson-Guptill, 1977.

Midgley, Barry. *The Complete Guide to Sculpture Modeling and Ceramics Techniques and Materials.* Chartwell, 1998.

Minogue, Coll. *Impressed and Incised Ceramics.* 2d ed. London: A & C Black; Oviedo, FL: Gentle Breeze, 2001.

Nigrosh, Leon I. *Sculpting Clay.* Worcester, MA: Davis, 1992.

Peck, Judith. *Sculpture as Experience: Working with Clay, Wire, Wax, Plaster, and Found Objects.* Radnor, PA: Chilton, 1989.

Waller, Jane. *The Human Form in Clay.* Wiltshire, England: Crowood, 2001. Wiltshire, England SN8 2HR

Zakin, Richard. *Hand-formed Ceramics: Creating Form and Surface.* Radnor, PA: Chilton, 1995.

Clays, Glazes, and Firing

Andrews, Tim. *Raku: A Review of Contemporary Work.* Radnor, PA: Chilton, 1994.

Bailey, Michael. *Glazes Cone 6 1240°C/2264°F.* London: A & C Black; Philadelphia: University of Pennsylvania Press, 2001.

Beard, Peter. *Resist and Masking Techniques.* Philadelphia: University of Pennsylvania Press, 1996.

Branfman, Steve. *Raku: A Practical Approach.* Radnor, PA: Chilton, 1991.

Brodie, Regis C. *The Energy-Efficient Potter.* New York: Watson-Guptill, 1982.

Burleson, Mark. *The Ceramic Glaze Handbook: Material, Techniques, Formulas.* New York: Lark/Sterling, 2001.

Caiger-Smith, Alan. *Lustre Pottery: Technique, Tradition and Innovation in Islam and the Western World.* Oviedo, FL: Gentle Breeze, 2001.

Chappell, James. *The Potter's Complete Book of Clay and Glazes.* New York and London: Watson-Guptill: Pitman, 1991.

Cochrane, Rosemary. *Salt-Glaze Ceramics.* Wiltshire, England: Crowood, 2001.

Coleman, Tom. *With a Little Help From My Friends: Glazes, Clays, and Ideas.* Henderson, NV: Tom Coleman, 2000.

Conrad, J. W. *Contemporary Ceramic Formulas.* New York: Macmillan, 1981.

Constant, Christine, and Steve Ogden. *The Potter's Palette: A Practical Guide to Creating over 700 Illustrated Glaze and Slip Colors.* Iola, WI: Krause, 1996.

Cooper, Emanuel. *The Complete Potter: Glazes.* London: Batsford, 1992.

Creber, Diane. *Crystalline Glazes.* London: A & C Black; Philadelphia: University of Pennsylvania Press, 1997.

Currip, Ian. *Revealing Glazes: Using the Grid Method.* Bootstrap, 2000.

————. *Stoneware Glazes: A Systematic Approach.* 2d ed. Bootstrap Press, 1986.

Currie, Ian, and Derek Royle. *Glazes for the Studio Potter.* Batsford, England: David & Charles, 1992.

Daly, Greg. *Glazes and Glazing Techniques: Contemporary Approaches to Colour and Technique.* London: A & C Black, 1998.

Eden, Michael, and Victoria Eden. *Slipware: Contemporary Approaches.* London: A & C Black; Philadelphia: University of Pennsylvania Press, 1999.

Eppler, Richard R. and Douglas R. Eppler. *Glazes and Glass Coatings.* Westerville, OH: The American Ceramic Society, 2000.

Fournier, Robert. *Illustrated Dictionary of Practical Pottery.* Radnor, PA: Chilton, 1992.

Fraser, Henry. *Ceramic Faults and Their Remedies.* London: A & C Black, 1986; Oviedo, FL: Gentle Breeze, 1986.

————. *The Electric Kiln: A User's Manual.* Oviedo, FL: Gentle Breeze, 1995.

————. *Glazes for the Craft Potter.* London: Pitman; New York: Watson-Guptill, 1974.

Giese, Hugh. *Metallics and Lustres.* Livonia, MI: Scott, 1993.

Green, Lynne. *Painting with Smoke.* Otley, England: Smith Settle, 2000.

Hamer, Frank. *Glazes for the Craft Potter.* London: Pitman; Philadelphia: University of Pennsylvania Press, 1991.

Healy, Kay. *Make Your Own Ceramics Decals: Complete Handbook.* Indiana: Amaco, 1985.

Herr-Rains, Cheryl. *Fire Marks: A Workbook on Low-Temperature Smoke Firing.* Oviedo, FL: Gentle Breeze, 2002.

Hesselberth, John, and Ron Roy. *Mastering Cone 6 Glazes: Improving Durability, Fit, and Aesthetics.* Ontario, Canada: Glaze Master, 2002.

Hessenberg, Karin. *Sawdust Firing. The Complete Potter Series,* Emmanuel Cooper, ed. United Kingdom: BTB; Philadelphia: University of Pennsylvania Press, 1994.

Hinchecliffe, John, and Wendy Barber. *Ceramic Style: Making and Decorating Patterned Ceramic Ware.* Cassell, UK: Cassell; Marysville, WA: Sterling, 1996.

Hopper, Robin. *The Ceramic Spectrum: A Simplified Approach to Glaze and Color Development.* Radnor, PA: Chilton, 1984.

Jones, David. *Raku: Investigations into Fire.* Wiltshire, England: Crowood, 1999.

Lane, Peter. *Contemporary Porcelain: Materials, Techniques and Expression.* Radnor, PA: Chilton, 1995.

Lou, Nils. *The Art of Firing.* London: A & C Black; Ovieda, FL: Gentle Breeze, 1998.

Mansfield, Janet. *Salt-Glaze Ceramics.* Radnor, PA: Chilton, 1991.

———. *Salt-Glaze Ceramics: An International Perspective.* Radnor, PA: Chilton, 1992.

Mason, Ralph. *Native Clays and Glazes for the North American Potter.* Portland, OR: Timber, 1981.

McKee, Charles. *Ceramics Handbook: A Guide to Glaze Calculation, Material and Processes.* Belmont, CA: Star, 1984.

Memmott, Harry. *An Artist's Guide to the Use of Ceramic Oxides.* Burwood, Australia: Victoria College, 1988.

Minogue, Coll. *Impressed and Incised Ceramics.* Oviedo, FL: Gentle Breeze, 1996.

Minogue, Coll, and Robert Sanderson. *Wood-Fired Ceramics: Contemporary Practices.* Philadelphia: University of Pennsylvania Press, 2000.

Nigrosh, Leon. *Low Fire: Other Ways to Work in Clay.* Worcester, MA: Davis, 1980.

Ostermann, Matthias. *The New Maiolica.* London: A & C Black; Philadelphia: University of Pennsylvania Press, 1999.

Parks, Dennis. *A Potter's Guide to Raw Glazing and Oil Firing.* New York: Scribner's, 1980.

Parmelee, Cullen W. *Ceramic Glazes.* 3d ed. Chicago: Industrial Publications, 1973.

Pegrum, Brenda. *Painted Ceramics: Colour and Imagery on Clay.* Wiltshire, England: Crowood, 1999.

Perryman, Jane. *Smoke-fired Pottery.* Oviedo, FL: Gentle Breeze, 1995.

Peters, Lynn. *Surface Decoration for Low-Fire Ceramics.* New York: Lark/Sterling, 1999. New York, NY 10016

Piepenburg, Robert. *Raku Pottery.* Rev. ed. Ann Arbor, MI: Pebble, 1991.

Rhodes, Daniel. *Clay and Glazes for the Potter.* Radnor, PA: Chilton, 1973.

———. *Stoneware and Porcelain.* Radnor, PA: Chilton, 1973.

Rogers, Phil. *Ash Glazes.* London: A & C Black, 1991. Radnor, PA: Chilton, 1991. Oviedo, FL: Gentle Breeze, 1991.

———. *Salt Glazing.* London: A & C Black; Philadelphia: University of Pennsylvania Press, 2002.

Scott, Paul. *Ceramics and Print.* Philadelphia: University of Pennsylvania Press, 1995.

Scott, Paul, and Terry Bennett. *Hot off the Press: Ceramics and Print.* Bellew, 1996.

Sutherland, Brian. *Glazes from Natural Sources: A Working Handbook for Potters.* London: Batsford, 1987.

Tichane, Robert. *Ash Glazes.* Iola, WI: Krause, 1998.

———. *Celadon Blues: Re-create Ancient Chinese Celadon Glazes.* Iola, WI: Krause, 1998.

———. *Ching-Te-Chen.* Painted Post, NY: New York Glaze Institute, 1983.

———. *Clay Bodies.* Painted Post, NY: New York Glaze Institute, 1990.

———. *Copper Red Glazes.* Iola, WI: Krause, 1998.

Tristram, Fran. *Single Firing: The Pros & Cons.* Oviedo, FL: Gentle Breeze, 1996.

Troy, Jack. *Salt Glazed Ceramics.* New York: Watson-Guptill, 1975.

———. *Woodfired Stoneware & Porcelain.* Radnor, PA: Chilton, 1995.

Tudball, Ruthanne. *Soda Glazing.* London: A & C Black; Philadelphia: University of Pennsylvania Press, 1995.

Tyler, Christopher, and Richard Hirsch. *Raku: Techniques for Contemporary Potters.* New York: Watson-Guptill, 1975; London: Pitman.

von Dassow, Sumi. *Barrel, Pit, and Saggar Firing: A Collection of Articles from* Ceramics Monthly. Westerville, OH: American Ceramic Society, 2001.

Wittig, Irene. *The Clay Canvas: Creative Painting on Functional Ceramics.* Radnor, PA: Chilton; London: A & C Black, 1994.

Wood, Nigel. *Chinese Glazes: Their Origins, Chemistry, and Recreation.* London: A & C Black; Philadelphia: University of Pennsylvania Press, 1999.

———. *Wood Firing Journeys and Techniques: A Collection of Articles from* Ceramics Monthly. Westerville, OH: American Ceramic Society, 2001.

Zakin, Richard. *Electric Kiln Ceramics: A Potter's Guide to Clay and Glazes.* 2d ed. London: A & C Black; Radnor, PA: Chilton, 1994.

Kilns

Colson, Frank A. *Kiln Building with Space-Age Materials.* New York: Van Nostrand Reinhold, 1975.

Gregory, Ian. *Kiln Building.* London: A & C Black; Oviedo, FL: Gentle Breeze, 2001.

Olsen, Frederick L. *The Kiln Book: Materials, Specifications, and Construction.* 3d ed. Iola, WI: Krause, 2001.

Rhodes, Daniel. *Kilns.* Radnor, PA: Chilton, 1983.

Rice, Prudence M., ed. *The Prehistory and History of Ceramic Kilns.* Vol. 7. Westerville, OH: American Ceramic Society, 1997.

Zakin, Richard. *Electric Kiln Ceramics: A Potter's Guide to Clays and Glazes.* Radnor, PA: Chilton, 1994.

Extruders

Baird, Daryl E. *The Extruder Book.* Westerville, OH: American Ceramic Society, 2000.

Conrad, John. *Ceramic Extruders for the Studio Potter.* San Diego, CA: Falcon, 1998.

Latka, Tom and Jean Latka. *Ceramic Extruding: Inspiration and Technique.* Iola, WI: Krause, 2001.

Pancioli, Diane. *Extruded Ceramics: Techniques, Projects, Inspirations.* New York: Lark/Sterling, 2000.

Mold-Making, Slip-Casting, Pressing-Clay

Chavarria, Joaquim. *Ceramic Class Molding Techniques.* New York: Watson-Guptill, 1999.

Clayton, Pierce. *Clay Lover's Guide to Making Molds.* New York: Sterling, 2000.

Colclough, John. *Mould Making.* London: A & C Black; Oviedo, FL: Gentle Breeze, 1999.

Frith, Donald E. *Mold Making for Ceramics.* Iola, WI: Krause, 1992.

Harvey, Reid. *Press Ceramics with Air Release.* Oviedo, FL: Gentle Breeze, 1993.

Martin, Andrew. *The Definitive Guide to Mold Making and Slip Casting.* San Rafael, CA: MAGUS Art, 1999.

Swant, Dale. *How to Pour Ceramic Molds.* Livonia, MI: Scott, 1997.

Wardell, Sasha. *Slipcasting.* London: A & C Black, 1997.

Specialized Techniques

Byrne, Michael. *Setting Tile.* Connecticut: Taunton, 1996.

Cowley, David. *Molded and Slip Cast Pottery and Ceramics.* New York: Scribner's, 1973.

Frith, Donald E. *Mold Making for Ceramics.* Radnor, PA: Chilton, 1985.

Giorgini, Frank. *Handmade Tiles: Designing, Making, Decorating.* Asheville, NC: Lark, 1994.

Herbert, Tony, and Kathryn Huggins. *The Decorative Tile in Architecture and Interiors.* United Kingdom: Phaidon; San Francisco: Chronicle, 1995.

Hilliard, Elizabeth. *Designing with Tiles.* New York: Abbeville, 1993.

Khalili, Nader. *Ceramic Houses: How to Build Your Own.* New York: Harper & Row, 1986.

Kosloff, Albert. *Ceramic Screen Printing.* 2d ed. Cincinnati, OH: The Signs of the Times, 1984.

———. *Photographic Screen Printing.* Cincinnati, OH: The Signs of the Times, 1972.

Whitford, Philip, and Gordon Wong. *Handmade Potter's Tools.* New York: Kodansha, 1986.

Restoration

Acton, Lesley, and Paul McAuley. *Repairing Pottery and Porcelain.* New York: Lyons & Burford, 1996.

Williams, Nigel. *Porcelain Repair and Restoration.* 2d ed. Philadelphia: University of Pennsylvania Press, 1983. Philadelphia, PA 19104-4011.

Careers and Presentation

Abbott, Susan, and Barbara Webb. *Fine Art Publicity: The Complete Guide of Galleries and Artists.* Stamford, CT: Art Business News Library, 1991.

Collins, Sheldan. *How to Photograph Works of Art: A Practical Guide.* New York: Amphoto/Watson-Guptill, 1992.

Crawford, Tad. *Legal Guide for the Visual Artist.* 4th ed. New York: Allworth, 1999.

DuBoff, Leonard D. *The Law (In Plain English) for Crafts.* 5th ed. New York: Allworth, 1999.

Grant, Daniel. *The Artist's Resource Handbook.* New York: Allworth, 1996.

Ito, Dee. *Careers in the Visual Arts: A Guide to Jobs, Money, Opportunities, and an Artistic Life.* New York: Watson-Guptill, 1993.

Kadubec, Philip. *Crafts and Craft Shows: How to Make Money.* New York: Allworth, 2000.

Health and Safety

Arena, J. M., M.D. *Child Safety Is No Accident.* Rev. ed. New York: Berkeley Press, 1987.

Barazani, Gail Coningsby. *Ceramics Health Hazards.* Rev. ed. Occupational Safety and Health for Artists and Craftsmen, 1984.

Center for Occupational Hazards. 5 Beekman St., New York. *Ventilation Handbook for the Arts.* New York: Center for Occupational Hazards, 1984.

Ceramic Guidelines. Appendix to ASTM C1023, American Society for Testing and Materials, 1916 Race St., Philadelphia, PA 19103.

Cutter, Thomas, and Jean-Ann McGrane. *Ventilation: A Practical Guide.* New York: Center for Occupational Hazards.

Data Sheets from the Art Hazards Project, Center for Occupational Hazards: *Ceramics, Respirators, Silica Hazards.*

McCann, Michael. *Artist Beware! The Hazards and Precautions in Working with Art and Craft Materials.* New York: Lyons & Burford, 1992.

———. *Health Hazards Manual for Artists.* New York: Nock Lyons Books, 1985.

Occupational Health Guidelines for Chemical Hazards. Cincinnati: NIOSH, 1981.

Perry, Rosemary. *Potter's Beware.* Booklet available from Rosemary Perry, 865 Cashmere Rd., Christchurch 3, New Zealand.

Rossol, Monona. *Ceramics and Health.* Articles compiled from Ceramic Scope. New York: Center for Occupational Hazards, 1984.

———. *Keeping Clay Work Safe and Legal.* 2d ed. Monona Rossol in cooperation with the National Council on Education for the Ceramic Arts, 1996.

Safe Practices in the Arts and Crafts. A Studio Guide. New York: College Art Association of America, no date.

Seeger, Nancy. *A Ceramist's Guide to the Safe Use of Materials.* Chicago: School of the Art Institute of Chicago, 1984.

Qualley, Charles. *Safety in the Artroom.* Worcester, MA: Davis, 1986.

Note: This list includes only a few of the books and pamphlets that are available on the subject of health and safety. New material appears frequently. Up-to-date information lists are available through the Art Hazards Project of The Center for Occupational Hazards, 5 Beekman St., New York, NY 10038, as well as local chapters of the American Lung Association.

VIDEOS

Most ceramic supply distributors now carry videos in their catalogues, and ceramics magazines review them. Check these for current availability.

Kalkspatz e V, a German potters' association (a member of the Studio Potter Network) has published an international catalog of over eight hundred films and videos in the ceramics field. Kalkspatz e V, Waldstr. 11, 0-2721 Lenzen, Germany.

Art on Video carries videos on all phases of the arts and crafts. For a catalog, write to: Art on Video, 12 Havemayer Pl., Department NY5, Greenwich, CT 06830, (203) 869-4694.

A large selection of books and videos is available from The Potter's Shop, 31 Thorpe Rd., Needham Heights, MA 02194, (617) 449-POTS.

WEBSITES

The Internet provides information on almost every aspect of ceramics from health and safety to glazes and wood firing. There are bulletin boards, newsletters, and chat groups. The following list is not complete but suggests a few sites where you can start to search.

http://www.ceramicsoftware.com/index.html
Information on clay, glazes, firing, toxicity, materials, books, people, events. Glossary, newsletter access, links to clay sites. Run by Tony Hansen, author of INSIGHT glaze calculation software. The site lists potters familiar with INSIGHT for help on troubleshooting glazes.

http://www.apple.sdsu.edu/ceramicsweb/ceramicsweb/
Archive of Clayart messages, glaze database, clay links, and interactive glaze analysis program by Gary Wang. Run by Richard Burkett, cofounder-author of Hypertext glaze calculation software for Macintosh.

http://www.potters.org/categories.html
Archive of discussions on Clayart, categorized by subject for ease of reference.

http://ceramics.miningco.com/blgazes.html
Information on ceramic artists, techniques, books, societies, educational institutions, and links to other clay sites.

http://members.aol.com/babsdeluxe/ceramics.html
Information on clay and glazes, ceramics materials, manufacturers, magazines, potters, with links to all.

http://www.arts.ufl.edu/nceca
Home page of the National Council on Education in the Ceramic Arts.

Index

Page numbers are in *italic type* for illustrations; page numbers in **boldface type** denote glossary entries.